Vermeer

Vermeer

Albert Blankert
John Michael Montias
Gilles Aillaud

Overlook • Duckworth
New York • Woodstock • London

This edition first published in the United States in 2007 by
Overlook Duckworth

NEW YORK:
The Overlook Press
141 Wooster Street
New York, NY 10012

WOODSTOCK:
The Overlook Press
One Overlook Drive
Woodstock, NY 12498
www.overlookpress.com
[for individual orders, bulk and special sales, contact our Woodstock office]

LONDON:
Duckworth
Gerald Duckworth & Co. Ltd.
90-93 Cowcross Street
London EC1M 6BF
www.ducknet.co.uk

Library of Congress Cataloging-in-Publication Data

Blankert, Albert.
Vermeer.

1. Vermeer, Johannes, 1632-1675. 2. Painters—Netherlands—Biography.
I. Aillaud, Gilles, 1928–2005 II. Montias, John Michael, 1928–2005.
ND653.V5A8713 1988 759.9492 88-42706

Design augmentation and type formatting by Bernard Schleifer
Manufactured in Singapore
10 9 8 7 6 5 4 3 2 1
ISBN 978-1-58567-979-9

Contents

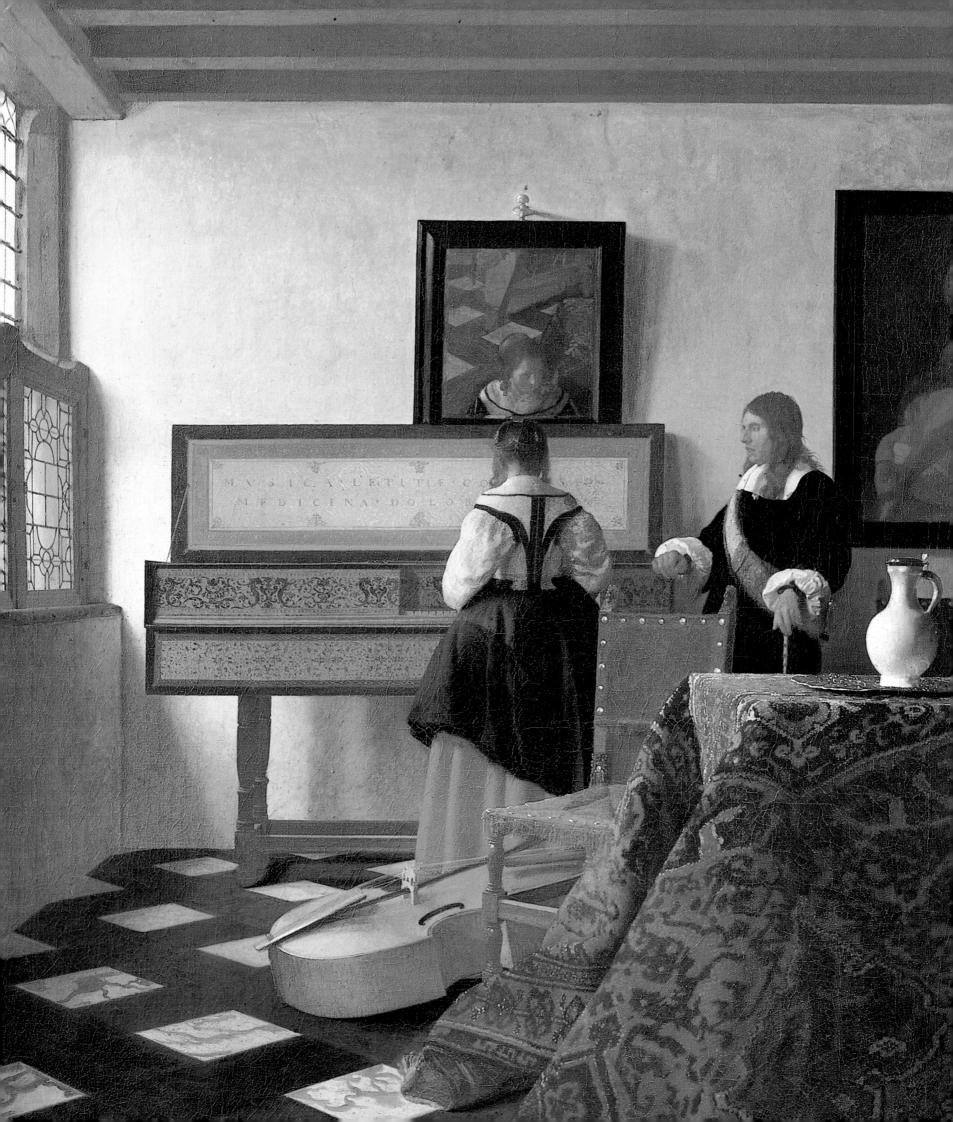

The Hidden Eye

Gilles Aillaud

Detail from *The Music Lesson* (plate 16)

I RECALL THE OCCASION, more than thirty years ago, when the Bestegui bequest was presented to the Louvre. The stage director, master of ceremonies, in fact the curator, had organized the event to perfection.

At the far end of the gallery stood a figure, the marchioness of Solona in Goya's full-length portrait, clad in a long black dress with a transparent white shawl, hands resting one on the other, posed on what appeared to be cardboard cut-out battlements above a dark and ravaged plain.

Portraits of ladies and gentlemen painted by Ingres were ranged in rows along each side of the gallery, their attitudes and expressions extraordinarily true to life—a veritable waxworks exhibition. It was like a collection of pressed flowers assembled by some master criminal, a savage hunt scene done by an incomparable draftsman, mercilessly laying these people bare, dragging them out of the muddy waters of life and using his pencil of steel to render them nakedly visible. These portraits presented their specimens with clinical precision, in the manner of botanical or zoological slides, without evasions, while the marchioness, reticent, seemed to remain in their presence only under duress, anxious to be gone.

The paintings of Vermeer are like this marchioness of Solona flanked by her bequest. They stand in isolation from the profusion of minutely detailed works by contemporaries, and, although carefully thought out, images of calm amid the storm, they are as fresh as if they had just been dashed off at high speed, their presence provisional and fleeting, as if they still had the freedom to stay or to go, elusive—it would seem—even to André Malraux.

In that presence there is a power that comes from the center of things, exerting pressure on the contours, however precise, and making them secondary, fluid and blurred, tentative, even tangential; whereas with Ingres, the outline of things is always more visible than the center.

And these things declare themselves with tact. Reserved, silent, exclusive, they are definitely things, not mere objects. That tact is Vermeer's hallmark.

The distinctive character of his painting made it inaccessible to his contemporaries. Quite unlike Rembrandt, or even Franz Hals, Rubens, or Velasquez, all of whom became famous in their lifetimes, it took Vermeer some while to discover what he wanted. He painted a small number of pictures in a short space of time, and then was gone, as they say, prematurely, without anyone paying great attention.

A singular achievement to paint so few pictures, among them such a high proportion of failures! A certain parallel exists with the poetry of Gérard de Nerval. How is it that two or three great sonnets contrive to suggest an exceptional poetic *oeuvre*?

> *Sainte napolitaine aux mains pleines de feux,*
> *Rose au coeur violet, fleur de sainte Gudule.*
> (Neapolitan saint with hands full of fire,
> Rose with violet heart, flower of St. Gudula.)

It is as though there is nothing more to say about a thing except to call it by other names. And yet what poetic power there is in that, finding no words to describe the beloved except to list her attributes. Each detail implies the whole, and in effect subsumes it. Metonymy can be the most abbreviated and slightest of metaphors, a metaphor that as it were fails to take flight—like a self-vaccination, the injection of a little more of the same.

Some such secret process is at work within the paintings of Vermeer. As in those convex distorting mirrors that you occasionally see, reality is both miniaturized and extended. Made smaller but more intense, mysteriously transformed yet still quite literally itself.

Vermeer paints what is most overt and most accessible. The appearance of that which is most apparent. Ordinary, peaceful domesticity, the infinity of days and moments in which nothing, or almost nothing, happens. He is, in short, the perfect example of what Pascal had in mind when he coined his famous aphorism: "What vanity is painting, which

wins admiration for its resemblance to things, the originals of which one does not admire in the least." And Vermeer somehow contrives not to interfere; he allows things to speak for themselves. He reveals what is open to view.

But does not that give rise to a suspicion? Is it not perhaps all just a little too obvious, too peaceful, too domestic, too familiar? For that which is open to view also attracts the least attention, and may in fact conceal the most closely guarded secret of all. One subtly disguised by its very obviousness so that it needs to be freed from its appearance in order to be seen.

To insist on being painted, a thing needs to have a *kind of significance*, something above and beyond its purely visual attributes. We may borrow Joyce's term and call that something an epiphany. The epiphany is an intentification of power, and, although there is nothing visual about it, it is also an illumination, like the surge that follows the boosting of an electric current. It is this illumination that lends the vision intensity. Of course, the epiphany of a thing is a function of the thing itself, but it is not always present; it can be inhibited (by, for example, an oversubjective vision), or, on the other hand, it may be left alone and allowed to emerge of itself.

This "letting alone" is not easy; it demands not only acute concentration but also an equal measure of relaxation, since the energy expended in achieving the effect must then be dissipated if it is not to form a barrier. It is in the channeling of this energy which has the power to disperse itself that Vermeer's so-called "creative" effort consists.

The high price to be paid for the particular sortlof fidelity involved in "letting things be" is demonstrated all too clearly by a painting such as *Allegory of Faith* (plate 31), a picture in which nothing works. No element is lacking, and yet there is nothing there. It could almost be a painting by Gustave Moreau.* An overweight girl with badly painted toes, swooning decently away in a room full of furniture.

For "faith," like any abstraction, is of a different order of reality from the things of this world. In the calm, clear light of day, the light of our world, the myth of divinity seems an insane interjection, an insult to the materiality of things.

"Faith" is a concept that implies a divided universe. For faith to be represented, the scene needs to be illuminated by a light that is not of this world. When Rembrandt paints an object, a thing, that thing ceases to be purely and simply itself; it occupies a position, it serves a function within the scene. Its presence is theatrical. An otherwordly light irradiates the picture's night. In this spiritual universe, no dimension is excluded, all parallels and contrasts are possible.

Vermeer's light is never otherworldly; in no way would it be capable of transporting us to another sphere. Rather, it plainly states that this world of ours is the only one there is.

Sometimes the *View of Delft* (plate 10) seems to me so beautiful that it is as if it did not exist as a painting, but that instead a window had been opened into the museum wall. A real window revealing a scene in comparison with which all the other pictures in the gallery, Rembrandts included, pale into insignificance, crude copies.

Not that "allowing things to speak for themselves" or "letting them be" necessarily rules out a directorial viewpoint. Unlike *Allegory of Faith*, *The Art of Painting* (plate 19), sometimes known as *The Allegory of Painting*, is a picture that functions perfectly precisely because it is not an allegory. It is a studio scene, the backstage world of the allegory: what goes on in the actor's dressing room rather than on the stage. The amusingly overelaborate dress of the painter, seen from behind as he starts his picture by painting the laurel crown, that is directorial comment, as too is the way the girl poses with an air of mockery and greedy complicity.

An element of direction, of active intervention, is almost always necessary. Letting things be is not the same as being open to all suggestions, putting down at random everything that offers itself. Things are enveloped in the cloud of dust raised by our own activity, or, like the scaly monster's skin in some old tale, are covered with the concretions of chance events, which hide them from view. A patient process of exploration and identification is necessary. It is a task in which Vermeer engages constantly, investigating forms and light. It is not a matter of extracting a quintessence, some rare and precious kernel from the dross of appearances, but of stripping each thing of all that does not belong to it and may therefore confuse. In comparison to the works of Pieter de Hooch and the other Dutch painters, Vermeer's paintings have a purified atmosphere; they are, in the literal chemical sense of the term, freed from the pollution of our overpopulated world.

* One needs to know how to look at a picture, and understand that works of art are never to be likened in terms of their technical similarities, but in terms of the spirit that inspires them.

It is the freshness that comes after the rain, combined with a simple geometry of rectangular forms, imparting to everyday life an emblematic quality, making it in every sense an emblem, a bright sharp pattern, an inlaid heraldic device, a badge of significance. And the significance it embodies is the restored unity of the material and the spiritual, as it once existed in an undivided world.

A woman reads a letter, another writes one. Where in that is the materiality of things? What is present that would not have appeared in a Rembrandt, or, what is absent that he would have included?

In Rembrandt, as in a novel, we would be attracted by the action, and we would want to find out what the woman was reading or writing. The painter would encourage us to participate. Our attention would be concentrated on the character of the woman, and the rest of the picture would dissolve away into darkness.

In Vermeer, this woman is not a character out of a novel. The materiality of things is expressed in the concentrated silence of her rapt absorption, which subsumes spiritual reality, enfolding it in a silence it would be unthinkable to disturb, and which at the same time heightens the surrounding presence of things, themselves silent, but different, guarding the woman's silence with their own. Silence shrouded in silence. Vermeer renders the domestic, everyday surroundings in all their detail, but it is as though they have fallen into disuse. In *Writing Lady in Yellow Jacket* (plate 22), in which the woman's eyes are fixed on some point in the empty air, it is not the nature of her task or her attitude that is stressed, but her struggle to find the right word; that effort detaches her from her surroundings, with the result that we become sharply aware, in turn, of the pearl necklace lying by the sheet of paper, the black of the ink in the inkwell, and the studs of the chest gleaming in the shadows. The point in the empty air on which the woman's gaze is fixed is that occupied by the beholder, who, poor innocent, feels he is being watched, and begins to wonder why.

Vermeer has been criticized for his lack of psychological penetration, ignoring the fact that all his efforts, herculean in their intensity, were devoted precisely to eliminating psychology, cleansing the fleeting moment of everything extraneous, of what would ensue as well as what went before, all the strands of experience. Whatever the superficial resemblance, his pictures are fundamentally different from the so-called genre scenes of the other Dutch painters.

For Vermeer paints time—not Proustian time, which seethes with activity, ramifying and meandering, time that abuts on and mingles with everything it meets in its course, but time that is in the act of passing, the infinitesimal moment in which a thing exists, static and monumental, as a presence. Time that is isolated from future and past, but possessed of duration in the present and possessed of an appearance-its duration, like its appearance, belonging to itself.

Through his unswerving concentration on appearances, Vermeer succeeds, perversely, in making visible something that is invisible. That is the enigma. It is more a question of sheer mental energy than any particular intelligence or foresight.

Things are separate from each other. That is the universal law. It is why language must be poetic, or in other words, transferred, if it is to speak a truth. In Vermeer's hands, the distances shrink. Things are brought closer together. closer to the primal state of unity. The compact fruit grows of itself, no one has thinned out the blossoms. The picture comes to fruition without the distractions of inspiration.

He could paint only what he liked.

Although he used the convention of the "black box," he seemed never to exaggerate, never to invent, still he did not have the objective eye of the photographer, equally interested in or indifferent to every aspect of reality. He concentrated on just a few things, always the same.

Two or three different women, captured or entrapped in a perpetual afternoon (because they are themselves their own time), and captured or entrapped also within themselves, opaque, as if reabsorbing their own intensity, which has no other outlet.

Jours devenus moments, moments filés de soie.
(Days become moments, moments spun of silk.)

Such is the nature of time in Vermeer's paintings: the stillness of an instant, the eternity of the ephemeral. The transparent present, bereft of future heroism or past majesty.

Cézanne said: "A minute in the life of the world passes, paint it as it is."

Droplets of light cling to the surface of things, drawn as by a magnet, as though seeking to find some tiny seam, some invisible crack, by which to penetrate—in vain. The door is sealed, and all around is pitch black.

Outside is the void, inside plenitude.

Emblems of contented toil, pearls of sweat cover the skin in an iridescent veil, marking the separateness that is the condition of human beings in their life together, their only point of contact a caress.

Lips parted with the effort of a slight breathing impediment, because the nasal passages are congested with hay fever; a sheen of mucus on the lips; eyes set forward in the head, slightly bulging, their prominence almost an impairment of vision. All these intimate details are painted without a hint of sensual indulgence, with a stern but becoming decorum in the face of physical attraction. It is a miracle of tact, of finding the right tone of voice.

This lack of duplicity in his reactions to what he sees, this refusal to temper reality in the resulting work of art, these are not Catholic responses—rather the reverse. Vermeer's unwillingness to compromise in this respect, in fact, reflects a typically Protestant rigor.

The indecent decency, the decent indecency of sincere feeling. If pleasure is the only true measure of feeling, then it is pleasure that will govern where the emotions light, inflexible in its rule as justice itself.

Yet surprisingly there are a few exceptions, even in the narrow compass of this restricted *oeuvre.*

Sometimes—who can say why?—perhaps because he did not want to indulge his own prejudices, or be rude, he would, out of humility or weakness, or because he needed the money, paint an unknown woman who did not appeal to him, a woman of a type other men might find attractive, like for example that rather ordinary woman with narrowed eyes who is to be seen in London, standing before her spinet. In themselves these pictures have no particular interest, but they do have the great merit of demonstrating the extent to which this materialist painting was in fact the most arduous form of spiritual exercise. There could be no shortcuts, no deviations. And that is why, even though he painted few pictures, not all are successful. It also explains why Vermeer's technical brilliance was so sensitive to the least hint of compromise.

The failures are not beautiful pictures, but there is something admirable about them.

All too often they are regarded as evidence of some lack of ambition or lowering of standards, and even Merleau-Ponty himself spoke, in regard to Vermeer, of "discordant details dashed off by his brush through fatigue, circumstance or self-imitation." Yet for the most part the failures are actually the proof of courage, an almost reckless audacity. Vermeer attempted the impossible, and refused to accept defeat. With *Allegory of Faith* he thought he could make it work, bring off the gamble of painting something he himself did not believe in (which is audacious to the point of stupidity), and so, with dogged persistence, he put the very best of himself into the work.

Most of the failures are in fact heroic defeats. One can well understand why Bonnard always had a particular affection for his own failed pictures.

A painting (like any other work of art) is not a systematic and coherent whole. The pace of its execution will vary from fast to slow. There are passages that must be right the first time, others that can be reworded, blurred over, tinkered with—in a word, polished. Sometimes these different sections quarrel with each other, and then it is practically impossible to subdue the discordant multiplicity—which is why even the finest of paintings will always end up, more or less felicitously, with something awry.

If, as Leonardo da Vinci said, it is "a sad pupil who does not overtake his master," then the man who would be accounted a great master will have no pupils, is in fact unable to have pupils, since he knows there is nothing he can teach them. He knows that what he has in himself is useless to anyone else, because it simply *happens,* it has no foundation, no discipline, no logic: an overwhelming bounty and at the same time a failing. In short, a great master is the painter who is no master at all.

Like Spinoza, Vermeer never taught. He settled instead for painting better than the rest. Undoubtedly he knew his true worth, but also understood it was nothing to boast of, success being quite literally a gift, the result

of chance or necessity, or something, at any rate, quite outside our human ken. No doubt he believed, like Spinoza, that everyone should be free to think and act "according to his complexion," and consequently that anyone who wished to teach should have the opportunity to do so, but "at his own risk and cost."

He must above all have agreed with Spinoza in thinking that time was too short to squander. Like the rose of Angelus Silesius's poem, Vermeer "asks no whys."

> *La rose est sans pourquoi, fleurit parce qu'elle fleurit.*
> *N'a souci d'elle-même, ne désire être vue.*
> (The rose asks no whys, blooms because it blooms,
> Careless of itself, cares not to be seen.)

It was certainly no chance, that extraordinary ability he possessed to pass unnoticed by his contemporaries-causing no stir, no scandal, invisible as if he simply belonged to another century, another species altogether.

The astounding beauty of Vermeer is like the beauty of the rose, a phenomenon of nature, a manifestation of necessity. Perhaps there were in fact two quite different sides to the man?

On the one hand, innocent, irresponsible, a holy fool; on the other, as painstaking, methodical and hard-working as the average citizen.

Success, whether it be miracle or necessity, does not depend on us, any more than in Calvinism is grace dependent on the purity of the individual soul. In vain do we strive to be without sin. Grace falls where it may. Perhaps it is not even God-given–for where is God to be found in these cloudless skies?

That is the harsh, implacable logic underlying all this unruffled serenity.

In many ways it is reminiscent of the intolerable tolerance we find in Spinoza. Indeed Vermeer could be Spinoza's brother, only blond, rather less impassioned. The odor of sulphur and damnation apart, their fates were not dissimilar.

After being ignored in his own time,* Vermeer was obliged to submit posthumously to the insult of being "discovered" by the bourgeoisie of the 1880s, who saw in him the very apotheosis of their own ideals. One cannot help thinking, how is it possible that he remained unrecognized, indeed unseen, for so long, only to become the darling of the most appallingly philistine public that ever existed—for, make no mistake, although great painters like Renoir and the other Impressionists admired Vermeer, it was those very same worthy bourgeois who abominated Renoir who were in raptures over Vermeer. His pictures were so popular that people hunted for them everywhere, and numbers of fakes were produced, each last more crude and ridiculous than the one before. How could this possibly have happened?

The point about Vermeer is that it is all so easy. It is beautiful and not in the least bit disturbing. It makes no demands and it does not set out to shock. The most inimitable of painters is, as it happens, a model of decency and respect for others. You could equally apply to him what Nietzsche once said of a Socratic dialogue: "His banality masks his depths, but his depth makes you forget his banality."

It is of course also true that all old painting bears the patina of use, and so soothes those people who cannot confront reality unless it is blurred by a mist of time. But in that case, why single out Vermeer, whose work even in our time is so sparklingly fresh and clear that it could have been painted yesterday?

In his lifetime, no one saw anything in his pictures; in his death, his very qualities have worked against him.

*In his lifetime Vermeer was a well respected painter. but practically unknown outside his native town of Delft. After his death, for more than a century and a half his work was regarded as part of the generality of Dutch painting—justifying claims by some historians that he was not in fact forgotten.

Quite simply, his paintings were regarded as indistinguishable from those of his compatriots. His individuality was not recognized until the second half of the nineteenth century. "The first person who can be said to have introduced Vermeer to a wider public was the French critic Thoré-Bürger." (Wheelock)

But, whatever the merits of that scholarly exile, this was not the blinding revelation of a lone prophet, his message falling on deaf ears among his contemporaries. Thoré-Bürger's articles, published in 1866, were influential precisely because they were timely, the first symptoms of a shift in public opinion destined to gain momentum and finally reach full force some twenty years later, in the 1880s—a period in which the "enlightened" public still execrated the Impressionists.

Vermeer's reputation reached its height at the dawn of the twentieth century. With the death of Ruskin, and the expiry of Proust's Bergotte before a little patch of yellow wall, canonization was a mere formality. Henceforth Vermeer was admitted definitively to the select company of the Olympians, and for the twentieth century, led by Malraux, all that has remained to do is seek further illumination of his genius.

Detail from *The Art of Painting* (plate 19)

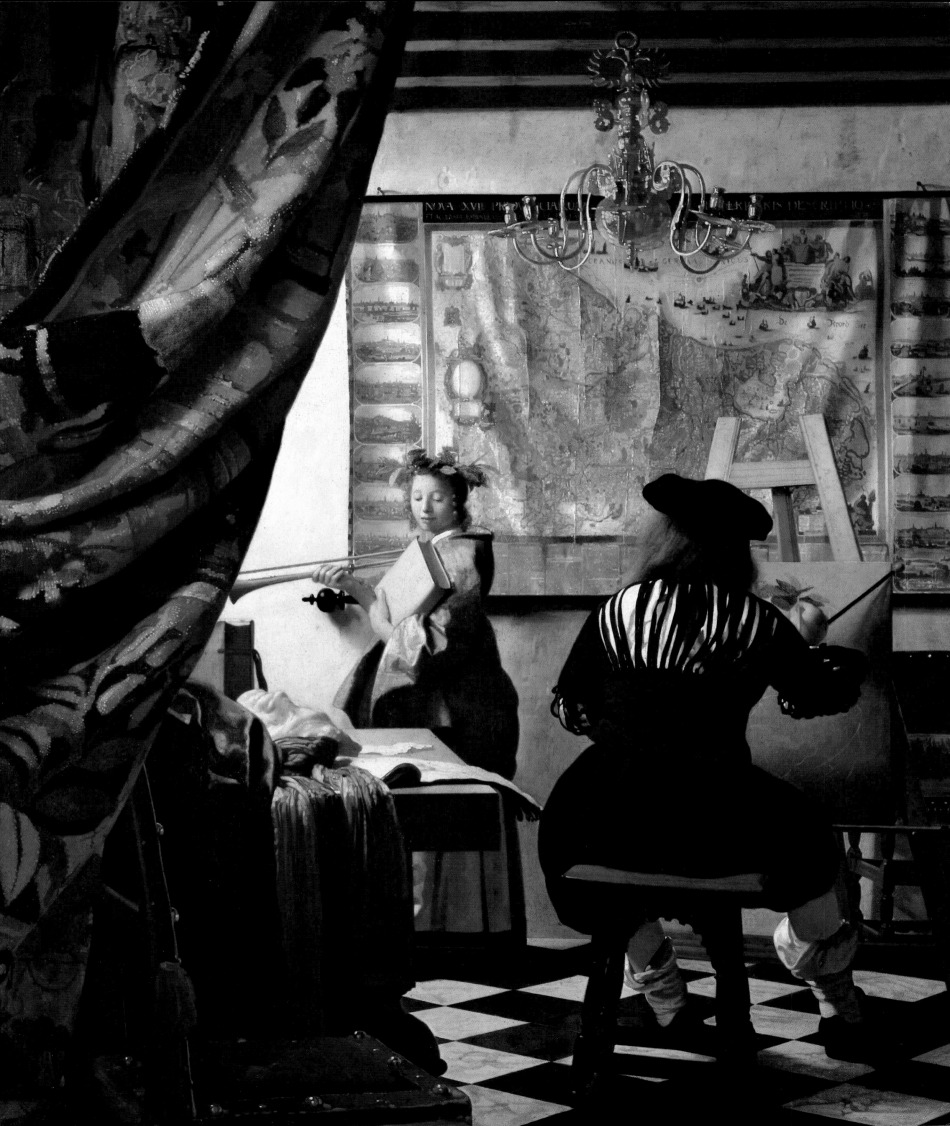

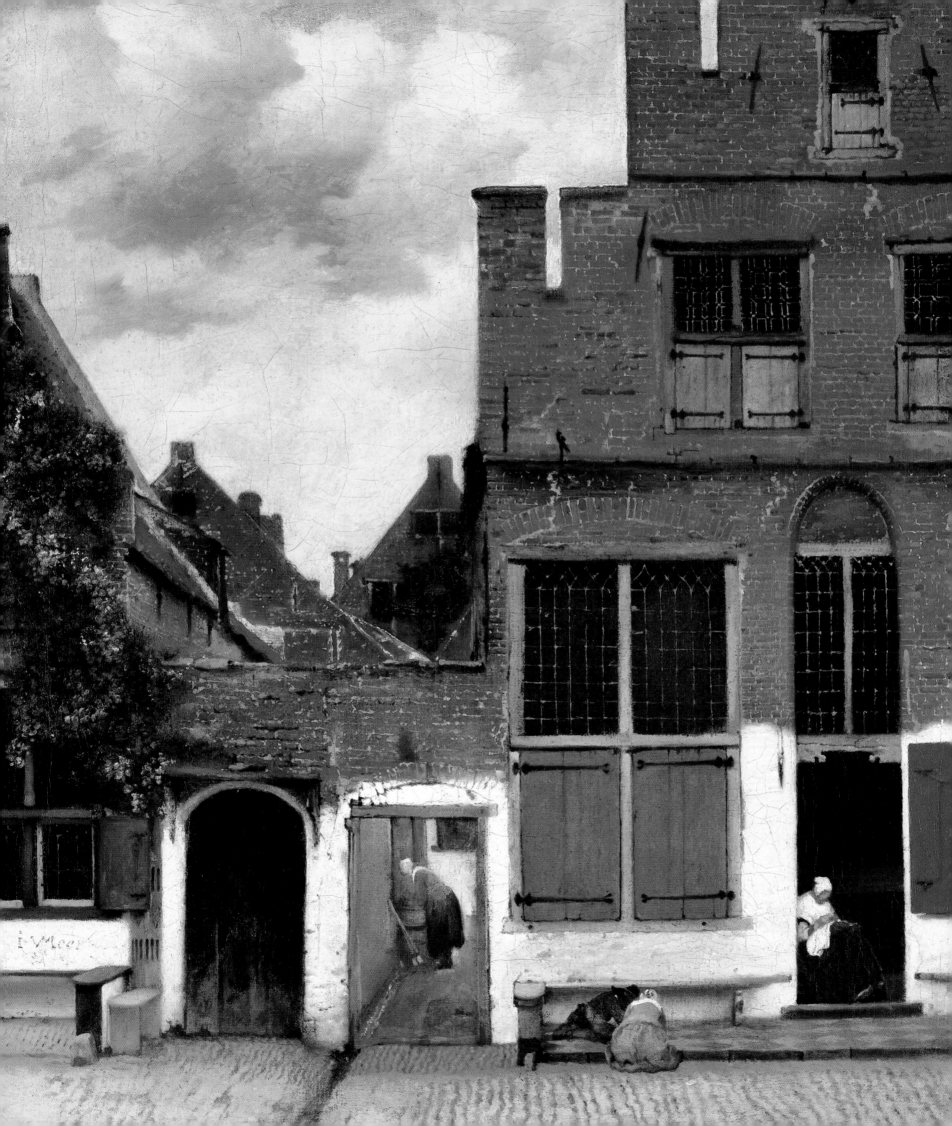

Chronicle of a Delft Family

John M. Montias

Detail from *The Little Street* (plate 9)

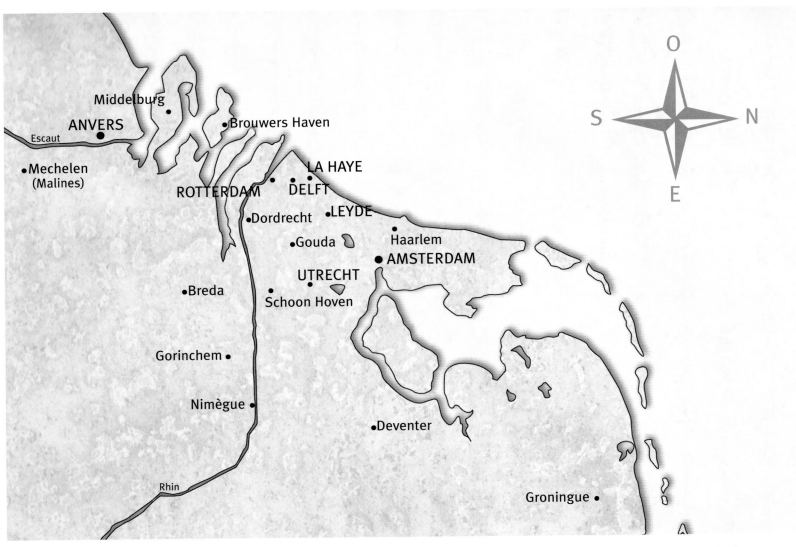

1. The Netherlands in the 17th century. Unlike modern maps, the orientation of 17th century maps of the Netherlands was shifted, North corresponding to the right side of the map, and West, naturally, to the top.

DELFT IN REVOLT IN THE LATE SIXTEENTH CENTURY

BEFORE THE REFORMATION, Delft was a small town with a homogeneous culture and religion. By the end of the sixteenth century it had grown into a major center, populated by Calvinists and Catholics, where emigrants from Flanders and Brabant in the south lived side by side with people native to the region. Vermeer himself was at the heart of these religious and political crosscurrents: his maternal grandparents came from the south, from Antwerp, while his grandparents on his father's side were almost certainly from Delft itself. Although born into a Calvinist family, he is believed to have converted to Roman Catholicism when he married a Catholic. For a proper understanding of his life and work it is essential to have an awareness of the conflicting influences that shaped Dutch society from the middle of the sixteenth century up to the period in which he lived.

In Delft, as everywhere else in the southern or northern provinces of the Netherlands under Spanish domination, the years 1550 to 1560 saw the austere doctrines of Jean Calvin gaining widespread support, gradually taking over from Lutheranism and Anabaptism as the leading "heretical" credo. In August 1566 groups of fanatical Calvinists destroyed the holy images in the churches of Delft. Similar instances of iconoclasm occurred throughout the country, and the repression that followed at the hands of the Inquisition

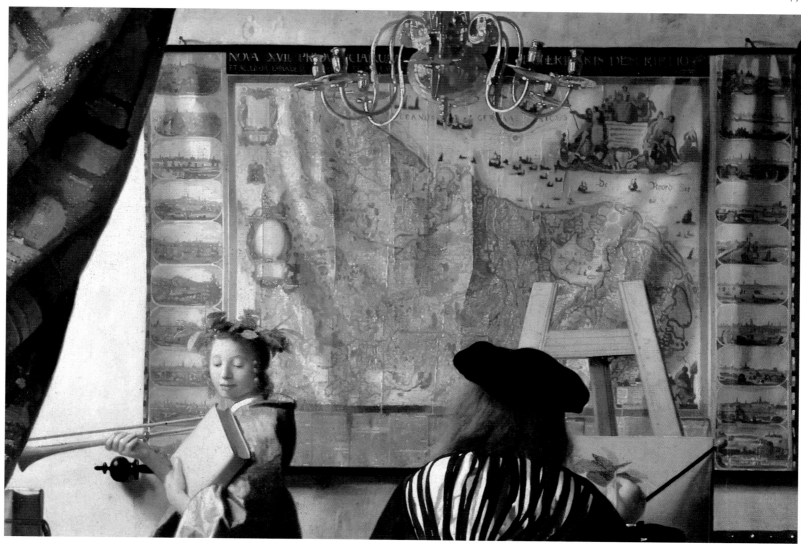

2. Detail from *The Art of Painting* (plate 19)

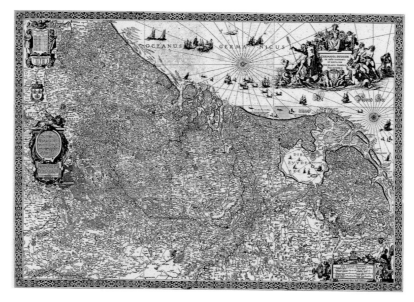

3. Claes Jansz. Visscher (1585-1652) or Nicolaus Claez. Visscher (1618-1679)
Map of the Seventeen Provinces, engraved on nine copperplates. III x 153 cm.
Bibliotheque Nationale, Paris.

4. Detail from *Soldier with a Laughing Girl* (plate 6)

5. Balthasar Floritsz. van Berkenrode:
Holland and West Friesland, published by Willem Jansz. Blaeu.
Westfries Museum, Hoorn

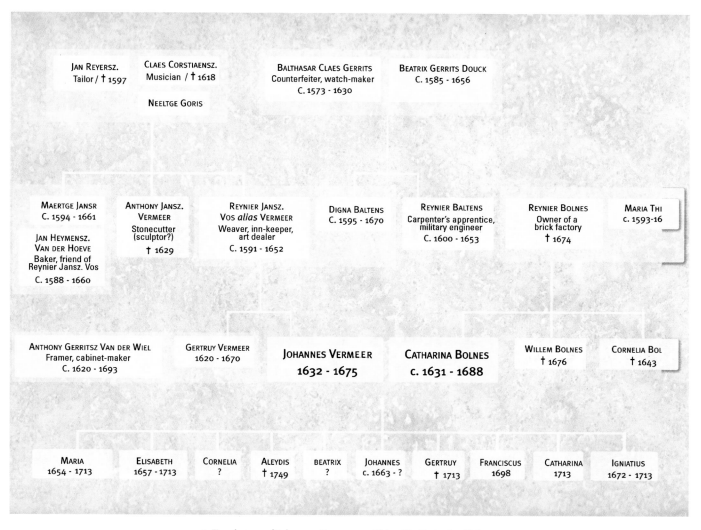

JAN REYERSZ. Tailor / † 1597	CLAES CORSTIAENSZ. Musician / † 1618		BALTHASAR CLAES GERRITS Counterfeiter, watch-maker C. 1573 - 1630	BEATRIX GERRITS DOUCK C. 1585 - 1656		
	NEELTGE GORIS					

| MAERTGE JANSR C. 1594 - 1661 | ANTHONY JANSZ. VERMEER Stonecutter (sculptor?) † 1629 | REYNIER JANSZ. Vos *alias* VERMEER Weaver, inn-keeper, art dealer C. 1591 - 1652 | DIGNA BALTENS C. 1595 - 1670 | REYNIER BALTENS Carpenter's apprentice, military engineer C. 1600 - 1653 | REYNIER BOLNES Owner of a brick factory † 1674 | MARIA THI c. 1593-16 |
| JAN HEYMENSZ. VAN DER HOEVE Baker, friend of Reynier Jansz. Vos C. 1588 - 1660 | | | | | | |

ANTHONY GERRITSZ VAN DER WIEL Framer, cabinet-maker C. 1620 - 1693	GERTRUY VERMEER 1620 - 1670	JOHANNES VERMEER 1632 - 1675	CATHARINA BOLNES c. 1631 - 1688	WILLEM BOLNES † 1676	CORNELIA BOL † 1643

MARIA 1654 - 1713	ELISABETH 1657 - 1713	CORNELIA ?	ALEYDIS † 1749	BEATRIX ?	JOHANNES c. 1663 - ?	GERTRUY † 1713	FRANCISCUS 1698	CATHARINA 1713	IGNIATIUS 1672 - 1713

6. Family tree of Johannes Vermeer and his wife, Catharina Bolnes.

served only to fan the flames of dissidence. In 1567 Philip II sent the duke of Alva to assist the regent, Margaret of Parma, in quelling the mounting rebellion against the dominion of Spain and the Catholic church. The victorious armies of the duke of Alva instituted a cruel and repressive regime in the rebel towns. The prince of Orange, William the Silent, Stadholder of Holland, was by temperament a man inclined to compromise, but he found himself forced to act. Raising an army in Protestant Germany against the duke of Alva, he operated from bases provided by other friendly Protestant princes; on several occasions he crossed the Dutch border but was unable to establish a permanent bridgehead. Affairs took a turn for the better in early April 1572, when the "Sea Beggars" who served under William took the port of Briell. After that, the other Dutch towns fell one by one into the hands of the insurgents. In July the Protestants seized the town hall in Delft and welcomed in the rebel troops led by Lumey. The Peace of Arras, in 1579, established a clear political and religious line of demarcation: seven northern provinces under Dutch domination were to remain Protestant; ten southern provinces, among them Flanders and Brabant, would continue to be subject to King Philip of Spain (although they retained a degree of autonomy) and would remain Catholic (fig. 2). Even so, it took the governor-general, the duke of Farnese, some considerable time to subdue the southern cities that continued to defy Spanish authority. Antwerp fell only after a long siege lasting until August 1585.

Henceforth the only options open to the Protestants in the south were to convert to the Catholic faith or to emigrate. When the insurgents blocked all traffic along the Scheldt,the waterway linking Brabant to the sea, the economic prosperity of the region suffered a sharp decline. Entire populations deserted Flanders and Brabant for religious or economic reasons, or a combination of the two. The road to the north took these

refugees from Antwerp to Amsterdam, via Dordrecht, Rotterdam, Delft, Leiden, and Haarlem. Until then Amsterdam had been no more than a middling-sized town, but in the last quarter of the century it expanded at a furious pace. It was the intended destination of large numbers of the emigrants, since the city had superseded Antwerp as the pivot of the Netherlands' economy and had become an international center for commerce and banking, and a depot for the staples of the world's trade. Some of the emigrants stayed a year or two in the towns they passed through on the way from Antwerp to Amsterdam, before moving on to the new capital. Others established themselves permanently in Delft, Leiden, or Haarlem.

EARLY RECORDS OF VERMEER'S ANCESTRY

Balthasar Claes Gerrits, Vermeer's maternal grandfather, was born in Antwerp about 1573. He was thus about twelve years old when the Spanish captured the town in 1585, and still lived there in 1595 at the time of the birth of his daughter Dingenum, or Digna, Vermeer's future mother. Shortly afterward he left for the northern provinces. We do not know if he stayed in Delft on the way, but he must have arrived in Amsterdam during the closing years of the century. His son Reynier, known as Reynier Baltens, was born there in or around the year 1600.

The first documentary evidence of Vermeer's ancestors in Delft is a deed witnessed by a notary, dated January 1597: a tailor called Jan Reyerszoon relinquished a debt acknowledgment in his possession to a person living outside the town in exchange for cash. Jan Reyerszoon (son of Reyer) was Vermeer's paternal grandfather. The deed was witnessed by a neighbor named Claes Corstiaensz.,* who lived, like him, on the Cattle Market. This was on the site of a very old Franciscan convent, a Catholic stronghold which had been razed to the ground a few years after the Protestants took control of the town. Jan Reyerszoon died four months after cashing his I.O.U. His widow, Neeltge Goris (Cornelia, daughter of Gregory), lost little time in remarrying. In October 1597 she became the wife of Claes Corstiaensz., also a tailor; he was the same neighbor who had witnessed the deed signed by her first husband.

The father of Neeltge's second husband was an emigrant, probably from Flanders, who had arrived in Delft in the middle of the sixteenth century. He had turned his hand to a variety of jobs, and from 1572 was one of the cantors of the reformed church. Claes Corstiaensz. already had one son, Dirck, born in 1582, who took the name Van der Minne on reaching his maturity. We do not know if this was the family's usual patronymic or whether he chose it for himself (a frequent practice in those days for people who had no family name).

Neeltge already had three children from her first marriage: Reynier (Vermeer's father), known as Reynier Jansz., born in 1591; Maertge (little Maria) born in 1594; and Anthony, the youngest, whose date of birth is unknown. The new couple had only one child together: Adriaentge (little Adriana), born in 1599. At ten years of age, Maertge was confirmed as a member of the reformed church. Since Neeltge Goris stated subsequently in a deposition that she too was a member of that religious community, there can be little doubt that all the family were Calvinists, belonging to the established church of the day.

From 1611 on, Claes Corstiaensz. is always referred to in notarial documents as Master Claes, musician (*speelman*). In the inventory drawn up after the death of his son Dirck, six musical instruments are listed— presumably inherited from his father by Dirck, who was himself a hatter. These were: a lute, a trombone, a shawn or pipe, two viols, and a cornet. In all probability they were the instruments played by Claes and his family (the first picture in the inventory of Vermeer's father's effects was of *An Italian Pipe-Player*; probably the pipe was the first instrument he learned to play) (document of 8 December 1623).

*Editor's note: following Dutch usage, we have placed a period after names ending in "z".

In 1611 Reynier Jansz., Vermeer's father, was sent to Amsterdam to learn the technique of weaving caffa (a blend of silk and cotton). His apprenticeship lasted four years, for this was a highly specialized craft demanding a good understanding of design in order to create the complex patterns traditional for that type of cloth. In 1615 he married Digna Baltens, daughter of Balthasar Gerrits, who had arrived from Antwerp some fifteen years earlier. He was twenty-four, she twenty. He wrote fluently, she was illiterate. The young couple soon returned to Reynier's native town of Delft and set up home at the Three Hammers in the square by the Cattle Market (fig. 9). In the meantime, Reynier's sister Maertge had married a baker named Jan Heymensz. van der Hoeve, and his half-sister Adriaentge had become the wife of a butcher, Jan Thonisz. Back. Reynier's brother Anthony Jansz. worked as a sculptor (or stonecutter, for the Dutch word *steenhower* has both meanings), and was married to Trijntge Isbrands (Catherine, daughter of Isbrand). Dirck Claesz., son of Corstiaensz., was in the business of manufacturing hats, which he sold at a stall in the market.

A COUNTERFEITER FOR A GRANDFATHER

With the exception of the stonecutter Anthony Jansz., all the male members of Vermeer's father's family were self-employed craftsmen or shopkeepers, members of guilds, typical products of the lower-middle classes. Their wives kept house and sometimes helped them with their work. When the husband died, his widow would either "take over" or find some other occupation. So, in 1617, after the death of her second husband, Claes Corstiaensz., Neeltge Goris embarked on a career as a mattress-maker, selling feather beds and quilts. On occasion she was also employed to wind up estates, which meant drawing up inventories of the dead person's effects and organizing the sale of his possessions. She also ran lotteries. Burdened by the debts run up by her husband Claes Corstiaensz. between 1611 and 1615 (for reasons that are unclear), she could not permit herself the luxury of idleness.

The likelihood is that Vermeer's maternal grandfather, Balthasar Gerrits, was originally apprenticed to some trade that involved metalwork, probably clockmaking, as that was the occupation he returned to late in life. But when we first meet him in Amsterdam, in 1609, he is working as a clerk, or "merchant's assistant." We know he was mixed up in the shady dealings of a group of businessmen from Antwerp who were speculating in the stock of the East India Company, founded in the early years of the century. One of them went bankrupt and spent sometime in prison for fraud. Gerrits's role was purely that of an intermediary and he gained no personal financial advantage from the affair; in fact he emerged from it virtually penniless.

In 1610 he bought a small house in a poor part of town; two years later the house was repossessed by the Amsterdam authorities because he had failed to keep up his payments on the mortgage. In 1615, as we have already heard, his daughter Digna married Reynier Jansz.; they were to have two children, Gertruy in 1620 and Johannes, the future painter, in 1632. In August 1618, Balthasar sent his son Reynier Baltens to Delft to be apprenticed as a carpenter, a craft that was relatively inexpensive to learn. (The parents of a young apprentice painter, notary, or surgeon would have to pay his master one hundred guilders a year, including board.)

In 1619 Balthasar Gerrits revealed an unsuspected side to his nature when he embarked on a new career as a forger. His first task was to purchase the "instruments of the trade" and have dies engraved for the counterfeiting of the various coins. He summoned his son from Delft to join him in The Hague and act as his assistant; another young apprentice was engaged to work with him. Balthasar was only the foreman; the prime movers in the affair were called Gerrit de Bury and Hendrick Sticke.

De Bury was a businessman with few scruples; Sticke, the silent partner who supplied the funds, was of a higher social class: he was the son of a former burgomaster of Deventer, and his brother Christoffel belonged to an order of knighthood and was Lord of Breems. Hendrick Sticke himself was a representative of the elector of Brandenburg, effectively his ambassador at the States General of the United Provinces. His

brother-in-law Pieter Hoeffijser, director of the "convoys and licences" of the States and one of the most eminent men in Amsterdam, was also mixed up in the affair.

The whole enterprise was short-lived. Offices were rented on the road to Scheveningen, just outside The Hague, in the summer of 1619. A few foreign coins were minted—mostly groschen, which were in circulation in the German principalities. Soon after, in early October, the police arrived and arrested the two young apprentices. Master Balthasar had already escaped to Antwerp, leaving his son Reynier Baltens to languish in prison. Back in Delft, Neeltge Goris and Reynier Jansz., Vermeer's future father, made heroic efforts to help their young relative. In 1620 Reynier Jansz. met de Bury in Amsterdam and told him he had sold everything he possessed, even his own bed, in the attempt to secure his brother-in-law's release. (He might have added that he now had family responsibilities of his own, following the birth of Gertruy, the artist's elder sister.) De Bury's only response was that he hoped to find a safe spot where, with Balthasar Gerrits's help, he could forge some more currency. If he was successful he would be able to reimburse him, and even let him make extra money. Every effort would be made to ensure that Reynier Baltens was freed as soon as possible. Sticke again became party to the plans, putting up the necessary funds so that operations could recommence. Balthasar was summoned from Antwerp. The conspirators assembled at an estate owned by Sticke's mother in the Duchy of Cleves, which was in the territories under the jurisdiction of the elector of Brandenburg. They hoped that work could proceed without fear of intervention from the police of the United Provinces. But only shortly afterward de Bury was arrested in Amsterdam. Under interrogation he eventually confessed the whole plot. Even when tortured—he was stretched on a rack with a weight of two hundred pounds on his feet—he could add little more to his original admissions.

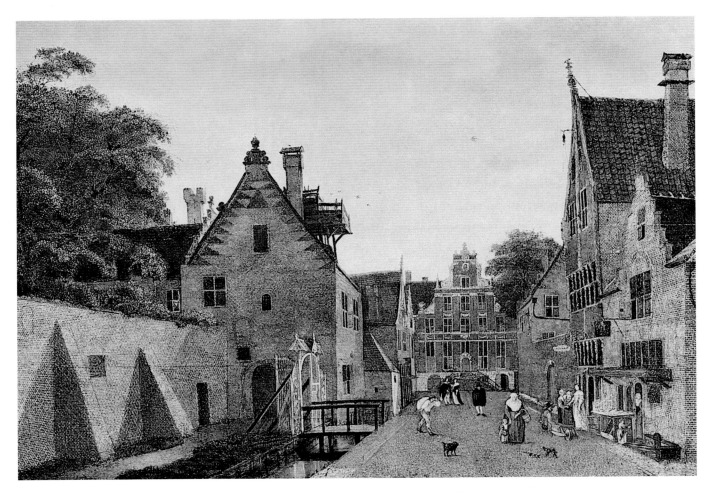

7. Dutch school, seventeenth century: *Street in a Dutch Town.*
Private collection, Paris

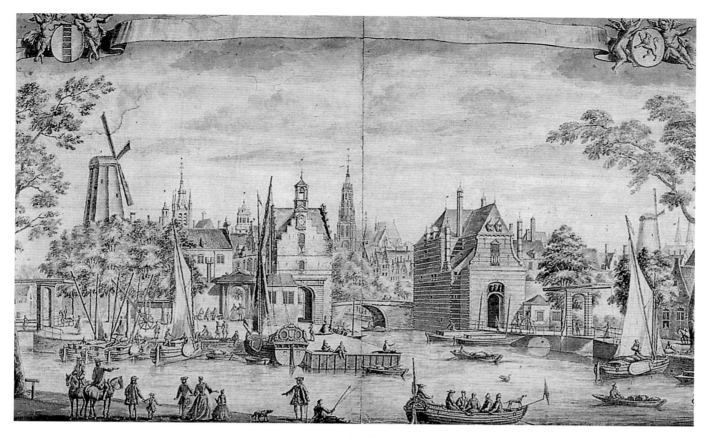

8. Abraham Rademaecker (1675-1735), *View of Delft with the Schiedam and Rotterdam Gates,*
drawing and wash, 66 × 106 cm. Stedelijk Museum, Delft

The conspiracy of forgery was viewed as a serious matter and the matter was taken over by the States of Holland and West Friesland, and ultimately the States General of the United Provinces. Prince Maurice, Stadholder since the assassination of William the Silent in 1584, was also kept informed. The officials decided to arrest Sticke, despite the influence he enjoyed with the elector of Brandenburg, who was an important ally of the United Provinces. The police tracked Sticke down, arrested him, and questioned him until he too confessed to his part in the plot. To fill in the gaps in the testimony, the police summoned Balthasar Gerrits, who had escaped to Antwerp. He was issued a safe-conduct guaranteeing that neither he nor his son would be arrested. At the end of June he arrived in Amsterdam and was interrogated in the presence of Sticke and Gerrit de Bury. The last details of the affair were cleared up over the next few days. The two prisoners were condemned to death by the Amsterdam magistrates, with the consent of the deputy counsellors to the States General of the provinces of Holland and West Friesland. On 8 August 1620 Sticke and de Bury were beheaded, in spite of the elector's appeals for clemency. Balthasar Gerrits returned to The Hague and lived there, in apparent tranquillity, until 1623. In December of that year he went to join his son Reynier Baltens in the town of Gorinchem.

INVENTORY, DEBTS, AND BRAWLS

On the journey from The Hague to Gorinchem, Balthasar stayed for a time in Delft. There he lent his stepson Reynier Jansz. a substantial sum of money—the exact amount was not recorded by the notary. Reynier (Vermeer's father) had an inventory drawn up of all his worldly goods, to serve as collateral for the loan agreed to by his stepfather. The inventory produced by the young caffa-weaver reveals that he lived in fairly comfortable circumstances, in spite of the expenses he had incurred in helping his stepbrother Reynier Baltens three years earlier. He owned 19 small pictures, which the notary's clerk—himself a painter by profession—judged to be worth 2 to 4 guilders apiece (document of 8 December 1623).

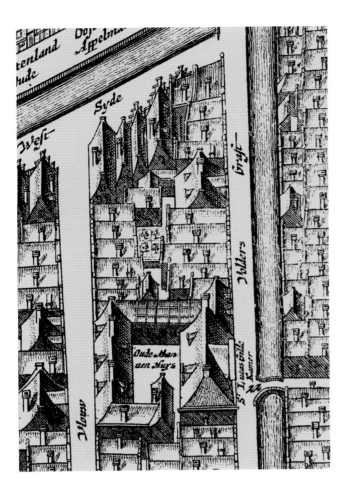

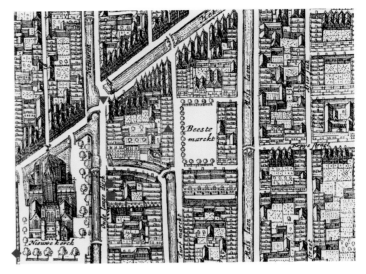

9. J. Blaeu: *Plan of Delft* (detail), Atlas of Delft, 1649, copperplate engraving 37.3 × 48.9 cm.
Gemeente Archief, Delft

● Jesuit church.
■ House of Maria Thins.
▲ The Three Hammers, house of Neeltge Goris and Claes Cortiaensz.
◆ Mechelen, the inn owned by Reynier Jansz. Vos.
▼ Vantage point for *View of Delft* by Fabritius

10. Detail of area around the Flying Fox and Mechelen.

A vase of flowers was valued at 6 guilders (by comparison, a master carpenter earned about one guilder a day at that time). The bed that Reynier shared with his wife was worth, together with the bedding, 60 guilders; the second bed, which probably belonged to his daughter Gertruy, 24 guilders; Digna's coat, 36 guilders; a silk apron, 36 guilders; 8 pairs of sheets, 48 guilders. The total amounted to 693 guilders, of which 7 per cent was accounted for by the pictures. The few references to furniture—not one table is mentionned, for example—and the absence of any equipment used for the weaving of caffa tend to suggest that not all of Reynier Jansz.'s possessions were included in the inventory.

All the goods listed "were transferred with full title to Balthasar Gerrits." However, in response to the urgent appeal of his stepson, Balthasar, "moved with paternal compassion," agreed to allow him enjoyment of the said goods *in precario* (in other words, Balthasar had the right to reclaim possession of his property at any moment he chose). Why Reynier Jansz. should have needed such a loan, we have no idea. One guess is that he wanted to help his mother, Neeltge Goris, whose situation had steadily declined since the affair of the forgery. Her lotteries were a disaster; the principal one was declared invalid by the deputy sheriff of Delft because the permit Neeltge Goris had obtained from the town was not in order. Meanwhile, interest continued to accumulate on the old debts contracted during her husband's lifetime. The baker Jan Heymensz., the butcher Jan Thonisz., and the stonecutter Anthony Jansz. were all three obliged to guarantee further loans taken out by Neeltge Goris. Perhaps Reynier Jansz. in his turn had been forced to come to his mother's assistance. Whatever the truth, their efforts were to no avail. In 1624 their house, The Three Hammers, had to be rented out, and in September 1627 Neeltge died, inundated with debts. The town sold the family house to payoff the creditors. The butcher Jan Thonisz. himself faced financial ruin. When he died in 1632, his wife,

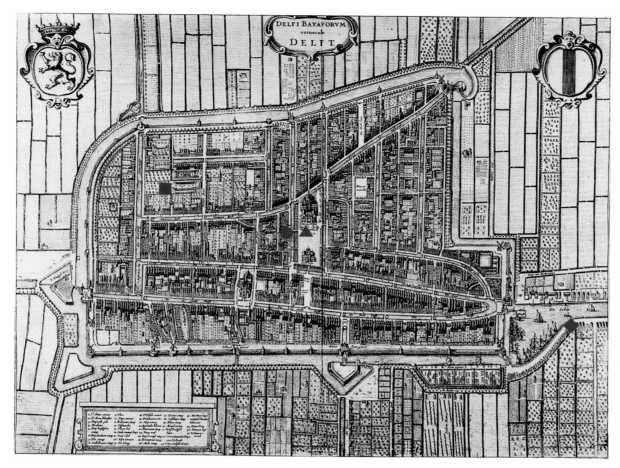

11. J. Blaeu: *Plan of Delft*, Atlas of Delft, 1649, copperplate engraving 37.3 × 48.9 cm. Gemeente Archief, Delft
● The Flying Fox inn, on the Voldersgracht, probable birthplace of Vermeer.
■ Site of the powder magazine, where an explosion caused the death of Carel Fabritius in 1654 (fig. 82).
▲ Mechelen, the inn owned by Reynier Jansz. Vos. Vantage point for Vermeer's
◆ *View of Delft* (plate 10)

Adriaentge Claes, Reynier Jansz.'s half-sister, abandoned the estate to her husband's creditors. She nevertheless continued her husband's business, selling pig's tripe. Anthony Jansz., Vermeer's uncle, had twice been forced to seek his fortune abroad, in the East Indies. In 1624, preparing to depart for the second time, he was obliged to mortgage a part of his future earnings to cover his initial expenses and to help his mother repay a large debt. He was never to return home. Before he left, he attended the christening of his daughter Neeltge in April 1625. His name was recorded by the clerk in the register of the new church as Anthony Jansz. Vermeer. This, as far as we know, was the first use of the family name, adopted subsequently by Reynier Jansz. and his son Johannes.

In the year that his brother Anthony Jansz. departed for the second time to the East Indies, Reynier Jansz. and two friends were involved in a quarrel with a corporal of the regiment garrisoned in Delft. The soldier was wounded, and the three young men took to their heels. The mothers of Reynier Jansz. and one of the men came to an agreement with the military authorities to pay 24 guilders each in compensation. It was also agreed that the corporal's recovery would be celebrated over a jug of wine. Unfortunately, the wounded man died shortly afterward. His mother was obliged to pursue the third of his assailants to claim the "blood money" he had failed to pay. Ten years later, the painter's father was again involved in a fight, together with four friends, this time with a captain of the States' Admiralty. Reynier Jansz. seems to have played a conciliatory role in the affair, which had no serious consequences, although knives were drawn. The two incidents illustrate the kind of disreputable company kept by Vermeer's father in his youth.

AT THE SIGN OF THE FLYING FOX

Before he called himself Vermeer, Reynier Jansz. took the name Vos, which means fox in Dutch. Everyone in Holland knew of "Reynaerd de Vos," the Romance of Reynard the Fox. The name Reynier became confused in people's minds with Reynaerd, and the combination Reynier Jansz. Vos developed naturally from it. Together with his new name, Reynier Jansz. acquired a new profession; from 1625 to 1629 he worked as an innkeeper, while continuing to weave caffa as a sideline. In the thirties, he rented an inn that bore the sign of the flying fox, deserting the old quarter by the Cattle Market for the Voldersgracht, a street that ran behind the houses on the north side of the great Market Square (figs. 9, 10). It was in this rather more distinguished part of town that Johannes Vermeer was born, in October 1632, twelve years after his sister, Gertruy. The child was baptized in the New Church on 31 October (document of 31 October 1632). The witnesses whose names are inscribed in the register were Pieter Brammer, Jan Heyndricksz., and Maertge Jans. The first may have been a captain named Pieter Simmons Brammer, although, if it was indeed he, we have been unable to trace any further connection with the Vermeer family. Jan Heyndricksz., cabinetmaker and picture framer, is known to have sold a number of ebony frames to the innkeeper a few years later when the artist's father began to deal in pictures. The godmother Maertge Jans was the child's aunt, the wife of the baker Jan Heymensz.; she had also attended Gertruy's christening in 1620.

In October 1631, about a year before the birth of his son Johannes, Reynier Jansz. registered with the Guild of Saint Luke as a dealer in works of art *(konstverkoper)* (document of 13 October 1631). Presumably

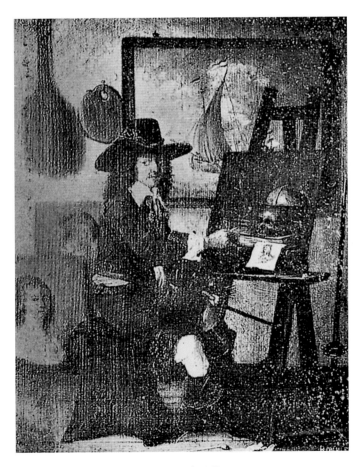

12. Pieter Steenwijck, *Self-Portrait.*
Reproduced in *Brügge und Ypern* by Henri Hymans
E. A. Seemann, 1900, Leipzig.

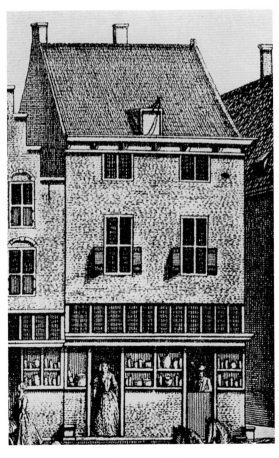

13. *The Inn Mechelen,*
after an engraving by
by A. Rademaecker, c. 1710.

this business was carried on in conjunction with the running of the inn, which provided a natural meeting place for artists and collectors. The landlord was in an ideal position to act as middleman between the painters and their clients; he bought pictures speculatively and displayed them on the walls in the hope of making a sale at some future date.

But before elaborating on the progress of Reynier Jansz. Vos's new career, we must return to Gorinchem, home of Balthasar Gerrits and his son Reynier Baltens. According to the records kept in that town, which in 1620 numbered some 8,000 inhabitants, Balthasar was by now known as a clockmaker. A document refers to his "marvelous inventions," without however specifying them. In a petition drawn up by his son after his death, he is described as a "master engineer." He was also concerned with a scheme for making steel, together with associates from Delft and Amsterdam. In this enterprise he no doubt put to good use the metalworking skills he had demonstrated as a counterfeiter, in which, judging by his early experience as a merchant's clerk in Amsterdam, he was more proficient than as a businessman. In April 1627 a deposition was drawn up at the request of one of his associates, which refers to his fine collection of paintings and well-stocked library. Since the purpose of the deed was probably to establish the financial situation of the former forger in order to determine his suitability for the steel venture, it is quite possible that some exaggeration may have crept into the account. Balthasar Gerrits died between 1629 and 1631. It is likely that his daughter Digna Baltens, Vermeer's mother, inherited a number of his pictures, if pictures there indeed were. If so, it is possible that her husband Reynier Jansz.'s decision to join the guild in 1631, as an art dealer, was a direct consequence of this inheritance.

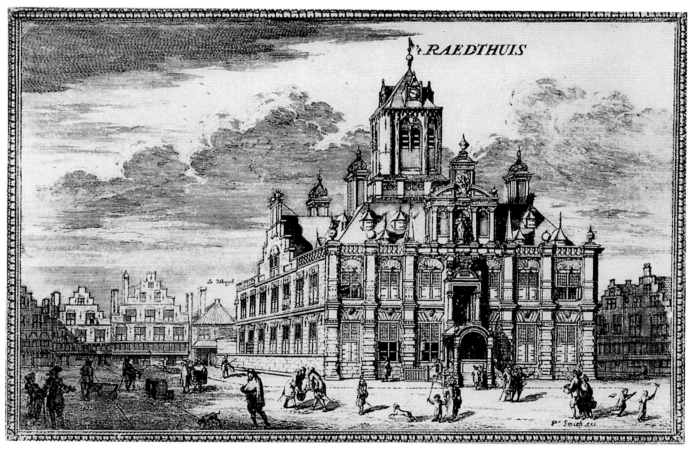

14. *The Town Hall, Delft*, 1667, copperplate engraving in Dirck van Bleyswyck,
Beschryvinghe der Stadt Delft, 1667, 16.7 × 25.6 cm.
Gemeente Archief, Delft

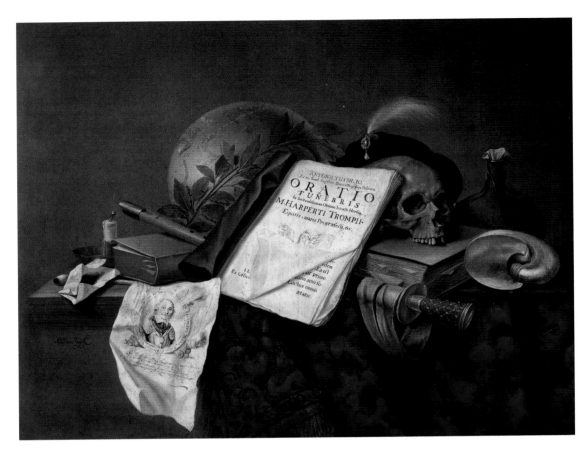

15. Pieter Steenwijck, *Vanitas (Still Life in Memory of Admiral Tromp)*, c. 1656,
oil on canvas, 79 × 101.5 cm. Stedelijk Museum of Lakenhal, Leiden

As for Balthasar's son Reynier Baltens, who had been apprenticed as a carpenter, he reappeared in Gorinchem as a military engineer, serving in the pioneers corps of the army of the States General. His imprisonment for counterfeiting was seemingly no bar to membership in the reformed church in Gorinchem, nor did it prevent him from becoming an army officer. (That is not to say that he was committed to the army indefinitely; he served on a contractual basis.) During the forties he remained in touch with his sister Digna, who visited him in Gorinchem three times, on each occasion to witness one of his children's christening. One of his partners went to Delft and signed a contract in the inn owned by his stepbrother Reynier Jansz.

MECHELEN AND ITS PAINTERS

Reynier Jansz. Vos, alias Vermeer, was not content to remain forever the landlord of the Flying Fox. In April 1641 he purchased a large sixteenth-century building, with seven hearths, known for the past hundred years as "Mechelen," after the Brabant city (fig. 13). The new inn cost 2,700 guilders, but it was heavily mortgaged. The interest amounted to almost as much as the rent for the Flying Fox. The advantage, however, was the inn's superior location. From the main windows that looked out over the market square one could see, on the left, the New Church, built in the thirteenth century and restored after the fire of 1536, with its large and elaborate belfry, and on the right, the baroque town hall with its majestic statuary, its corbeling, gilded spirals and cornices (fig. 14). It was a magnificent prospect for anyone as visual as the young Vermeer must have been. From the records we have, it seems that Reynier Jansz.'s customers in Mechelen were mainly drawn from the respectable middle classes: a captain's wife, a military contractor (an acquaintance of his stepbrother Reynier Baltens), a doctor. Undoubtedly he had risen in the word since the street brawling of his earlier years.

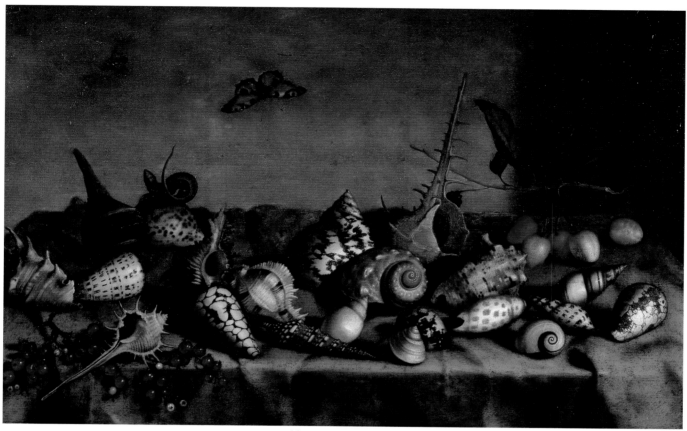

16. Balthasar van der Ast (1594-1657), *Still Life with Shells*
30 × 47 cm. Boymans-van Beuningen Museum, Rotterdam.

Once admitted to the Guild of Saint Luke in 1631, Reynier Jansz. began to associate regularly with painters. Keeping the name Vos purely for his innkeeping activities, he increasingly used the surname Vermeer. Two documents of 1640 provide evidence that in 1631, the year of his registration as a dealer, he provided room and board in his inn the Flying Fox for the son of the Hague flower painter Jan Baptista van Fornenburgh; the young man was due to leave for the East Indies, where he was later killed by a shot from a musket. The purpose of the depositions of 1640 was to legitimize the father's claim to his deceased son's assets, and the witnesses to these deeds were Reynier Jansz. Vermeer himself and three well-known painters: Balthasar van der Ast, flower painter; Pieter Steenwijck, painter of still lifes; and Pieter Groenewegen, landscapist. They, together with van Fornenburgh, were among the best masters in Delft and The Hague in the 1630s. Van der Ast, the most prominent of them, was a talented exponent of the Middelburg tradition of flower painting, as exemplified by Ambrosius Bosschaert and followers. He was also known for his still lifes of shells, artfully contrived displays set out on a velvet cloth and lit by a soft light (fig. 16). Van Fornenburgh specialized in bunches of flowers in a style altogether simpler and more fluent than that adopted by the mannerist Middelburg group. On the cracked marble slabs that supported his flower vases, he would often place a mouse or a lizard, symbolizing the precariousness of existence. Pieter Steenwijck, like his brother Harmen with whom he shared a studio in Delft, surpassed even van Fornenburgh in pursuing the tradition of the *vanitas* then current in Haarlem and Leiden (fig. 12). His still lifes are often illuminated by a glowing shaft of light that picks out the polished skulls, the violins with their broken strings, and the old manuscripts that make up his macabre displays. The importance of Pieter Groenewegen lies in the fact that he was the only artist in Delft at that time to paint Italianate views in the antique manner (fig. 19), of the type imported to Utrecht from Italy by Cornelis Poelenburg and to Amsterdam by Bartholomeus Breenbergh. A deed sworn and witnessed in March 1643 throws some light on Reynier Jansz. Vermeer's activities as a dealer (document

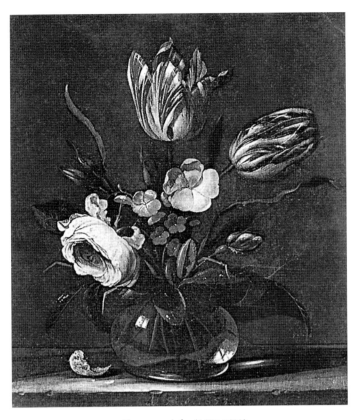

17. Evert van Aelst (1627-1683),
Still Life with Flowers, 1653, panel, 35 × 28 cm.
Richard Green collection.

18. Leonaert Bramer (1596-1674), *Drawing*, after a picture by
Jan Lievens which may have belonged to Vermeer's father, 1652
Staatliche Museen Preussischer Kulturbesitz, Berlin

19. Peter Anthonisz. Groenewegen (?-1658), *Roman Landscape with the*
Palatine Hill and Forum, panel, 56 × 90.5 cm. Rijksmuseum, Amsterdam.

of 21 March 1643). The flower and fruit painter Evert van Aelst is known today chiefly as the teacher of his nephew Willem van Aelst, but in those days he enjoyed a good reputation in Delft as a painter of "modern" pictures (fig. 17), more fluent and plastic than the polished, linear compositions of his predecessors in the genre. He left one of his works with the landlord of Mechelen, hoping for its eventual sale. The sum raised was intended to liquidate his debts to Reynier Jansz., possibly run up in the course of the drinking bouts to which he was prone. After two or three years the picture was still not sold, and van Aelst sent the framer Gerrit Jansz. to Reynier to reclaim the painting, for which he had found a purchaser. On several occasions van Aelst declared he would payoff the debt directly, but two years passed and Reynier still had not been paid. The artist's father then asked the framer for a sworn statement of the true facts of the case, no doubt intending to pursue his claim in the courts.

The framer Gerrits Jansz. had three sons, all skilled carpenters. One of them, Anthony Gerritsz.,who took the name van der Wiel, was to marry the innkeeper's daughter, four years after his father made his deposition. By then Gertruy was twenty-seven years old. Van der Wiel was clearly an excellent craftsman—he later sold frames to famous collectors in The Hague and Amsterdam—but their match could hardly be considered a good one, even for a spinster. The three van der Wiel brothers were illiterate. Their sister Maria, a maidservant, was accused by a neighbor of having given birth to an illegitimate child three years earlier; although there may have been no truth in the accusation, it is nevertheless an indication of the milieu in which the family lived.

There is other evidence too in notary's records of Vermeer's father's links with the artistic community. In 1651 Reynier Jansz. signed a document at his inn in the presence of Egbert van der Poel, newly arrived from Rotterdam. An artist working in the Flemish tradition of genre painting, in the manner of Teniers, he

20. Cornelis Saftleven (1607-1681), *Scene of Witchcraft,*
panel, 46 × 63 cm. Musée de Chalon-sur-Saône.

also painted scenes of urban life; he was notable for his use of a brighter palette than his Flemish predecessors, which was well suited to his "modern" treatment of light, in the manner later perfected by the School of Delft (Gerard Houckgeest, Carel Fabrjtius, Pieter de Hooch, Adam Pynacker). Reynier Vermeer's name also turns up in Rotterdam, where he owed a sum of money to Cornelis Saftleven, from whom he had purchased some pictures. Saftleven was a fine painter of inn scenes and stable interiors; he too was influenced by the "little masters" of Flemish genre painting. *The Peasant Stable,* unattributed in the inventory drawn up in 1676 after Johannes Vermeer's death, may have been the work either of van der Poel or of Saftleven.

Finally, Vermeer's father figures in a list of eleven local owners of paintings after which Leonaert Bramer drew copies in an album (fig. 18). We can infer from a list of names on the back of one of Bramer's drawings that the paintings' owners consisted of seven private collectors, two dealers (Abraham de Coge and Reynier Vermeer), and two painters (Adam Pick and Leonaert Bramer himself). The album originally contained about one hundred sketches made by Bramer after these paintings. It was probably completed shortly before the death of Reynier Vermeer in October 1652. Most of the works copied by Bramer reflected the dominant trends in Dutch and Flemish painting of that era, among them a few Italianate landscapes by young artists such as Nicolaes Berchem, Jan Asselijn, and Carel Dujardin. In addition there were a few paintings of historical and mythological scenes of a fairly traditional type, by the Delft painter Christiaen van Couwenbergh and Pieter Monincx of The Hague. Unfortunately, we have no means of knowing which works belonged to which collector. At this period Bramer was the most prominent of the Delft painters, known especially for his history paintings. His name crops up again, after the death of Reynier Vermeer, in a document also bearing the names of Digna Baltens and Johannes Vermeer. He was evidently a friend of the family, perhaps a close one.

It seems that the pursuit of a dual career as innkeeper and art dealer did not bring Vermeer's father riches. Perhaps his customers failed to pay their bills, or at least needed encouragement to do so—in 1651 Reynier van Heuckelom, for example, owed him 126 guilders for board and lodging, a sum that exceeded the annual interest on the mortgage of the inn. Like his mother before him, Reynier Vermeer was often in debt. Unwiling to pay for anything in ready cash, he would allow the interest to accumulate and would settle his accounts only when forced to do so. Fifteen years after his death, his heirs were still paying off the interest on loans he had contracted in his lifetime.

FORTIFICATIONS, FINANCIAL STRAITS, AND SOLIDARITY

We have evidence to suggest that Vermeer's father may have faced an additional drain on his purse, one that was directly responsible for the financial crisis, little short of bankruptcy, that engulfed him at the end of his life. Reynier Vermeer's stepbrother Reynier Baltens, we recall, had for some time been engaged in building fortifications and other constructions for the engineering corps of the States' army. The Peace of Westphalia of 1648 brought an end to the war of independence that had dragged on for eighty years, and the need for his services must, therefore, have been much reduced. Since he was not a career officer, the military authorities were under no obligation to find him employment. The only work remaining was with the various municipal authorities. In 1652, together with his associate and partner Tobias Bres, a former captain in the engineers with whom he had worked for many years, Baltens took on the job of restoring the foundations of the port of Brouwershaven, in the province of Zeeland. The contract had already been turned down by two other entrepreneurs, who judged it an impossibility "unless God grant us an autumn drier than any we have enjoyed in living memory." As it turned out. it was a wet autumn: as fast as the mud was dug out from the canal bottom, in order that the sides could be reinforced, it slid back into the trench. The investors who had put up the cap-

ital had the two friends arrested, "in view of the fact that they had nothing in this world and were suspected of planning to flee." A magistrate of a higher court ordered their release. When they left prison in November or December of 1652, Reynier Vermeer had only recently been buried (on 12 October of that year).

In the later months of the year—we do not know if Reynier Baltens and Tobias Bres were still in prison at the time—Digna Baltens, the painter's mother, traveled to Brouwershaven, either to seek her brother's release or to help organize his defense. She stayed with the family of Tobias Bres, and was present when an important letter contained in a chest belonging to Bres was forcibly seized by the principal plaintiff, a man named Copmoyer, a former alderman magistrate of Brouwershaven. In February 1653 he mounted an appeal demanding that Bres and Baltens be reincarcerated. The judges signaled their agreement by writing in the margin of his petition: *Fiat ut petitur* ("Let what is asked be done"). Nevertheless, two months later the young painter's uncle was still at liberty (or had again been released). He visited a notary in Delft for the purpose of drawing up a power of attorney for a man in Zierikzee, a port near Brouwershaven where he had also done work on the fortifications, to help him recover the 1,500 guilders still due him for the earlier contract. The young Vermeer, not yet a member of the painter's guild, added his name as a witness. Two weeks later his mother went to the same notary and, at Bres's request, made a statement about the letter purloined in Brouwershaven. This time the painters Leonaert Bramer and Evert van Aelst acted as witnesses. No more is known of Reynier Baltens, who must have died soon afterward; his wife was called a widow in the register of taxes in Gorinchem for the following year.

The misadventures that befell Reynier Baltens in 1652 and 1653 coincide with the marked deterioration in the financial situation of the Vermeer family. Their shortage of funds showed itself in a number of ways. Vermeer's father's heirs paid not so much as one guilder to the Charity Commissioners ("*camer van charitate*") after his death in October 1652, an unusual omission even following the death of a man of modest means. Some of the father's debts were not settled until three or four years later when the family situation had

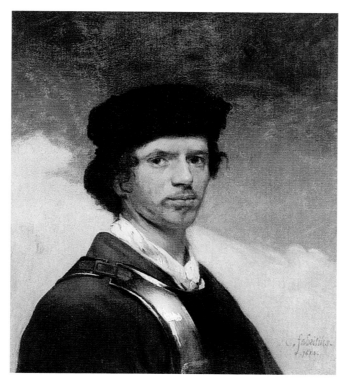

21. Carel Fabritius (1622-1654), *Presumed Self-Portrait*, 1654,
panel, 70.5 × 61.5 cm. National Gallery, London.

improved, thanks no doubt to the early successes of the young Vermeer. In the interim he must have been extremely hard pressed, since he could not even raise the six guilders necessary for his admittance to the Guild of Saint Luke. It took him two and a half years to pay off the full amount, from the time he was admitted in December 1653 until July 1656. For a young master of the guild, this was a most unusual circumstance. All this lends support to the supposition that the family's financial crisis was directly related to the catastrophe that overtook Reynier Baltens. It is, for example, possible that Digna Baltens paid a large sum of money to secure the release of her brother from prison. She may also have put up bail for him with the Brouwershaven authorities, in which case she would have lost the whole amount if Baltens subsequently failed to clear his debts. It would have been a repetition of the events of 1619 to 1620 when the family was bled dry by the young Baltens. The loyalty and cohesion that bound together the members of Vermeer's family are among their most salient (and attractive) characteristics.

VERMEER'S FORMATIVE YEARS

So far we have had only glimpses of the young Vermeer and his involvement in the crises of 1652 and 1653, without learning very much about other aspects of his life and career. Yet these were important years for him, covering the end of his apprenticeship, his betrothal and marriage, and his admission to the painter's guild. The truth is that we have virtually no information at all about Vermeer while he was apprenticed as a painter. Only one certain fact remains: anyone who enrolled as a master in the Guild of Saint Luke had to prove he had served six years' apprenticeship with at least one recognized painter, from Delft or elsewhere. But which one? A number of possible names have been advanced, some more likely than others. Bramer is often suggested because he is known to have had regular contacts with Vermeer. (We have referred above to the sworn statement made by Digna Baltens, which was witnessed by Bramer; later we will learn of the part

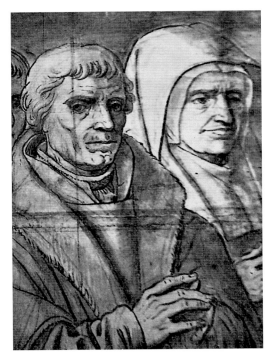

22. Lambertus van Noort, *Great-grandparents of
Catharina Bolnes*, wife of Vermeer, 1561,
sketch for a stained-glass window. Saint-Janskerk Gouda.

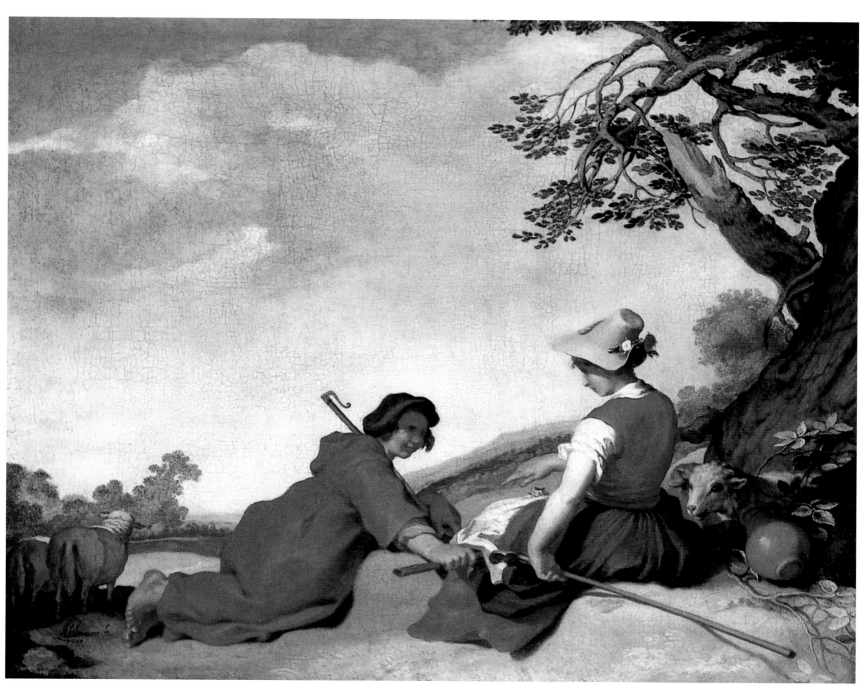

23. Abraham Bloemaert (1564-1651), *Pastoral Scene*, 1627,
canvas, 60 × 74.4 cm. Niedersächsisches Landesmuseum, Hanover.

he played when Maria Thins refused to give her consent to the marriage of her daughter Catharina to Vermeer.) Yet an examination of the works of both painters does not support the argument for a master-pupil relationship, as Blankert points out in this book.

Another name that has frequently been proposed, chiefly during the nineteenth century, is that of Carel Fabritius (fig. 21), who imported Rembrandt's teachings to Delft in the early 1650s. We know that when Vermeer died, he owned three works by Fabritius (document of 29 February 1676). There are certain similarities, particularly in the way both artists handled light and used color to create form; but Fabritius did not enroll in the Guild of Saint Luke until October 1652, too late for him to have been Vermeer's master for the required length of the young artist's apprenticeship (Fabritius in fact arrived in Delft in 1650, but there was a generally observed rule that barred a painter from taking pupils before he was registered). Another possible candidate is Evert van Aelst, known from documentary evidence to have had dealings with Vermeer's father and mother; however, there seems little relationship between his still lifes and the history paintings executed by the young Vermeer. As for Gerard ter Borch, who we know co-signed a legal document with Vermeer two days after the young artist's wedding, it is hard to see what influence he could possibly have had at this early date—although undeniably there is an influence toward the end of the 1650s. The most obvious indebtedness in these early works by Vermeer is to the painters of Amsterdam and Utrecht. It is very likely that Vermeer visited Amsterdam, easily reached from Delft by horse-drawn water-coach along the network of canals linking the two towns; the journey could be done in less than a day and cost very little. Obviously he would have wanted to experience for himself the beauties of the town and see the latest in the art that it had to offer.

A final question remains: by what route did the Caravaggesque influence of the school of Utrecht reach Vermeer? Here I would like to advance a hypothesis of my own—very far from being an established fact—which is that the young painter may actually have been trained in Utrecht, spending a few years with Abraham Bloemaert, Jan van Bronckhorst or some other Utrecht painter. To justify this idea, I must first examine the family history of Vermeer's fiancée and future wife, Catharina Bolnes. She was the daughter of one of the leading families in Gouda (fig. 22). These were not simple craftsmen, members of the lower middle class, like Vermeer's parents, grandparents, uncles and cousins. They were burgomasters, magistrates, and bailiffs, at least in the period before the Reformation; they remained Catholics after the Alteration and therefore could no longer aspire to the highest municipal or provincial offices. Nevertheless, most of them kept their land, which they rented out to farmers; they either lived off the land or from the interest on capital invested by their ancestors in government bonds, Catharina's father owned a brick factory together with its surrounding land, on which the clay pits were situated.

Catharina's maternal grandfather died young, in 1601; a wealthy nephew from Utrecht called Jan Geensz. Thins assumed responsibility for the children. There were five of these orphans in all: Willem, who died young; Maria Thins, Catharina's mother and Vermeer's future mother-in-law; Jan Willemsz. and Cornelia Thins, who lived for many years with Maria; and Elisabeth Thins who, in 1618, at the age of nineteen, entered the convent of the Annunciates in Leuven, in the Spanish Netherlands, and remained there as a nun until her death in 1640. All his life Jan Geensz. Thins remained very close to Maria and her brother Jan Willemsz., and they regarded him more as an elder brother or guardian than simply a cousin. It was he who, in 1641, bought the house in the Papists' corner in Delft, where Maria Thins and later Johannes Vermeer and his wife were to live; it was there that the artist died.

It so happens that Jan Geensz. Thins, the cousin of the five orphans, was related by marriage to Abraham Bloemaert, the leading member of the mannerist school of Utrecht. Bloemaert's first wife, named Judith van Schonenburch, was Jan Geensz.'s maternal aunt. In addition, when Jan Geensz. remarried in 1646, following the death of his first wife, his bride was Susanna van den Bogaert, the widow of Adriaen de

Roy, whose sister Gerarda was Bloemaert's second wife. Abraham Bloemaert attended Jan Geensz's second wedding as a "next-of-kin" of the groom. Although by then an old man—he died five years later, aged eighty-seven—Bloemaert still had pupils. My suggestion is that Vermeer could have worked with him in the late 1640s, or possibly with his son Hendrick or another of his pupils in the early fifties. The master-pupil relationship would account for the meeting of Johannes and Catharina. Otherwise it is hard to see the link or common denominator between this boy of a Calvinist family, grandson of a counterfeiter and a penniless mattress-maker, and a girl from a wealthy and patrician family of devout Catholics. In that day and age, the young man could hardly have paid court to her in the marketplace. An acquaintanceship struck up in Utrecht at the home of one of the Bloemaerts, or even of Jan Geensz. himself, seems much more likely. Another hypothesis, although less attractive, is that the couple met through the painter Bramer, also a Catholic.

We have also learned since the previous edition that Willem, the brother of Maria Thins, was a painter in Rome, where, in 1621, he was living with three colleagues, two of whom carved out careers for themselves: Willem van Bylert and Paulus Bor. He died soon after. When Maria gave her daughter to marry Vermeer, perhaps she was reminded of her younger brother. Willem, then, would serve as another bond linking Vermeer to the art of Utrecht (it is hardly necessary to recall that the Historical painters Bor and Bylert are important representatives of this art).

Without claiming to have solved the mystery of Vermeer's apprenticeship once and for all. I would conclude from the scanty evidence available that Vermeer probably spent some time learning his craft in Utrecht, and possibly in Amsterdam as well, before returning to his home town in 1653. This hypothesis does not, of course, exclude the possibility that he may, when he was thirteen or fourteen, have had an initial apprenticeship of two to three years in Delft with Bramer, Evert van Aelst, or some other acquaintance of his father's.

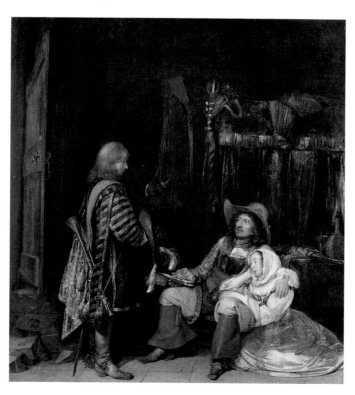

24. Gerard Ter Borch (1617-1681), *The Unwelcome News*, 1653,
panel, 67.76 × 59.5 cm. Mauritshuis, The Hague.

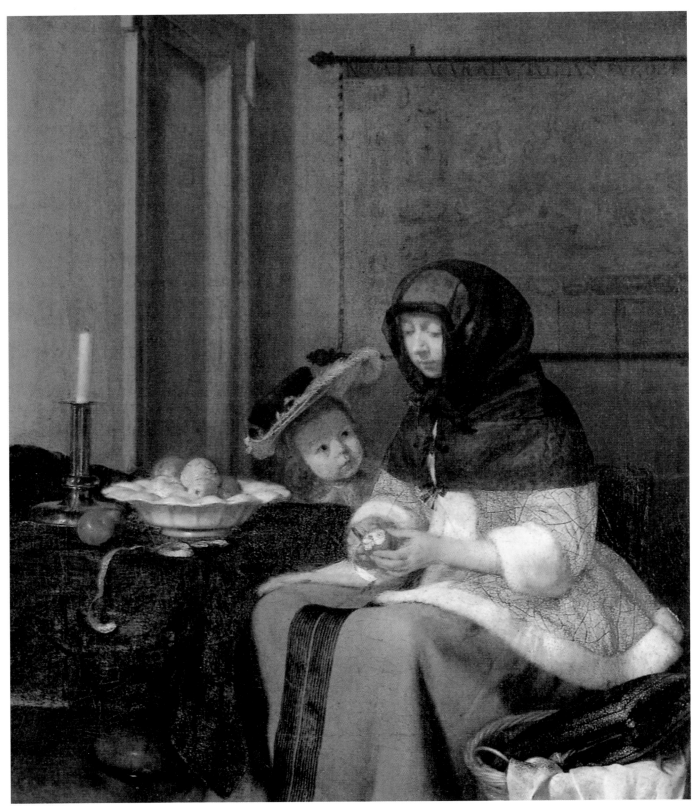

25. Gerard Ter Borch (1617-1681), *Woman Peeling an Apple*, c. 1660,
panel, 36.3 × 30.7 cm. Kunsthistorisches Museum, Vienna

MARRIAGE

Johannes Vermeer first appeared before a Delft notary on 5 April 1653 (document of 5 and 20 April 1653). He was twenty years and six months of age and was about to marry Catharina Bolnes, approximately one year older than himself. Bramer and a sergeant-major from the army of the United Provinces were called on to testify that they had been present on the previous day when Maria Thins, Catharina's mother. had refused to give her consent to the marriage between Johannes and her daughter. On the other hand, she had several times repeated that she would not stand in their way and was prepared to allow the banns to be published. The deed was signed and witnessed by the notary Willem de Langue, a collector of pictures and an old friend of the Vermeer family.

On the same day, the betrothal was registered at the town hall. Two weeks later, on Sunday, 20 April, the couple were married in Schipluy (today Schipluiden), about an hour's walk from Delft. The place was probably chosen because there were many Catholics in the village and the Roman faith was openly tolerated, as it was not in Delft itself. A Jesuit from the Mission in Delft was in charge of the Catholic parish. It was probably he who conducted the wedding ceremony. Although there is no direct proof. the strong presumption is that Johannes converted to Catholicism between 5 and 20 April. That would explain the behavior of Maria Thins, who refused to give the marriage her consent because Johannes was still a Protestant and yet did not wish to ban the match altogether as she knew he was on the point of converting.

On the following Tuesday, the newly married Vermeer was present in the office of the Delft notary Willem de Langue, this time in the company of the painter Gerard ter Borch. Both signed a deed in which a Captain van der Bosch agreed to act as guarantor for an advance on payments of money due to a woman called Dido de Treslong, the widow of the Governor of Briell (document of 22 April 1653). What was ter Borch doing in Delft? He had been travelling a good deal for the past few years between his home town of Deventer, Amsterdam, and The Hague. He may have come from The Hague, only a few hours away by horse-drawn coach, to attend Vermeer's wedding or to meet colleagues in Delft, such as Pieter de Hooch and Anthonie Palamedesz, who were also painting genre pictures, "conversation pieces" and portraits of high society of the type that ter Borch had been perfecting. It was probably while staying in Delft that ter Borch saw a picture by Palamedesz., on which he later drew for the composition of his celebrated genre painting *Dispatch* in the Mauritshuis in The Hague (fig. 24).

Before she married Vermeer, Catharina Bolnes lived with her mother, Maria Thins, in the house bought by her cousin Jan Geensz. in 1641, in the Papists' Corner; this was near the southern side of the big Market Square and only a few steps away from the New Church. Maria Thins had been separated for some years from her husband, Reynier Bolnes. In the epic quarrels that used to take place between husband and wife (which we know about from the numerous sworn statements lodged by Maria Thins in the course of her attempts to persuade the magistrates at Gouda to grant a judicial separation), Maria was always supported by her sister Cornelia and brother Jan Willemsz. Thins, while her son Willem always took his father's side. The quarrels even extended to the respective families of the two protagonists. Reynier's brother Pauwels is known to have inflicted a stab wound on Jan Willemsz. Thins in the course of a fight. Under the terms of the separation agreed to by the magistrates in 1641, Maria acquired half her husband's assets. She was now free to establish herself in Delft with her daughter Catharina. Reynier Bolnes remained in Gouda until his death in 1676; his violent and impulsive nature ruined his business. Following the collapse of his brick factory, he became dependent on the generosity of close relatives. His son Willem had a small house built at Schoonhoven, where the family owned an estate called Bon Repas (the name deriving from the legend that the Duc de Chatillon once held a memorable banquet there). He lived on his investments and spent most of

his time in neighboring taverns. In the early sixties he joined the household of Maria Thins in Delft.

It is likely that Vermeer and Catharina moved in with Maria Thins within a few years of their marriage. Yet the first confirmation that they lived on the Oude Langendijck (the street or canal on which the house bought by Jan Geensz. Thins was located) comes in a document dated 1660, seven years later. It concerns the burial of one of their children in the New Church. (It was a curious feature of Dutch religious practice at that time that Catholics were buried in reformed churches.)

EARLY PAINTINGS

A few documents help chart the progress of Vermeer's life in the four years after his marriage. As we have already seen, he registered with the Guild of Saint Luke in December 1653 (document of 19 December 1653). He was now a free master who could take on his own work, teach painting, and even buy and sell pictures as his father had done before him. He was just twenty-one years of age.

Less than two weeks after his enrollment in the guild Vermeer visited the Catholic notary Vrijenbergh. He signed a deed on which the widow of the master auctioneer of Delft—a sort of official assessor who organized weekly auctions of the effects of deceased persons—formally acknowledged that she owed 500 guilders for goods taken from the house of a deceased citizen. In Delft the custom was to sell off a dead man's movable assets to the highest bidder, so that the proceeds could be passed on to his heirs; for the painters and picture dealers it was an opportunity to buy up works of art. When Vermeer added his signature to the acknowledgment. the notary described him as a master painter. The other witness was a certain Captain Morleth, of the Duchy of Cleves. One wonders whether it was purely by chance that Vermeer's name was associated in four successive legal documents with those of army officers: Sergeant-Major Melling at the time of his betrothal; Captain van der Bosch when he was co-witness with ter Borch; his uncle, Lieutenant Baltens, on

26. Detail from *The Procuress,*
presumed self-portrait of Vermeer (plate 3)

27. Frans van Mieris (1622-1747), *The Charlatan*, c. 1650-55, panel, 45 × 36 cm. Uffizi Gallery, Florence.
Frans van Mieris is represented by the person on the left.

28. Detail from *Soldier with a Laughing Girl* (plate no. 6)

the following day; and Captain Morleth just a few months later. After all, soldiers, and especially officers, formed only a tiny minority of the witnesses who appeared before notaries in Delft. They were far more numerous in Gorinchem, the fortified town where Vermeer's uncle Baltens lived. Perhaps the young painter had frequented this military milieu when he was in the company of his uncle Baltens and his associate Captain Bres. In Vermeer's work, the only glancing reference to such contacts is the figure of a soldier—or at least a man who passes for a soldier because of the broad-fringed sash he wears bandolier-fashion across his shoulders—in the famous painting in the Frick Collection *Soldier with a Laughing Girl* (plate 6).

In December 1655 the painter and his wife Catharina acted as guarantors for a debt contracted by Vermeer's father in 1648. Nine years later they were still paying the interest on the transaction, which by then had been transferred to one of the original creditor's heirs. There was nothing in the least unusual about this; in Holland at that time debts were rarely reduced or written off; they were simply passed on from one generation to the next.

Between the end of 1653, when Vermeer became a master of the painter's guild, and 1656, the year he signed his first picture–or at least the first signed picture that has survived to the present day-there are only two major canvases we can identify, with a fair degree of certainty, as being by his hand: *Christ in the House of Mary and Martha* (plate 2) and *Diana and Her Companions* (plate 1). Mention should also be made of a "Visit to the Tomb" by "Van der Meer," listed in an inventory of 1657 (document of 21 June 1651). This painting, no longer in existence, should more properly be entitled "Visit of the Three Marys to Christ's Sepulcher." It too is likely to have been an early work by Vermeer. Judging by the subject matter, it must have been painted before the artist abandoned history painting, thus before 1656.

To this short list should be added a *Saint Praxedis,* not universally accepted as the work of Vermeer (see Blankert, note 5), although Arthur Wheelock believes the picture to be authentic. If so, its theme would be entirely consistent with the argument of the following paragraph.

The common theme of these early pictures is the labor, possibly even the servitude, of women. Martha serves Christ while Mary listens. A nymph washes Diana's feet. The "Visit to the tomb" refers obliquely to

the theme, since the three Marys are visiting Christ in his sepulcher in order to anoint his body with oils. The choice of subject matter may have echoed Vermeer's own family situation, for he grew up in the shadow of older women—his mother, his sister Gertruy, twelve years his senior—whose work it was to serve the male customers at the inn. The painting of *Christ in the House of Mary and Martha* may be an unconscious reflection of his own situation as a creative artist, accepting the ministrations of hard-working women. I assume, of course, that Vermeer was free to chose his subject matter and that the painting was not, as it may well have been, a commission.

With *The Procuress* of 1656 (plate 3) Vermeer began to move closer to the mainstream of contemporary Dutch painting. This picture includes what may well be an ironic self-portrait. in the person of the quizzical observer: it is a device reminiscent of that used by the young Frans van Mieris in *The Charlatan* (fig. 32). painted only shortly before, and which in its turn was based on a work by the latter's master Gerard Dou. Rembrandt's influence upon Vermeer was less direct than it was upon the great master's pupil Gerard Dou and the latter's own pupil Frans van Mieris. (I owe to Otto Naumann, author of a major work on van Mieris, the comparison of Vermeer's *Procuress* with van Mieris's *Charlatan.* Naumann's dating of the van Mieris picture has made it possible to establish the influence in this instance of van Mieris on Vermeer. and not the other way around.) Although the debt to van Mieris is undeniable, there is no denying Vermeer's superior skill in integrating the presumed self-portrait into the composition (by enlarging the artist's beret as compared with that of the van Mieris picture, and making the contour of the beret form a curve exactly paralleling the curly brim of the hat worn by the young rake (fig. 26).

In *Girl Asleep at a Table* (plate 4) in the Metropolitan Museum in New York, which is possibly a year or two later than *The Procuress,* the most readily detectable influence is that of Nicolaes Maes, another former pupil of Rembrandt. By the time he painted *Soldier with a Laughing Girl* (plate 6) Vermeer was using a much brighter palette. Light floods through his composition. The handling of light and even the orchestration of the figures (advanced to the foreground) are borrowed directly from Pieter de Hooch, who at the time had just passed the four most productive years of his life in Delft. As an artist Vermeer progressed slowly but surely; by the late fifties it was he who was influencing his colleagues, among them van Mieris and de Hooch.

MARIA THINS, MOTHER-IN-LAW AND MAINSTAY

The fact that we know in broad detail about all the major landmarks of Vermeer's domestic life is largely due to the mania of his mother-in-law, Maria Thins, for drawing up wills and changing the disposition of her estate. Six of these wills have survived to the present day: including the first one, drawn up in 1657 and the last one from early in 1680, the year in which she died at the age of eighty-seven. From the document dated 1657, we learn that the young couple already had one daughter, named Maria after her grandmother, who was also her godmother. The child was very probably baptized by a priest from the Jesuit Mission in Delft, but, since the registers of baptisms at the Mission have not been preserved before about 1672, we cannot say exactly when she was born. (Although Maria Vermeer lived to be an old woman, we know of no document in which her precise age is stated.) In her first will, Maria Thins left to her daughter Catharina and son-in-law Johannes the sum of 300 guilders, the equivalent of the amount she had already lent them in 1656. This loan is proof that her initial reservations about the match had been dispelled. She left to her daughter all her clothes, a cupboardful of household linen that she had inherited from her brother Jan, who had died in 1651, and all the silver "which her daughter had already received from her," including a silver belt, a number of bracelets and gold metal chains. To her goddaughter Maria she left 200 guilders. The rest of her movable goods were to be divided equally between her daughter Catharina and her son Willem. As to the other assets,

securities and credits which represented the major part of the estate, Catharina and Willem were to receive their legal shares of one-sixth each; the remaining two-thirds were to go to the existing or future grandchildren of Catharina and of Willem, half to each branch of the family. As Willem was not married—and was never to marry—her grandchildren by Catharina were her presumptive heirs. Given the problems she had experienced with her son, which were later to get much worse, it is hardly surprising that she favored her daughter in this respect.

Maria Thins's financial contributions alone cannot have been sufficient to support Vermeer, his wife, and two children. In November 1657 he was obliged to borrow 200 guilders from Pieter Claesz. van Ruyven. In the course of the next fifteen years van Ruyven was to buy a number of pictures from Vermeer, which he left to his daughter Magdalena, the wife of Jacob Dissius. (There were twenty Vermeers listed in the Dissius inventory of 1682; see document of April 1683.) At that time works by Vermeer could be had for a relatively modest sum. From an Amsterdam inventory of 1657 we learn that "The Visit to the Tomb" was valued at 20 guilders (document of 27 June 1657.) A picture on an unspecified subject went for 20 guilders and 10 stuivers at an auction of the effects of an innkeeper who died in 1661 (document of 16 May 1661). A "trony" (an expressive head or portrait) sold after the death of the The Hague sculptor Johannes Larson in 1664, perhaps purchased when Larson had business in Delft in 1660, was valued at only 10 guilders. In Leiden, the

29. Abraham Bloemaert (1564-1651), *Seated Woman with a Basket,*
red chalk drawing, 27.6 × 17.4 cm
École des Beaux-Arts, Paris

30. Hendrick Goltzius (1558-1617), *Sketch with Figures,*
pen and brown ink, 30 × 19 cm
Musée des Beaux-Arts, Besançon

31. Abraham Rademaecker (1675-1735), *The Jesuit Church,* c. 1670,
pen and crayon drawing, 16 × 23 cm. Gemeente Archief, Delft

prices commanded by Gerard Dou or Frans van Mieris were much higher, as much as 300 guilders or more in the early sixties. Later Vermeer's prices were to rise considerably, but they never matched those achieved by his Leiden colleagues.

As Vermeer's reputation grew and his income from painting increased, so too did the size of his family, In all he fathered fifteen children. Four of these children died young, in 1660, 1667, 1669, and 1673. We shall return to this later.

THE PAPISTS' CORNER

What did the "Papists' Corner" *(paepenhoeck),* where Maria Thins lived with her daughter, son-in-law, and grandchildren, consist of? Besides the homes of Roman Catholics, there was the church, called the Mission of the Cross, run by the Jesuits. The only picture we have of the church, which faced the canal of the Oude Langendijck, is a drawing by Abraham Rademaecker from the early eighteenth century (fig. 31). It shows the church after the street façade had been extended by some three-eighths in about 1680. The original church, as it was known to Vermeer, corresponds to the left part of the large building with two doors under a single roof. To the left of the church, as one faces the drawing, was a private house, and beyond that a small school run by the Jesuits. The house bought by Jan Geensz. Thins was on the eastern corner of the Oude Langendijck and the Molenpoort; it may have been one or two doors to the west of the church— perhaps the very building of which a small part is visible on the extreme right of Rademaecker's drawing.

It may seem strange that the Jesuits, identified with the Inquisition and the promoters of the Counter-Reformation, should have been allowed a base in a reformed town such as Delft. Actually theirs was a "secret" or "hidden" church (Dutch: *schuilkerk).* Worshipers had to be very discreet and were not allowed to arrive in groups, let alone in a procession. In principle, the Catholic priests permitted to operate in Delft were not supposed to belong to a religious order. The other "hidden church" in Delft, near the old church, was indeed under "secular" jurisdiction. Its priests, for the most part of a quietist or Jansenist persuasion, were on bad terms with the more militant Jesuits. When a priest from the Jesuit mission wished to obtain an official residence permit, he would describe himself as a secular priest, and the magistrates and burgomasters would simply turn a blind eye. This was the procedure followed when the Jesuit father Balthasar van der Beke was admitted to the town on 10 August 1663 (a date to which we shall return). The reasons for this tol-

erant attitude on the part of the municipal authorities were many. The great families of the governing classes and regents were themselves split, with one branch owing allegiance to the reformed church and another to Roman Catholicism, and the ruling Protestants were unwilling to deal too severely with their Catholic relatives. Equally, a too zealous persecution would have had an adverse effect on trade, and hence on the prosperity of the town under their regency. The manufacture of faience, begun in the late sixteenth century, had grown by the 1660s into one of Delft's principal commercial and industrial activities. Many of the great makers of Delft ware, such as Abraham de Coge and Willem Cleffius, were Catholics. Tolerance paid handsome dividends. For their two "hidden churches" the Catholics were obliged to pay the municipality 2,000 guilders per year. Smaller sums of money were regularly handed over if a particular license had to be granted (for festivals or meetings held outside the town).

In the complicated network of relationships that existed between the Jesuits and the Delft authorities, a key role was played by two lay Catholics called Hendrick van der Velde and Adriaen Vreem. It was van der Velde who, back in 1641, had sold Jan Geensz. Thins the house on the corner of the Molenpoort and the Oude Langendijck, one of a number of properties he owned in the area. Among them may also have been the Jesuit church and school, which belonged either to him or to the rich Catholic Jonckeer Lambert van der Horst; at all events, the Jesuits paid no rent. Lambert van der Horst had fled Amsterdam after the Calviniss came to power in 1578. The other houses at Papists' Corner owned by van der Velde, van der Horst. and Vreem were let out to individuals who paid their rent directly to the Jesuit Mission. In 1686 the revenue from these houses amounted to 607 guilders, rather less than was needed to pay the "protection money" exacted by the town. The evidence suggests that Maria Thins never owned the house she lived in. Either she paid the rent to her cousin Jan Geensz., and after his death in 1647 to his heirs, or else it went directly to the Jesuits.

The Catholic neighbors of Maria Thins and Vermeer were a very mixed lot. Among the wealthier of them was the artist Jacob Jansz. van Velsen (fig. 32), a genre painter of an earlier generation, and the widow Machtelt van Beest. a close relative of Hendrick van der Velde, who owned a fine collection of paintings and drawings of the Dutch school. The widow lived on the Oude Langendijck in a house near the western corner of the Molenpoort. Vermeer certainly knew Hendrick van der Velde, and must have been familiar with the collection, which included paintings by Cornelis van Haarlem and drawings by Goltzius (fig. 30). The house next door to Machtelt van Beest belonged to the sculptor Adriaen Samuels, a master of the Guild of Saint Luke. One of his apprentices was asked by Maria Thins to give evidence of Willem Bolnes's misconduct. Adriaen's son Simon Adriaensz. Samuels, a master sculptor, witnessed a deed drawn up by Maria Thins one month after Vermeer's death. The nearby inn, named The Paternoster, was run by Catholics, first by Johan de Coorde and later by his son Willem, who was also called as a witness to testify against Willem Bolnes.

VERMEER'S HOUSE

It is possible to obtain some idea of the house in which Vermeer lived from an inventory drawn up in February 1676, two months after his death (document of 29 February 1676). Although it does not cover all the movable assets of the painter and his wife, and in particular the items of silver and gold that Maria Thins gave her daughter over the years, it nevertheless provides a list of furniture, paintings, clothes, and cooking and household utensils located in eleven rooms, corridors, and closets, "upstairs" and "downstairs," plus a basement room and an attic. The number of rooms noted "downstairs" was much larger than the number "upstairs" (eight compared to two), reflecting the fact that some upstairs rooms contained no furniture or other items relevant to the inventory, probably because these were reserved for the use of Maria Thins.

The family lived, slept, and entertained in the downstairs quarters, while Vermeer occupied part of an

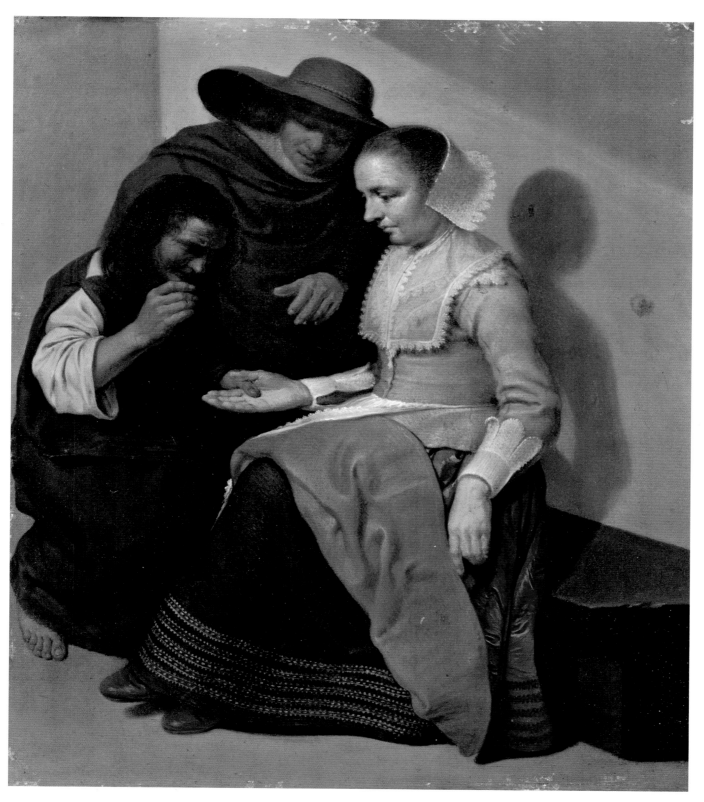

32. Jan Jacobsz. van Velsen (?-c. 1656-7), *The Fortune Teller*, 1631,
copper, 26 × 23 cm. Musée du Louvre, Paris

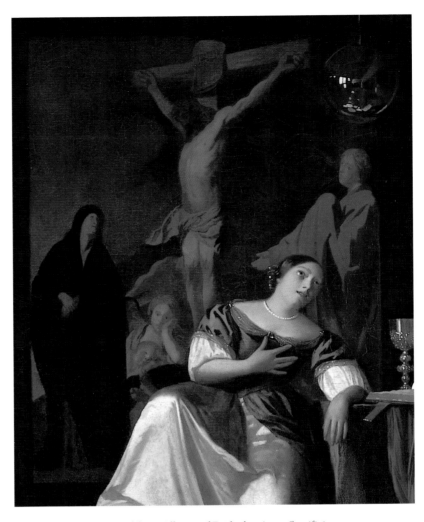

33. Detail from *Allegory of Faith,* showing a *Crucifixion*
by Jacob Jordaens (plate 31)

upper floor: a back room (where the notary recorded thirty or so books, a wickerwork cradle, and two pictures) and another room at the front of the house, used as a studio. The contents included two easels, three palettes, six panels, ten artist's canvases, three rolls of prints, an ivory-knobbed stick, two leather chairs, a small desk, an oak table, and a cupboard. There were paintings hung virtually everywhere in the house. The front vestibule on the ground floor contained a painting of fruit, a seascape, a picture by Fabritius, a large Apollo, and six other works of which no description was supplied in the inventory. In the hall was a painting of a peasant stable, two heads ("tronies") by Fabritius, a painting of three pumpkins and other fruits, portraits of Vermeer's father and mother, three small drawings over the hearth, ten portraits of members of Maria Thins's family, a "Mother of Christ" and "The Three Magi" (a nativity scene). There were also a number of cabinets, chairs, chests, and tables in the vestibule and hall, but no bed. A small room leading off the hall contained a child's bed, a few unspecified pictures, and other items of furniture. Two beds with bedding were listed in the contents of the kitchens (the "inner kitchen" and the "kitchen for cooking"); there was another bed in the basement room. Of these, only the inner kitchen contained paintings: a large "Christ on the Cross," two "tronies" by Samuel van Hoogstraeten, a picture full of all manner of female paraphernalia, a "Veronica," a still life with a bass viol and a skull, two "tronies" in Turkish style, a small seascape, and an unidentified picture hanging over the hearth.

The basement room contained a bed, coverlets, and pillows. It must have been one of the main bedrooms, since two of the best pictures in the house were hung there: a large painting of Christ on the Cross (fig. 33), possibly that which appears behind the woman in the *Allegory of Faith* in the Metropolitan Museum

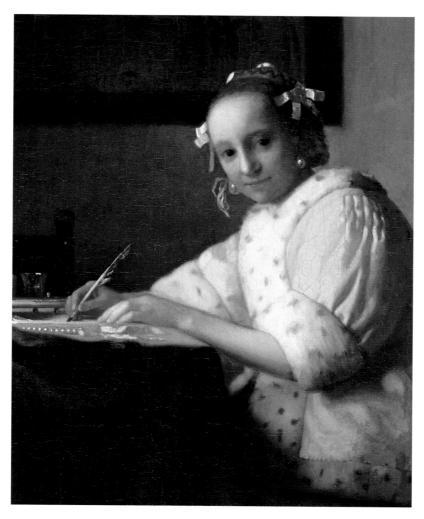

34. Detail from *Young Woman in Yellow Writing a Letter*
(plate 22)

in New York, and a "woman wearing a necklace," presumably the *Woman with a Pearl Necklace* in the Berlin-Dahlem museum (plate 13).

The house contents also included underlinen and clothes, among these a Turkish coat that belonged to Vermeer, an "innocent" (a kind of dressing gown, also his), a pair of Turkish trousers, a yellow satin jacket with fur trimmings (probably that worn by the woman represented in *Woman with a Pearl Necklace* and *Writing Lady in Yellow Jacket* in Washington (plate 22), together with other coats, corsets, and robes belonging to Catharina Bolnes. There seem to have been few undergarments for adults (2 women's shifts, 2 nightgowns), as compared with the clothing listed for the children: 21 shirts and shifts, 28 bonnets, and 11 collars. On the other hand, Vermeer possessed 10 collars and 13 sets of cuffs, suggesting that he dressed like a well-off bourgeois.

Alongside all the pictures, furniture, and linen, there were also innumerable iron and copper buckets, tubs, lamps, pitchers, chafing dishes, plates, dishes, and other household utensils made of metal and earthenware. The fact that there were only four beds (there is also reference to a child's bed, a camp bed, and two cradles, including one in the attic, perhaps no longer in use) may seem surprising in a house occupied, at the time of the painter's death, by two adults and eight or nine children, only one still a baby (and that is not counting Maria Thins in her private apartments, Vermeer's daughter who married in 1674, and the son Johannes, who may already have been studying away from home). But the children would certainly have shared a bed, and three beds would have been sufficient to accommodate seven or eight children. (In the early sixties there were, in any case, only four or five children, of whom one or two were still in the cradle.)

THE BEGINNINGS OF A REPUTATION

Early in 1661 Maria's beloved sister Cornelia Thins, who lived in Gouda, was taken seriously ill. Cornelia had never married. At the time of her illness she drew up a will leaving almost everything she possessed to Maria Thins and her descendants. In particular, she bequeathed to her niece Maria Vermeer, the painter's five-year-old daughter, the Bon Repas estate near Schoonhoven. The property was to be hers to enjoy during her lifetime but could not be sold or transferred until it had passed in due course to her grandchildren. Cornelia's other estate, in the Oud Beyerland near Rotterdam, was left to Maria Thins. It too was entailed and was to pass automatically to her children and grandchildren. The nephew Willem Bolnes was excluded from the succession because, Cornelia explained, of "his dissolute behavior and idle life, the wrongs he had done to his mother and the worry he had caused her."

Two days after the will was drawn up, Maria Thins arrived in Gouda to visit her ailing sister. The notary was again summoned, and Cornelia, probably at her sister's insistence, revoked the clause leaving Bon Repas to Maria Vermeer. The deed offers no explanation of this change of heart. Perhaps Maria Thins feared that the oldest child would receive too substantial a proportion of her aunt's inheritance, leaving the other children without means of subsistence when their parents died. (Vermeer and Catharina probably had four daughters at this time, Maria and Elisabeth among them; if they were to be reared in a manner befitting genteel young ladies they would never be capable of earning their own living.)

A year after Cornelia's death, which occurred some few days after these events took place, Maria Thins drew up her own second will and testament. To Catharina she bequeathed, in addition to the silver mentioned in her first will, a gold cross, two silver plates, and a silver-gilt wine pitcher (fig. 35). To her son-in-law Johannes Vermeer she left 50 guilders per year for the remainder of his life, the capital sum passing on his death to his children by Catharina. To her late sister Cornelia's maid she left a silver spoon and to her own maidservant 20 guilders, on condition that at the time of her mistress's death she was deemed by Catharina

35. Detail from *Woman with a Water Jug* (plate 11)

to have deserved it. Real estate, bonds and shares, over and beyond that part legally due to Catharina and Willem, were to be divided equally between the children of Catharina and Willem, as stipulated in the first will. Willem was still unmarried, hence the presumptive heirs remained the children of Vermeer.

On 18 October 1662, Saint Luke's Day, the members of the guild (which included glassmakers, faienciers, printers, and embroiderers as well as painters and sculptors) gathered to elect their officers (literally headmen, *hoofdmens* in Dutch) for the following year. The system was for six names to be put forward—two painters, two glassmakers, and two faienciers—to the town magistrates and burgomasters, who then chose three headmen, one for each of the principal crafts. Vermeer's was among the names submitted, and he was elected headman sometime before the end of 1662 (document of 1662). He would have been expected to hold the position for two years, the first as an "incoming" headman, the second as a "retiring" headman. Vermeer was then barely thirty years old and the youngest man to have held office since the guild was reconstituted in 1613. That fact alone demonstrates the respect he enjoyed among his contemporaries, although it has to be admitted that the community of painters was much depleted compared with the previous decade: Fabritius was dead, and Pieter de Hooch, Emanuel de Witte, Abraham van Beyeren, and many others had left town. Apart from the aging Bramer and Cornelis de Man, those who remained were mediocre talents. Certainly it was a mark of distinction that such a young man should be appointed; but, given the lack of competition, it was hardly astounding. (The fact that Vermeer was Catholic was not so relevant to his success; other Catholic painters, Bramer among them, had held office before him.)

Already, no doubt, Vermeer was seen as a "Phoenix" risen from the ashes of Fabritius, as Arnold Bon was to describe him in a poem included in the *Description of the Town of Delft* by Dirck van Bleyswyck, published in 1667 (document of 1667). Although Vermeer did not date any of his pictures between *The Procuress* of 1656 and *The Astronomer* of 1668, it is possible to establish a probable dating from the evidence of stylistic development (assuming that his development was steady rather than made in sudden spurts). Accordingly, Albert Blankert and Arthur Wheelock suggest that *Soldier with a Laughing Girl* and *Girl Reading a Letter at an Open Window* both date from the late fifties, while *A Lady Drinking and a Gentleman, The Little Street, The Milkmaid,* and the *View of Delft* all belong to the early 1660s. It thus seems more than likely that Vermeer had already produced his fair share of masterpieces before being elected to office in the guild.

Another indication of the growing reputation he enjoyed among his fellow painters was supplied by Balthasar de Monconys on the occasion of his visit to the town in 1663. Raised by the Jesuits in Lyon, Monconys was a curious mixture: scholar, scientifically inclined, connoisseur of art; yet a credulous soul. He was interested in everything—religion, art, optics, medicine, chemistry, alchemy—but showed no particular aptitude or understanding in any of these subjects. In his *Journal de Voyage,* published in 1666, he relates how he arrived in Rotterdam toward the end of July 1663 and then stayed briefly in Delft, without however making the acquaintance of any of the town notables. Moving on to The Hague, he paid a courtesy visit to the French ambassador and several times attended the mass conducted by Father Leon, the ambassador's chaplain. A famous preacher of the day, Father Leon was a member of the Carmelite order, which enjoyed a privileged status at the French embassy. On 11 August, two weeks after his first visit, Monconys returned to Delft by water-coach, accompanied this time by Father Leon and a certain Captain Gentillo, also a Catholic.

We can now identify this Captain (or Colonel) Gentillo with a high degree of probability: he is none other than Louis Cousin (also known as Luigi Gentile, 1606-1667), the painter from Brussels who had spent many years in Rome and who had recently gone to Breda to paint the portrait of a member of the Nassau family. An anecdote related by Gentile on the road to Delft about the church of Breda, which remained Catholic at the testamentary request of Philips Willem de Nassau, the half-brother of the stadhouders Maurits and Frederick Hendrick, also seems to confirm the identity of Gentile. In recent years, and espe-

cially in the Sweerts exhibition at the Wadsworth Atheneum Museum of Art in Hartford, Connecticut, very suggestive parallels have been drawn between Vermeer's work and that of Sweerts, including strong similarities in their handling of light and the modeling of the human face. Some of Vermeer's research in these areas seems to have been anticipated by Sweerts by two or three years. Could Gentile be the link between Sweerts and Vermeer? Could he have brought him some samples of his work—some engravings perhaps—that may have influenced Vermeer? This is a lot to speculate based on a single concrete fact—the presence of Gentile in Delft—but the hypothesis is in any case worth retaining.

This is his account of the visit: "In Delphes I saw the painter Vermer [sic] who had none of his [own] works: but we saw one at a baker's for which six hundred livres had been paid, although there was only a single figure, for which I would have thought six pistoles too much." The baker in question was almost certainly Hendrick van Buyten. Even then a fairly wealthy man—he was to become even richer in later years—he had money to lend. Vermeer's father had known his father, Adriaen van Buyten, a shoemaker and leather merchant. After Vermeer's death, Catharina Bolnes was obliged to hand over two pictures to Hendrick van Buyten as security for a large debt run up over the years for bread. Perhaps van Buyten had boasted to Monconys that he had paid 600 livres for "a painting of a single figure" by Vermeer (a sum probably equivalent to 600 guilders), while Monconys, a regular purchaser of paintings and well informed as to their value, judged the picture to be worth no more than a tenth of that sum (the pistole being equivalent to 10 guilders). It may be noted that *The Milkmaid* fetched 175 guilders at the great auction of Vermeer paintings of 1696 and the *Woman Holding a Balance,* 155 guilders, The other paintings "of a single figure" sold for less than 65 guilders. At all events, the price of 600 guilders was well over the average, and one can hardly blame Monconys for being skeptical.

Another aspect of Monconys's second visit to Delft has remained undiscovered until the present. We may recall that Balthasar van der Beke, a Jesuit priest newly arrived in Delft, was officially admitted by the town authorities on 10 August 1663. He had lodgings in the house owned by Hendrick van der Velde on the Oude Langendijck, next door to Maria Thins. Would it not have been natural for Father Leon to have visited van der Beke on the day after his admission? Is it not indeed likely that this was the prime purpose of the visit of the three foreigners? Monconys had made no attempt to see Vermeer on his first trip to Delft. Since he had already attended mass at a "hidden church" in Rotterdam, he would no doubt have wished to see for himself the Mission in Delft. The visit to Vermeer was an added attraction.

VIOLENCE

In 1663, the same year in which Monconys visited Vermeer, the peace of the Vermeer household was shattered by a series of unpleasant incidents. In 1666, at the request of Maria Thins, sworn depositions were made by the innkeeper Willem de Coorde, the apprentice sculptor Gerrit Cornelisz., and a certain Tanneke Everpoel (presumably the maidservant, possibly the model for *The Milkmaid,* plate 8) concerning the offensive and violent behavior of Willem Bolnes toward his mother and sister. Three years before, according to their testimony, Willem had called his mother an old Papist sow and a she-devil, as well as various other terms of abuse. The old lady was so upset by her son's insults that she dared not leave her room and even had her meals brought up to her. Willem had also committed acts of violence "against Catharina Bolnes, the wife of Johannes Vermeer, threatening on a number of occasions to beat her with a stick, although she was in the last stages of pregnancy." The witness Tanneke Everpoel testified that Willem would actually have beaten his sister had she herself not intervened. De Coorde related how, at Catharina's request, he had prevented Willem from entering his sister's house and subjecting her to physical attack. He had seen Willem beat his sister several times with a steel-tipped stick. The witnesses were in agreement that Willem was not entirely in his right

36. Detail from *The Little Street* (plate 9)

mind. And indeed, his violent and abusive acts echoed the appalling behavior of his father to his mother twenty years earlier. Reynier Bolnes at that time had forced his wife to eat all her meals alone; he had constantly insulted her and had also beaten her with a stick when she was pregnant. Such a pattern of violent acts, repeated from one generation to the next, is a familiar phenomenon in our day as well.

A few months later Maria Thins won permission from the Court of Delft to have her son committed to a private house of correction, the "House of Taerling." The cost, for board, lodging, and laundry, was 310 guilders per year. The judges allowed Maria Thins to deduct this amount from the revenues of her son's estate and vested her with full power to administer his affairs.

Willem's attacks on Vermeer's pregnant wife seem to have left little mark on the artist's painting. Vermeer never deviated from his peaceful vision of the world, leaving to others—the Haarlem painters, for example—the images of war and pillage that such scenes of violence might have been calculated to inspire. On the other hand, it is possible that in his three paintings of apparently pregnant women *(Woman Holding a Balance* in the National Gallery of Art Washington, plate 15; *Woman in Blue Reading a Letter* in the Rijksmuseum, plate 14; and *Woman with a Pearl Necklace* in Berlin, plate 13), he intended to celebrate the serene dignity of the woman with child, unruffled by violence. Certainly the dating of these three pictures suggested by Blankert and Wheelock—1662 to 1664—is compatible with that view. In which case, the sidereal calm of Vermeer's painting may to be viewed as an idealized transposition of an everyday reality that itself was sordid to a degree. Vermeer, who lived and worked surrounded by the tribe of his offspring, never places a child prominently in one of his pictures; perhaps that too can be explained by a similar phenomenon of psychological repression. Such speculations, tenuous as they are, should perhaps be better left to psychologists.

We are on firmer ground if we confine ourselves to establishing the relations between Vermeer's pictures and the tangible items inhabiting the world in which he lived. Some of these items we know from the wills drawn up by Maria Thins, from the inventory of personal effects made by Maria Thins and her husband at the time of their separation in 1641 (document of 21 November 1641) and from the inventory drawn up two months after Vermeer's death (document of 29 February 1676). There is, for example, the silver-gilt jug

(fig. 35) mentioned in Maria Thins's second will, which we recognize in *Woman with a Water Jug* in the Metropolitan Museum in New York. I doubt whether the Thins-Vermeer household possessed any other object as rare and precious as that represented here. Similarly, there is a long list of objects referred to in the inventory of Vermeer's possessions which can be identified with items shown in the paintings. First, there are the "pictures within pictures." Baburen's *Procuress* (fig. 70), which belonged to Maria Thins and Reynier Bolnes in 1641, appears in *The Trio* (detail, fig. 71) and in *Lady Seated at a Virginal* (detail, fig. 72). The "painting with a bass viol and a skull," referred to in the inventory of Vermeer's effects (document of 29 February 1676), is the same as can be seen in the background of *Writing Lady in Yellow Jacket* (plate 22). Catharina's jacket of yellow silk with trimmings of white fur shows up in three paintings. Everyone of the maps seen hanging on the walls of interiors painted by Vermeer has been identified (by James Welu). The globe in the foreground of *Allegory of Faith* (detail, fig. 38) can only have been copied from the second of three editions of that globe (fig. 37), differing from each other only in minute details. All of this is overwhelming evidence of Vermeer's concern for fidelity in the painting of real objects. But, as several art historians have demonstrated, among them Lawrence Gowing and Albert Blankert, Vermeer also manipulated the items he used, altering them as necessary to obtain a desired effect. The yellow jacket with white fur cuffs becomes a blue jacket in *Woman Holding a Balance* (plate 15). The frame of Baburen's *Procuress* is ebony when it appears in *The Trio* (detail, fig. 71), but gilt in *Lady Seated at a Virginal* (detail,

37. Jodocus Hondius, *Terrestrial Globe*, 1618, Germanisches National Museum, Nuremberg

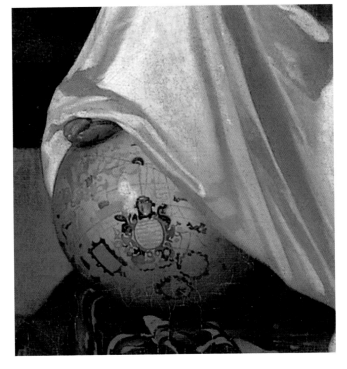

38. Detail from *Allegory of Faith*, (plate 31).

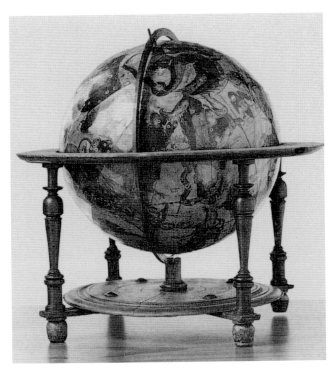

39. Jodocus Hondius, *Celestial Globe*, 1600. Nederlandsch Historisch Scheepvaart Museum.

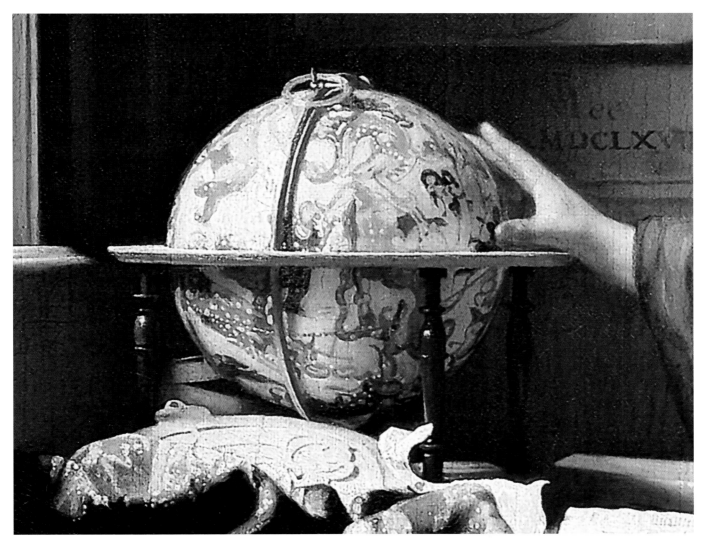

40. Detail from *The Astronomer* (plate 24).
The globe represented is that shown in fig. 39.

fig. 72), presumably because the artist wanted a play of light around the picture. The virginal itself varies, from one picture to another, depending on the composition and the color harmonies. The large medallion on the rug with a broad orange border, seen on a table in *Christ in the House of Mary and Martha* (plate 2), is yellow, the only medallion visible on the same rug, lying on the table in *Girl Asleep at a Table* (plate 4), is green. There are many other examples, but the principle is the same. Vermeer builds up his compositions from precisely rendered details—a characteristic method of composition that he shared with many of his contemporaries, including Adriaen van Ostade and Pieter de Hooch—but neither he nor his contemporaries can be said to have reproduced entire scenes "realistically."

INHERITANCES

After this digression into the relationship between Vermeer's painting and his environment let us return to his domestic life.

Maria Thins's troubles with her son did not end in 1663, with the events described above. Three years later, Willem, still living at the House of Taerling, had been given permission to come and go as he pleased. He had fallen in love with one of the maids, a girl called Mary Gerrits who came from the town of Waelwijck, and he was determined to marry her. The banns were made public in Waelwijck on 23 May 1666. Maria

Thins was determined that the marriage would not take place. There was much at stake: if Mary had a child, it would stand to inherit half the real estate of the matriarch that was left after the legal shares had been given out. It was thus imperative to discredit the young woman's character. Prompted by Maria Thins, witnesses gave sworn statements to the effect that Mary had stolen linen and a purse, that she had led Willem astray from the path of duty and told lies in order to alienate mother and son, and that the two young people had slept together.

Maria Thins achieved what she wanted: the wedding did not take place. Six months later, Willem was back at the house of correction. At his mother's request he now made a statement admitting that having come to know Mary Gerrits over a period of time, he had finally realized that she was an evil woman. He thanked his mother for opposing the match and for "having subjected him once more to her discipline."

Suit followed countersuit. Mary Gerrits tried again, apparently without success, to renew her ties with Willem, entreating him to run away with her. It was not until 1668 that the court of Holland issued a provisional judgment in favor of Willem's mother. Mary was ordered to pay costs, which amounted to 32 guilders. We do not know the exact details, but it is likely that at this point the young woman abandoned the fight, either wearying of the struggle or because she lacked the means to continue. Of Willem Bolnes we know nothing more until his death in 1676. In the interim his affairs were administered by his mother, Maria Thins. On her death, his estate passed to her daughter Catharina and later to the children and grandchildren of Vermeer.

By pure chance, Vermeer and his wife were to inherit at various times in their lives, either directly or indirectly, from persons who had not married or who had no children. On Catharina's side, there was first Elisabeth Thins, who entered a convent in Leuven. On her death in 1640, her estate passed to her brother Jan Willemsz. and her sisters Maria and Cornelia. When Jan and Cornelia died without descendants—they never married—their heirs were Maria Thins and her children. Willem Bolnes, as we have seen, also died without issue. Even the father and sister of Reynier Bolnes, Maria Thins's husband, left some part of their possessions to Catharina Vermeer.

Later, there was a further piece of good fortune for the Vermeer family when the granddaughters of the family's rich cousin Jan Geensz. Thins, whose names were Aleydis Magdalena and Cornelia Clementia, determined to devote their lives to God's service as members of the Beguine sisterhood. They left the major part of their estate to a granddaughter of Vermeer, whom one of them had brought up practically as her own child. The Vermeer family also profited from the inheritance left by Catharina's great-aunt Oiewertje Hendricks van Hensbeeck (the sister of Maria Thins's mother). She died in the early years of the century, without children, leaving a considerable fortune. Maria Thins had the first claim to a part of the estate, while a further sum was set aside to help needy descendants of the van Hensbeeck family. Many years later, Vermeer's grandchildren obtained assistance from these funds, which were deposited with the Orphan Chamber in Gouda.

On Johannes Vermeer's side of the family, there were smaller expectations. When his mother died in February 1670, he shared the inheritance with his sister Gertruy and brother-in-law Anthony. His part of the legacy was the inn Mechelen, which had been rented out for the past year. But the amount of the rent in 1670 was scarcely more than the interest on the mortgage with which the inn was encumbered. In a will drawn up two days before Digna Baltens was buried, Gertruy, Vermeer's sister, who was childless, made a bequest of 400 guilders to her brother (or, more precisely, to her heirs *ab intestate,* which in practice meant her brother). Vermeer in fact received only 148 guilders when Gertruy died soon afterward, in May 1670, probably because he had to pay some debts on Mechelen before he could get the money.

Six years after Monconys's visit, another well-born amateur met Vermeer. His name was Pieter Teding van Berkhout (1643-1713). This young man—just twenty-six—who was related to several great Dutch families, was interested in painting. In his journal, he records that one month before his visit to Delft, he had been

to see "Cornelius Bishop, excellent painter of perspective." Later, in December, he met Caspar Netcher in the Hague and the "famous Gerard Dou in Leiden."

Here is how he describes his first visit to Vermeer's studio in his journal, which he wrote in French:

"*Le 14 mai 1669 : je fus levé assez matin, parlois à mon cousin Brasser de la Brile, et m'en fus promené à Delft avec un jacht ou estoit Monsieur de Zuylechem van der Horts et [Monsieur de] Nieuwpoort. Estant arrivé ie vis un excellent peijntre nommé Vermeer, qui me montra quelques curiosités de sa main.*" ["14 May 1669: I got up quite early, spoke with my cousin Brasser de la Brile, and went to visit Delft in a yacht with Mr. Zuylechem van der Horts and [Mr.] Nieuwpoort. When I arrived I saw an excellent painter named Vermeer, who showed me some curiosities he had executed himself."]*

Behind the name of Mr. Zuylechem van der Horts is hidden that of Constantin Huygens (1628-1692), the most preeminent statesman of his time, private secretary of the Princes of Orange, Willem II and III. A great connoisseur of the arts, a poet and a musician, he had known quite well, at least in their beginnings, Jan Lievens and his colleague Rembrandt, from whom he had commissioned a series of religious paintings that marked the first great success of Rembrandt. But he was also an orthodox Calvinist, tolerant perhaps, but rather disinclined to associate with Catholics. Did he visit Vermeer on this occasion? Teding van Berkhout speaks to us in the singular ("I saw," "who showed me"); some researchers have no doubt that this meeting occurred. We remain skeptical.

Here is the summary of the second visit, which took place on 21 June 1669:

"*J'escrivis à mon cousin Berkhout, qui demeure à la Brile et aussji à Breda, ie sortis ensuite et fus voijr un célèbre peijntre nommé Vermeer, qui me monstra quelques échantillons de son art dont la partie la plus extra-ordinaire et la plus curieuse consiste dans la perspective. Je me promenoijs au sortir de là au marché, parlais à quelques amijs et entroijs ensuite chez mon cousin C. Bogaert pour voir ses peijntures.*" ["I wrote to my cousin Berkhout, who resides in Brile and also in Breda, then I went out and saw a famous painter named Vermeer, who showed me some samples of his work, of which the most extraordinary and curious part is the perspective. Leaving from there I went to the market, spoke to some friends and then went on to my cousin C. Bogaert's home to see his paintings."]

(A few years later, during the war with France, Cornelius Bogaert was named "Commissioner of Contracts and Engagements." In 1673, he told Bramer that, thirty years before, he had ordered a copy of a painting in Rome from the painter Giovanni del Campo, probably a copy after an original by Valentin de Boulogne, a painting Bramer had brought to Delft. Apart from this copy, we know nothing of Bogaert's collection.)

Here then is our "famous" painter. Was he as famous as the "famous" Gerard Dou? Certainly not, unless the documentation at our disposal today—in the books by Hoogstraten, Houbraken, and others—has given us a false impression of their respective reputations. But he must however have enjoyed a rather strong reputation outside Delft in order to justify such a description. It is the last time we have proof of this, at least before the high prices obtained at the posthumous sale in 1696 of the paintings of Jacob Dissius, inherited from Vermeer's financier.

PROBLEMS

If Vermeer and Catharina had not had such a large family, they might perhaps have got by with the help of gifts and loans from Maria Thins, the various legacies of which they were beneficiaries, and the proceeds from the two or three pictures that Vermeer managed to sell even in a bad year. But in the early 1670s it required a very considerable income to support nine or ten children, the more so as all but one or two (boys) had been

*I chose to reproduce the original French because of the exceptional fact the journal was written in French, and because it contains several linguistic anomalies, mostly "dutch-isms," that could be of interest. In any case I have also given an English translation.

reared without any thought of apprenticing them to a craft so that they might one day be capable of earning their own living. This was especially true in regards to the numerous daughters: Maria (born around 1654), Elisabeth (around 1657), Cornelia, Aleydis, Beatrix, all born before the first boy Johannes whose birth we situate in 1663. After this date, the repartition of boys and girls became more even: another boy (Franciscus) arrived in 1667; next, two other girls (Gertruy and Catharina) and the last boy Ignatius, was born around 1672. (The eleventh child to have survived beyond infancy seems to have been born around 1674, and to have died at the age of four. We do not know whether it was a boy or a girl.) These eleven children plus the four laid in the grave in infancy comes out to fifteen children in twenty-one years, a rate of almost a child per year!

It is only recently that we have been able to fix the date of Franciscus's birth, since we found his engagement certificate, signed in Amsterdam in 1689, on which his age is given (twenty-two years old). In the same document he also declares that he is a surgeon. The young surgeon later resurfaces again in Rotterdam and in the Hague. It is worth remarking at this point that two of the three members of the Vermeer family for whom we know the town of their apprenticeship—Reynier Jansz. Vos, that is, Vermeer and Franciscus Vermeer—were apprentices in Amsterdam. It had perhaps become a tradition, which would add to the probability that Vermeer was an apprentice there as well, at least for a time.

Besides Franciscus, about whom we have just spoken, we only know of Ignatius, whose very name strongly suggests that Vermeer converted to Catholicism and testifies to the family's sympathies for the Jesuits. By the time he was fourteen, he turns up again in the archives of the Hague, where he signed numerous documents. He was still alive in 1713. Unfortunately, we know nothing more of him, not even his occupation.

Even so, the couple might have managed if the economy of Holland had not collapsed in 1672, dealing a fatal blow to the market in works of art. That year is always referred to in Dutch history as the disaster year (het rampjaar). Louis XIV had invaded the Republic. England too had found a pretext to declare war on the States. To defend Amsterdam, the sluices were opened and an area of the country was flooded. Agriculture and cattle-breeding were hard hit. For several years the tenants of the farms that Maria Thins owned in the vicinity of Schoonhoven were unable to pay their rents. Paintings were virtually unsalable, or fetched very low prices. After Vermeer's death, his widow recounted how her husband, who occasionally acted as a dealer for other painters' works, found himself unable to sell a single painting by anyone.

This black year nevertheless saw Vermeer reelected as a headman of the Guild of Saint Luke, succeeding Cornelis de Man, who automatically became a "retiring headman." In May 1672 Vermeer was summoned to The Hague to verify the authenticity of a small collection consisting almost exclusively of paintings of the Venetian and Roman Renaissance (document of 23 May 1672). It was the only recognition he ever received outside his native town. The collection belonged to the dealer Gerard Uylenburgh, who had offered it to the grand elector of Brandenburg, Friedrich-Wilhelm, grandson of the elector who had been involved in the affairs of Balthasar Gerrits in 1620. The prices asked by Uylenburgh were very steep, between 500 and 800 guilders a picture.

Friedrich-Wilhelm contemplated the purchase for a time but withdrew after consulting his adviser in artistic matters, the painter Hendrick Fromantiou. Uylenburgh was reluctant to take his pictures back. Fromantiou called in experts to prove they were copies and fakes. Uylenburgh summoned his own experts to prove the opposite. By the time Fromantiou invited Vermeer to offer his opinion the controversy had been going on for some months. Vermeer arrived in The Hague with a colleague from Delft Hans Jordaens, who had spent several years in Italy. They delivered their verdict in the presence of a notary. In their view, the twelve pictures—nine attributed to Venetian painters, the remainder to Michelangelo, Raphael, and Holbein—were entirely without value. They were bad paintings, "great pieces of rubbish not worth a tenth of the price asked for them." We do not know who was closer to the truth in the affair, but Uylenburgh was declared bankrupt a short while afterward.

In 1674 Vermeer enjoyed a welcome distraction from his monetary anxieties on the occasion of the marriage of his eldest daughter, Maria, to Johannes Cramer, an affluent silk merchant. The wedding was celebrated in Schipluy, where Vermeer himself had been married twenty-one years before. Cramer too was a Catholic, and all the children of the union were later baptized at the Jesuit Mission of the Cross in Delft. Maria was the only one of Vermeer's children to marry within the painter's lifetime.

According to the account given by the painter's widow two years after her husband's death, Vermeer had sold practically nothing after the outbreak of war with France in 1672 (document of 21 January 1676). There is reason to believe that at the time of his death he still had in his possession at least four paintings, including *The Art of Painting* (plate 19), *The Guitar Player* (plate 29) (or a version thereof), *Lady Writing a Letter with her Maid* (plate 27), and *Woman with a Pearl Necklace* (plate 13). We may suppose that he sold at least one painting after 1672, the *Allegory of Faith* (plate 31), for there is strong circumstantial evidence that this was a commission.

The *Allegory of Faith* is the only work by Vermeer systematically founded on traditional iconography, as Blankert points out in his description of the painting (see page 154). A number of art historians have suggested that Vermeer's *Allegory* is sufficiently close to Jesuit iconography to have been commissioned by the fathers of the Mission in Delft. In my view it could equally well have been commissioned by lay members of the congregation. To a modern eye the work may seem overly full of symbols, but compared with the devotional works habitually favored by the Jesuits it is in fact relatively restrained; sufficient in this context to cite the statue commissioned by the Delft Jesuits in 1678, on the day of the Feast of the Immaculate Conception, which was intended to adorn the altar of their church. According to a contemporary description, the Virgin stood on a crescent moon, supporting Christ. He in turn held the Cross, which rested on his mother's foot. Under the same foot she was crushing the serpent. The Virgin's clothes were richly encrusted with gold and pearls. This type of image has more in common with an idol than with Vermeer's painting, yet it was highly prized by the Jesuits, for whom it symbolized their difference from the secular priests on the Oude Delft canal who, under Jansenist influence, repudiated "scapulars, rosaries and relics."

VERMEER AND THE COMMUNITIES OF DELFT

How must we situate Vermeer in relation to the society, or rather to the various societies, of his time and in the first place in Delft? Were his relations with Maria Thins and the local Catholics exclusive? Or did he have attachments in other communities? Let us begin with the Catholics. A very interesting archive document rediscovered some years ago reveals to us that in 1669 two Catholic women from Amsterdam, daughters of a well-known bookseller and editor named Barent Hartochvelt, issued a mandate to Vermeer, charging him to "defend, prosecute and pursue" a dispute—probably a trial—in Delft in which they were involved. It may have concerned an affair involving the town's Catholic community. We suspect that the two maids, who were single and already quite old, were Beguines, like Aleydis Magdalena and Cornelia Clementia van Rossendael.

But the recent discovery of Vermeer's enlistment in the Delft militia, at least in 1674, the only year in which the militia archives were preserved, forces us to rethink his social situation. As a rifleman (shutter), he must certainly have had connections with the Calvinist elite of Delft, in the first place with the officers of his company ("the orange regiment"). We do not know if he was already a member of the militia at the time of the French invasion in 1672. It is significant that many Catholics, including Vermeer and his brother-in-law, the framer and cabinet-maker Anthony van der Wiel, were still (or once again) riflemen in 1674—there was a purge of the officers in 1672, but, as far as we know, it did not affect the riflemen of the lower ranks. There is reason to believe that Vermeer was what was then called a staatsgesind, which is to say that he was a Catholic and a patriot, ready to defend his country against the invaders, despite his adhesion to the Catholic faith.

We are not sure that Maria Thins was of the same mindset. In 1679, she signed a declaration in Delft in the presence of the painter Adriaen Isselsteyn, who collaborated vigorously with the French authorities during the occupation of Utrecht and who, subsequently, had to flee the city.

We shall soon come back to one final contact between Vermeer and the Remonstrant community during his last trip to Amsterdam in 1675.

THE LAST YEARS, "NIET TE HALEN"

For most of his life Vermeer led a relatively quiet existence and was disinclined to appear before notaries more often than necessary—in this respect quite unlike his father, whose signature occurs on literally dozens of sworn statements and depositions. But in the two years before he died, Vermeer took an increasingly active role in the running of his family's affairs. He showed up before the family notary on several occasions, either on his own account or in connection with administering the affairs of his mother-in-law, who by now trusted him implicitly (proof of his gentle and amenable disposition, for Maria Thins had at one time or another fallen out with every other male member of the family, including her brother Jan). She granted Vermeer power of attorney to collect the arrears in rent due to her and also entrusted him with renewing leases and paying interest on assets held by the authorities in Gouda, and if necessary the selling of securities that were transferable.

In July 1675 Vermeer made a last trip to Amsterdam to borrow 1,000 guilders. He was desperately short of money. The lender, named Jacob Rambouts, was the son of Gertruyd Arminius, who was in turn none other than the daughter of Jacobus Arminius, the founder of the religious faction that tore Holland apart during the first quarter of the century. The mother of Maria, Gertruyd Arminius, was a member of the literary and artistic circle that met in the castle at Muyden belonging to the poet Pieter Cornelisz. Hooft. One can wonder whether Vermeer went to Jacob Rambouts because his commander Pieter van Ruyven had recommended him (we know he died two years earlier) or for another reason. In any case, there can be no doubt about the convictions of Jacob Rambouts and his wife Joanna Kieft, who continued to have their children baptized in the Remonstrant Church (tolerated since the early 1630s).

Since none of the pictures he painted in the 1670s is dated, it is impossible to say whether his increased business activity had an adverse effect on his painting. There is, however, a perceptible diminution of energy in the late works, as exemplified by the *Allegory of Faith* (plate 31) and *Lady Seated at a Virginal* (plate 30). Blankert even detects a certain coarseness of execution in the latter painting. Yet Vermeer remained in good physical health to the end of his life, and if there was any diminution of power, in my view it must be attributed largely to psychological causes. For over twenty years Vermeer had painted beautifully orchestrated interiors containing one, two, or three silent and immobile figures. He had simply come to the point where he had exhausted the possible combinations, reached the end of his inspiration. Perhaps too the financial problems that gnawed away at him had finally sapped his creative powers.

This is how his widow, writing two years afterward, described the painter's decline: "During the long and ruinous war with France, not only could [my husband] not sell his work, but in addition, at great loss to himself, the pictures by other masters which he bought and traded were left on his hands. In consequence of that and because of the large burden of his children, having no personal fortune, he fell into such a frenetic state and decline that in one day or a day and a half he passed from a state of good health unto death." He was forty-three years old.

The body of Johannes Vermeer was carried to the Old Church on 15 December 1675 (document of that date). On the next day he was buried in the family vault purchased by Maria Thins in 1661. According to the church register, he left eight underage children (that is to say, children who were either unmarried or below

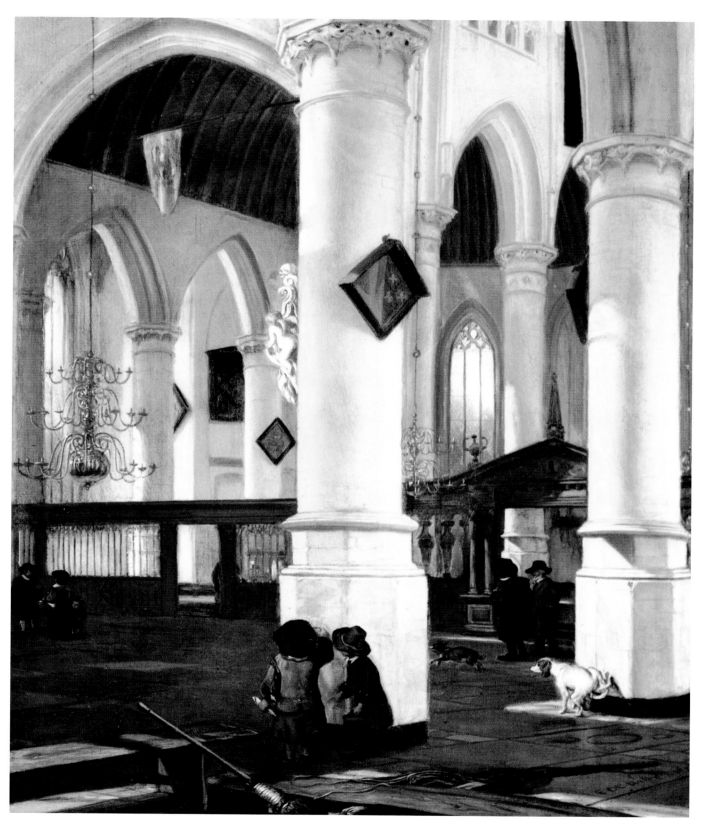

41. Emanuel de Witte, *Interior of the Oudekerk in Delft*, 1650,
panel, 48.3 × 34.5 cm. Collection of Mr. and Mrs. Michal Hornstein, Montreal

the age of twenty-five). In fact this must have been a clerical error, for all subsequent documents agree that the number of children was eleven, including the eldest daughter Maria, married in the previous year. The clerk may have understood that there were eight children still living in the family home.

In the Charity Commissioners' register for 15 December 1675 there is an entry for Johannes Vermeer, artist painter. Next to his name appears the phrase *niet te halen* ("nothing to get"), meaning that no donation would be made to the Commissioners (document of 16 December 1675). When Vermeer's mother and sister Gertruy died in 1670, the heirs (Vermeer and Antony van der Wiel) donated 6 guilders and 6 stuivers to the Commissioners for each of the deceased, a modest enough contribution but about average for a lower-middle-class family in Delft.

CREDITORS AND HEIRS

Vermeer's creditors did not wait long before they began to put pressure on his widow. On 27 January 1676 Catharina Bolnes attended the notary's office to make a formal acknowledgment of a debt of 617 guilders 6 stuivers to the baker Hendrick van Buyten (document of 27 January 1676). As security she handed over to him two of her husband's paintings, *Lady with a Maidservant Holding a Letter* (plate 23), in the Frick Collection, and *The Guitar Player* (plate 29), probably the painting in the Iveagh Bequest at Kenwood. It was understood that van Buyten would return the pictures when the debt—together with a further 109 guilders 5 stuivers, also for deliveries of bread-had been paid off, at the rate of 50 guilders per year. If she failed to keep up the payments, he would have the right to sell the pictures, and she would be liable to pay him the difference between the proceeds of the sale and the amount owed.

A loaf of white bread weighing 11 pounds cost at that time about a guilder. The accumulated debt of 726 guilders was thus the equivalent of about 8,000 pounds of bread. A family of two adults and ten children, four still quite young, might consume as much as 6 to 10 pounds of bread in a day, assuming that their diet was otherwise typical of an average bourgeois family. The total debt thus represented arrears of two or three years on bread supplied by the baker. Vermeer probably had not paid his bills for bread since 1672 or 1673, which would coincide more or less with the beginning of the period of acute financial difficulty bemoaned by his widow.

Catharina also had to meet the demands of Jannetge Stevens, a woman who sold linen and wool cloth. In February 1676 she went to the Three Lemons inn in Amsterdam and handed over to the dealer Jan Coelenbier "on account for Jannetge Stevens" a lot of 26 paintings estimated to be worth 500 guilders. As Jannetge owed him money, Coelenbier was to pay her less than this sum. In the meantime he took the paintings back to Haarlem, where he lived, and kept them as security for the debt she owed him.

The average price of one of the 26 paintings was thus a little under 20 guilders, while a painting by Vermeer would probably have been worth 60 to 150 guilders. We know that Catharina still had at least two of her husband's pictures: *The Art of Painting* (plate 19), which she later ceded to her mother. and *Woman with a Pearl Necklace* (plate 13) listed in the inventory drawn up only a few days after the transaction with Coelenbier. In addition she had sold two of her husband's paintings to van Buyten. If the artist painted on average two pictures a year, it is unlikely that he had kept in addition to the four paintings mentioned above, more than two or three of his own works, even if he had sold practically nothing since 1672. All of which would tend to suggest that most of the pictures sold to Coelenbier were not by Vermeer himself. Probably they comprised a collection of pictures by other artists for which he was hoping to find a buyer. If these paintings represented his entire stock, then he can only have been a dealer on a small scale, for with assets worth 500 guilders (or even 800 to 1,000 guilders if Catharina had not been forced to accept a distress price), he could not have expected to make a profit of more than 80 or 100 guilders a year, an insignificant sum compared with what was required to support his family.

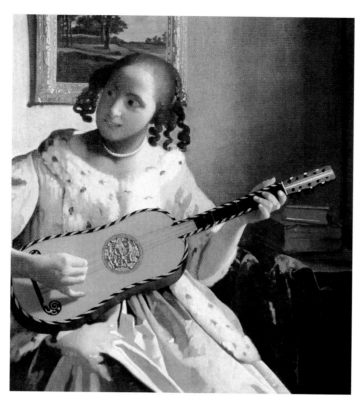

42. Detail from *The Guitar Player* (plate 29)

Two weeks after the 26 paintings were sold, Catharina visited a notary in The Hague to carry out a rather unusual transaction. To her mother Maria she ceded, in full title, the canvas *The Art of Painting* (plate 19), the rents due to her from the Bon Repas estate, half the income from the smaller property in Oud Beyerland, and annuities totaling 200 guilders per year, all this in part payment of her debts to her mother (document of 24 February 1676). It seems highly likely that this transfer of ownership, which was effected just two days before the inventory of the couple's possessions was due to be made, was in fact a legal device to prevent Catharina's assets from being dispersed among her creditors. As we shall see, these latter did not accept willingly to go along with a stratagem designed to bilk them of the money that was their due.

We have already mentioned the inventory drawn up on the last day of February 1676 (document of 29 February 1676). I will add only that the furniture, pictures, clothes, and household articles were divided into two lots, one reverting automatically to Catharina Bolnes, the other to be divided equally between Catharina and her mother. The personal assets of Vermeer and his wife seem to have been included in the first lot, as well as most of the pictures and books (30 out of 36). The second lot consisted for the most part of pieces of furniture, household and culinary articles, and various domestic items, probably inherited by Maria Thins from her sister Cornelia. Although presumably the major part of Vermeer's possessions was included in the first lot, a number of the more precious items mentioned in Maria Thins's first two wills appear to be missing, among them the silver-gilt pitcher. Nor is there any reference to items of gold and silver in Catharina's portion. Are we to believe that Maria Thins never gave her daughter the articles she promised her? What is far more likely is that Catharina's most valuable possessions—possibly including some of the musical instruments that appeared in Vermeer's pictures—had either been hidden away or their title transferred to her mother, in order to keep them from being given to the estate's creditors.

The hapless Willem Bolnes died in late March 1676. He was buried in the family vault at the Old Church, beside Vermeer and three of his children. Maria Thins was his heir and now acquired all his assets.

On 30 April 1676 Catharina Bolnes submitted a petition to the High Court of Holland. In it she explained

to the magistrates how her husband had left her a widow with eleven children, that he had derived practically no profit from his painting during the war with the king of France, and had been forced to put on the market at ridiculously low prices the works by other painters in which he traded. As a result she was heavily in debt and unable to satisfy her creditors "who were unwilling to make allowance for her large losses and the misfortunes brought about by the war." For these reasons she was asking for letters of cession enabling her to defer payment of her debts. Permission was granted on the same day. The Delft magistrates were then obliged to appoint a curator to administer the artist's estate, for, by her act, Catharina had legally given up the estate, handing everything over to her creditors. On the list of creditors that has come down to us there is only one familiar name, that of the baker Hendrick van Buyten. "Emmerentia," however, is probably the baker's sister, and "Tanneke" the maid who prevented Willem from attacking Catharina. There are also references to Rombouts, an Amsterdam businessman from whom Vermeer borrowed 1,000 guilders, and to Hogenhouck, a beer-seller.

On 25 September 1676 Maria Thins drew up a new will. She was staying at the time in The Hague with Aleydis Magdalena and Cornelia Clementia van Rosendael, the granddaughters of her cousin Jan Geensz. On this occasion she appointed as her heirs the children of Vermeer and Catharina. To Catharina herself she left only what was legally due, namely one-sixth of all her estate. She also stipulated that the inheritance should be reduced by the amount of Catharina's debts to herself, not only those debts contracted during her husband's lifetime but also those incurred after his death, together also with the sum of any expenditure she was obliged to make on behalf of the grandchildren after the date of the deed of transfer and up to her death. Once again, Maria Thins was trying to prevent the family's possessions from falling into the hands of the creditors, who had a legal claim on Catharina's estate but not on the inheritance of her children.

On the next day the old woman made a formal request to the States of Holland and West Friesland to transfer a "vicary" (a sum of money deposited with a church in Schoonhoven, formerly the property of her son Willem) to the name of Johannes, son of her daughter Catharina. The income from this sum of money was later to finance the young man's education.

VAN LEEUWENHOEK

On 30 September 1676 Anthony van Leeuwenhoek (fig. 43) was officially appointed to administer Catharina Bolnes's estate on behalf of her creditors. By this time van Leeuwenhoek, born in the same year as Vermeer, was a well-known and respected scientist. He had made a number of improvements in the design of the microscope and, by means of precise observations, had established the role played by the capillaries in the circulation of the blood. In the following year he was also to describe and illustrate the spermatozoa. Largely self-taught, he pursued only empirical research. We do not know if he ever met Vermeer. It has often been suggested that the two men must have encountered one another because of their common interest in optics—Vermeer, for his part, is said to have made use of the camera obscura. Yet there is absolutely no evidence of a direct connection. Even if they were acquainted, that would not in itself explain why van Leeuwenhoek was appointed by the Delft magistrature to oversee Vermeer's estate. First, he was a Protestant. Given the choice, Maria Thins and Catharina Bolnes would presumably have preferred a Catholic. Then, it was van Leeuwenhoek's responsibility to look after the interests of the estate's creditors, if necessary at Catharina's expense. There is actually no reason at all to presume that he was appointed because of any particular sympathy or friendship toward the artist or his family.

It was probably at van Leeuwenhoek's request that the Delft magistrates sent the lawyer Christiaen van Vliet to The Hague on 19 November 1676 to interview Maria Thins. Van Vliet wanted to establish whether or not certain properties belonging to Willem Bolnes had passed directly to Catharina on his death (in which case they would form part of her estate). Maria Thins had to make a sworn statement in the presence of a notary

to the effect that her son Willem had possessed no other properties beyond the vicary at Schoonhoven, a farm in the vicinity of Schoonhoven and some land in the Barony of Liesveld. One week later, Pieter de Bye, representing Maria Thins, and van Leeuwenhoek, representing Vermeer's bankrupt estate, reached an agreement before the Delft magistrates concerning the estate left by Willem Bolnes. Maria Thins was obliged to payoff all her son's debts, but was permitted to reimburse herself from a legacy left to her son—a legacy which had not been mentioned to van Vliet when he interrogated Maria about her son's property. Van Leeuwenhoek, for his part, had acquiesced in the transfer of Catharina's rights in this inheritance to Maria Thins, in return for which she was to pay him 500 guilders on account of the bankrupt estate, plus 60 guilders for his services.

But van Leeuwenhoek was still not satisfied. In December the courts again sent van Vliet to The Hague, this time to check whether Maria Thins had not concealed the existence of certain of Catharina's assets *in fraudem creditorum.* On this occasion she swore that the income Catharina made over to her in February, together with *The Art of Painting,* amounted in total to no more than 167 guilders, and not 200 as she had declared at the time. She had made a gift of these annuities to her daughter a few years before. Three of them were valid only during the life time of Willem Bolnes and had therefore lapsed on his death. One belonged to Elisabeth Vermeer. It was thus only the last two, worth 50 guilders 5 stuivers, that were actually in Catharina's name. Again she gave her word that she had in no way acted with fraudulent intent toward Catharina's creditors.

One month later—in January 1677—Maria dictated a new will. It differed from the previous document largely in the provisions she made for the long-term management of her assets for the benefit of her grandchildren. First, if the expenses of Johannes Vermeer's education exceeded the proceeds from the vicary at Schoonhoven, the executors were authorized to draw on other funds from the estate. In addition, the prop-

43. Jan Verholje (1650-1693), *Anthony van Leeuwenhoek,*
canvas, 56 × 47.5 cm. Rijksmuseum, Amsterdam

erties passing to the grandchildren were not to be divided until the youngest had attained the age of four-teen. (As the child in question was then only one and a half years old, the date on which the inheritance could be shared out was advanced to 1689). The four youngest children were to be fed, clothed, and assisted in the craft or occupation chosen by their guardian, using the income derived from the properties left jointly to the children on her death.

In February van Leeuwenhoek appeared in the Delft courts as plaintiff against Jannetge Stevens: at issue was the fate of the 26 paintings transferred to Coelenbier on her behalf, and her claim on Vermeer's estate. The following compromise was agreed: van Leeuwenhoek, representing the painter's estate, was to pay Jannetge Stevens 342 guilders, which would be regarded as a full settlement of the debt of 442 guilders claimed by her. In return, Jannetge Stevens would, with Coelenbier's approval, return the 26 paintings lodged with him in the meantime. The paintings would be put up for auction, and profits not exceeding 500 guilders would go to the estate.

The sale was to be held in Delft at the offices of the Guild of Saint Luke on 15 May 1677. On 12 March, Maria Thins, still in The Hague, sent to van Leeuwenhoek an "insinuation." This was a formal statement of her grievances, drawn up in due form by a notary, and threatening to pursue the case against van Leeuwenhoek in the courts if she received no satisfaction. First the notary reminded the administrator that Maria Thins had provided him with a copy of the deed of transfer relating to *The Art of Painting,* dated 24 February in the previous year. Since the picture now belonged to her, she failed to understand how van Leeuwenhoek could be intending to sell it at auction on 15 May. The painting represented the repayment of her daughter's debts to her mother. If, however, van Leuwenhoek persisted in going ahead with the sale, then she would have first claim on any money raised. Van Leeuwenhoek replied to the notary that he had only managed to recover the painting by taking Jannetge Stevens to court and by paying her 342 guilders, not counting the costs of the case. He therefore intended to proceed with the sale of the painting in spite of her complaint. If Maria Thins had any prior right to its title, it was open to her to make her case in the courts.

All this controversy is somewhat confusing. How could *The Art of Painting* have been included in the transactions of 10 February 1676 concerning the lot of 26 paintings, when Catharina had transferred owner-ship of the picture to her mother a full two weeks afterward? It is of course possible that the sale to Coelenbier, on Jannetge Stevens's behalf, was entirely fictitious; or van Leeuwenhoek may have been mis-taken in believing that the picture belonged with the lot of 26 paintings. But if it were no more than a sim-ple mistake on his part, how then did the painting leave Maria Thins's possession and end up in van Leeuwenhoek's hands? Unfortunately, that is where the story ends. We know nothing of what happened at the sale of 15 May (or even whether it actually took place) and nothing more about the fate of *The Art of Painting* from that day on—until its eventual reappearance as part of the Czernin collection in Vienna in the early years of the nineteenth century, at which time it was attributed to Pieter de Hooch.

DEATH OF MARIA THINS AND CATHARINA BOLNES

In July 1677 Maria Thins authorized Aleydis van Rosendael to act on her behalf in the matter of funds lodged with the Orphan Chamber in Gouda, money originally deriving from the estate of Diewertje van Hensbeeck. Aleydis duly submitted to the Chamber a petition from Catharina Bolnes, in which she explained how she had come to be in her present difficulties, recounting the whole history of how her husband was reduced to a frenetic state and had then died under the mounting weight of his debts. She now found herself with ten underage children, the youngest only two years old. The eleventh child—Maria—by virtue of her marriage, was no longer considered "under age." None of the children was in a position to earn his own living. Catharina was therefore obliged "to ask for help not only from her family but also from strangers, something she did with reluc-

tance as she came of honest stock." Her request was approved and she was granted permission to draw on the nontransferable capital, the income from which belonged to her mother. One year later Maria Thins and Catharina Bolnes asked permission of the Orphan Chamber in Gouda to transfer from mother to daughter 1,200 guilders of the capital sum lodged with the Chamber. (Trusts of this type were strictly administered and protected.) On this occasion, Catharina alleged that two of her children were very ill and that one of them had been severely wounded following an explosion on board a vessel returning from Mechelen. The child in question is presumed to have been Johannes, who had probably been sent to pursue his studies in a Catholic country. Because of all these problems, and as her children earned practically nothing themselves, she could neither afford to feed them nor pay the apothecaries and surgeons. Apparently her request was granted.

In 1678 Maria Thins began an action to have herself declared preferential creditor of Vermeer's bankrupt estate. The formalities were successfully completed in July 1679. Toward the end of that year she authorized the lawyer Jan Bogaert to represent her interest as preferential creditor, in negotiations with van Leeuwenhoeck; she continued to claim that the repayment to her of her daughter's debts was still outstanding.

Early in 1680, having reached the ripe old age of eighty-seven, the "matriarch" drew up her last will and testament. For the most part the dispositions of her property were unchanged, but there were additional stipulations designed to ensure that the estate would remain undivided until her grandchildren had reached the age of sixteen. The children's guardians and the executors would not have the right to mortgage the said properties unless her daughter Catharina was in need of money (this to be a matter for the executors' discretion). In that event the underage children should have a prior claim in the allocation of funds.

In October 1680, three months before her death, the seemingly indefatigable old woman was back in Delft and once again paid a visit to the notary, this time to draw up a deed thanking Aleydis and Cornelia van Rosendael for administering her properties since July of that year. We do not know the precise nature of these administrative tasks, but they had clearly started some time before, since the deed makes reference to the previous settlement of accounts for administration "before the notary Boyman and certain witnesses in Mechelen on 8 July last." The Rosendael sisters must therefore have traveled to Mechelen, perhaps accompanied by Maria Thins, in order to sort out some piece of business. Why Mechelen? We have already raised the possibility that Johannes, then fifteen or sixteen, may have attended a Catholic school in the town. Although, on the face of it, there would be no need to visit the place just to pay fees or organize the boy's studies, nevertheless, if it was a Catholic school, there was a legal prohibition on transferring funds to an organization regarded in Holland as subversive.

Four days before Chrismas of 1690, Maria Thins was given extreme unction by a Jesuit priest from the Delft Mission. On 27 December fourteen pallbearers carried her coffin to the Old Church, where she was interred in the family vault. The vault, by then full, was sealed.

Vermeer's widow continued to be short of money. In 1681 she borrowed two sums of 400 guilders, perhaps to pay to van Leeuwenhoek who, in March 1682, cashed in two debentures on behalf of the creditors to Vermeer's estate. Since this is the last we hear of Anthony van Leeuwenhoek in connection with his activities as curator of the estate, it is possible that by this act he finally cleared the debt to the creditors.

Two years later we find Catharina Bolnes in Breda, a town in Brabant near the frontier with the Spanish Netherlands, a region which had remained largely Catholic. Once again she approached the Orphan Chamber in Gouda for assistance, alleging that she still had in her charge in Breda eight of the eleven children with whom she was left on the death of her husband. Her income was too small to support a family of this size, and in particular her daughter Gertruy "whom God has afflicted with sickness and who can earn nothing." (The Gertruy in question survived in spite of her illness: she was still alive thirty years later.) The burgomasters granted Catharina the sum of 96 guilders per year for two years, the sum to be deducted from the funds deposited by her ancestors. Subsequently that pension was extended for a further three years.

But this money, together with what was left of her mother's estate, was not enough for Catharina. On 29 October 1687 she borrowed 300 guilders from her landlady in Breda. She also acknowledged a debt to her of 175 guilders for bills in respect of food and lodging, and for deliveries of goods intended for the use of herself and her children. These debts were settled after her death by Cornelia and Aleydis van Rosendael.

Two months after borrowing money in Breda, Catharina visited her daughter Maria, who lived with her husband, Johannes Cramer, in the Verwersdijck. There she was taken ill. Philippus de Pauw, from the Jesuit Mission, gave her extreme unction. She was buried on 2 January 1688, aged only fifty-six (document of that date). Although one might have assumed she had no money left of her own, her coffin was carried to the church by twelve pallbearers. The church register notes that she left five underage children.

VERMEER'S CHILDREN AND GRANDCHILDREN

Of Vermeer's seven daughters, only two, to our knowledge, ever married. Maria married the textile merchant Johannes Cramer, and Beatrix married Johannes Chistophorus Hopperus (or Hosperius) sometime around 1686. Gertruy, the next-to-the-last daughter, seems to have been in fragile health throughout her youth and was perhaps not in a state amenable to marriage. It is quite possible that several of the daughters devoted their lives to God, as Beguines following the examples of their younger Roosendael cousins. In any case, the low marriage rate in the Vermeer family is striking—undoubtedly rare at the time. At least two of the three sons married: Johannes married Anna Frank (sometime before 1689) and Franciscus married Maria de Wee (or Duee) in 1689.

The trajectory of Johannes, the oldest, is particularly interesting. His studies were paid for thanks to a vicariate based in a church in Schoonhoven (where Maria Thins had connections to the town's Catholic regents). It was customary in particularly pious Catholic families of the time to set aside the revenues from such vicariates for the priestly training of the eldest son in the family. This was, we think, the case of Johannes. Such studies could not be undertaken legally in the United Provinces. Johannes had to enroll in one of the numerous seminaries in the southern Catholic provinces, perhaps with the Oratorian Fathers at Malines, where one of his younger Roosendael cousins had already undertaken his studies. In 1678, when Johannes was about fifteen years old, Catharina Bolnes said that "one of the children"—probably him—had been gravely wounded in an explosion on a boat coming from Malines. Catharina did not have the means to pay the doctors and surgeons to treat him. Did this accident interrupt his vocation? Was the revenue from his vicariate was no longer sufficient to pay for his studies, or had the accident left him too handicapped to become a priest? And yet, as we have said, he married and had a son, Jan, who was baptized in a Catholic church near Rotterdam in 1688.

A few months later, the familial domain Bon Repas near Schoonhoven was awarded to him by adjudication. On that occasion, the authorities in the Hague charged with the administration of the feudal domains of the United Provinces declared that he was still a legal minor, thus under twenty-five years of age. He was probably twenty-three or twenty-four. After that, we find him once more in Bruges in 1698, where he seems to have been working as a notary.

The estate was sold in 1721, the proceeds going to those of Vermeer's children who were still alive (Maria, Alida, Catharina, Gertruy, and Ignatius) and to his grandchildren (Jan Vermeer and Elisabeth Catharina Hosperilus, daughter of Beatrix Vermeer). Franciscus, who had become a master surgeon by 1684, was apparently dead. It is sad to record that Jan Vermeer, the painter's grandson, a weaver by trade, was illiterate. He moved to Leiden, the major center for weaving, and married a girl from Delft. Together they had a large number of children, all of whom were baptized in the Catholic faith.

Elisabeth Catharina, Beatrix's daughter, was just two years old when her parents died. She was brought up by the good angel of the family, Aleydis van Rosendael. In December 1703, Aleydis, then an old woman,

drew up a most extraordinary will in which she solemnly declared that she had never become a nun, that no priest had ever recited to her, "Receive this vestment of purity and guard it for eternity." Although she had spent fifty years in the Beguine sisterhood, and wore a black silk habit, she had never taken her vows. This formal denial was a necessary preliminary if she was to dispose of her property as she pleased, something she would not have been legally entitled to do in Holland if she belonged to a Catholic order. After making various minor bequests to members of the Rosendael family, she named her "niece" Elisabeth Catharina Hosperius as her residuary legatee.

The other grandchildren were the sons and daughters of Maria Vermeer and Johannes Cramer. The name Vermeer underwent various changes. Every time Maria baptized one of her children at the Jesuit Mission, her surname was written differently: Maria van Meren in 1680 and 1682, Maria Thins in 1683, Maria van der Meer in 1690. Three times she gave a newborn son the name Aegidius. Only the third of these children survived. He reappears with the title "dominus" at the baptism of one of his nieces in 1719, which suggests that he had been ordained as a Catholic priest. None of the children or grandchildren of Vermeer, as far as we know, showed the slightest inclination toward painting. The last of his children, Alida or Aleydis, died in The Hague in 1749. Right up to the time of her death she continued to receive money from the Orphan Chamber in Gouda, the amounts being deducted from the van Heensbeck estate.

THE SALE OF 1696

Vermeer's painting was not entirely forgotten in the last two decades of the century. Without a doubt the most important owner of his works in Delft was Jacob Dissius, a printer with premises on the big mar-

Op Woensdag den 16 Mey 1696. fal men tot Amfterdam, in 't Oude Heeren Logement aen de meeftbiedende verkopen eenige uytftekende konftige Schilderyen, daer onder zyn 21 ftuks uytnemende krachtig en heerlyk gefchildert door wylen J. Vermeer van Delft; verbeeldende verfcheyde Ordonnantien, zynde de befte die hy oyt gemaekt heeft, nevens nog eenige andere van de voornaemfte Meefters, gelyk vorder met Biljetten en Catalogen fal bekent gemaekt worden.

ket square under the sign of the Golden ABC. Dissius was a Protestant, the grandson of a pastor. On the death of his wife, Magdalena van Ruyven, in 1682, he had an inventory drawn up of their joint property, which lists 20 pictures by Vermeer, without further description or title, together with a number of paintings by other masters (document of April 1683). The Vermeers owned by Dissius undoubtedly came from the collection assembled by his father-in-law, Pieter Claesz. van Ruyven, who had been Vermeer's patron since 1657. Jacob Dissius died in October 1695. Six months later an advertisement appeared in Amsterdam announcing an auction of 21 paintings by Vermeer together with works by other painters (document of 16 May 1696). Apparently this was the Dissius collection, to which one further Vermeer had been added since 1682. According to the advertisement, the 21 works by Vermeer were "extraordinarily vigorously and delightfully painted." The sale took place on 11 May 1696. The *View of Delft* brought 200 guilders, *The Milkmaid* 175 guilders, *Woman Holding a Balance* 155 guilders. The other prices ranged from 17 guilders for a "trony" to 95 guilders for a *Gentleman Washing His Hands* (now lost). *The Lacemaker,* probably the painting now in the Louvre, fetched only 28 guilders. Nevertheless, these were on the whole perfectly respectable sums, on a par with the prices commanded by other well-liked painters of the day, although they did not begin to compare with the amounts fetched by painters in vogue such as Gerard Dou or Frans van Mieris, whose paintings sold for 800 to 1,000 guilders, or even more if the purchaser happened to be a prince.

At a sale that took place on 22 April 1699, a "seated woman with several meanings representing the New Testament by Vermeer of Delft, vigorously and glowingly painted" was sold for 400 guilders. Today known as the *Allegory of Faith,* this highly classical picture, perhaps better described as polished rather than glowing, apparently appealed to the collectors of the day almost as much as a Dou or a van Mieris.

VERMEER, OR THE GOLDEN AGE OF DELFT

Let us return for the last time to Vermeer's family. We have followed its fortunes over five generations, starting with the painter's grandparents, craftsmen near the bottom of the social scale—a tailor, a fiddle player, a mattress-maker, and a forger. Then came Vermeer's father, a weaver of caffa who turned innkeeper and ended his life as a picture dealer. The high point of distinction was achieved with the painter himself and his wife, descended from burgomasters and related to the most eminent Catholic families in the land. Decline set in with the artist's numerous progeny, none of whom appeared to be particularly distinguished, and who produced nothing more illustrious in the following generation than a priest, a master surgeon (who shaved heads, bled veins, and mended bones), and an illiterate weaver.

The rise and fall in the family fortunes was clearly linked to demographic factors. Reynier Jansz. Vos, alias Vermeer, could probably not have afforded to give his son an artistic education if he had been responsible for a large family. In practice, the future artist was reared almost as an only child, having been born twelve years after his sister. Although Vermeer had the misfortune to father eleven children (not counting those who died in their infancy), he would have been in an even worse situation had he not inherited from the various members of his close and extended family who themselves had not had children. He had particular cause to be thankful for the penchant of the Thins family for celibacy. Great-aunt Diewertje van Hensbeeck died a spinster. None of Maria Thins's four brothers and sisters ever married. Her son, although for a short while betrothed, remained a bachelor all his life. On Vermeer's side, Gertruy had only one child, who died young, so that she was able to leave something to her brother in her will.

The fate of the Vermeer household was linked as well to the rise and decline of the town of Delft as a center of artistic excellence. The wave of immigrants from Flanders and Brabant in the years 1580 to 1610 injected new spirit and life into Dutch art and culture, hitherto somewhat provincial in character. Thus the marriage of the daughter of an immigrant from Antwerp with a caffa weaver from Delft proved a felicitous combination. It is unlikely that Reynier Jansz. would ever have become a dealer in works of art had it not been for the influence of his father-in-law, Balthasar Gerrits, the counterfeiter turned art collector. Vermeer's marriage to a young girl of Catholic family also symbolized the reconciliation between Protestants and Catholics, and the gradual overcoming of the hatred and suspicion fostered during the war with Spain, which, apart from a brief interval of twelve years, lasted from 1568 to 1648. Vermeer became a master of his guild in 1653, the year when Delft itself was at its apogee: Fabritius was still living, and Pieter de Hooch had not yet left for Amsterdam. There were masters who excelled in every field, experts in portraiture, landscape, still life, history painting, and genre scenes, men whom Vermeer could talk to and learn from. The unfolding of his career coincided with Delft's artistic decline. At his death, the only glory of which the town could still boast was the manufacture of blue and white faience; otherwise it had sunk back into the provincial mediocrity from which it had been awakened by immigrants from the south a century before.

ACKNOWLEDGMENTS

Published documents up to 1975 are to be found in Albert Blankert's book (with contributions by Rob Ruurs and Willem van Watering), *Johannes Vermeer van Delft, 1632-1675*, Utrecht, 1975. (English translation, *Vermeer of Delft, Complete edition of the paintings*, London, 1978). Documents that I discovered between 1975 and 1980 are also summarized in my two articles ("New Documents on Vermeer and his family," *Oud-Holland,* vol. 91, 1977, pp. 267-87; and "Vermeer and his milieu: Conclusion of an Archival Study," *Oud-Holland,* vol. 95, 1980, pp. 44-64). I have also referred to an unpublished manuscript by A. J. J. M. van Peer, "Een zeventiende eeuwse familie geschiedenis," of 1979, which was kindly placed at my disposal by M. van Peer three years before his death. I have consulted the book by Dr. C. J. Matthijs, *De takken van de dorre boom: genealogie van de Goudse familie van Hensbeeck,* Gouda, Lapide Gouda, 1976; the article by F. van Hoeck, ''De juzuieten-statie te Delft'' in *Haarlemsche Bijdragen,* vol. 60, 1948, pp. 407-44; and that by H. E. van Berckel, "Priesters te Delft en Delfshaven 1641-1696" in *Bijdragen voor de geschiedenis van het Bisdom van Haarlem,* vol. 25, 1900, pp. 230-63. A few as yet unpublished documents discovered by me after 1980, in the archives at Gouda, Gorinchem, Rotterdam, Leiden, and Delft, are quoted *in extenso* in my book *Vermeer and His Milieu: A Web of Social History,* Princeton University Press, Princeton, 1988. M. W. A. Wijburg of Utrecht has been kind enough to communicate to me his notes on the genealogies of several families related to Maria Thins, Vermeer's mother-in-law. For information on the artistic milieu in Delft, I have drawn on material already published in my book *Artists and Artisans in Delft: A Socio-Economic Study,* Princeton University Press, Princeton, 1982. The majority of documents discovered after 1989 are cited in my article (written cum sociis) "A Postscript on Vermeer and His Milieu," Mercury 12, 1991, pp. 42-52.

Vermeer's Work

Albert Blankert

Detail from *Diana and Her Companions* (plate 1)

THERE IS GOOD REASON TO BELIEVE that Vermeer's artistic production was small. Three of his paintings were described in 1676 after the painter's death. Twenty-one more were listed in 1696 in the catalogue of an auction of paintings which probably had belonged to the Delft printer Jacob Dissius. And three other Vermeers appeared in auction catalogues from the end of the seventeenth and early eighteenth centuries. Remarkably enough, nearly all of these paintings can still be identified. Moreover, all but a few of the thirty-odd works now regarded as autograph are mentioned in these few early sources. This is strong evidence that the Vermeers known today constitute nearly the entire *œuvre* of the master.[1] His limited production is apparently due at least in part to his meticulous working method.

The preservation of his *œuvre,* largely intact, allows us to attempt a reconstruction of his artistic development with the knowledge that there are no large hiatuses to contend with. On the other hand, however, very few paintings are dated, and further clues to their time of origin are even scarcer. Consequently any sketch of Vermeer's artistic development is largely based on a personal view. This leads to a discussion that deepens the intensity of looking at, studying, and admiring Vermeer's masterpieces for all participants.

The immense popularity of his paintings demonstrates that the modern public needs no instruction in order to recognize Vermeer's excellence. Yet as with any human achievement (or indeed failure), these paintings are better understood and experienced when examined in the light of the options available to the artist in his place and time. For that reason the artistic context in which Vermeer's paintings originated is here presented in greater detail than is usual in studies on the master.

VERMEER'S SCHOOLING AND HIS EARLY WORKS (PLATES 1, 2)

When Vermeer was a child, Delft was not a major center of Dutch painting. Before 1650, the year when he turned eighteen, the new artistic currents originated in Amsterdam, Haarlem, Utrecht, or Leiden. Although Delft numbered among its painters some very capable craftsmen, such as Anthonie Palamedesz.

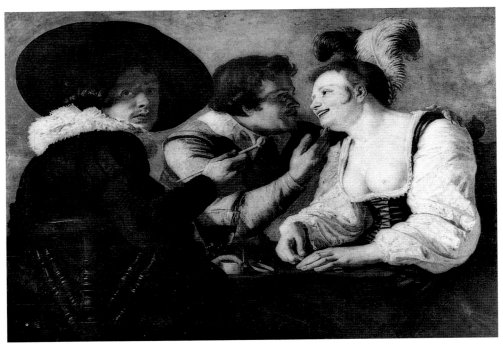

44. Christiaen van Couwenbergh (1604-1667), *Brothel Scene,*
monogramed and dated 1626, canvas, 110 × 77 cm
Formerly private collection, Belgium. Present whereabouts unknown.

and Christiaen van Couwenbergh, on the whole their work simply followed developments that had originated elsewhere. Palamedesz., for example, painted a type of society picture—the so-called "Merry Company" scene—which had originated in Haarlem and Amsterdam (fig. 64). Van Couwenbergh produced figure paintings modeled on those of the Utrecht Caravaggisti (fig. 44).

A notable exception was Leonaert Bramer (1596-1674). As a young man Bramer spent over ten years in Italy, where he developed a personal style that remained virtually unchanged from 1628, the year of his return to Delft, until his death in 1674. Bramer's forte was painting groups of small lively figures, posed balletically against a dark background. He applied this formula impartially to Biblical and mythological as well as genre scenes (fig. 45).

In the Delft of Vermeer's youth Bramer was the most esteemed local painter, and deservedly so. For this reason alone it is likely that Vermeer studied with him.[2] Although Vermeer's style as we know it today reveals no obvious debt to Bramer, it was not unusual in seventeenth-century Holland for a painter to develop an approach quite different from that of his teacher, once he had learnt from him the rudiments of his craft. The lasting impact of Rembrandt's work on that of his pupils is, in fact, an exception to this general trend. Unfortunately, there is no definite proof that Vermeer was a pupil of Bramer, but Bramer's recommendation of Vermeer to his prospective mother-in-law in 1653 indicates that the two were on very close terms (see document of 5 April 1653).

At the end of that year, on 29 December 1653, Vermeer was accepted as a master in the painters' guild in Delft. This indicates that he had completed his apprenticeship and was entitled to sign and sell his own works. The thirty-odd paintings by Vermeer which are known—of which roughly two-thirds are signed— must therefore have been produced between the beginning of 1654 and his death in 1675.

An outline of Vermeer's artistic development must be based almost entirely upon a stylistic consideration of the paintings themselves, for the master dated only three of his works, and other evidence is rare.[3] The three dated Vermeers are *The Procuress* of 1656 (plate 3), *The Astronomer* of 1668 (plate 24), and *The Geographer* of

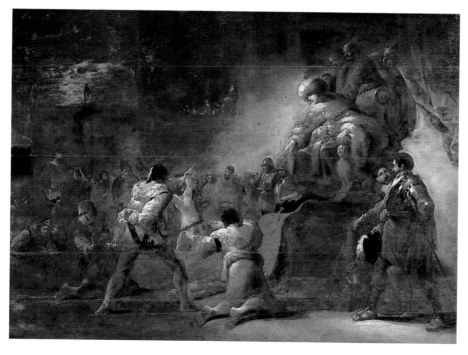

45. Leonaert Bramer (1596-1674), *The Judgment of Solomon,*
panel, 78 × 100 cm
Metropolitan Museum of Art, New York

1669 (plate 25). The two latter paintings are characteristic examples of the interiors for which Vermeer is so well known, whereas *The Procuress* bears little resemblance to these works. Its date, in fact, forms a turning point in Vermeer's development: as we shall discuss below, all the most characteristic Vermeers must date from after 1656.[4] Two paintings which are even less representative of Vermeer's mature style than *The Procuress*—*Christ in the House of Mary and Martha* (plate 2) in the National Gallery, Edinburgh, and *Diana and her Companions* (plate 1) in the Mauritshuis, The Hague—must therefore date from between 1654 and 1656.[5]

The signature *V Meer* (with the *V* and *M* intertwined) on *Christ in the House of Mary and Martha* (plate 2) first appeared in 1901, when the painting was in the possession of an art dealer. Its form corresponds exactly with the signature that appears on *The Procuress* (plate 3). It is sometimes advisable to treat with scepticism paintings whose signatures are "discovered" in the hands of art dealers, but in this case all doubts are dispelled by a fortunate find: thirty years after the signature emerged it was discovered that a painting by Jan Steen is clearly derived from *Christ in the House of Mary and Martha*. Steen worked in Delft for a short time around 1655. He executed the painting in his own style, which was distinctly different from that of Vermeer, and reworked the composition. Nevertheless, the positioning of the three main figures around the table is unmistakably adopted from Vermeer's picture (fig. 49).[6]

In *Christ in the House of Mary and Martha* (plate 2) three substantial figures join to form a monumental group. Unlike Vermeer's later work, with its glossy finish, the picture is broadly painted; the broken brushwork adds life to the painting's surface, vitalizing its otherwise solemn appearance. Certain elements prefigure Vermeer's later development—for example, the brightness of the lighter passages, and the color scheme based upon the primary colors, red, blue, and yellow. The design of the carpet seen behind the seated Mary strongly resembles that of the carpet in the foreground of the later *Girl Asleep at a Table* (plate 4) in New York. Martha's downward gaze, which hides her eyes from the viewer, is a device that Vermeer often repeated.

46. Detail of *The Music Lesson* (plate 16)

47. Detail of *Girl Asleep at a Table* (plate 4)

The second early painting by Vermeer, *Diana and Her Companions* (plate 1), was bought in 1876 by the Mauritshuis in The Hague as a work by Nicolaes Maes. when the painting was restored shortly afterwards, the signature of Maes disappeared and the letters *J [?] Meer* dimly emerged.[7] The painting was accordingly attributed to a little-known master to whom very few paintings can be assigned: Jan Vermeer—of Utrecht. It was not until the discovery and acceptance of the signature on *Christ in the House of Mary and Martha* that *Diana and Her Companions* was given its proper place in the *œuvre* of the young Jan Vermeer of Delft.

The arrangement of figures in *Diana and Her Companions* is related to that in *Christ in the House of Mary and Martha*. Both pictures contain a prominent seated figure, a second figure at the feet of the first, and, uniting these two, the vertical form of a third figure standing behind them. *Diana and Her Companions,* however, is a more complex composition. Diana—identified by the crescent moon on her forehead—is flanked by two additional figures. Moreover, one of these figures is seen from behind, which introduces a new element. On the whole, *Diana and Her Companions* conveys a more stately effect thant *Christ in the House of Mary and Martha.* Incidentally, the cropped figure and the rather abrupt ending of the composition at the right indicate that the painting must have been cut along the right edge.[8]

HISTORY PAINTING

Christ in the House of Mary and Martha is a Biblical representation, and *Diana and Her Companions* a mythological one. Both belong to the category known in seventeenth-century art theory as "history painting." Although it may seem strange that the greatest master of Dutch *genre* painting began his career as a *history* painter, his choice of subject matter, as well as his shift to genre painting, is quite understandable when considered in the light of broader developments in seventeenth-century Dutch painting.

Dutch painters in the seventeenth century were the first to develop landscape, still life, and interior scenes into independent branches of painting. These were practiced by specialists at an amazingly high level of artistic quality. But these Dutch masters, while perfectly capable of creating new *forms* of art, apparently lacked the assurance necessary to develop an accompanying artistic art *theory.* They continued to pay tribute to the notion, imported from Italy, that the most noble form of art was history painting. This is understandable if we remember that Holland, with its solidly middle-class culture, was no more than a small island in a Europe still dominated by princes and prelates.

A theory which elevated genre, still life, and landscape painting was not conceived until the nineteenth century, when the Dutch masters were first celebrated as the great recorders of "everyday reality." This nineteenth-century conception, which we have inherited, clarified much about the Dutch school, but also obscured a great deal. Until a few decades ago, scholars and the public were unaware of the numerous symbolic and allegorical elements hidden in the art of "everyday reality." Moreover, it was not recognized that even in seventeenth-century Holland the history painter was still the acknowledged aristocrat of artists and that this conviction exercised a tremendous influence on many artists.

In Haarlem, history painting flourished for over fifty years in the work of the so-called Academists. If these painters have not received the attention from art historians that they deserve, it must be primarily because of a lingering prejudice against their choice of subject matter. The quality of their work is often of the very highest level, and their style is personal and distinguished. [9] Rembrandt devoted his best energies to history painting, as did most of his pupils, including Ferdinand Bol, Gerbrand van den Eeckhout, and Aert de Gelder. (The secondary theme of Rembrandt and his pupils was portraiture, which artistic theory held in low esteem. It was nevertheless considered indispensable, because the constant demand for portraits ensured artists a livelihood.) Several ambitious and talented young artists of Vermeer's generation, who eventually became specialists in one or another genre, began their careers, like Vermeer, as history painters. Among the earliest works of Emanuel de Witte, for example, now famous as a painter of church interiors (fig. 61), are

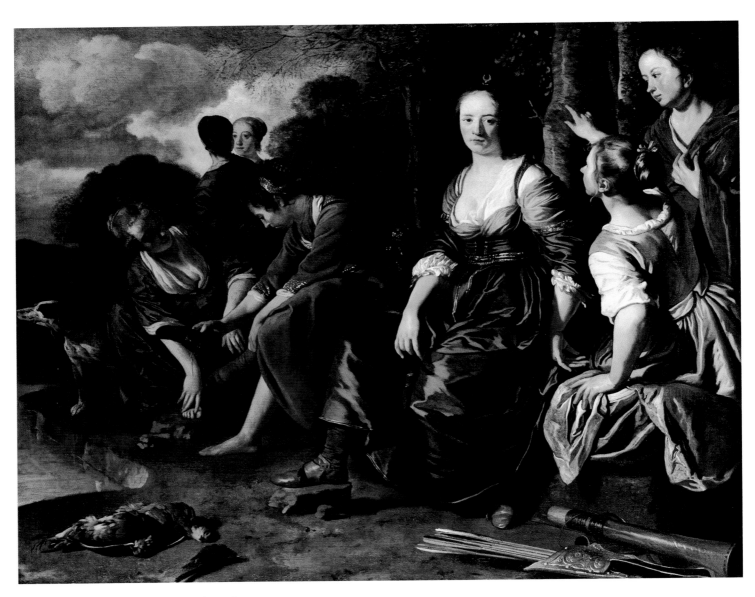

48. Jacob van Loo (1614-1670), *Diana and Her Companions*,
1648, canvas, 134 × 167 cm. Staatliche Museen, Berlin (East).

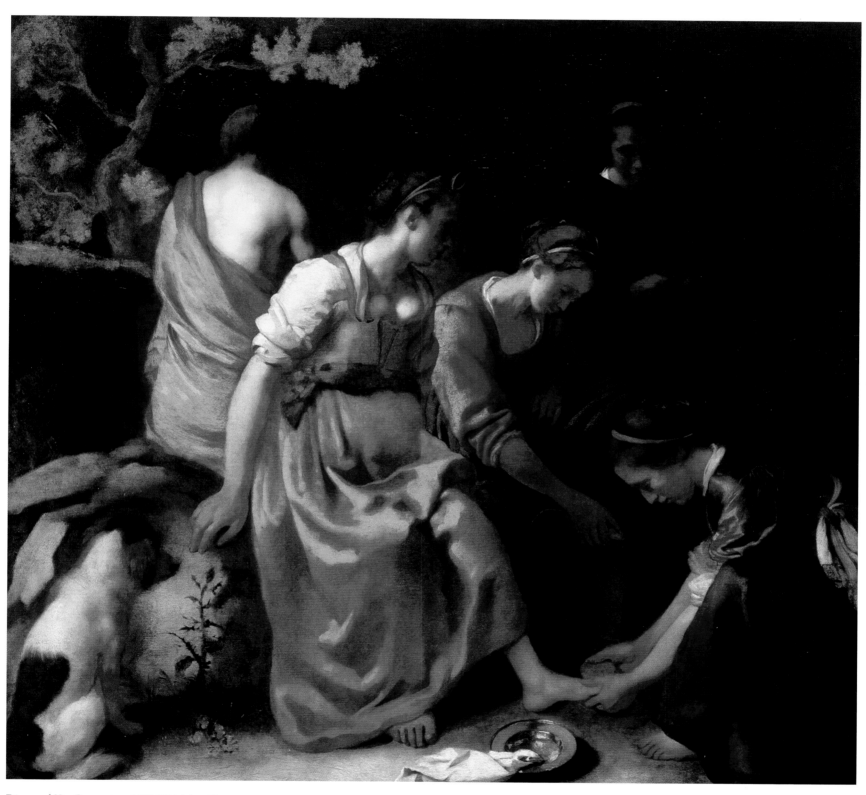

Diana and Her Campanions, 1654-1656 (plate 2)
98.5 × 105 cm. The Hague, Mauritshuis

mythological subjects.[10] The most important early work of Gabriel Metsu of Leiden, who later like Vermeer specialized in interior scenes, is *Christ and the Adulteress* of 1653 (fig. 50). Its robust manner, heavily draped figures, and bright colors placed against a dark background recall very much the two early Vermeers painted one or two years later (plates 1, 2).

Vermeer's two early works indicate that he was aware of current trends in seventeenth-century Dutch history painting. As well as Rembrandt and his pupils, another group of history painters was working in Amsterdam. Jacob Backer, Jan van Noordt, and Jacob van Loo are not widely known today, but their achievements should not be underestimated.[11] Their fluently composed and smoothly painted groupings of large figures have much in common with Vermeer's earliest two paintings. Vermeer seems to have been particularly interested in the work of van Loo. The figures in *Diana and Her Companions* closely resemble those in the background of van Loo's painting of the same subject (fig. 48).[12] Similarly, in *Christ in the House of Mary and Martha* Vermeer adopts van Loo's lively arrangement of linear highlights which suggests the play of light over folds of fabric.[13]

History painting in Amsterdam was stimulated by the completion shortly after 1650 of the new Town Hall (now the Royal Palace) on the Dam. The burgomasters decided to decorate its walls with large-scale historical scenes, and commissioned various Amsterdam painters to depict subjects from the Old Testament, and from Roman and Batavian history.[14] One of the early commissions, however, for the ceiling of the "Moses Hall," went to Erasmus Quellinus, a follower of Rubens in Antwerp.[15] Vermeer seems to have been aware of this exceptional honor that had been bestowed upon the Fleming. At the time when Quellinus was working for Amsterdam, Vermeer was painting *Christ in the House of Mary and Martha.* This work so closely resembles Quellinus's version of the subject—particularly in the figures of Christ with Mary at his feet and the open door in the background—that we must assume that Vermeer had seen the Flemish painter's work (fig. 51).[16]

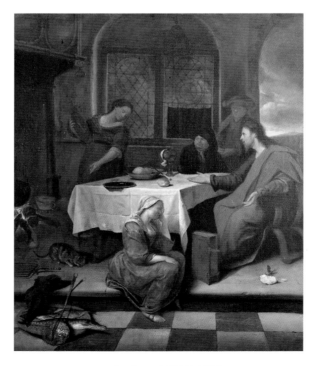

49. Jan Steen (1625/6-1679)
Christ in the House of Mary and Martha,
canvas, 106 × 89 cm. Private collection, Nemeguen.

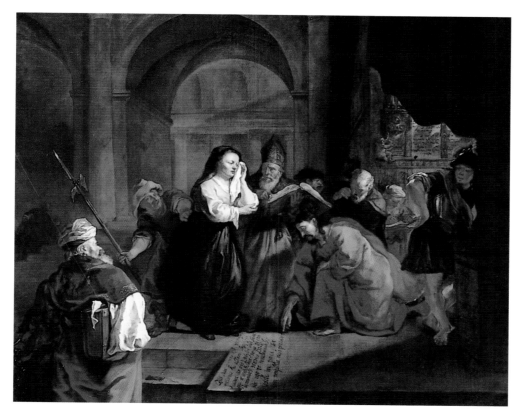

50. Gabriel Metsu (1629-1667), *Christ and the Adulteress,*
signed and dated 1653, canvas, 135 × 164 cm. Louvre, Paris

Vermeer's youthful work clearly reveals his desire—shared by many of his contemporaries—to create history paintings, which were considered the "highest" achievement of the painter. Although he lived in Delft, he seems to have known and responded to developments in Amsterdam. Yet despite his artistic links with the work of other painters, his early pictures possess traits which are quite unique in seventeenth-century Dutch painting. Their exceptionally vigorous brushwork and deep colors convey a strongly Italian impression, and in this respect differ markedly from the work of the Amsterdam history painters. The facture of *Diana and Her Companions* (plate 1) has even been compared to that of Titian. Moreover, its overall composition derives from depictions of *Diana and Actaeon* by Titian and Rubens.[17] Despite the overwhelmingly Italian quality of the two early Vermeers, there is no reason to believe that he visited Italy: he had every opportunity to study Italian art in Holland, where there was a flourishing trade in Italian painting.[18] Vermeer was in fact recognized as a connoisseur of Italian art. In May 1672 he was among the experts asked to judge a disputed collection of paintings. Gerrit van Uylenburgh, an art dealer of Amsterdam, had sold a group of works which he claimed to be by Michelangelo, Titian, and Raphael, to the elector of Brandenburg. A number of artists from Amsterdam and The Hague were summoned by Uylenburgh and attested to the paintings' authenticity. However, Vermeer and a fellow townsman, Hans Jordaens, who came to The Hague especially for this case, were among those who thought otherwise. Vermeer's pronouncement, which is the only statement on painting we have from him, was among the strongest. He declared that "not only [are] the paintings no outstanding Italian paintings, but on the contrary, great pieces of rubbish and bad paintings" (see document of 23 May 1672).

Vermeer may have learned about Italian art from Leonaert Bramer, for although Bramer's style was influenced by his contemporaries from Haarlem and Utrecht, it was shaped primarily by the work of Domenico Feti, a master prominent during his ten-year stay in Italy.

Bramer may also have inspired Vermeer's ambition to become a history painter—for nearly three-quarters of Bramer's *œuvre* consists of Biblical, mythological, and allegorical subjects.[19] It even seems possible

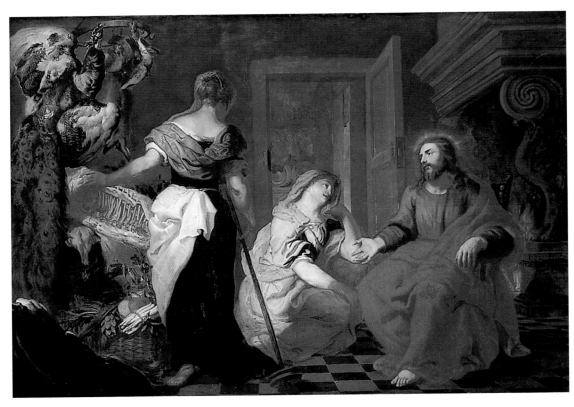

51. Erasmus Quellinus (1607-1678), *Christ in the House of Mary and Martha,*
signed, canvas, 172 × 243 cm. Musée des Beaux-Arts, Valenciennes

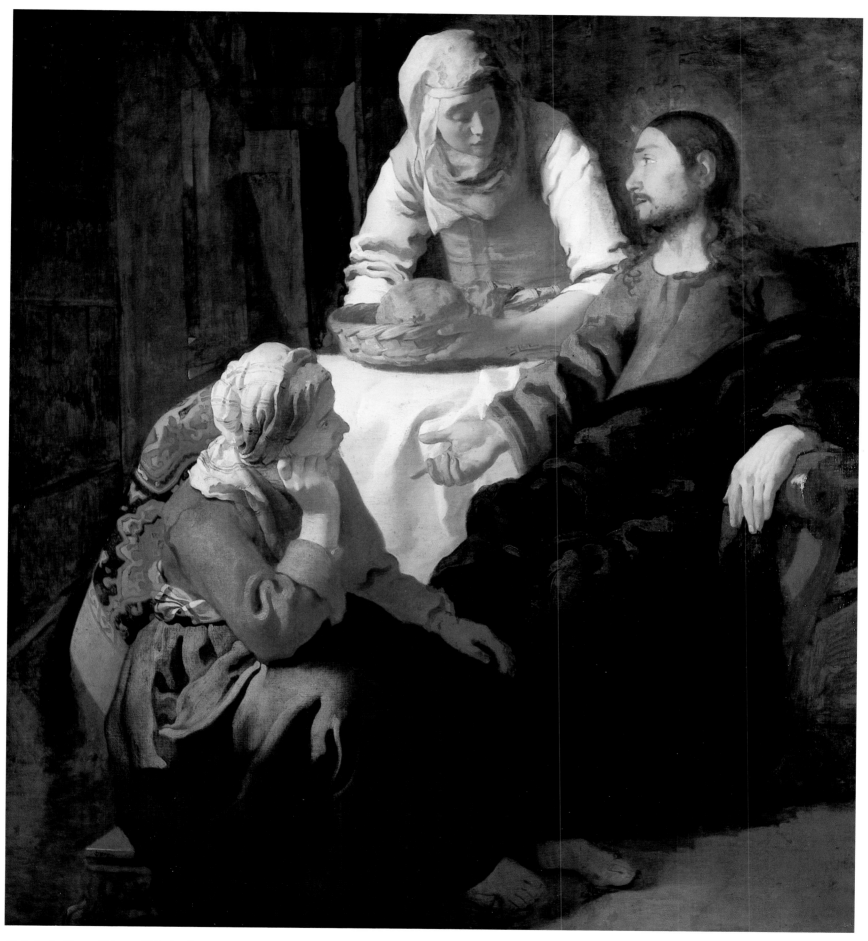

Christ in the House of Mary and Martha, about 1654-1656 (plate 2)
160 × 142 cm. National Gallery of Scotland, Edinburgh.

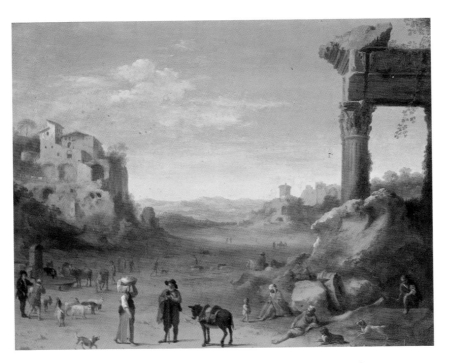

52. Cornelis van Poelenburch (c. 1594-1667), *Pastoral Scene among Ruins,*
monogrammed, c. 1620-1625, copper, 32 × 40 cm. Buckingham Palace, London.

53. Adam Pijnacker (1621-1673), *Mountainous Landscape with a
Silver Birch and Birds*, canvas, 74 × 62 cm, Louvre, Paris

that a now lost "large painting" by Bramer, representing "the Magdalen washing Christ's feet," was a significant influence on Vermeer's early works.[20] The subject suggests a grouping of the main figures reminiscent of that found in both *Christ in the House of Mary and Martha* and *Diana and Her Companions*.

Apart from the work of Bramer, Delft was artistically provincial in Vermeer's youth. This situation was dramatically transformed around 1650 by an influx and flowering of new talent, which included such painters as Adam Pijnacker, Willem van Aelst, and Carel Fabritius.

Documents indicate that Adam Pijnacker, one of the most important members of the Dutch Italianate school of landscape painting, was living in Delft in 1649. It was Pijnacker and the other painters of his generation who brought this tradition to its height of artistic accomplishment.[21] Italianate landscape painting had begun in the 1620s, with Cornelis van Poelenburch's detailed, sunlit views of the Roman Campagna—landscapes picturesquely sprinkled with ruins, animals and tiny figures (fig. 52). Pijnacker's works of the fifties—basically derived from those of Poelenburch—are arranged with a calculated balance of compositional features, which convey an atmosphere of peace and harmony. Massive hillsides or ruins are viewed at close quarters, and tightly knit groups of figures add life to the scene (figs. 53, 54).

Even more important than Pijnacker's delightful contribution to the Italianate landscape tradition were the innovations in still life of Willem van Aelst, a master who was trained in Delft. Still-life painting in Delft before 1650 is exemplified in the work of Harmen van Steenwijck, whose competent, precisely worked compositions show tabletops laid with drinking cups, shells, books, and pipes, all decoratively arranged in curving patterns (fig. 55). In the 1650s van Aelst transformed this formula, retaining a precise rendition, of texture, but

54. Adam Pijnacker, *Mooring Place beneath a Stone Bridge*,
signed, canvas, 77 × 63 cm. Private collection, Scotland.

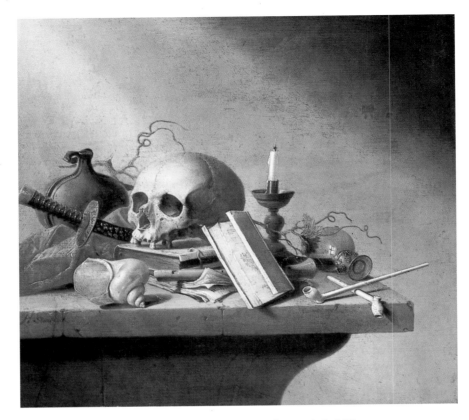

55. Harmen van Steenwijck (1612-after 1665), *Still life,*
panel, 37.7 × 38.2 cm. Municipal Museum, "De Lakenhal," Leiden.

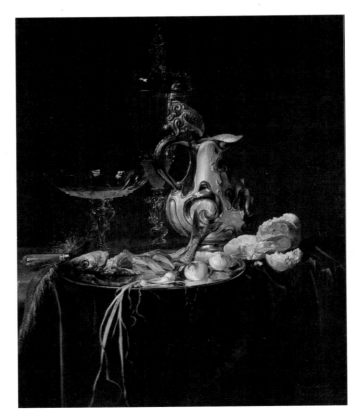

56. Willem van Aelst (1625-after 1683), *Still life*, 1657,
canvas, 57 × 46 cm. Statens Museum for Kunst, Copenhague

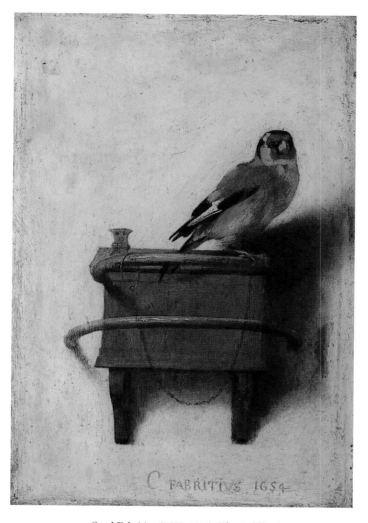

57. Carel Fabritius (1622-1654), *The Goldfinch*,
signed and dated 1654, panel, 33 × 23 cm. Mauritshuis, The Hague.

replacing the everyday objects of van Steenwijck's tabletops with costly silverwork and exotic fruits (fig. 56). Moreover, he drastically reduced the number of objects depicted, bringing them closer to the viewer and highlighting a single area. All this gives his works a greater focus and stability than those of his predecessor.[22]

The most prominent artist to arrive in Delft during this period, and the one whose work was to have the greatest consequences for Vermeer, was Carel Fabritius, Rembrandt's most gifted pupil. He moved to Delft around 1650.[23]

Fabritius had begun his career as a history painter working in Rembrandt's style, but once in Delft he began to explore new artistic problems. Taking to heart Rembrandt's dictum, "follow nature," Fabritius attempted to create as vivid an illusion of reality as possible. The amazingly lifelike *Goldfinch,* painted in 1654, the year of Fabritius's death, is an example of such an early attempt at illusionistic painting (fig. 57).[24]

Fabritius maintained close ties with Samuel van Hoogstraten of Dordrecht, with whom he had established a friendship while they were both apprentices in Rembrandt's studio. In the same year in which Fabritius painted *The Goldfinch*, van Hoogstraten created the earliest known true trompe-l'oeil painting, thus initiating a tradition that was to survive well into the nineteenth century (fig. 58).[25]

A trompe-l'oeil painting—which in the Netherlands was often called "cheater"—depicts relatively flat, inanimate objects against a flat, even background. Both the low relief and the lack of animation contribute to the effectiveness of the illusion. Since the objects are shown in a very shallow space, the viewer who moves in front of them does not readily perceive that they remain fixed in relation to the background, a clue which usually enables us to distinguish a painting from reality. Since the objects depicted are inanimate they do not

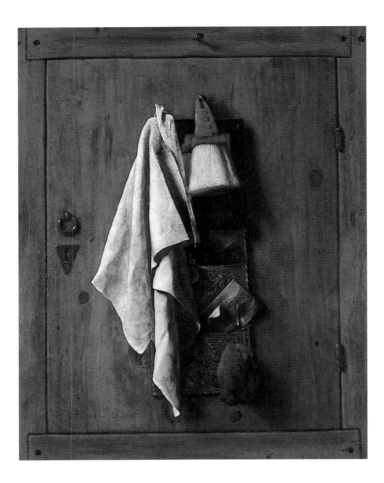

58. Samuel van Hoogstraeten (1627-1678)
"Trompe-l'œil" painting, 1654,
canvas, 90 × 71 cm.
Akademie der bildenden Künste, Vienna

59. Cornelis Gijsbrecht (active c. 1660-1675).
Picture representing the back of a picture,
canvas, 66 × 86.5 cm.
Statens Museum for Kunst, Copenhagen

induce any expectation of movement, and so produce a still more deceptive illusion than Fabritius's living goldfinch.

In keeping with their fascination with perfect illusion, Fabritius and van Hoogstraten also experimented with effects of linear perspective. Most of Fabritius's *œuvre* has been lost: only one small panel, dated 1652, survives to testify to this aspect of his interests (fig. 81). Yet van Hoogstraten's writings reveal that Fabritius also produced large perspective paintings.[26]

Van Hoogstraten's own peep-box in the National Gallery in London provides us with some idea of what Fabritius's perspective paintings must have been like.[27] Such peep-boxes were apparently a Dutch invention. Once our traditional prejudice against artistic "tricks" is overcome, a peek through either of the holes at each end of the box provides a delightful surprise: we experience an almost perfect illusion of standing within a seventeenth-century interior (fig. 60). In this box van Hoogstraten manages to combine the illusion of space with a trompe-l'œil effect: since the interior of the box can be viewed only from a fixed point, through the peephole, the spectator cannot step aside and test the reality of the space.

In van Hoogstraten's peep-box we see a floor of black and white marble tiles leading through an open door giving a view into the room beyond (fig. 60a, b). Similar tiled floors combined with a view into an adjacent room appear in paintings by Pieter de Hooch, who was working in Delft in the 1650s (figs. 74, 75, 76). The same combination is also found in pictures by Nicolaes Maes of c. 1655 (fig. 73). Maes and van Hoogstraten had both come from Dordrecht to be taught by Rembrandt in Amsterdam, and both returned to Dordrecht after their apprenticeship. Both their work has such close affinities with developments in Delft that it has sometimes been assumed that these two painters too lived there for a time. However, the close connections between their work and that of painters in Delft can be explained by the fact that Delft lies on the road from Dordrecht to Amsterdam. It is surely not too farfetched to imagine that on trips to Amsterdam, van Hoogstraten and Maes were in the habit of stopping in Delft to visit Carel Fabritius, another former student of Rembrandt. Such

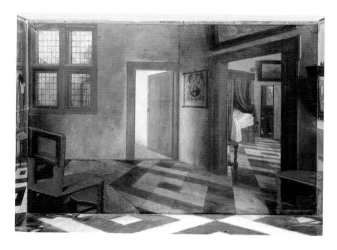

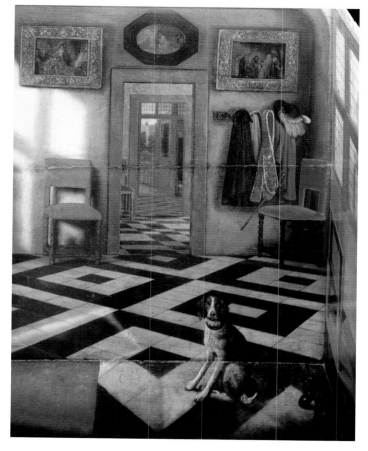

60, a and b,.
Samuel van Hoogstraeten (1627-1678)
Perspective box,
National Gallery, Londen.
In order to photograph the inside of the box,
one wall has been removed.
Space and objects seem chaotic.
Only when the viewer looks through the peephole in
the wall does everything fall into its proper place.

visits would have given them a first-hand acquaintance with the city's current artistic trends.[28]

Our reproductions reveal that these Delft and Delft-linked painters developed a passion for depicting "natural" domestic interiors, using atmospheric and perspective devices. They were not the only artists in Delft to be interested in effects of spatial illusion. A group of painters of church interiors who were active in Delft around 1650 were concerned with these same problems. Some of them also constructed peep-boxes,[29] and in their paintings they did everything possible to depict interior space as illusionistically as paint on a flat surface would allow.

Twenty years earlier, Pieter Saenredam from Haarlem had taken the first step in the creation of illusionistic church interiors.[30] Unlike his predecessors, who had created architectural fantasies, Saenredam depicted the interiors of existing Dutch churches. He bathed his views in an even light and clearly delineated all the architectural details (fig. 62).

Often he selected viewpoints which embrace a large area of the church. His desire for perfect accuracy is evident from the careful measurements and notations that appear on his drawings, and from his scrupulous adherence to the laws of perspective.

In one respect, however, Saenredam still adhered to tradition. Like his predecessors, he always situated the picture plane so that it was exactly parallel to one of the walls of the building being represented. In contrast, the painters who were active in Delft around 1650 achieved a more natural effect by placing the picture plane at an oblique angle to the walls of the church. In his view of the *Oude Kerk* (Old Church) in Delft, for example, Emanuel de Witte did not attempt to show the entire building: he sought instead a more casual view of the interior, which gives us a glimpse through the church diagonally (fig. 61). Despite the informality of the view, de Witte's composition is by no means randomly conceived. Lights and darks are unobtrusively but carefully organized into a few large tonal areas, and the multitude of picturesque details is subjected to the dominating rhythm of a few large and imposing columns, arches and choir screens.

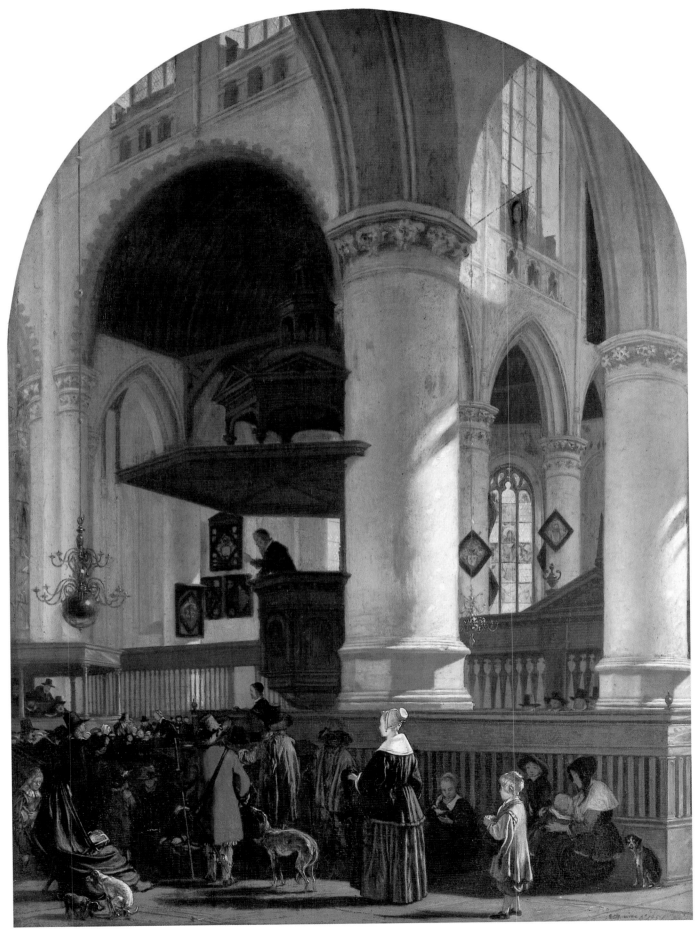

61. Emanuel de Witte (1617-1692), *The Old Church at Delft*,
signed and dated 1651, panel, 61 × 44 cm. Wallace Collection, London

62. Pieter Saenredam (1597-1665), *The Church in Assendelft*,
signed and dated 1649, panel, 50 × 76 cm. Rijskmuseum, Amsterdam

Thus, by 1650 practitioners of many varieties of painting in Delft had come to share a common goal—that of making the most complete and convincing visual illusions possible.

DUTCH INTERIOR SCENES

Nearly all of Vermeer's paintings show interiors in which one or more well-dressed figures play an instrument, drink wine, or perform simple household tasks. In order to understand this aspect of Vermeer's art it is necessary to consider developments that took place outside Delft.

Before 1650, pictures of taverns, with drinking and quarreling peasants, were popular. They were painted with superior artistry by Adriaen Brouwer, Adriaen van Ostade, and others. After 1650, however, no major Dutch painter, with the solitary exception of Jan Steen, undertook to specialize in such unruly scenes. The talented new generation of genre painters preferred respectable households, staffed with elegantly attired ladies and gentlemen. Perhaps the upper-class costumes and furniture they depicted made genre painting seem more acceptable to artists who had, in many cases, begun their careers with a higher ambition: to be history painters.[31]

Hidden symbolic allusions, generally of a moralizing nature, also gave genre painting a new aura of respectability. This use of symbolism made it a close neighbor of allegory, which had always enjoyed a high position in the theoretical hierarchy of subject matter.

63. Gerard Ter Borch (1617-1681), *Man and Two Women,* c. 1654, canvas, 71 × 73 cm. Rijksmuseum, Amsterdam

64. Anthonie Palamedesz., (1601-1673), *Company Dining and Making Music*,
signed and dated 1632, panel, 47 × 73 cm. Mauritshuis, The Hague.

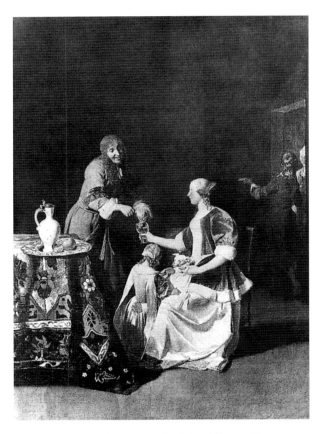

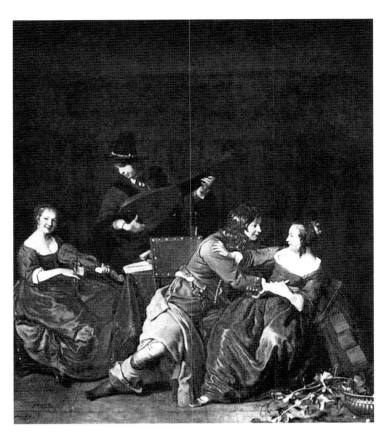

65. Jacob Ochtervelt (1634-1682) *A Man Offering a Woman Lemon in her Wine*, signed and dated 1669, canvas, 81 × 60 cm. Staatliche Kunstsammlungen, Dresden

66. Jacob van Loo, *Courtship During the Music*, signed and dated 1649, canvas, 73 × 62 cm Present whereabouts unknown.

Interiors with elegant ladies and gentlemen playing music and drinking wine—scenes nearly always laden with erotic overtones—were first painted by masters in Haarlem and Amsterdam. Willem (known as "witty William") Buytewech, Dirck Hals, and Pieter Codde invented and perfected this type of society painting in the 1620s and 1630s; they were soon joined by Anthonie Palamedesz. of Delft. For the most part, their paintings are limited to a single compositional scheme which they inventively varied. Palamedesz.'s *Company Dining and Making Music* of 1632 in the Mauritshuis (fig. 64), is composed of two monochromatic strips of floor and wall, which provide a neutral backdrop for a wide horizontal frieze of many crowded figures. Palamedesz. renders the shining costumes and the musical instruments with such skillful meticulousness that they seem palpable.

This formula first underwent a change when a new generation of talented young painters turned their attention to society painting around 1650. Gerbrand van den Eeckhout, for example, whose work for the most part consists of Biblical scenes, painted a number of elegant society paintings in the 1650s (fig. 67). The somewhat older painter Jacob van Loo, who also specialized in history paintings, produced a group of handsome interiors which seem to date from shortly before 1650 (fig. 48, compare fig. 66). Gabriel Metsu, who was also originally a history painter, converted around 1655 to genre themes representing ladies and gentlemen in interiors (fig. 101).[32]

The greatest innovator in the field of genre painting was Gerard ter Borch (1617-1681), who worked in the somewhat provincial town of Deventer in Overijssel. Before 1650 his work consisted of scenes of soldiers at rest and portraits. After that year—conscious, no doubt, of what van den Eeckhout and van Loo had done in the field of elegant society pictures—he became a specialist in the latter genre. Ter Borch retained contact with the tradition established by Cod de and Palamedesz., as is revealed by his sensitivity to the gloss of silk and satin, which he rendered with unequaled virtuosity (fig. 63). But he enriched the genre tradition with a whole series of new motifs of his own invention, motifs which were to find a permanent place in the repertory of later masters.[33]

Among other themes, a lady writing at a table, and a girl in front of a mirror were first painted by ter Borch (fig. 68). As we shall see, they recur in the work of Vermeer (plates 13, 22, 23, 27). This adds fascination to Montias's recent discovery that Vermeer and ter Borch had actually met (see document of 22 April 1653).

In their scenes of elegant company, van den Eeckhout, van Loo, and ter Borch drastically reduced the number of figures, and enlarged these figures in relation to the overall space (compare fig. 63, 66, 67 to fig. 64). They also replaced the light background of the earlier interiors with a dark one, thus concentrating the viewer's attention on the masterly balancing of light and shadow among the figures. These changes in elegant genre scenes reflect a more widespread stylistic shift in Dutch art of the period.

Around 1650 a group of gifted Dutch painters made decisive formal changes in subjects that had been treated for decades in an established manner. What van Loo and ter Horch achieved in their painting of interiors is in many respects parallel with the accomplishment of masters like Adam Pijnacker, Willem van Aelst, and Emanuel de Witte in their respective fields of Italianate landscape, still life, and church interiors. A typical work by one of their predecessors—Poelenburch, Steenwijck, Saenredam, or Palamedesz.—shows a neat, evenly lit, horizontal arrangement of small objects, whether these be human figures, dishes and pipes, or church columns. The younger painters adopted the refined technique of their predecessors, but varied their compositional formula, choosing a vertical format, and employing a more casual grouping of large and small elements. With great ingenuity de Witte, ter Borch, and others brought a new visual unity to the placing of objects in space, the arrangement of outlines, and the division of light and shadow—problems which previously had been dealt with individually rather than as interlocking parts of one whole. They thus attained a simple, more natural, and at the same time more dignified effect than their predecessors. By the time Johannes Vermeer turned to specifically Dutch subjects, this new manner—which is often termed "classical" —had become a well established visual vocabulary.

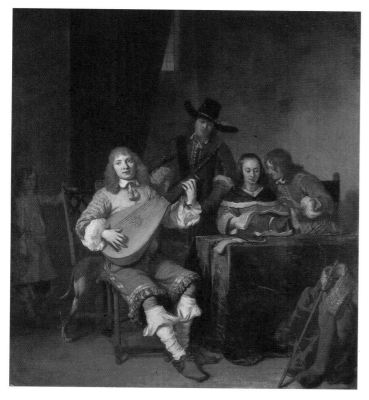

67. Gerbrand van den Eeckhout (1621-1674),
Music Making Company, signed and dated 1653, canvas,
91 × 83 cm. Gemeentemuseum, The Hague, Music Department,
on loan from the Rijksdienst Beeldende Kunst, The Hague

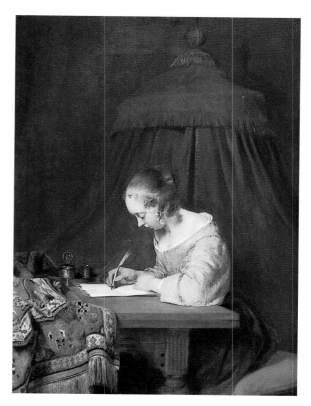

68. Gerard Ter Borch (1617-1681),
Woman Writing a Letter, c. 1655
panel, 38 × 29 cm. Mauritshuis, The Hague

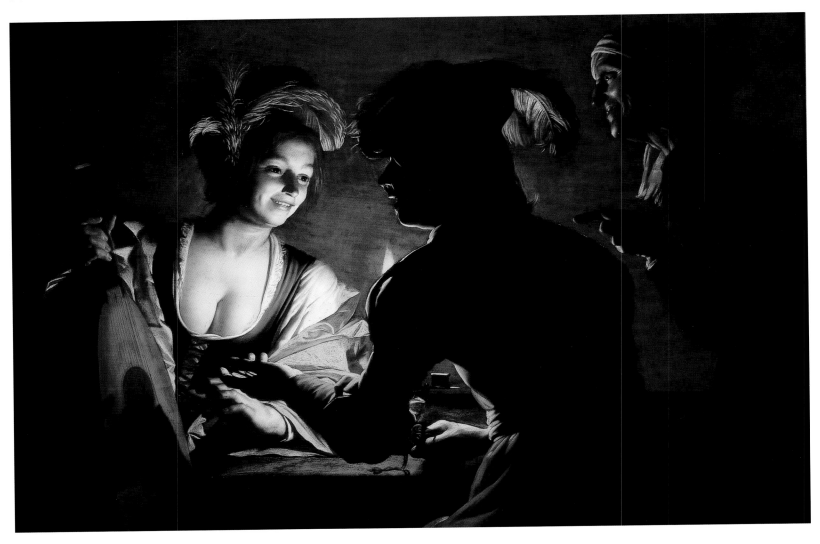

69. Gerard van Honthorst (1590-1656), *The Procuress*, 1625
panel, 71 × 104 cm. Centraal Museum, Utrecht

HISTORY AND GENRE—*THE PROCURESS* (PLATE 3)

This emerging elegance and the use of symbolism in genre painting were eventually to influence Vermeer decisively. So it is very surprising that during the first years of his career he remained out of touch with these innovative ideas circulating in Delft and elsewhere in Holland. While the subject of *The Procuress* (plate 3) in Dresden, dated 1656, may reflect the success his colleagues were enjoying with erotic subject matter, it owes nothing in style or composition to the work of the new generation of genre painters.

The depiction of a consistent interior space, a problem which was of central importance to the circle of Carel Fabritius and to the church painters of Delft, was not one to which Vermeer addressed himself in 1656. In *The Procuress* his figures are unclearly placed: the young woman seems to be seated behind a table which leaves no room for the lute held by the laughing young man to the left. Some have speculated that the latter figure may be a self-portrait.[34]

In keeping with Vermeer's enthusiasm for monumental history painting, he drew his inspiration not from contemporary masters, but from an earlier group of painters, the so-called Utrecht Caravaggisti. They had created comparable erotic scenes, on a large scale, with life-size figures. The theme of the procuress had been treated by several of them, for example Oirck van Baburen in a painting of 1622 in the Museum of Fine Arts in Boston (fig. 70).

The Procuress, 1656 (plate 3)
143 × 130 cm. Staatliche Gemäldegalerie, Dresden

In both van Baburen's and Vermeer's versions of the subject a few half-length figures occupy the larger part of the picture. Both the composition and the use of gesture in the two paintings are quite similar. In both pictures a man in the center reaches his arm over the shoulder of a young woman while offering her a coin with his free hand, and an aged procuress watches from the side. This is more than mere coincidence, for Vermeer depicted this very composition by van Baburen in the background of two of his own paintings (figs. 71, 72), and a recently discovered document makes it highly probable that Vermeer's mother-in-law owned the van Baburen (document of 27 November 1641). It is, therefore, virtually certain that Vermeer used the general composition and the arrangement of the figures in van Baburen's *Procuress* as a model for his own. The motif of an Oriental carpet which closes off the foreground of the composition must have been borrowed from other works by the Caravaggisti of Utrecht.[35] The only figure in Vermeer's *Procuress* (plate 3) who is missing in van Baburen's version (fig. 70) is the young man on the left, the presumed "self-portrait." He seems to be dissociating himself from the two mercenary lovers by grinning at the spectator. A very similar figure occurs in a very similar *Brothel Scene* painted in 1626 by Christiaen van Couwenbergh, the Delft Caravaggist (fig. 44). So apparently Vermeer also drew his inspiration from the work of a fellow townsman. Had Vermeer continued in this direction he might well have brought about a revival of the Caravaggist compositional schemes, which were rather outdated by the 1650s.

Despite his borrowings, Vermeer's painting contains some very original features. His conception is quieter than that of his models. Van Baburen and van Couwenbergh strongly accentuated facial expressions and

70. Dirck van Baburen (c. 1595-1624), *The Procuress*,
signed and dated 1622, canvas, 101 × 107 cm.
The picture was in Vermeer's house; he depicted it in two
of his own painting (see figs. 71 and 72).

71. Detail of *The Trio* (plate 17)

72. Detail of *Lady Seated at a Virginal* (plate 30)

emphatic hand gestures, while Vermeer minimizes animated movements. The peculiar beauty of Vermeer's picture is largely due to a warmth of coloring distinctly unlike that of the Utrecht school. The girl's face and her yellow jacket are luminously highlighted against the muted dark tones of the background and the glow of the red tapestry in the foreground.

The Procuress stands alone in Vermeer's *œuvre;* it cannot be placed in any trend or with any group. Yet it played a decisive role in his development. for it forms the chronological link between his early history paintings and the interior scenes—often overlaid with erotic allusions—which were to follow.

GIRL ASLEEP AT A TABLE (PLATE 4)

The *Girl Asleep at a Table* (plate 4), in the Metropolitan Museum in New York, is Vermeer's first attempt at pure genre painting. In many respects it recalls *The Procuress* (plate 3): in its large size, in the dominance of red and yellow hues, and in the Oriental carpet which, more ostentatiously than effectively, closes off the foreground space. In neither *The Procuress* nor the *Girl Asleep at a Table* is the relationship of the carpet to the table clearly indicated: the physical type and facial expression of the young women in both works are very similar. For these reasons the *Girl Asleep at a Table* can be dated shortly after *The Procuress*—that is to say, about 1657.

Vermeer's new interest in pure genre painting led him to take another look at the artists in the circle of Carel Fabritius. The *"doorkijkje"* motif—the view from one room into another—must have been derived from them (see fig. 60); and the theme of the "girl asleep" reminds us of a painting by Nicolaes Maes of 1655, a time when he was closely associated with developments in Delft (fig. 73).

In discussions of seventeenth-century art the phrase "genre painting" should be used with discretion. The seventeenth-century artist did more than merely present a picturesque view of an interior room—as was believed in the nineteenth century, when pure genre painting became popular. Nineteenth-century critics read into seventeenth-century art the values of their own time; thanks to much recent research, however, we are now aware that the seventeenth-century painter frequently filled his pictures with symbolic and moralistic allusions.

Seymour Slive rightly reminds us that the *Girl Asleep at a Table* is listed in the auction catalogue of 1696 as "A drunken girl sleeping at a table." Slive argues that this early title should be taken literally, pointing out

73. Nicolas Maes (1634-1693),
A Sleeping Servant and Her Mistress, signed and dated 1655,
panel, 70 × 53 cm. National Gallery, London

that wineglasses and a wine jug are on the table, and that the girl's collar is not decently closed, as was proper at the time, but hangs indiscreetly open. Captions accompanying prints of the same subject from the period make it clear that such a depiction had moralizing implications. The image is meant to convey the idea that drunkenness is undesirable: it is more virtuous to walk the path of temperance and moderation. At the same time, a sleeping woman can also personify the vice Sloth.[36]

Leaving aside the question of possible lost works, the *Girl Asleep at a Table* is best regarded as Vermeer's first, imperfect attempt at pure genre painting. The perspectival effects, which so intensely interested the other Delft masters, seem to have provided him merely with decorative additions to a composition originally conceived on a plane; the picture space is not defined at all clearly. The serene mood of the painting derives from the artist's concentration on a few broad and simple outlines. Strict verticals and horizontals—which foreshadow those in his later works—here make their first appearance.

PIETER DE HOOCH

As we have seen, Vermeer's work from 1654 to 1656 reveals remarkably little interest in the contemporary developments that were revolutionizing Dutch painting. He did not participate in the successful campaign waged by his colleagues in Delft to find a thoroughly convincing method of representing interiors. Nor, initially, did he show any awareness of the important compositional change that had taken place in genre painting, the shift to scenes dominated by a few large figures placed prominently in the picture space. It was not until around 1657 that he incorporated superficial adaptations of these innovations in the *Girl Asleep at a Table* (plate 4). But nothing in this painting would lead us to suspect that its author was destined to develop a perfect synthesis of illusionism and "classical" composition. It certainly was an external impulse—the work of Pieter de Hooch—which stimulated Vermeer to attempt this synthesis.

De Hooch, Vermeer's senior by three years, originally trained in Haarlem under Nicolaes Berchem.

Plate 4 (cat. no. 4)*Girl Asleep at a Table*, about 1657
86.5 × 76 cm. Metropolitan Museum of Art, New York.

74. Pieter de Hooch (1629-after 1684), *Couple with a Parrot*
canvas, 73 × 62 cm. Wallraf-Richartz Museum, Cologne.

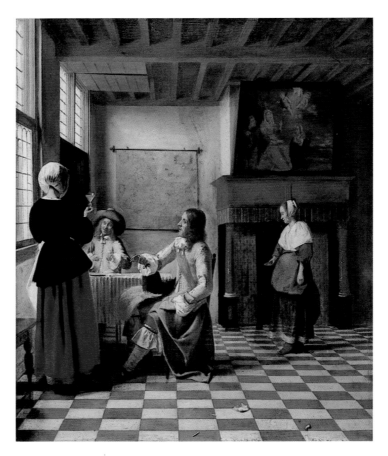

75. Pieter de Hooch (1629-after 1684), *Interior Scene,* monogrammed,
c. 1658, canvas, 74 × 65 cm. National Gallery, London

Before about 1653, when he settled in Delft, he painted soldiers at rest, reminiscent of the work of the Amsterdam painters Codde and Duyster. He apparently began painting the domestic interiors that make up the greater part of his *œuvre* under the influence of the new Delft milieu.

We do not know to what extent de Hooch had adopted his new Delft manner in the period before 1658, the year of his earliest dated works.[37] Of his dated paintings, those of that and the following three years are the most mature and accomplished we have from his hand. His artistic career seems to have taken the form of a long, arduous trek to a peak which he was able to sustain only briefly. Shortly after 1660, the quality of his production began slowly to decline. His best undated works all resemble those dated between 1658 and 1660; in about 1662 he moved to Amsterdam, where he eventually died in a lunatic asylum.

It is not difficult to imagine the kind of sensation that one of de Hooch's early masterpieces of around 1658 must have caused (fig. 75). The lady with the wineglass and the two gentlemen with whom she is coquettishly flirting are all displayed prominently in the picture space, in a manner that reminds us of the work of artists like ter Borch, Metsu, van den Eeckhout. and van Loo (figs. 63, 66, 67).[38] But while these masters tend to focus attention on their figures by placing them against a dark background, de Hooch dares to pose his figures in the middle of a large, brightly lit chamber. Furthermore, the lines of the ceiling beams, tiled floor, and window frames conform exactly to the laws of linear perspective, while the minute gradations of light reflected from walls and objects are recorded with the sensitivity and precision that we associate with the work of painters from Delft.

We should not underestimate de Hooch's achievement in successfully combining Delft's tradition of illusionistic space with the lively figures and tight internal unity found in genre painting. As early as 1655 Nicolaes Maes of Dordrecht had attempted the same synthesis (fig. 73). Like van Hoogstraten, Maes was a former student of Rembrandt. who probably kept in touch with developments in Delft through an acquaintance with Carel Fabritius. However, although he was a talented painter, Maes failed where de Hooch succeeded. The figures in his painting threaten at any moment to slide off the steep floor; their expressions and gestures are overly emphatic, and their outlines lack coherence. De Hooch was the first to place figures in interior space with perfect "truth to life."

VERMEER'S DISCOVERY OF SUNLIGHT (PLATES 5, 6, 8)

To judge from a closely related group of four paintings, Vermeer was one of the first artists to recognize de Hooch's achievement. All four paintings convey a very de Hoochlike impression. Although we have no positive proof of their date, the four canvases would appear to have been painted in 1658 and shortly thereafter, under the immediate impact of de Hooch's breakthrough.

These paintings differ completely in technique, color, and composition from all Vermeer's previous work. Clearly, his new goal was the placement of figures of palpable physical presence in brightly lit interiors. It must have been immediately apparent to him that he could improve upon de Hooch by adopting a more simplified and concentrated approach.

The *Soldier with a Laughing Girl* in the Frick Collection in New York shows a man with a large hat conversing with a girl who is holding a glass in her hand (plate 6). Their action is not essentially different from that of the couple in *The Procuress* (plate 3). The *Soldier with a Laughing Girl,* however, is dominated by the man, who is placed in the forefront. The perspective makes him many times larger than the girl close by him at the same table. All the emphasis is on the placement of the figures in space, and de Hooch must have been Vermeer's model. The *Soldier with a Laughing Girl* seems on close inspection to be little more than a free copy of the central left-hand section of the de Hooch painting (fig. 76). The woman in front of the table has exchanged places with the man behind it, but otherwise the general composition is identical—even the map on the wall charts the same regions. Vermeer's depiction of the fall of sunlight from the left is, however,

brighter and less diffuse than de Hooch's, calling for a still greater virtuosity in rendering the minute gradations of value in both the bright and obscure passages. Such brilliant illumination in a painting was not considered advisable at the time. Handbooks directed painters to work in studios with north light, or, if they could not avoid direct sunlight, to line their windows with oil paper.

It seems that part of Vermeer's strategy for meeting this challenge was to paint the final canvas as far as possible from nature, an uncommon practice for the time. Even the most "true to life" works of "naturalists" like Pieter de Hooch contain arbitrarily arranged elements. For example, de Hooch pictures exactly the same house in two of his works, but places it in completely different surroundings, and changes various details (fig. 82, 83). The tiles in the foreground, the wall of the corridor, and the view seen through it. all differ in the two pictures.

Vermeer's working method was quite different. In the *Soldier with a Laughing Girl* (plate 6) and in two of the paintings related to it *(Girl Reading a Letter at an Open Window,* plate 5, and *The Milkmaid,* plate 8). he represented, very exactly, the same corner of the same room with the same window. His faithfulness to nature is demonstrated by his representations of maps and globes, which are depicted with great accuracy, and which, in nearly all instances, can be precisely identified.[39]

This should not, however, imply that Vermeer did no more than record what met his eye.[40] In strictly practical terms this was in any case not possible for him. He wished to convey all the nuances of the fall of light at a single moment, but his perfectionism obliged him to work for long periods over each painting—it would appear that he turned out no more than a few each year. Given the fickle Dutch weather, the intensity of light must have constantly changed in front of him.

Striving for complete technical mastery, Vermeer limited his subjects from 1658 on to a few objects in a small corner of a particular room. The hypothesis that he used a camera obscura seems very plausible.[41]

The *Girl Reading a Letter at an Open Window* (plate 5) in Dresden provides a better idea of the growth of Vermeer's technique than the *Soldier with a Laughing Girl* (plate 6), which has a slightly abraded surface.[42] If the latter painting represents a simplification of the format invented by de Hooch, the *Girl Reading a Letter* carries this process even further. One solitary figure remains; the visible surface of the left wall is halved; only the right-hand part of the window is shown. The wall map is omitted, allowing the light wall to function as an unbroken backdrop to the strictly ordered elements of window, figure, table, and curtain. Vermeer adjusts his treatment of objects in accordance with their distance and texture, so that spatial relationships are rendered with crystalline clarity, and differences of texture are not so much visible as palpable. Having recognized the fact that spots of sunlight in dark surroundings are perceived partly as splotches and dots of light, he reproduced this phenomenon in paint: in the *Girl Reading a Letter* and the other pictures of this group he used his famous *pointillé* technique for the first time (compare plates 8 and 10).

Art-historical conclusions are inevitably based on the accidents of survival. Fortunately, we know that Vermeer's *Girl Reading a Letter at an Open Window* (plate 5) followed a compositional scheme already current in Delft, but we owe this conclusion entirely to a chalk sketch by Leonaert Bramer, which in turn records a lost painting by Adam Pick, a master who lived in Delft from 1642 until 1653. Bramer's drawing and one painting are all that remains of Pick's *œuvre* (fig. 77). The drawing belongs to an album of sketches Bramer made before 1654 of a Delft collection of paintings, some of which belonged to Vermeer's father.[43] From the paintings that still survive, we know that Bramer rendered the compositions of his models accurately, but made no attempt to adjust his lively draftsmanship to their different styles. Judging from its subject, Pick's painting may well have resembled a lost *Smoking Soldier* by Carel Fabritius.[44]

Thanks to the fortunate survival of Bramer's drawing, we know that by 1654 pick (and perhaps other masters in Delft at that time, such as Carel Fabritius) had developed a compositional scheme which was a direct precursor of Vermeer's *Girl Reading a Letter at an Open Window.* Both Vermeer's painting and the drawing after Pick depict a table with still-life objects, which closes off the foreground and is placed in front

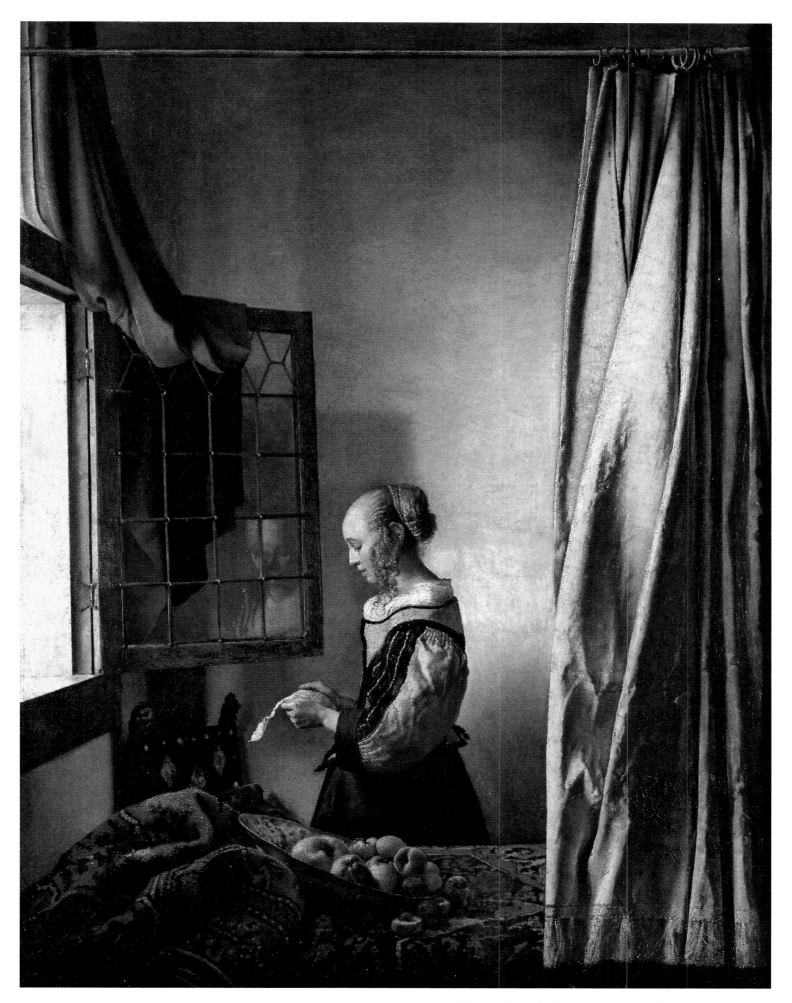

Plate 5 (cat. no. 6) *Girl Reading a Letter at an Open Window,*
about 1659, 83 × 64.5 cm. Staatliche Gemäldegalerie, Dresden.

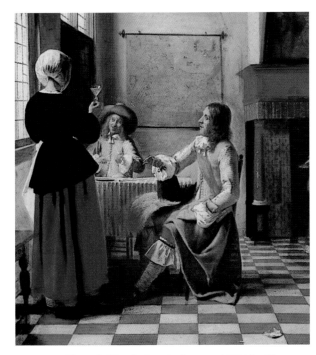

76. Pieter de Hooch, *Interior Scene*, c. 1658 (detail)

of a single figure, shown against an unbroken background. Pick's composition, like that of Vermeer, is framed on one side by a drawn curtain.[45] But while works like the lost painting by Pick provided Vermeer with a model for his *Girl Reading a Letter,* he simplified them, just as he did with de Hooch's compositions. Instead of Pick's extensive display of miscellaneous objects, Vermeer places on his table a single bowl of fruit. Originally his composition was even more similar to Pick's. The enormous wine glass on Pick's table (fig. 77) can also be seen in an X-ray of the *Girl Reading a Letter;* only in the definitive stage did Vermeer hide it behind the curtain (see fig. 110).

"STILL-LIVING" FIGURES

In an evenly lit space it is no easy matter to imbue large figures with life. The gestures and facial expressions of the figures in de Hooch's painting (fig. 76) and the lively duo in Vermeer's *Soldier with a Laughing Girl* (plate 6) have a frozen look about them. In the real world, figures move, but Vermeer's meticulous technique prevented him from creating an effective suggestion of movement. The practitioners of true trompe-l'oeil wisely circumvented this dilemma by depicting only inanimate objects (fig. 58, 59).

Like the trompe-l'oeil painters, Vermeer wished to achieve a completely illusionistic effect, but he also wanted to depict figures. In many of his works he solved this problem of movement by showing his figures performing activities that imply no movement. The only motion we might expect from a girl standing quietly reading a letter would be the almost imperceptible movement of her eyes—and the girl in Vermeer's painting glances downward, hiding her eyes from us (plate 5). The lowered gaze was a device that Vermeer first used in *Christ in the House of Mary and Martha* (plate 2). and he was to use it repeatedly thereafter to transform the women in his paintings into still life (plates 8, 14, 15, 17, 19, 26, 27).

THE MILKMAID AND *A LADY DRINKING AND A GENTLEMAN* (PLATES 7, 8)

If the painting in Dresden (plate 5) shows a greater concentration and simplicity than the one in New York (plate 6), *The Milkmaid* (plate 8) in the Rijksmuseum in Amsterdam is a further step toward the same goal, and represents the culmination of Vermeer's work in this direction. This last painting cannot be much

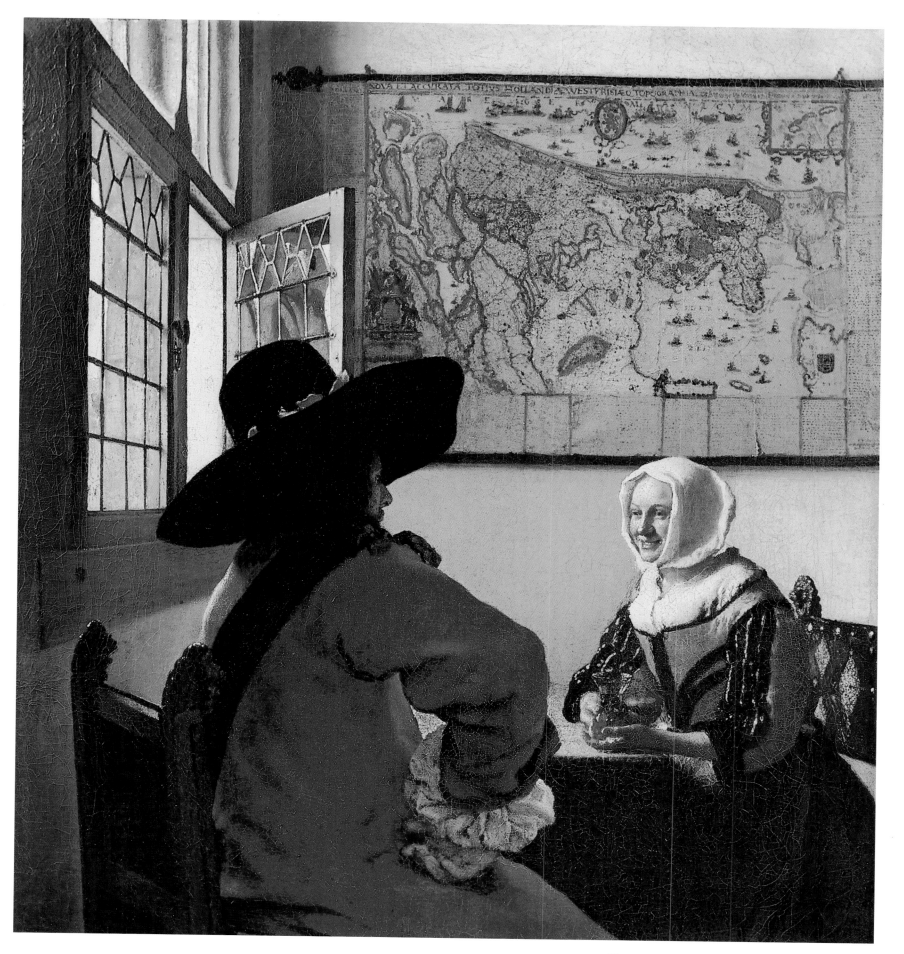

Plate 6 (cat. no. 5), *Soldier with a Laughing Girl*, about 1658,
50.5 × 46 cm. Frick Collection, New York,

later than the *Girl Reading a Letter at an Open Window:* it has the same cool clarity and bright colors, and again the scene is laid in the very same corner of the same room. Vermeer applies his *pointillé* technique in the highlighted areas more daringly than before—particularly in the loaves of bread on the table. Still more significant is the reduced contrast between foreground and background. The silhouette of the seated soldier in the *Soldier with a Laughing Girl,* and the curtain to the right in the *Girl Reading a Letter at an Open Window* are rather obvious *repoussoirs.* Vermeer abandoned this device in *The Milkmaid* and moved closer to the subject. We now see only a small fragment of the window, and the solid figure of the milkmaid dominates the whole picture. The theme carries on a typical Delft tradition of "kitchen pieces" (see text on cat. no. 7).

In *The Milkmaid* Vermeer lovingly dwells on the fabrics, crockery, and metal, the structure of the plaster wall, and the light that plays over them all. The effect is one of spontaneous naturalism, but he avoids any disjunction of form or disorder of color by means of a calculated dispersal of light and shadow, of large and small forms, and of curved and straight lines. A diagonal line running from the upper left to the lower right of the picture would separate a predominantly illuminated area from one mainly cast in shadow. Only the flat, neutral wall in the background is evenly lit. The patches of light and shadow between the empty wall surface and the busy foreground are connected by the massive vertical of the milkmaid herself. The eye-catching still life on the table, which defines the foreground area, also catches the light, but is comfortably anchored by the area of shadow around it.

The first change that Vermeer effected in the composition of the de Hooch type of interior scene was to reduce the number of figures to one or two, and to move them to a corner. This enabled him to concentrate on a few closely observed objects, which he varied from painting to painting. This is how he achieved the extraordinary mastery displayed in *The Milkmaid.* Only after working on these limited problems did he

77. Leonaert Bramer (1596-1674) after a painting by Adam Pick
(active c. 1650). Chalk drawing, 37.7 x 29.3 cm.
Printroom Rijksmuseum, Amsterdam.

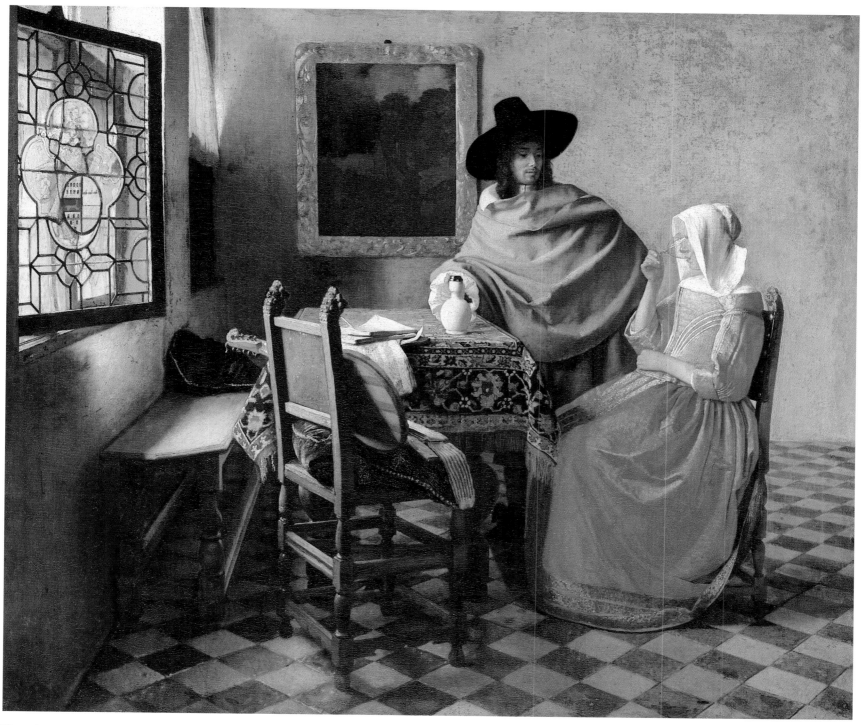

Plate 7 (cat. no. 8), *A Lady Drinking and a Gentleman*, about 1660-1661,
65 × 77 cm., Gemäldegalerie-Dahlem, West Berlin

78. Detail from *The Milkmaid* (cat. no. 7).

attempt to compete with de Hooch on his own ground. The *Lady Drinking and a Gentleman* (plate 7) in Berlin is the first example of such an attempt. Its general composition recalls de Hooch more directly than any of the paintings we have discussed so far. For the first time Vermeer follows him also in placing a man and a woman in a spacious interior (fig. 76). The man stands at a table on which he is placing a wine jug. He is attentively watching the seated lady, who is drinking from the glass that he has poured her. He holds the handle of the jug, apparently ready to serve her a refill. It seems they have made music or are planning to do so: on the table and on the chair in front lie music sheets and a stringed instrument.

Vermeer has not surrendered any of the masterful rendition of textures which he had perfected in the *Soldier with a Laughing Girl* (plate 6). *Girl Reading a Letter* (plate 5), and *The Milkmaid* (plate 8), for even in its smallest details the *Lady Drinking and a Gentleman* clearly differentiates between polished wood, nubbly rug, and smooth silk. This vivid sense of texture is in sharp contrast to de Hooch's work. When we look closely at de Hooch's painting in London (fig. 76) we can barely distinguish the individual materials of the rug, clothing, and other objects. At the same time, even in this complicated composition, Vermeer preserves a sense of unity and inner logic. In its sobriety and quiet harmony the *Lady Drinking and a Gentleman* far surpasses anything accomplished by de Hooch.[46]

VERMEER'S CITYSCAPES:
THE LITTLE STREET AND *VIEW OF DELFT* (PLATES 9, 10)

Carel Fabritius and the masters of his circle not only depicted interiors in a new way but exteriors as well. We have already mentioned the only surviving painting of this type by Fabritius himself (fig. 87). It is a view of the Oude Langendijk in Delft, with the Nieuwe Kerk (New Church) and the Town Hall in the background. The strange distortion of the perspective has led to the speculation that the canvas might once have been attached to the back wall of a peep-box.[47]

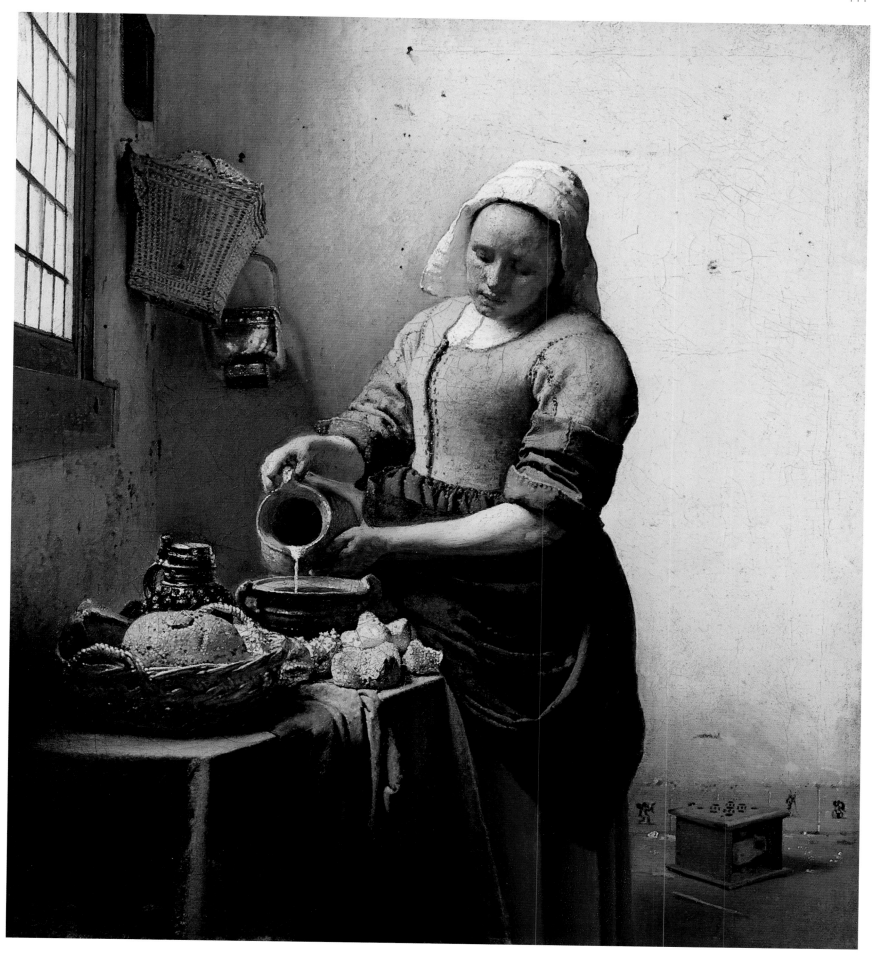

Plate 8 (cat. no. 7) *The Milkmaid*, about 1660-1661,
45.5 × 41 cm. Rijksmuseum, Amsterdam.

112

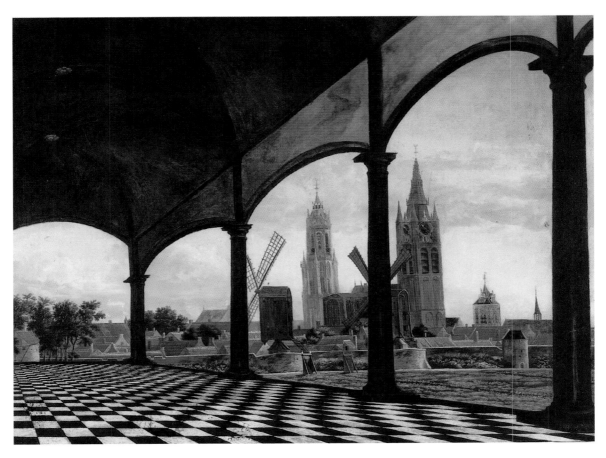

79. Daniel Vosmaer, *View of Delft*, signed and dated 1663, canvas 90 × 113 cm.
Museum "Het Prinsenhof," Delft, on loan from the Rijksdienst Beeldende Kunst, The Hague.

80. Egbert van der Poel (1621-1664), *View of Delft after the Explosion of the Powder House in 1654*,
signed and dated 1654, panel, 36 × 49 cm. National Gallery, London.

A curious, rather awkwardly designed painting by Daniel Vosmaer of Delft may reflect Fabritius's larger works of this type (fig. 79).[48] Like Fabritius's painting (fig. 81), Vosmaer's picture combines a contrived perspective with a real view of Delft. A number of works by Vosmaer and his fellow townsman Egbert van der Poel show Delft as it looked after the explosion of the gun powder warehouse on 12 October 1654 (fig. 80). Among the victims of this terrible disaster, which left a great part of the city in ruins, was Carel Fabritius.

These Delft paintings from the 1650s, together with representations by Saenredam and Jan Beerstraten of the old Amsterdam Town Hall, which was destroyed by fire in 1652, are the first true cityscapes known to us.[49] The *vedute* as an autonomous genre did not develop until later. when it was practiced with great success by such masters as Jan van der Heyden, the Berckheyde brothers, and subsequently by Venetian artists of the eighteenth century.

Pieter de Hooch, in a series of works painted around 1658, the period when he rejuvenated the painting of interiors, was the first to capitalize on the potential of exterior views. The *Courtyard with Three People at a Table* (fig. 83), dated 1658, provides impressive evidence of his achievement. Paintings such as this must have persuaded Vermeer also to direct his vision out-of-doors.

Vermeer was, however, no more a mimic of de Hooch's models of exterior painting than he had been of the latter's interior scenes. In place of de Hooch's boxlike construction of spatial compartments in his *Courtyard* (the corridor, the terrace), Vermeer's *The Little Street* ("*Het Straatje,*" plate 9) in the Rijksmuseum depicts a continuous wall, pierced only by an occasional doorway. De Hooch succeeded in imbuing his *Courtyard* with a degree of naturalism unrivaled by his contemporaries. Vermeer achieved still more refined effects through brighter coloring and meticulous modeling, combined with his *pointillé* technique.

Leaving aside another "View of some houses" mentioned in the Dissius sale of 1696 but no longer known, we presume that Vermeer first dedicated himself to genre before trying to surpass de Hooch in cityscapes as well. That might explain why his *Little Street* (plate 9) immediately displays the perfection that he only achieved in *The Milkmaid* (plate 8) after trial and error. Both pictures must date from the same period, a few years after 1658, possibly from 1661.

81. Carel Fabritius (1622-1654), *View in Delft*, signed and dated 1652, canvas, 15 × 32 cm. National Gallery, London

We also presume that in his cityscapes as in his interior scenes, Vermeer moved on from relatively modest compositions to more ambitious ones. The success in a small format of *The Little Street* probably encouraged him to attempt an outdoor painting on a large scale—his *View of Delft* (plate 10) in the Mauritshuis, The Hague. It is an altogether astonishing achievement. While some paintings strike us forcefully on one occasion, only to leave us unimpressed the next. the *View of Delft* is endlessly fascinating. Many authors have compared its vibrant luminosity with the work of the French Impressionists. However, the *View of Delft* has just as strong an affinity with the painstakingly exact city views of Dutch *vedute* painters of the late seventeenth and eighteenth centuries. It is, in fact, a topographical view—a precise rendering of the *Schiekade* in Delft, between the Rotterdam and Schiedam gates, viewed from across the Schie River (compare fig. 8). The very house from which Vermeer worked can be identified.[50] As in other works, he may have painted directly from nature with the aid of a camera obscura. Yet we should realize that for Vermeer the camera obscura could be no more than an aid. The *View of Delft* depicts one fleeting moment. A fraction of a second later the clouds will have moved, causing other parts of roofs and steeples to catch light or shadow. Our modern camera is able to capture such a moment, but that makes it easy to forget that if Vermeer used the camera obscura it hardly allowed him time and occasion even to make his roughest first sketch.

Vermeer's obsession with topographical accuracy was not unique. The Delft archives tell of a "Great Picture Map of Delft" which was started for the city government in 1675, only a few months after Vermeer's death. Large sums of money were spent on this compilation of exact renderings of buildings in Delft, all made on the spot. The project included not only an illuminated ground plan, but also a drawing (for which 72 guilders were paid) representing "the profile of the city drawn most fastidiously from nature, without sparing time or effort."[51]

Vermeer's achievement in the *View of Delft* was to combine just this sort of topographical exactitude with a magical sensitivity to the play of light. While some later artists have excelled in either objective, Vermeer's synthesis of the two is unequaled.

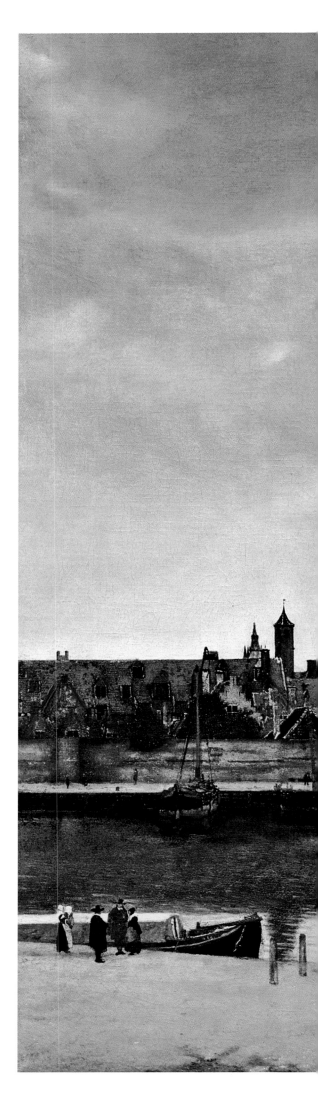

Plate 10 (cat. no. 10) *View of Delft*, about 1661, 98 × 117.5 cm. Mauritshuis, The Hague

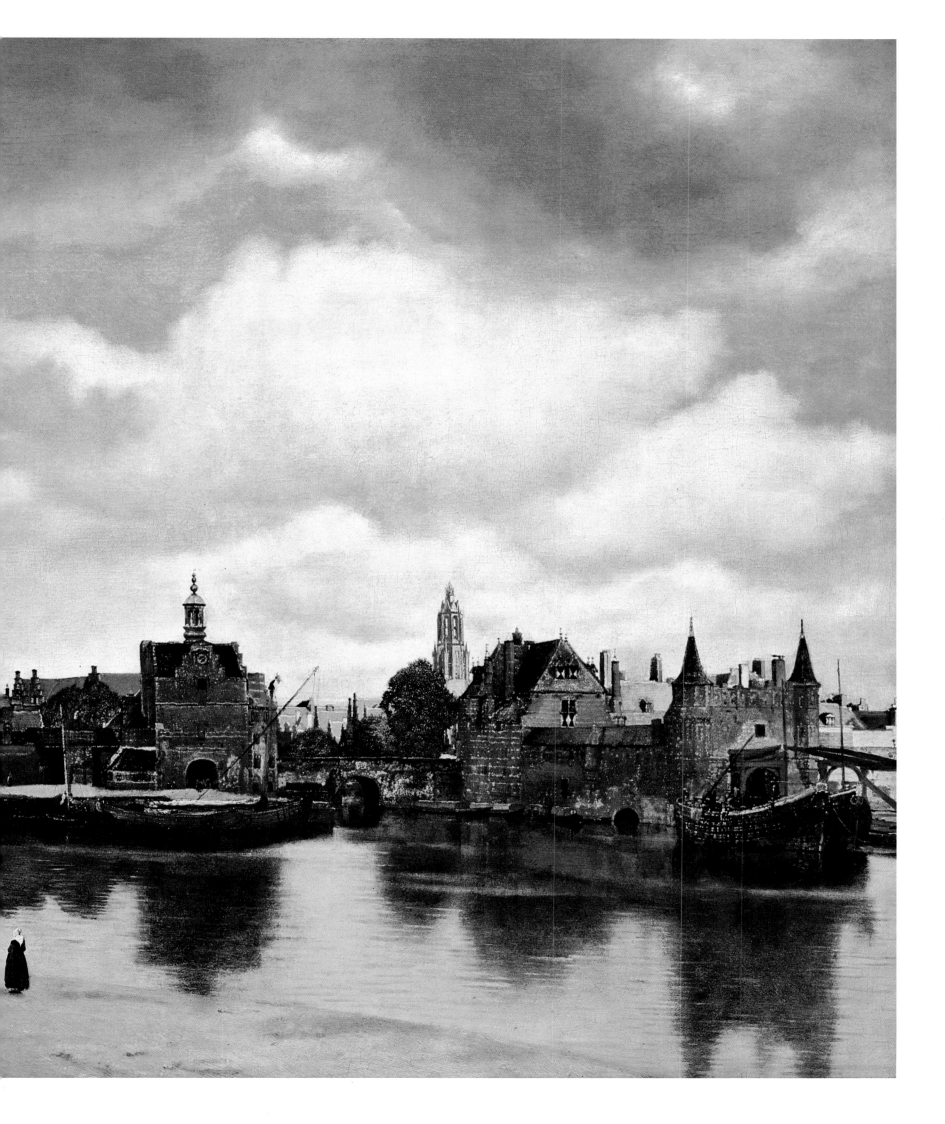

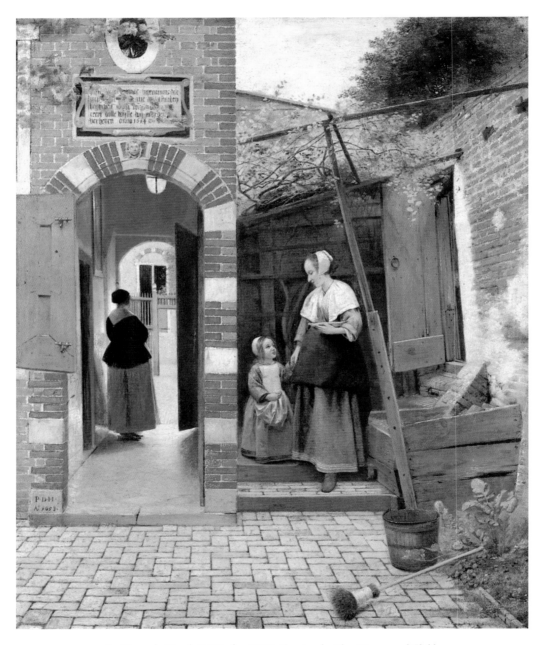

82. Pieter de Hooch (1629-after 1684), *Courtyard with a Woman and Child*,
signed and dated 1658, canvas, 73 × 60 cm. National Gallery, London

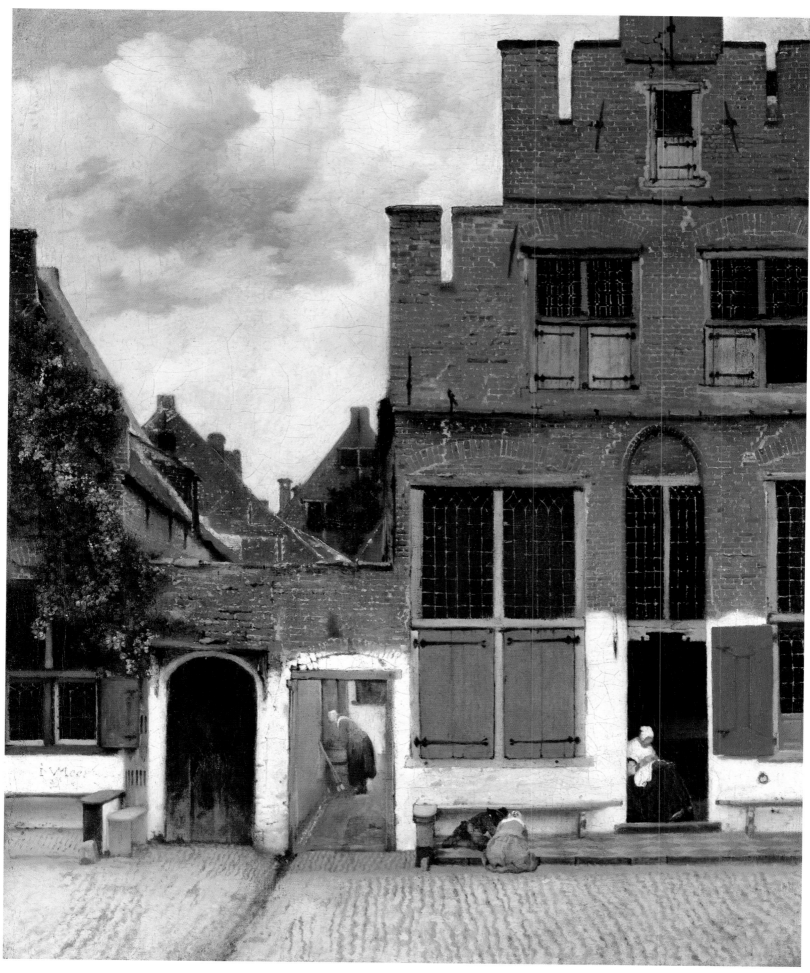

Plate 9 (cat. no. 9) *The Little Street*, about 1661,
54.3 × 44 cm. Rijksmuseum, Amsterdam.

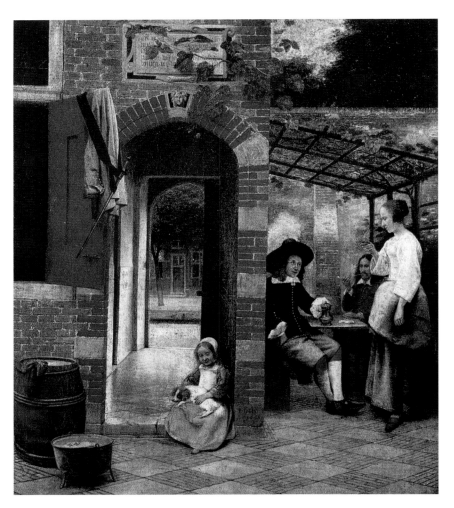

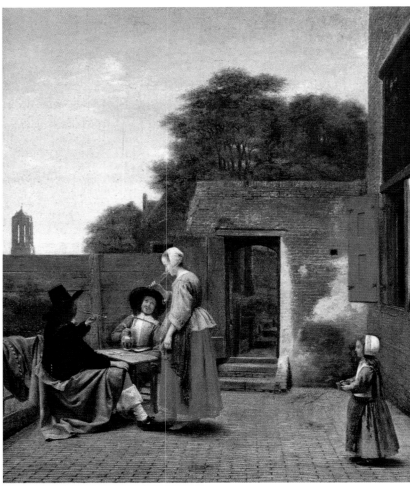

83. Pieter de Hooch, *Courtyard with Three People at a Table*, monogrammed and dated 1658, canvas, 66.5 × 56.5 cm. On loan to the National Gallery of Scotland, Edinburgh.

84. Pieter de Hooch, *Courtyard,* canvas, 68 × 59 cm. National Gallery, Washington

FURTHER REFINEMENT, AND THE INFLUENCE OF
FRANS VAN MIERIS (PLATE 11, 12)

The *Soldier with a Laughing Girl,* the *Girl Reading a Letter at an Open Window, The Milkmaid,* the *Lady Drinking and a Gentleman, The Little Street,* and the *View of Delft* (plates 5-10) were evidently painted in rapid succession presumably in the years 1658 to 1661. In technique they form a distinct group within Vermeer's *œuvre.* All exhibit the same solid, emphatic modeling; close inspection also reveals an uneven paint surface, marked by lumps and small areas of impasto, particularly in the brighter passages.

In his later paintings—the date of transition in style is probably about 1662—Vermeer abandons the very explicit and pasty modeling of these early works in favor of a smoother paint surface, a more restrained and less individualized treatment of texture, an increasingly subdued lighting, and a generally greater refinement.

A Lady and Two Gentlemen (plate 12) in Braunschweig is an early example of this new departure. Although it repeats many of the features of the *Lady Drinking and a Gentleman* (plate 7) in Berlin, it replaces the heavy impasto employed in that picture with a more delicate modeling. The pronounced contrasts of form and texture in the Berlin painting—between the glossy chair and the rough carpet, for example—are avoided in the Braunschweig piece. Changes in fashions of dress suggest that the *Lady and Two Gentlemen* is several years later than the *Lady Drinking and a Gentleman.*[52] Apparently Vermeer had spent the intervening time working on his cityscapes and only belatedly returned to the format of the *Lady Drinking and a Gentleman.*

The *Lady and Two Gentlemen* (plate 12) are behaving more exuberantly than the *Lady Drinking and a Gentleman* (plate 7). In the former a cavalier bows after serving the woman her glass of wine. He uses the occasion to caress her hand lightly with his fingertips. Another man sits withdrawn at the table on which an opulent still life is displayed. Both paintings depict the same coat of arms surmounted by a vaguely discernible woman holding reins. She probably personifies Temperance, a virtue all too easily forgotten by drinkers and lovers alike (see text of cat. 11).

The *Woman with a Water Jug* (plate 11). in the Metropolitan Museum, is also a transitional piece. Its brilliant lighting recalls Vermeer's work of 1658-61, but its refinement of technique places it with his later work. It is Vermeer's only painting in which the action seems to lack coherence. With her right hand the model holds the window, with her left a silver jug placed on a basin of a type used for washing the body. It is unclear what these two actions have to do with each other. Or is she closing the window before undressing? Maybe on this one occasion Vermeer was acting like a nineteenth-century artist, concentrating solely on the splendor of light on the silver and on the peaceful atmosphere of the scene bathed in sunlight.

Although the delicate modeling of Vermeer's new style has some affinity with Gerard ter Borch's manner of the 1650s (see fig. 63), a more direct influence on Vermeer was the work of Frans van Mieris the Elder, the most gifted pupil of the Leiden *Feinmaler* ("precision painter") Gerard Dou. A precociously talented artist, by 1658, at the age of twenty-three, van Mieris was producing works of comparable quality to those of that period by Pieter de Hooch, who was six years his senior (fig. 85). Van Mieris drew inspiration from ter Borch as well as benefiting from his training under Dou and from the example of the Delft interior painters. During his lifetime his work fetched high prices, and his fame lasted until the nineteenth century, when with the advent of Impressionism his meticulous style fell out of favor.[53]

Inasmuch as external influences could shape Vermeer's very personal development, van Mieris's art was of primary significance. This is illustrated by his *Duet* of 1658 (fig. 85), a fine example of his early work in which large figures are placed against a light background with an elegance reminiscent of ter Borch. Both the theme of Van Mieris's *Duet* and its arrangement of figures and objects (the chair in the right foreground, for example) presage features that would soon appear in Vermeer's art (see plates 16, 19). Even such a detail in the *Duet* as the red brocade-trimmed gown worn by the girl at the clavecin, is repeated precisely—as regards color, fashion, and the way in which it is painted—in Vermeer's *Lady and Two Gentlemen* (plate 12).

Vermeer was influenced by van Mieris somewhat later than by de Hooch—not until sometimes after 1660. This is hardly surprising, for since van Mieris worked in Leiden, his work was surely less accessible than that of Vermeer's fellow townsman de Hooch. Moreover, it was not until about 1660 and the following years that van Mieris perfected his distinctive style, with it glossy, velvet-soft modeling and vividly sculptural treatment of form (fig. 97).

THE THREE "WOMEN" (PLATES 13, 14, 15)

Vermeer's *Lady and Two Gentlemen* (plate 12) and *Woman with a Water Jug* (plate 11) are followed by seven paintings which are still more refined and mature in execution and yet clearly precede Vermeer's late style, which commences in about 1667. As a group these paintings fit roughly into the years 1662 to 1666, but their individual sequence is difficult to determine; the various arguments in favor of one or another chronology tend to confound one another. The problem remains intriguing, however, for during this period Vermeer was at his artistic zenith.

The *Woman with a Pearl Necklace* (plate 13) in Berlin, the *Woman in Blue Reading a Letter* (plate 14) in Amsterdam, and the *Woman Holding a Balance* (plate 15) in Washington demonstrate once again Vermeer's habit of reemploying a basic scheme in several pictures (each of which, in this instance, is almost equally perfect).[54] In each of these three paintings a horizontal, formed by a table covered partly with a few objects, sets off the prominent vertical of a woman standing nearly at full length. This stress on horizontal and vertical is repeated in the accessories of each scene—for instance, the seat and back of a chair in the foreground (plates 13, 14); the right angle of a map (plate 14); or a painting on the back of a wall (plate 15). Within this simple framework Vermeer outlines forms with unrivaled delicacy.

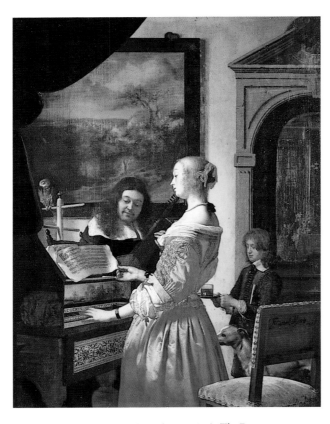

85. Frans van Mieris (1635-1681), *The Duet*,
signed and dated 1658, panel, 32 × 25 cm.
Staatliches Museum, Schwerin.

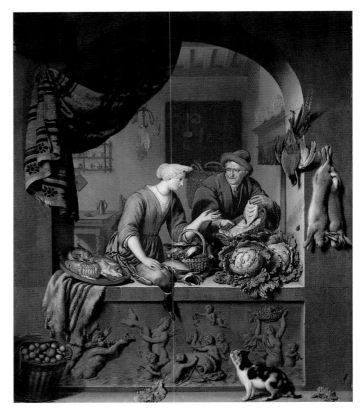

86. Willem van Mieris, *A Woman and a Fish-Pedlar in a Kitchen*,
signed and dated 1713, panel, 49 × 41 cm.
National Gallery, London.

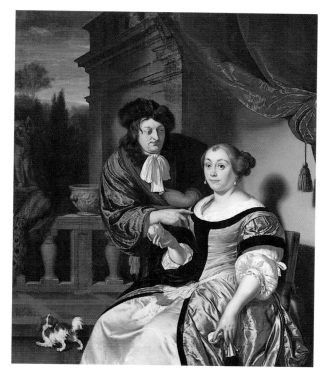

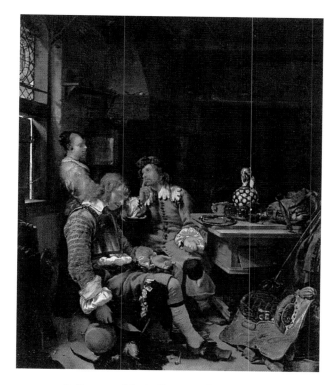

87. Frans van Mieris (1635-1681), *Couple on a Terrace*, signed and dated 1678, panel, 36 × 30 cm. Rijksmuseum, Amsterdam

88. Frans van Mieris, *Sleeping Officer in an Inn*, signed, panel, 41 × 33 cm. Alte Pinakothek, Munich

In attempting to evoke the mood of these paintings writers have been driven to despair by the limitations of language and the tools of art-historical description. "Pure poetry," "perfect harmony" are phrases typically invoked. The effect that these terms seek to convey is not difficult to sense or appreciate. However, in order to understand how Vermeer achieved such an effect we should compare his paintings with the works of his contemporaries which served him as a starting point—for example, van Mieris's *Duet* (fig. 85), itself a "classical" painting. In contrast with the restful, perfectly balanced poses of Vermeer's three women in Berlin, Amsterdam, and Washington, van Mieris's clavecin player arches her back with obvious effort, introducing a note of tension into the composition. Vermeer's women (whose repose is enlivened only by the accents of hands and profile) are described with smooth, almost uninterrupted outlines, while van Mieris's contours seem mobile and somehow disrupted. Vermeer's only animating note is the graceful outline of the rug, and the table filled with objects. He veils the entire left-hand area in shadow, while van Mieris clutters the left side of his composition with music papers, a parrot, and other paraphernalia.

In the *Woman in Blue Reading a Letter* (plate 14) Vermeer exploits the same motionless but evocative motif he had used earlier in his *Girl Reading a Letter at an Open Window* (plate 5). In the *Woman with a Pearl Necklace* (plate 13) and the *Woman Holding a Balance* (plate 15) he manifests an even subtler expressive skill, in selecting a *moment* of immobility which exploits the tension between rest and action. The woman with a pearl necklace is shown pausing to study herself in the mirror as she debates whether or not to tie the ribbons of her necklace; the woman holding a balance is caught in an instant of intense concentration as the pans of her scales come to rest.

For all their shared features, the three paintings are not merely mechanical repetitions of a single prototype, as is so often the case with the work of Vermeer's contemporaries. In each one, Vermeer reveals an entirely new approach to lighting and coloring. The *Woman with a Pearl Necklace* (plate 13) possesses a silvery light, with predominating tones of muted yellow and white. The *Woman in Blue* (plate 14) has a more diffuse illumination, and a blue ground that suffuses the whole surface. This is the only Vermeer with such a strong overall tonality, and it is probable that the blue appears more exaggerated now than when the picture was originally painted. In other paintings by Vermeer the original green (a color obtained by mixing yellow and blue) has

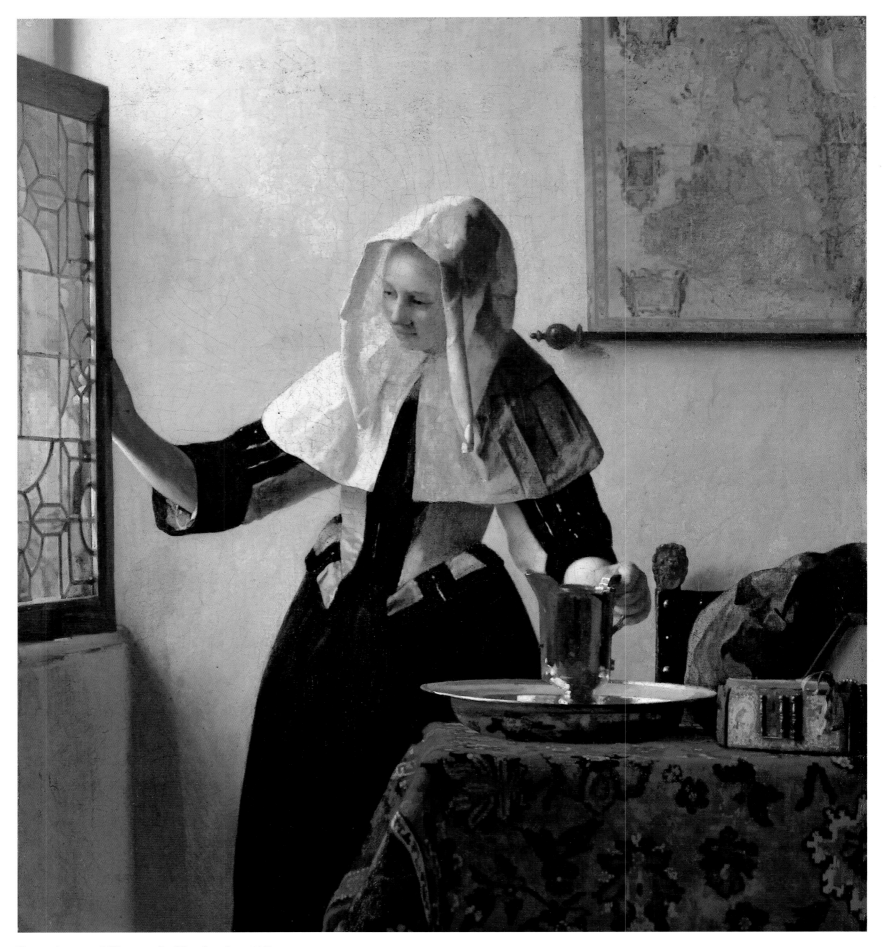

Plate 11 (cat. no. 12) *Woman with a Water Jug*, about 1662
45.7 × 40.6 cm. Metropolitan Museum of Art, New York.

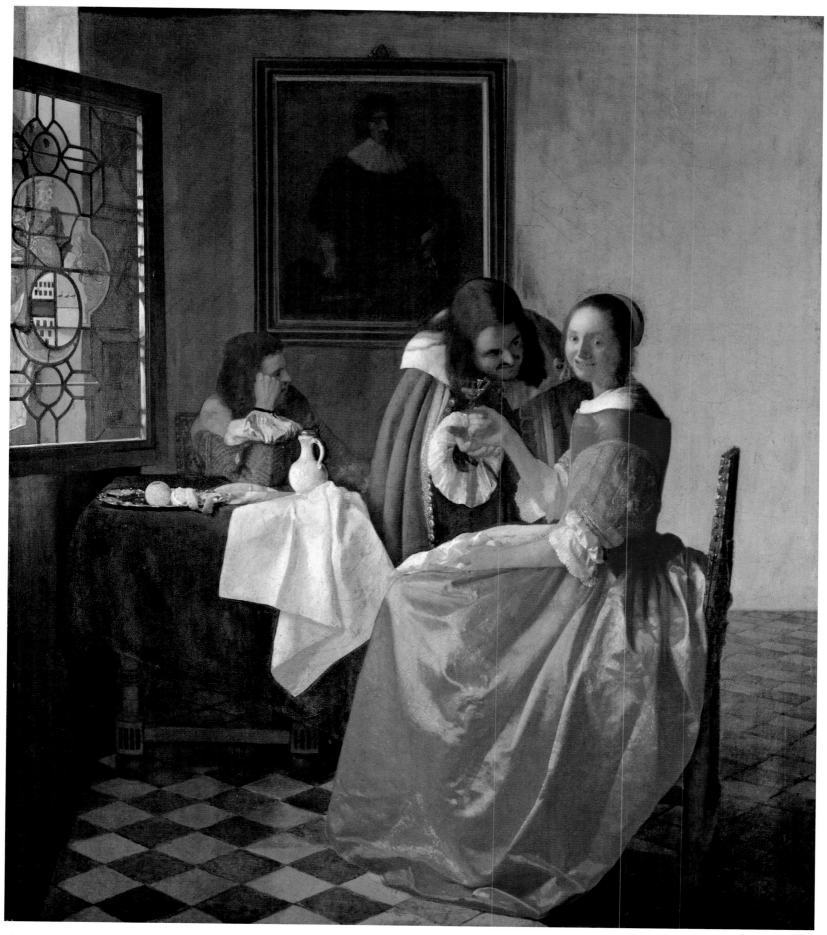

Plate 12 (cat. no. 11) *A Lady and Two Gentlemen*, about 1662
78 × 67 cm. Herzog Anton-Ulrich Museum, Braunschweig.

89. Detail of *Woman with a Pearl Necklace* (plate 13)

turned blue as the yellows in the mixture have oxidized, a change sometimes referred to as "blue-green disease." The oddly inappropriate blue vegetation in *The Little Street* (plate 9) and in the *View of Delft* (plate 10), and the blue laurel wreath in *The Art of Painting* (plate 19), are examples of this green-to-blue shift. It seems likely that the blue in the *Woman in Blue* was also originally balanced by green and yellow passages.

In the *Woman Holding a Balance* (plate 15), to my mind the most impressive of the three pictures, evening light is partly filtered by an orange-red curtain, enveloping the scene in a shimmer. The dreamy mood evoked by this twilight is in perfect balance with the utmost delicacy of the modeling of the large lighted area that is the focus of the composition: the woman's face, her white headscarf, and the white fur of her jacket. These soft forms are firmly embedded in the rectangular structure of the horizontal lines of the table set off against the straight vertical strips of highlight in the mirror and on the frame of the painting in the background.

The theme of the *Woman Holding a Balance* had earlier precedents in Delft. Leonaert Bramer painted the subject more than once, although unfortunately none of these works has survived; they are known only through descriptions in eighteenth-century sales catalogues.[55] A painting in a style related to Bramer's, by Willem de Poorter of Haarlem, probably reflects the spirit of Bramer's treatment of the theme (fig. 91). It can hardly be mere coincidence that the general format of de Poorter's painting resembles that of Vermeer's work. The comparison also illustrates how Vermeer succeeded in transforming a simple Dutch genre motif into a masterpiece.

Vermeer's contemporaries undoubtedly saw more than a pictorial masterpiece. They must have recognized the connection between the action of the woman and the painting on the wall behind her. She is balancing her scales for weighing the gold and pearls lying around on the table. The painting on the wall represents the Last Judgment—the fatal day when all souls will be weighed. The mirror is a frequently employed symbol of vanity, while the gold and the strings of pearls on the table represent the transience of earthly wealth which will have no value on the Day of Judgment, for only the alloy of the soul will then have weight.[56] With characteristic subtlety, Vermeer has hidden the representation of St. Michael weighing souls behind the woman's head. An interesting recent theory holds that Vermeer's ideas were even more complex and that the *Woman Holding a Balance* in fact personifies Truth (see text of cat. no. 15).

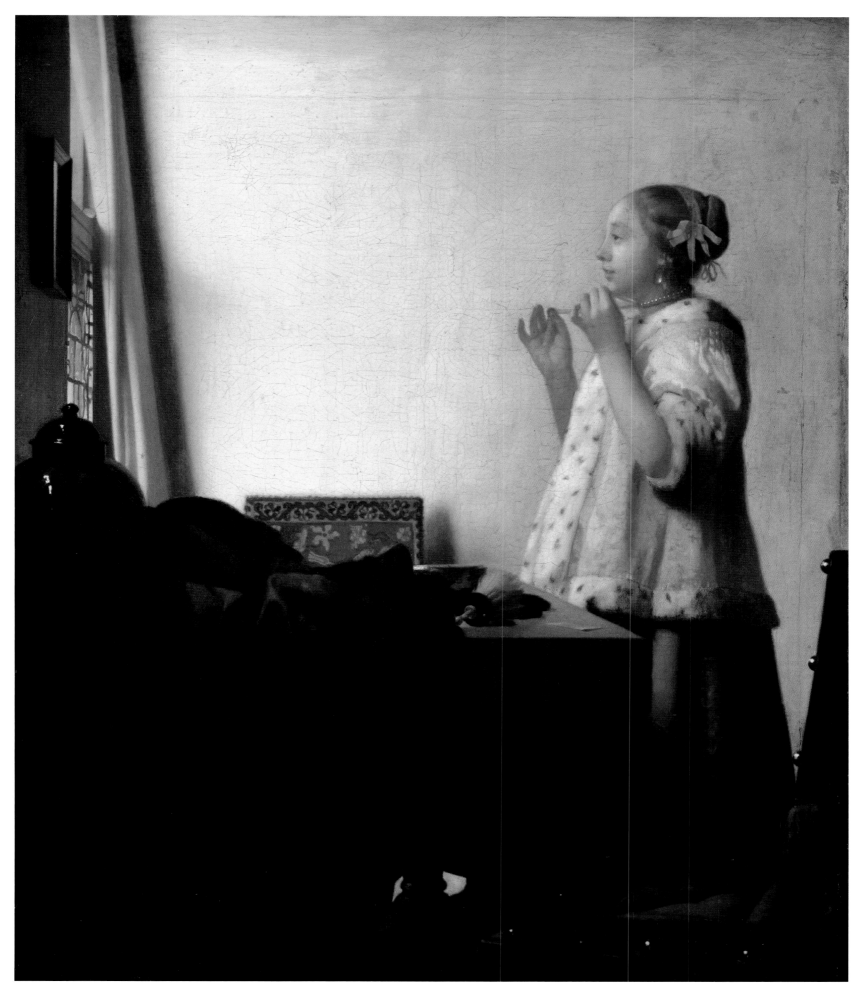

Plate 13 (cat. no. 13) *Girl with a Pearl Necklace*, about 1662-1665,
55 × 45 cm. Gemäldegalerie Dahlem, West Berlin.

90. Detail of *Woman in Blue Reading a Letter* (plate 14).

"COMPANION OF JOY, BALM FOR SORROW" (PLATES 16, 17, 18)

Without doubt the splendid *Music Lesson* (plate 16) in Buckingham Palace in London is a later work than the three paintings of women we have just discussed. Admittedly, it has occasionally been dated earlier. Some writers, apparently impressed by the similarity of the richly painted carpet in the foreground to the carpet in the *Girl Reading a Letter* (plate 5), even date it before 1660. But *The Music Lesson* has none of the experimental and transitional qualities we have noted in the *Girl Reading a Letter.* As in the three paintings of women (plates 16, 17, 18), action and repose are in a perfectly balanced tension, and sensitively rendered individual forms are integrated into an overall geometric order. However, the structure of *The Music Lesson* is considerably more complex than that of the previous paintings. And given the complexity of the new undertaking, it seems perfectly understandable that Vermeer should borrow such motifs as the conspicuously displayed carpet from his earlier manner.

"MUSICA LAETITIAE CO[ME]S MEDICINA DOLOR[UM]" ("Music: companion of joy, balm for sorrow"). Written in capitals on the cover of the clavecin, this text may express Vermeer's ambition for painting to have the same impact as music.[57] A lively, forceful rhythm leads our glance over the opulently covered table in the foreground, the upright chair, and the viola de gamba lying on the floor; it does not dissipate when our gaze reaches the rectangular back wall, for then the rhythm is picked up by a series of clearly indicated oblong forms set against the wall and parallel to it—a mirror, a painting, and the clavecin. The carefully calculated movement into depth, and the carefully placed rectangles in the background, all contribute to a single impression—that of a commodious, boxlike space which scrupulously obeys the laws of perspective.

The spatial arrangement evokes one of the finer pictures of Pieter de Hooch (see fig. 76), while the subject matter evokes Frans van Mieris (see fig. 85). But in contrast to van Mieris's *Duet,* Vermeer shows his performer from behind so that her active hands are not visible. Her face is seen only at one remove, reflected

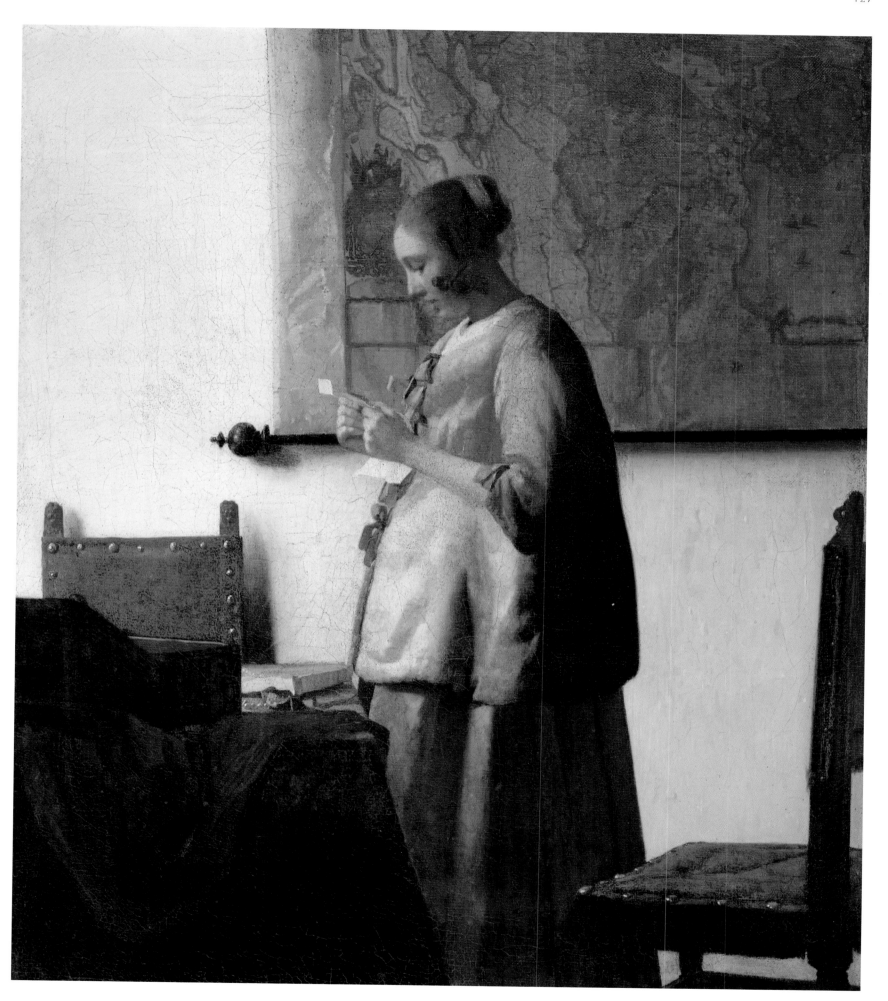

Plate 14 (cat. no. 14) *Woman in Blue Reading a Letter*, about 1662-1665, 46.5 × 39 cm. Rijksmuseum, Amsterdam.

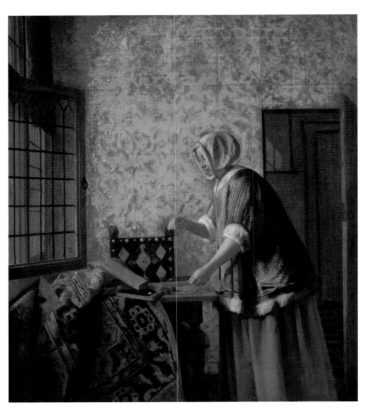

91. Willem de Poorter (1608-after 1648)
Woman Weighing Gold, signed, panel, 46 × 41 cm.
North Carolina Museum of Art, Raleigh.

92. Pieter de Hooch (1629-after 1684), *Woman Weighing Gold,*
canvas, 61 × 53 cm.
Gemäldegalerie Dahlem, West Berlin

in the dimly lit mirror (where we also see part of the painter's easel). Thus we do not expect movement either from her or from her quietly listening companion.

The huge table in the immediate foreground makes a striking contrast with the diminutive figures at the back of the room. There is, in fact, a parallel for this surprising effect, in a painting by Frans van Mieris from the same period in which the contrast in scale is even more pronounced *(The Soldier's Boot,* Alte Pinakothek, Munich). This would seem to confirm that Vermeer and van Mieris were in contact during these years.

The general arrangement of *The Music Lesson* (plate 16) recurs in *The Trio* (plate 17) in the Isabella Stewart Gardner Museum in Boston, which presents a more circumscribed view, omitting the ceiling and the side walls of the room. Now it is the man who is seen from the back: the woman at the clavecin is viewed in profile and a woman singing is seen in three-quarters view. This time the hands of the latter are clearly visible. It is unclear whether *The Trio* is slightly earlier than *The Music Lesson* or a later variation of it.

The *Girl with a Pearl Earring* (plate 18) in the Mauritshuis in The Hague is even more difficult to place in sequence than *The Trio.* Here Vermeer concentrates on the glance the girl casts over her left shoulder as her eyes meet ours. Her shining eyes and moist lips, and the modeling of her face and dress succeed in convincing us of their perfect naturalness. But if we compare this painting with a work by Frans van Mieris from about 1658 (fig. 95), a work which may even have been Vermeer's source of inspiration, Vermeer's tendency to idealize becomes apparent. Van Mieris dresses his model in clothes of the current fashion, and conscientiously differentiates between the nearly palpable textures of velvet, fur, and linen. Vermeer, by contrast, avoids specifics: his girl wears an apparently fanciful costume of a single, indeterminate fabric. While van Mieris delicately models the plasticity of the face, indicating all its imperfections and idiosyncrasies, creating the effect of a portrait, Vermeer only indicates the beautiful, smooth contour of the face, and keeps detail to a minimum. The line of the nose is, in fact, invisible; the bridge of the nose and the right cheek flow into each

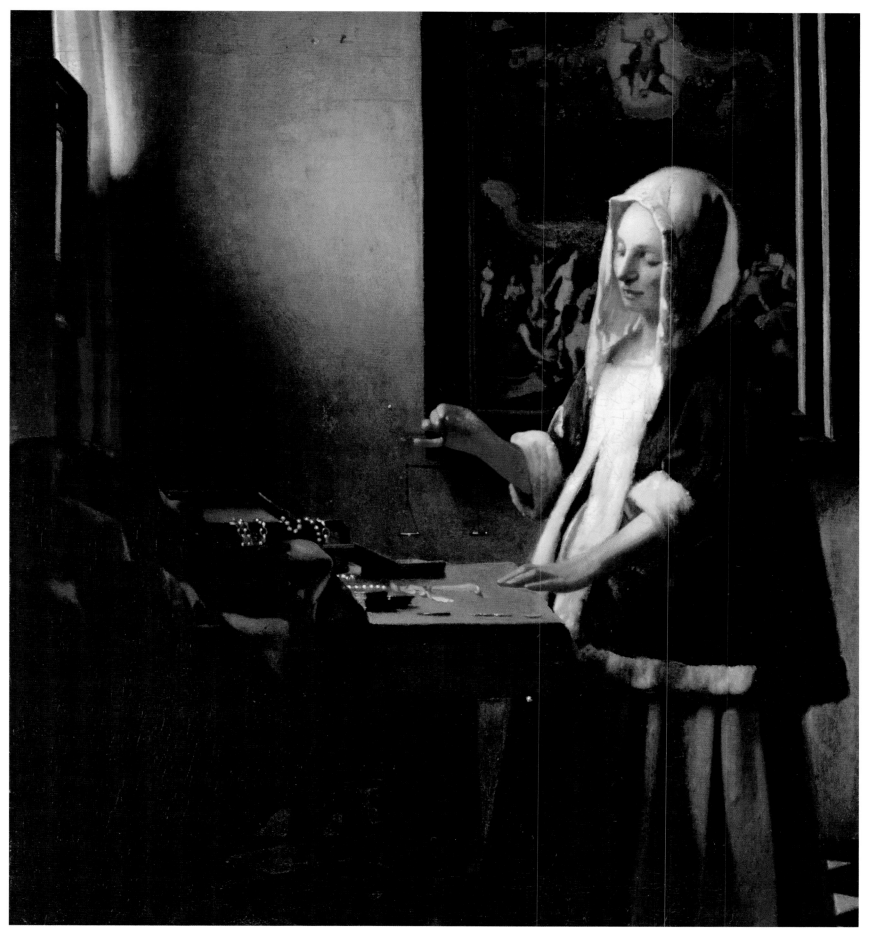

Plate 15 (cat. no. 15) *Woman Holding a Balance*, about 1662-1665,
42.5 × 38 cm. National Gallery of Art, Washington.

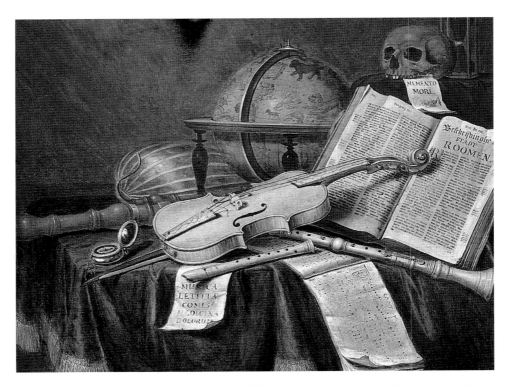

93. Edwaert Collier (c. 1640-after 1706), *Vanitas* (*Still life*), 1690, panel, 41 × 52.5 cm. Paris, private collection.
On the piece of paper handing from the table can be read: "MUSICA LETITIAE COMES MEDICINA DOLORUM."
The same text appears on the clavecin on Vermeer's *The Music Lesson* (plate 16). The skull, the hourglass, and
the inscription "MEMENTO MORI" beneath them allude to the transitoriness of human life, as do the watch
and the musical instruments. The large book is opened at the chapter "Description of the City of Rome"
(*Beschrijvinghe der stadt Roomen),* thus referring to the transitoriness of earthly power.

other, forming a single area of absolutely even color. In no other painting by Vermeer do we see so clearly how his truthfulness to nature was coupled with a desire to represent it in its ideal state.

THE ART OF PAINTING (PLATE 19)

In 1661 construction of new quarters for the Delft Guild of Saint Luke in which the painters were organized, was begun on the Voldersgracht, directly behind Vermeer's paternal house. The classicizing façade of the new building—which unfortunately no longer exists—was surmounted by a bust of Apelles, the most famous painter of antiquity. The interior was decorated with allegorical representations of Painting, Architecture, and Sculpture. In the eight sections of the ceiling one could admire the seven liberal arts—and an additional eighth art. "Painting," executed by Leonaert Bramer "out of love for the Guild."[58] Bramer was one of the officers of the guild in 1661, but in the following year he was succeeded by Vermeer, who was reelected in 1663 (and served on the board again in 1670 and 1671).

The new quarters of the guild must still have been unfinished when Vermeer took office in 1662. Consequently he must have been involved, if not in the planning of the building, at least in its completion-and particularly in its decorations, which consisted of the symbolic representation of the arts, including the all-important art of painting. It is against the background of this project that we should consider Vermeer's own treatment of *The Art of Painting* (plate 19), now in Vienna and often called *An Artist in his Studio.*

Documents tell us that the picture was in the possession of Vermeer's widow after his death in 1675, and that she did everything in her power to avoid selling it (documents of 24 February 1676 and 12 March 1677). The fact that Vermeer kept the painting during his lifetime, and the special care that he seems to have taken in its execution, suggest that it enjoyed a privileged place in his *œuvre,* and may very well have been on his easel for a period of years.

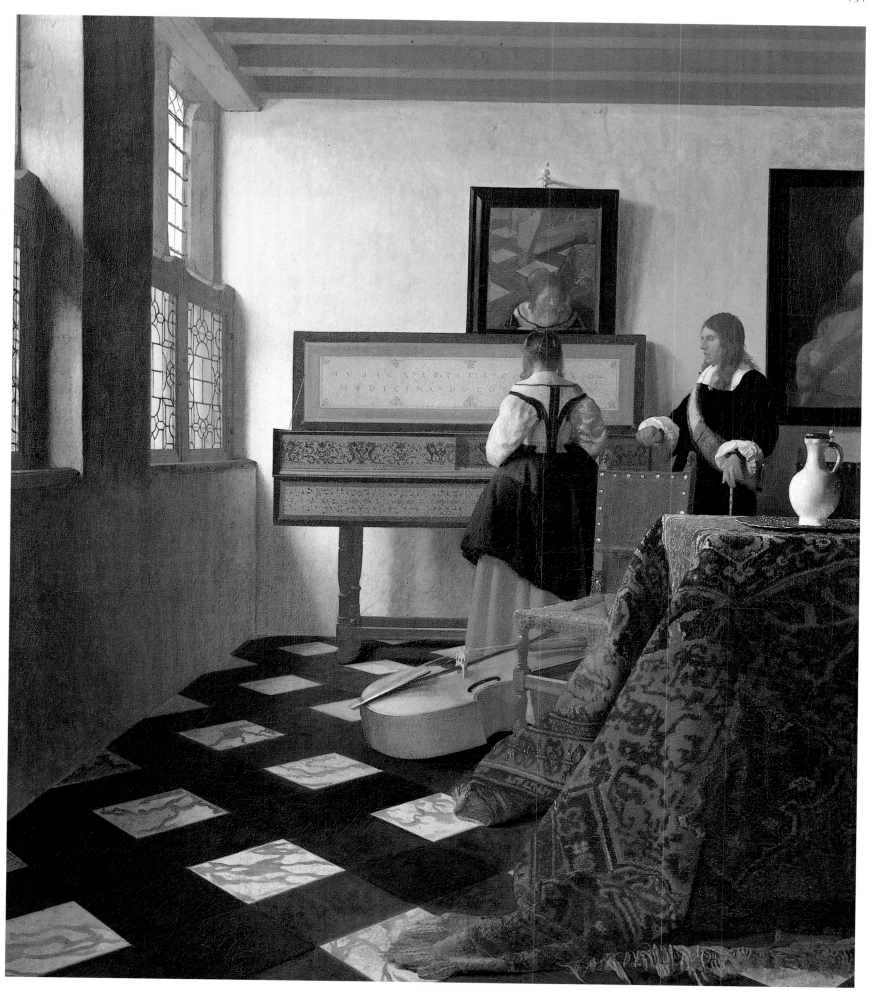

Plate 16 (cat. no. 16) *The Music Lesson*, about 1664,
73.3 × 64.5 cm. Buckingham Palace, London.

Vermeer's painting was of an established type, if we consider, rather than the specific subject, the general motif: a painter depicting a young woman, who appears again in the unfinished painting on his easel. More than a century earlier, Maerten van Heemskerck (1498-1574) had painted this combination in his *Saint Luke Painting the Madonna* (fig. 96). Demonstrating a "love for the guild" which recalls that of Vermeer's friend Leonaert Bramer, van Heemskerck donated his picture to the Haarlem Guild of Saint Luke. Vermeer may well have known of Heemskerck's picture (and of its donation), for it is described in Carel van Mander's famous treatise on Netherlandish painters, published in 1604.[59] It is even conceivable that Vermeer's painting was also originally intended to be a gift to his guild.

In the nineteenth century—when Vermeer had just been rediscovered—*The Art of Painting* was considered a realistic glimpse into a painter's studio. Théophile Thoré even speculated that the figure of the painter might be Vermeer's self-portrait. Today, however, we return to the picture's earliest title in the documents of 1676 and 1677: "De Schilderconst" ("The Art of Painting") and we recognize the allegorical intention. Many of the details are clarified in the *Iconologia* by the highly influential Italian inventor and explicator of symbols Cesare Ripa, which had been published in a Dutch translation in 1644.

Since painting is an art of imitation, the mask on the table is an appropriate symbol for it. Ripa wrote that "the mask and the ape show the imitation of human activities." The costume of the painter is not contemporary, but inspired by clothing depicted in late medieval art. Thus to a seventeenth-century viewer the painter was dressed in "the antique way." The woman who poses for him wears a laurel wreath and carries a book and trumpet, attributes mentioned by Ripa as those of Clio, the Muse of History. Thus the painter depicts History, and she in turn inspires the painter.[60] Vermeer has thus expressed in symbolic guise the concept that history painting was an artist's noblest calling. Clio wears a laurel wreath that never withers, and carries a trumpet to broadcast her praise. It would surely seem that Vermeer had a high opinion of his profession!

The map in the background, which depicts the Netherlands, evidently alludes to the fame and impor-

94. Detail of *The Trio* (plate 17)

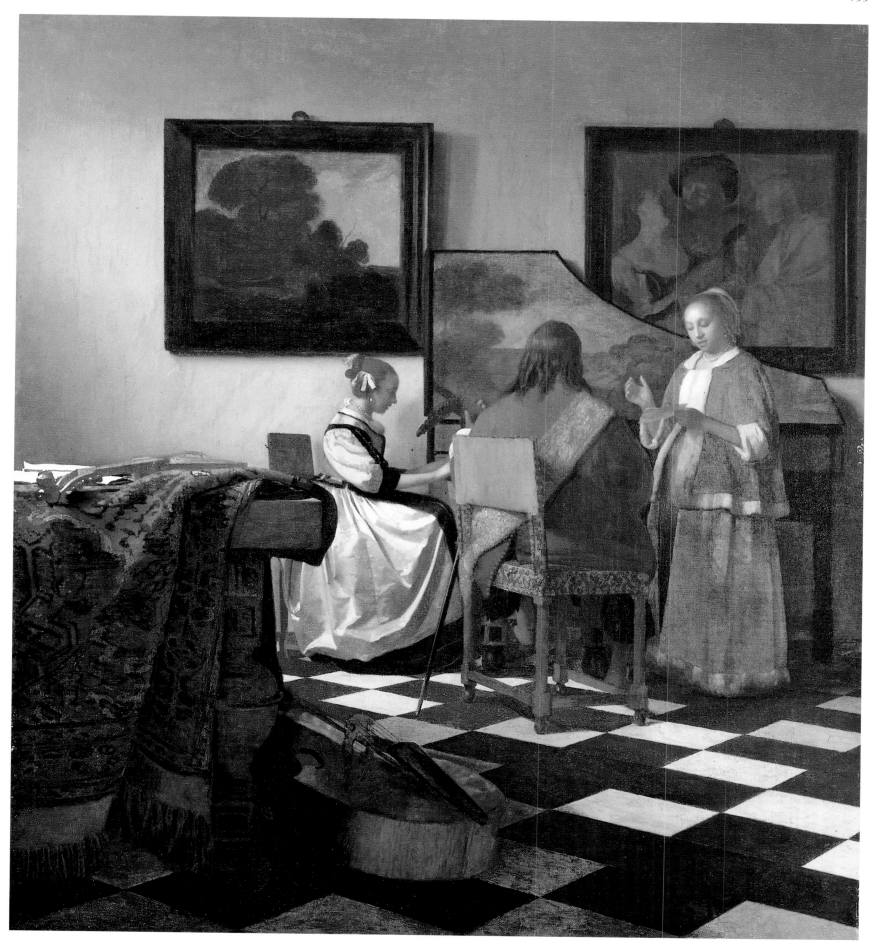

Plate 17 (cat. no. 17) *The Trio*, about 1664,
69 × 63 cm. Isabella Stewart Gardner Museum, Boston.

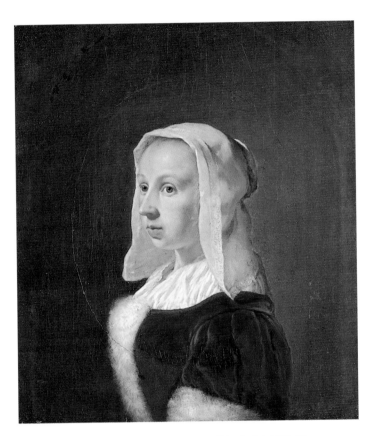

95. Frans van Mieris (1635-1681), *The Artist's Wife* (?),
panel, 11 × 8 cm. National Gallery, London

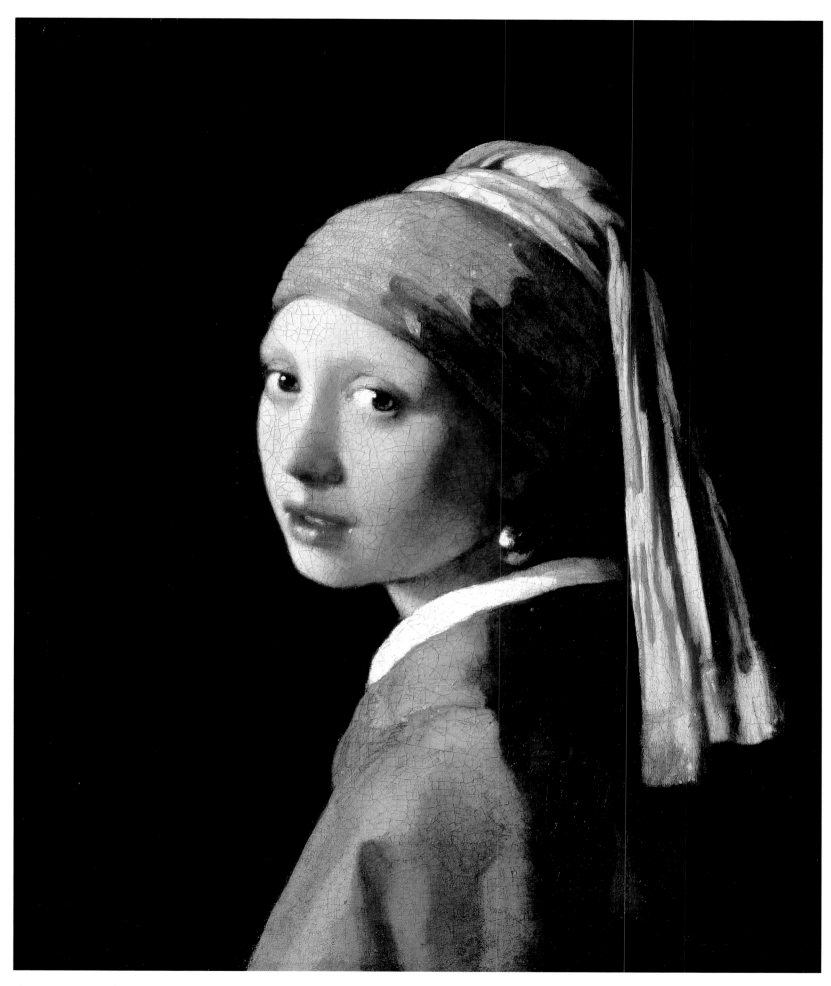

Plate 18 (cat. no. 18) *The Girl with a Pearl Earring*,
about 1665, 46.5 × 40 cm. Mauritshuis, The Hague.

96. Maerten van Heemskerck (1498-1574), *Saint Luke Painting the Madonna*,
monogrammed and dated 1532, panel, 168 × 235 cm. Frans Hals Museum, Haarlem

tance of Netherlandish painting.[61] It is revealing in that it does not show the political boundaries as they existed in Vermeer's lifetime, but as they were before 1581, when the entire Netherlands were part of the Hapsburg Empire. In 1648, at the Peace of Westphalia, the original Netherlands had been divided: the northern half, roughly the present-day Netherlands, became a Protestant republic; the southern half, now Belgium, remained a province of a Roman Catholic monarchy.

Artists and connoisseurs, however, ignored this political division. In his autobiography of about 1630 Constantijn Huygens groups painters according to subject matter, such as history or landscape; regardless of whether they lived in the north or the south, he calls them "my fellow Netherlandish countrymen."[62] It made no difference to him whether a painter lived in Amsterdam or Utrecht, or in Antwerp or Brussels, and when in 1650 he organized the decoration of the Stadholder's palace, the *"Huis ten Bosch"* in The Hague, he gave commissions not only to masters from Utrecht and Haarlem, but also to Jacob Jordaens from Antwerp. Even Arnold Houbraken, in his book on Netherlandish painters (which was published as late as 1718 to 1721) indiscriminately mixes northern and southern Netherlandish artists in his discussion, without a hint of any division between them. Vermeer also clearly conceived the art of both the north and south Netherlands as a single entity.

In *The Art of Painting* Vermeer unified the delicate attention to detail of his three earlier paintings of women (plates 13, 14, 15) with the complex spatial effects of *The Music Lesson* (plate 16). No other work so flawlessly integrates naturalistic technique, brightly illuminated space, and a complexly ordered composition. Exquisitely worked-out details—the chair in the foreground, the crinkled wall map, and the painter's jacket—may be enjoyed individually, and yet are perfectly integrated within the serenity of the larger sunlit space.

Once again a work of Frans van Mieris, who addressed a similar compositional and iconographical challenge, provides an illuminating parallel with Vermeer's painting (fig. 97).[63] Van Mieris sets brightly lit forms against a dark background, thereby preventing the numerous picturesque background details from disturbing the overall effect. Vermeer selects a light background, which obliges him to keep the number of miscellaneous objects to a minimum, and to define those objects he retains with the greatest care. Van Mieris's painter and model communicate with each other through lively gestures and facial expressions. Vermeer, on the other hand, depicts a moment of inaction which still retains the vitality of life—an effect which he achieves here with more ingenuity than in any of his other works. The girl who poses is, quite naturally,

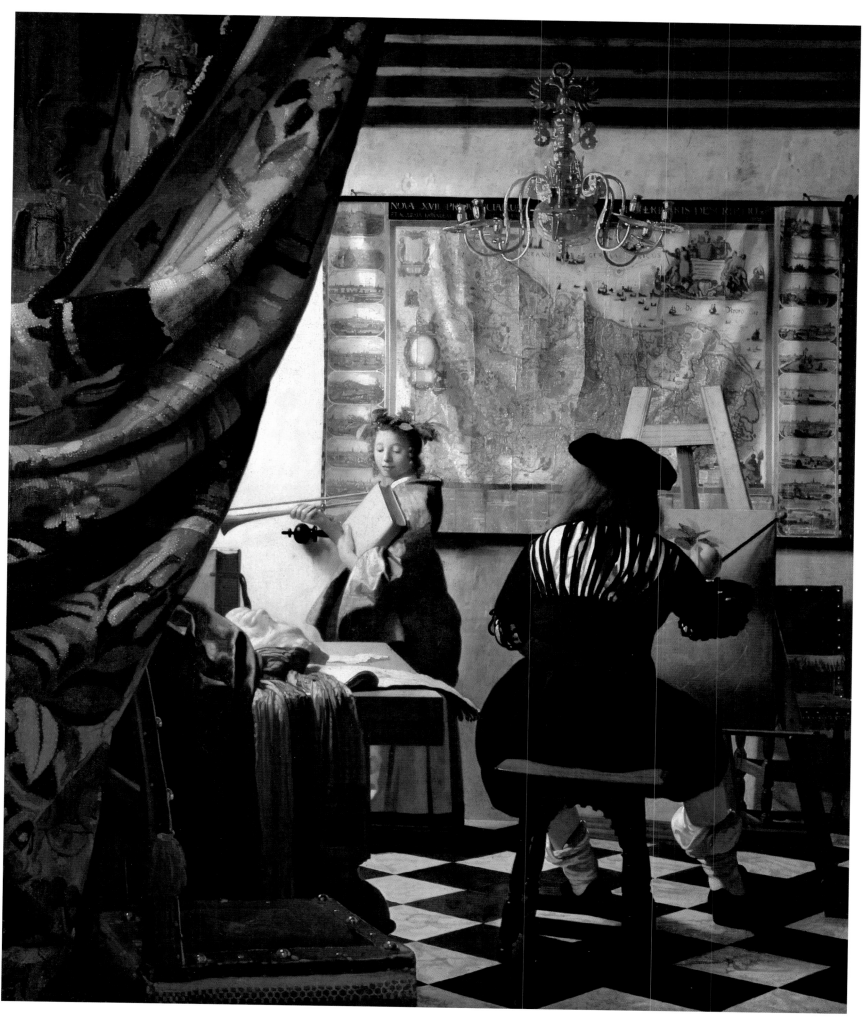

Plate 19 (cat. no. 19) *The Art of Painting*, about 1662-1665, 120 × 100 cm. Kunsthistorisches Museum, Vienna.

97. Frans van Mieris (1635-1681), *A Painter's Studio,*
signed, panel, 60 × 46 cm.
Formerly Gemäldegalerie, Dresden, lost during World War II.

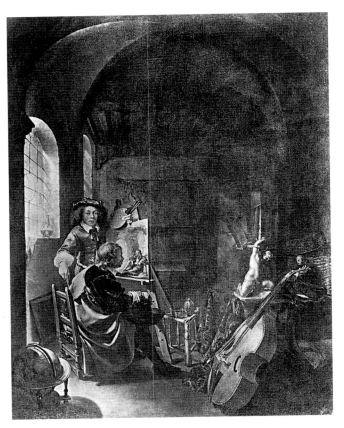

98. Frans van Mieris, *The Amateur Visiting the Painter,*
panel, 63.5 × 47 cm.
Staatliche Gemäldegalerie, Dresden.

motionless. We might, however, expect some movement from the painter's right hand, which is engaged in painting the laurel wreath. Vermeer cleverly convinces us that this hand should be still by showing the moment when the painter has turned his head to the left to study his model. For an instant he rests motionless while studying nature in order to learn from her how to place his next brushstroke.

The *Woman Holding a Balance* is listed in the auction catalogue of 1696 as "A young lady, weighing gold, in a box" *(in een kasje).* This led the late H. E. van Gelder to suggest that the picture, and other Vermeers as well, may have formed the back wall of a perspective box. Critics of this theory have argued that in the seventeenth century precious paintings sometimes were enclosed for protection behind wooden shutters, also called *"kasjes."* The *Woman Holding a Balance* could have belonged to this category.[64] Yet one thing that has been overlooked in this discussion is that even in the printer Dissius's very summary inventory of 1682, three "pictures by Vermeer" are listed with only one specification added: "in boxes" *(in kastjes;* see document of 20 June 1682). So perhaps van Gelder was right after all. Even *The Art of Painting,* although many times larger than the *Woman Holding a Balance* may originally have been intended for a perspective box: that would have been the logical consequence of Vermeer's preoccupations. We have seen how he used the trompe l'œil experiments of Fabritius and van Hoogstraeten as his starting point. These artists had succeeded in creating trompe l'œil effects by two means: by placing flat objects against a flat wall or by leading our view through a peephole into an empty box (see figs. 58, 60). Vermeer aimed at the seemingly unattainable goal of combining trompe l'œil with the depiction of human figures, and he attacked the problem by turning his figures into "still lifes." Yet if we are allowed to move freely in front of these pictures the effect is reduced, because foreground and background do not follow our movements. This problem would be solved if pictures such as *Woman Holding a Balance* and *The Art of Painting* were part of a perspective box, for our view would be tied to the peephole.

99. Jan Aertsen Marienhof, *The Artist's Studio*,
signed and dated 1648, panel, 37.5 × 32.5 cm.
The Hermitage, Leningrad.

100. Quiringh van Brekelenkam (c. 1620-1668),
Visitors in the Painter's Studio, monogrammed and dated 1659,
panel, 49 × 36.5 cm. The Hermitage, Leningrad.

is reduced, because foreground and background do not follow our movements. This problem would be solved if pictures such as *Woman Holding a Balance* and *The Art of Painting* were part of a perspective box, for our view would be tied to the peephole.

VERMEER'S LATE STYLE (PLATES 20-25)

It is difficult to imagine a more successful realization of Vermeer's artistic ideals than *The Art of Painting* (plate 19). After achieving such perfection in the illusionistic depiction of reality there was little room for improvement, and the other alternative, repetition, could only lead to sterility and tedium. Vermeer now confronted a situation that other Dutch painters, whether consciously or unconsciously, also faced at this time.

Between 1650 and 1670 the detailed depiction of "reality" had reached a virtually unsurpassable level of perfection in the works of Vermeer, Frans van Mieris, Jan van de Cappelle, Willem Kalff, Adriaen van de Velde, Jacob van Ruisdael, and others of their generation. Most of the later painters working in a "realistic" manner derived their inspiration from these masters, but seldom reached the same level of quality. By about 1660 the goals of Dutch art, as they had been defined shortly after 1640, had been realized in such convincing form that other approaches were preempted, and younger artists faced no challenge but that of rivaling their teachers. This lack of room for the further development of Dutch painting after 1670 is perhaps the chief cause of its gradual decline, for which so many explanations have been advanced.

Artists reacted to this challenge in various ways. The sons of Frans van Mieris merely strove to elaborate the "classical" compositions of their father into longwinded narratives (fig. 86). More talented masters, realizing that a peak of perfection had already been reached, created works dominated by restlessness and tension. Adam Pijnacker, for example, who painted harmonious, balanced landscapes in the 1650s (fig. 53),

expressions often look like grimaces (fig. 65). Both Pijnacker and Ochtervelt explored that tense balance between the orderly and the erratic which can be termed manneristic.[65] It is equally and even simultaneously possible that these mannerist features are due to the artists' ambition to further refine and improve upon the work of their predecessors.[66]

Vermeer, who appears to have been an artist of imperturbable self-assurance, did not seek to resolve this problem by means of Willem van Mieris's excursiveness or the exaggeration of Pijnacker or Ochtervelt—but rather in an increased stylization. In his late work he Simplified details, schematized his modeling, and made his shapes more rigorously geometric. A typical example of this late style in its fully developed form is the *Lady Standing at a Virginal* of about 1670 in the National Gallery in London (plate 20). Its composition is stripped of all the incidentals which are so noticeable in his earlier works—nails and cracks in the walls, rugs and other objects scattered around the room. Light and shade are now more rigorously bounded, and more distinctly separated from each other than before. For example, Vermeer sharply sets off the sides of the virginal from each other and from the background wall, and crisply demarcates the line between light and shadow in the seat of the chair in the foreground. He achieves a new purity and sobriety. The folds of the model's gown, and the molding of the window frame in the upper left remind us of the fluting of Greek columns. He now gives full play to his love of straight edges and right angles: the frame of the landscape on the lid of the virginal, and the sharp strip of light along the right side of the larger painting on the wall even bring to mind the art of Mondrian.

Vermeer's pursuit of a simpler and more abstract depiction of reality led him to a radical change in technique. Instead of gradual transitions in the modeling, he now juxtaposes clearly defined and unmodulated tones of light and dark. We see this most clearly in the sleeves of the woman and the gilt frame of the smaller painting depicted on the wall. Though the modeling is simpler, it is no less precise than in Vermeer's earlier works. Writers on Vermeer tend to disparage his later style, but to my taste the *Lady Standing at a Virginal* is one of the master's finest works.

Once again there is a parallel between Vermeer and Frans van Mieris, for in the later paintings of van Mieris (which are seldom very attractive) we find a glassy or metallic manner which in many respects is a stylized version of his earlier velvety technique (fig. 87).

We cannot say precisely when Vermeer initiated this new style, which culminated in his *Lady Standing at a Virginal* of about 1670 (plate 20). Presumably it was not later than 1667. Until recently, Vermeer's painting of *The Love Letter* (plate 21) in the Rijksmuseum, Amsterdam, which bears all the markings of the new style, seemed to provide a secure indication of this date. Pieter de Hooch clearly borrowed its unusual spatial arrangement for a painting that, when it turned up on the art market, was said to be dated 1668 (fig. 76). Unfortunately, this date was not accurate. When de Hooch's painting, now in the Wallraf-Richartz Museum in Cologne, was thoroughly examined a few years ago, no date was found, and the fashion of the costumes indicated that it was probably painted in the latter half of the 1670s.[67] So it is no longer of much value for dating the Vermeer. Fortunately, the date of *The Love Letter* need not remain completely in limbo. A date of about 1667 is still very plausible since the painting seems also to have inspired one of the very last works of Gabriel Metsu, who died in the autumn of that year (fig. 101).[68]

Like the later *Lady Standing at a Virginal* (plate 20), *The Love Letter* (plate 21) is crisply linear. This is particularly striking in the jambs of the door: the molding on the right side of the doorway is indicated by a single sharp vertical stroke of light. Vermeer's new schematic technique of modeling is already boldly and skilfully employed. Nuances and gentle transitions of shading are eliminated, yet Vermeer perfectly captures the overall distribution of values. The painting's unorthodox viewpoint places us in a dark hallway, looking into a brightly lit room. To borrow photographic terminology, it is divided into an "underexposed" and an "overexposed" area. Vermeer flaunts his skill in correctly reproducing the varied brightness of all the details of the scene under the most difficult lighting conditions.

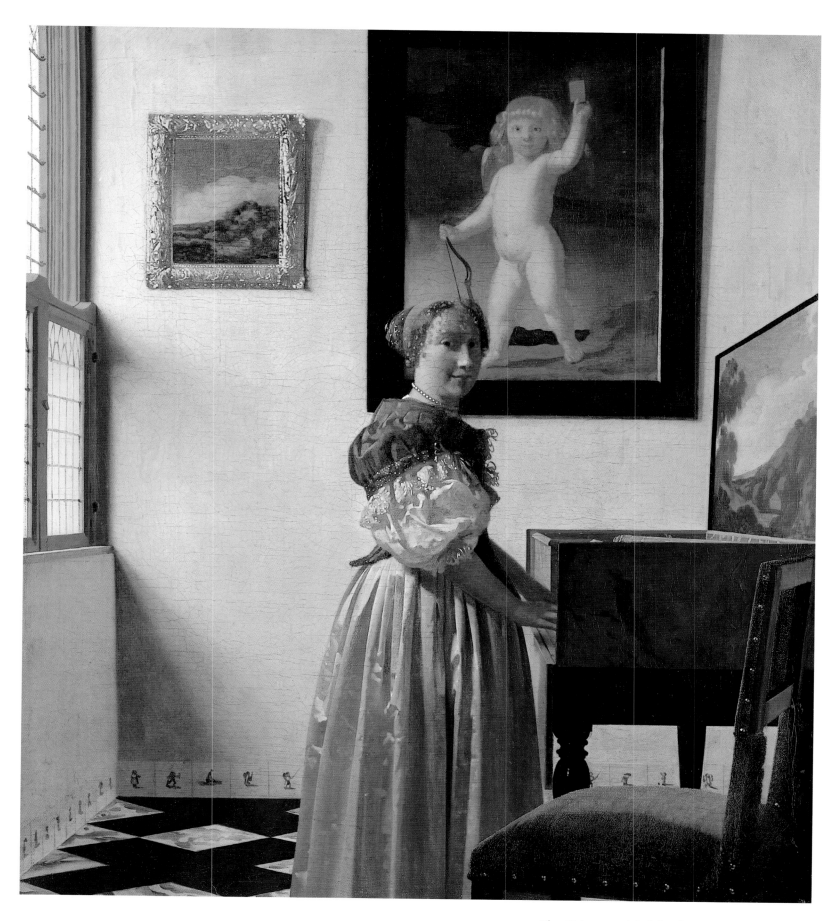

Plate 20 (cat. no. 25) *Lady Standing at a Virginal*, about 1670, 51.7 × 45.2 cm. National Gallery London.

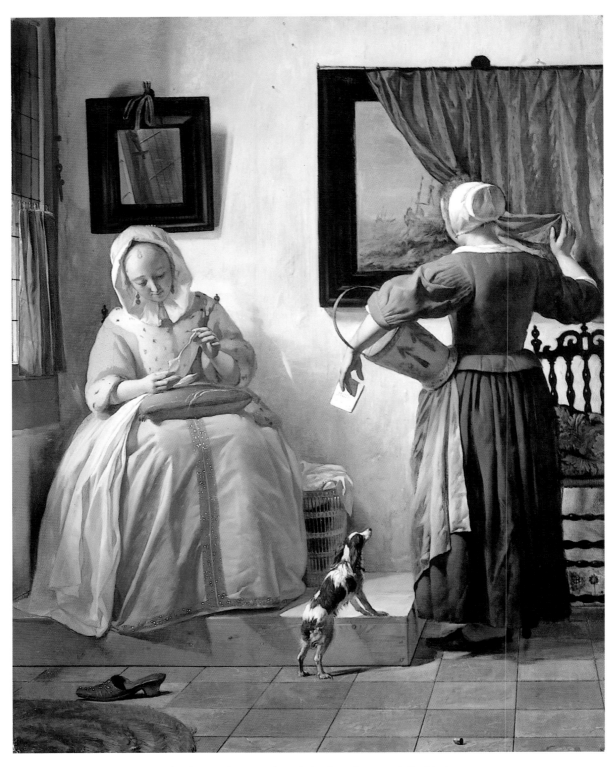

101. Gabriel Metsu (1629-1667), *Lady Reading a Letter with Her Maidservant,*
signed, panel, 32 × 20 cm.. Beit Art Collection, Blessington, Ireland.

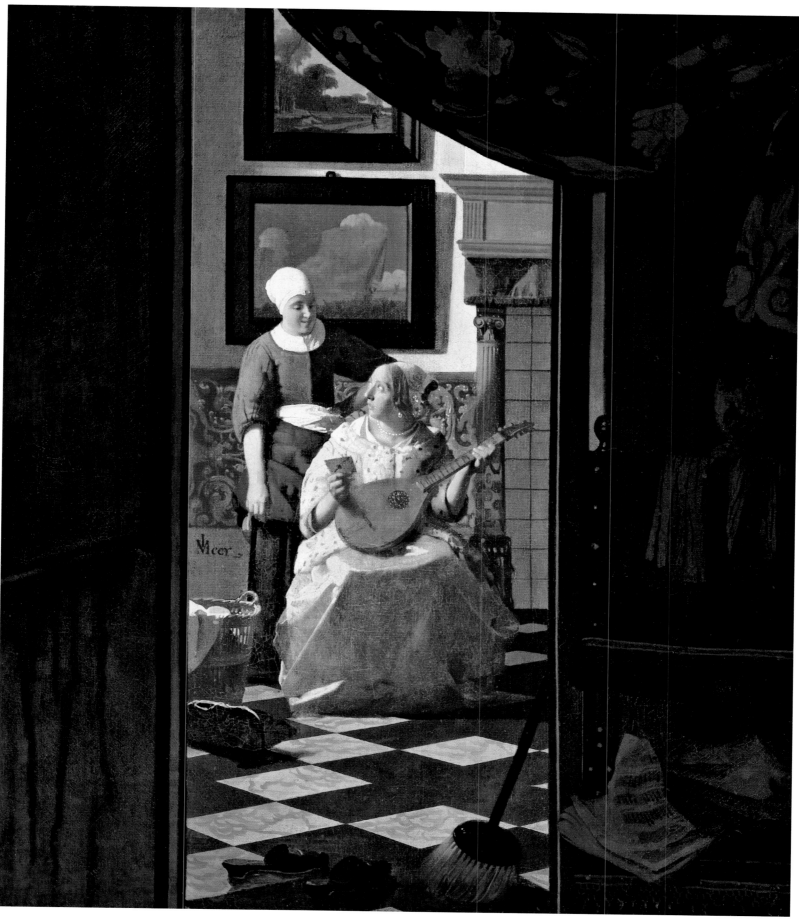

Plate 21 (cat. no. 22) *The Love Letter*, about 1667,
44 × 38.5 cm. Rijksmuseum, Amsterdam.

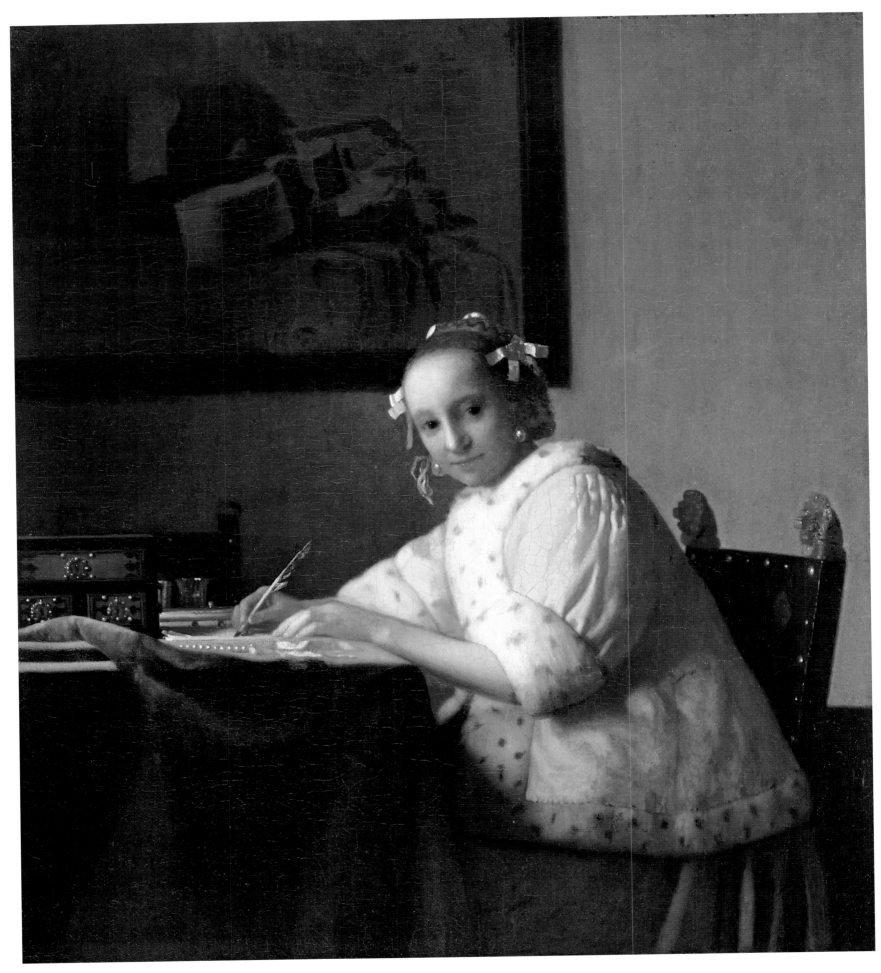

Plate 22 (cat. no. 20) *Writing Lady in Yellow Jacket*, about 1666
45 × 39.9 cm. National Gallery of Art, Washington.

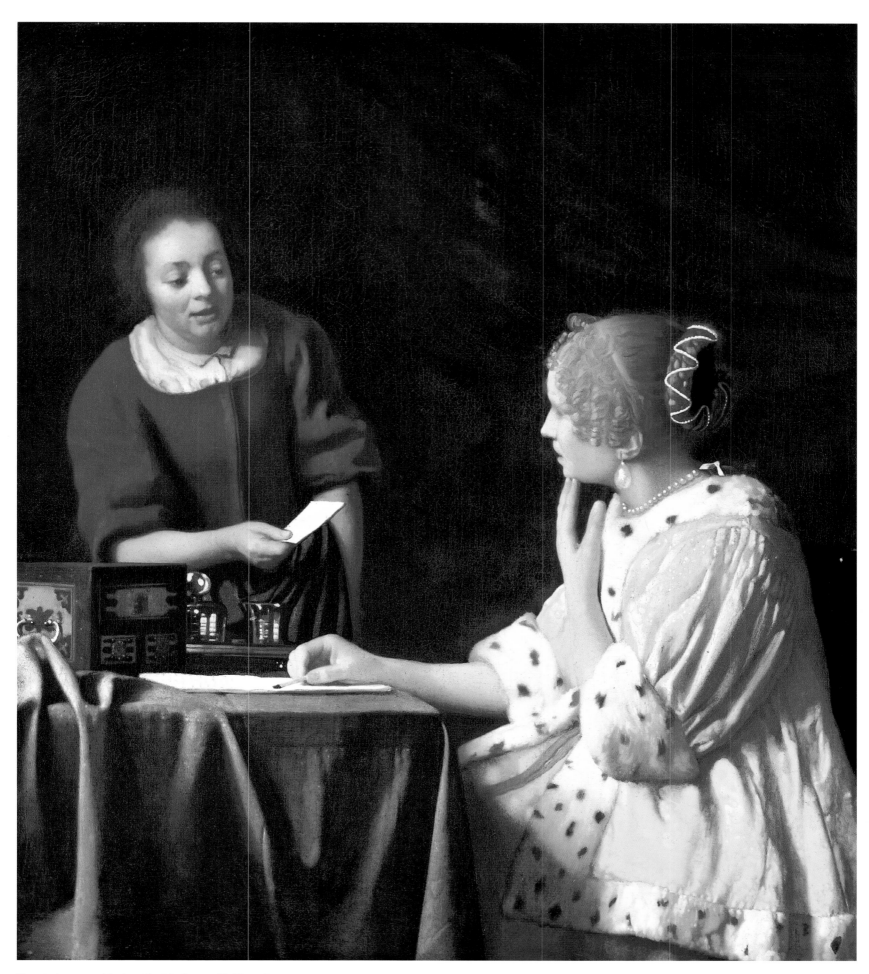

Plate 23 (cat. no. 21) *Lady with a Maidservant Holding a Letter,*
about 1666-1667, 92 × 78.7 cm. Frick Collection, New York.

102. Detail of *The Astronomer* (plate 24).

into a brightly lit room. To borrow photographic terminology, it is divided into an "underexposed" and an "overexposed" area. Vermeer flaunts his skill in correctly reproducing the varied brightness of all the details of the scene under the most difficult lighting conditions.

In the brightly lit background a lady interrupts her music to receive a letter from her maid. Vermeer's contemporaries would have deduced, from the seascape on the wall behind, that this was a letter of love. Other Dutch paintings, as for example the canvas by Metsu (fig. 101), show the same juxtaposition of a lady receiving a letter and a seascape on the wall in the background. Contemporary emblem books reveal the intention of this combination. Their wide popularity shows that the seventeenth-century Dutch delighted in representations with a double meaning. Such books contain illustrations of quite ordinary subjects accompanied by captions that provide a metaphorical or moralizing interpretation, often in rhyme. Harmen Krul's *Minnebeelden* ("*Images of Love*"), a well-known emblem book of 1634, interprets a print of a seascape with the lines:

> *De ongebonde Zee, vol spooreloose baren*
> *Doet tusschen hoop en vrees, mijn lievend herte varen:*
> *De liefd' is als een zee, een Minnaer als een schip,*
> *U gonst de haven lief, u af-keer is een Klip*

> In the boundless sea, full of trackless waves,
> my loving heart sails between hope and fear.
> Love is like a sea, the lover like a ship,
> your favor, my love, is the harbor, your rejection a reef.

The lute which the lady in the painting sets aside is also significant. Music-making is a sign of love in many emblem books, for it symbolized the harmony between lovers. Sometimes the lover is compared with a musical instrument whose strings or keys are touched by the beloved. Vermeer alluded to the connection between music and love not only in *The Love Letter* (plate 21) but also, still more clearly, in his *Lady Standing at a Virginal* (plate 20). In the larger of the two paintings behind the standing lady making music, Amor, the little god of love, holds his emblem, the bow. He holds up the playing card of "chance," which symbolizes the acci-

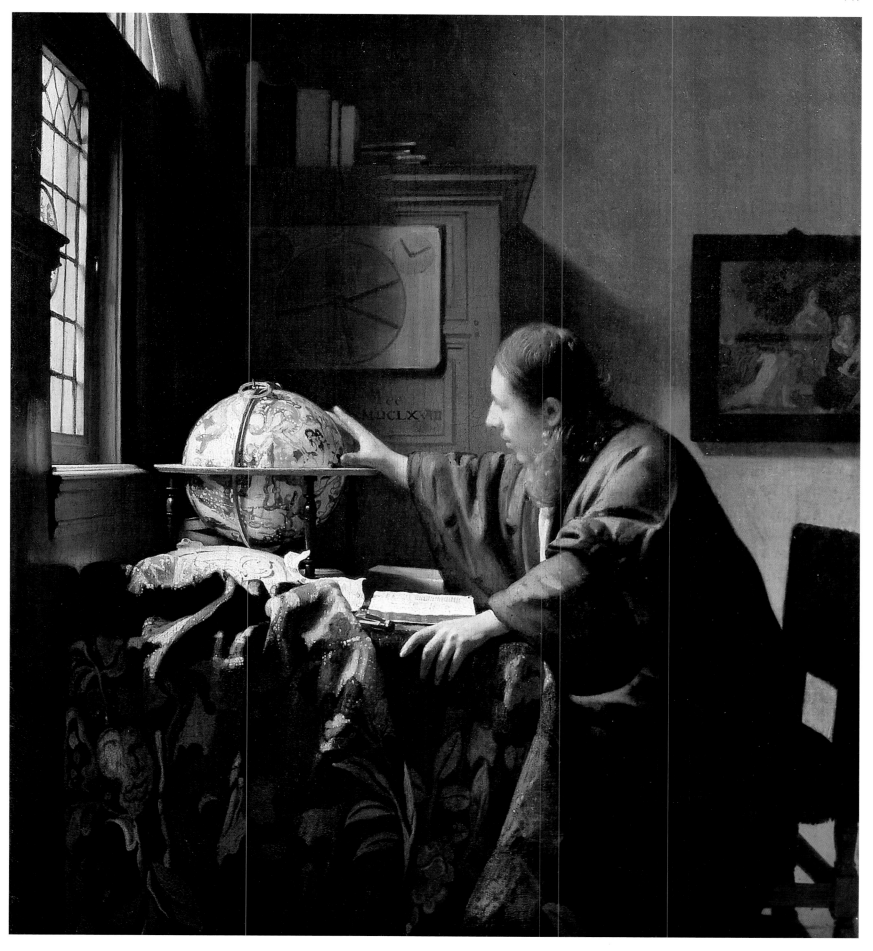

Plate 24 (cat. no. 23) *The Astronomer*, 1668,
50 × 45 cm. Louvre, Paris.

103. Detail of *The Geographer* (plate 25).

Gallery in Washington, D.C. When he composed this canvas Vermeer must have had his three earlier paintings of solitary women (plates 13, 14, 15) in mind, for it resembles those works in its composition and refinement of execution. However, many details, such as the woman's sleeve and hair ribbons, already display the stylization that emerges in his later work. If *The Love Letter* was painted in 1667, we can assign the *Writing Lady in Yellow Jacket* to about 1666. A young woman receiving or reading a (love) letter had by then become a traditional theme with Vermeer (plates 5, 14, 21). In the *Writing Lady in Yellow Jacket* she is composing her reply. Her outward gaze draws the onlooker into the action.

The *Lady with a Maidservant* (plate 23), in the Frick Collection, New York, belongs to the same period as the *Writing Lady in Yellow Jacket*. The motif, the arrangement of the picture surface, the jacket worn by the seated girl, and the writing materials on the table are all very similar in both paintings. The *Lady with a Maidservant* is a more ambitious composition, for it depicts not a solitary figure, but (as in *The Love Letter*) the contact between two women. The protagonist receives a letter from her maid. Or is she sending her away with a message? In any event her fingers resting against her chin seem to indicate that she is in doubt. She exchanges a glance with the half-smiling servant the two of them are the only ones who know exactly what is going on. The large format and the large-scale figures strike an unusual note in Vermeer's *œuvre;* this is his only attempt to give a humble household theme truly monumental force. The result must not have satisfied him, for we can deduce from the flat undifferentiated areas, especially in the main figure, that he left the painting unfinished.[70]

Vermeer embarked upon a new theme in *The Astronomer* (plate 24), in the Louvre in Paris, and the closely related *Geographer* (plate 25), in the Stadelsches Museum in Frankfurt. Once again, he explores a specific thematic and compositional type in more than one painting. Half-length views of scholars amidst their books, globes, compasses, and other attributes were first painted by the young Rembrandt around 1630. His pupils picked up the motif and it was popularized by many later masters. Significantly, Vermeer's probable teacher, Bramer, was one of those who treated this subject.[71]

Vermeer's interpretation of the theme is somewhat reminiscent of that by the Leiden *Feinmaler* Gerard Dou, who had studied with Rembrandt around 1630. At the same time, the compositional arrangement of *The Astronomer* and *The Geographer* harks back to Vermeer's own earlier works. Again he depicts a single

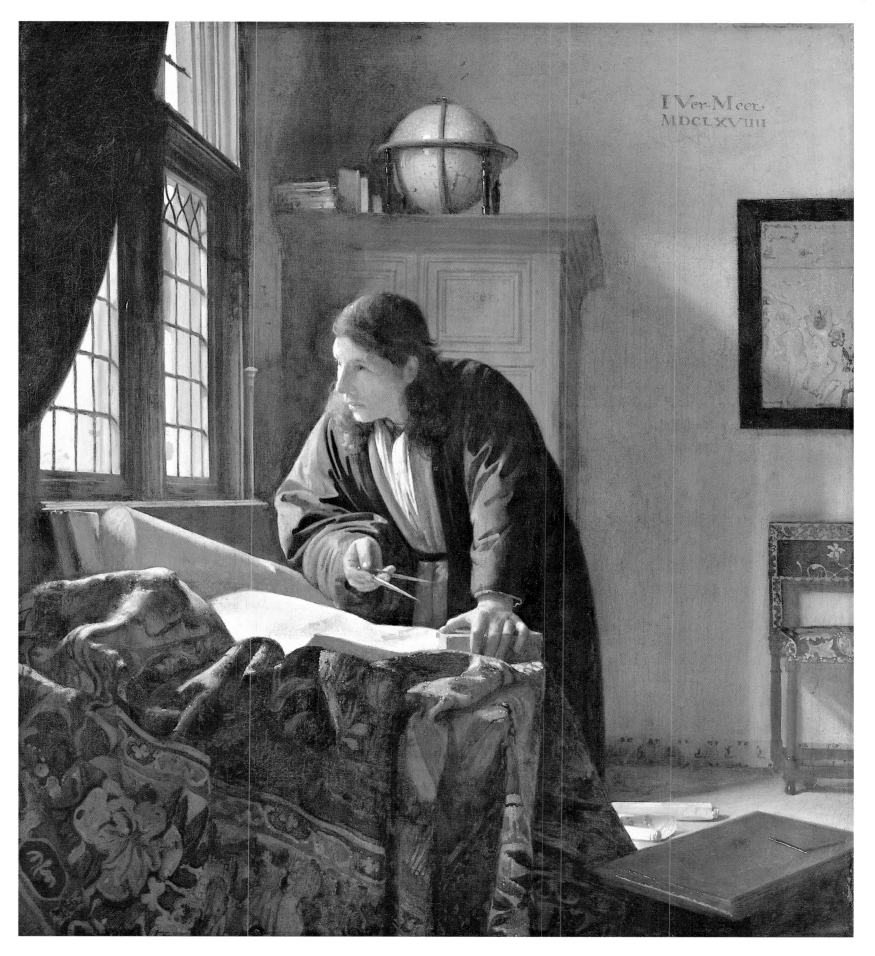

Plate 25 (cat. no. 24) *The Geographer*, 1669,
53 × 46.6 cm. Städelsches Kunstinstitut, Frankfort.

104. Caspar Netscher (1635/6-1684), *The Lacemaker*, signed and
dated 1664, canvas, 33 × 27 cm. Wallace Collection, London.

figure, in the corner of a room lit through a window at the left at a table with draped carpets.

Together with *The Procuress* (plate 3) of 1656, these are the only Vermeers to bear a date. On *The Astronomer* we read "MDCLXVIII" (1668) under the signature, and on *The Geographer* "MDCLXVIIII" (1669). The irregularity of the inscriptions gives an odd impression, and their authenticity has often been doubted. Further cause for skepticism is the absence of a date on a very accurate print which was made of *The Astronomer* in 1792.[72] In general. however, it is assumed that the inscriptions, even if they are later additions rather than clumsy restorations, are still based on original inscriptions by Vermeer. The dates of 1668 an 1669 are plausible. The paintings are in the late style, although less so than *The Love Letter* (plate 21), which nonetheless was painted a little earlier: we have found Vermeer backtracking on other occasions. Possibly he modified his schematic modeling in these pieces under the influence of his prototype, which was doubtless in the meticulous style of Dou.[73] However. a faithful copy after *The Astronomer* by Abraham Delfos (1731-1820) suggests an even later date for Vermeer's painting: on this copy the year is clearly rendered as "MDCLXXIII" (1673).

THE CULMINATION OF VERMEER'S LATE STYLE (PLATES 26, 27)

Vermeer's best works in the new style date from about 1670. Judging by the woman's costume, the *Lady Standing at a Virginal* (plate 20), which has already been discussed, can be placed at about this date.[74] The astonishing reductiveness that characterizes that painting appears in an even more striking arrangement in *The*

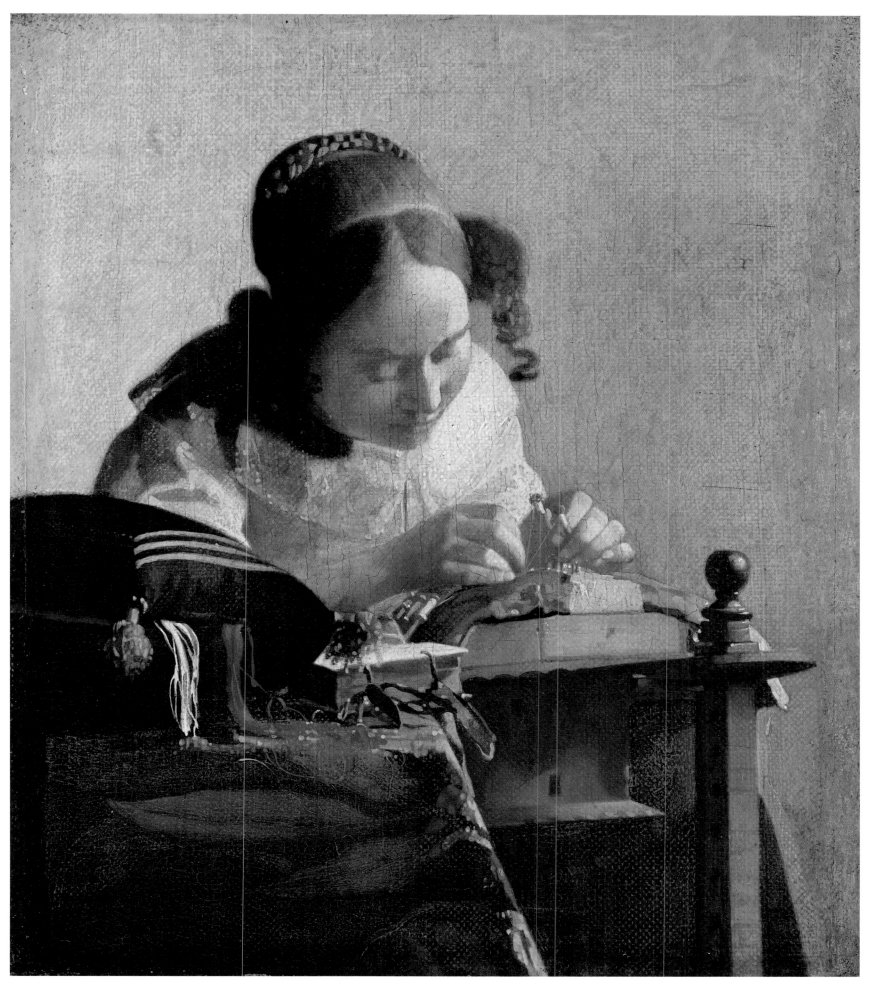

Plate 26 (cat. no. 26) *The Lacemaker*, about 1670-1671, 24 × 21 cm. Louvre, Paris.

105. Detail of *Lady Writing a Letter with her Maid* (plate 27). The painting on the wall representing
The Finding of Moses, should be attributed to Peter Lely, rather than to Christiaen van Couwenbergh or Jacob van Loo.

Lacemaker (plate 26) in the Louvre. Seldom has a human activity been recorded with such concentration. Vermeer focuses on the face and hands of the girl, eliminating every distracting feature. Caspar Netscher's less focused and far more fussy treatment of the same theme makes an interesting contrast (fig. 104).

Vermeer was no less successful in the *Lady Writing a Letter with Her Maid* (plate 27) in the Beit Collection in Blessington, Ireland. Twice already in his late period he had painted a woman writing a letter, both with and without a maidservant (see plates 22, 23), a theme that originated with ter Borch (fig. 68). This time the servant stands with folded arms waiting for the writer to complete her letter, and is passing the time by looking out of the window. A discarded draft lies crumpled in the right foreground. In the overall composition Vermeer combined elements from his earlier paintings. In an arrangement that by now looks quite familiar to us, he depicts the figures near a table, in a room lit from the left through a window, while the left foreground is closed off by a curtain (compare plates 19, 24, 25). Yet the *Lady Writing a Letter* combines Vermeer's characteristic serenity with a solemnity and grandeur which are lacking in his earlier works.

This monumental quality is one result of his new tendency toward stylization. The straight lines of the solid green curtain are handled altogether differently from the rippling waves of the patterned carpet that occupies the same place inthe earlier *The Art of Painting* (plate 19). Moreover, the rug on the table hangs with the unnatural flatness of a screen, in contrast with the similar rug in the earlier *Music Lesson* in the Royal Collection (plate 16), which is handled far more sensuously. As in the *Lady Standing at a Virginal* (plate 20), all incidentals and accessories are suppressed. The subdued coloring eschews bright accents. The painting on the back wall is represented as a single dark area, its principal features delineated schematically, in contrast with the richly detailed wall map in *The Art of Painting.*

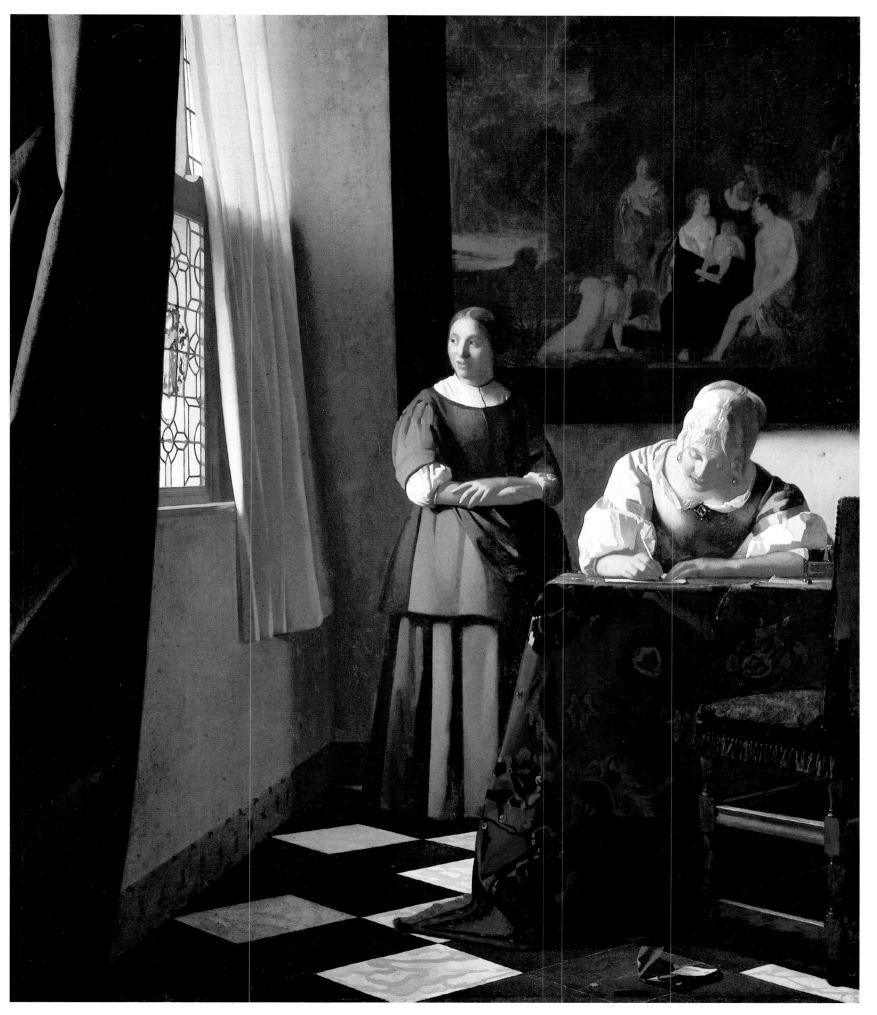

Plate 27 (cat. no. 27) *Lady Writing a Letter with Her Maid*, about 1671,
72.2 × 59.5 cm. Beit Art Collection, Blessington, Ireland.

MANNERISM (PLATE 29)

The late style reaches its most extreme form in *The Guitar Player* (plate 29) in Kenwood House, London. Here the gilded frame of the painting on the wall is treated with the same striking schematization as that of the small painting on the wall in the *Lady Standing at a Virginal* (plate 20). In other passages this schematization is carried even further: the head of the guitar is accented by daubs of solid tones laid on in an effect that resembles gouache.

The composition of *The Guitar Player* is unique in Vermeer's *œuvre*. The figure is placed so far to the left that her right arm is cut off by the edge of the picture. The main background motif, the painting on the wall, is also far to the left directly over the head of the woman. The right side of the picture, however, remains dramatically empty, with the result that the composition as a whole makes a strangely unbalanced effect.[75]

As unprecedented for Vermeer as this unbalanced composition is the smiling face and lively pose of the model. Here Vermeer departs from his usual formula of motionless figures who merely suggest activity. However, the woman appears unnaturally stiff, delineated by hard outlines in Vermeer's most stylized late technique. Both the uncomfortable composition and the peculiar rendition of the figure endow the painting with some of the tension of the work of Ochtervelt and the late Pijnacker (figs. 56, 65). Thus in *The Guitar Player* Vermeer seems resolutely to question and hazard all the goals and accomplishments of his earlier work.

VERMEER'S LAST YEARS; COMMISSIONS (PLATES 28, 30, 31)

In the economic crisis of 1672, which followed the French invasion of Holland, Vermeer encountered financial difficulties that plagued him until his death three years later. Some of the peculiarities in what appear to be his last paintings may be connected with his financial problems.

The *Allegory of Faith* (plate 31) in the Metropolitan Museum, New York, differs in essential respects from everything else Vermeer had previously painted. Here he does not merely invert his old values, as he did in the Kenwood *Guitar Player* (plate 29), but he introduces some altogether alien ones. Vermeer's earlier paintings, no matter how schematic or imbued with symbolic intentions, always make sense on a primary level as "natural" representations of "reality." The *Allegory of Faith,* on the other hand, contains elements such as the snake crushed under a stone and the impassioned woman with a globe beneath her feet which are intelligible only at the secondary level of their symbolic meaning (see below). Even if we understand the symbolism, it is unclear why the scene takes place in a fashionable Dutch living room. It would seem that Vermeer wanted to make a history painting of the type of *Mary Magdalene Forsakes the World in Favor of Christ* by the Utrecht Caravaggist Jan van Bijler, while at the same time producing one of his own typical interiors. These peculiarities are most readily explained by the assumption that the subject was dictated by someone other than Vermeer himself, presumably by the patron who commissioned the piece.

The best candidates for the authorship of the iconography are the learned Jesuit fathers who lived a few doors down the street from Vermeer.[76] The patron may well have been a wealthy Catholic of Delft who, desiring a devotional piece, naturally turned to a fellow Catholic, Vermeer. Vermeer's acceptance of a commission with such precise specifications can be explained by his financial situation. Probably the patron was impressed by the use of allegory in *The Art of Painting* (plate 19), which Vermeer still had in his home, and asked for an allegory of faith with a similar composition. Such a course of events would explain the strong external resemblance between the two pictures (compare the tapestry hanging on the left the beamed ceiling, the black and white marble floor, and the general disposition of the space). In technique, however, the two paintings are fundamentally different for the *Allegory of Faith* is a work in the stylized late manner.

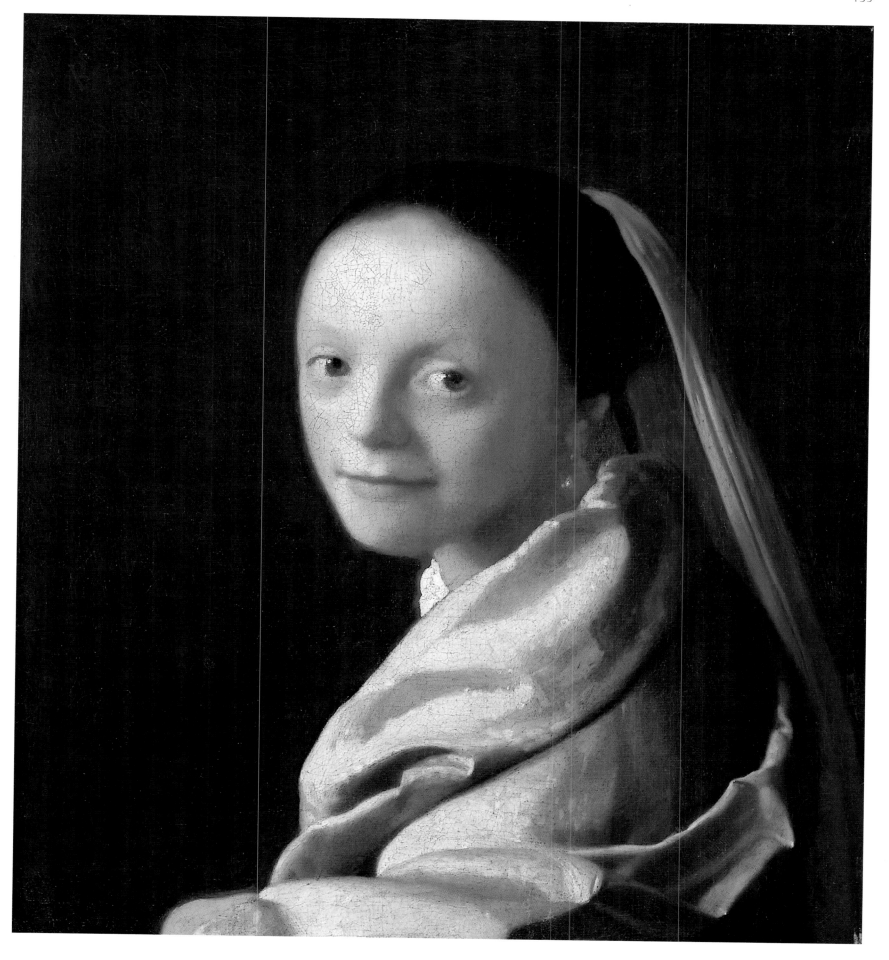

Plate 28 (cat. no. 30) *Head of a Girl*, about 1672-1674,
44.5 × 40 cm. Metropolitan Museum of Art, New York.

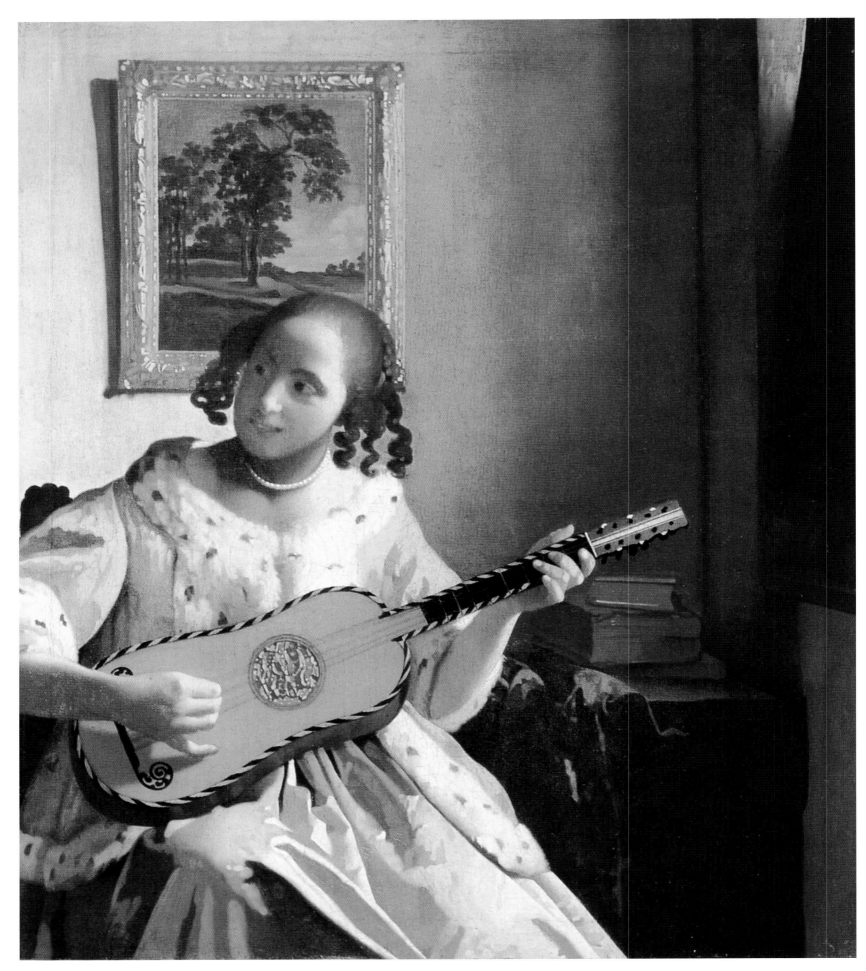

Plate 29 (cat. no. 28) *The Guitar Player*, about 1661-1672,
53 × 46.3 cm. Iveagh Bequest, Kenwood.

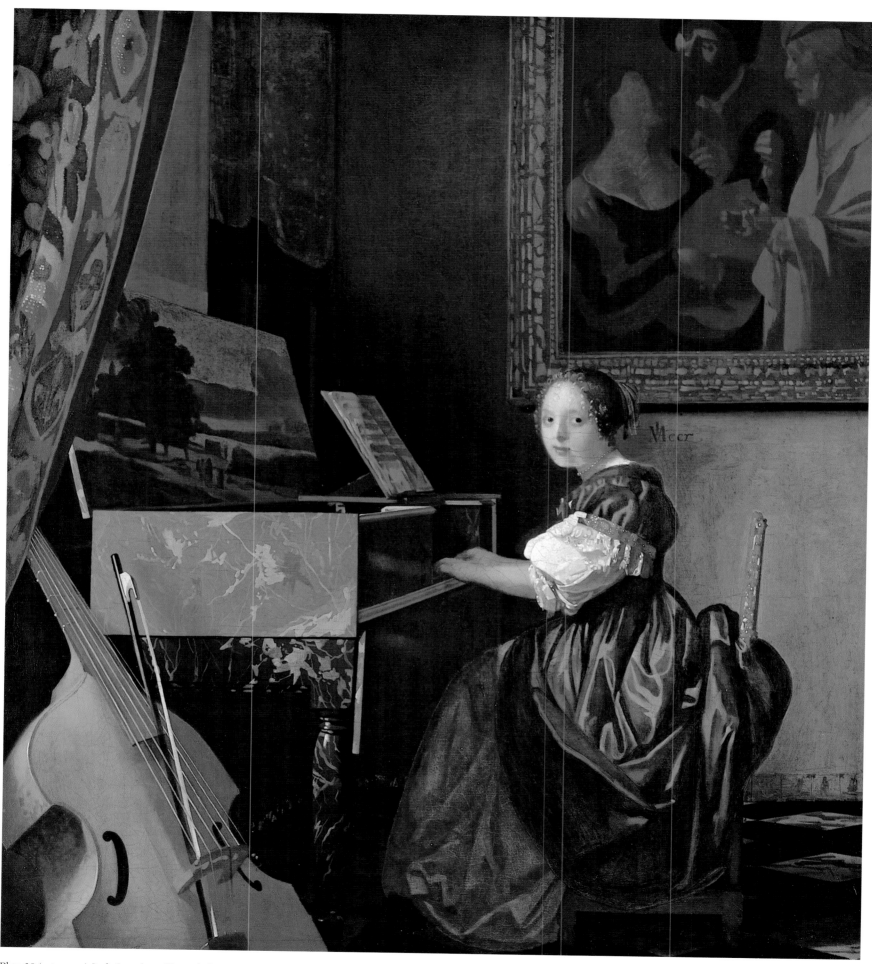

Plate 30 (cat. no. 31) *Lady Seated at a Virginal*, about 1674-1675,
51.5 × 45.5 cm. National Gallery London.

A similar chain of events could explain the origin of the *Head of a Girl,* also in the Metropolitan Museum in New York (plate 28). It too is a variant of an earlier painting—the *Girl with a Pearl Earring* (plate 18) in the Mauritshuis. Yet it is painted in the schematizing style of the late period (compare the different treatment of the cloth in the two paintings). The women in Vermeer's previous paintings generally had handsome faces with regular features, and were even somewhat idealized, as in the painting of the *Girl with a Pearl Earring* (see above). In the New York painting, plate 28, however, the model's face, with its broad proportions and wide-set eyes, is of quite unprepossessing appearance, if disarming in its friendliness. Perhaps in these needy years Vermeer accepted a portrait commission—for the first time in his career, as far as we know—with the stipulation that he use *Girl with a Pearl Earring* as his point of departure.

The *Lady Seated at a Virginal* (plate 30) in the National Gallery, London, is another product of these last years. The lady has turned her eyes from her music to the spectator. She seems to be inviting us to join her and to play the viola da gamba that stands waiting in the left foreground. Yet we may wonder if she is sufficiently respectable for us. Her pose is very reminiscent of that of the frivolous girl in *A Lady and Two Gentlemen* (plate 12). The large painting of a brothel above the musician's head in plate 30 also sets us thinking. The window on the left is the only window in a Vermeer to be closed off completely by a curtain and shutters. No ray of light or curious glance can penetrate here.

A few passages—the viola da gamba, and the marbleized virginal—are executed with the strength and virtuosity displayed not long before in the closely related *Lady Standing at a Virginal* (plate 20). But the folds of the costume are now harsh and coarsely executed, and the blots making up the frame of the painting on the back wall lack the sureness of touch that is apparent in the frame on the small landscape in the earlier picture. An expert frame-maker would be able to remake the gilded frame depicted in plate 20, but for a reconstruction of the frame in plate 30 he would have to rely on guesswork and improvisation. All in all, the *Lady Seated at a Virginal* (plate 30) shows a noticeable decline in Vermeer's powers and must have been painted shortly before his death.

CONCLUSION

Vermeer introduced neither a new style nor a new conception of art. On the contrary, his style and subject matter were derived from painters of his Dutch milieu. He freely appropriated the unified compositions, constructed around a few large forms, which had come into vogue around 1650; he borrowed from de Hooch's clear and illusionistic construction of space, and from van Mieris's refined technique. Vermeer's distinction lies in his appreciation of the possibilities inherent in modes that had already been developed. Others adopted new approaches more quickly, but more superficially. Vermeer, with single-minded dedication, followed each new approach through to its most profound consequences.

Even in his very earliest works, his history paintings, Vermeer strikes us as a purist. In a genre based upon the accomplishments of Italian art only Vermeer, among the Dutch painters of his day, turned directly to Italian models for inspiration. In his later work he developed with remarkable logic and consistency. He seldom altered his course, and when he did so it was with a keen awareness of his objectives. He concentrated on one problem at a time, and this intensity of concentration resulted in an unrivaled mastery. He visualized a perfect world in a form so natural that it seems almost effortless.

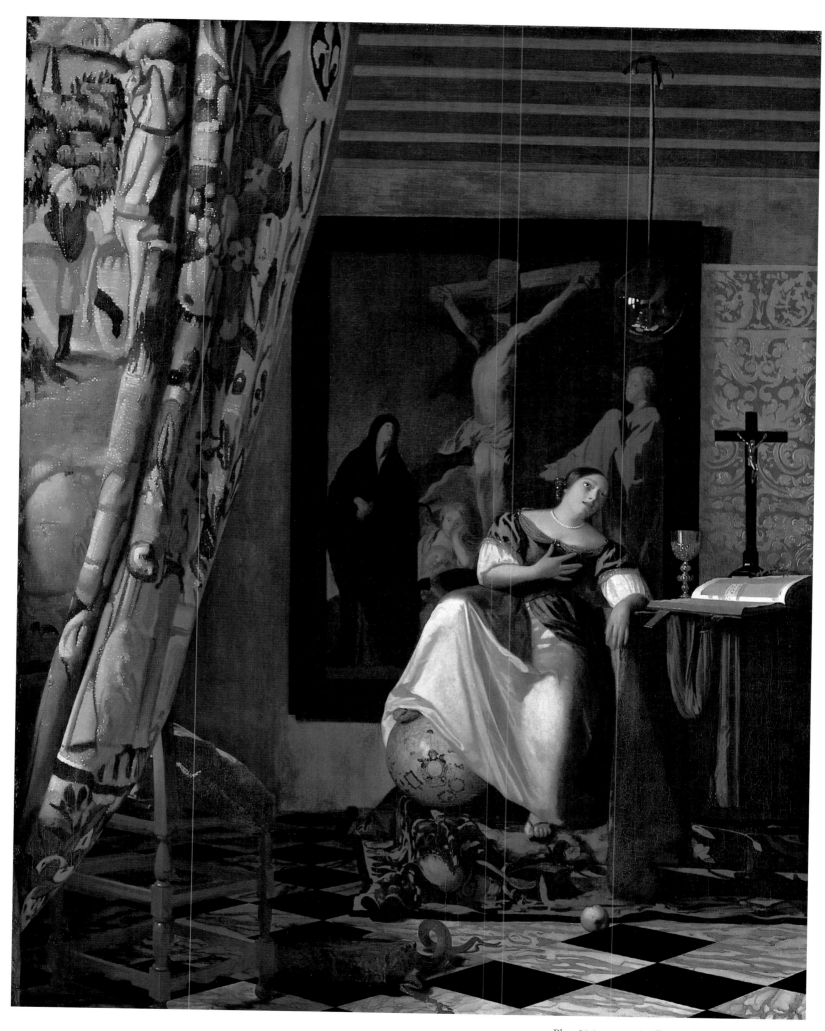

Plate 31 (cat. no. 29) *Allegory of Faith*, about 1672-1674,
113 × 88 cm. Metropolitan Museum of Art, New York.

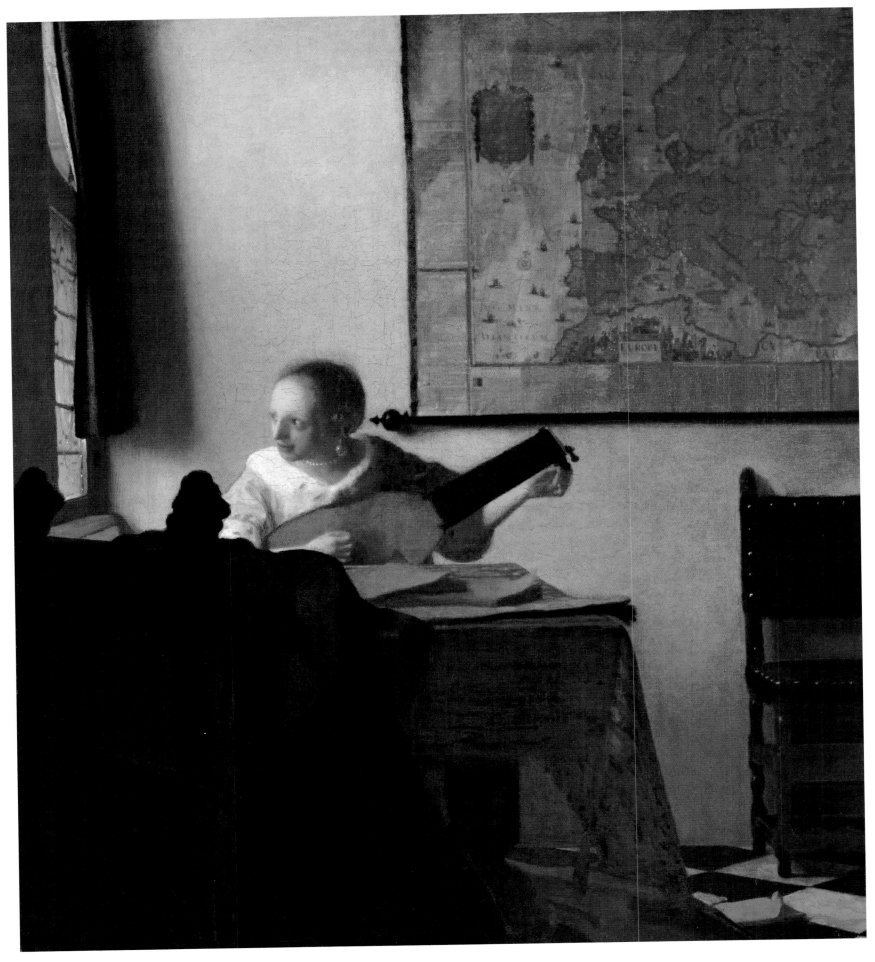

Plate B1 (cat. b1) *Woman with a Lute Near a Window,*
51.4 × 45.7 cm. Metropolitan Museum of Art, New York.

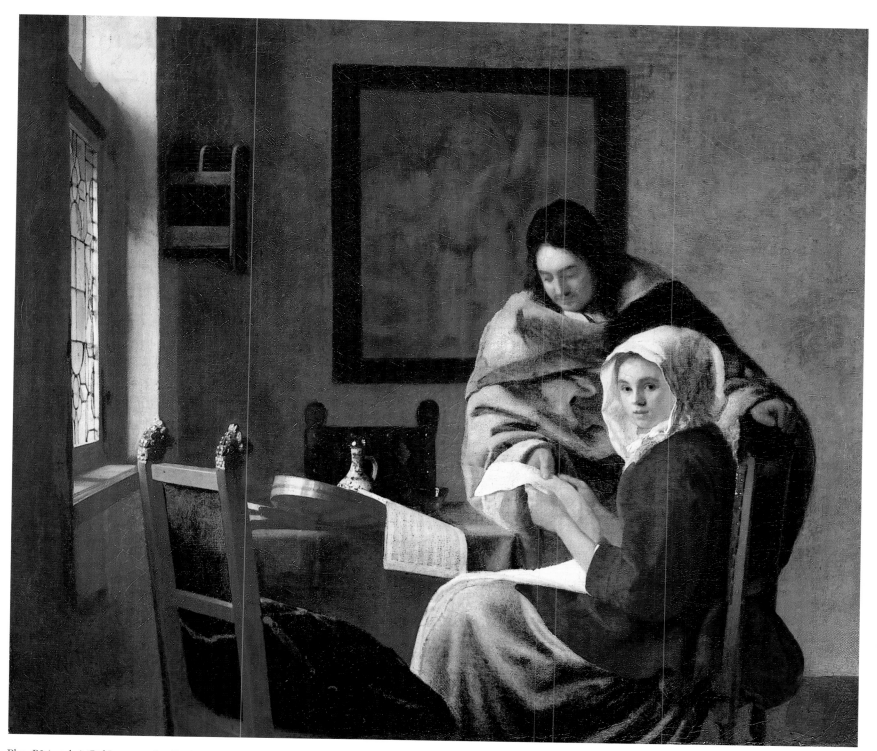

Plate B2 (cat. b2) *Girl Interrupted at Her Music,*
39.3 × 44.4 cm. Frick Collection, New York

The *Woman with* a *Lute Near* a *Window* and the *Girl Interrupted at Her Music*
are discussed in text of cat. nos. b1 and b2 and in notes 46, 54 and 102.

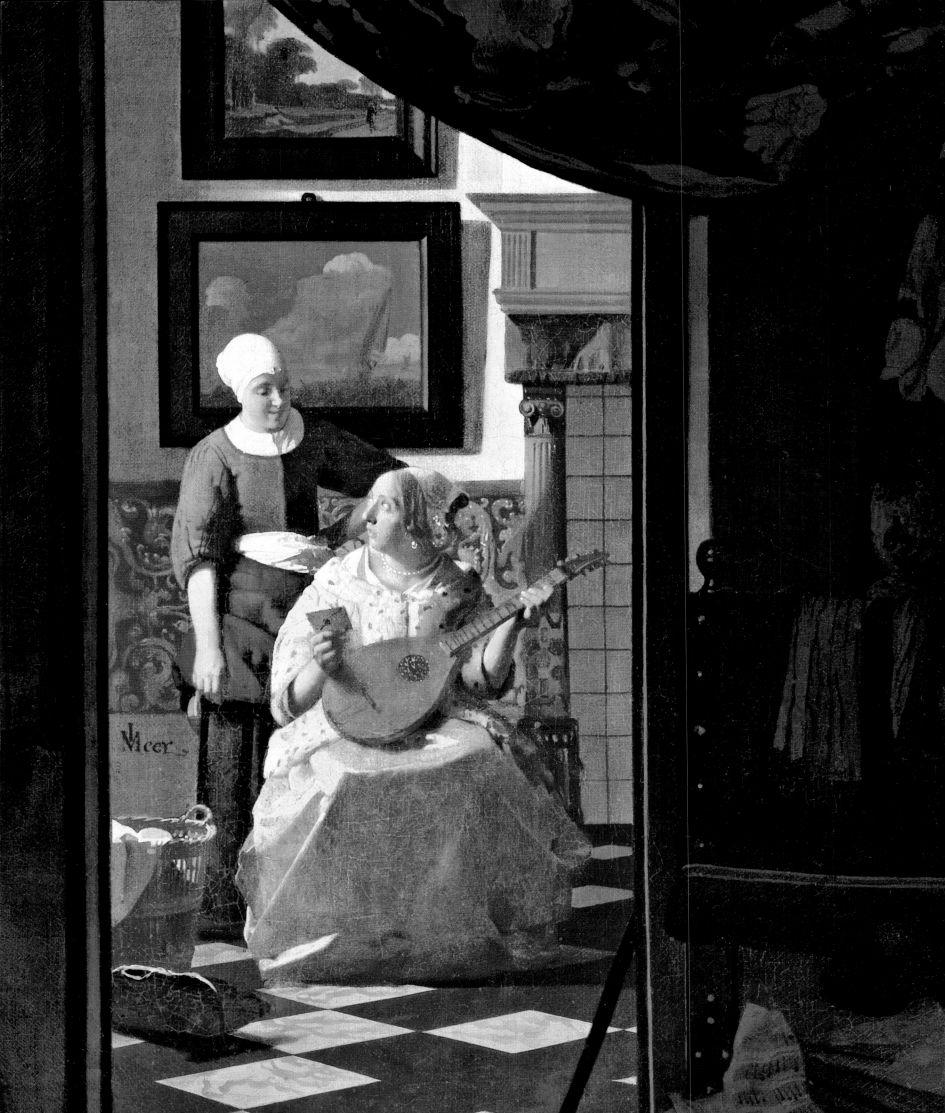

Vermeer
and His Public

Albert Blankert

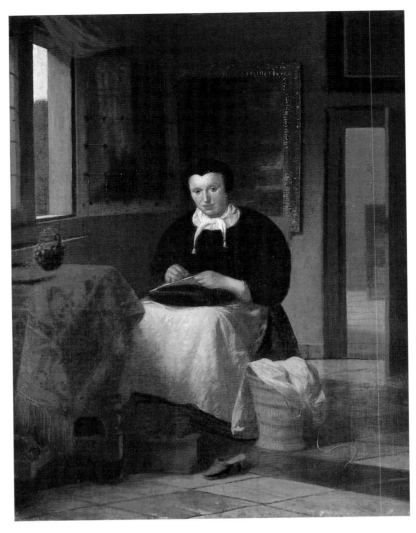

106. Anonymous artist, *Woman Sewing,*
canvas, 50 × 38.5 cm. Niedersächsisches Landesmuseum, Hanoverre
In 1779 and 1792 the picture was sold as a Vermeer.

SEVENTEENTH AND EIGHTEENTH CENTURIES

VERMEER IS OFTEN CITED AS an example of neglected genius. During his lifetime and for almost two centuries after his death—so the tale goes—he and his work went unappreciated until, in the nineteenth century, he was finally discovered and properly esteemed. Was Vermeer really so long underestimated? In fact, he was not. While it is true that he did not achieve widespread fame until the nineteenth century, his work had always been valued and admired by well-informed connoisseurs.

During his lifetime Vermeer's paintings commanded relatively high prices.[77] On four different occasions he was elected to the ruling body of the Guild of Saint Luke in Delft. Moreover, he is mentioned by Dirck van Bleyswyck in *The Description of the City of Delft* (1667) as an artist of the city. The relevant passage in van Bleyswyck's book is sometimes produced to support the argument that Vermeer was underestimated, since he is mentioned only by name and date of birth, while other Delft artists and their works are discussed in greater detail. This is of little significance, however, since chroniclers of Dutch cities generally wrote eloquently only about masters who were dead, or who had left the city in question. Vermeer was still alive and working in Delft when van Bleyswyck's book appeared. He is mentioned in a short list of painters "still alive today"—and he is by far the youngest of those mentioned.

In his book van Bleyswyck includes a poem by the printer Arnold Bon in honor of Carel Fabritius, Rembrandt's great pupil. who had died in the terrible explosion of the Delft powder magazine in 1654—an explosion which, as already mentioned, leveled much of the central part of the town. The last stanza of Bon's poem reads:

Soo doov' dan desen Phenix t'onser schade
In't midden. en in't beste van zyn swier
Maar weer gelukkig rees' er uyt zyn vier
Vermeer, die meesterlyck betrad zyn pade.

Thus did this phoenix, to our loss, expire,
in the midst and at the height of his powers.
But happily arose out of his fire
Vermeer, who masterly trod his path.

The last line implies that after the death of Fabritius, Vermeer was considered the foremost painter in Delft. This could hardly have been written as early as 1654, when Vermeer's talent was still undeveloped; it must have been written sometime later. but obviously before the publication of van Bleyswyck's book in 1667. Perhaps it was composed when the new headquarters of the Guild of Saint Luke were dedicated, a few years after 1661. Vermeer was by then at the peak of his artistic powers and indeed following Fabritius's principles.

It has not previously been noted that the poem exists in two versions. Although van Bleyswyck's book exists in only one edition, the first and last line of the poem are given differently in the various copies I have examined. It can be shown that the version quoted above is the earlier of the two, while in later copies the first line is changed to "*Dus bleev' dien Phenix op zyn dertig jaren*" ("Thus died this Phoenix, in his thirtieth year"), and the last line to "*Vermeer, die 't meesterlyck hem na kost klaren*" ("Vermeer, who masterly emulated him"). The change was apparently made while the book was actually being printed, for the copies are identical in all other respects.

Arnold Bon, who wrote the poem, was the printer of the book, and may have thought of the change himself.[78] But it is quite possible that it was suggested by Vermeer, who lived near Bon on the Market Square. Legal records show that Vermeer's obsession with precision was not restricted to his paintings. In two surviving documents he had his name crossed out and corrected, apparently because he found fault with the spelling (see documents of 14 December 1655 and 13 July 1670). This is the more remarkable because his Dutch contemporaries often spelled their names in various ways themselves. Vermeer presumably took written statements about himself and his art very seriously, and if he was not satisfied with the first version of the stanza he might well have persuaded Bon to change the typesetting.[79]

Who were Vermeer's customers? For a long time it was believed that the main one was Jacob Dissius, a Delft printer, because in his 1682 inventory a total of twenty "paintings by Vermeer" are recorded. Yet John Montias very recently demonstrated that Dissius had most probably inherited this whole collection only a few years earlier from his father-in-law, Pieter Claesz. van Ruijven. Van Ruijven (1624-1674), who now turns out to have been Vermeer's likely Maecenas, was a wealthy Delft amateur living off his means. He provided Vermeer with a loan in 1657, mentioned him in a will of 1665, and probably bought the bulk of his paintings immediately after they were completed.[80] In addition, a Delft innkeeper bequeathed a Vermeer in 1661 and a Delft baker owned one in 1663.

Yet Vermeer's patrons were not restricted to merchants in his own city. In 1664 "a head by Vermeer" was in the estate of the sculptor Jean Larson in The Hague.[81] In 1682 another Vermeer was in the collection of Diego Duarte, an immensely wealthy banker of Antwerp. It is interesting that Duarte maintained contact with Holland through Constantijn Huygens the Younger, who, like Larson, lived in The Hague. Duarte's

father had a clavecin made for Huygens, and Duarte himself corresponded with Huygens about music. With his musical interests it seems altogether appropriate that Duarte's Vermeer represented "a lady playing the clavecin, with accessories" (see document of 12 July 1682).

In Amsterdam there was interest in Vermeer even before 1657, when a picture by the artist was listed in the estate of a major art dealer (document of 25 June 1657). Shortly before or after Vermeer's death the Amsterdam city physician Jan Sysmus referred to Vermeer in a handwritten note. In the years 1669 to 1678 Sysmus drew up a collection of short notes on many artists. On some matters he was much better informed than on others. He seems to have had a notion of Vermeer's themes: "Dandies and castles" *(Jonkertjes en casteeltjes),* yet he was mistaken about his first name, which he gave as "Otto" (see document of 1669-1678).

Printed texts after van Bleyswyck's book of 1667 were laconic on Vermeer.[82] Arnold Houbraken's *Groote Schouburgh der Nederlantsche Konstschilders en Schilderessen* ("The Great Theater of Male and Female Netherlandish Painters")—for many generations the chief source of information on Dutch painters of the seventeenth century—simply reproduces van Bleyswyck's entry on Vermeer. (It is included in Volume I [1718] without addition or commentary.)[83] Houbraken recorded all the information on artists he could find, whether in print or from oral tradition; nevertheless, his neglect of Vermeer is not particularly significant. for he was poorly informed with regard to painters in Delft. Concerning Carel Fabritius he recounts only what he could read in van Bleyswyck's book and in Samuel van Hoogstraten's *Inleyding tot de Hooge Schoole der Schilderkunst* ("Introduction to the Great School of Painting") of 1678. In the case of de Hooch, he gives only a summary and superficial indication of the subjects that he painted.

The small size of Vermeer's *oeuvre* made it easy for his name to be lost. Attribution in the eighteenth century—not yet facilitated by photographs and good reproductions—was entirely based on the stock of impressions that a connoisseur could build up at auctions, and from studying private collections. Painters with a huge output, whose works could be seen most frequently, were those whose work was easiest to remember, and it was such masters as these—Adriaen van Ostade, Rembrandt van Rijn, Nicolaes Berchem, Philips Wouwerman—who were the great names in Dutch painting in the eighteenth century. Very often works by obscure artists were attributed to better known ones. Vermeer's *Girl Reading a Letter at an Open Window* (plate 5) in Dresden was acquired as a Rembrandt and on later occasions attributed to Govaert Flinck; other works by Vermeer went under the names of Gabriel Metsu, Pieter de Hooch, and Frans van Mieris (plates 11, 16, 19, cat. nos. 12, 16, 19).

However, the eighteenth century seems to have had a keen appreciation of the quality of Vermeer's paintings, even if unaware of the identity of their creator. The fact that his *œuvre* has survived through the centuries nearly intact is in itself strong evidence that his works were always objects of value. In the auction of 1696 his paintings fetched considerable prices. Later his name was forgotten, but between 1710 and 1760 four Vermeers—then attributed to other artists—were acquired by the duke of Brunswick, the elector of Saxony, and King George III of England (plates 3, 5, 12, 16, cat. nos. 3, 6, 11, 16). Historical accuracy was not the strong point of eighteenth-century collectors and connoisseurs; their taste, however, was superb.

It is surprising that Vermeer's fame had reached France as early as 1727. In the June issue of the *Mercure de France* there was a long letter of advice to would-be collectors by the connoisseur and author on art, Dezallier d' Argenville. One of the northern artists he specifically recommends for a good "cabinet" is "Vandermeer."[84]

A much richer but untapped source of information on the eighteenth-century view of Vermeer is provided by printed auction catalogues. These catalogues—generally from the sale of a complete collection, after the death of the owner—were at first brief in their descriptions, but later became more detailed, and came to include the dimensions of the painting and its support-whether canvas or panel. Many such catalogues have been preserved in which the buyer and the price fetched have been inscribed by someone present at the auction.

The important sales in Holland were held in Amsterdam in the "Oudezijdsherenlogement" (formerly the city's official lodging house for guests of high rank) and later in the Trippenhuis at the Kloveniersburgwal.

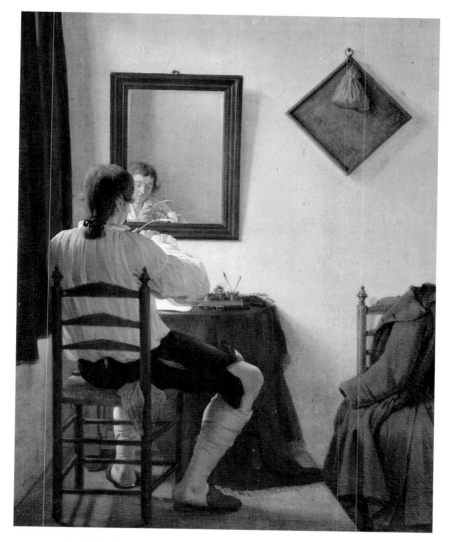

107. Jan Ekels the Younger (1759-1793), *Man Seated in Front of a Mirror*, 1784, panels, 27 × 23 cm. Rijksmuseum, Amsterdam.

From 1760 on Philips van der Schley and his associates were the chief auctioneers. Most of the Vermeers we know today are described in these early sales catalogues and in the early catalogues of the above-mentioned princely collections.

In our own catalogue we collect all the early descriptions and reprint them in full for the first time. They first of all provide a better insight into the earliest history of a picture. The "Merry Company in a Room," mentioned in the auction catalogue of 1696, was long supposed to have been lost, but turns out to be the *Lady and Two Gentlemen* in Braunschweig (plate 12, cat. 11).

Yet these early descriptions also contain information on the reputation of a painting or the artist. As early as 1719 *The Milkmaid* (plate 8, cat. 7) was called "The *famous* Milkmaid by Vermeer." The *Woman in Blue Reading* a *Letter* (plate and cat. 14) was praised in a sale catalogue of 1791 for its "fine composition, which is generally characteristic of the work of this *famous* master" (italics added).

These early mentions have other fascinating aspects. In 1765 *The Milkmaid* was said to be "vigorous in light and brown, and very expressive." In 1798 was added: "The light, falling in through a window, gives a miraculously natural effect." In 1778 *The Astronomer* (plate 24, cat. 23) was commended with the words: "The pleasing light . . . makes a beautiful and natural effect." The light in *The Geographer* (plate 25, cat. 24) was termed "striking" in 1803. So the well-known "Light of Vermeer" over which so much ink has flowed is apparently not a modern invention![85]

In 1800 *The Little Street* (plate and cat. 9) was defined thus: "A view of two burgher houses in the city of Delft, between them one sees an alley, at the far end of which a woman stands washing at a tub, in the house on the right a woman sits sewing in the hall at the front door and two children lie playing on the sidewalk." This description suddenly makes us realize that in this most tranquil of paintings no less than four people are active.

The 1813 description of *The Milkmaid* does not say she *is* pouring milk, but "she *seems* to pour milk" (italics added). The anonymous author of this text apparently was well aware of the same paradox that Magritte formulated more than a century later in his warning on his painting of a pipe: "This is not a pipe."

So we repeat and fully endorse what the great English connoisseur John Smith observed as early as 1829, though writing about other artists: "Much genuine information has been derived from the Dutch and French catalogues of pictures: and here the author desires to render justice to the talents of their writers, as well for their perspicuity and intelligence, as the correctness and veracity with which they are generally written . . . reasonable confidence may be placed in the encomiums bestowed upon [the pictures'] merits. In Holland the catalogues are written under the direction of several persons conversant in the arts."[86]

Wherever possible, our catalogue lists the prices that Vermeer's paintings fetched, which also is informative about their appeal and reputation. Shortly before and after 1800 it seems that the value of Vermeers, and of paintings generally, fell sharply, doubtless due to war and economic crisis.

Apart from these catalogue entries nothing was printed about Vermeer between 1718 and 1727 (when Houbraken and Dezallier d'Argenville only mentioned his name) and the end of the eighteenth century. In 1781 Joshua Reynolds—distinguished both as a painter and an art critic—visited the Netherlands to look at Dutch and Flemish paintings of the seventeenth century. His journal gives a resume of the pieces—mainly genre paintings and landscapes—that most impressed him. Among these is "A Woman pouring milk from one vessel to another: by D. Vandermeere"—that is, Vermeer's *Milkmaid* (plate 8). Although mentioned without further comment. it was certainly a work that impressed Reynolds, for he writes: "I have mentioned only those [paintings] which I considered worthy of attention." Reynolds closes his report with the words: "The account which has been given of the Dutch pictures is, I confess, more barren of entertainment than I had expected. One would wish to be able to convey to the reader some idea of that excellence, the sight of which has afforded me so much pleasure."[87]

The earliest reproductions after Vermeer's works, three engravings, were printed in 1783 (after plate 5, which was then still attributed to Govaert Flinck) and in 1784 and 1809 (after plates 23, 24). The engraving of 1784, after Vermeer's *Astronomer* (plate 24), appears again in a volume of prints published by the art dealer Jean-Baptiste Lebrun in 1792. The volume reproduces paintings in his possession, accompanied by short captions. The text added to his reproduction of the Vermeer reads: "This Van de Meer, never once mentioned by historians, merits special attention. He is a very great painter, in the manner of Metsu. His pictures are rare, and are better known and more appreciated in Holland than anywhere else. He was especially fond of rendering effects of sunlight, and sometimes succeeded to the point of complete illusion."[88]

That Vermeer received attention in Holland at this time is corroborated by a previously unnoticed passage in a speech delivered in November 1789 by the professor of anatomy at Amsterdam, Andreas Bonn. The occasion was the opening of the drawing studio in the large new building of the *Felix Meritis* ("Happy through Merit") Society of Amsterdam, an association of both amateurs and practitioners of the arts and sciences. In his long discourse Bonn praised a number of Dutch artists, allotting a few words to each, when he came to depictions of "Companies of burghers" *("burger-gezelschappen")* he mentioned "the satin and velvet costumes of ter Borch and Metsu; the elaborate figures and neat accessories of Dou, Slingelandt, van Mieris senior and junior, and the Delft van der Meer."[89]

We find a more significant indication of the reputation Vermeer enjoyed in the art market, and among

collectors, from an auction of 1765 in which Pieter de Hooch's famous *Woman with a Child in a Pantry,* now in the Rijksmuseum, was put up for sale. The seven-line description of the painting in the auction catalogue ends with the words: "being as good as the Delft van der Meer." This description was reprinted in a list of paintings sold at auctions which was published by Pieter Terwesten in 1770. In 1774 another de Hooch was recommended in an auction catalogue to prospective buyers with the comment that "in composition and color it *very* much resembles the paintings of the Delft van der Meer."[90]

108. Portrait of E. J. Th. Thoré (1806-1869). After photo-engraving in the auction catalogue of Thoré-Bürger's collection, 1892.

A surprising number of paintings which were not by Vermeer were given his name in auction catalogues in the period from about 1780 on. A "Woman weighing Gold" which was auctioned as a Vermeer four times in the years from 1780 to 1809 is undoubtedly the well-known painting by Pieter de Hooch now in the museum in West Berlin (fig. 92).[91] A painting for which no satisfactory attribution has been found in modern times was sold as a Vermeer in sales of 1779 and 1792 (fig. 106).[92] Many pictures by Jacob Vrel and Esaias Boursse were in the early nineteenth century brought under the hammer as Vermeers, and a splendid Job Berckheyde was suddenly baptized Vermeer in 1824.[93] So it is hardly surprising that in a Paris auction catalogue of 1804, which included *The Trio* (plate and cat. 17). Vermeer is described as one of those artists "whose products have always been considered classic and worthy to adorn the most beautiful collections."

One of the first to attempt writing a general characteristic of Vermeer's *œuvre* was the Dutch merchant and engraver Christiaan Josi. Around 1800 he wrote: "The paintings of Jan van der Meer . . . so remarkable for the simplicity of their subject and their truth of expression, were once little known. . . Today connoisseurs appreciate the works of this master."[94]

One of these connoisseurs was the merchant and poet of Amsterdam, Pieter van Winter, who in 1800 purchased *The Little Street* (plate 9) for a considerable sum. When he died in 1807 his daughter Lucretia inherited it. and in 1813 she herself acquired another Vermeer, *The Milkmaid* (plate 8), at an even higher price than her father had paid for his picture.

A passage from the *Geschiedenis der Vaderlandsche Schilderkunst* ("History of Painting of the Fatherland") of 1816, by the two enthusiasts, Roeland van Eynden and Adriaen van der Willigen, confirms that Vermeer, and these two paintings in particular, were indeed admired in Holland. "It is hardly necessary," they write, "to point out that the works of the so-called Delft van der Meer deserve a place in the most distinguished collections of art. All amateurs of art know that his paintings are ranked with those of the most outstanding masters of the Dutch school. and are paid with great sums. Nor should this cause any surprise if one takes into consideration that, just as Adriaen van Ostade is sometimes called "the Peasant Raphael" for his artful union of the ideal character with the simple imitation of nature, so also Johannes Vermeer may well be called the Titian of the modern painters of the Dutch school, because of his strong colors and easy brush technique."

Remarkably, van Eynden and van der Willigen knew only two Vermeers at first hand. *The Milkmaid* (plate 8) they "saw with exceptional pleasure" noting that "we must say that we know no other painting of this kind of subject that surpasses it in power and naturalness of expression." *The Little Street* (plate 9) so impressed them that they wrote that they "cannot recommend it enough to the attention and judicious imitation of young painters who wish to devote themselves to similar subjects."[95]

In fact, this recommendation was superfluous. *The Little Street* had already been copied by Cornelis van Noorde (1731-1795) and by at least two other Dutch artists. At least ten copies after five other paintings by

Vermeer were made by Dutch painters born since 1724. The best known of these masters today is Wybrand Hendriks (1744-1831), who made a copy after Vermeer's *View of Delft* (plate 10).[96] A number of works executed by young Dutch painters around 1800 show an unusual grasp of seventeenth-century art, and a striking ability to imitate it successfully. In the best of these works it is certainly the Vermeer-like qualities which these artists sought to recapture (fig. 107).[97]

Van Eynden and van der Willigen concluded their entry on Vermeer with the remark: "There exists a picture of the City of Delft seen from the south by him which is praised highly, as done in an amazingly artistic way . . . but we do not know where it is now to be found." Six years later, in May 1822, the *View of Delft* (plate 10) turned up at an auction in Amsterdam, and was purchased for the state museum the Mauritshuis in The Hague, which had opened earlier that year. It was the first Vermeer acquired by a public collection.

To finance the purchase, the state paid 2,900 guilders—a very substantial sum at that time for the work of a master who was not widely known. The decision to purchase the painting showed remarkable aesthetic insight. Doubtless the instigators belonged to the small circle of connoisseurs who since the eighteenth century had recognized Vermeer as a great artist.

THÉOPHILE THORÉ AND APPRECIATION IN THE NINETEENTH CENTURY

In the nineteenth century two developments had a decisive influence on Vermeer's reputation. The first was the acceptance, from c. 1820-30 on, of the daily activities of "ordinary" people, and of landsape in its "natural" condition, as suitable subjects for painting. In a gradual turnabout, history and allegory, hitherto the most prestigious subjects in art, came to seem artificial and contrived, and were replaced by depictions of reality and daily life. This change coincided with the rise of the liberal bourgeoisie in Western Europe, and was forcefully reflected in the work of artists such as Corot, Millet, and Courbet. As a consequence of this shift in artistic standards, the best of the Dutch painters of the seventeenth century could from now on be ranked with such prestigious Italian masters as Raphael and Michelangelo.

The second change was the application of the scientific approach to history, which had led to such impressive results in the study of archaeology and political history, to the field of art.

In 1816 van Eynden and van der Willigen could cite only three paintings by Vermeer. In 1834 the English connoisseur John Smith was equally summary in his mention of Vermeer, despite his extensive research for his famous series of *Catalogues Raisonnes of the Works of the Most Eminent Painters.* Under "pupils and imitators of Gabriel Metsu" he writes of Vermeer: "Writers appear to have been entirely ignorant of the works of this excellent artist, [whose] pictures are treated with much of the elegance of Metsu mingled with a little of the manner of De Hooge." Under "Pupils and Imitators of Peter de Hooge" Smith adds: "This master is so little known, by reason of the scarcity of his works, that it is quite inexplicable how he attained the excellence many of them exhibit."[98]

Nonetheless Smith had recognized Vermeer's hand in three paintings which in his day were catalogued as "Jacques van der Meer de Utrecht," "De Hooch," and "Metsu" (see text for cat. nos. 3, 6, 15). In his own copies of the catalogues of the collections in which these paintings were then located he crossed out these names and wrote above them "Delft Van der Meer." These three discoveries, however, were not included in his own publications.

As early as 1792, Lebrun had encouraged connoisseurs to pay "particular attention" to Vermeer's work. But not until half a century later. when Lebrun's countryman Étienne-Josephe-Théophilé Thoré fell in love with the *View of Delft* (plate 10), did anyone undertake serious research into Vermeer and his *œuvre.*

As a radical democrat, Thoré (1807-1869) viewed politics, art criticism, and art history as parts of a single whole.[99] To him "All history is a perpetual insurrection against the powers that rule the world." In his

own time he saw "three forms of slavery: Catholicism, Monarchism, and Capitalism" and "three forms of liberty: Republicanism, Democracy, and Socialism." In the 1840s Thoré founded a "Societe des Artistes" in Paris, which he conceived as a kind of trade union. Strongly maintaining that art should present a true image of the daily life of the common people, he also was one of the first to recognize and propagate the special qualities of Theodore Rousseau's "natural" landscapes. In opposition to the popular phrase "art for art's sake" Thoré launched the slogan "art for man."

Thoré's admiration of seventeenth-century Dutch painting stemmed naturally from his political views, for he saw it as the art of an emancipated society. He observed that "in Holland, since its emancipation at the end of the sixteenth century, only domestic and civic painting has existed."

Elected to the legislative assembly after the Revolution of 1848, Thore became involved in an abortive leftist coup, launched in the name of the proletariat of Paris. He was forced to flee France, and for many years shuttled between England, Holland, Belgium, and Switzerland. Exile gave him the opportunity to pursue his passion for intensive historical research, which he saw as a logical extension of his political and artistic beliefs. He struck a typical stance when he refused to deliver a lecture in Brussels in 1864 because of the lack of political liberty: "It seems impossible to me to speak for instance on Rembrandt without cursing hypocrisy and despotism and without glorifying the light of liberty and all those human qualities that have to do with the Revolution and with progress and civilisation."[100] It was equally characteristic that he was the first to seriously set about collecting all the widespread data on Vermeer, and he was unremitting in his search. He looked everywhere, culling old auction catalogues and visiting archives in order to urge Dutch archivists to be on the lookout for the name Vermeer in seventeenth-century documents. "I spent lots of money" ("J'ai fait des folies"), he writes, "for a photograph of the *View of Delft.*" Everywhere he went he examined the signatures on paintings, and he was able to reattribute to Vermeer works which had previously gone under the name of de Hooch.

He was forced to adopt an alias during a stay in Belgium, where the secret police of Napoleon III operated unrestrained. It was under the pseudonym of William Bürger—the surname is the German word for citizen—that he published the first major study of Vermeer, which appeared in the *Gazette des Beaux-Arts* in 1866.[101]

Thoré's persuasive and enthusiastic account of Vermeer's art, which included a catalogue of his works, brought Vermeer wide international repute for the first time. An immediate consequence of this new attention was a rise in the prices paid for his work, which increased by a factor of ten over the next few years. The advent of Impressionism during this period aided Thoré's efforts to revive Vermeer. For with his stress on bright color and the effect of sunlight, Vermeer is a precursor of the Impressionists among the old masters. At this time was born the notion, nearly axiomatic in modern art literature, that Vermeer and the Impressionists were pursuing the same goal.[102]

Thoré's brilliant study quickly elevated Vermeer to the status of a Great Master. But despite his intense appreciation of the artist, and his passion for historical accuracy, the picture Thoré painted of Vermeer left much to be desired. Unfortunately, he interpolated into Vermeer's *œuvre* the works of other painters, such as the landscapes of another Vermeer, Jan Vermeer of Haarlem, and the cityscapes of Jacob Vrel, which had been described as Vermeers since the end of the 1790s. The result was that he gave a most contradictory impression of the painter's style. It is hardly surprising that he dubbed Vermeer "the Sphinx of Delft."

Fortunately, later art historians trimmed these additions from the corpus of Vermeer's paintings. Henry Havard made a notable contribution in his study of 1888,[103] and in 1907 Cornelis Hofstede de Groot compiled a *catalogue raisonne,* which until now has remained the primary source of information about the pedigree of Vermeer's paintings.[104] The first monograph that incorporated all the new findings was written in 1911 by the young Eduard Plietzsch.[105] He included many new facts, unknown to Thoré and Havard, which research in the Dutch archives had brought to light after 1880, and his account of Vermeer, while obsolete in some details, still has validity.

Notes for Chapters 3 and 4

A NOTE TO THIS EDITION

After this book's first publication in the Netherlands in 1975, updated editions appeared in 1977 (Dutch; publishing house "Het Spectrum" Utrecht/Antwerp) and 1978 (English; Phaidon, Oxford). In the present book I have aimed to include and comment on all new findings, plausible ideas and hypotheses that have since been published. I have also added unpublished or hitherto neglected data, and some new thoughts of my own. A few ideas presented in the previous editions turned out to be untenable and have been dropped, and are remarked on only in the notes.

Quite a few publications on Vermeer are difficult to comment on. What to make, for instance, of a highly speculative hypothesis like: "Vermeer was greatly influenced by examples of Indonesian art. . . . This art, deriving from Hindu, Buddhist and native religious inspiration, transcribes a psychological approach that stresses both the concept of depersonalization and physical characteristics, that are at variance with Western culture. Vermeer fell under the spell of Eastern thought and artistic realizations" (E. Larsen, "Jan Vermeer de Delft and the Art of Indonesia," in *Revue Belge d'archeologie et d'histoire de l'art* 54, 1985, p. 27). In other cases I simply do not understand whether a text is intended as a contribution to art history, to art criticism, to philosophy, to psychology, or to literature: "The experience depicted within the painting . . . mirrors the experience of looking at the painting itself. We know how it feels inside the woman because it feels the same way inside us as we gaze upon the painting . . . We are given an image of an autonomous feminine counterpart, seen at a distance, as a whole body; and on our ability to incorporate this spectacle, and feel ourselves mirrored and inwardly enlarged by it, depend not only our own stable self-image, but the possibility of well-being and the capacity for love."

Can the reader guess which of Vermeer's pictures the author is talking about? And why is a book that consists of such impressions called a *study* of Vermeer? (Edward A. Snow, *A Study of Vermeer,* Berkeley etc. 1979, p.130: on the *Woman with a Pearl Necklace,* plate 13). Equally mysterious is H. Berger Jr., "Conspicuous exclusion in Vermeer, an essay in Renaissance pastoral," in *Yale French Studies* 47, 1972, pp. 243-65.

Complete titles of sources referred to only by italicized author's name can be found in the list of "Abbreviated literature" on p. 225.

1

This conclusion derives from the provenances of the pictures as listed in our catalogue. Described in 1676 were cat. nos. 19, 27, and 28 (plates 19, 27, 29). The auction catalogue of 1696 is reprinted on p 212. Described for the first time between 1699 and 1713 are cat. nos. 23, 24, and 29 (plates 24, 25, 31). Other pictures appearing earlier than 1746 are cat. nos. 3, 6, 8, and 31 (plates 3, 5, 7, 30). Not listed at all before 1838 are cat. nos. 12 (pl. 11) and the "untypical" early works cat. and pl. nos. 1 and 2. Only four Vermeers mentioned in early sources are most probably lost: cat. nos. 32A, 34, 36 and 37.

2

See on Bramer: *Wichmann.* In the past, Bramer has been suggested as Vermeer's possible teacher only by *Swillens* (pp. 172-74). After the first edition of our book, A. Wheelock also has supported this idea (see note 20 below). Most often Carel Fabritius is supposed to have been Vermeer's teacher, I think without justification. While Vermeer did indeed exhibit an interest in Fabritius's preoccupations, this occurred only several years after the latter's death. Goldscheider published a copy after *A Lady Drinking and a Gentleman* (plate 7), in which Vermeer's figures are replaced by a clumsily drawn guitar-playing lady. Suggesting that this copy was a joint work by Vermeer and Hendrick van den Burch (active 1649-1664) Goldscheider interpreted this as proof that van den Burch was Vermeer's teacher (L. Goldscheider, "Vermeers Lehrer," in *Pantheon* 22, 1964, pp. 35-38; *Goldscheider,* pp. 14, 127, fig. 4).

3

While nowadays a consensus seems to exist about the global chronology of Vermeer's development, historians are not yet in agreement about the details. Compare the chronology given here with the sequence proposed by *Trautscholdt, Gowing, Rosenberg-Slive, Gerson,* and *Gudlaugsson-Kindler.* The more precise dates given by *de Vries, Bloch, Goldscheider,* and *Wheelock 1981* are listed in our catalogue. Often the costumes depicted in seventeenth-century paintings, because they reflect changes in fashion, provide helpful indications of a work's date (see pp. 108 and 142). But the most able specialist in this field, the late Dr. S. J. Gudlaugsson, in his short essay on Vermeer did not indicate how far the chronology he proposed for the paintings is based on the study of costumes (*Gudlaugsson-Kindler*). In some cases the conclusions based on costume study are confusing. For example, a specialist in seventeenth-century fashion believed that the clothing of the painter in *The Art of Painting* (plate 19) dated from "hardly later than shortly after 1660" (*van Thienen,* p. 46). Van Gelder, however, has subsequently pointed out that the painter wears a fancy archaic costume, derived from depictions of 150 years earlier (*van Gelder 1958*).

4

Only Valentiner attempted to date a number of domestic scenes before *The Procuress,* but his arguments did not convince any later author (*Valentiner 1932*).

5

A third early Vermeer must have been the *Three Mary's at Christ's Tomb* mentioned in an inventory in 1657 (see document of 27 June 1657, cat. 32A, and *Montias* 1980, pp. 47-48). M. Kitson has proposed adding a still existing painting, a *Holy Praxedis* in the art trade in New York, to the two early Vermeers (M. Kitson, "Florentine Baroque Art in New York," in *Burlington Magazine* III, 1969, pp. 409-10). The attribution, however, cannot be sustained. Vermeer's "signature" on this work is irregular and the "M" does not fit with the following let-

ters. The indications that the painting is no more than a copy after the Florentine painter Felice Ficherelli are corroborated by its typically Italian technique. Recently Arthur Wheelock published an elaborate and well-illustrated plea for the authenticity of the picture (A. Wheelock, *"St. Praxedis:* New Light on the Early Career of Vermeer." in *Artibus et Historiae. Rivista Internazionale di Arti Visive e Cinema* 14 (V11), 1986, pp. 71-89).

More seductive, but in my view not convincing, is van Regteren Altena's attribution of some other pieces, including a drawing, to the young Vermeer (J. O. van Regteren Altena, "Een jeugdwerk van Johannes Vermeer," in *Oud Holland* 75, 1960, pp. 175-94).

Sometimes the most illogical theories get a maximum of attention in the mass media. A striking example is a small volume written by D. Hannema. He tried to enrich Vermeer's œuvre with no less than six paintings, which caused a sensation in the form of front-page news in serious newspapers and extensive television coverage (D. Hannema, *Over Johannes Vermeer van Delft, twee onbekende jeugdwerken,* Stichting Hannema-de Stuers Fundatie, 1972). While some of these paintings are no doubt seventeenth-century works, none of them has anything to do with the known work of Vermeer. Before his death in 1984, Hannema "published" a seventh "early Vermeer," a very poor *Three Mary's at Christ's Tomb* ("problemen rondom Vermeer van Delft," in *Boymans bijdragen, Opstellen van medewerkers en oud-medewerkers van het Museum Boymans-van Beuningen voor J. C. Ebbinge Wubben,* Rotterdam, 1978, pp. 89-103, fig. 9, with English summary).

All these paintings belonged to his own museum, the Hannema-de Stuers Fundatie in Heino, Holland. The best of these paintings was also reproduced as possibly another "early Vermeer" by Chr. Wright, *Vermeer,* London, 1976, p. 9, with ill. (also illustrated in Hannema, op. cit., fig. 10). This work was said to represent *Esther and Ahasuerus* and to be signed and dated: "Meer fecit 1654." It clearly is by a close follower and contemporary of Hendrick fer Brugghen (1588-1629), which explains why B. Nicolson listed it as "wrongly attributed to Ter Brugghen." He recognized the subject as *Athenais Banished by Her Husband the Emperor Theodosius II* (B. Nicolson, *The International Caravaggesque Movement,* Oxford, 1979, p. 98). Wright and Nicolson mention the picture as being on loan to the Musee des Beaux-Arts in Tournai from the Jean Decoen Collection, Knokke-Zoute, while Hannema called it a gift from the Decoen Collection to the Hannema-de Stuers Fundatie. Today neither museum is able to supply any information on its present location. L. J. Slatkes attributed the picture to Johannes van Swinderen (I 5941636) (L. J. Slatkes, "A Self-Portrait Reidentified, an Oeuvre Reconstructed: Johannes van Swinderen (1594-1636)," in *Essays in Northern European Art, Presented to Egbert Haverkamp-Begemann on his Sixtieth Birthday,* Doornspijk, 1983, pp. 245-48, fig. 3).

6

This borrowing was detected by M. D. Henkel, "Jan Steen und der Delfter Vermeer," in *Kunstwanderer* 14, 1931-32, pp. 265-66.

7

The signature on *Diana and Her Companions* is illustrated in the catalogues of the Mauritshuis of 1895 and 1935. The text of the latter added, however, that by 1935 the signature had become indiscernible under the darkened varnish. After a new cleaning of the painting in 1952, the letters again became vaguely visible. See A. B. de Vries, "Vermeer's Diana." in *Bulletin van het Rijksmuseum* 2, 1954, pp. 40-42, with a drawing of the signature which is slightly different from the one in the above-mentioned catalogues of the Mauritshuis.

8

Observation of J. G. van Gelder *(van Gelder 1956).* This idea is now confirmed by the X-rays (see text of cat. no. 2). Van Gelder also suggested that the hunter Actaeon might have been depicted to the right (on a portion that was cut off). However, this seems less plausible. Actaeon encountered Diana and her companions bathing, i.e. nude. And Actaeon is not represented on a number of other Dutch paintings of *Diana and Her Companions* which are comparable to Vermeer's (see fig. 51).

9

The most important of these painters are Pieter de Grebber, Jan and Salomon de Braij, and Caesar van Everdingen. See now on these artists and on Dutch seventeenth-century history painting in general: A. Blankert et al.. exhibition catalogue *Gods, Saints and Heroes, Dutch Painting in the Age of Rembrandt (God en de goden, Verhalen uit de bijbelse en klassieke oudheid door Rembrandt en zijn tijdgenoten),* National Gallery of Art, Washington; the Detroit Institute of Arts: Rijksmuseum, Amsterdam, 1980-1981.

10

Manke cat. nos. 3 and 4, with illustrations: *Vertumnus and Pomona* and *Jupiter and Mercury Visiting Philemon and Baucis.*

11

These artists have now been presented as a *group* in which Vermeer finds his logical place in my essay "Classicism in Dutch Painting, 1614-1670" in exhibition catalogue *Gods, Saints and Heroes* (op. cit., note 9), pp. 182-235.

12

This was noticed by W. von Bode, *Rembrandt und seine Zeitgenossen,* Leipzig, 1906, p. 50. Postwar publications repeatedly state that van Loo's painting was burned during World War II. However, it is preserved in the Bode-Museum in East Berlin.

13

In Vermeer's *Diana and Her Companions* (plate 1) such van Loo-like folds are conspicuous only in the sleeve of the woman who washes the feet of the goddess. The surface of this painting is so worn, however, that the original modeling may have looked quite different and may have been much more similar to the modeling of the picture in Edinburgh.

14

On these commissions: H. van de Waal, *Drie eeuwen vaderlandsche geschieduitbeelding, 1500-1800,* 2 vols, The Hague, 1952: A. Blankert, *Kunst als regeringszaak in Amsterdam in de 17e eeuw,* Lochem, 1975. Vermeer's connections with Amsterdam can be better understood when we consider how many first-rate artists moved from Delft to Amsterdam during 1640-1660 (ef. *Montias* 1982, pp. 177-78).

15

H. Schneider. "Erasmus Quellinus in

Amsterdam," in *Oud Holland 42,* 1925, pp. 54-57. Quellinus's ceiling is dated 1656, but the artist's first contacts with Amsterdam must have taken place sometime earlier.

16

The connection between Vermeer's picture and the one by Ouellinus was detected by Trautscholdt, who also showed that Ouellinus's piece must have been painted before 1652 (*Trautscholdt,* p. 267). Additional information on Quellinus's painting in exhibition catalogue De eeuw van Rubens, Koninklijk Museum voor Schone Kunsten, Brussels, 1965, no. 175. Previously the resemblances between the Christ in Vermeer's piece and similar Christ figures in works by Vaccaro and Allorj were thought to be significant. Gowing, however, demonstrated those resemblances to be of a too general character to prove a direct relation between the work of Vermeer and the Italians (Gowing, p. 81).

Recently it has been suggested that the "most likely source . . . of the composition of the three figures" in Vermeer's *Christ in the House of Mary and Martha* (plate 2) is an engraving of c. 1597/98 by G. van Velden after Otto van Veen, reproduced in J. Muller-Hofstede, "Zum Werke des Otto van Veen 1590-1600," in *Musees Royaux des Beaux-Arts* (Koninklijke Musea voor Schone Kunsten), Brussels, 6, 1957, p. 163, fig. 21. (See C. Thompon and H. Brigstocke, *National. Gallery of Scotland. Shorter Catalogue,* Edinburgh, 1978, p. 110, no. 1670). The composition of this small print indeed resembles to a certain extent that of Vermeer's large painting.

17

See A. Blankert, in *Gods, Saints and Heroes* (op. cit., note 9), cat. no. 54, and A. Blankert. "Dutch history painting in the Mauritshuis," in *Art Treasures of Holland, The Royal Picture Gallery Mauritshuis,* edited by H. R. Hoetink, Amsterdam/New York, 1985, pp. 38, 39, figs. 8, 7. The Titian is now on loan to the National Gallery of Scotland, Edinburgh; the Rubens is known from a print and through a fragmentary painting in the Museum Boymans-van Beuningen, Rotterdam.

18

See F. Lugt. "Italiaansche kunstwerken in Nederlandsche verzamelingen van vroeger tij-den," in *Oud Holland* 53, 1936, pp. 97-135. See also *Montias* 1982, p. 250. See on a well-documented collection of first-rate Italian paintings in Amsterdam, brought together before 1646: A. M. S. Logan, *The "Cabinet" of the Brothers Gerard and Jan Reynst,* Amsterdam, Oxford, New York, 1979.

19

That is, 246 of the 351 paintings in the catalogue raisonne of Bramer's work compiled by *Wichmann,* pp. 91-165.

20

Bramer's painting is mentioned in 1765 (*Wichmann,* p. 119, no. 108). Wheelock cites as additional evidence for Bramer having been Vermeer's teacher a drawing by Bramer in the Rijksprentenkabinet, Amsterdam, representing the *Washing of Christ's Feet by His Disciples* that is similar in composition to Vermeer's *Christ in the House of Mary and Martha* (*Wheelock 1977, Review,* p. 440; *Wheelock 1977,* p. 269, fig. 67; *Wheelock 1981,* fig. 60).

21

On the Italianate landscape painters: A. Blankert, exhibition catalogue *Nederlandse 17e eeuwse italiainiserende landschapschilders,* Centraal Museum, Utrecht, 1965; reprint with *Introduction* in English, Soest, 1978. The sketch presented here of developments in Delft has now been worked out in more detail and with interesting additions and references by *Sutton 1980,* p. 16 ff. (who rightly cites the importance of Paulus Potter's stay in Delft in 1646-c. 1648); *Brown,* pp. 57-61; and *Montias 1982,* pp. 179-82. See also E. J. Sluijter & J. Breunesse, "De schilderkunst van ca. 1570 tot ca. 1650," in exhibition catalogue *De stad Delft. cultuur en maatschappij van 1572 tot 1667,* Stedelijk Museum "Het Prinsenhof," Delft, 1981, 1, pp. 172-90.

22

Compare on Dutch still life: I. Bergstrom, *Dutch Still-life Painting in the Seventeenth Century,* New York, 1956. It should be added that after a trip to Italy, van Aelst worked primarily in Amsterdam, although van Bleyswyck included him with the painters of Delft (*Bleyswyck,* p. 855). In Delft his uncle Evert van Aelst must have worked in the same style. From 1657 to 1661, the excellent still-life painter Abraham van Beyeren also lived in Delft.

23

On Fabritius: K. E. Schuurman, *Carel Fabritius,* Amsterdam, 1947, and *Brown.*

24

Literature on the painting is listed in *Mauritshuis, Illustrated General Catalogue,* The Hague, 1977, pp. 86-87, no. 605. See also B. Broos, exhibition catalogue *De Rembrandt a Vermeer, Les peintres hollandais au Mauritshuis a La Haye,* Grand Palais, Paris, 1986, no. 21.

25

On trompe-l'œil painting: A. P. de Mirimonde, "Les peintres flamands de trompe-l'œil et de natures mortes au XVIIe siecle et les sujets de musique," in *Jaarboek Koninklijk Museum voor Schone Kunsten, Antwerpen,* 1971, pp. 223-72, with literature. The importance of van Hoogstraten's picture has not previously been mentioned. An early forerunner of van Hoogstraten was the Venetian Jacopo de Barbari. who had explored the principle of trompe-l'œil in his *Still life* dated 1504 in the Alte Pinakothek, Munich (cat. 1936, no. 5066-1443). So it is interesting that van Hoogstraten mentions as painters of trompe-l'œil effects, in addition to himself and Carel Fabritius, another early sixteenth-century Venetian, Giorgione (S. van Hoogstraten, *Inleyding tot de Hooge Schoole der Schilderkunst,* Rotterdam, 1678, p. 275). Recently trompe-l'œil painting received more attention. See e.g. the beautiful illustrations in C. Dars, *Images of Deception, The Art of Trompe-l'œil,* Oxford, 1979 (bibliography on p. 6). Yet in this and other books the definition of trompe-l'œil tends to be very vague, and consequently a great variety of ways of rendering space is indiscriminately included. The sole exception I know of is M. Milman, *Les Illusions de la réalité le Trompe-l'œil,* Geneva, 1982. Page 36 of this beautiful book presents a definition of trompe-l'œil that roughly corresponds with the one given here.

26

S. van Hoogstraten, *Inleyding,* op. cit., note 25, p. 274. Also Dirck van Bleyswyck, in his description of the city of Delft, calls Fabritius

"incomparable in matters of perspective" (*Bleyswyck,* p. 852).

27

On these perspective boxes, see *Koslow.* See also the articles by Wheelock and Liedtke in note 47, and F. Leeman, *Anamorphosen, Ein Spiel mit der Wahrnehmung . . . ,* Cologne, 1975, pp. 82-84, figs. 67-96; exhibition catalogue *Anamorfosen . . . ,* Rijksmuseum, Amsterdam/Musee des Arts Decoratifs, Paris, 1975-76.

28

From May 1651 to the end of 1654 van Hoogstraten traveled to Vienna, Rome, and again to Vienna. In the latter city he made "illusionistic" paintings like fig. 60 from 1654. When he returned to Holland at the end of the same year, Fabritius had just died. Thus the contacts between the two artists must have taken place before van Hoogstraten's departure in 1651. We may conclude that this concern for illusionistic representation on the part of both artists had already taken definitive shape in or before 1651.

29

See the illustrations and references to sources in *Koslow.*

30

On Saenredam: (H. J. de Smedt), exhibition catalogue *Pieter Jansz. Saenredam,* Centraal Museum, Utrecht, 1961. R. Ruurs, *Saenredam, The Art of Perspective,* Amsterdam/Philadelphia, 1986.

31

It was mentioned above (p. 79) that a similar change occurred in the repertory of motifs used by still-life painters. After 1650 the commonplace objects which had been depicted by masters like Steenwijck (figs. 21, 57) were replaced by embossed silver, richly decorated glassware, and exotic fruits in the work of van Aelst and van Beyeren (see fig. 58).

32

On van den Eeckhout: W. Sumowski. *Gemalde der Rembrandt-Schüler,* 11, Landau, Pfalz, 1983, pp. 719-909. On van Loo a monograph by W. L. van de Watering is in preparation. On Metsu:

Gudlaugsson 1968 and F. W. Robinson, *Gabriel Metsu (1629-67),* New York, 1974.

33

See *Gudlaugsson 1959,* 1, pp. 72-101.

34

See C. Wilnau, "Ein Selbstportrat Vermeers?" in *Zeitschrift fur Kunst* 4, 1950, pp. 207-12. Compare *Goldscheider,* pp. 17, 32, note 28.

35

For instance, the *Merry Company* by Jan Gerritsz. van Bronchorst in Sibiu (Hermann stadt; illustrated in *Gowing,* p. 84).

36

Slive, p. 457: "If Vermeer's picture was meant as an admonition to use alcoholic beverages moderately, it was probably a failure. The chance of looking as beautiful as Vermeer's sleeping young woman is enough to drive a woman to drink!" For the more recent interpretation of the painting as personifying Sloth, see text of cat. no. 4.

37

For the dates on de Hooch's paintings, see *MacLaren,* p. 184, and recently the large monograph by *Sutton 1980;* also the latter's pp. 23 ff. and 34 on the relation between de Hooch and Vermeer.

38

As mentioned earlier, ter Borch was in Delft in 1653 (see document of 22 April 1653). This explains why his *Unwelcome News* of that year (our fig. 27) is clearly derived from a picture by the Delft artist Anthonie Palamedesz. It also explains how ter Borch's *Unwelcome News* could in its turn be the direct source of inspiration for de Hooch's picture of the same subject of c. 1654-57 (Barcelona, Museo de Arte de Cataluna; *Gudlaugsson 1959,* p. 109, text to cat. 99 and ills.; *Sutton 1980,* p. 13, fig. 5, cat. 16, plate 15).

39

See especially: *Welu.* Also the text of our cat. nos. 5, 12, 14, 17, 19, 23, 24, 29, 31, b1. The yellow satin jacket hemmed with white fur which is worn by Vermeer's models in plates 13, 21, 22, 23, and 29 (cat. nos. 13, 20-22, 28)

must be the one mentioned in his inventory of 29 February 1676 (see document of that date).

40

This point of view has been most strictly adhered to by *Swillens.* Compare the critical comments on this approach in *Wheelock 1977,* p. 275 ff.

41

See Daniel A. Fink, "Vermeer's use of the Camera Obscura, a comparative study," in *The Art Bulletin* 53, 1971, pp. 493-505. Wheelock agrees that Vermeer probably used the camera obscura, yet is very critical of Fink's ideas *(Wheelock 1977,* pp. 277 ff., 283 ff., d. pp. 263, 304, note 7). According to Wheelock, Vermeer may also have used other optical devices. See also *Wheelock 1978; Wheelock 1981,* p.160, note 41, cf. *Montias 1980,* p. 60, note 97. However, see also my comment on p. 104.

42

See on the *Girl Reading a Letter at an Open Window* (plate 5): *Mayer-Meintschel.* She places the picture in a tradition of depictions of reading women that harks back to medieval representations of Mary reading.

43

The scarce information on Pick was assembled in *Thieme-Becker* XXVI, p. 588, before any work by his hand was known. A few years ago the Museum het Prinsenhof in Delft acquired a *Still Life in an Interior* signed A. Pick, resembling the work of Rotterdam painters. See now on Pick: *Montias 1982,* passim and fig. 8. On the album of which the drawing is a part: M. Plomp, "Een merkwaardige verzameling Teekeningen door Leonaert Bramer," in *Oud Holland* 100, 1986, pp. 81-153.

44

Listed in *Hofstede de Groot* 1, p. 573, no. 5b, auctioned in 1729.

45

The motif of the curtain pushed aside occurs exactly as on the *Girl Reading a Letter at an Open Window* (plate 5) in several views in Delft churches by Emanuel de Witte and Gerard Houckgeest. dating from 1650-1655

(our fig. 44, *Manke* figs. 11, 13, 14). For the curtain motif in Dutch seventeenth-century painting, see P. Reutersward, "Tavelförhänget: Kring ett motiv holländskt 1600-talmaleri," in *Konsthistorisk Tidskrift* 25, 1965, pp. 97-113.

46

Another aspect of this stage in Vermeer's development is represented in the *Girl Interrupted at her Music* in the Frick Collection, New York (plate and cat. no. b2). While the painting is very charming and unmistakably Vermeerlike, its modeling, especially of the costumes, is very superficial and gives no evidence of Vermeer's superior technique.

47

See *Koslow*. Wheelock objected to this idea ("Carel Fabritius: Perspective and Optics in Delft," in *Nederlands Kunsthistorisch Jaarboek* 24; 1973, pp. 63-83). He ingeniously explained that the distortions in the painting can only be understood if we assume that Fabritius depicted the buildings while looking through a concave lens. This creates an effect similar to that of a wide-angle lens in photography.

Wheelock continued that Fabritius, with regard to this wide-angle effect, "felt free to utilize its expressive characteristics without concern for the distortions it created" (idem, p. 73). To me this last observation seems to stem from a twentieth-century point of view. I wonder if perhaps Fabritius intended the painting to be viewed from a fixed point through a convex lens or a glass sphere—which would compensate for the distortions. The hypothesis that Fabritius's painting originally was part of a perspective box was revived by W. A. Liedtke, "'The View in Delft' by Carel Fabritius," in *Burlington Magazine* 118, 1976, pp. 61-73. A reply to this article is presented in *Wheelock 1977*, p. 4 ff.

48

This note in the 1975 edition of this book was elaborated on by J. Bruyn, who adduced documents of 1666 on a painting done by Vosmaer and Fabritius together ("Naschrift," in *Oud Holland* 97, 1983, pp. 291-92).

49

Compare W. Stechow, *Dutch Landscape Painting of the Seventeenth Century,* London,

1966, p. 124 ff., and my review of the book in *Simiolus* 2, 1967/8, p. 106. On Dutch cityscapes, see also: exhibition catalogue *Opkomst en bloei van het Noordnederlandse stadsgezicht in de 17e eeuw (The Dutch Cityscape in the 17th Century and Its Sources),* Historisch Museum, Amsterdam, and Art Gallery of Ontario, Toronto, 1977. Wheelock draws attention to the interesting fact that Jan van der Heyden's *View of Delft* in the Detroit Institute of Arts was probably painted in the mid-1650s and may have been a source of inspiration for Vermeer and/or de Hooch (*Wheelock 1977*, p. 278, fig. 83).

50

Swillens, p. 90 ff. See our fig. 7, and also the article by Wheelock and Kaldenbach mentioned in text for cat. no. 10. Swillens also assembled impressive arguments to prove that *The Little Street* too depicts an exact view: on the Voldersgracht in Delft as seen from the rear window of Vermeer's father's house Mechelen (*Swillens,* p. 98 ff.). This theory was doubted by *van Peer* (1959, pp. 243-44). Yet I accepted it and drew further conclusions that led to c. 1661 as a probable date for *The Little Street,* in previous editions of this book. This theory has since been convincingly refuted by *Montias 1980,* pp. 58-59, and by C. J. van Haaften, *Nieuwe Langendijk Delft Bouwhistorisch en archeologisch onderzoek van pan den 22 tim 28,* I, Delft 1986, pp. 157-63.

51

Obreen 111, p. 197 ff. 52

52

Gowing (reporting the opinion of Dr. S. J. Gudlaugsson), p. 118: "the dress in the Berlin picture was worn before 1660. The fashion which is seen in the work at Braunschweig does not appear until 1663 or later." *Van Thienen,* p. 29, notes that the costume on the painting in Braunschweig is "not later than the first years after 1660."

53

An early positive reappraisal of van Mieris is to be found in W. Martin, *De Hollandsche schilderkunst in de zeventiende eeuw,* II, Amsterdam, 1936, p. 220 ff. The possibility that Vermeer was influenced by van Mieris was men-

tioned for the first time by E. Plietzsch, *Vermeer van Delft,* ed. Munchen, 1939, p. 41. More recently van Mieris regained his rightful place as one of the foremost Dutch genre painters in the large monograph by *Naumann 1981.*

54

To be connected with these three paintings is the *Woman with a Lute near a Window* in the Metropolitan Museum in New York (plate and cat. no. b1). The surface of this painting is so worn that only the high quality of the rendering of the map on the wall demonstrates that the painting is a "lost" authentic Vermeer.

55

Wichmann, oeuvre catalogue nos. 267-71: "A person weighing gold at a table upon which are many precious objects."

56

See H. Rudolph, "'Vanitas': Die Bedeutung mittelalterlicher und humanistischer Bildinhalte in der niederländischen Malerei des 17. Jahrhunderts," in *Festschrift Wilhelm Pinder,* Leipzig, 1938, p. 408 ff. See also *Slive,* p. 454.

57

Vermeer was not the first to render this inscription on a clavecin on a painting. It is also legible on a clavecin in the background of a *Portrait of a Woman* by Karel Slabbaert, who died in 1654 in Middelburg (Museum in Zhitomir. U.S.S.R.; see Y. Kuznetsov & I. Linnik, *Dutch Painting in Soviet Museums,* Amsterdam/Leningrad, 1982, plate 40). The inscription also appears, written on a piece of paper. on several Vanitas still-life paintings signed by Edwart Collier (c. 1640-after 1706): 1. our fig. 93; 2. Van der Heyden Gallery, Rotterdam, Antique Fair, Delft, 1975; from a book hangs a paper with another text: "Haec mea voluptas"; 3. The same or a very similar painting, dated 1693, with Art Gallery Friederike Pallamar, Vienna, exhibition catalogue, October-November 1978, no. 4 with ill.; 4. Private collection, France, exhibition *Collections privees du Tarn,* Musee Goya, Castres, 1956, cat. no. 12.

The same inscription is written in full on two preserved instruments, dating from 1624 and 1640, made by the Antwerp manufacturer of keyboard instruments Andries Ruckers (B. Nicolson, *Vermeer, Lady at the Virginals,* Gallery

Books, no. 12, London, 1946). Nicolson reproduced a musical instrument by Ruckers in the Musee Instrumental du Conservatoire, Brussels, which is almost identical to the one depicted in plate 16. An instrument by Ruckers in the Gemeentemuseum, The Hague (inv. no. EC 34X-1976, on loan from the Rijksmuseum, Amsterdam) has around the keyboard exactly the same decoration as in plate 16. See a complete list of the still extant virginals by Ruckers in D. H. Boalch, *Makers of Harpsichord and Clavichord 1440-1840,* Oxford, 1974, p. 129 ff. More details on the instrument in plate 16 and its decoration may be found in *Mirimonde,* p. 52, note 34, and in Chr. White, *The Dutch Pictures in the Collection of Her Majesty the Queen,* Cambridge etc., 1982, no. 230.

Nicolson (loc. cit.) labeled the instrument in plate 16 "a virginal" since this is the correct term from a musicological point of view. Since then publications of the National Gallery in London call plate 20 (cat. 25) and plate 30 (cat. 31), in which similar instruments are depicted, *Lady Standing at a Virginal* and *Lady Seated at a Virginal* (see *MacLaren,* nos. 1383 and 2568). Dutch seventeenth-century inventories, however, always denote these instruments as "clavesingel" (spelled in various ways). Moreover, in 1682 plate 16, 20, or 30 is mentioned as a "piece with a lady playing the clavesingel," and in 1696 as a "klavecimbael-player" (see text on cat. no. 25). Thus I usually use the word "clavecin" to denote the instrument.

It seems likely that Vermeer was educated in music (see *Montias 1980,* p. 49).

58

Bleyswyck, p. 646 ff. 59

59

C. A. van Mander, *Het Schilder-Boeck waer in . . . 't leven der vermaerde doorluchtigheschilder . . .* Haarlem/Alkmaar. 1604, fol. 245.

60

See *Van Gelder* 1958. The first author to recognize the girl on *The Art of Painting* as Clio was K. G. Hulten, "Zu Vermeers Atelierbild," in *Konsthistorisk Tidskrift* 18, 1949, p. 92.

61

This interpretation of the map was proposed for the first time by H. Sedlmayer. "Der Ruhm der Malkunst. Jan Vermeer 'De Schilderconst,'" in *Festschrift fur Hans Jantzen,* Berlin, 1951, p. 173. Other interpretations of the map are mentioned in *van Gelder* 1958, pp. 10, 23, and in H. Miedema (op. cit. in text of cat. no. 19), p. 74. Compare *Welu,* p. 540.

62

De jeugd van Constantijn Huygens door hemzelf beschreven . . . vertaald door A. H. Kan, Rotterdam/Antwerp, 1946, p. 66 ff.

63

Naumann places the picture very early in van Mieris's career, c. 1655-1657 (*Naumann* II, p. 22).

64

H. E. van Gelder, "Perspectieven bij Vermeer," in *Kunsthistorische Mededeelingen van het Rijksbureau voor Kunsthistorische Documentatie* 3, 1948, pp. 34-36; K. Bostrom, "Peep-show or case?" in idem 4, 1949, pp. 21-24; J. Q. van Regteren Altena, "Hoge Kunst of Spielerei?" in idem 4, 1949, p. 24. Sometimes pictures were also painted on the doors of such cases.

65

Compare W. Friedlander's lucid exposition on the transition from "high renaissance" to "mannerism" in Italian painting of the sixteenth century in his Mannerism and Antimannerism in Italian Painting, two essays, New York, 1957 (originally published in 1925).

66

See *Sutton 1980,* p. 66, note 10. Compare the "positive" definition of mannerism given by J. Shearman, *Mannerism,* Harmondsworth, 1967. Shearman seems to oppose Friedlander's theses (see note 65), but fails to mention Vasari's biography of Pontormo which Friedlander used as his starting point.

67

H. Vey and A. Kesting, *Katalog der niederlandischen Gemalde . . . im Wallraf-Richartz-Museum* Cologne, 1967, p. 57, no. Dep. 239. See *Sutton 1980,* pp. 110-111. cat. no. 122, where the picture is also dated "in the late 1670s."

68

This was convincingly argued in *Gudlaugsson* 1968, p. 37.

69

All this information from *Mirimonde,* p. 41, and from *De Jongh 1967,* pp. 49-52. See also the latter author on the *Love Letter* in exhibition catalogue *Rembrandt et son temps/Rembrandt en zijn tijd,* Palais des Beaux-Arts, Brussels, 1971, pp. 176-77, and *de Jongh 1976,* p. 269.

Comparing paintings to emblem books can also lead to farfetched conclusions. An example is L. Seth, "Vermeer och van Veens *Amorum Emblemata,*" in *Konsthistorisk Tidskrift* 49, 1980, pp. 17-40. The author thinks that almost all Vermeer's paintings were inspired by the allegorical prints in Otto van Veen, *Amorum Emblemata,* Antwerp, 1608.

70

On the unfinished state of the *Lady with a Maidservant Holding a Letter* (plate 23), see *The Frick Collection, an Illustrated Catalogue 1, Paintings . . . ,* New York, 1968, p. 296.

71

On the origin and dissemination of the theme, see H. van de Waal, "Rembrandt's Faust etching, a Socinian document, and the iconography of the inspired scholar," in *Oud Holland* 79, 1964, p. 37 ff. That Bramer also treated the subject is apparent from the description of a painting by him in an auction of 1776: "A philosopher stands in a room at a table, upon which a globe and several books" (*Wichmann,* cat. no. 251, see also, e.g., no. 258). Ample discussion of the subject with Vermeer and other artists: *de Jongh* 1976, p. 83.

72

This was pointed out by P. Bianconi in P. Ungaretti and P. Bianconi. *L'Opera Completa di Vermeer,* Milan, 1967, p. 96.

73

Gudlaugsson pointed out the relation with Dou's work (*Gudlaugsson Kindler).*

74

MacLaren, p. 437.

75

Mirimonde (p. 41) thought the *Guitar Player* was cut at a later date, but that is unlikely

because a fine old copy exists of exactly the same dimensions and composition (fig. 123; see text of cat. no. 28).

76
See *van Peer 1968*, p. 2 2.

77
Cf. *Montias 1982*, pp. 196-97.

78
C. de Wolf, The Hague, proposes the following reason for the change. Before citing the poem, van Bleyswyck notes that Fabritius died at "only thirty years of age." When Bon proofread the first sheets from the press, he decided that he should actually have mentioned this fact in his poem. It was not unusual in elegies and funeral poems to mention the age of death of the deceased, especially when there was something remarkable about it—in the case of Fabritius, his young age and the tragic cause of his death. See on Bon: *Montias 1982*, p. 284.

79
Vermeer is named in the poem as the successor of the great Fabritius. That an artist should imitate his great forerunners was a prevailing idea at the time, but it was considered even more important to emulate and, if possible, surpass them. These concepts were termed *"imitatio"* and *"aemulatio"* (see E. de Jongh, "The Spur of Wit: Rembrandt's Response to an Italian Challenge," in *Delta* 12, 1969, no. 2, pp. 49-67). Perhaps Vermeer felt that the phrase "who masterly trod his [Fabritius's] path" (reminiscent of "downtrodden paths") stressed too much his *"imitatio"* of Fabritius, at the expense of the more important *"aemulatio."*

80
See *Montias 1987*.

81
See documents of 16 May 1661. August 1663. and 4 August 1664. cf. *Montias 1987*, who also discusses the Amsterdam collector Herman van Swoll, the owner of the *Allegory of Faith* (plate 31, cat. 29).

82
It has surprised modern scholars that Samuel van Hoogstraten in his book on painting, *Inleyding tot de Hooge Schoole der Schilderkunst* of 1678, makes no mention of Vermeer at all (see *van Gelder 1958,* p.6). This is remarkable indeed, as his contacts with Fabritius make it highly probable that he was well acquainted with the Delft milieu. And in fact he does include remarks on the Leiden painters Dou and van Mieris. In one passage mentioning these artists he adds overemphatically: "But let me stop. In order not to excite envy, I want to leave out the painters who are stil alive" *(Inleyding,* p. 257). Van Mieris was still alive at the time, Vermeer had died three years before.

It is equally remarkable that old copies do exist only after our cat. no. 24 (plate 25) and no. 28 (plate 29) (the latter illustrated in fig. 123). In that respect, Vermeer's *œuvre* attracted less attention than that of such artists as ter Borch and van Mieris: we know of numerous copies after all the masterpieces of these two, in large part old ones (listed in *Gudlaugsson* 1959 and *Naumann*). It is interesting to note that neither of the two Vermeers of which old (seventeenth century?) copies exist belonged to Dissius's collection, which up to 1696 contained the bulk of Vermeer's works (see document of 16 May 1696).

83
A. Houbraken, *De Groote Schou burgh der Nederlantsche Konstschilders en Schilderessen,* 1, Amsterdam, 1718, p. 236. He also left out the last stanza of Arnold Bon's poem (see document of 1667 and Wheelock, "Carel Fabritius" [op. cit., note 47], p. 77, note 4).

84
Dezallier d'Argenville, "Lettre sur le choix & l'arrangement d'un Cabinet curieux . . . ," in *Mercure de France,* Juin 1727, p. 1298; reprint Geneva, 1968, XII, p. 333. This passage was rediscovered by *Wheelock 1977, Review,* p. 439. The other "maitres flamans" that Dezallier d'Argenville judged worthwhile for a cabinet are (their names often terribly garbled): Dürer, Holbein, Lucas van Leyden, Bruegel, Pourbus, Bril, Elsheimer, Rottenhammer. Rubens, Steenwijck, Van Dyck, Jordaens, Diepenbeeck, "Corneille" (Cornelis van Haarlem?), Poelenburch, Brouwer, Teniers, Fouquier, van Laer, Both, Swanevelt, Rembrandt, Dou, van Mieris, Schalcken, Netscher, Snijders, Bertholet Flémalle, Miel, Wouwerman, Berchem, van Ostade, van der Meulen, van der Kabel, Genoels, Lairesse.

85
The concept and title of the exhibition "In the Light of Vermeer" *("In het licht van Vermeer"),* Mauritshuis, The Hague/Louvre, Paris (1966) led to a lengthy and heated discussion by art historians and critics in the Dutch press.

86
J. Smith, *A Catalogue Raisonne of the Works of the Most Eminent Dutch. Flemish and French Painters,* I, London, 1829, p. XXI.

87
The Literary Works of Sir Joshua Reynolds, II, London, 1819, pp. 367, 369, 374.

88
J. P. Lebrun, *Galerie des peintres flamands, hoffandais et affemands,* II, Paris, 1792-96, p. 49. See on Lebrun, as a pioneer in discovering forgotten artists: *Haskeff* 1976, pp. 18-23 and passim.

89
Redevoeringen ter inwijding der volbouwde tekenzaal . . . en voor de Gehoorzaal . . . in het Gebouw der Maatschappije Felix Meritis te Amsterdam gehouden den Illen en XXen November 1789 door A. Bonn, Amsterdam, 1790, p. 52.

90
The painting sold in 1765: P. Terwesten, *Catalogus of naamlijst . . .* (third volume of *Hoet*), The Hague, 1770, p. 504, no. 15. The one sold in 1774: Sale Frans van de Velde, Amsterdam, 7 September 1774, no. 43; it is now in the City Museum of Art. Birmingham *(Sutton 1980,* cat. no. 62, fig. 66).

91
See *Hofstede de Groot* I, no. 9a. He mentions the auctions of 1780 and 1809, where the picture was sold as a Vermeer, but failed to connect it with de Hooch. W. L. van de Watering has found the painting also attributed to Vermeer in auction catalogues: G. H. Trochel, Amsterdam, 11 May 1801, no. 48, and Amster-

dam, 16 June 1802, no. 99. Peter Sutton confirms these identifications *(Sutton 1980, p. 96, cat. no. 64).*

92

Hofstede de Groot, no. 12. The descriptions in the auction catalogues make it clear that the painting is identical with the painting fig. 106 (as already stated in cat. Provinzialmuseum, Hannover, 1930, no. 57). The picture is listed as "wrongly attributed to De Hooch . . . closer in design and figure type to Van Hoogstraten," in *Sutton 1980,* p. 139, cat. no. d4. Recently Willem L. van de Watering proposed an attribution to Michiel van Musscher, in his early period (oral communication).

93

For the paintings by Berckheyde, VreL Boursse, etc., see *Hofstede de Groot* I, pp. 612-13. Other paintings, described as Vermeers in *Murray* (pp. 19, 23, 140, 177), surely are or were by other artists.

94

Josi wrote in French. See S. Sulzberger. "Ajoute a la biographie de Vermeer de Delft," in *Kunsthistorische Mededeelingen van het Rijksbureau voor Kunsthistorische Documentatie* 3, 1948, p. 37. Josi adds that in 1798 he himself had bought a Vermeer at the Nyman auction: "l'homme tenant un compas a la main pour 7 louis." In fact he bought the painting in 1797 (see text of cat. no. 24).

95

R. van Eynden and A. van der Willigen, *Geschiedenis der vaderlandsche schilderkunst sedert de helft der XVIII eeuw,* I, Haarlem, 1816, pp. 164-68. In later years the authors maintained their strong interest in Vermeer and duly recorded the changes of ownership of *The Milkmaid* (vol. III, 1820, pp. 421, 446, 464). Another champion of Vermeer in that period was van der Willigen's friend Jeronimo de Vries, who in an essay of 1813 recommended Vermeer as an exemplary genre painter (see P. Hecht, "Candlelight and dirty fingers, or royal virtue in disguise: some thoughts on Weyerman and Godfried Schalcken," in *Simiolus* 11, 1980, p. 23, note 4).

96

See the copies mentioned in the text of cat. nos. 7, 9, 10, 13, 24, 26 by: A. Brondgeest, A. Delfos, W. Hendriks, G. Lamberts, C. van Noorde, H. Numan, P. E. H. Praetorius, J. Stolker, S. Troost, R. Vinkeles, V. van de Vinne, and J. G. Waldorp.

97

A View on a Canal by Dirk Jan van der Laan (1759-1829), which Thoré-Bürger published in 1866 as a Vermeer (de Vries, plate XXVIII), dates from the same period. See now on these artists: exhibition catalogue *Op zoek naar de Gouden Eeuw, Nederlandse schilderkunst 1800-1850,* Frans Halsmuseum, Haarlem, 1986.

98

J. Smith, *A Catalogue Raisonne of the Works of the Most Eminent Dutch Flemish and French Painters,* IV, London, 1834, pp. 110, 242.

99

My data on Thoré is primarily derived from Stanley Meltzoff's fascinating article, "The rediscovery of Vermeer," in *Marsyas* 2, 1942, pp. 145-66; unless stated otherwise, this article is the source of our quotations from Thoré. See also: A. Heppner, "Thoré-Bürger en Holland, de ontdekker van Vermeer en zijn liefde voor Neerlands Kunst," in *Oud Holland* 55, 1938, pp. 17-34, 67-82, 129-44; A. Blum, *Vermeer et Thoré-Bürger,* Geneva, 1946. For an extensive exploration of Thoré's ideas, see P. Grate, *Deux critiques d'art de l'epoque romantique: Gustave planche et Théophile Thoré,* Stockholm, 1959, and the recent publications of F. Suzmann Jowell, "Thoré-Bürger and the Revival of Frans Hals," in *The Art Bulletin* 56, 1974, pp. 101-17; *Thoré-Bürger and the Art of the Past.* New York, 1977. See on Thoré's appreciation of contemporary painting and of Vermeer the nuanced opinion of *Haskell,* pp. 86, 89 and passim. There are interesting comments on Haskell's theses in Ch. Rosen and H. Zerner. *Romanticism and Realism, the Mythology of Nineteenth-Century Art,* London/Boston, 1984, pp. 193-202. Haskell as well as Rosen and Zerner fail to take into account that Vermeer's works were always greatly appreciated by connoisseurs all over Europe long before Vermeer's name became fashionable, as I outlined above.

100

P. Grate, Deux critiques, op. cit., note 99, p. 252 ff.

101

Bürger. As early as 1860 Thoré had published a short article on Vermeer with a catalogue of works (W. Bürger, *Musées de la Hollande,* II, *Musée van der Hoop à Amsterdam et Musée de Rotterdam,* Brussels/Ostende, 1860, pp. 67-88). The earliest monograph on Vermeer is the four-page chapter in Ch. Blanc, *Histoire des peintres de toutes les écoles . . .* II, Paris, 1861, under: birthyear 1632. Blanc still thought of the *View of Delft:* "L'exécution en est grossière, l'empâtement brutal et l'aspect monotone." He credits Thoré for his research on Vermeer and refers to his *Musées de la Hollande.* He adds, however: "M. Bürger voit maintenant des *Delftsche* un peu partout." Another early reappraisal of Vermeer was presented by G. F. Waagen, *Handbuch der deutschen und niederländischen Malerschulen* II, Stuttgart, 1862, pp. 109-10. Waagen was the first to recognize *The Art of Painting* (plate 19) as a Vermeer.

102

Appreciation of the "Impressionistic" qualities of Vermeer's work lingers, more than is justified. The paintings cat. b1 and b2 are (at the least) so strongly abraded that their "Impressionistic" aspects are accentuated. Hardly anything is visible of the meticulous, pinpoint modeling that is so characteristic of Vermeer. Nevertheless, the two paintings are presented again and again, without much comment, as Vermeers.

103

H. Havard, *Van der Meer de Delft,* Paris, 1888.

104

Hofstede de Groot. German edition, Esslingen/Paris, 1907.

105

E. Plietzsch, *Vermeer van Delft,* Leipzig, 1911 (2nd edition, Munich, 1939).

Catalogue by Albert Blankert

Provenances by Willemm L. van de Watering

There is almost universal agreement today as to which paintings are authentic Vermeers and which ones were in the course of time mistakenly ascribed to him. In my opinion the most careful and reliable lists of "authentic Vermeers" are those of *de Vries* (1948) and *Bloch* (1963). Our catalogue includes all paintings considered by them to be autograph. Attributions of more recent date are discussed at the end of chapter four in the notes 2 and 5.

For each painting, the names of the authors of earlier lists of Vermeer paintings are given, each followed by the number the author gave the painting. followed by the date if the author proposes one (example: De Vries: 2, 1654-55). *Bloch* provides no continuous numbering of Vermeers.

Our catalogue lists the paintings in the order of the chronology proposed in chapter 3. This order varies slightly from the order of the plates, which follows the text most closely.

Facsimiles of all signatures can be found in *de Vries* (p. XXIX) and *Swillens*.

Dimensions: height precedes width.

All information in this book on a particular painting by Vermeer can be culled by consulting the Index on p. 227.

The provenances of the paintings were compiled by W. L. van de Watering, revised by Nora Kohler, with final editing and additions by Albert Blankert. Descriptions from early catalogues are given verbatim. Mentions preceded by an asterisk do not, so far as we know, occur in the earlier literature.

After a listing of a location the publication that first mentioned it is given in parentheses.

Sales are listed as in this example: Sale N. D. Goldsmid (The Hague). Paris (Drouot), 4 May 1876, no. 68. Which means: Sale of the N. D. Goldsmid collection (living in The Hague), held in Paris (at auction house Drouot) on 4 May 1876, printed catalogue number 68.

Prices and buyers are taken from annotated copies of the sales catalogues. Present locations of these copies are given in F. Lugt, *Répertoire des catalogues de ventes publiques intéressant pour l'art ou la curiosité*, 3 volumes, The Hague, 1938-64. Sales information in square brackets is taken from Lugt.

Where sources are cited by author's name only, see "Abbreviated literature" on p. 225 ff for full data.

Abbreviations: cat.=catalogue; d.="duim," which between c. 1750 and c. 1816 equaled a modern English inch, thereafter a centimeter; exh.=exhibition; F=florins=guilders= guldens; Fr=francs; h.=height, hoogte, hauteur; l.=width, lang, largeur; P.=on panel (N.B.: in the eighteenth century, canvases pasted on panel were often mentioned as merely "panel"); p=pouce="duim"; R.K.D.=Rijksbureau voor Kunsthistorische Documentatie (Netherlands Institute for Art History), The Hague; v.=voet=foot=12 d(uim).

1. (Plate 2)
CHRIST IN THE HOUSE OF MARY AND MARTHA.

Edinburgh, National Gallery of Scotland.
Signed lower left on the small bench.
Canvas, 160 x 142cm. (63x56in.).
Hofstede de Groot: 1. De Vries: 2, 1654-55. Bloch: before 1656. Goldscheider: 1. 1654. Wheelock: 1654-55.
1654-1656.

The painting was published as a Vermeer in 1901 (see publications mentioned in de Vries).

Swillens was the only recent author who did not believe the painting to be by Vermeer (Swillens, p. 64, no. B).

"Repentirs" prove that the master somewhat changed the position of Christ's right hand and the index finger of his left.

Provenance:
• Bought by a furniture dealer from a Bristol family for £8 (cat. National Gallery, Edinburgh, 1929) or "81 st." (*de Vries*).
• Collection Arthur Leslie Collie, London (*de Vries*).
• Art gallery Forbes & Paterson, London, exh. April 1901, cat. no. 1; in the catalogue W. A. Coats is mentioned as the owner.

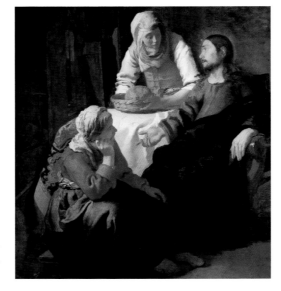

PLATE 2.
Christ in the House of Mary and Martha.

• Collection W. A. Coats, Skalmorlie Castle, Scotland, cat. 1904, no. 37, with the note: "engraved."
• Given to the museum in 1927 by Coats's two sons in memory of their father (cat. National Gallery, Edinburgh, 1929, p. 277 ff.; cat. 1978, no. 1670).

2. (Plate I)
DIANA AND HER COMPANIONS.

The Hague, Mauritshuis.
Indistinctly signed lower left on rock (see p. 164. note 7).
Canvas, 98.5 x 105 cm. (38 3/4 x 41 1/4 in.).
Hofstede de Groot: 3. De Vries: 1, 1654. Bloch: before 1656. Goldscheider: 2, 1655. Wheelock: 1655-56.
1654-1656.

The idea that the right side has been cut off (proposed by van Gelder 1956) is confirmed by a study of the pattern of the threads of the canvas as it is visible in the X-rays in the conservation department of the Mauritshuis (fig. 109). At the left, upper, and lower borders the threads display an undulating pattern, caused by the stretching of the canvas on the tenter before grounding. A pattern of straight threads is found in the rest of the canvas, including its right border. This almost certainly means that the canvas was cut there later (discussion with Hans Susijn, restorer at the Mauritshuis).

The picture has been compared to another Delft history painting, also featuring large-scale figures, dated 1657: Willem Verschoor's Cephalus and Procris in the Centraal Museum, Utrecht (E. J. Sluijter, in exh. cat. De stad Delft . . . van 1572

blocked

blocked

y

108. X-ray of the upper right corner of *Diana and Her Companions*. (cat. no. 2, plate 1). At the upper edge the horizontal threads undulae, at the right edge he vertical threads are straight.

tot 1667, Stedelijk Museum Het Prinsenhof, Delft, 1981, 1, p. 175; II, fig. 173).

Provenance:

• Sold by Dirksen art gallery, The Hague, to N. D. Goldsmid for F 175 (cat. Mauritshuis, 1935, no. 406).

• Sale Neville D. Goldsmid (The Hague), Paris (Drouotr) 4 May 1876, no. 68, as by Nicolaes Maes with reference to C. Vosmaer, *Rembrandt Harmens van Rijn . . .* The Hague, 1868 (p. 232: "*la Diane de la Collection Goldsmid.*" mentioned there among Maes's "chefs-d'œuvre") for Fr 10,000 to the state of the Netherlands, destined for the Mauritshuis. In cat. Mauritshuis 1876, no. 71a, as Nicolaes Maes; in the catalogues after 1877 with the addition "*marqué N.M. 1650*" and, from 1883 on, "*wellicht van Johannes ver Meer*" ("perhaps by Johannes ver Meer"). In cat. 1888, no. 71c, as "*Johannes ver Meer . . . 1650*". In cat. 1891, no. 194, again as Maes and with the remark (translated): "falsely signed, N. M. 1650 . . . not an ascertained Maes. It must very

PLATE 1.
Diana and Her Companions.

much be doubted that it could be by Vermeer of Delft." In cat. 1895, no. 406, as Johannes Vermeer van Utrecht. with facsimile of the signature and the note (translated): "also attributed to Joh. Vermeer of Delft." In cat. 1898, no. 406, as Vermeer of Utrecht, with the remark: "*niet zeker . . . ; vroeger . . . aan . . . Maes en door Sommigen aan den Delftschen Vermeer toegeschreven*" ("not certain . . . ; formely . . . ascribed . . . to Maes and by some to the Delft Vermeer").

3. (Plate 3)
THE PROCURESS.

Dresden, Staatliche Gemaldegalerie.
Signed and dated lower right 1656.
Canvas, 143 x 130 cm. (56 1/4 x 51 1/8 in.).
Bürger: 1. Hofstede de Groot: 41. De Vries: 3, 1656. Bloch: 1656. Goldscheider: 1656. Wheelock: 1656.
1656.

The young man on the left is wearing a costume and a beret that strongly resemble the dress of the painter in *The Art of Painting* (plate 19).
Provenance:

• Acquired in 1741 for the collection of the Elector of Saxony from the Wallenstein collection, Dux (cat. Dresden, 1896, no. 1335).

• Mentioned in the Dresden catalogues as follows: cat. 1765, no. 299: "*Jean van der Meer. Une jeune Courtisane entre les bras d'un Homme, qui lui donne de l'argent en presence de deux autres Hommes. Sur toile, de 5 pieds 1 pouce de haut, sur 4 pieds 7 pouces de large.*" ("Jean van der Meer. A young courtesan in the arms of a man who gives her money in the presence of two other men. On canvas, height 5 feet 1 inch, width 4 feet 7 inches"); cat. 1782, no. 299, as is clear from context, as by J. Vermeer van Haarlem; cat. 1826, no. 371: "*Jacques van der Meer, de Utrecht. Une jeune fille en société de trois hommes, dont l'un lui donne une pièce d'argent en l'embrassant; elle tient un verre à vin dans la main gauche. La partie inférieure du tableau est couverte d'un tapis. Figures de grandeur naturelle. Sur t. 5' 1" de h. 4' 7" de l.*" ("Jacques van der Meer, of Utrecht. A young girl in the company of three men, one of whom gives her a coin and embraces her; she holds a glass of wine in her left hand. The lower part of the painting is covered by a carpet. Life-size figures. On canvas height 5' 1" width 4' 7".)
N.B.: In the copy of this catalogue belonging to J.

PLATE 3.
The Procuress.

Smith now in the R.K.D., "Jacques" is crossed out and "Delft" written above.

Again recognized as Vermeer of Delft by Thoré (see W. Bürger, *Musées de la Hollande*, II, Brussels, etc., 1860, p. 77).

• In the Soviet Union from 1945 to 1955, see cat. *Ausstellung der von der Regierung der UDSSR an die Deutsche Demokratische Republik Übergebenen Meisterwerke*, Dresden, 1956, pp. 7-14, cat. no. 1335.

4. (Plate 4)
GIRL ASLEEP AT A TABLE.

New York, Metropolitan Museum of Art.
Signed on the left above the girl's head.
Canvas, 87.6 x 76.5 cm. (34 1/2 x 30 1/8 in.).
Hofstede de Groot: 16. De Vries: 4, 1656. Bloch: 1655-60. Goldscheider: 3, 1656. Wheelock: 1657.
1657.

The painting fragment visible in the top left corner is the Cupid ascribed to C. van Everdingen. This painting can be seen complete in plates 20 and b1. However, in the *Girl Asleep at a Table* a mask is added, lying at Cupid's feet. Contrary to the opinion of de Jongh and Kahr, Slive thinks that no symbolic significance can be attached to this mask (*Slive: de Jongh 1967*, p. 95, note 69; M. Millner Kahr, "Vermeer's Girl Asleep, a Moral Emblem," in *Metropolitan Museum Journal* 6, 1972, pp. 115-32, with the assembled data on cat. no. 4). In my opinion it is quite hazardous to draw interpretations from the *Cupid* in plate 4, as

PLATE 4.
Girl Asleep at a Table.

Mrs. Kahr does in her otherwise most careful study. No more than a part of one of his legs is visible: only those who know the complete painting from plates 20 and B1 could recognize Cupid in plate 4. Mrs. Kahr's theory that Vermeer was representing "Sloth" in plate 4 is more plausible. In a number of sixteenth- and seventeenth-century prints this vice is represented by a sleeping woman leaning on her arm in the same way (Kahr, op. cit.; her interpretation elaborated in *de Jongh 1976*, p. 146).

X-rays reveal that Vermeer probably first painted a dog in the door opening and a portrait of a man instead of a mirror in the back room and that the fallen rummer (bottom left) was painted or repainted by a later hand (*Walsh and Sonnenberg*, fig. 95; Kahr, op. cit., figs. 3, 10).

The quite new and promising technique of autoradiography revealed that Vermeer at some point planned to include on the table: 1. a dish in front of the sleeping girl., touching her left hand; 2. grapes and grape leaves added to or instead of the present right part of the still life; 3. minor changes in other details. (See M. A. Ainsworth et al., *Art and Autoradiography: Insights into the Genesis of Paintings by Rembrandt, Van Dijck, and Vermeer*, Metropolitan Museum of Art, New York, 1982, pp. 18-26, plates 7-10.)

Provenance:

• Collection Dissius, Delft, 1682; sale Amsterdam, 16 May 1696, no. 8: "*Een dronke slapende Meyd aen een Tafel. F 62*" ("A drunke sleeping girl at a table. F 62"). (See document of that date.)

• *Sale Amsterdam (V. Postumus), 19 December 1737, no. 47: "*Een Slapent Vrouwtje, van de Delfse van der Meer*" ("A sleeping woman. by the Delft van der Meer") to Carpi for F 8.5 st.

• Sale John W. Wilson (Paris), Paris (Ch. Pillet), 14 March 1881, no. 116, with etching by Courtry and elaborate description, for Fr 8500 to Sedelmeyer. N.B.: The picture does not (yet) occur in cat. *Collection de John W. Wjfson exposé dans la Galerie du cercle artistique et littéraire de Bruxelles*, Paris, 1873.

• Art gallery Sedelmeyer, Paris, *Illustrated catalogue of 300 paintings . . .* , Paris, 1898, no. 88, with ill. N.B.: We know from notes made by Sedelmeyer in a copy of this cat., now at the R.K.D., that the painting was sold to Rodolphe Kann, Paris, in 1881 for Fr 12,000.

• Collection Rodolphe Kann, Paris, cat. 1907, I, no. 89, with ill.

• Collection Benjamin Altman, New York (exh. cat. *Hudson-Fulton Celebration*, New York, 1909, cat. I, addenda no. 137 A).

• Bequeathed by Altman to the museum, 1913 (cat. *Metropolitan Museum*, 1931, no. V 59-2).

5. (Plate 6)
SOLDIER WITH A LAUGHING GIRL.
New York, The Frick Collection.
Canvas, 50.5 x 46 cm. (19 3/4 x 18 1/8 in.).
Bürger: 7. Hofstede de Groot: 39. De Vries: 6, 1657. Bloch: 1655-60. Goldscheider: 5, 1657. Wheelock: 1658.
1658.
The map on the wall. also depicted in no. 14 and in the left foreground of no. 22 (plates 14 and 21) represents Holland and West Friesland, as indicated by the Latin inscription "NOVA ET ACCVRATA TOTIVS HOLLANDIAE WESTFRISIAEQ. TOPOGRAPHIA." Other legible words: "HOLLAND, MARE GERMANICVM" and "DE ZUYDER ZEE." The wall map was made in 1620 by Balthasar Florisz. van Berckenrode; in 1621-1629, editions of the map were published by Willem Jansz. Blaeu (our fig. 4; see *Welu*, p. 529 ff.).

It seems to me that Vermeer's main source of inspiration for the painting was Pieter de Hooch's *Interior Scene*, now in London. our fig, 77, Others have linked the picture to de Hooch's *Two Soldiers Playing Cards* and *A Girl Filling a Pipe* of c. 1657/58, now in a private collection in Switzerland (*Gowing 1952*, fig. 20; *Sutton 1980*, plate 22, p. 81, no. 25, with reference to older literature).

Provenance:

• Collection Dissius, Delft. 1682; sale Amsterdam, 16 May 1696, no. 11: "*Een Soldaet met een laggent Meysje, zeer fraei. F 44.10*" ("A soldier with a laughing girl, very beautiful. F 44.10"). (See document of that date.)

• *Sale Charles Scarisbrick, London (Christie's). 10 May 1861, no. 89: "De Hooghe. Interior of an apartment with a cavalier in a red dress and large hat, in conversation with a lady in a yellow and black dress; they are seated at a table, near an open window, through which the light falls on the lady's face with admirable effect; a map of Holland is suspended against the wall," for £ 87.3 to Lee Mainwaring (identified as our cat. no. 5 by Peter Sutton).

• Collection Leopold Double (lender to *Exposition retrospective, tableaux anciens . . .* , Palais des Champs-Elysées, Paris, 1866, cat. no. 107); acquired by Double in a sale in London as by Pieter de Hooch for 235 guineas according to Bürger (*Bürger,* p. 548, with etching by J. Jacquemart).

• Sale Double (Paris), Paris (Pillet), 30 May 1881, no. 16, with detailed description, for Fr 88,000 to Gauchey for Prince Demidoff (see P. Eudel. *L'Hôtel Drouot en 1881*, Paris, 1882, p. 233).

• Collection Samuel S. Joseph (lender to exh., Royal Academy, London, 1891, cat. no. 52).

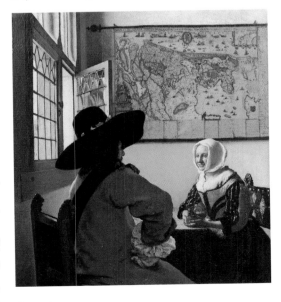

PLATE 6.
Soldier with a Laughing Girl.

• Collection Mrs. Joseph (lender to exh. Royal Academy, London, 1900, cat. no. 18, and 1909/10, cat. no. 50).

• Art gallery Knoedler, New York; acquired by H. C. Frick, 1911 (cat. Frick, 1968).

6. (Plate 5)
GIRL READING A LETTER AT AN OPEN WINDOW.

Dresden, Staatliche Gemäldegalerie.
Traces of signature to the right in the middle.
Canvas, 83 x 64.5 cm. (32 3/4 x 25 1/4 in.).
Bürger: 31. Hofstede de Groot: 34. De Vries: 5, 1657. Bloch: 1655-60. Goldscheider: 6.1658. Wheelock: 1657.
1659.

X-rays (see our fig. 110) reveal a glass on the left on the table, another very large glass in the lower right corner (now covered by the curtain), slight changes in the position of the figure, and, in the upper right, the same picture of a *Standing Cupid* that Vermeer left visible in cat. nos. 25 and b2 (plates 20 and B2) and in part in cat. 4 (plate 4) (the X-rays first published by *Wheelock 1981*, fig. 29, and *Mayer-Meintschel 1982*, figs. 1, 3, 4). In cat. 6 this Cupid was gigantic in comparison. being of the same size as the reading girl herself. The inclusion of Cupid in cat. 6 would have led us to believe that the girl is reading a love letter. By leaving out the picture-within-the-picture in his final version, Vermeer apparently wanted to subdue this hint.
Provenance:

• ? Sale Pieter van der Lip, 1712 (see cat. no. 14).

• Acquired in 1742 by de Brais in Paris for August III, Elector of Saxony, Dresden, as by Rembrandt. as can be concluded from a letter by de Brais in Paris to Graf Brühl, dated 23 April 1742: "*Dans le nombre des tableaux que votre Excellence recevra if y en a un de Rembrant représentant une jeune fille vis à vis d'une fenêtre. Il m'a été donné par desseus le marché.*" ("Among the pictures that Your Majesty will receive there is one by Rembrandt, representing a young girl opposite a window. It has been given to me in addition to the deal.")

In the inventory of the Dresden collection by Guarienti (1747-1750) under no. 1530: "*Maniera di Rembrandt. Quadro in tela, con una Donna, che legge una carta, appoggiandosi ad una tavola copperta d'un tapeto, con sopra un piatto di frutta*

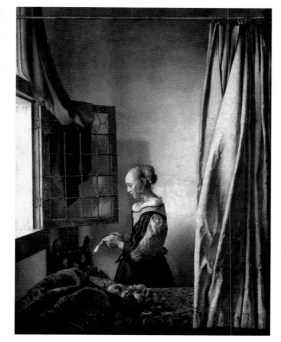

PLATE 5.
Girl Reading a Letter at an Open Window.

2' 11 1/2" x 2' 3 1/2" ("Manner of Rembrandt. Painting on canvas, with a lady, who reads a paper, leaning herself against a table that is covered by a tapestry, on top of it a bowl of fruit"). In the 1754 inventory again as an authentic Rembrandt. In the printed catalogues of the years 1756-1801 as "*School of Rembrandt*," in 1801 with the addition "*par Gobert*" (Govert Flinck). In 1783 engraved by Joh. Ant. Riedel as Flinck. In 1806 for the first time catalogued as "*Van der Meer aus Delft. Eine junge Hollanderin steht am offenen Fenster und liest einen Brief; Kniestück. Ein vorzügliches Gemalde im starksten Effecte des Tageslichtes*" ("Van der Meer from Delft. A young Dutch woman stands at the open window and

109.
X-ray of *Girl Reading a Letter at an Open Window.*

reads a letter; three-quarter length. An excellent picture with the strongest daylight effect"). In 1812 again as "*J. van der Meer*," in 1817 again as Flinck. From 1826 to 1860 as Pieter de Hooch. Ever since 1862 (when the signature was mentioned for the first time) as Vermeer. (Data taken from *Mayer-Meintschel*, pp. 91, 94, and p. 97. notes 4, 5, 7.)

• In addition to this: *Cat. des tableaux de la Galerie Electorale à Dresde*, 1765, p. 68, no. 346: "*De l'ecole de Rembrandt. Une jeune fille debout devant une fenêtre ouverte, lisant une lettre, figure jusqu'aux genoux. Sur toile, 2 pieds, 9 pouces de haut sur 2 pieds 3 pouces de large*" ("School of Rembrandt. A young girl standing before an open window, reading a letter, three-quarter length figure. On canvas, height 2 feet 9 inches, width 2 feet 3 inches"). The same description occurs in *Abrégé de la vie des peintres dont les tableaux composent La Galerie . . . Dresde*, 1782, p. 317, no. 346.

• *Verzeichnis der Gemälde . . . zu Dresden*, 1801. p. 49, no. 346, as "*Aus der Schule Rembrandts, von Gobert*" ("From the school of Rembrandt, by Gobert," i.e., Govert Flinck).

• *Cat. des tableaux de la Galerie Royale de Dresde*, '1826, p. 74, no. 486, as by "*Pierre de Hooghe*," with a note in J. Smith's handwriting in his copy at the R.K.D.: "*Delfts van der Meer.*"

• Recognized anew as Vermeer of Delft by G. F. Waagen. *Einige Bemerkungen über die . . . Koeniglichen Gemäldegalerie zu Dresden*, Berlin, 1858, pp. 35, 36 (see W. Bürger. *Musées de la Hollande* II, Brussels, etc., 1860, p. 75).

• *Verzeichnis der Dresdner Gemäldegalerie*, 1862, no. 1433, as "*Jan van der Meer (van Delft).*"

• From 1945 to 1955 in the Soviet Union (see cat. *Ausstellung der von der Regierung der UDSSR an die Deutsche Demokratische Republik Obergebenen Meisterwerke*, Dresden, 1956, p. 22, cat. no. 1336).

7. (Plate 8)
THE MILKMAID.

Amsterdam, Rijksmuseum.
Canvas, 45.5 x 41 cm. (17 7/8 x 16 1/8 in.).
Bürger: 25. Hofstede de Groot: 17. De Vries: 9, 1658. Bloch: 1655-60. Goldscheider: 9,1660. Wheelock: 1658-60.
1660-1661.

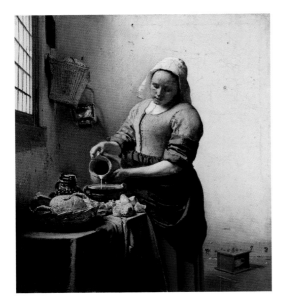

PLATE 8.
The Milkmaid.

The Milkmaid may have been intended as a modernized, strongly reduced version of a "kitchen-piece," a genre created by the sixteenth-century masters Pieter Aertsen and Joachim Betickelaer, which had become archaic and uncommon in the seventeenth century except in Delft, where it was continued after 1600 by numerous artists including Cornelis Delff, Pieter van Rijck, and Willem van Odekercke. The Delft topographer van Bleyswyck praises in 1667 *"keuckens"* ("kitchens") by the Delft painters Christiaen van Bieselingen and Michiel van Miereveld (*Bleyswyck*, pp. 842-50). Listed in the 1632 inventory of the ex-king of Bohemia's palace in Rhenen is: *"Ein stück von allerhand Küchenwirtschaft von einem Meister von Delft"* ("A picture representing a variety of kitchenware by a Delft artist"). Apparently the author of the inventory did not know the artist of the picture but recognized its subject as typical of "Delft" (see J. Kretschmar, "Das Kurpfälzische Schloss zu Rhenen . . ." in *Mitteilungen zur Geschichte des Heidelberger Schlosses IV*, Heft 2, Heidelberg. 1902, p. 114).

It would seem that Vermeer derived his motif of a frontally seen girl who pours a liquid from one vessel into another from Gerard Dou's so-called *Cuisinière hollandaise* in the Louvre in Paris (fig. 112; observed by Gowing, p. 111). That picture is dated ca. 1635-1640 in W. Martin, *Gerard Dou, Des Meisters Gemälde* (Klassiker der Kunst), Stuttgart/Berlin, 1913, ill. p. 118,. but may

have been painted in the 1640s. Vermeer's *Milkmaid* has been linked to prints by Lucas van Leyden and Hendrick Goltzius representing *Temperance*, which also depict a woman pouring a liquid from one vessel into another (L. D. Couprie, "Melkmeisje als symbool voor de Matigheid," in *NRC Handelsblad*, 19 December 1975, p. CS 2 and 6). But to interpret Vermeer's *Milkmaid* as a depiction of *Temperance* is untenable, as it would mean that Vermeer took away the essence from the personification: in depictions of *Temperance* the woman always pours water into wine, illustrating how the effect of alcohol is tempered.

Provenance:

• Collection A. Dissius. Delft; sale Amsterdam. 16 May 1696, no. 2: *"Een Meyd die Melk uytgiet uytnemende goet.* F 175.-" ("A Girl pouring Milk, outstandingly good, F 175.-"). (See document of that date.)

• Sale Amsterdam, 20 April 1701, no. 7: *"Een Melkuytgietstertje, van dito* [=Vermeer van Delft], *krachtig geschildert"* ("A Milkpouring Girl, by the same [Vermeer of Delft], vigorously painted"), for F 320 (*Hoet* I, p. 62). *This was a sale of paintings belonging to Isaac Rooleeuw; in his inventory the painting is mentioned as *"Een melkuytgietsertie van dezelve"* ("a milkpouring girl by the same") (S.A.C. Dudok van Heel, op. cit., under cat. no. 15).

• Sale Jacob van Hoek, Amsterdam, 12 April 1719, no. 20: *"Het vermaerde Melkmeysje, door Vermeer van Delft konstig"* ("The famous milkmaid, by Vermeer of Delft, artful"), for F 126 (*Hoet* I, p. 221).

• Sale [Pieter Leender de] N[eufville], Amsterdam

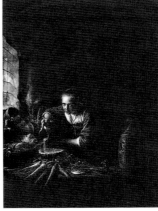

(See text of cat. no. 7.)

110 Gerard Dou (1613-1675), *Woman Pouring Water from a Jug into a Saucer,* also called *La cuisinière hollandaise*, 1635-40, panel, 36 × 27.4 cm. Louvre, Paris.

(J. M. Cok), 19 June 1765, no. 65: *"Delftse vander Meer. Een keuken-Vrouwtje, met Bywerk; zijnde krachtig van licht en bruin, en sterk werkende. P, 17 1/2 duim hoog, 15 1/2 duim breed"* ("Delft vander Meer. A kitchen-maid, with accessories; vigorous in light and brown, and very expressive. Panel, height 17 1/2 inches, width 15 1/2 inches"), for F 560 to Yver *"voor een Engels lord"* ("for an English lord") (note of C. Hofstede de Groot).

• *Sale of *"Een voornaam Liefhebber"* ("A distinguished amateur") [Dulong], Amsterdam (H. de Winter and J. Yver), 18 April 1768, no, 10: *"De Delfsche vander Meer. Een Binnen-vertrek. op Doek geschilderd, hoog 17, breed 15 1/2 duim. In dit stuk ziet men een Vrouwtje aan een Tafel staanm gietende Melk uit een Kan in een Panm die op de Tafel staat; waarby een Mantje met brood en eenig ander bywerk gezien wordt: zynde krachtig van licht en bruin, en van een natuurlijke werking"* ("The Delft vander Meer. An inner room, painted on canvas, height 17, width 15 1/2 inches. In this painting one sees a woman standing at a table, pouring milk from a jug into a bowl, which stands on the table; also a little basket with bread and some more accessories: being vigorous in light and brown, and giving a natural effect"), for F 925 to Van Diemen.

• Seen in 1781 by J. Reynolds at J. J. de Bruyn's (see p. 158).

• Sale Jan Jacob de Bruyn, Amsterdam (Ph. van der Schley), 12 September 1798, no. 32: *"De Delfsche vander Meer. Dit uitmuntend en fraai Tafreel, verbeeld in een Binnevertrek, een Vrouwtje in oude Hollandsche Kleeding staande voor een tafel, met een groen kleed bedekt, waar op een korfje met brood, eenig ander gebak, een aarde bierkan en pot geplaatst is, in welke zy uit een aardekan melk, schynt te gieten: verder aan de muur hangt een mandje en koperen emmer, en op den grond staat een stool, het licht, het geen door een vengster ter zyde invalt geeft eene verwonderlyk natuurwerking, is kragtig van coloriet en uitmuntende van penceel behandeling, en een der schoonste van deezen onnavolgbaaren Meester, hoog 18, breed 16 duim. Doek"* ("The Delft vander Meer. This excellent and beautiful scene, represents in an inner room a woman dressed in old Dutch costume standing before a table covered with a green cloth, on which are placed a little basket with bread, some other pastry, an earthenware tankard and a

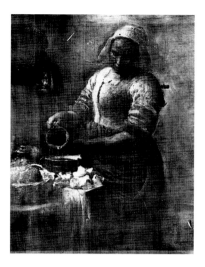

III.

X-ray of *The Milkmaid.* The underpainting of the figure is in a much broader and quicker touch than that of the still life on the table. Vermeer may have begun painting the figure in a short session with a life model. The still life could be done at more leisure because the objects remained at his disposal. Weelock mentions an X-ray as providing proof that Vermeer originally painted an extra object on the wall *(Wheelock, 1981).*

pot into which she seems to pour milk from an earthenware jug; on the wall hangs a small basket and a brass bucket, and on the floor is a foot-warmer; the light, falling in through a window at the side, gives a miraculously natural effect, the painting is of vigorous coloring, and excellent for its handling of the brush and one of the most beautiful of this inimitable Master. Height 18, width 16 inches. Canvas") for F 1550 to J. Spaan.

• Sale Hendrik Muilman, Amsterdam (Ph. van der Schley), 12 April 1813, no, 96: "*De Delftsche vander Meer. In een Keukenvertrekziet men eene Dienstmaagd in oud Hollandsche Kleeding, staande voor eene Tafel met een groen Kleed bedekt waarop een Korf met Huisbakken Brood: op de Tafel zijn nog andere dergelijke stukken brood, als mede een aarden Bierkan en Pot in welken zij uit een aarden Kan melk schijnt te gieten; aan den Muur, waarop zeer kunstig en natuurlijk de ingeslagen spijkers zigtbaar zijn,. hangt een Mandje en Koperen Emmer: op den voorgrond staat een Stoof, onder tegens den Muur gebakken Steentjes; het licht ter zijde door een venster invallende, doet eene voortreffelijke werking, overeenkomstig de natuur. Het is krachtig van kleur, stout van behandeling, en het best van dezen Meester. Hoog 18, breed 16 duimen Doek*" ("The Delft vander Meer. In a kitchen-room one sees a servant girl in old-fashioned Dutch costume,

standing before a table covered with a green cloth on which a basket with homemade bread; on the table are other such pieces of bread, as well as an earthenware tankard and a pot, into which she seems to pour milk from an earthenware jug; on the wall, where the hammered-in nails are visible in a very artful and natural way, hangs a little basket and a brass bucket; in the foreground stands a foot-warmer, below against the wall baked tiles; the light, falling in through a window at the side, makes an excellent effect, in accordance with nature. It is of vigorous color, audacious of treatment, and the best of this Master. Height 18, width 16 inches. Canvas") for F 2125 to "De Vries W." N.B.: This should be understood as: "to Art Dealer Jer. de Vries by order of van Winter," i.e., Lucretia Johanna van Winter (1785-1845). In 1822 she married Jhr. Mr. Hendrik Six van Hillegom (1790-1847). At the same Muilman auction other paintings were also sold to "De Vries W." which, like our cat. no. 7, later became part of the collection of the direct descendants of Hendrik Six (Muilman no. 131: J. Ruisdael and no. 138: R. Ruysch are exh. cat. Six Collection, 1900, nos. 120 and 181).

• Six collection, Amsterdam, seen in 1819/23 by J. Murray: "A woman in a yellow dress, with a mess of porridge before her: the figure is clumsy, but there is great nature and beauty in the execution. Her gown is of coarse materials, and she wears a large white cap. The wall of the room is light" (*Murray,* p. 155). Exh. cat. Six Collection, Amsterdam, 1900, no. 70.

• Purchased by the museum, 1907/8 (see also F. Lugt, *Is de aankoop door het Rijk van een deel der Six-collectie aan te bevelen?* brochure, 1907, 2 printings).

Copies:

A watercolor copy after the picture signed by *S[ara] Troost* (1732-1803) was at sale ploos van Amstel, 3 March 1800, kunstboek Y no. 5. A copy by *Reinier Vinkeles* (1741-1816), with additions by him. was sold at the Jan van Dyk sale. Amsterdam (Ph. van der Schley), 14 March 1791, Portfolio G., no. 11 (for F 50 to Van Loon) and at an Amsterdam sale (Roos), 14 February 1855, cover C, no. 94 (to Gruyter, for F 30). A colored drawing after the painting was made by *Jan Gerard Waldorp* (1740-1808). sale W. T. Groen, Amsterdam, 2 November 1813, Portfolio C, no. 39.

8. (Plate 7)

A LADY DRINKING AND A GENTLEMAN.

West Berlin, Gemäldegalerie Dahlem.

Canvas, 66.3 x 76.5 cm. (26 x 30 1/8 in.).

Bürger: 20. Hofstede de Groot: 37. De Vries: 11. 1658-60. Bloch: 1655-60. Goldscheider: 11. 1660. Wheelock: 1658-60.

1660-1661.

The picture on the rear wall is in the style of the landscape painter Allaert van Everdingen. When cat. no. 8 was acquired by the Berlin Museum the leaded window had been overpainted and replaced by a curtain and a view through a wholly open window into a landscape; the overpaintings were subsequently removed. The old condition is reproduced in E. Plietzsch, "Randbemerkungen zur Ausstellung hollandischer Gemälde im Museum Dahlem," in *Berliner Museen. Berichte aus den ehem. preussischen Kunstsammlungen* NF, 1, 3/4, 1951 (pp. 36-42), p. 41, fig. 6. More data on the picture are given by J. Kelch in *Sutton 1984,* p. 339.

The coat of arms in the window (depicted in the same way in plate 12. see our fig. 113) is believed to have been the coat of arms of the family of Jannetje Jacobsdr. Vogel, the first wife of Moses Jans van Nederveen, who died in 1624 in Delft; possibly this couple lived in the house where Vermeer later resided; according to *Neurdenburg 1942,* p. 69, the artist may have found this coat of arms in a window and painted it.

On top of the coat of arms the same woman holding reins is visible as in the same place in plate 12 (cat. 11). She probably personifies *Temperance* and was included as a hint that the drinking woman in the painting or the onlooker who watches her should practice that virtue (see

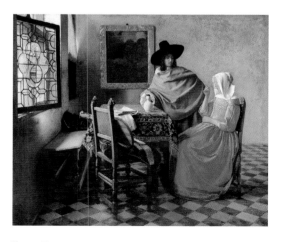

PLATE 7.

A Lady Drinking and a Gentleman.

112.
Detail of *A Lady and Two Gentlemen* (cat. no. 11, plate 12); the coat of arms in the window and the representation of Temperance above it. The same combination appears on *A Lady Drinking and a Gentleman* (cat. no. 8, plate 7).

text of our cat. no. II and Klessmann's article referred to there).

Provenance:

• Sale Jan van Loon. Delft. 18 July 1736, no. 16: "*Een zittend drinkend Vrouwtje, met een staande Mans-Persoon, door van der Meer h 2 v. 2 d. br. 2 v. 6 d. f. 52*" ("A seated woman, drinking with a standing man, by van der Meer, h. 2 f. 2 inches w. 2 f 6 inches. f. 52") (*Hoet* II, p. 390).

• Bought by John Hope. Amsterdam, in 1774, "uit de hand" (J. W. Niemeijer, "De Kunst-verzameling van John Hope [1737-1784]," in *Nederlands Kunsthistorisch Jaarboek* 32, 1981 [pp. 127-232], p. 187).

• Collection J. Hope, Amsterdam, 1785; the hand-written Catalogus van het Cabinet Schilderyen of this collection at the R.K.D. states: "*Meer (van der) bijgenaamd de Delftse. Een Heer staande by een dame die in een groot vertreck aan een tafel zit en een glas uitdrinkt . . . 26 1/4 x 30 1/4 D.*" ("Meer [van der] alias the Delft one. A gentleman standing with a lady who in a large room sits at a table and empties a glass. 26 1/4 x 30 1/4 in.").

John Hope (1737-1784) was a prominent merchant and banker in Amsterdam. His sons Thomas (died 1830) and Henry Philip Hope (died 1839) fled to England when the French invaded Holland in 1794. In England they both had an important collection of paintings, yet our cat. no. 8 does not figure in Waagen's full description of Thomas Hope's collection in London, which he visited in 1830 (G. F. Waagen, *Treasures of Art in Great Britain* II, London, 1854, p. 112 ff.). The collec-

tions of both brothers were inherited by Sir Henry Thomas Hope of Deepdene, Surrey (died 1862), then by his daughter Henrietta Adela (died 1884), who married Henry Pelham, 6th Duke of Newcastle-under-Lyme (1834-1879). Henry Francis Hope Clinton-Hope, who owned the Vermeer in 1891, was their son and heir (these data derive from sale cat. *Hope Collection of Pictures of the Dutch and Flemish School*, 1898, introduction; Burke's Peerage, 1953, p. 1555; J. E. Elias, *De vroedschap van Amsterdam*, II, Haarlem, 1905, pp. 933 and 934, and Niemeijer, op. cit.).

• Collection Lord Henry Francis Hope Pelham Clinton Hope (cat. 1891, no. 54).

• Sold in 1898, as part of the complete H. F. Clinton Hope collection, for £121 550 *in toto*, to art dealers P. & D. Colnaghi and A. Wertheimer (sale cat. *Hope . . .* op. cit., introduction and no. LIV, with ill.).

• Purchased by the museum in 1901 (cat. Berlin, 1931, no. 912 C).

9. (Plate 9)
THE LITTLE STREET ("HET STRAATJE").

Amsterdam, Rijksmuseum.
Signed left below the window.
Canvas, 54.3 x 44 cm. (21 3/8 x 17 1/4 in.).
Bürger: 49. Hofstede de Groot. 47. De Vries: 7, 1658. Bloch: 1655-60. Goldscheider: 7,1659. Wheelock: 1657-58.
1661.

Provenance:

• Collection Dissius, Delft, 1682; sale Amsterdam, 16 May 1696, no. 32: "*Een Gesicht van een Huys staende in Delft f. 72-10*" ("A view of a House standing in Delft f. 72-10"). (See document of that date.)

• On 22 November 1799 in the estate of Mrs. Croon, widow of G. W. van Oosten de Bruyn: "*Een gezigt op 2 huysjes in de stad Delft door de Delftsche Vermeer*" ("A view of 2 little houses in the town of Delft by the Delft Vermeer") (A. Bredius. in Oud-Holland 39, 1921, pp. 59-62).

• Sale [van Oosten de Bruyn], Haarlem (Van der Vinne), 8 April 1800, no. 7: "*Een Gezigt op twee Burger Huizen in de Stad Delft, tusschen byde ziet men een Gang, alwaar agter in, een Vrouw aan een Tobbe staat te waschen, in 't Huis ter regterzyde zit in 't Voorhuis voor aan de deur een Vrouw te naai-jen, en op de Stoep leggen twee Kinderen te speelen,*

dit stuk is wonder natuurlyk en fraai geschildert. door de Delftsche vander Meer, h. 1 v. 10, b. 1 v. 3/4 d." ("A view of two burgher houses in the city of Delft, between them one sees an alley, at the far end of which a woman stands washing at a tub, in the house on the right a woman sits sewing in the hall at the front door and two children lie playing on the sidewalk, this painting is wonderfully natural and beautifully painted, by the Delft vander Meer, h. 1 f. 10,w. 1 f. 3/4 inches"), for F 1040 (the first digit is indistinct) to H. van Winter. N.B.: This refers to the Amsterdam merchant and poet Pieter van Winter (1745-1807), father of Lucretia van Winter. who later inherited his collection.

• Inherited by the Six family (on this inheritance, see cat: no. 7).

• Collection Six, Amsterdam, 1819-1824 seen by J. Murray: "A side view of part of a street. At the open door of one house an old woman is sitting at work: down an alley another woman is washing the pavement. The whole is touched with that truth and spirit which belong only to this master" (*Murray*, p. 155).

• Exh. cat., Collection Six, Stedelijk Museum, Amsterdam, 1900, no. 71.

• Bought by H. W. A. Deterding and presented to the Rijksmusem, 1921 (cat. Rijksmuseum, 1934, no. 2528b).

Copies:

A painted copy after the painting was in the sale E. B. Rubbens et al., Amsterdam, 11 August

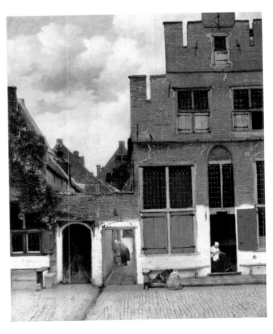

PLATE 9.
The Little Street ("Het Straatje").

114

X-ray of *The Little Street* (cat. no. 9, plate 9). It reveals that Vermeer originally planned to depict a standing girl in front of the house, directly to the right of the open alleyway.

1857, no. 67. From the early nineteenth century on numerous drawn and watercolor copies by the following artists are mentioned: *C. van Noorde* (1731-1795): sale A. Watering, Amsterdam (c. F. Roos), 7 November 1866. no. 158. *R. Vinkeles* (1741-1816): sale D. Baron van Leyden, Amsterdam (Ph. van der Schley), 13 May 1811, cover K, no. 20; sale W. Baartz, Rotterdam (Lamme), 6 June 1860, Portfolio B, no. 43; sale Blussé van Zuidland & Velgersdijk, Amsterdam, 15 March 1870, no. 324. *G. Lamberts* (1776-1850): sales 1825 and 1826 (see *Hofstede de Groot*) and sale Jer. de Vries, Amsterdam (Roos), 15 November 1853, Portfolio J, no. 244; sale D. van Lankeren, Amsterdam (Roos), 22 January 1856, Portfolio G, no. 166; sale A. Watering, Amsterdam (Roos), 7 November 1866, Portfolio E, no. 171. *A. Brondgeest* (1786-1849); sale J. Schepens et al., Amsterdam (Ph. van der Schley), 21 January 1811, Portfolio L, no. 13.

Some of these copies may have been not after our cat. no. 9, but possibly after our cat. no. 10 or 36 or after one of the paintings by Vrel (see p. 160), which at one time were attributed to Vermeer.

10. (Plate 10)
VIEW OF DELFT.

The Hague, Mauritshuis.
Signed with monogram below left, on the boat. Canvas, 98.5 x 117.5 cm. (38 3/4 x 46 1/4 in.). Bürger: 48. Hofstede de Groot: 48. De Vries: 8, 1658. Bloch: 1660. Goldscheider: 10, 1660. Wheelock: 1660-61.
1661.

To the right of the two women in the foreground a man was painted and then overpainted by Vermeer himself. Today he is again vaguely visible, through the paint (see *Swillens*, fig. 69A and B).

The reflection in the water of the porch and its two steeples, which now reaches into the bottom of the picture, was originally planned much shorter, as is revealed by X-ray in our fig. 115 (cf. *Wheelock 1981*, Art Journal). A detailed study of the painting and of the depicted site appears in A. K. Wheelock. Jr,. and C. J. Kaldenbach, "Vermeer's View of Delft and his Vision of Reality," in *Artibus et Historiae. Rivista internazionale di arti visive e cinema* 6, 1982, pp. 9-35. The authors point out that the area was a busy harbor and probably most often made a less quiet impression than in Vermeer's painting. They conclude that in other respects too "Vermeer made a number of small adjustments in his depiction of the site to enhance its pictorial image." Recent guesses on the picture's connotations appear in E. Haverkamp Begemann and A. Chong, "Dutch Landscape and its Associations," in *Art Treasures of Holland, The Royal Picture Gallery Mauritshuis*, ed. H. R. Hoetink, Amsterdam/New York, 1985, pp. 60-61.

Provenance:
• Collection Dissius, Delft, 1682; sale Amsterdam, 16 May 1696, no. 31: "*De Stad Delft in perspectief, te sien van de Zuyd-zy. F 200-0*" ("The Town of Delft in perspective as seen from the South. F 200." (See document of that date.)
• Sale S. J. Stinstra et al. (Harlingen). Amsterdam (Jer. de Vries), 22 May 1822, no. 112: "*Dit kapitaalste en meestberoemdste Schilderij van dezen meester, wiens stukken zeldzaam voorkomen, vertoont de stad Delft, aan de Schie; men ziet de geheele stad met hare poorten, torens, bruggen als anderzins: op den voorgrond heeft men twee vrouwen, met elkander [in] gesprek, terwijl ter linkerzijde eenige lieden zich als gereed maken in eene jaagschuit te treden: verder liggen voor en aan de stad verscheiden schepen en vaartuigen. De schildering is van de stoutste, kragtigste en meesterlijkste, die men zich kan voorstellen: alles is door de zon aangenaam verlicht; de toon van licht en water, de aard van het metselwerk en de beelden maken een voortreffelijk geheel, en is dit Schilderij volstrekt eenig in zijn soort, hoog 9 p. 8d., breed 1 el 1 p. 6d. Doek.*" ("This most capital and most famous painting by this master, whose works seldom occur, shows the city of Delft, on the Schie river; one sees the whole town with its gates, towers, bridges etc.; in the foreground there are two women in conversation, while on the left some people seem to be preparing to step on board a tow barge; furthermore in front of and against the town lie various ships and vessels. The way of painting is of the most audacious, powerful and masterly that one can imagine; everything is illuminated agreeably by the sun; the tone of light and water, the character of the brickwork and the figures make an excellent ensemble, and this painting is absolutely unique of its kind. Height 9 dm., 8 em., width 1 m., 1 dm., 6 em. Canvas", for F 2900 to de Vries.

• Purchased by the State of the Netherlands, as stated in a letter from the Minister of the Interior, dated 5 June 1822, to the director of the museum (cat. Mauritshuis, 1935. no. 92). According to A. B. de Vries, the decision to acquire the picture for the Mauritshuis was instigated by King Willem I. The museum's director. Jonkheer Johan Steengracht van OostCapelle, had reported: "*Er zijn nog op deze verkooping een schilderij van Hobbema en een door den Delftschen Van der Meer welke bijzonder zijn, dog na mijn oordeel, minder geschikt voor het kabinet*" ("At this auction are also a painting by Hobbema and one by the Delft Van der Meer which are special, but in my opinion less fit for the museum"). But the director of the Amsterdam Rijksmuseum, Cornelis Apostool, was eager to buy the picture for his museum (A. B. de Vries, in *150 jaar Koninklijk Kabinet van Schilderijen, Koninklijke Bibliotheek, Koninklijk Penningkabinet*, The Hague, 1967, p. 55).

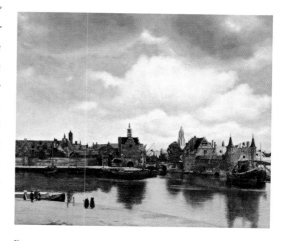

PLATE 10.
View of Delft.

114.
X-ray of a detail right part of the *View of Delft.*

• Seen in the Mauritshuis by Sir John Murray 1822/1823: "*Van der Meer . . . A view of Delft: the effect of it at a distance is wonderful: but on approaching it appears a coarse daub*" (Murray, p. 50).

Copies:

A "*Stadsgezigt, zijnde een Kopie naar een beroemd Schilderij van den Delftschen van der Meer*" ("View of a town, being a copy after a famous painting by the Delft van der Meer") by P. E. H. Praetorius (1791-1876) was at the exh. *Levende Meesters*, Amsterdam, 1814, cat. no. 116. Another copy, on panel, after the "*Gezigt op de Stad Delft*" was at sale Amsterdam, 8 November 1824, no. 46 (for F 126 to de Vries). Drawn and watercolor copies were made by: *C. van Noorde* (1731-1795; sale 1834); *R. Vinkeles* (1741-1816; sale 1833); *W. Hendriks* (1744-1831; sale 1819), and *H. Numan* (1744-1820; sale 1793, 1800, and 1820), For specifics on these sales, see *Hofstede de Groot*. The last-mentioned copy was also in the sale of Dr. D. Baron van Leyden, Amsterdam (van der Schley), 13 May 1811, Portfolio N, no. 15. An anonymous copy done "*in sapverwen*" (watercolors) was in the sale J. Nauta et al., Amsterdam (de Vries), 12 April 1842, Portfolio O, no. 10. Undoubtedly one of these copies is a drawing in the Staedelsches Kunstinstitut at Frankfurt that sometimes has wrongly been considered a preliminary study by Vermeer. This drawing presumably originates from sale de Vos, Amsterdam, 1833, where it was sold for F 92. In the municipal archives in Delft is a drawing representing a view of the same site by P. van Liender, dated 1752 (information from cat. Mauritshuis, 1935). Other depictions of the site are reproduced in A. K. Wheelock and C.

J. Kaldenbach, op. cit., figs. 4, 12, 15-18, 21. For other copies possibly after cat. no. 10, see cat. no. 9.

11. (Plate 12)
A LADY AND TWO GENTLEMEN.
Braunschweig, Herzog Anton Ulrich-Museum.
Signed left on the window.
Canvas, 78 x 67 cm. (30 5/8 x 26 3/8 in.).
Bürger: 6. Hofstede de Groot: 38, De Vries: 12, 1658-60. Bloch: 1660. Goldscheider: 15, 1663. Wheelock: 1659-60.
1662.
For the coat of arms in the window, see fig. 113 and text of cat. no. 8. The portrait in the background may be after one of the family portraits mentioned in the inventory of Vermeer's widow (see document of 29 February 1676). Judging from the descriptions of the painting made in 1744 and 1776 (cited below) the sitting man was at that time overpainted.

It has often been stated that the painting is in poor condition. As early as 1900 Jan Veth remarked that the Berlin restorer Hauser had "handled it too roughly" ("*te zeer heeft aangepakt,*" in *De Kroniek* 6, 1900, p. 68). Under the decayed varnish, however, the details appear to be generally well preserved.

R. Klessmann ingeniously explained several details of the picture (in exh. cat. *Die Sprache der Bilder*, Herzog Anton Ulrich-Museum. Braunschweig, 1978, no. 39). He pointed out that the lady drinking in the company of two men while simultaneously flirting with the onlooker probably looked indecent to the 17th-century viewer. The wine makes her an easy prey for her obtrusive companion. The rich costumes, the silver plate with two citrus fruits on the table, and the paper next to it which probably contains tobacco, show indulgence in luxury. This spendthrift luxury may have been intended to contrast with the "forefather" in his sober attire on the portrait in the background. On top of the coat of arms in the window a woman holds two strings that look like reins (fig. 113). A woman holding reins was a traditional personification of Temperance. So this figure hints that the "actual" woman in the painting should keep within bounds in drinking, as well as resist yielding to her courtier (*Klessmann*, op. cit.; the identification of Temperance was made by Wolfgang J. Muller in Kiel; earlier,

Mirimonde, p. 46, tentatively interpreted this figure as *Dialectica.* holding a spiraling serpent).

It has been suggested that Vermeer characterized the man sitting at the table as the woman's mournful, jilted lover, B. Bedaux, in *Antiek* 10, 1975, p. 35). Another possibility is that his passivity is caused by inebriation (Klessman, op. cit., p. 167). In any case. he seems to have given in to Intemperance, be it in love or in wine or both. Klessman (loc. cit.) and Naumann (*Naumann I,* pp. 61, 64) suggest that cat. no. 11 is influenced by Frans van Mieris's *Teasing the Pet* and/or *The Oyster Meal*, both now in the Mauritshuis in The Hague (our fig. 116; *Naumann*, plate and cat. no. 35). Indeed, in both paintings by van Mieris, as in the Vermeer, the main theme is a lady sitting at a table being approached by a man standing behind. But his approach is subdued in character in the Vermeer, when compared to the amorous gestures and flirting grin of the gentleman in both van Mierises. The latter are dated 1660 and 1661 respectively, which would make them indeed slightly earlier than the Vermeer. The data on our cat. no. 11 have been compiled by R. Klessmann, cat. Herzog Anton Ulrich-Museum. *Die holländischen Gemälde*, Braunschweig 1983, no. 316.
Provenance:

• *Collection Dissius, Delft; sale Amsterdam, 16 May 1696, no. 9: "*Een vrolijk gezelschap in een kamer, kragtig en goet. F 73*" ("A merry company in a room, vigorously and well painted. F 73").

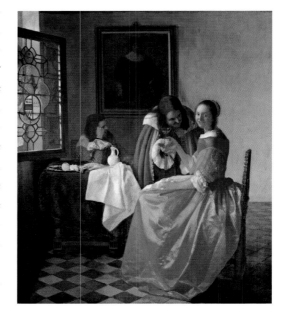

PLATE 12.
A Lady and Two Gentlemen.

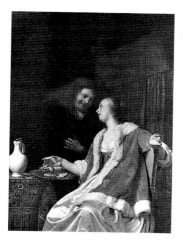

115.
Frans van Mieris, *The Oyster Mead*, signed and dated 1661, panel, 27 × 20 cm. Mauritshuis, The Hague.

(See document of that date.) N.B.: This text has never before been associated with our cat. no. 11. Since this painting was, fifteen years later. in 1711, again, called *"Eine lustige Gesellschaft"* ("A merry company," see below), it seems probable that the two paintings are the same.

• First mentioned as being in Braunschweig around 1711, in T. Ouerfurt, *Kurtze Beschreibung des fürstlichen Lust-Schlosses Saltzdahlum . . . Braunschweig, Catalogus derer vornehmsten Schildereyen so in dem Furstl. Saltzdahlischen Lust Schlosse befindlich . . .* : *"Eine lustige Gesellschaft."* In a manuscript of 1744 as *"Einen jungen Herrn mit seiner Geliebten"* ("A young gentleman with his beloved"; see H. Riegel, *Beiträge zur Niederl. Kunstgeschichte* II, Berlin, 1882, p. 331 ff,). Described in C. N. Eberlein, *Verzeichniss der . . . Bilder-Galerie zu Saltzthalen*, Braunschweig, 1776, pp. 127, 128, no. 30: *"Johann von der Meer, Ein Frauenzimmer in einem rothen Kleide von Atlas, sitzet mit einem Glase Wein in der Hand, an einem Tische, und lachelt. Hinter ihr steht eine Mannsperson, welcher ihr Glas mit anfasst und sie zartlich ansieht. Das Zimmerhat ein bemahltes Fenster, und an der Wand hangt ein Portrait. Auf Leinwand, 2 Fuss 4 Zoll breit, 2 Fuss 8 Zoll hoch"* ("Johann von der Meer. A woman in a red satin dress, sits with a glass of wine in her hand at a table. and smiles. Behind her stands a man, who holds her glass with her and looks at her tenderly, The room has a painted window. and on the wall hangs a portrait. On canvas, 2 feet 4 inches wide, 2 feet 8 inches high").

• During the period of Napoleon I, 1807-1815, in Paris (Klessman, loc. cit., 1983).

• In catalogue by L. Pape, 1849, no. 142, as by *"Jacob van der Meer."*

• Recognized by Thoré as Vermeer van Delft (W. Bürger, *Musées de la Hollande*, 11, Brussels, etc., 1860, p. 72 ff.).

12. (Plate 11)
WOMAN WITH A WATER JUG.
New York, Metropolitan Museum of Art.
Canvas, 45.7 x 40.6 cm. (18 x 16 in.).
Hofstede de Groot: 19. De Vries: 10. 1658-60. Bloch: 1660, Goldscheider: 16.1663. Wheelock: 1664-65.
1662.

In the background, part of a map of the Seventeen Provinces published by Huyck Allart is visible, one copy of which has been preserved (our fig. 117: see *Welu*, p, 534), On the technique of the painting, see the article, illustrated with an X-ray photograph, etc., by H. von Sonnenburg (*Walsh and Sonnenburg*).
Provenance:

• *Collection Robert Vernon. 1838 (exh. Pictures by Italian . . . Masters. British Institution. London, 1838, cat. no. 29: "A Female at a window, Metzu").

• *Sale Robert Vernon (Hatley Park. Cambridgeshire), London (Christie), 21 April 1877, no. 97: "Metzu Interior, with a lady at a table covered with a carpet, on which is an ewer and dish, opening a window," for £404.5 sh., to art dealer Colnaghi, London, N.B.: The above has never been associated with our painting, but was published by Hofstede de Groot as referring to a lost work by Metsu (*Hofstede de Groot* I, Metsu, no. 62).

• Sold by Colnaghi to Lord Powerscourt for 600 guineas (author's copy of Hofstede de Groot at R.K.D.), (i.e., Mervyn Wingfield, 7th Viscount Powerscourt, 1836-1904; see *Burke's Peerage*, ed. 1953); in his collection as early as 1878, as is evident from exh. cat. *Old Masters, Winter Exhibition*, Royal Academy, London, 1878, no. 267: "Jan van der Meer, of Delft. Lady at a casement. Three-quarter figure of a lady, in a blue and yellow jacket and blue skirt, and white hood and cape, standing near a table, on which is a basin and ewer, and a casket: she has her l. hand on the ewer, and is in the act of closing the casement with her r. Canvas, 17 1/2 by 15 1/2 in."

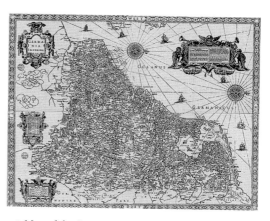

116. Map of the Seventeen Provinces of the Netherlands, published by Huyck Allart. The map is depicted on plate 11. (See text of cat. no. 12)

• Art dealer Thos. Agnew. London (author's copy of *Hofstede de Groot* at R.K.D.).

• Art dealer Ch. Pillet, Paris, sold to Henry G. Marquand, New York, 1887, for $800 as by Pieter de Hooch (author's copy of *Hofstede de Groot*), N.B.: According to W. R. Valentiner in *Monatshefte für Kunstwissenschaft* III, 1910, p. 11, acquired by Marquand for "800 dollars at an American sale. as by Pieter de Hooch."

• Given to the museum in 1888 by Marquand (cat. Metropolitan Museum of Arts, 1931, no. V 59-1).

13, (Plate 13)
WOMAN WITH A PEARL NECKLACE.
West Berlin, Gemaldegalerie Dahlem.
Signed on the table.
Canvas, 55 x 45 cm. (21 5/8 x 17 3/4 in.).
Bürger: 33. Hofstede de Groot: 20. De Vries: 18,

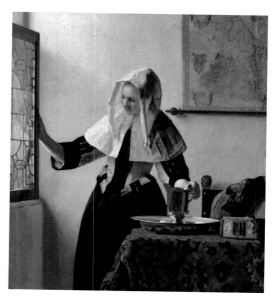

PLATE 11.
Woman with a Water Jug.

1662-63. Bloch: 1665, Goldscheider: 18.1665. Wheelock: 1664.

1662-1665.

Wheelock mentions unpublished scientific research indicating that Vermeer originally painted an object on the seat of the chair, probably a lute (*Wheelock 1981, Art Journal*). He also argues that the outer rims of the painting were at some time tampered with. but that by now they would have been restored to their original dimensions (Wheelock 1977, p. 330, note 97; Wheelock 1981, p. 110).

Provenance:

• Collection Dissius, Delft, 1682; sale Amsterdam, 16 May 1696, no. 36: "*Een Paleerende dito* [=juffrouw], *seer fraey. . .*" ("Another ditto [=a young lady] adorning herself, very beautiful") for F 30. (See document of that date.)

• Sale Johannes Caudri, Amsterdam (Ph. van der Schley), 6 September 1809, no. 42: "*De Delfsche van der Meer. In een gemeubileerde Kamer staat eene bevallige jonge Dame voor een Tafel, waar boven een Spiegel geplaatst is, zij is gekleed in een geel Satijn Jakje met Bont gevoerd, en schijnt zig te Paleeren: het invallende zonlicht versprijdt zig tegen een witte Muur en doet alle de Voorwerpen met luister voorwaards koomen; dit bevallig tafreel is een der natuurlykste en alleruitvoerigst gepenceelden van deze beroemde Meester, hoog 20, breed 17 duim. Doek*" ("The Delft van der Meer. In a furnished room stands a graceful young lady at a table, above which a mirror is placed, she is dressed in a yellow satin jacket lined with fur, and seems to be adorning herself; the incoming sunlight spreads against a white wall and makes all objects stand out with splendor; this elegant scene is one of the most natural and most elaborately painted of this famous Master, height 20, width 17 inches. Canvas"), for F 55 to Ths. Spaan.

• Sale [D. Teengs], Amsterdam (Ph. van der Schley), 18 April 1811, no. 73: "*De Delftsche van der Meer. In een gemeubileerde Kamer, ziet men eene jonge bevallige Dame voor eene Tafel, zij is gekleed in een geel Satijn Jakje met Bont, het invallende zonlicht verspreidt zich tegen een witte Muur en doet een schoone werking. Het is zeer fraai en uitvoerig gepenceeld. Hoog 18, breed 16 duimen. Doek*" ("The Delft van der Meer. In a furnished room, one sees a young graceful lady at a table, she is, dressed in a yellow satin jacket

with fur. the entering sunlight spreads against a while wall and makes a beautiful effect. It is very beautifully and elaborately painted. Height 18, width 16 inches. Canvas"), for F 36 to Gruyter.

• *Sale Amsterdam (Roos), 26 March 1856, no. 93: "*De Delftsche van der Meer. Een Binnenvertrek: voor eene tafel staat een rijk gekleede Dame, bezig zijnde een snoer paarlen om te doen, zeer natuurlijk en fraai behandeld, h. 52, br. 46 d. Doek*" ("The Delft van der Meer. An inner room; at a table stands a richly dressed lady. occupied in putting on a string of pearls; very naturally and beautifully done. h. 52, w. 46 em. Canvas") for F 111 to Philip.

• Collection H. Grevedon (*Bürger*, p. 559) (not as Vermeer in sale Grevedon, Paris, 15 January 1853).

• Collection Thoré-Bürger, 1866 (*Bürger*, p. 559, with engraving on p. 325).

• Sale Comte C[ornet de Ways Ruart of Cremer. George H. Philips and W. Bürger], Brussels (E. Le Roy), 22 April 1868, no. 49, with description copied from Bürger, pp. 558-59, for 3500 to Sedelmeyer. (N.B.: It is therefore improbable that Bürger possessed the painting in 1869, as has always been stated.)

• Collection Suermondt, 1874 (cat. Kaiser-Friedrich-Museum, Berlin, 1911 and 1931, no. 912 B).

Copy:

A drawn copy after the painting done by *Jan Gerard Waldorp* (1740-1808) was in the sale of P. Yver, Amsterdam (Ph. van der·Schley), 31 March 1788, no. 27 (for F 10.10 to Pruyssenaar).

14. (Plate 14)
WOMAN IN BLUE READING A LETTER.
Amsterdam, Rijksmuseum.

Canvas, 46.5 x 39cm. (18 1/4 x 15 1/4 in.).
Bürger: 32. Hofstede de Groot: 31. De Vries: C. 1662-63. Bloch: 1660-65. Goldscheider: 17, 1664. Wheelock: 1662-64.

1662-1665.

The map is the same as the one depicted in cat. nos. 5 and 22 (see there and *Welu*, p. 532 ff.). Wheelock thinks that Vermeer himself folded the outer rims of his original picture around the stretcher and that they were added to the actual surface later by a restorer (*Wheelock 1977*, p. 330, note 97; *Wheelock 1981*, p. 110).

Provenance:

• The following reference from 1712 may concern either cat. no. 14 or cat. no. 6: Sale Pieter van der Lip, Amsterdam, 14 June 1712, no. 22: "*Een leezent Vrouwtje. in een kamer, door vander Meer van Delft 110.0*" ("A woman reading, in a room, by vander Meer of Delft 110.0") (*Hoet*, I, no. 22).

• *May very well be identical with "*Blauwe meisje door Vermeer van Delft f. 15*" ("Blue girl by Vermeer of Delft, 15 guilders") in the inventory of the late Mozes de Chaves, dated 9 December 1759 (Municipal Archives, Amsterdam, Notarial Archives, Notary Jan Willem Smit; see Jacob Meijer, *The Stay of Mozes Haim Luzzato at Amsterdam 1730-1743*, Amsterdam, 1947, p. 12; kind communication of Volker Manuth).

• *Sale Amsterdam, 30 November 1772, no. 23: "*Van der Neer, de Delftsche. Dit Kabinet-stukje, verbeeld een Binnevertrek; waar in een bevallig Dametje, staande een Brief te leezen voor haar Toilet; ziende men agter dezelve, aan de Muur, een Land-Kaart. Zeer fraai, uitvoerig en natuurlijk behandeld: op Doek, hoog 18 en een half, breed 16 duim*" ("Van der Neer, the Delft one. This cabinet-piece, depicts an inner room; in it a graceful lady, standing and reading a letter at her toilet: behind her, on the wall, one sees a map. Very beautifully, elaborately and naturally treated; on canvas, height 18 and a half, width 16 inches").

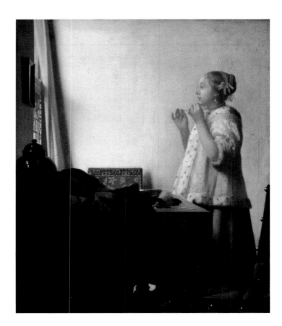

PLATE 13.
Woman with a Pearl Necklace.

• Sale P. Lyonet, Amsterdam, 11 April 1791, no. 181: "*De Delfsche van der Meer. In een Binnenvertrek ziet men een jonge Dame gekleed in een Blaauw Zatyn Jakje, staande voor een Tafel waar op een Koffertje. Paarlen en Papieren leggen: schynende beezig met veel aandagt een Brief te lezen: aan de witte Muur hangt een groote Landkaart, gestoffeerd met verder Bywerk; dit Stuk is fraay en natuurlyk behandeld op Doek, door de Delfsche van der Meer, het bevallig ligt en donker geeft een schoone welstand, gemeenlyk eigen aan de werken van deeze beroemde Meester, h. 18, br. 15 duim*" ("The Delft van der Meer. In an inner room one sees a young lady dressed in a blue satin jacket, standing at a table on which lie a small box, pearls,. and papers; she seems to be reading a letter with much attention; on the white wall hangs a large map, filled in with other accessories; this piece is beautifully and naturally treated on canvas, by the Delft van der Meer, the pleasing light and dark lend it a fine appearance as is commonly characteristic of the works of this famous Master, h. 18, w. 15 inches"), for F 43 to Fouquet.

• *Sale Amsterdam (Ph. van der Schley), 14 August 1793, no. 739: "*Delfsche van der Meer. In een Binnekamer staat een Vrouwtje, in 't blauw Satyn gekleed voor een tafel, bezig zynde een brief te leezen die zy met beide handen vasthoud, op de Tafel ziet men een Koffertje en een snoer Paarlen, en aan de muur hangt een groote*

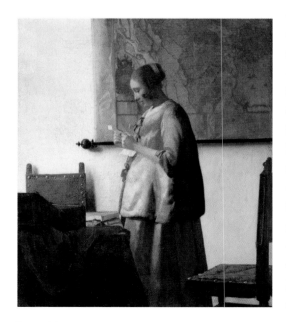

PLATE 14.
Woman in Blue Reading a Letter.

Landkaart; dit schildery dat van een byzondere natuurlyke werking is, is ongemeen fraai, uitvoerig en meesterlyk gepenceeld. Doek, hoog 19, breed 15 1/2 duim" ("Delft van der Meer. In an inner room stands a lady, dressed in blue satin at a table, reading a letter which she holds with both hands, on the table one sees a little box and a string of pearls, and on the wall hangs a large map; this painting, which makes an extremely natural effect, is unusually beautiful, elaborate and masterly painted. Canvas, height 19, width 15 1/2 inches"), for F 70.

• Sale Herman ten Kate, Amsterdam (Ph. van der Schley), 10 January 1801, no. 118: "*Delftsche van der Meer. Een Dame in 't blauw Fluweel gekleed, staat voor een Tafel, een brief te Leezen, tegen de muur hangt een Landkaart het licht in dit stukje geeft een goede uitwerking en is kloek gepenceeld. Hoog 19, breed 16 duim. Doek*" ("Delft van der Meer. A lady dressed in blue velvet, stands at a table. reading a letter, on the wall hangs a map, the light in this piece gives a good effect and it is of vigorous touch. Height 19, width 16 inches. Canvas"), for F 110 to Taijs.

*Sale [Lespinasse de Langeac], Paris (A. paillet), 16 January 1809, no. 85: "*Van der Meer de Delft. L'Intérieur d'un Appartement où l'on voit au milieu une jeune Femme dans un déshabillé du matin. Elle est debout et occupée à lire une Lettre attentivement. Une Table, des Chaises et une Carte de Géographie forment des accessoires rendus avec beaucoup de vérité. Cette Production, quoique très-simple, est recommandable par l'expression naïve de la Figure et l'effet de lumière, mérite ordinaire des Ouvrages de ce Peintre. Peint sur toile, haut. 17, largo 14 p.*" ("Van der Meer of Delft. The interior of an apartment where one sees in the middle a young lady in a morning dressing gown. She is standing and engaged attentively reading a letter. A table, seats and a map form the accessories. which are rendered with much truth. This work, although very simple, is recommendable because of the naive expression of the figure and the effect of the light, which is a usual merit of the works of this painter. Painted on canvas, high 17, wide 14 inches"), for F 200 (mentioned by *Bürger*, p. 558, and repeated by later authors, but always incomplete).

• Sale L[apeyriere], Paris (Henry), 19 April 1825, no. 127: "*Van der Meer. La Toilette. Une Femme*

117.
X-ray of *Woman in Blue Reading a Letter* (cat. no. 14, plate 14)..

vue à mi-corps, debout nue tête, vêtue d'une camisole de soie bleu de ciel, est placée vis-à-vis d'une toilette sur laquelle on remarque un collier de perles et un coffre ouvert. Elle tient dans ses mains une lettre qu'elle parait lire avec beaucoup d'attention. Cette figure se détache en demi-teinte sur une muraille blanche, ornée d'une grande carte géographique suspendue à des rouleaux. Outre que ce tableau est très-piquant d'effet, rien n'est plus naturel que la pose de la femme, ni mieux exprimé que l'intérêt que lui inspire la lettre qu'elle lit. Toile, hauteur 17 pouces, largeur 14 pouces" ("Van der Meer. The Toilet. A woman seen at half-length, standing, bareheaded, dressed in a chemise of sky-blue silk, is placed before a dressing table, on which one notes a string of pearls and an open box. In her hands she holds a letter which she seems to be reading with much attention. This figure detaches itself in half-tones from a white wall, adorned with a large map suspended by rollers. This painting is of a very piquant effect and moreover nothing is more natural than the pose of the woman, nor better expressed than the interest inspired by the letter she reads. Canvas, height 17 inches, width 14 inches"), for Fr 2060 (according to *Bürger*, p. 558: possibly for Fr 1122 to Bellandel).

• N.B.: Ever since cat. *Rijksmuseum . . . schilderijen*, 1885, p. 103, no. 164, it has been stated that the painting was in the sale Comte de Sommariva, Paris (Paillet), 18 February 1839, sold for Fr 882, but it does not appear in the catalogue of that sale.

• Bought from J. Smith. London, 1839, by A. van der Hoop, Amsterdam (cat. Rijksmuseum 1934, no. 2527).

• Collection van der Hoop, bequeathed to the city of Amsterdam, 1854; on loan to the Rijksmuseum, 1885.

15. (Plate 15)
WOMAN HOLDING A BALANCE.

Washington, National Gallery of Art.
Canvas, 42.5 x 38 cm. (16 3/4 x 15 in.).
Bürger: 26127. Hofstede de Groot: 10. De Vries: 17, 1662-63. Bloch: 1660-65. Goldscheider: 21, 1665. Wheelock: 1662-64.
1662-1665.

The picture was always designated "The woman weighing gold" or "weighing pearls," but Wheelock observed that the scales of the balance are in fact empty (*Wheelock 1977, Review*, p. 440). He also noted that the frame of the picture on the wall reaches lower at the right side of the girl than at the left (*Wheelock 1981*, p. 108). In this "unnatural" way Vermeer created a blank background for the balance. This painting on the wall seems to be an (otherwise unknown) work by a sixteenth-century Netherlandish master. To Goldscheider it "looks like a later version of a famous composition by Jean Bellegambe" (*Goldscheider*, p. 130).

Ivan Gaskell proposed the ingenious theory that the *Woman Holding a Balance* is an *Allegory of Truth*. He linked it to the following passage in the Dutch edition of Cesare Ripa's *Iconologia of uytbeeldingen des Verstands . . .* , translated by D. P. Pers, Amsterdam, 1644, p.590: "*Verita, Waerheyt. Een Blinckende vrouwe, van een eedel opsicht, met een gouden Paruyck cierlyck in 't wit gekleet, houdende in de rechter hand een Spiegel, die met eedelsteenen verciert is, en in de ander hand een gulden Balance of Weechschael*" ("Truth . . . A shining woman, of noble appearance, with a golden hairdress, elegantly dressed in white, holding in her right hand a mirror, decorated with jewels, and in her other hand a golden balance or scales"). If Gaskell is right, Vermeer took some liberties with Ripa: he left out the "golden hairdress," reduced the white dress to white ermine trimming, put the mirror on the wall, the jewels on the table, and the balance in the woman's right hand. Ripa explained this image of Truth with the aid of religious connotations, in which Christ's second coming is also mentioned. Similarly, by adding the picture of the Last Judgment in the background, Vermeer would have alluded to

Christian Truth (I. Gaskell, "Vermeer, Judgment and Truth," in *The Burlington Magazine* 126, no. 978, September 1984, pp. 557-61).

It may be added that in Roemer Visscher's emblem book *Sinnepoppen* of 1614 the image of the empty balance stands for "silent and just" ("*stom en rechtveerdigh*"), because: "A right kind of Balance, that has not been tampered with, displays (without respect of persons) the correct weight and reveals truth to the light of day" ("*Een rechten aert van de Balance, die ongevalst [sonder aensien van persoone] de rechte wichte toont, ende de waerheydt aen den dagh brenght*"); *Roemer Visscher, Sinnepoppen, Het derde Schock*, no. XXXIX; emphasis mine.

Moreover, Professor E. de Jongh kindly draws my attention to a print by Jan Wierix (1549-1615 or later) representing *Veritas* triumphing over the powers of the world (our fig. 119; on this print: M. Mauquoy-Hendrickx *Les Estampes des Wierix*, vol. 2, Brussels, 1979, p. 277, no. 1519, ill. on p. 206). These powers are visible in the globe under the left foot of the woman standing in the center, who represents *Veritas*. In her left hand she holds a book with seven seals hanging from it, on which is written: "*Ego sum Via, Veritas et Vita, Joan, 14*" ("I am the way and the truth and the life. John 14, 6"). With her right hand she holds a balance, and in the background is depicted the Last Judgment. This is the same combination as in Vermeer's *Woman Holding a Balance*. In the print a lighted candle is placed over the middle of the balance. Vermeer may have replaced the candle by the light falling only through the upper part of the window in his painting.

Nanette Salomon revived the old idea that the women in cat. and plate 15 and in cat. and plate 14 are pregnant (Nanette Salomon, "Vermeer and the Balance of Destiny," in *Essays in Northern European Art Presented to Egbert Haverkamp-Begemann on his Sixtieth Birthday*, Doornspijk, 1983, pp. 216-21). However, the fashion of the 1660s made normal women's stomachs look as protruding as in the two Vermeers, as can be observed in countless portraits of women of the period. Salomon also interprets cat. no. 15 as depicting Vermeer's ideas on the question of predestination, on astrology subordinated to Christianity, on the Catholic religion, on "the significance of the mother and the value of

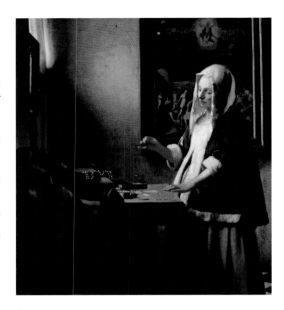

PLATE 15.
Woman Holding a Balance.

the home," and on various other matters. Her proof seems to me very farfetched and arbitrary and for that reason difficult to discuss. It has elsewhere been proposed that the lady in cat. no. 15 being pregnant, is balancing pearls in order to find out the sex of her unborn child, a method known as "pendeln" and said to be practiced in Germany until recently (R. Cartensen, "Ein Arzt betrachtet ein Bild von Vermeer," in *Deutsches Aerzteblatt, Aerztliche Mitteilungen* 68, 52, 1971, pp. 1-6). A recent discussion and more data on this painting appear in Sutton 1984, cat. no. 118.
Provenance:

• Collection Dissius, 1682; sale Amsterdam, 16 May 1696. no. 1: "*Een Juffrouw, die goud weegt, in een kasje . . . extraordinaer konstig en kragtig geschildert. F 155*" ("A young lady, weighing gold, in a box . . . painted in an extraordinarily skilful and vigorous way. F 155"). (See document of that date.)

• Sale Amsterdam, 20 April 1701, no. 6: "*Een Goudweegstertje, van Vermeer van Delft*" ("A woman weighing gold, by Vermeer of Delft"), for F 113 (*Hoet* 1, p. 62). This was a sale of painting owned by the Amsterdam merchant Isaac Rooleeuw (c. 1650-1710). who had gone bankrupt. In his inventory. which also included our cat. no. 7. the painting is similarly called "Een goutt weegstertie van Van der Meer van Delft" (S.A.C. Dudok van Heel, in *Jaarboek van het Genootschap Amstelodamum* 37. 1975. p. 162).

• *On 15 August 1703 in the inventory of Paulo van Uchelen (c. 1641-1702), Amsterdam: "*Een

goudt weegstertien van Van der Meer" ("A woman weighing gold by Van der Meer"), valued at F 150, allotted to Paulo van Uchelen, Jr. (*Dudok van Heel*, loc. cit.).

• *Sale Amsterdam (B. Tideman), 18 March 1767, no. 6: "*Een Binnevertrek in het zelfe een Goudweegster, zynde een staand Vrouwtje voor een Tafel, hebbende een Jakje aan met een witte Bontte rand, en is van vooren en op de zyde te zien, in haare Regterhand heeft zy een. Goud schaaltje, en verder is de Tafel half overdekt met een Kleed, op dezelven leggen Paarle en andere Kleinodie, kragtig uytvoerig en Zonagtig op Doek geschildert, hoog 16 duim, breed 14 duim*" ("An inner room in which a woman weighing gold, being a woman standing at a table, wearing a jacket with a border of white fur, and is seen from the front and from the side, in her right hand she holds a pair of gold scales, and furthermore the table is half covered with a rug, on which lie pearls and other trinkets, painted in a vigorous elaborate and radiant way, on canvas, height 16 inches, width 14 inches"). for F 170 to Kok.

• Sale Nicolaas Nieuhoff, Amsterdam (Ph. van der Schley), 14 April 1777, no. 116: "*De Delftsche van der Meer. Een binnenkamer: alwaar een vrouwtje bezig is, goud te wegen, haar hoofd is gedekt met een wit kapje, hebbende een donker blaauwen fluweelen mantel, met wit bont gevoerd, om: zy staat voor een tafel, waarop een blaauw kleed legt, beneffens een kasje met paarlen, en andere kleinodien: ten einde van 't vertrek aan de muur een schildery, verbeeldende 't laatste oordeel, dit is zeer malsch en vet in de vert geschilderd, en wel in den besten tyd, van dezen meester. Hoog 16 114, en breed 14 duim. Pnl.*" ("The Delft van der Meer. An inner room, where a woman is engaged in weighing gold, her head is covered with a white cap, wearing a dark blue velvet coat, lined with white fur; she stands at a table, on which lies a blue cloth, next to a little box with pearls and other trinkets; at the end of the room on the wall a painting, representing the Last Judgment; this is painted very softly and thickly and certainly is from the best period of this master. Height 16 1/4, width 14 inches. Panel"), for F 235 to Van den Bogaard. The word "Pnl." seems to indicate that the canvas at that time was laid down on panel.

• Sale [Roi de Bavière], Munich, 5 December 1826, no. 101: "*Gabriel Metzu, et selon d'autres van der Meer. L'intérieur d'une chambre oú une

femme debout devant une table tient une balance de la main droite, sur la table on voit des perles éparses et un écrin auprès d'un tapis bleu foncé. La muraille qui est derrière la femme est ornée d'un grand tableau. Sur toile. H. 1' 3" 6"', L. 1' 4" (pieds, pouces et lignes de France). Ce tableau est marqué du monogramme: GM*" ("Gabriel Metsu, and according to others van der Meer. The interior of a room where a woman standing at a table holds a pair of scales with her right hand, on the table one sees scattered pearls and a jewel case next to a dark blue cloth. The wall behind the woman is decorated with a large painting. On canvas. H. 1' 3" 6", W. 1' 4" [French measurements]. This painting is marked with the monogram: GM"). N.B.: In J. Smith's copy of this sale cat. in his handwriting: "*Delft van der Meer*" (copy at the R.K.D.).

• Sale Due de C[araman], Paris (Lacoste), 10 May 1830, no. 68: "*Vander Meer de Delft. La peseuse de perles. Une jeune dame, la balance a la main, est debout dans sa chambre à coucher, près d'une table en partie couverte d'un tapis; des perles sont sur la table à côté d'un écrin, et c'est par désœuvrement, sans doute, qu'elle s'amuse à les peser. M.le duc de C . . . a fait acheter ce délicieux tableau à la vente du Cabinet particulier du feu roi de Bavière, aux yeux de qui on l'avait fait passer pour un ouvrage de Gabriel Metzu. Il n'est point de peinture dont l'exécution soit d'une douceur plus exquise. La figure vêtue d'un japon et d'un manteau de lit garni d'hermine (costume simple que le goût ne réprouvra jamais) se détache sur un fond de muraille grisâtre, ce qui produit un effet aussi naturel qu'il est heureusement rendu. Un tableau masque une partie du mur. Les productions de Vander Meer de Delft sont si rares que nous ne pouvons nous dispenser de signaler celle-ci d'une maniere toute particuliére aux amateurs. T., h. 15 p. 61., 1. 16 p.*" ("Vander Meer of Delft. The woman weighing pearls. A young lady, a pair of scales in her hand, stands in her bedroom, at a table partly covered with a rug; on the table lie pearls next to a jewel box, and it is certainly from idleness that she amuses herself weighing them. The Count of C . . . ordered to buy this delicious painting at the sale of the private collection of the late king of Bavaria, to whom they had passed off the painting as a work by Gabriel Metsu. There exists no painting of which the execution is of a more exquisite softness. The figure wearing a

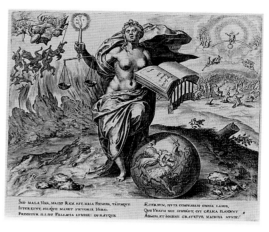

118. Jan Wierix, *Triumphant Truth,* engraving. Printroom Rijksmuseum, Amsterdam. The Latin verses under the print read: "Wine and women are evil, as is kinghood; they perish in the end. Only Truth may expect victory. Her light exposes deceit and she continues to exist eternally, weighing everything with a just balance. Who does not crave for Truth, applauded as she is by the celestial hosts and thanked by the immense artifact earth?" (Translation by Dr. A.M.M. Dekker, Utrecht). (See text of cat. no. 15.)

gown and a bed-jacket trimmed with ermine (a simple costume which taste can never find fault with) detaches herself from a background of a grayish wall, which produces an effect as natural as it is felicitously represented. A painting fills part of the wall. The works of Vander Meer of Delft are so rare that we cannot avoid calling the art lover's attention to this one in a very special way, C., h. 15p, 61., w. 16p."), for Fr 2410.

• Sale Casimir perier, London (Christie), 5 May 1848, no. 7: "Van der Meer. An Interior, known as 'La Peseuse de perles'; a woman dressed in velvet corset lined with fur, is weighing some jewels at a table near a window. 1 ft. 3 in. by 1 ft. 5 in.—upright. From the Delapeyriere collection," bought in by the son of Perier for £141.15 sh.

• Collection Comtesse de Segur-Perier; Art gallery F. Lippmann, London; Art Gallery P. & D. Colnaghi, London (author's copy of *Hofstede de Groot* at R.K.D.).

• Collection P. A. B. Widener, Lynnewood Hall, Elkins Park, Pennsylvania, cat. 1913, vol. I, no. 47, with ill.

• Collection Joseph Widener, Lynnewood Hall, cat. 1931. p. 50.

• PAB. and J. E. Widener collection in the museum (cat. National Gallery, Washington, 1965, no. 693. N.B.: The painting is not yet included in the *Preliminary Catalogue of Paintings . . .* Washington, 1941).

16. (Plate 16)
THE MUSIC LESSON.

London, Buckingham Palace.
Signed at right on lower edge of picture frame.
Canvas, 73.3 x 64.5 cm. (28 7/8 x 25 3/8 in.).
Bürger: 10. Hofstede de Groot: 28. De Vries: 1,
1659-60. Bloch: 1660, Goldscheider: 13, 1662.
Wheelock: 1662-65.
1664.

The painting in the right background is just suffi-
ciently visible to be recognized as a Caritas
Romana, painted in the style of the Utrecht
Caravaggists. It shows Pero suckling her father.
Cimon, who is starving to death in prison. Such a
"painting of a figure who sucks the breast"
("*schilderije van een die de borst suygt*") was
owned by Vermeer's mother-in-law in Delft (see
document of 27 November 1641).

De Mirimonde doubts whether the traditional
title of cat. no. 16, *The Music Lesson*, is correct.
He plausibly argues that the two figures have
played a duet and that the man has risen from his
chair and put his bass viol down beside it
(*Mirimonde*, p. 47).

A detailed discussion of the picture by Chr.
White appears in *The Dutch Pictures in the
Collection of Her Majesty the Queen*, Cambridge,
etc., 1982, no. 230, pp. 143-45, White thinks the
picture may have been the pendant to our cat. no.
17. However, the articulation of space in the two
pictures differs more than in any ascertained pair
of companion pieces known to me.

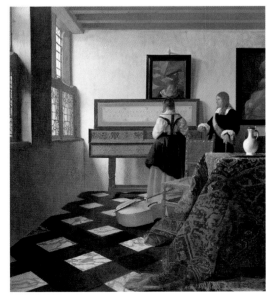

PLATE 16.
The Music Lesson.

Wheelock reports on scientific research indi-
cating that Vermeer originally painted the man
slightly closer to the woman (*Wheelock 1981*, p.
100). He also claims that the position of the
woman's head was first rendered differently, but
this conclusion has been contradicted by Chr.
White ("Book Review." in *Apollo*, January 1983,
p. 64). Conjectures on the meaning of several
details of the picture can be found in Sutton
1984, cat. no, 119.

Provenance:

• Perhaps in collection Diego Duarte, Antwerp,
1682 (see under cat. no. 25).

• Sale Amsterdam, 16 May 1696, no. 6: "*Een
speelende Juffrouw op de Clavecimbael in een
Kamer, met een toeluisterend Monsieur. F 80*" ("A
young lady playing the clavecin in a room, with a
gentleman listening. F 80"). (See document of
that date.)

• Possibly sale Amsterdam, 11 July 1714, no. 12:
"*Een klavecimbaelspeelster in een Kamer, van
Vermeer van Delft konstig geschildert. F 55-0*" ("A
woman playing the clavecin in a room, by
Vermeer van Delft, artfully painted. F 55-0")
(*Hoet*, I, p. 176). N.B.: Until now it has been
assumed that this reference could just as well
concern cat. no. 25 or cat. no. 31. However,
Joseph Smith (1675-1770), English consul in
Venice, bought Dutch paintings in that city in
about 1741 from the widow of the painter
Giovanni Antonio Pellegrini (1675-1741). Our
cat. no. 16 is mentioned in the inventory of
Pellegrini: "*Altro [quadro] con Donna alIa
Spinetta*" ("Another painting, with a lady at the
spinet"). (*White*, op. cit., p. 143). Later on, Smith
sold the greater part of his collection to King
George III (F. Haskell, *Patrons and Painters*,
London, 1963, p. 307; F, Herrmann, *The English
as Collectors*, London, 1972, p. 26). One of the
paintings acquired by George III from Joseph
Smith was our cat. no. 16: "nr. 91. Frans van
Mieris. A woman playing on a Spinnet in pres-
ence of a Man seems to be her father, 2 feet, 5
inches, 2 feet 1 1/2 inches" (list of 1762; see A.
Blunt and E. Croft-Murray, *Venetian Drawings of
the XVII & XVIII Centuries in the Collections of
Her Majesty the Queen at Windsor Castle*, London,
1957, p. 21; F. Vivian, *I1 console Smith mercante
e collezionista*, Vicenza, 1971, p. 206. cat. no. 91;
cf. White, op. cit., p. 143). Pellegrini stayed in

The Hague in 1718 (*Obreen*, V, p. 141) and we
may assume that he bought his Dutch paintings
on that occasion. The painting that was auctioned
in 1714 was, as far as we know, the only "*clavec-
imbaelspeelster*" by Vermeer for sale in the
Netherlands during that period, so it may have
been our cat. no. 16. Subsequently the prove-
nance was: collection Pellegrini; collection Jos.
Smith; collection George III; English Royal
Collection.

Copy:

Joseph Smith probably had a copy made after the
painting, listed thus in his inventory of 1770:
"*Altro quadrato con specchio sopra, soaza detta
(dorata d'intaglio) rappresenta una Giovane che
tocca il Clavicembalo con il Maestro al di lei
fianco*" ("Another picture with a mirror in top . . .
in gilded frame, representing a young lady play-
ing the clavecin with her teacher at her side")
(*Vivian*, loc. cit.).

17. (Plate 17)
THE TRIO.

Boston, Isabella Stewart Gardner Museum.
Canvas, 69 x 63 cm. (27 1/4 x 24 3/4 in).
Bürger: 23. Hofstede de Groot: 29. De Vries: 14,
1658-60. Bloch: 1660. Goldscheider: 14. 1662.
Wheelock: 1665-66.
1664.

The painting in the right background is the
Procuress by van Baburen (our fig. 72; noticed by
H. Voss, in *Monatshefte für Kunstwissenschaft* 5,
1912, p. 79 ff.). It was in the possession of
Vermeer's mother-in-law (see document of 27
November 1641). It is also depicted in cat. no. 31,
plate 30. The landscape painting on the left can
roughly be dated in the 1650s or 1660s and
recalls Jacob van Ruisdael (Stechow 1960, p. 180).
In my opinion, cat. no. 17 is not the pendant of
cat. no. 16 (see there).

A. P. de Mirimonde thought that cat. no. 17
represented a brothel, the lady at the right being
the procuress (*Mirimond* , p. 42). I. L. Moreno,
on the other hand, sees it as a domestic scene and
the same lady as representing Temperance,
because she keeps time with her right hand. In his
view the "moderate" behavior of the three musi-
cians is intended to contrast with the brothel in
Baburen's Procuress on the wall (Ignacio L.
Moreno, "Vermeer's *The Concert*: A Study in

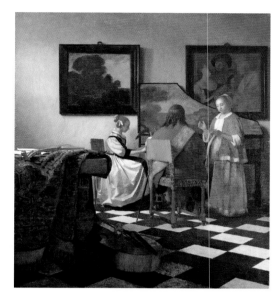

PLATE 17.
The Trio

Harmony and Contrasts," in *Rutgers Art Review*, January 1982, vol. 3, pp. 51-57). Moreno also thinks the standing lady is pregnant, but that seems anyhow improbable (see commentary under cat. no. 15).

Provenance:

• *Sale Johannes Lodewijk Strantwijk (Amsterdam), Amsterdam (Ph. van der Schley), 10 May 1780, no. 150: "*Jan vander Meer, de Delfze. In een binnenkamer zit eene Dame die op 't Klavier speelt, werden de geaccompagneert door een Heer die op een Gitar speelt, en een Vrouwtje die zingt, beneffens eenig bywerk, ongemeen fraay en meersterlyk behandelt, hoog 28, breed 24, op Doek*" ("Jan vander Meer, the Delft one. In an inner room sits a lady who plays the clavecin, being accompanied by a gentleman who plays a guitar, and a woman who sings, and some accessories, treated in an extraordinary beautiful and masterly way, height 28, width 24, on canvas"), for F 315 to A. Delfos for the "Heer van Vlaardingen." This undoubtedly refers to Diederik van Leyden. "Heer" of Vlaardingen (1744-1810).

• Sale M[onsier] van Leyden (Amsterdam), Paris (Paillet), printed catalogues dated 5 July 1804, 10 September 1804, and of the definitive sale, 5 November 1804, no. 62: "*Jean van der Meer de Delft. L'Intérieur d'un Salon, avec grands Carreaux de marbre noir et blanc. On y voit dans le milieu un Homme assis, et vu par le dos, faisant de la Musique avec deux jeunes Personnes. L'une touche du Clavecin, tandis que l'autre chante en battant la mesure. À droite est une Table négligemment cou-verte d'un Tapis de Turquie, où sont posés des Livres de Musique et une Guitare. On distingue encore dans la demi-teinte une Basse jetée à terre. Van der Meer, de Delft, est un des Peintres qui a le plus approché de la manière large et moelleuse de Gabriel Metzu, et ses Ouvrages sont tellement rares, particulièrement en Sujets composés, que les Amateurs sont réduits aujourd'hui à se contenter de quelques Portraits d'Artistes, de la main de cet Auteur, dont les productions ont toujours été regardees comme classiques, et dignes de l'ornement des plus beaux Cabinets. Peint sur toile, haut. 25 1/2, largo 23 p.*" ("Jan van der Meer of Delft. The interior of a drawing room, with large tiles of black and white marble. One sees in the middle a sitting man, seen from the back, music making with two young persons. One woman plays the clavecin, while the other one sings and beats time. On the right is a table carelessly covered with a Turkish carpet on which music books and a guitar have been put. Also, in the semishade, one distinguishes a bass thrown on the floor, Van der Meer, of Delft, is one of the painters who has come nearest to the broad and mellow manner of Gabriel Metzu, and his works are so rare, particularly extensive compositions,that the amateurs have to content themselves nowadays with a few portraits of artists by the hand of that author, whose products have always been considered classic and worthy to adorn the most beautiful collections. Painted on canvas, height 25 1/2, width 23 inches"), for Fr 350 to Paillet.

• *Sale London (Foster), 26 February 1835, no. 127: "*Vanderneer of Delft. Interior of an Apartment, with a Lady at a piano, Gentleman singing &c. A capital specimen of this rare master.*" Printed in capitals, with five other paintings on the title page of the catalogue: "those most entitled to notice . . . An interior with three figures. Vandermeer de Delft" (mention found by Peter Sutton).

• Sale Admiral Lysaght et al. (part: "A different Property"), London (Christie), 2 April 1860, no. 49: "Van der Meer, of Delft. A musical party," for £ 21 to Toothe.

• *Sale D[emidoff], Paris (Pillet), 1 April 1869, no. 14: "*Jan van der Meer ou Vermeer de Delft. Concert avec trois personnages. Intérieur d'un salon hollandais. Une jeune fille, vue de prom, touche du clavecin. Un gentilhomme, vu de dos, pince de la mandoline. A droite, une jeune femme chante en battant la mesure. Divers accessoires. Vente de la baronne Van Leyden, Paris 1804. Toile, Haut., 67 cent.; large., 60 cent.*" ("Jan van der Meer or Vermeer of Delft. Concert with three persons. Interior of a Dutch drawing room. A young girl, seen in profile, touches the clavecin. A gentleman, seen from the back, plucks the mandolin. On the right, a young woman sings, beating time. Various accessories. Sale of the baronne Van Leyden, Paris 1804. Canvas, height 67 centimeters; width 60 centimeters"), for Fr 5100. in our, opinion most likely to Thoré-Bürger.

• Sale (heirs) Thoré-Bürger, Paris (Drouot), 5 December 1892, no. 31, with illustration and description taken from sale cat. 1804, for Fr 29,000 to Robert.

• Acquired at this sale by Mrs. Isabella Stewart Gardner "who ordered the bidding of her agent Robert with a handkerchief" (cat. Isabella Stewart Gardner Museum by Ph. Hendy, Boston. 1931. p. 407),

18. (Plate 18)
THE GIRL WITH A PEARL EARRING.

The Hague, Mauritshuis.
Signed top left.
Canvas, 46.5 x 40cm. (18 1/4 x 15 3/4 in.).
Hofstede de Groot: 44. De Vries: B. 1660. Bloch: 1660-65. Goldscheider: 23, 1665. Wheelock: 1665. 1665.

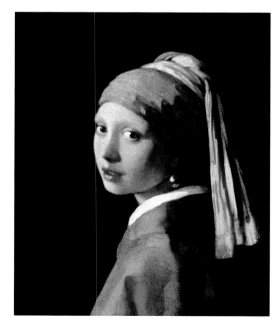

PLATE 18.
The Girl with a Pearl Earring.

Provenance:

• *Possibly "een tronie van Vermeer,"* estimated at F 10-0-0 in the inventory of Jean Larson, The Hague, 1664 (our cat. no. 32B).

• Possibly sale Amsterdam, 16 May 1696, no. 38, 39, or 40; probably not sale Luchtmans, 20 April 1816, no. 92 (see our cat. no. 30).

• Collection A. A. des Tombe, The Hague, purchased at sale Braam, The Hague, beginning of 1882, for F 2.30 (cat. Mauritshuis 1935, no. 670); lent to exh. Schilderijen van oude meesters. Pulchri Studio, The Hague, 1890, cat. no. 117: *"Johannes Vermeer. Meisjeskop. Borstbeeld naar links, met een blauw en witte doek om het hoofd gewonden, en een geel jak. In het linker oor een groote parel. Gemerkt links bovenaan: I. V. Meer. Hoog 0.45, breed 0.38 1/2. Op doek"* ("Johannes Vermeer. Head of a girl. Bust to the left, with a blue and white cloth wound around the head, and a yellow jacket. In the left ear a large pearl. Signed top left: I. V. Meer. Height 0.45, width 0.38 1/2. On canvas"). The collection des Tombe at 26 Parkstraat, The Hague, was a public collection (see Lafenestre and Richtenberger, *La Peinture en Europe, La Hollande*, Paris, s.a. [1899?], p. 106).

• Bequeathed by des Tombe in 1903 to the museum (cat. Mauritshuis, 1935, no. 670).

19. (Plate 19)
THE ART OF PAINTING.

Vienna, Kunsthistorisches Museum.
Signed on map, to the right of the girl.
Canvas, 120 x 100 cm. (47 1/4 x 39 3/8 in.).
Bürger: 5. Hofstede de Groot: 8. De Vries: 23, 1665. Bloch: 1665-70. Goldscheider: 24, 1666. Wheelock: 1666-67.
1662-1665.

The painter's costume strongly resembles that of the young man on the left in the Procuress (plate 3). On the map, which shows the Northern and Southern Netherlands, can be read, partly covered by the chandelier:

"NOVA XVII. PROV[IN]CIARUM [GERMA-NIAE INF]ERI[O]RIS DESCRIPTIO/ ET ACCURATA EARUNDEM . . . DE NO[VO] EM[EN]D[ATA] . . . REC[TISS]IME EDIT [AP]ER NICOLAUM PISCATOREM."

"Nicolaus Piscator" is the Latin name of the Amsterdam cartographers Nicolaes Visscher Sr. and Jr. The map also appears on paintings by Maes and Ochtervelt. Only one copy of it has been preserved, of an edition of 1692, on which the cityscapes, depicted in the borders on the left and right of the map used by Vermeer, are missing (see *Welu*, p. 536). Nonetheless James Welu recently succeeded in reconstructing the complete map and identifying all 20 cityscapes (J. A. Welu, "The map in Vermeer's Art of Painting," in *Imago Mundi, The Journal of the International Society for the History of Cartography* 30, second series, vol. 4, 1978, pp. 9-30, fig. 14). Wheelock observed that Clio stands closest to a view of the "Hof" in The Hague; the "Hof" was (and still is) the seat of government in Holland (*Wheelock 1981*, p. 162, note 89). It seems also remarkable that provincial cities like Deventer and Groningen are included, but not Delft.

It has been guessed that in cat. no. 19 the Roman Catholic Vermeer expressed a longing for the past by way of the painter's historicizing costume and of the 16th-century political situation depicted on the map (Ch. de Tolnay, "L'atelier de Vermeer," in *Gazette des Beaux-Arts* 95, VI, 41, 1953, pp. 269-70). The decorative double bird on top of the brass chandelier inspired the peculiar fantasy that here a phoenix is represented as an "illustration" of Vermeer being called a phoenix in Arnold Bon's poem in Bleyswyck's book of 1667 (see document of 1667 and p. 155; Sabine Eiche, "'The Artist in his Studio' by Jan Vermeer: about a chandelier," in *Gazette des Beaux-Arts* 6, 99, May/June 1982, pp. 203-4).

A full listing and critical discussion of the literature on the picture up to 1972 is given by K. Demus, *Kunsthistorisches Museum Wien, Katalog der Gemäldegalerie, Hollandische Meister des 15, 16, und 17, Jahrhunderts*, Vienna, 1972, pp. 95-97. See also H. Miedema, "Johannes Vermeers schilderkunst," in *Proef, Kunsthistorisch Instituut van de Universiteit van Amsterdam*, September 1972, pp. 67-76.

Provenance:

• On 24 February 1676 Vermeer's widow conveyed to her mother *"een stuck schilderie, geschildert...bij haeren man za: waerin wert uytgebeelt de Schilderconst"* ("a piece of painting, painted by her late husband, in which is depicted the Art of Painting"); on 12 March 1677 the mother declared to have received indeed *"seeker stuck Schilderije geschildert bij . . . Vermeer, waerinne wert uytgebeelt de Schilder-konst"* ("a certain piece of painting painted by Vermeer, in which is represented the Art of Painting") and further declared that it is not fair that her daughter's trustee wants to have it auctioned, as can be deduced from *"gedruckte billietten"* ("printed notices") (see documents of 24 February and 11 December 1676 and 12 and 13 March 1677).

• ?Sale Amsterdam, 16 May 1696. no. 3: *"'t Portrait van Vermeer in een Kamer met verscheyde bywerck ongemeen fraai van hem geschildert"* ("The portrait of Vermeer in a room with various accessories, uncommonly beautifully painted by him"), for F 45. (See our cat. no. 33 and document of that date.) N.B.: It is uncertain whether this painting was our cat. no. 19, as is generally assumed, since this is not a "portrait" and the price of F 45 is improbably low for such a large and richly filled major work in Vermeer's œuvre. Other major works, the *Woman Holding a Balance*, *The Milkmaid*, and the *View of Delft* (our cat. nos 15, 7, and 10). fetched at the same auction F 155, F 175, and F 200 respectively.

• Acquired by Johann Rudolf Count Czernin, according to his own notes, in 1813 from the estate of Gottfried van Swieten, via a saddle

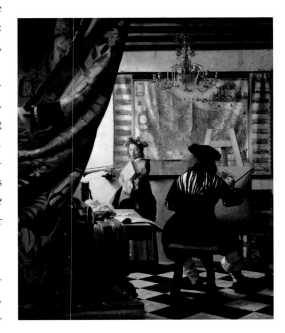

PLATE 19.
The Art of Painting

maker, for 50 fl., as a Pieter de Hooch. N.B.: Gottfried Freiherr van Swieten (died 1803) was first a diplomat. His father, Gerard baron van Swieten, occupied numerous functions at the court of Maria Theresa of Austria. When he died, in 1772, his son succeeded him as prefect of the imperial court library. The young van Swieten may have inherited the painting from his father, since the latter was greatly interested in the arts (see W. Müller, *Gerhard van Swieten . . .* , Vienna, 1883, inter alia pp. 2, 39, 110-12).

Until 1860 in the Czernin Collection as by de Hooch (cat. Collection Czernin, Vienna, 1936, no. 117); in 1860 recognized as a Vermeer by Waagen (according to G. F. Waagen, *Handbuch der deutschen und niederlandischen Malerschulen* II, Stuttgart, 1862, p. 110).

• Brought by A. H[itler] to his residence at Berchtesgaden (*de Vries*).

• Acquired by the museum in 1946 (cat. Kunsthistorisches Museum, Gemaldegalerie, II, Vienna, 1963, no. 395).

20. (Plate 22)
Writing Lady in Yellow Jacket.
Washington, National Gallery of Art.
Signed on the frame of the painting in the background.
Canvas, 455 x 39.9 cm. (17 3/4 x 15 3/4 in).
Bürger: 40. Hofstede de Groot: 36. De Vries: 19, 1663-64. Bloch: 1665. Goldscheider: 20, 1665. Wheelock: 1665-66.
1666.

The painting in the background is probably the one "*waerin een bas met dootshoofd*" ("in which a bass with skull"), which was listed in the inventory of Vermeer's widow on 29 February 1676 (see document of that date). K. Boström plausibly suggested that it was a work of the still-life painter Corn. van der Meulen (K. Boström, "Jan Vermeer van Delft en Cornelis van der Meulen," in *Oud-Holland* 66, 1951, pp. 117-22). Wheelock wondered whether cat. no. 20 might in the first place have been intended as a portrait (*Wheelock 1981*, p. 124).
Provenance:

• Collection Dissius, Delft; sale Amsterdam, 16 May 1696, no. 35: "*Een schrijvende Juffrouw heel goet F 63.0*" ("A young lady writing very good, F 63.0"). (See document of that date.)

• *Sale J. van Buren, The Hague (Scheurleer), 7 November 1808, p. 264, no. 22: "*Een bevallig vrouwtje in 't geel satyn met bont gekleed, zittende te schryven aan een tafel waar op een snoer paerlen in een kistje geplaast zyn, uitmuntend fraai, uitvoerig en meesterlyk gepenseeld door de Delfsche van der Meer D. zeer raar*" ("A graceful woman dressed in yellow satin with fur, sitting and writing at a table on which a string of pearls is placed in a box, excellently beautiful, elaborately and masterfully painted by the Delft van der Meer. C. very rare").

• Sale "Un amateur a Rotterdam" [Dr. Luchtmans], Rotterdam (Muys), 20 April 1816, no. 90: "*J. van der Meer, de Delft. Une jeune personne en négligé dans un mantelet jaune, bordé de pelleterie; occupée à écrire sur une table, sur laquelle sont placés une cassette, écritoire etc. Haut 16 pouces, large 14 1/2 pouces; Toile*" ("J. van der Meer. of Delft. A young woman in a morning dress with a yellow jacket, trimmed with fur; engaged in writing at a table, on which are placed a box, inkstand etc. Height 16 inches, width 14 1/2 inches; Canvas") (according to *de Vries* for F 70).

• *Collection "Kammerman" [should be Kamermans, see below], Rotterdam, 1819/23: "Van der Meer, of Delft. A lady sitting writing at a table. She wears a yellow jacket trimmed with ermine, her arms are bare nearly to the elbow, and her hair is tied up with bows of ribbon. The painting is remarkable for its softness" (seen by *Murray 1819/23*, p. 29).

• Sale J. [should be F.] Kamermans, Rotterdam (Lamme), 3 October 1825, no. 70: "*De Delfsche van der Meer. Eene bevallige Jonge Dame, die op een tafel met een blauw kleed er over, zit te Schrijven, zeer fraai van dezen Meester, h. 42 d. b. 37 d. D.*" ("The Delft van der Meer. A graceful young lady, who sits writing at a table with a blue rug on top. Very beautiful by this Master, h. 42 inches w. 37 inches, canvas").

• Sale Hendrik Reydon et al., Amsterdam (Jer. de Vries), 5 April 1827, no. 26: "*De Delftsche van der Meer. Eene deftig gekleede Dame, zittende aan eene tafel te schrijven, waarop eenig bijwerk ligt. Uitnemend fraai van toon en behandeling, hoog 4 p. 7 d., breed 3 p. 6 d. Doek*" ("The Delft van der Meer. An elegantly dressed lady, sitting and writing at a table, on which lie some accessories.

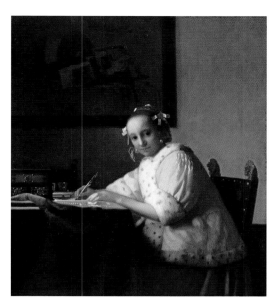

PLATE 22.
Writing Lady in Yellow Jacket.

Excellently beautiful of tone and treatment, height 4 p. 7 d., width 3 p. 6 d. Canvas"), withdrawn.

• Sale Comte F. de Robiano (Brussels), Brussels (Barbé), 1 May 1837, no. 436: "*J. van der Meer. Devant une table couverte d'un tapis, est assise une jeune et jolie fille occupée à écrire; elle est vêtue d'une casaque jaune claire, garnie en hermine blanche, et tient la tête levée vers le spectateur. L. 38, H. 45. T.*" ("J. van der Meer. At a table covered with a rug, sits a young and lovely girl who is busy writing; she is dressed in a bright yellow jacket, trimmed with white ermine, and she holds her head upward toward the spectator. W. 38, H. 45, canvas"), for Fr 400 to Heris, Brussels.

• Art market Paris, 1907 (according to exh. cat. *Vermeer*, Boymans Museum, Rotterdam, 1935, no. 86a).

• Collection Pierpont Morgan, New York, exhibited in Metropolitan Museum of Art (newspaper report of 6 October 1908).

• Art gallery Knoedler, New York; collection Lady Oakes, Nassau, Bahamas (*de Vries*).

• Art gallery Knoedler, New York, 1958; collection Horace Havemeyer, New York (*Goldscheider*).

• Gift of Harry Waldron Havemeyer and Horace Havemeyer, Jr. to the museum in 1971, in memory of their father, Horace Havemeyer, 1962.

21. (Plate 23)

LADY WITH A MAIDSERVANT HOLDING
A LETTER.

New York, The Frick Collection.

Canvas, 92 x 78.7 cm. (36 1/8 x 30 7/8in.).

Bürger: 8. Hofstede de Groot: 33. De Vries: 25, 1666-67. Bloch: 1665-70. Goldscheider: 29, 1670. Wheelock: 1667-68.

1666-1667.

Provenance:

• In our opinion the following description applies more exactly to this painting than to our cat. no. 22: Collection Dissius, Delft; Sale Amsterdam, 16 May 1696, no. 7: "*Een Juffrouw die door een Meyd een brief gebragt wordt. F 70-0-*" ("A lady who is brought a letter by a maid. F 70-0"). (See document of that date.)

• N.B.: Dimensions and description indicate that cat. no. 21 is not the painting in sale Jos. van Belle, 1730 (see cat. no. 27).

• Sale Amsterdam (Haring). 15 October 1738, no. 12: "*Een schryvent Juffertje in haar Binnekamer die een Brief ontfangt, door de delfse van der Meer*" ("A girl writing in her inner room who receives a letter, by the Delft van der Meer"), for F 160 to Oortman.

• N.B.: Since the painting was auctioned in 1738, it cannot be the "*juffer die een brief schrijft en een meid bij haar*" ("lady who writes a letter with her maid servant") in collection Franco van Bleiswyck, because that painting remained in one family from (before) 1734 until (after) 1761 (see cat. no. 27).

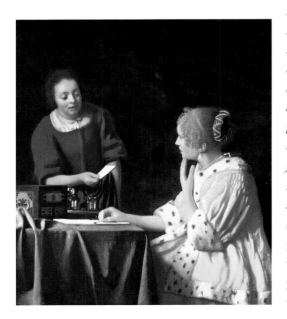

PLATE 23.
Lady with a Maidservant Holding a Letter

• N.B.: Bürger and all later authors stated that the painting is the one sold in the Blondel de Gagny sale, Paris, 10 December 1776, no. 72, as by ter Borch ("*une femme qui écrit, sa servante la regarde,*" to Poullain) and in the Poullain sale. Paris, 15 March 1780, no. 40 bis. From the description in the latter sale catalogue, in which it is remarked that "*on voit encore un lit et un fauteuil rouge*" ("a bed and a red chair are also visible"), it is clear that this painting cannot have been our cat. no. 21, nor the pastiche in the Steenokerzeel sale (Brussels, 13 October 1953, no. 374, with ill.), with which S. J. Gudlaugsson identified sale Poullain no. 40 bis (*Gerard ter Borch* II, The Hague, p. 128, no. 114n).

• N.B.: No reference has previously been made to the following sale, in which our cat. no. 21 seems to figure though the dimensions given are smaller and a mirror is mentioned. The painting fetched a remarkably high price: *Sale van Helsleuter et al. (anonymous part), Paris (Paillet), 25 January 1802, no. 106: "*Van der Meer de Delft. L'intérieur d'une chambre hollandaise. A gauche et sur le devant on voit de profil une jeune et jolie femme de carnation blonde, ajustée d'un manteau de lit d'une étoffe d'un jaune vif et brillant, bordé d'hermine. Elle est assise auprés d'une table couverte d'un tapis vert, sur laquelle sont un miroir, un coffret et autres accessoires; elle vient de remettre à sa servante, qui est de l'autre côté de la table, en troisième plan, un billet sur lequel il n'y a point d'adresse; et semble éprouver, ainsi que son geste l'indique, beaucoup d'embarras pour expliquer a sa servante, qui la regarde en souriant, l'objet du message. Voici la première fois que nous avons occasion de citer dans nos catalogues cet habile peintre, et d'offrir aux amateurs un de ses ouvrages marquants. Le Brun, dans son œuvre sur la vie des peintres, page 49, tome 2, en fait le plus grand éloge; et son mérite étonnant, ainsi qu'on peut le juger par ce beau tableau, a droit de fixer l'attention des curieux. Peint sur toile, haut de 30, large de 24 p.*" ("Van der Meer of Delft. The interior of a Dutch room. In the left foreground one sees in profile a young and lovely woman of blond flesh-tints, dressed in a bedjacket of clear and brilliant yellow fabric, trimmed with ermine. She sits at a table covered with a green rug, on which are a mirror, a little box and other accessories; she has just handed over to her maid-servant, who is on the other side of the table, in the background, a note on which there is no address and she seems to feel, as her gesture indicates, much embarrassment at explaining to her servant, who looks at her smilingly, the object of the message. It may be noted that this is the first time that we are able to cite this able painter in our catalogues, and to offer one of his striking works to art lovers. Le Brun gives him the highest praise in his work on the life of the painters, p. 49, vol. 2; and his astonishing merit justifies the attention of the curious, as one can judge from this beautiful painting. Painted on canvas, height 30, width 24 p."), for Fr 2000, with the note "retire" (withdrawn).

• Art gallery Ch. Lebrun, Paris. as is proven by the engraving of the outlines in Lebrun, *Recueil de gravures au trait . . . d'aprés un choix de tableaux, de toutes les écoles, recueillies dans un voyage fait en Espagne, au midi de la France et en Italie dans les années 1807 et 1808, II, 1809, no. 166,* with note: "*hauteur 33 pouces, largeur 29 pouces, sur toile.*"

• *Sale [Lespinasse de Langeac], Paris (Paillet), 16 January 1809, no. 34, with the same description as in sale cat. van Helsleuter, 1802, but with dimensions "*Haut. 33, Larg. 29 p.,*" for Fr 600 to Lebrun.

• Sale Lebrun, Paris (Lebrun), 20 March 1810, no. 143: "*Vander Meer, de Delft. No. 166, gravé, t. 2: Une jeune Femme comptant avec sa domestique; figures vues a mi-corps, sur toile*" ("Vander Meer of Delft. No. 166, engraved, vol. 2: A young woman counting with her housemaid; figures seen at half-length, on canvas"), for Fr 601 to Chevallier.

• *Sale D[rouillet] & De B[ertival], Paris (Ch. Paillet), 24 March 1818, no. 48: "*Vandermeer de Delft. Une jeune dame vêtue d'une pelisse jaune et doublée d'hermine, vient de remettre une lettre a sa servante. Sur la table couverte d'un tapis bleu, sont posés une écritoire et un coffret. Tableau d'une grande finesse de tons et d'une suavité de pinceau. h. 36, l. 22. t.*" ("Vandermeer of Delft. A young lady dressed in a yellow pelisse and lined with ermine, has just handed over a letter to her servant. On the table, covered with a blue rug, are an inkstand and a little box. A painting of great delicacy of tones and softness of brush, h. 36, w. 22, canvas"), for Fr 460.

• *Collection Duchesse de Berry, sale exh., London, 1834, cat. no. 11: "An interior, with a Lady despatching a letter by a female Attendant, on canvas, 35 x 31 in.," asking price £ 80.

• Sale Ancienne Galerie du Palais de l'Elysée [Duchesse de Berry], Paris (Bataillard), 4 April 1837, no. 76: "*Vandermeer de Delfdt. Une jeune personne de carnation blonde, coiffée en cheveux et la tête ornée de perles en bandeau; elle est accompagnée de sa servante, debout et tenant une lettre dont elle cherche à lire l'adresse. Ces deux figures se détachent sur un fond d'appartement mystérieusement éclairé, et rappellent, par leur exécution large et bien prononcée, les bons ouvrages de Terburg, Toile; hauteur, 32 pouces, largeur 28.*" ("Vandermeer of Delft. A young person of blond flesh-tones, her hair done and adorned with a bandeau of pearls; she is in the company of her servant, standing and holding a letter of which she tries to read the address. These two figures stand out against a background of a mysteriously lighted room, and recall, by their broad and highly articulated execution, the beautiful works of Terburg. Canvas; height, 32 pouces; width, 28"), for Fr 415 to Paillet. N.B.: The price is low compared with those for other works at this auction; nos. 36 (Metsu), 77 and 89 (both W. van Mieris), and 93 (Schalcken) fetched respectively Fr 1000, 4200, 4100, and 4000.

• Collection Dufour, Marseilles, from 1819 or earlier (L. Lagrange, in *Gazette des Beaux-Arts*, I, 1859, pp. 60, 61).

119.
X-ray of *The Love Letter* (cat. no. 22, plate 21). The right knee of the sitting lady was first indicated with broad brushstrokes.

• Sale E. Secretan, Paris (Boussod), 1 July 1889, no. 139, with description and illustration, for Fr 75,000 to Sedelmeyer.

• Collection A. Paulovstof, St. Petersburg (*Hofstede de Groot*).

• Art gallery Lawrie & Co., London (cat. Frick, 1968, p. 298).

• Art gallery Sulley, London (*Hofstede de Groot*).

• Exh. *Werke alter Kunst, Kaiser-Friedrich-Museums-Verein*, Palais Redern, Berlin, 1906. N.B.: Not mentioned in the cat., but, according to notes at R.K.D., sold there to James Simon, Berlin, for 325.000 R.M.; in 1914 still in his possession, as stated in exh. cat., Berlin, 1914, no. 183.

• Art gallery Duveen, London/New York (*de Vries*).

• Collection H. C. Frick, 1919 (cat. Frick, 1968, p. 298).

22. (Plate 21)
THE LOVE LETTER.

Amsterdam, Rijksmuseum.
Signed on wall, on the left of the servant.
Canvas, 44 x 38.5 cm. (17 3/8 x 15 1/8 in).
Hofstede de Groot: 32, De Vries: 24, 1666. Bloch: 1665-70. Goldscheider: 31, 1670. Wheelock: 1669-70.
1667.

On the left the map of Holland and West Friesland that is also depicted in our cat. nos. 22 and 5 (q.v.) is partly visible (*Welu*, p. 533). The marine painting on the back wall may be the "*zeetje*" ("small seascape") that figures in his

wife's inventory after Vermeer's death (see document of 29 February 1676). The landscape above it recalls Jacob van Ruisdael (*Stechow 1960*).

Otto Naumann observes that in our cat. no. 22 as well as in paintings by Frans van Mieris and Metsu "the woman . . . keeps her shoes off and beside her, a gesture rich in erotic implications" (*Naumann 1981*, p. 111, with reference to literature). If Naumann is right, it would seem that Vermeer counterbalanced and neutralized the shoes' erotic impact by placing a broom next to them: a broom creates purity.

In 1971, at the exhibition *Rembrandt en zijn tijd* in the Paleis voor Schone Kunsten in Brussels, *The Love Letter* was stolen by a man who had got himself locked in the museum at night and demanded a high ransom destined for war casualties in Pakistan. His deed was alarmingly well received by the public. The only result was that the painting, greatly damaged, was handed over with some ceremony to the Dutch government. Fortunately, of the paint surface only parts of the most evenly colored areas in the shadow parts were lost. These were ably restored by L. Kuiper of the Rijksmuseum (see A. F. van Schendel, P. J. J. van Thiel, and L. Kuiper, in *Bulletin van het Rijksmuseum*, 20, 1972, pp. 127-67).

Provenance:

• Sometimes, in our opinion, mistakenly, identified with sale Amsterdam, 16 May 1696, no. 7 (see cat. no. 21).

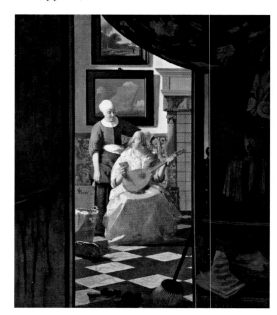

PLATE 21.
The Love Letter

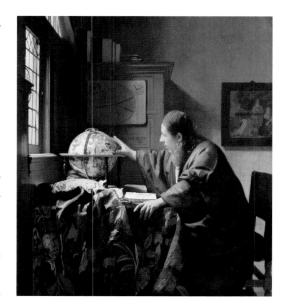

PLATE 24.
The Astronomer.

120.
A. Delfos, copy in water colors after *The Astronomer* (cat. no. 23, plate 24). Printroom, Rijksmuseum, Amsterdam. The date in the background reads "MDCLXXIII" (1673) instead of "MDCLXVIII" (1668), which is presently visible on the painting.

• Collection Pieter van Lennep (1780-1850) and his wife, Margaretha Cornelia Kops (1788-1825); subsequently to their daughter Margaretha Catharina van Lennep (1815-1891), who married Jan Messchert van Vollenhoven (1812-1881) in 1850 (from the introduction in sale cat. 1892).
• Sale Messchert van Vollenhoven, Amsterdam (Roos), 29 March 1892, no. 14, with elaborate description, for F 41.000+10% to the Vereeniging Rembrandt.
• Since 1893 in the museum (cat. Rijksmuseum, 1934, no. 2528).

23. (Plate 24)
THE ASTRONOMER.
Paris, Louvre.
Signed and dated 1668 on the
cupboard (later addition?).
Canvas, 50 x 45 cm. (19 5/8 x 17 3/4 in).
Bürger: 36. Hofstede de Groot: 6. De Vries: 27,
1668. Bloch: 1668. Goldscheider: 27, 1668.
Wheelock: 1668.
1668.
An unpublished watercolor copy by A. Delfos (1731-1820) after the picture is in the Rijks-prentenkabinet of the Rijksmuseum, Amsterdam (our fig. 121; inv. no. 18:358, Collection Pape). The signature and date on it clearly read "I Meer MDCLXXIII," a date (1673) five years later than the one presently visible on the picture (1668).

The celestial globe (fig. 42) can be identified as a globe produced by the Hondius family of cartographers of which three copies have been pre-

served (fig. 43). It was sold as one of a pair with the terrestrial globe depicted in cat. no. 24 (*Welu*, p. 544 ff., with data on the other astronomical instruments). This might indicate that cat. nos. 23 and 24, which between 1713 and 1778 were sold four times together as companion pictures, were also originally intended as such. This idea was given up in modern literature, because in both paintings the figure turns to the left.

The partly visible painting in the right background is depicted on another scale in cat. no. 27 (plate 27). It represents the "Finding of Moses in the bulrushes." It may have been included in no. 23 because Moses warned against the cult of celestial bodies (suggestion in *de Jongh 1976*, p. 83; cf. *Wheelock 1981*, p. 138, yet also my note below). Jacob van Loo and Christiaen van Couwenbergh have been mentioned as possible authors of the Moses painting, but W. L. van de Watering attributes it to the early Peter Lely, which seems convincing.

The open book on the table has recently been identified by James Welu by means of the illustration that is visible (see fig. 102). It is Adriaen Metius's *Institutiones Astronomicae Geographicae*, second edition, Amsterdam, 1621. The left page depicts an astrolabe of a type Metius invented. In Vermeer's picture a similar astrolabe lies against the globe (J. Welu, "Vermeer's Astronomer: Observations on an Open Book," in *The Art Bulletin* 68, 1968, pp. 263-67). In the same article Welu relates the *Finding of Moses* in the background to the fact that in the seventeenth century Moses was seen as "the oldest geographer." L. J. Slatkes had already observed that the Acts of the Apostles (7:22) relate how Moses, after being found, "was instructed in all the wisdom of the Egyptians"; astronomy was always considered as belonging to "the wisdom of the Egyptians" (L. J. Slatkes, *Vermeer and His Contemporaries*, New York, 1981, p. 82). Thus the painting in Vermeer's painting would serve as historical background to the activity of the astronomer.

It seems farfetched to identify cat. nos. 23 and 24 as possible portraits of Anthonie van Leeuwenhoek, as Arthur Wheelock does—all the more so when they are compared to the documented portrait of van Leeuwenhoek reproduced by the same author (*Wheelock 1981*, pp. 13, 181, fig. 35; cf. our fig. 45).

121.
Engraving by Garreau after *The Astronomer* (cat. no 23, plate 24), signed and dated "Garreau Scul. en 1784." From J.B. P. Lebrun, *Galerie des peintres*, vol. II, 1792.

Provenance:
• For the provenance up to 1785, see cat. no. 24,
• *Sale Jacob Crammer Simonsz. (Amsterdam), Amsterdam (Ph. van der Schley), 25 November 1778, no. 18: "*J. van der Meer bygenaamt de Delfsche. Dit Stukje verbeeld een Kamer, waar in een Philosooph zittende in zyn Japon voor een Tafel met een Tayptje overdekt, waar op een Hemel Globe, Boeken, en Astronomische Instrumenten, hy schynt met aandagt de Globe te beschouwen, het bevallige Ligt, het geen door een Vengster ter linkerzyde nederdaalt, doed een fraaije en natuurlyke Werking. Verder is het voorzien met eenige Meubelen, alles meesterlyk en fiks Gepenceelt. Op Doek, hoog 20, breed 18 duim*" ("J. van der Meer called the Delft one. This piece depicts a room, in which a philosopher sits in his gown before a table, covered with a small rug on which a celestial globe, books, and astronomical instruments, he seems to be studying the globe attentively, the pleasing light, which descends from a window on the left side, makes a beautiful and natural effect. Furthermore it is equipped with some pieces of furniture, everything painted masterfully and vigorously. On canvas, height 20, width 18 inches") (together with our cat. no. 24, see there).
• Collection Jean-Étienne Fiseau, The Netherlands (according to J.B.P. Lebrun, 1792, see below).
• Art dealer Lebrun, Paris. Under his supervision an engraving after the painting by Garreau appeared in: J.B.P. Lebrun, *Galerie des peintres flamands, hollandais et allemands,* II, Paris, 1792-96, p. 49 (see our fig. 122). The first state of the

engraving is only signed and dated: "*Garreau 1784*"; on the second state is added: "*tiré du cabinet de M. Lebrun a Paris*" (see Jolynn Edwards, op. cit. in our cat. no. 24).

• *Brought to Paris in 1785 (see under cat. no. 24).

• Sale Jan Danser Nyman, Amsterdam (Ph. van der Schley), 16 August 1797, no. 167: "*Den Delfsche van der Meer, Een Philosooph, zittende in een Binnevertrek voor een Tafel, die met een Tapyt gedekt is, met eenige Boeken voor hem, hy heeft zyn regter hand aan een Hemel Globe, die op den Tafel staat; konstig en natuurlyk verbeeld, en fraai van penceelbehandeling. Hoog 20, breed 16 duim. Doek*" ("The Delft van der Meer. A philosopher, sitting in an inner room before a table, which is covered with a rug, with several books in front of him, he has his right hand on a celestial globe, which stands on the table; artfully and naturally represented, and beautiful of brushwork. Height 20, width 17 inches. Canvas," for F 270 to Gildemeester (at this sale our cat. no. 24 was no. 168).

• Sale Jan Gildemeester Jansz., Amsterdam (Ph. van der Schley), 11 June 1800, no. 139: "*De Delftsche van der Meer. Een Philosooph in zyn binnenvertrek. Hy is verbeeld, zittend voor een tafel met een tapyt bedekt, en eenige boeken voor hem, waar by geplaatst is een hemelglobe, op welke hy zyn hand houd; zeer natuurlyk en kunstig van behandeling, hoog 20, breed 18 duim. Doek*" ("The Delft van der Meer. A philosopher in his inner room. He is depicted sitting in front of a table covered with a rug, and several books in front of him, next to which a celestial globe is placed, on which he places his hand; very natural and artful of treatment. Height 20, width 18 inches. Canvas"), for F 340 to La Bouchère.

• ?Sale London (Christie), 1863, no. 73, with description (this sale according to *Bürger*, p. 324 and p. 560, no. 36 and repeated by later authors. but we did not succeed in tracing it).

• Sale Léopold Double (Paris) (Pillet et al.), 30 May 1881, no. 17, with elaborate description; for Fr. 44,500 to Gauchey.

• Collection Alphonse de Rothschild, Paris (mentioned by H. Havard, *Van der Meer de Delft*, Paris, 1888). Bequeathed to his son:

• Collection Edouard de Rothschild.

• During World War II abducted to Hitler's "museum" at Linz, Austria. Restored to owner in 1945 (Foucart, op. cit.).

• Paris, Musée du Louvre, acquired 1983, no. RF 1983-28.

24. (Plate 25)
THE GEOGRAPHER.

Frankfurt, Stadelsches Kunstinstitut.
Signed on the cupboard and signed and dated 1669 top right. Both (?) later additions.
Canvas, 53 x 46.6 cm. (20 7/8 x 18 1/4 in.).
Bürger: 34. Hofstede de Groot: 5. De Vries: 28. 1669. Bloch: 1668 [sic]. Goldscheider: 28, 1669. Wheelock: 1669.
1669.

On the cupboard is the same globes as in cat. no. 29 (see also cat. no. 23). Next to it is a framed map of Europe with sea routes (see *Welu*, p. 543 ff., also on the various geographical instruments). E. de Jongh made a comparison with a very similar geographer portrayed in an engraving in the book *Leerzame Zinnebeelden* by Adriaan Spinneker (Haarlem, 1714); the poem below counsels man to "travel" with the aid of the two "maps": the Gospel and the life of Jesus (*de Jongh 1967*, pp. 67, 68, figs. 51, 52).
Provenance:
This painting was sold several times together with cat. no. 23, both paintings being described in much the same wording until 1778:

• Sale Rotterdam, 27 April 1713, no. 10: "*Een stuk verbeeldende een Mathematis Konstenaar, door vander Meer; no. 11. Een dito door denzelven*" ("A painting representing a mathematical artist, by vander Meer; no. 11. A ditto by the same"), together for F 300 (*Hoet* II, p. 365; this may have been the sale of part of the collection Adriaen Paets; see J. G. van Gelder in Rotterdams Jaarboekje, 1974, p. 169).

• Sale Hendrik Sorgh, Amsterdam, 28 March 1720, no. 3: "*Een Astrologist: door Vermeer van Delft, extra puyk, no. 4. Een weerga, van dito, niet minder*" ("An Astrologer: by Vermeer of Delft, extra good, no. 4. A pendant of ditto, not inferior"), together for F 160 (*Hoet* I, p. 242).

• Sale Govert Looten, Amsterdam, 31 March 1729, no. 6: "*twee Astrologisten van de Delfze van der Meer, heerlyk en konstig geschildert*" ("two astrologers by the Delft van der Meer, wonderfully and artfully painted"), for F 104 (*Hoet* I, p. 333).

• Sale Jacob Crammer Simonsz. (Amsterdam), Amsterdam (Ph. van der Schley), 25 November 1778, no. 19 (not no. 20, as Hofstede de Groot erroneously states): "*J. van der Meer bygenaamt de Delfsche. Een Philosooph in zyn studeer Vertrek, staande voor een Tafel met een Tapytje overdekt, waar op legt een op Parkament geteekende Landkaart, houdende in de Regterhand een Passer, en rustende met de andere op de Tafel. verder ziet men een Kast, waar op een Globe, Boeken en ander bywerk, het bevallige ligt, is in alles niet minder konstig waargenoomen, als in de voorgaande, zynde een weerga van dezelve. Doek, hoog en breed als de voorige*" ("J. van der Meer nicknamed the Delft one. A philosopher in his study, standing in front of a table covered with a little rug, on which lies a map drawn on parchment, holding in his right hand a pair of compasses, and resting the other on the table, furthermore one sees a cupboard, on which a globe, books and other accessories, the pleasing light, is observed no less artfully in all this, than in the preceding piece. being a pendant of the same. Canvas, height and width as the preceding one") (i.e., 20 x 18 inches; see our cat. no. 23), for F 172 (*de Vries*).

• *In 1785 both cat. nos. 23 and 24 were brought from Amsterdam to Paris by the art dealer Alexandre Joseph Paillet, who intended to sell them to the French king through the latter's Directeur Général des bâtiments, the Comte d'Angiviller. For unknown reasons the sale did

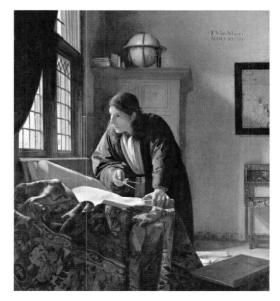

PLATE 24.
The Geographer..

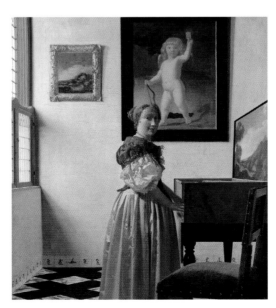

PLATE 20.
Lady Standing at a Virginal.

not take place. At the time Paillet described the paintings in a note: "*van der Meer, ou Meer. Un architecte paroissant occupée a tracer un plan; il est vu a my corps et caracterisé par differens accessoirs de son art. Ce tableau nest pas encore du premier ordre mais son effet piquant et le moileux du pinceau le distingue. On ne conois ici aucun ouvrage de ce peintre. Ils sont tres rares et lon nen cite que chez les Electeurs. Hauteur 19 pouces. Largeur 16 p. Sur toile. Un astronome etudiant sur le globe de la terre par le meme et grandeur du precedent. Il est aussi bien peint mais lautre lui fait beaucoup deton(nement)*" ("van der Meer, or Meer. An architect seems engaged in drawing a plan. He is seen at half length and is characterized by various accessories. This picture is not yet of the first rank, but it is distinguished by its pungent effect and softness of brush. No work by this painter is known here. They are very rare and they are only mentioned [as being] with the [Prince] Electors. High 19 inches, wide 16 inches, on canvas. An astronomer studying the globe of the earth by the same and the same size as the preceding. It is equally well painted, but the other does not fit to it at all") (Jolynn Edwards. "La curieuse histoire de l'Astronome de Vermeer et de son 'pendant' au XVIIIᵉ siècle," in Revue du Louvre 36, 1986, 3, pp. 197-201).

• Sale Jan Danser Nyman, Amsterdam (Ph. van der Schley), 16 August 1797, no. 168: "*Den Delfschen van der Meer. In een Binnenvertrek, bij een Glaase Raam, staat een Persoon voor een Tafel, met een Tapytkleed bedekt, waar op een Landkaart legd, houdende in de regter hand een Passer, en met de linker hand op de Tafel rustende, verder een Kast met Boeken, waar op een Globe staat; konstig en meesterlyk gepenceeld, hoog 20 breed 18 duim. Doek*" ("The Delft van der Meer. In an inner room, near a glass window, stands a person in front of a table, covered with a rug, on which lies a map, holding in his right hand a pair of compasses, and with the left hand resting on the table, further a cupboard with books, on which stands a globe; painted in an artful and masterly manner. Height 20 width 18 inches. Canvas"), for F 133 to Joszi (cf. p. 160 and 169, note 94).

• *Sale Arnoud de Lange, Amsterdam (Ph. van der Schley), 12 December 1803, no. 55: "*In een Gemeubileerd Binnenvertrek staat een Geleerde*

aan een Tafel, met een Tapyten Kleed gedekt, houdende een Passer in zyn Hand, waar mede hy een voor hem liggende Landkaart schynt af te meeten; het zonlicht, dat door het Vengster invalt, is frappant, en de schildering meesterlyk, op Doek, door de Delfsche van der Meer" ("In a furnished inner room stands a scholar at a table, covered with a rug, holding a pair of compasses in his hand, with which he seems to be measuring a map lying in front of him; the sunlight, falling in through the window, is striking, and the way of painting masterly, on canvas, by the Delft van der Meer"), for F 360 to Coclers. According to a note in the sale catalogue at the R.K.D., the painting came from the Greve heirs. It was one of the few paintings in the sale that had belonged to de Lange himself; see S.A.C. Dudok van Heel, in *Maadblad . . . Amstelodamum* 64, 1977, p. 53 ff.

• Sale Jhr. Johan Goll van Franckenstein (Amsterdam), Amsterdam (Jer. de Vries), 1 July 1833, no. 47: "*De Delftsche van der Meer. In een Binnenvertrek staat voor een vensterraam een geleerde met eene passer in de hand, bezig zijnde eene kaart te beschouwen, nevens hem liggen op den grond eenige boeken en teekeningen, tegen de muur staat eene kast met eene globe op dezelve, en naast de kast een stoel en verder bijwerk; fraai van schildering en uitdrukking, hoog 5 p. 2 d. breed 4 p. 6 d. Doek*" ("The Delft van der Meer. In an inner room a scholar stands before a window with a pair of compasses in his hand, engaged in studying a map, beside him on the floor lie sev-

eral books and drawings, against the wall stands a cupboard with a globe upon it, and next to it a chair and more accessories; beautiful in manner of painting and of expression, height 5 f. 2 inches, width 4 f. 6 inches. Canvas"), for F 195 to Nieuwenhuys.

• Collection Alexandre Dumont, Cambrai (see P. Mantz, "Collections d'amateurs, I, Le Cabinet de M. A. Dumont, a Cambrai," in *Gazette des Beaux-Arts*, II, VIII, 1860, pp. 304-5; also Ch. Blanc, *Histoire des Peintres . . . Ecole Hollandaise*, 11, Paris, 1863, engraving on p. 3).

• Collection Isaac Pereire, 1866, acquired directly from Dumont (Bürger, p. 561, with ill.).

• Sale M. M. Pereire, Paris (Pillet), 6 March 1872, no. 13, with engraving by Deblois and detailed description; for Fr 17,200 (*Hofstede de Groot* and *de Vries* erroneously say Fr 7200). N.B.: See on the Pereire brothers as collectors: *Haskell*. p. 83 ff.

• Collection Max Kann, Paris (according to cat. Sedelmeyer, 1898).

• Sale [Demidoff], Palais de San Donato, Florence (Ch. Pillet), 15 March 1880, no. 1124, with engraving by Deblois and the note "*Signé deux fois*" ("signed twice") for 22,000 lire.

• Sale Ad. Jos. Bösch (Döbling). Vienna (G. Plach), 28 April 1885, no. 32, for 9000 to Kohlbacher for the museum. N.B.: *In our opinion, the painting was at some time, between about 1872 and 1880, with art dealer Ch. Sedelmeyer, Paris. as appears from his *Catalogue of 300 Paintings . . .* , 1898, no. 87, with ill.

Copies:

Probably a copy after our cat. no. 23 or 24 was: "*Een Doctor in zijne studeerkamer, uitmuntend met kleuren naar de Delftsche van der Meer door V[incen]t v. d. Vinne*" (1736-1811) ("A doctor in his study, excellent with colors after the Delft van der Meer by Vincent v.d. Vinne"); sale of drawings Haarlem (Engsemet), 20 July 1835, Portfolio C, no. 2. A painted copy after the painting was in the sale Math. Neven (Cologne), Cologne (Heberle), 17 March 1879, no. 131; later at sale J. B. Foucart (Valenciennes), Valenciennes (J. de Brauwere), 12 October 1898, no. 115, with ill., for Fr 2500; note of A. Bredius in the sale cat.: "*toch wel uitstekende oude copie*" ("nevertheless an excellent old copy"); at both sales as by Vermeer.

25. (Plate 20)

LADY STANDING AT A VIRGINAL.

London, National Gallery.

Signed on the instrument.

Canvas, 51.7 x 45.2 cm. (20 1/4 x 17 3/4 in.).

Bürger: 29. Hofstede de Groot: 23. De Vries: 30, 1670. Bloch: late. Goldscheider: 35, 1671. Wheelock: 1673-75.

1670.

The large painting on the wall has plausibly been attributed to Caesar van Everdingen (by G. Delbanco, *Der Maler Abraham Bloemaert*, Strasbourg, 1928, p. 64, note 39; see also *MacLaren*, p. 437). It is also depicted in cat. nos. 4 and B1 and is visible on the X-ray of cat. no. 6 (our fig. 110). It may well be identical with the *Cupid* listed in the house of Vermeer's widow (see document of 29 February 1676). The landscape on the left is completely in the manner of Jan Wynants (more than of Wouwerman; cf. *Stechow 1960*, p. 180). Wheelock speculates on the possibility that cat. nos. 25 and 31 were intended as pendants (*Wheelock 1981*, p. 152).

Provenance:

• This painting or cat. no. 31 (or perhaps cat. no. 16?) is probably the painting owned by Diego Duarte in 1682 in Antwerp described as *"Een stuckxken met een jouffrou op de clavesingel spelende met bywerck van Vermeer, kost guld, 150"* ("A small piece with a lady playing the clavecin with accessories, by Vermeer, costs florins 150"). (See document of 12 July 1682.)

The following two items may refer to either cat. no. 25 or no. 31:

• 1. Collection Dissius; sale Amsterdam, 16 May 1696, no. 37: *"Een Speelende Juffrouw op de Clavecimbael F 42,10"* ("A lady playing the clavicembalo F 42.10"). (See document of that date); 2. Sale Amsterdam, 11 July 1714, no. 12: *"Een Klavecimbaelspeelster in een kamer, van Vermeer van Delft, konstig geschildert, F 55.-"* ("A lady playing the clavicembalo in a room, by Vermeer of Delft, artfully painted, F 55.-") (*Hoet* I, p. 176); but see also the provenance of our cat. no. 16.

• Sale Jan Danser Nyman, Amsterdam (Ph. van der Schley), 16 August 1797, no. 169: *"Den Delfsche van der Meer. Een Juffrouw, staande voor een Clevecimbaal te speelen; aan de wand hangen Schilderyen; zeer fraai van penceelbehandeling. Hoog 20 breed 17 duim. Doek"* ("The Delft van der Meer. A lady, standing and playing a clav-

icembalo; on the wall hang paintings; very beautiful of brushwork. Height 20 width 17 inches. Canvas"), for F 19 to Bergh.

• Collection E. Solly, London, see below (not—as has been claimed since *Bürger*—in the Solly sale, 1847; see *MacLaren*, pp. 437-38, note 10).

• Sale Edward W. Lake, London (Christie), 11 July 1845, no. 5: "Van der Meer, of Delft. The Interior of an Appartment, in which a young lady richly habited is standing by a harpsichord. The sunlight is admitted from a side window, with the effect of De Hooghe. Highly finished. An excellent example of this rare master. 21 in. by 18 in. C. From the collection of E. Solly, Esq."

• Sale [J. P. Thom], 2 May 1845, no. 5, for 14 1/2 guineas, to Grey (see *MacLaren,* pp. 437, 438, note 12).

• Collection Thoré-Bürger, 1866 (*Bürger*).

• Inherited by the Lacroix family (see introduction in sale cat. 1892 and *MacLaren*, p. 437, note 14).

• Sale Thoré-Bürger, Paris (Drouot), 5 December 1892, no. 30, with detailed description and ill. with wrong number, for Fr 29,000 to art dealer Bourgeois (note in sale cat. at R.K.D.) and/or art gallery Lawrie, London: acquired by the museum in that same month (*MacLaren*, p.437).

26. (Plate 26)

THE LACEMAKER.

Paris, Louvre.

Signed top right.

Canvas, on panel 24 x 21 cm. (9 3/8 x 8 1/4 in.).

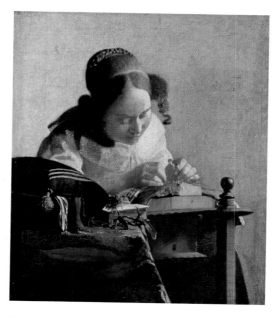

PLATE 26.
The Lacemaker.

Bürger: 37. Hofstede de Groot: 11. De Vries: D. 1664. Bloch: 1665 -70. Goldscheider: 22, 1665. Wheelock: 1669-70.

1670-1671.

The cushion on the left is a so-called *"naaikussen"* ("sewing cushion"). The red and white strings are bundles of yarn hanging out. Cushions of this type were made of hard material covered with velvet or cloth; they were opened by lifting the upper half. Inside were wooden compartments in which sewing materials were stored. The cushions were taken on the lap to sew on them (see M.G.A. Schipper-van Lottum, "Een naijmantgen met een naijcussen," in *Antiek* 10, 1975, p. 151).

Provenance:

• Collection Dissius, Delft, 1682; sale Amsterdam, 16 May 1696, no. 12: *"Een Juffertje dat speldewerkt. F 28"* ("A young lady doing needlework. F 28"). (See document of that date.)

• Sale Jacob Crammer Simonsz. (Amsterdam), Amsterdam (Ph. van der Schley), 25 November 1778, no. 17: *"Jvan der Meer bygenaamt de Delfsche. Een bevallige Dame, verbeeldende een Speldewerkster, zy zit ter zyde een Tafel, met een Tapytje overdekt, waar op een groen Werkkussen, een Boek en verder bywerk, zeer natuurlyk en sonaghtig geschiJdert. Op Paneel, hoog 9 1/2 breed 8 duim"* ("Jvan der Meer nicknamed the Delft one. A charming lady, representing a needle worker, she sits next to a table covered with a small rug, on which a green working cushion, a book and other accessories, very naturally and sunnily painted. On panel, height 9 1/2 width 8 inches"), for F 150 to Nyman.

• *Sale Jan Wubbels, Amsterdam (Ph. van der Schley), 16 July 1792, no. 213: *"J. van der Meer, bygenaamd de Delfsche. Dit natuurlyk stukje verbeeld een Dame, zittende neevens een Tafel met een Tapytkleedje bedekt, beezig Kant te werken, ter zyde legt een Boek en Naaikussen: alles zonagtig, fraay, en bevallig gepenceeld, hoog 10, breed 8 duim, P."* ("J. van der Meer, nicknamed the Delft one. This natural painting represents a lady, sitting next to a table covered with a small rug, engaged in working lace, at her side lie a book and a sewing cushion; all painted sunnily, beautifully, height 10, width 8 inches, P."), for F 210 to J. Spaan.

• N.B.: Since Hofstede de Groot it has been asserted that the painting was in the Schepens

sale, Amsterdam, 21 January 1811, no. 5; that painting, however, was a drawn copy (see below).

• Sale Hendrik Muilman (Amsterdam), Amsterdam (Ph. van der Schley), 12 April 1813, no. 97: "*De Delftsche van der Meer. Eene bevallige jonge Dame in oud Hollandsche kleeding; zij is bezig met veel aandacht kant te werken, en is gezeten bij eene Tafel, met een Kleed bedekt, en waarop een Naaikussen, Boek, enz. alles is breed en fiks gepenseeld, en bevallig van kleur. Het voorwerp doet eene treffende uitwerking tegen den witten achtergrond, hoog 9 1/2, breed 8 duimen. Doek op Paneel*" ("The Delft van der Meer. A charming young lady in old Dutch dress; she is engaged in making lace with much attention, and is seated at a table covered with a rug, on which a sewing cushion, book, etc. everything is broadly and vigorously painted, and pleasing in color. The subject makes a striking effect against the white background. Height 9 1/2, width 8 inches. Canvas on panel), for F 84 to Coclers. Not in sale Amsterdam, 24 May 1815 (see below).

• Sale [A.] L[apeyrière], Paris (Lacoste), 14 April 1817, no. 30: "*Vander Meer de Delft. Un tableau peint avec le plus grand art et où le peintre a su, dans une manière large, rendre le fini de la nature, la différence des objets, le soyeux des étoffes, par la justesse de ses teintes et de l'effect, Il représente une jeune femme occupée à faire de la dentelle, et entourée de divers accessoires con venables à cette occupation. Les Tableaux de cet artiste sont extrêmement rares et recherchées. Haut. 9 p., Larg. 8 p. Marouflée*" ("Vander Meer of Delft. A painting done most artfully and in which the painter has, in a broad manner, succeeded in rendering the finish of nature, the difference between the objects, the silkiness of the materials, by the accuracy of his colors and of the effect. It represents a young woman busy working lace, and surrounded by several accessories appropriate to this occupation. The paintings of this artist are extremely rare and sought after. Height 9 p. Width 8 p. Canvas laid down on panel"), for Fr 501 to Coclers.

• *Collection Baron Nagell van Ampsen, The Hague, between 1819 and 1823 seen by Murray: "Van der Meer.—A woman sitting with a cushion before her making lace. The painting is very soft, and the half tints are beautifully transparent" (*Murray*, p. 70).

• Sale A. W. C. Baron van Nagell van Ampsen (The Hague), The Hague (Jer. de Vries), 5 September 1851, no. 40: "*Jan van der Meer. Jeune femme. Elle s'occupe à faire des dentelles, occupation qui paraît attirer toute son attention, h. 23, l. 20 centimètres. Bois*" ("Jan van der Meer. Young woman. She is busy making lace, an occupation that seems to engage all her attention, h. 23, w. 20 centimeters. Panel"), for F 260 to Lamme.

• Collection Blokhuyzen, Rotterdam, 1860 (W. Bürger, *Musées de la Hollande* II, Brussels, 1860, p. 70).

• Sale D. Vis Blokhuyzen (Rotterdam), Paris (Ch. Pillet), 1 April 1870, no. 484, with elaborate description taken from *Bürger,* as: canvas, for Fr 6000 to Gauchey, "*revendu par Ferral 7500 frs au Louvre*" ("resold by Ferral 7500 frs to the Louvre"). At first, in 1870, the complete Blokhuyzen collection had been offered to the city of Rotterdam for a comparatively small sum, but this was rejected; see P. Haverkorn van Rijswijk, *Het Museum Boymans te Rotterdam,* The Hague/Amsterdam, 1909, pp. 215-29.

Copies:

A painted copy after the painting was in our opinion: Sale Daniël de Jongh Az., Rotterdam, 26 March 1810, no. 51: "*Een Dame, gezeten aan eene tafel, bezig met speldewerken, bevallig geschilderd . . . De Delftsche Vermeer of zijn manier, hoog 10, breed 7 1/2 duimen, paneel*" ("A lady, seated at a table, doing needlework, pleasingly painted, by the Delft Vermeer or in his manner, height 10, width 7 1/2 inches, panel"), for F 10.5 st. to van Yperen; *Hofstede de Groot,* no. 12a. *Jan Stolker (1724-1785)* made at least two copies after the painting, mentioned in the following sale catalogues. One in black ink: 1. Sale Jan Stolker, Rotterdam, 27 March 1786, Portfolio E, no. 193, for F 22 to Van Zante. The other(s) in watercolor: 2. Sale C. Ploos van Amstel, Amsterdam (Ph. van der Schley), 3 March 1800, Portfolio W, no. 50, for F 22 to Bolten; 3. Sale J. Schepens et al., Amsterdam (Ph. van der Schley), 21 January 1811, Portfolio K, no. 5; 4. Sale [J. Kobell?], Amsterdam (H. Vinkeles Jzn.), 24 May 1813, Portfolio B, no. 12, for F 9 to Gruyter.

The sale catalogues state that the scene is seen "through a niche." This does not necessarily imply that the painting itself was larger at that time and included a niche, for Stolker often took

great liberties in his copies after old masters. On two calques of cat. no. 26 published by van Gelder, probably dating from the eighteenth century, the lacemaker is also seen behind a niche (J. G. van Gelder, in *La Revue de l'Art* 15, 1972, pp. 111, 112, fig. 5, 6). These were probably made after or in connection with Stolker's copy, not (directly?) after the Vermeer.

27. (Plate 27)
LADY WRITING A LETTER WITH HER MAID.
Blessington (Ireland), Russborough House, Beit Art Collection.
Signed on the table, under the left arm of the lady writing.
Canvas, 72.2 x 59.5 cm. (28 1/8 x 23 3/8 in.).
Hofstede de Groot: 35. De Vries: 16, 1660-62. Bloch: 1665-70. Goldscheider: 30, 1670. Wheelock: 1670.
1671.

For the painting in the background, see text of cat. no. 23. The painting cat. no. 27 was seized on 26 April 1974, with other masterpieces from the Beit Collection, by a group led by Dr. Rose Dugdale, whose aim was to serve the Irish cause. The paintings were recovered practically undamaged after some ten days. On the subsequent restoration, see A. O'Connor, "A note on the Beit Vermeer," in *Burlington Magazine* 119, 1977, pp. 272-73. In May 1986 the picture was stolen again; in February 1988 it was still missing.

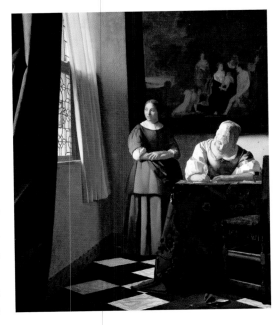

PLATE 27.
Lady Writing a Letter with her Maid.

Provenance:

• Given as a security by Vermeer's widow on 27 Ianuary 1676 to the baker van Buyten, a painting by her husband: *"vertonende twee personagien waeroff d'een een brief sit te schrijven"* ("representing two persons of whom one is seated writing a letter"), together with our cat. no. 28, because of a debt of F 617. (See document of that date.)

• Sale Josua van Belle, Heer van St Huybertsgerecht, Rotterdam, 6 September 1730, no. 92: *"Een Juffrouw zittende een Brief te schryven daer de Meid nae staet te wagten, door Vander Meer, h. 2 v. 3 d. br. 1 v. 11 en een half d."* ("A lady sittting and writing a letter which the standing maidservant is waiting for, by Vander Meer, h. 2 f. 3 inches w. 1 f. 11 and a half inches"), for F 155.

• Collection Franco van Bleyswyck, Delft, deceased 1734, mentioned in his estate: *"Een stuk, juffer die een brief schrijft en een meid bij haar, van J. van der Meer"* ("A painting, lady who writes a letter and a maidservant with her, by J. van der Meer"), valued at F 75, by someone else at F 100; inherited by drawing of lots by Maria Catharina van der Burch, wife of Hendrik van Slingelandt: in the latter's collection in 1752: *"Een Juffrouw die schrijft door J.v.d.Meer van Delft, 27 x 24 d."* ("A lady who writes by J.v.d.Meer of Delft, 27 x 24 inches") *(Hoet* II, p. 408); after the death of this couple, valued by A. Schou man in 1761: *"nr. 17. Een schrijvent Vrouwtje door J. van der Meer"* ("no. 17. A writing woman by J. van der Meer"),

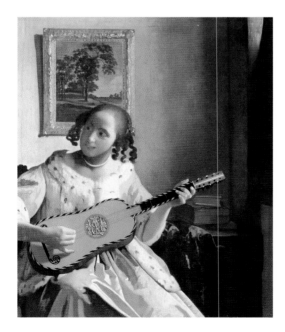

PLATE 29.
The Guitar Player.

F 30; inherited by one of their two daughters, Agatha or Elisabeth Maria (see C. Hofstede de Groot. "Schilderijenverzamelingen . . . Slingelandt . . . ," in *Oud-Holland* X, 1892, p. 229 ff).

• Collection Miller von Aichholz, Vienna; bought by art dealer Sedelmeyer, 6 April 1881; sold to Secretan, 17 April 1881, for Fr 60,000 (according to handwritten notes by Sedelmeyer in his copy, now at R.K.D., of exh. cat., *300 Pictures . . . sedelmeyer,* Paris, 1898, no. 86, with ill.).

• Sale E. Secrétan, Paris (Boussod), 1 July 1889, no. 140, with ill. and detailed description, for Fr 62,000 (to Boussod, Valadon & Co, according to a note in author's copy of *Hofstede de Groot).*

• Collection Marinoni, Paris; art dealer F. Kleinberger, Paris; collection A. Beit, London *(Hofstede de Groot).* Collection Beit, Blessington, Ireland. This collection became a Foundation in 1976.

28. (Plate 29)
THE GUITAR PLAYER.

London, Kenwood, Iveagh Bequest.
Signed on the right on the lower edge of the curtain.
Canvas, 53 x 46.3 cm (20 7/8 x 18 1/4 in.).
Hofstede de Groot: 26. De Vries: 26, 1667. Bloch: 1665-70. Goldscheider: 32, 1670. Wheelock: 1672. 1671-72.

The landscape on the wall is "à la Adriaen van de Velde, but basically Vermeer's own creation" *(Stechow 1960,* p. 180). Naumann observed that Vermeer's starting point when conceiving cat. no. 28 may very well have been a *Woman Playing the Lute* by Frans van Mieris of 1663 *(Naumann 1981,* I, pp. 64, 67, II, plate 52; present whereabouts unknown).

The painting was stolen from the museum in February 1974, apparently for political reasons. It was recovered in May 1974.

Provenance:

• Given as a security by Vermeer's widow on 27 January 1676 to the baker van Buyten, a painting by her husband: *"Een personagie spelende op een cyter"* ("A person playing the guitar"), together with our cat. no. 27, because of a debt of F 617. (See document of that date.)

• Sale Amsterdam, 16 May 1696, no. 4: *"Een Speelende Juffrouw op een Guiteer, heel goet"* ("A lady playing a guitar, very well done"). (See document of that date.)

122.
Old copy after *The Guitar Player* (cat. no. 28, plate 29), canvas, 48.7 x 41.2 cm. Museum of Art, Philadelphia. Only the coiffure is different. The hairstyle on this copy seems to reflect the fashion of around 1700. This makes it unlikely that it was painted much later, because at a later date the coiffure on Vermeer's original would not have semed so out of fashion anymore that the copyist would have felt the need to modernize it.

• Collection 2nd Viscount Palmerston, mentioned in his Travelling Account Book: "1794. Bought at The Hague from Monsr. Nyman . . . A woman playing on a Lute, Vandermeer of Delft, 18 Louis d'or"; from him to Collection W. Cowper-Temple at Broadland, later Baron Mount-Temple, 1871; from him to A. E. Ashley, sold 1888 to art gallery Thos. Agnew, London; purchased by the Earl of Iveagh, 1889 (data from *The Iveagh Bequest, cat. of Paintings,* London, 1960, p. 34).

• N.B.: Since the painting was in England from 1794 on, it is not—as has always been claimed—the same piece that was auctioned in Amsterdam on 22 December 1817. In our opinion, that painting is our cat. no. b1.

Copy:

The provenance of our cat. no. 28 has often been confused with that of an old copy after it in the collection John G. Johnson, Philadelphia (our fig. 123; cat. 1972, no. 497). The pedigree of this copy is as follows: ? Sale 1817 (see our cat. no. b1); Art dealer Gruyter, Amsterdam; Collection Cremer, Brussels, 1866; Sale Comte C[ornet de Ways Ruart fils of Cremer and Georges H. Phillips and W. Bürger], Brussels (Le Roy). 22 April 1868, no. 50, with description, for 2075 to Stevens; Sale William Middle-ton, "Collection . . . received from Brussels." London (Christie). 26 January 1872, no. 192: "Van der Meer of Delft. The guitar-player," for £ 106. 1 sh. to Cox; Collection H. L. Bisschoffsheim, London; Art dealer Gooden, London. See also M. W. Brockwell,

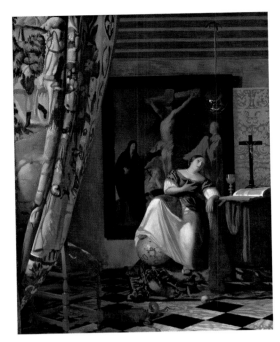

PLATE 317.
Allegory of Faith.

in *Gazette des Beaux-Arts* 65, 5th period, 1922, pp. 61-62; E. Trautscholdt, in *Burlington Magazine* LII, no. 300, 1928, p. 146. See note 75 on p. 168.

29. (Plate 31)
ALLEGORY OF FAITH.

New York, Metropolitan Museum of Art.
Canvas, 114.3 x 88.9 cm. (45 x 35 in.).
Bürger: 41. Hofstede de Groot: 2. De Vries: 29, 1669-70. Bloch: after 1670. Goldscheider: 37, 1672. Wheelock: 1671-74.
1672-1674.

The *Crucifixion* on the rear wall is a work by Jacob Jordaens. A version of it is preserved in the Terningh Foundation, Antwerp (*Swillens,* plate 56). This is probably the *"groote schildery, sijnde Christus aen 't Cruys"* ("large painting, being Christ on the Cross") in the possession of Vermeer's widow in 1676 (see document of 25 February 1676). E. de Jongh observed that the loose piece of gilt leather to the right and the ebony crucifix on the table may be the objects mentioned in this same inventory (E. de Jongh, "Pearls of Virtue and Pearls of Vice," in *Simiolus* 8, 1975/6 (pp. 69-97), p. 71. De Jongh (p. 71, note 9) says that the same piece of gilt leather is depicted in our plate 21 (cat. 22) but its pattern is clearly different.

The woman's foot rests on a globe, which can

be identified with the second edition, dated 1618, of a globe produced by the Hondius family of cartographers (see figs. 40, 41). It is also depicted, from another angle, in cat. no. 24 (see *Welu,* pp. 541, 544).

The program for the *Allegory of Faith* was mainly taken from Cesare Ripa's book *Iconologia,* as Barnouw noted as far back as 1914. Page 147 of Dirck Pers's Dutch translation, published in 1644, of that Italian book reads: "Faith is also represented by a Woman, who is sitting and watching very attentively, holding a Chalice in her right hand, resting her left on a Book, that stands on a fixed cornerstone, that is to say *Christ,* having the World under her feet. She is dressed in Sky blue with a crimson outer garment. Beneath the cornerstone a serpent lies crushed, and Death with his arrows broken. Next to this lies an Apple, the cause of Sin. She is crowned with Laurel leaves, which means, that we conquer by Faith. Behind her hangs a Crown of Thorns on a nail. Which all speaks for itself, needing little explanation. In the distance Abraham is also seen, where he was about to sacrifice his son." Apart from "Death with his arrows" and the "Laurel leaves" all attributes mentioned in this text are present in the painting, though they are arranged differently than in Ripa's prescription. That the woman holds her hand on her breast and wears a white dress has been derived from another text in Ripa (p. 148), in which he describes the *"Catholyck of algemeen geloof"* ("Catholic or universal faith"): "A woman dressed in white, who holds her right hand on her breast, and in her left a chalice, which she regards intently" (A. J. Barnouw, "Vermeer's zoogenaamd Novum Testamentum," in *Oud-Holland* 32, 1914, pp. 50-54).

Details of the painting inconsistent with or not mentioned by Ripa were explained by E. de Jongh. Vermeer replaced the Old Testament prototype, Abraham sacrificing Isaac, by its traditional New Testament antitype, the Crucifixion. The glass sphere hanging from the ceiling and the crucifix on the table can be related to a print representing Faith in the Jesuit Willem Hesius's book *Emblemata Sacra de Fide, Spe, Charitate* of 1636. The print represents a crucifix and a sphere, the latter hanging from the extended hand of a little angel. The text beneath explains the image: the

human mind, limited as it may be, is able to contain the vastness of the belief in God, just as a little sphere can reflect the entire universe. Gold and pearls, depicted in cat. no. 29 in the form of gilt leather and of the lady's necklace respectively, figure in many seventeenth-century texts as symbols of Faith (E. de Jongh, op. cit.).

Provenance:
• Sale Herman van Swoll, Amsterdam, 22 April 1699, no. 25: *"Een zittende Vrouw met meer beteekenisse, verbeeldende het Nieuwe Testament, door Vermeer van Delft, kragtig en gloejent geschildert"* ("A sitting woman with several meanings, representing the New Testament, by Vermeer of Delft, vigorously and glowingly painted"), for F 400 (*Hoet* I, p. 48). See on Herman Stoffelsz. van Swoll (1632-1698): *Montias 1987,* p. 74.
• Sale Amsterdam, 13 July 1718, no. 8: *"Een zittende Vrouw, met meer betekenisse, verbeeldende het Nieuwe Testament. door Vermeer van Delft, kragtig en gloejend geschildert"* ("A sitting woman, with several meanings, representing the New Testament. by Vermeer of Delft, vigorously and glowingly painted"), for F 500 (*Hoet* I, p. 216).
• Sale Amsterdam, 19 April 1735, no. II: *"Een Kamer, waer in een Vrouwtje, verbeeldende het Nieuwe Testament, konstig en uytvoerig geschildert, door de Delfsche vander Meer"* ("A room, in which a woman, representing the New Testament, artfully and elaborately painted, by the Delft vander Meer"), for F 53 (*Hoet* I, p. 438).
• Sale David Ietswaart, Amsterdam, 22 April 1749, no. 152: *"Een Dame in haar Kamer, in haar devotie, met veel uitvoerig bywerk, door de Delfse van der Meer, zo goed als Eglon van der Neer, h. 4 voet 1 duim, br. 3 voet 3 duim"* ("A lady in her room, in her piety, with many elabo-

123. Jan van Bylert (1603-1671), *Mary Magdalene Forsakes the World in Favor of Christ,* signed, c. 1630, canvas, 114 x 111 cm. Bob Jones University, Greenville, South Carolina.

rate accessories, by the Delft van der Meer, as well done as Eglon van der Neer, h. 4 feet 1 inch, w. 3 feet 3 inches"), for F 70 (*Hoet* II, p. 248) to Ravensberg (according to a note of *Hofstede de Groot*).

• Private collection, Austria, 1824, because the painting appears in the background of a portrait of a cartographer and his wife, dated 1824, by the Viennese painter F. G. Waldmuller (1793-1865) (*de Vries;* see B. Grimschitz, *Ferdinand Georg Waldmuller,* Salzburg, 1957, p. 286, no. 129, with ill.). The painting is now in the Westfalisches Landesmuseum, Münster, cat. 1975, p. 170, with ill.

• Collection D. Stchoukine, Moscow; from there to Art gallery Wächtler, Berlin, as by Eglon van der Neer, but with a false signature of C. Netscher; bought from this gallery by Dr. A. Bredius (note of *Hofstede de Groot*); on loan to the Mauritshuis, The Hague (cat. 1914, no. 625), 1899-1923; to Boymans Museum, Rotterdam, 1923-1928 (*Jaarverslag* of the museum, 1923, p. 7, and 1928, p. 9).

• Art gallery F. Kleinberger, Paris; Collection colonel M. Friedsam, New York, 1928 (*de Vries*).

• Bequeathed by Friedsam to the museum, 1931.

30. (Plate 28)
HEAD OF A GIRL.

New York, Metropolitan Museum of Art.
Signed top left.
Canvas, 44.5 x 40 cm. (17 5/8 x 15 3/4 in.).

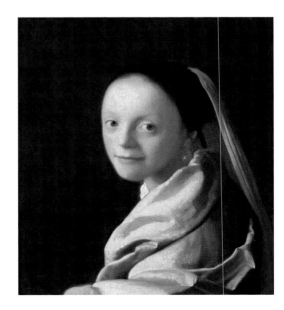

PLATE 28.
Head of a Girl.

Bürger: 2. Hofstede de Groot: 42. De Vries: 15. 1660. Bloch: 1660-65. Goldscheider: 34, 1671. Wheelock: 1666-67.
1672.
Provenance:

• This painting and/or cat. no. 18 may be one of the following paintings in sale Amsterdam, 16 May 1696: *"nr. 38. Een Tronie in Antique Klederen, ongemeen konstig. F 36.-; nr. 39. Nog een dito Vermeer. F 17.-; nr. 40. Een weerga van denzelven. F 17.-"* ("no. 38. A head in antique dress, uncommonly artful. F 36.-; no. 39. Another ditto Vermeer. F 17.-; no. 40. A pendant of the same. F17"). (See document of 16 May 1696.)

• Sale "Un amateur a Rotterdam" [Dr. Luchtmans], Rotterdam (Muys), 20 April 1816, no. 92: *"J. van der Meer de Delft. Le portrait d'une jeune personne, haut 17 pouces, large 15 pouces, toile"* ("J. van der Meer of Delft. The portrait of a young person, height 17 inches, width 15 inches, canvas"), according to de Vries for F 3. N.B.: The similarity of their dimensions might indicate that this painting may have been our cat. no. 18. Since this painting is called a "portrait," however, in our opinion it is much more likely to be cat. no. 30 (cf. p. 148).

• Collection Prince Auguste d'Arenberg, Brussels, cat. 1829, no. 53: *"Jean van der Meer de Delft. Portrait d'une femme affuble d'un manteau bleu, sur toile, hauteur 17 pouces, largeur 14 pouces"* ("Jean van der Meer of Delft. Portrait of a woman dressed up in a blue coat, on canvas, height 17 inches, width 14 inches"); cat. Galerie d'Arenberg in Brussels, by W. Bürger, 1859, p. 140, no. 35, with elaborate description and mention of the signature.

• Between 1914 and 1948 the whereabouts of the picture was kept secret; during World War I, however, the picture remained in the possession of the Duke of Arenberg and was transferred from Brussels to Schloss Nordkirchen, Westphalia (see *de Vries* and exh. cat. *In het Licht van Vermeer,* Mauritshuis, The Hague, 1966, cat. no. VI; E. Fahy, *The Wrightsman Collection,* V, New York, 1973, p. 313 with more details).

• Subsequently in the collection of Mr. and Mrs. Charles B. Wrightsman, New York/Palm Beach, Florida (Fahy, op. cit.).

• Presented to the museum by Mr. and Mrs. Wrightsman, 1979.

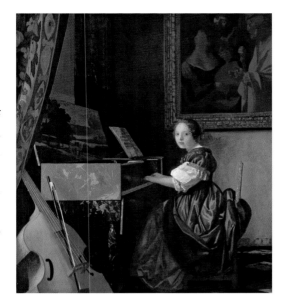

PLATE 30.
Lady Seated at a Virginal.

31. (Plate 30)
LADY SEATED AT A VIRGINAL.

London, National Gallery.
Signed on the wall, to the right of the head.
Canvas, 51.5 x 45.5 em. (20 1/4 x 18 in.).
Bürger: 30. Hofstede de Groot: 25. De Vries: 31, after 1670. Bloch: pendant of cat. no. 25, Goldscheider: 36, 1671. Wheelock: 1672-75.
1674-1675.

The overall composition is probably inspired by Gerard Dou's *Woman Playing the Virginal* at Dulwich (our fig. 125; observed by K. Bostrom, op. cit., p. 167, note 64). As he had done in the *Lady Standing at a Virginal* (cat. no. 25, plate 20). which is closely related both in style and theme, Vermeer furnished the wall behind the main figure with a painting of erotic content, in this case the *Procuress* by van Baburen, which is also depicted in cat. no. 17 (on the relation between the erotic and music, see also p. 136). It has unconvincingly been speculated that cat. no. 31 is the companion piece to cat. no. 25. De Mirimonde observed that the bass viol in the foreground of cat. no. 31 has six strings, whereas from 1675 on, seven strings became usual for this instrument (*Mirimonde*, p.38).

Provenance:

• Possibly in the collection Diego Duarte, Antwerp, 1682, and/or sale Amsterdam, 1696, and/or sale Amsterdam, 1714 (see cat. no. 25).

• Collection Count Schönborn, Pommersfelden (mentioned from 1746 on: see sale cat. 1867

124.
Gerard Dou, (1613-1675), *Woman Playing the Virginal,* panel, 36.5 × 28 cm, Dulwich College, London. (See cat. no. 31, plate 30).

below and *MacLaren,* p. 439, note 7) as: Jacob van der Meer (G. Parthey, *Deutscher Bildersaal,* II, Berlin, 1864, p. 98, no. 2).

• Mentioned as Jan Vermeer of Delft in 1866 by *Bürger,* p. 557.

• Sale Count Schönborn-Pommersfelden, Paris (Pillet), 17 May 1867, no. 78: *"Jan van der Meer ou Vermeer de Delft. Jeune femme au clavecin. Assise. de profil, devant le clavecin, elle retourne la tête de trois quarts. Boucles de cheveux blonds; jupon bleu. En avant, sur le parquet, un violoncelle. Signé: I.Meer (l'I en monogr. sur l'M). Nr. 30 du Cat. publié par la Gazette des Beaux-Arts. Mentionné dans le Cat. de 1746. No. 60 du Cat. de 1857, sous le nom de Jacob van der Meer. T. h. 0,50 m, l. 0,42 m"* ("Jan van der Meer or Vermeer of Delft. Young woman at the clavecin. Seated, in profile, before the clavecin, she turns her head three quarters. Curls of blond hair; blue dress. In front. on the floor, a violoncello. Signed: I.Meer [he I in monogram on the M]. No. 30 of the Cat. published by the *Gazette des Beaux-Arts.* Mentioned in the 1746 Catalogue. No. 60 of the Cat. of 1857, under the name of Jacob van der Meer. Canvas, height 0.50 m., width 0.42 m."), for Fr 2000 to W. Bürger.

• Inherited from the latter by the Lacroix family (see introduction to sale cat. 1892 and *MacLaren,* p. 439).

• Sale Thoré-Bürger, Paris (Drouot), 5 December 1892, no. 32, with description, for Fr 25,000 to Art gallery Sedelmeyer; cat. *300 Pictures., Sedelmeyer. . . .,* Paris, 1898, no. 85, with ill.; in Sedelmeyer's handwriting in his own copy of this cat. at the R.K.D. in French: "Sold by Sedelmeyer to

Lawrie & Co. 25 February '93. F. 33.100, who sold it to G. Salting."

• However, still at Art gallery T. Humphry Ward, 1894 (partners of Lawrie's?), as appears from exh. cat., Royal Academy, London, 1894, no. 93.

• In 1900 in the collection George Salting; bequeathed by him to the museum in 1910 (*MacLaren,* p. 439).

The following paintings nos. 32-39, mentioned in documents of Vermeer's time or later, are either lost or not definitely identifiable today. They are listed in the chronological order in which they first appeared in the documents:

32A. *"Een Graft besoeckende van van der Meer, 20 guldens"* ("A person visiting the grave"), i.e., the Three Marys at Christ's tomb, assessed at 20 guilders by the painter Adam Camerarius and the gentleman-dealer Marten Kretzer in their appraisal on 27 June 1657 of the estate of the late Johannes de Renialme *"Kunstkooper"* ("art dealer") in Amsterdam. See A. Bredius, *Kunstler-Inventare,* I, The Hague, 1915, p. 233. This reference was first linked to Vermeer of Delft by Montias, who also pointed out that Renialme had many contacts in Delft and possessed a score of paintings by other Delft artists (*Montias 1980,* pp. 47/48, document no. II; *Montias 1982,* pp. 214-15).

32B **"Een tronie van Vermeer"* ("A 'tronie' by Vermeer"). N.B.: There is no English world for *"tronie"* (literally, "face") as it was used in the seventeenth century, viz., for all kinds of paintings of a face up to a halflength figure. This *"tronie"* is mentioned in the inventory of the estate of Jean Larson, *"in zijn leven beelthouwer in Den Hage . . . gemaeckt ten sterfhuijze, 4 augustus 1664"* ("during his lifetime sculptor in The Hague, drawn up in the house of the deceased, 4 August 1664"). In the *"Contrabouck"* that goes with the inventory the piece is mentioned again: *"nr. 65. 1 principael van van der Meer F10-0-0"* ("no. 65. One original by van der Meer F10-0-0"). (A. Bredius. *Kunstler-Inventare,* The Hague, 1915 ff., pp. 325, 328). See also our cat. no. 18.

Cat. nos. 33-37 were in Collection Dissius, Delft; sale Amsterdam, 16 May 1696 (see document of that date):

33. No. "3. *'t Portrait van Vermeer in een Kamer met verscheyde bywerk ongemeen fraai van hem geschildert. F 45-0"* ("3. The portrait of Vermeer in a room with several accessories uncommonly beautifully painted by him. F 45-0"). *Hofstede de Groot:* 46. See also cat. no. 19.

34. No. "5. *Daer een Seigneur zyn handen wast, in een doorsiende Kamer, met beelden, konstig en raer. F 95-0"* ("5. Where a gentleman washes his hands, in a room with a through view, with figures, artful and rare. F 95-0"). *Bürger:* 39; *Hofstede de Groot:* 21.

35. No. *"10. Een musicerende Monsr. en Juffr. in een Kamer. F 81-0"* ("10. A gentleman making music and a lady in a room. F 81-0"). *Hofstede de Groot: 30.*

36. No. "33. *Een gesicht van eenige Huysen. F 48-0"* ("33. A view of some houses. F 48-0). *Hofstede de Groot:* 49. As Hofstede de Groot remarked, one of the copies mentioned under our cat. nos. 9 and 10 may have been a copy after this painting.

37. No. "38. *Een Tronie in Antique Klederen, ongemeen konstig. F 36-0. Nr. 39. Nog een dito Vermeer. F 1 7-0. Nr. 40. Een weerga van denzelven. F17-0"* ("38. A *tronie* in antique clothes, uncommonly artful. F 36-0. No. 39. Another ditto Vermeer. F 17-0. No. 40. A pendant of the same. F 17-0"). *Hofstede de Groot:* 45. Only two

PLATE B1.
Woman with a Lute near a Window.

paintings answering this description have been preserved—our cat. nos. 18 and 30—so at least one has disappeared.

37a. *"*Een stuk van Van der Meer, sijnde een juffer in haer kamer*" ("A piece by Van der Meer, being a lady in her room"), mentioned on 8 October 1703 in the inventory of the paper merchant Paulus Gijsbertsz (born Amersfoort; died after 1714), drawn up on behalf of his creditors (Municipal Archives Amsterdam, N.A.A. no. 4719, fol. 414; kind information of S.A.C. Dudok van Heel). Twelve preserved Vermeers answer to this description.

38. Sale Pieter de Klok, Amsterdam, 22 April 1744, no. 87: *"Een Vrouwtje dat bezig is het hair te Kammen, door van der Neer van Delft, h. 1 v. 3 d. br. 1 v. 1 d., 18-0"* ("A woman combing her hair by van der Neer of Delft, h. 1f. 3 inches w. 1 f. 1 inch, 18-0") (*Hoet* II, p. 136). *Bürger:* 47, *Hofstede de Groot:* 22. The subject recalls a much larger, monogrammed painting by C. van Everdingen (c. 1620-1678), in which the relation between height and width is exactly the same (sale Steengracht, Paris, 9 June 1913, no. 22, with ill., 70.5 x 61.5 cm).

39. *Sale L. Schermer, Rotterdam, 17 August 1758, no. 67: *"Een schilder in zyn Schilderkamer, spelende op de Viool, door Vermeer"* ("A painter in his painting room, playing on the violin, by Vermeer"). In our opinion, this was possibly a work by M. van Musscher. On depictions of this subject by various Dutch seventeenth-century artists, see H. J. Raupp, "Musik im Atelier: Darstellungen musizierender Künstler in der niederländischen Malerei des 17 Jahrhunderts," in *Oud-Holland* 92, 1978, pp. 106-29, with ills.

PROBLEMATIC PAINTINGS:

b1. (Plate B1)
WOMAN WITH A LUTE NEAR A WINDOW.
New York, Metropolitan Museum of Art.
Vaguely signed on the wall, below the tablecloth.
Canvas, 51.4 x 45.1 (20 1/4 x 18 1/4 in.).
De Vries: 20, 1663-64. Bloch: 1665. Goldscheider: 19, 1664. Wheelock: 1664.
1662-1665.

See p. 166, 169: notes 54 and 102. The painting has been much damaged. On the map the word "EUROPAE" is legible. It is a map published by Jodocus Hondius in 1613, of which a new edition was published in 1659 by Joan Blaeu (*Welu,* p. 535). De Mirimonde observed that the lady is tuning her instrument rather than playing it (*Mirimonde,* p. 37). Conjectures on the iconography of the painting are presented by Otto Naumann in *Sutton 1984,* cat. no. 117 (with more data, literature, etc.).
Provenance:
• *Sale Ph. van der Schley (Amsterdam) and Daniel du Pré, Amsterdam (Roos), 22 December 1817, no. 62: *"Delftsche vander Meer. In een gemeubileerd Binnenvertrek zit eene vrouw in Hollandsche Kleeding, op de guitar te spelen. Frappant van licht en fraai gepenceeld, op P., h. 22, br. 18 d."* ("Delft vander Meer. In a furnished inner room sits a woman in Dutch dress, playing the guitar. Striking of light and beautifully painted, on P., h. 22, w. 18 inches"), for F 65 to Coclers. N.B.: The description might be thought to apply to our cat. no. 28, but that picture was in England before 1817. Moreover, the wording "furnished inner room" is more appropriate for cat. no. b1 than for 28, so the mention in 1817 probably does not concern the copy mentioned under cat. no. 28 either.
• Bought in England by Collis B. Huntington, New York; bequeathed to the museum with his complete collection in 1897; transferred to the museum in 1925 (*Goldscheider*).

b2. (Plate B2)
GIRL INTERRUPTED AT HER MUSIC.
New York, Frick Collection.
Canvas, 39.3 x 44.4 cm. (15 1/2 x 17 1/2 in.).
Bürger: 9. Hofstede de Groot: 27. De Vries: 13, 1658-60. Bloch: 1655-60. Goldscheider: 12, 1661. Wheelock: 1660-61.
See p. 166, 169: notes 46 and 102.
In the background hangs the *Standing Cupid,* which also appears in cat. nos. 4 and 25 (plates 4 and 20) and in the X-ray of cat. no. 6 (fig. 110). The painting has so many weaknesses that when studying it on the spot I was unable to decide if it is the ruin of an original or a copy. Later on, the latter seemed the more probable since the violin on the wall mentioned in the sale catalogues of

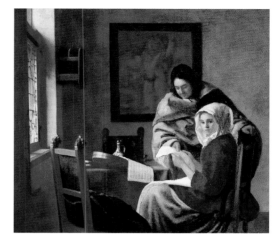
PLATE B2.
Girl Interrupted at her Music.

1810 and 1811 is lacking. However, when Hofstede de Groot studied the painting in 1899 he complained about overpaintings: *"Zoo zijn er tegen den achterwand een vogelkooi en een viool met strijkstok geheel nieuw ingeschilderd"* ("On the rear wall, for instance, a birdcage and a violin with bow have been painted in completely new"). The birdcage is still there, but the violin is not. Also absent now is *"rechts een stuk van een schoorsteen"* ("to the right a part of a mantelpiece") which Hofstede de Groot saw, not noting it as an overpainting. He also deplored the fact that the painting (in the old condition) had suffered *"door sterk schoonmaken"* ("from vigorous cleaning") (C. Hofstede de Groot. "De een en dertigste Vermeer," in *De Nederlandsche Spectator* 1899, p. 224). In 1985 I studied the picture anew. Some excellently painted still-life details now lead me to believe that it is the ruin of a Vermeer.
Provenance:
• Sale Pieter de Smeth van Alphen (Amsterdam), Amsterdam (Ph. van der Schley), 12 August 1810, no. 57: *"De Delfsche van der Meer. In een Binnenkamer zit een bevallige Vrouw bij een Tafel, nevens haar een staand Heer, welke haar in de Toonkunde onderwijst, aan den Wand eene Viool en ander bijwerk, hoog 15 1/2, breed 17 duimen. Doek"* ("The Delft van der Meer. In an inner room sits an attractive woman at a table, next to her a standing gentleman, who teaches her music, on the wall a violin and other accessories, height 15 1/2, width 17 inches. Canvas"), for F 610 to de Vries (bought in).
• Sale Henry Croese Ez., Amsterdam (Ph. van

der Schley), 18 September 1811, no. 45: *"Van der Meer de Delft. On voit dans une chambre une femme d'une pyhysionomie agréable; elle est assise: debout à côté d'elle est son maître de musique qui lui donne leçon; un violon pendu au mur et d'autres accessoires terminent cet ensemble. Ce tableau no. 57 du Catalogue de Mr. P. de Smeth est dans le genre de Terburg: il est d'une touche agréable, d'un coloris clair et d'une action très expressive. Haut. 15 1/2, larg. 17 pouces. Toile"* ("Van der Meer of Delft. One sees in a room a woman of agreeable countenance; she is seated, standing next to her is her music teacher, who instructs her; a violin hanging on the wall and other accessories complete this ensemble. This painting no. 57 from the catalogue of Mr. P. de Smeth is in the manner of ter Borch: it is of pleasant touch, bright coloring and of very expressive action. Height 15 1/2, width 17 inches. Canvas"). for F 399 to Roos.

• Sale Cornelis Sebille Roos, Amsterdam (Jer. de Vries), 28 August 1820, no. 64: *"Jan van der Meer bijgenaamd de Delfsche. In een Binnenvertrek ziet men eene juffrouw, welke in de zangkunst wordt onderwezen door eenen daarbij staanden man, in eene mantel gehuld. Breed van behandeling. Hoog 15, breed 17 duimen. Paneel"* ("Jan van der Meer nicknamed the Delft one. In an inner room one sees a lady, who is being taught singing by a man standing next to her, enveloped in a cloak. Broad

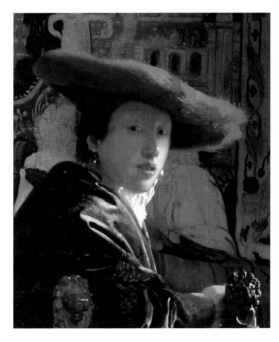

PLATE B3.
Girl with a Red Hat

of treatment. Height 15, width 17 inches. Panel"), for F 340 to Brondgeest (according to *Bürger* and *Hofstede de Groot*) or for F 420 to N.N. (according to a note in the copy of the sale cat. at the R.K.D.).

• Sale Samuel Woodburn, London (Christie), 24 June 1853, no. 128: "Delft van der Meer. Interior of an apartment, with a cavalier handing a paper to a lady seated, in a red corset, a guitar and music on a table before her. The light enters from the window with admirable effect," for £ 42 to Smith (note in sale cat. at R.K.D.), or directly to Francis Gibson in Saffron Walden, deceased 1858; inherited by his daughter Mrs. Lewis Fry of Clifton near Bristol (according to cat. Frick, 1968, p. 294).

• Art gallery Lawrie & Co., London (*Hofstede de Groot*).

• Art gallery Knoedler, New York, acquired by H. C. Frick in 1901 (cat. Frick, 1968, p. 294).

b3. (Fig. 126)
GIRL WITH A RED HAT.

Washington, National Gallery of Art.
Monogram upper left.
Panel, 23 x 18 cm. (9 1/8 x 7 in.).
Bürger: 47. Hofstede de Groot: 46A. De Vries: 22, 1664. Bloch: ill. 56. Goldscheider: 25, 1667. Wheelock: 1666-67.

Ever since *Bürger* and *Hofstede de Groot* (who described the sitter as a young *man*), all monographs on Vermeer until *Walsh and Sonnenburg* in 1973 erroneously stated that the painting is on canvas (instead of panel). An X-ray reveals that it has been painted on an upside down Rembrandt-esque portrait of a man *(Walsh and Sonnenburg,* ills. 93, 94; *Wheelock 1978,* fig. 12). See also under cat. no. b4. Cat. nos. b3 and b4 have been regarded as authentic Vermeers since the turn of our century. Cat. no. b3 is very attractive and a great favorite with the public, yet I find it impossible to believe that these two paintings are by Vermeer. Apparently the late Dr. S. J. Gudlaugsson also had serious doubts about them (cited in *Bloch* under nos. 24 and 25; the two pictures are not mentioned in *Gudlaugsson-Kindler).* Earlier, H. M. van Dantzig had questioned the authenticity of cat. no. b3, while Swillens catalogued both paintings in his section of "Works wrongly attributed to Vermeer" (H. M. van Dantzig, *Johannes

Vermeer, de Emmausgangers en de critici, Leiden/ Amsterdam, 1947, p. 89, note 50; *Swillens,* pp. 64-65, nos. E and G).

The support of the *Girl with a Red Hat* and the *Girl with a Flute* is uncharacteristic of Vermeer: both are on panel, while all unquestionable Vermeers are on canvas. The anecdotal liveliness of the *Girl with a Red Hat* does not fit with Vermeer's way of working. He never created such a "snapshot" effect, but always carefully chose from "reality" the moment most consonant with the overall composition as well as with the depicted action of the picture at hand. The treatment of the girl's sleeve and of the lions' heads on the chair displays virtuosity and recalls Vermeer's method of modeling similar objects in his works of about 1665, but in those authentic Vermeers the transition from the highlights to the darker parts is extremely gradual and depicted with great precision, while in cat. nos. b3 and b4 this transition is left vague and indeterminate.

The way the figure in the *Girl with a Red Hat* is positioned is remarkably odd. She seems to be sitting on a chair in a turned-around position, with her arm leaning over the back. However, the lions' heads on the chair are also turned toward the viewer. Since on seventeenth-century chairs such lions always face the seat (see our plates 4-7, 11, 14, 16, and 22 and fig. 70), we must conclude that she is not seated on this chair, but sitting, stooping, or standing behind it, in a wholly unclear position. Seventeenth-century artists—and none more than Vermeer—always showed a concern for consistency in the depiction of action and of the relationships of figures and objects in space, which would never allow for such incongruities.

The same applies to the depicted materials. The texture of all objects in Vermeer's paintings is palpably "real," while in cat. no. b3 it is unclear whether the red hat is made of (dyed?) straw or velvet or (and?) some other component.

The provenance of the *Girl with a Red Hat* seems to indicate that as early as 1822 it was considered a work by Vermeer. However, attributions to Vermeer in the eighteenth and nineteenth centuries are by no means reliable (see p. 159). Most probably seventeenth- or eighteenth-century pigments have been found in cat. no. b3 (see M. Kühn, "A study of the Pigments and the Grounds used by Jan Vermeer," in *National Gallery of Art,*

Report and Studies in the History of Art II, Washington, 1968, pp. 155-202). These pigments might well stem from the portrait underneath.

Provenance:

• Sale [Lafontaine], Paris, 10 December 1822, no. 28. *"Van der Meer de Delft. Jeune femme représentée un peu plus qu'en buste, la tête couverte d'un chapeau de panne rouge à grand bord, et le corps enveloppé d'un manteau bleu. Un rayon de soleil éclairé en partie sa joue gauche; le reste de son visage se ressent fortement de l'ombre du chapeau. B., h. 9 p., l. 7 p. Il ya dans ce joli tableau tout ce qui fait connaître le véritable peintre; l'exécution en est coulante, la couleur forte, l'effet bien senti"* ("Van der Meer of Delft. Young woman represented a little more than bust-length, her head covered with a red plush hat with large brim, and the body enveloped in a blue coat. A ray of sun partly lights her left cheek; the rest of her face is strongly affected by the shadow of the hat. B., h. 9 inches, w. 7 inches. In this pretty painting everything that shows the real painter is present; its execution is fluent, the color strong, the effect well felt"), for Fr 200.

• The painting which is now in Washington: Collection General Baron Atthalin, Colmar; collection Baron Laurent Atthalin; Art gallery Knoedler & Co., New York, 1925; collection Andrew W. Mellon, Washington *(de Vries)*.

• Since 1937 in the museum *(Preliminary catalogue . . . , Washington, 1941, no. 53).*

b4. (Figure 127)
GIRL WITH A FLUTE.

Washington, National Gallery of Art.
Panel, 20.2 x 18 cm. (7 7/8 x 7 in.)
Hofstede de Groot: 22 d. De Vries: 21, 1664. Bloch. ill. 57. Goldscheider: 26, 1667. Wheelock: 1666-67.

My rejection of the attribution to Vermeer of cat. no. b4 (see above and the 1975 and 1977 editions of this book) has been followed by A. K. Wheelock in 1978. He thinks it is by a direct follower or pupil of Vermeer (yet he remains convinced that cat. no. b3 is an authentic Vermeer: *Wheelock 1978*; cf. *Wheelock 1981*, p. 130). Since 1980 the museum displays cat. no. b4 as "Circle of Vermeer" (cf. "Changes in attribution," in *Studies in the History of Art, National Gallery of Art, Washington* 9, 1980, p. 89: now changed to "Circle of Jan Vermeer").

Yvonne Brentjes pointed out that the vertical parallel stripes on the girl's hat on cat. no. b4 cannot exist on an actual round hat. She thinks that the costumes on both cat. nos. b3 and b4 indicate that the pictures originated in the eighteenth century (Y. Brentjes, "Twee meisjes van Vermeer in Washington, Een kostuumstudie," in *Tableau* 7, no. 4, February 1985, pp. 54-58). It may be added that the fingerholes on the flute are not in line with the mouth piece, but are down the side of the instrument, which would seem impossible for this type of recorder.

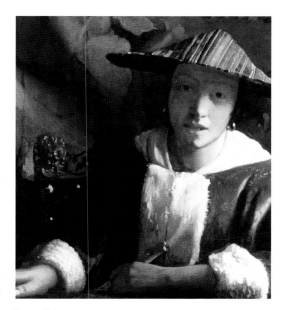

PLATE B4.
Girl with a Flute.

Provenance:

• Collection Jan Mahie van Boxtel en Liempde, Bois-le-Duc; collection Maria de Grez-van Boxtel en Liempde, Brussels; collection Jhr. de Grez, Brussels; noticed there by A. Bredius and exhibited in the Mauritshuis, The Hague, 1906/7; collection August Ianssen, Amsterdam; art gallery J. Goudstikker, Amsterdam (exh. cat. Goudstikker, The Hague, 1919, no. 131); art gallery Knoedler & Co, New York; collection Joseph E. Widener, Philadelphia (according to cat. collection Widener 1931, *de Vries* and *Goldscheider).*

• Since 1942 in the museum *(Summary catalogue . . . , Washington, 1962, no. 694).*

Documents
by Rob Ruurs

This list includes in chronological order all known documents, handwritten or printed, from before 1700 that refer to Vermeer himself, his family, or his work. A similar series of documents published by Swillens in 1950 was only a selection (*Swillens*, p. 181 ff.). Since then, van Peer has published a number of new archival finds in several periodicals, and Montias has published three important series of new documents on Vermeer and his family (*Montias 1977, 1980,* and *1987*). From these articles by Montias, our list includes only those documents that mention Vermeer himself, his father and mother, wife, children or sister.

Three entries in this list-those headed 1667, 1669-1678, and 12 July 1682—were furnished by Albert Blankert.

27 June 1615 Publication of the bans (betrothal) between Reynier Jansz. "*caffawercker*" ("silk-satin worker"), twenty-four years of age, and Digna Baltens from Antwerp, twenty years of age. (Amsterdam, Municipal archives, Register of Marriages: *van Peer 1959*, p. 240.) Johannes Vermeer was the second child of this marriage.

23 December 1616 Digna Baltens witnesses the baptism of a son of Jan Heymensz., baker, and of Maertge Jans, the sister of Reynier Jansz. (Delft. Municipal Archives; *Montias 1977*, p. 268.)

21 December 1618 Reynier Jansz. signs as witness at the baptism of Tanneken, the daughter of a "*Reijnier*", perhaps Reynier Baltens, the brother of Digna Baltens. (Delft, Municipal Archives; *Montias 1977*, p. 268).

15 March 1620 "*1 kint genaemt Geertruijt vaeder Reijer Janssoon caffawercker moeder Dingenum Baltens.*" ("a child named Geertruijt father Reijer Janssoon silk-satin worker mother Dingenum Baltens.") Gertruy was Johnnes Vermeer's only sibling. (Delft, Baptismal Register, New Church; *Montias 1977*, p. 269.)

16 October 1620 Reynier Jansz. testifies that he has been fully satisfied and contented by Neeltge Goris, his mother, with respect to any assets that might accrue to him from the property left behind by the late Claes Corstiaensz., his stepfather. (Delft, prot. not. H. van der Ceel, no. 1635; *Montias 1977*, p. 270.)

9 January 1622 Reynier Cornelisz. Bolnes and Maria Thins, both from Gouda, marry before the Aldermen in Gouda. (*Swillens*, p. 193.) Catharina Bolnes, who was to be the wife of the painter, was a child of this marriage.

20 September 1622 Reynier Jansz., "*caffawercker*," witnesses an attestation. (Delft, prot. not. H. Vockestaert, no. 1587; *Montias 1980*, p. 49)

30 April 1623 Reynier Jansz., "*caffawercke*r," and Jan Thoonisz. Back, butcher, guarantee a loan of 749 gulden 5 stuivers 8 pennies to Neeltge Goris (Reynier Jansz.'s mother). (Delft, prot. not. H. van der Ceel, no. 1638: *Montias 1977*, p. 274.)

8 December 1623 "Inventaris van alsulcke meubile ghoederen als Reynier Jansz. caffawercker [. . .] es vercoopende [. . .] aen . . .] Balten Claes Gerritsz. in Sgravenhage" ("Inventory of all such movables as Reynier Jansz. silk-satin worker [. . .] is selling [. . .] to [. . .] Balten Claes Gerritsz, in The Hague.") Balten Claes Gerritsz, was the father-in-law of Reynier Jansz.

The inventory includes sixteen paintings sold at prices set by the painter Joris Gerritsz. van Lier:

eerstelijcken een Italiaense pyper ("Italian piper or flutist") *met een vergulden lijst voor*	*iij ghulden*
een bloompottyen met een vergulden lyst	*vj ghulden*
twee contrefeytsels voor	*xij ghulden*
twee aelbasterde bordekens ("paintings on alabaster")	*iij ghulden*
een bordeken van een nachtyen ("night scene") `	*iij ghulden x stuivers*
een druyff schootel ("grape dish") *met een vergulden lyst voor*	*iiij ghulden*
een contrefeytsel van de prins met de princesse	*viij ghulden*
een contrefeytsel van zijn excelentye (prince Maurice) *ende prins Henrick*	*iiij ghulden*
een bordeeltye ("brothel scene") *voor*	*iij ghulden*
een Abrams offerhande ("sacrifice of Abraham") *voor een lantschaptye*	*ij ghulden*
een bort van Loth ("panel painting")	
twee aelbasterde bordekens ("paintings on alabaster")	*xxx stuivers*

(Delft, prot. not. H. van der Ceel, no. 1630; *Montias 1977*, p. 275.)

The prices of the above paintings add up to 53 gulden 10 stuivers, or 7.6 percent of the value of the entire inventory, according to Montias's reckoning (693 gulden). Bedding, including sheets, blankets, and eiderdowns, comes to 152 gulden. There are no silver, gold, or books in the young couple's possession, but a good deal of copperware and tinware. The fact that sheets, towels, shirts, collars, mantles, and dresses are listed, along with a full complement of bedding, suggests that the inventory comprises most of the personal possessions of Reynier Jansz. and Digna Baltens. It is noteworthy also that the inventory contains no loom or other *caffawercker's* equipment.

Two attestations, also dated 8 December, follow the inventory. In the first, Reynier Jansz., living in the Broerhuis in Delft, affirms that he has sold the goods in the inventory to Balten Claes Gerritsz., but now the words "in Sgravenhage" have been crossed out and "tot Gorricom" ("in Gorcum") written above the buyer's previous place of residence. (In the entire document the name of the buyer has been inserted after the text was written, which suggests that Reynier Jansz. had caused the inventory to be drawn up before he—or the notary—knew who would buy his possessions.) The goods are said to be ceded to Balten Claes Gerritsz. as counterpart for a sum equal to the value of the inventory, which sum had been lent by Balten to Reynier. In the second attestation. Balten declares that the goods have been sold to him for a sum of —, which goods were caused to be removed from the house of Reynier Jansz. onto the public street and delivered to the attestor. Furthermore, the attestor, out of consideration for Reynier Jansz.'s difficult situation and out of fatherly affection, had the goods transported back to Reynier Jansz.'s house and lent to him again, up to such times as they might be requested by him, Balten Claes Gerritsz., or his heirs. The seven-page document is signed three times by Reynier Jansz. and Joris van Lier and twice by Balten Claes Gerritsz. The transaction between Reynier Jansz. and his father-in-law may have been nothing but a fictitious sale to avoid confiscation of Reynier's goods following a bankruptcy or for some other reason. (*Montias 1977*, p. 275.)

2 January 1625 "*Reynier de Vos*" is named as witness in a document and signs "*Reynier Jansz. Voos.*" This is the first known use of the last name Vos. (Delft, prot. not. Corn. Brouwer, no. 1659; *Montias 1977*, p. 276.)

26 July 1625 and **4 August 1625** It appears from notarial acts of these dates (published by A. C. Boogaard-Bosch in the *Nieuwe Rotterdamse Courant*, 25 January 1939, evening edition, reprinted in *Swillens*, pp. 181-182) that Reynier Jansz. Vos, together with two other men, wounded the soldier Willem van Bylandt in a brawl in the inn "Mechelen." While Reynier Vos was still a fugitive, "*Dingenom Baltasardr., huysvrouwe van Reynier Jansz. Vos*" ("Dingenom Baltasardr., housewife of Reynier Janszn. Vos") and the mother of one of the two other perpetrators settled this matter by the payment of blood money to van Bylandt. (See also *Montias 1977*, p. 276)

26 September 1626 Reynier Jansz. is said to have paid in full a debt of 17 gulden that he owed to the estate of the brandy merchant Cornelis Claesz. (Delft, Orphan Chamber, *boedel* no. 315; *Montias 1980*, p. 61.)

9 February 1629 Reynier Jansz. Vos witnesses a document in which, for the first time, he is identified as a "*herbergier*" ("innkeeper"). (Delft, prot. not. W. de Langue, no. 1686; *Montias 1977*, p. 276.)

3 June 1631 Reynier Jansz., "*caffawercker*," is said to owe 9 gulden 15 stuivers to the estate of Franchois Camerling, silk-cloth merchant. (Delft, prot. not. H. Vockestaert, no. 1598; *Montias 1980*, p. 61.)

12 August 1631 Aryen Hendricksz. van Buyten, shoemaker, declares having brought some shoes to the house of Reynier Jansz., innkeeper. There is no indication in this or in the preceding document that Vermeer's father owned the inn in which he worked. (Delft, prot. not. W. de Langue, no. 1688; *Montias 1977*, p. 276.)

13 October 1631 "*Den 13 October 1631 heeft Reijnier Vos off Reijnier van der Minne hem doen aenteijckenen als Mr Constvercoper. sijnde burger, sal betalen het recht 6 gulden.*" ("The 13th October 1631 Reijnier Vos or Reijnier van der Minne has himself registered as Master Art Dealer and being a burgher will pay the fee of 6 gulden.") (From "*Register van alle de nieuwe meesters die sindt den iare 1613 in Ghilde syn gecomen*" ["Register of all new masters who entered the Guild since the year 1631." Delft]; The Hague, Royal Library; *Obreen I*, p.27.) Reynier van der Minne must be identical with Reynier van der Meer (*Bouricius*, p. 272: *Van Peer 1959*, p. 241.) "Van der Minne" is likely to have been the last name of his first stepfather, Claes Corstiaensz. (*Montias 1977*, p. 276.) 31 October 1632 "*Dito* [31 October 1632] 't kint Joannis, vader Reynier Janssoon, moeder Dingnum Balthasars, getuijgen Pr. Brammer, Jan Heijndricxz., Maertge Jans." ("Ditto [31 October 1632] the child Joannis, father Reynier Janssoon, mother Dingnum Balthasars, witnesses Pr. Brammer, Jan Heijndricxz., Maertge Jans.") (Delft. New Church. Baptismal Register no. 12; *Obreen IV*, p. 29.)

24 November 1633 A rental contract from this date cites a property in Delfshaven owned by Reynier Jansz. Vos. (Delft, prot. not. J. van Steelant, no. 1836; *Montias 1977*, p. 270)

27 January 1635 Reynier Jansz. Vos. 43 years old, together with three other "*caffawerckers*" living in Delft, testifies about a knife fight which he and his companions had helped to break up. (Delft, prot. not. G. van der Wel, no. 1938; *Montias 1980*, p. 45.)

13 October 1635 Reynier Jansz. Vos, "*Caffawercker ende waert in de vliegende Vos aende Voldersgracht*" ("Silk-satin worker and innkeeper in the Flying Fox on the Voldersgracht"), discharges Hugh Jansz. van Boodegem, brewer in the Oeyevaer, of his guarantee or surety for an obligation incurred by him, Reynier Jansz., amounting to 202 gulden 6 stuivers for beer delivered by Hester van Bleyswijk, widow of the brewer Ghysbrecht van Zuijele. He also binds his person and his goods to guarantee repayment of any future deliveries of beer delivered to him, Reynier Jansz., by van Boodegem. (Delft, prot. not. G. van der Wel, no. 1938; *Montias 1980*, p. 61.)

17 February 1638 Renier Jansz. Vos. "*caffawercker*," and Digna Baltens, man and wife, living on the Vooldersgracht in Delft, draw up a testament in which they declare the longer lived of the two to be the sole and unique heir of the other. After the death of his or her spouse, the survivor is bound to feed, clothe, and send to school their child or children, teach them a trade, and provide them with a trousseau and a banquet for their marriage, according to his or her means. (Delft, prot. not. W. de Lange, no. 1689; *Montias 1977*, p. 276.)

1 March 1638 Reynier Vos on the Voldersgracht owes 4 gulden 15 stuivers to the estate of a peat merchant for peat delivered. (Delf, prot. not. G. Rota, no. 1976; *Montias 1980*, p. 61.)

6 September 1640 "*Reynier Jansz. Vermeer woonende aende Voldersgracht alhiier out ontrent XLIX jaren*" ("Reynier Jansz. Vermeer living on the Voldersgracht in this town, about 49 years of age") declares that Barent Batista, son of the painter Jan Batista (van Fornenburgh), has been living in his house and has shipped out of Delft in 1631 to become a soldier in the East Indies. The document is witnessed by the painters Pieter van Groenewegen and Balthasar van der Ast, Reynier Jansz., for the first time as far as is known, appended the last name *Vermeer* to his signature

The next day, **7 September 1640**, Jan Batista, painter, had an attestation drawn up in connection with the same affair. The witnesses were "*Reynier Jansz. Vermeer alias Vos*" (he signs "*Vermeer*") and Pieter Steenwijck, painter. The attestor signs "Jan Batt^a van Foorenberch." (Delft, prot. not. A. van der Block; *Montias 1977*, p. 277.)

28 March 1641 Reynier Jansz. appears as a witness, signing with his last name "*Vosch*." (*Montias 1977*, p. 278.)

March(?) 1641 "*Willem Jansz. Sloting ende Pieter Willemsz. van Vlijet vercoopen aen Reijnier Vosch een huiis ende erve genaemt Mechelen aende marct, voor twee duijsent seven hondert gulden.*" ("Willem Jansz. Sloting and Pieter Willemsz. van Vlijet sell to Reynier Vosch a house with grounds, named Mechelen, on the market, for two thousand seven hundred gulden.") (Delft, camer van charitate, no. 237, vol. 40; *Montias 1977*, p. 277.)

20 April 1641 Jan Thins, brother of Maria Thins (the future mother-in-law of the painter), buys a house on the Oude Langedijk in Delft. For this he pays 2400 car. gulden. (Delft, prot. not. C. P. Bleyswijck, no. 1914. fol. 120; *van Peer 1968*, p. 223.)

27 November 1641 About 1640 the marriage between Reynier Bolnes and Maria Thins came to an end. The divorce was not without problems, since furniture and paintings belonging to the Thins family as their family property were part of the estate. Jan, Maria's brother, and Cornelia, her sister. demanded these goods via a judgment of the court of aldermen. By order of the latter. the goods were divided into three parts and then drawn by lot: "*Lotingh van de onderschrevene Goederen toecomende Johan Thins voor tweederde part Cornelia Thins en Reynier Bolnes voor een derde part nomine uxoris, gestelt in drie coten: welcke goederen onder Reynier Bolnes berustende zijn geweest.*" ("Apportionment of the goods mentioned below, two-thirds earmarked for Johan Thins, and one-third for Cornelia Thins and Reynier Bolnes in his wife's name, made up in three lots: which goods have been lodged with Reynier Bolnes.")

> *Het Lot A.*
> *Een schilderij van een man die gevilt wort.*
> *Een Homo Bulla.*
> *Een trony van Dirck Cornsz. Hensbeek.*
> *Een cipresse kist.*
> *Dit lot is te beure gevallen Johan Thins.*
> *Het Lot B.*
> *Een schilderije van een die op een trompet speelt.*
> *Een dito die op een fleuit speelt.*
> *Een landscap van daer men in de hant kijckt.*
> *Een kasgen.*
> *Een sermoenboeck Hendr. Adriani.*
> *Dit lot is te beure gevallen Reynier Bolnes.*
> *Het Lote C.*
> *Een schilderije van een die de borst suyght.*
> *Een dito die de werelt beschreyt.*

2 wapenkussens.

Dit lot is te beure gevallen Iohan Thins.

Noch siin bij denselven Reynier Bolnes overgeleverd deze.

navolchende goederen Iohan Thins Willemszn. aileen toecomende.

Een schilderije van de winter daer men op schaetsen rijdt.

Een schilderije daer een coppelerste die in de hant wijst.

> *Actum ter Goude in presentie van Hendryck cornsz. Camp ende Corns.*
> *Franszn. Rotteval. als arbiters bij de Heeren Schepenen tot dese lotinghe*
> *geëlegeerd, ter oirconde desen bij hen ondertekent, den 27 november 1641.*

("Lot A.

A painting of a man being skinned.

A Homo Bulla.

A "trony" of Dirck Cornsz. Hensbeek.

A cypress chest.

This lot fell to the share of Johan Thins.

Lot B.

A painting of someone playing on a trumpet.

A ditto of someone playing on a flute.

A landscape wherein someone looks in the hand.

A box.

A sermon-book of Hendr. Adrianus.

This lot fell to the share of Reynier Baines.

Lot C.

A painting of one who suckles the breast.

A ditto of one bewailing the world.

Two cushions with coats of arms.

This lot fell to the share of Johan Thins.

Furthermore the goods mentioned next, due solely to Johan Thins Willemszn., were delivered by the same Reynier Baines.

A scene of winter with people skating.

A painting of a procuress pointing in the hand.

> Act made in Gouda in the presence of Hendryck Cornszn. Camp and. Corns. Franszn. Rotteval, arbiters named for this drawing of lots by the Lords Aldermen, signed by them in witness to the above, 27 November 1641.")

(Gouda, Municipal Archives, prot. not. Straffintvelt; *van Peer 1968*, p. 221.)

According to van Peer (1968) all these goods later were inherited by Maria Thins. The "*schilderije daer een coppelerste die in de hant wijst*" ("painting of a procuress pointing in the hand") is undoubtedly the painting of that subject by D. van Baburen, 1622, which can be seen in the background of two paintings by Vermeer (our fig. 72, plate 19 and plate 30). Likewise the "*schilderije van een die de borst suyght*" ("painting of one who suckles the breast") must be the *Cimon and Pero* hanging on the wall on another painting by Vermeer (see plate 16). For the events in connection with the divorce, see also *Swillens*, p. 193 ff.

3 July 1642 Reynier Jansz. appears as a witness, signing with his last name "*Vosch*." (Delft, prot. not. W. de Langue, no. 1690; *Montias 1977*, p.278.)

27 March 1643 "*Op huyden den 27 Martij anno 1643 Compareerde Gerrit Jansz. ebbewercker wonende binnen deser stad Delft, ende heeft etc. ten versoucke van Reijer Vosch borger alhier waerachtich te wesen, dat hij deposant ten versoecke van Evert van Aelst meermalen is geweest by den requirant ende versochte van hem te hebben seecker stuck schilderj, hem van Aelst toebehoorende (het welcke hij den requirant hadde gegeven om vooor hem te vercoopen) [. . .] also hij Aelst het stuck nu selfs vercoft wiste, belovende [. . .] dat hij den requirant soude binnen corten tiit betaelen met eerste gelegentheijt, op welck vertrouwen hij deposant bij den requirant gegaen ende hem eijndelick beweecht heeft, sulcx dat het stuck nu mey toecomende al 2 jaeren hem Aelst gevolcht is.*"

("Today 27 March 1643 appeared Gerrit Jansz., ebony worker, living in

this town Delft, and has testified at the request of Reijer Vosch citizen of this town, that it is true that he [Gerrit Jansz.] at the request of Evert van Aelst has called several times on the *requirant* [Reijer Vosch] and has asked him to return a certain painting, which belonged to van Aelst (which he had given to the *requirant* in order to sell it for him) [. . .] because now van Aelst could sell it himself, promising [. . .] that he would pay the *requirant* in short time and with the first opportunity; trusting upon this, the *deposant* [Gerrit Jansz.] had gone to the *requirant* and at last had induced him to do it, with the result that next May the picture will be with Aelst for already two years.") (Delft, prot. not. W. de Langue, no. 1691; *Montias 1977*, p. 278.)

11 February 1645 Reynier Jansz. Vos testifies about the confession that a Sara Pots had made in his house (i.e., in "Mechelen") concerning the theft of a silver spoon. (Delft, prot. not. A. van der Block, no. 1745: *Moritias 1980*, p. 45.)

15 March 1645 Reynier Jansz. Vos signs as witness to a declaration by his brother-in-law Reynier Baltens. (The Hague, prot. not. D. van Schoonderwoert, no. 134; *Montias 1977*, p. 282.)

30 July 1645 In the estate papers of Johan Crosier, brewer *Int swaenhals*, Reynier de Vos appears as a debtor for 82 gulden 10 stuivers for beer delivered. (Delft, Orphan Chamber, *boedel* no. 589; *Montias 1980*, p.61.)

2 August 1645 Reynier Jansz. Vos testifies about a discussion he had heard in his house ("Mechelen") concerning a testament. (Delft, prot. not. G. Rota, no. 1978; *Montias 1980*, p. 45.)

22 June 1647 Reynier Jansz. Vos witnesses a deed by Bayke de Meijer, widow of Gerrit Jansz. van der Wiel. (Delft, prot. not. W. de Langue, no. 1098; *Montias 1980*, p. 61)

8 February 1648 Pieter Vermeer, brewery worker in Amsterdam (no relation to the artist), recognizes a debt owed to Jacob Franckens Croostwijck in Rotterdam. The notarial document is drawn up in the house of Reynier Jansz. Vos, innkeeper in "Mechelen," in the presence of Egbert Lievensz. van der Poel, master painter. On the same day, both Reynier Jansz. and Egbert van der Poel witness a document for the notary. (Delft, prot. not. G. Rota, no. 1980; *Montias 1980*, p. 46.)

4 December 1648 Anthony Gerritsz. van der Wiel, "*ebbewercker*" ("ebony worker") and "*Geertruyt Reyniersdr. van der Meer*" (this last name written above the crossed-out "*Vosch*") make their first testament. Gertruy was the sister of Johannes Vermeer. (Delft, prot. not. W. de Langue, no. 1693; *Montias 1977*, p. 278.)

5 December 1648 Reynier Jansz. Vos, innkeeper, has a loan agreement for 250 gulden drawn up by a notary. He commits himself to return the sum plus interest at 5 1/2% precisely within a year. The name of the person accepting this obligation. i.e., the lender, is left blank. (Delft, prot. not. S. Mesch, no. 2045; *Montias 1977*, p. 278.)

10 October 1649 In the estate settlement of the brewer Louris van der Hoeve, the following entry occurs among a list of persons owing money to the estate: "*Reynier Vos opte Marct in Mechelen lxiiij gul. xv st.*" ("Reynier Vos on the Marketplace in Mechelen 64 gulden 15 stuivers.") (Delft, prot. not. Gerrit van der Wel, no. 1929; *Montias 1977*, p. 278.)

5 June 1650 Anthony Gerritsz., husband of Johannes Vermeer's sister, sells the house "*de Molen*," on the south side of the Vlamingstraat, to the painter Willem Willemsz. van den Bundel. Reynier Jansz. Vos signs as witness. (Delft, prot. no. W. de Langue, no. 1694; *Montias 1977*, p. 278.)

24 June 1650 Reynier Jansz. Vos, 58 years old, gives a testimony at the request of Frans Adriaensz. Le Cock, shoemaker. (Delft, prot. not. G. Rota, no. 1981; *Montias 1980*, p. 61.)

8 July 1651 Reynier Jansz. van der Meer, living on the "*marcktvelt*," and Jan Heymensz., baker, guarantee a loan of 250 gulden extended to Harmen Gerritsz. Valckenhoff, delftware maker. (Delft, Register of the Orphan Chamber, no. 6. fol. 451 v.; *Montias 1977*, p. 279.)

12 August 1651 "*Op huyden den 12 Augustus 1651 compareerde voor mij Andries Bogaert, openbaar notaris bij den Hove van Holland geadmitteert, binnen de stad Delft residerende, ter presentie van de getuyghen onder genoemt Reynier van der Meer, Anders genoemt Vos, herbergier wonende aan de noortsijde vant marcktvelt binnen de voorsz. stede, mij Notaris bekent . . .*"

("Today on the 12th of August 1651 appeared before me, Andries Bobaert, notary public admitted to the Court of Holland and residing in the town of Delft, in the presence of the witnesses mentioned below, Reynier van der Meer, alias Vos, innkeeper living on the northern side of the market place in said town, known to me, Notary . . .") in order to name Aernolt Swieers in The Hague his correspondent to collect a debt of 126 gulden 7 stuivers from the painter Reynier van Heuckelom incurred for "*teerkosten*" (provisions and/or board). (Delft, prot. not. A. Bogaert, no. 1887; *van Peer 1959*, p.240; *Montias 1977*, pp. 279-80: and *Montias 1980*, p. 46.)

5 May 1652 Reynier Jansz. Vermeer signs as witness to the sale of a house. (*Montias 1977*. p. 280.)

15 June 1652 and **10 September 1652** Six references to Reynier Jansz.'s name occur in the estate papers of the wine merchant Simon Jansz. Doncker who died on 10 September 1652. They concern the delivery of French and Spanish wines "*aen Reynier Vermeer*" on 15 June 1652. (Delft, Orphan Chamber, *boedel* no. 493; *Montias 1980*, p. 46.)

12 October 1652 "*Reinier Jansz. Vermeer op 't Marctvelt*" is buried 12 October 1652 in the New Church in Delft. (Delft, Municipal Archives. Burial book New Church; *van Peer 1959*, p. 240.)

20 January 1653 "*Dingnum Jans*" appears before the Orphan Chamber in Delft to show the testament that she and her husband Reynier Jansz. Vos had drawn up on 17 February 1638. This testament, now confirmed by her husband's death, stated that the Orphan Chamber was not to become involved in supervising the succession. (Delft, Archives of the Orphan Chamber, no. 84, fol. 368; *Montias 1980*, p. 61.)

5 April 1653 and **20 April 1653** At first Maria Thins refused to give her consent to the marriage of her daughter Catharina ("*Trijntgen*") to Johannes Vermeer ("*Jan Reijniersz*"). Thereupon two friends of the couple accompanied by a notary paid a visit to Maria Thins on the evening of 4 April 1653; of this visit notary Ranck drew up an act in which he stated the next morning that: "*Op huijden den 5den april 1653 compareerde vor mij Johannes Ranck, openbaer notaris, bij den Hove van Holland geadmitteert, binnen der stad Delft residerende, in presentie van de ondergeschreven getuigen, capiteyn Melling, out ontrent 59 jaeren, ende Leonart Bramer, schilder, out ontrent 58 jaeren, beyde burgers alhier, die verclaerden ende attesteerden ten versoucke van Jan Reijniersz ende Trijntgen Reijniers waerachtich te weesen, dat sij getuijgen neffens mijn, notaris, gisteren avont sijnde den 4den deser, sijn geweest ten huijse aen ende bij de persoon van loffrouwe Maria Tints, woonende alhier, als wanneer bij den voornoemden notaris Ranck in onser presen tie is versocht off de voorseyde ioffrouwe Tints (geadsisteert met Cornelia Tints, haer suster) gelieffde te teijckenen de acte van consent van het aenteyckenen van de huijwelijcks gebooden van haer ioffrouwe Maria Tints dochter, genaemt Trijntgen Reijniers, met Jan Reyniersz, mede woonende alhier. beyden voornoemt, om deselve gebooden te doen vercondigen naer gebruijck deser stad: die wij alsdoen tot antwoort hebben hooren geven, niet van meninge was te teijckenen ende haer hant bekent te maken, maar wel mochte lijden dat de gebooden gingen ende hetselve soude aensien, ende tot verscheyde maelen seyde, dat sy die niet soude beletten off verhinderen. Wijders niet getuijgende, presenteerende tgeene voorseyt staet des noot ende versocht sijnde tselve met eede te conijrmeeren, consenteren hiervan acte gemaeckt ende gelevert te werden omme te strecken ende dienen naer behooren. Aldus verleden ende gepasseert binnen der stad Delft in presentie van Gerrit lansz van Oosten ende Willem de Lange, mede notaris alhier, als getuygen ten desen versocht ten dage voorseyt.*"

("Today 5th of April 1653 appeared before me, Johannes Ranck, public notary, admitted to the Court of Holland, residing in the town of Delft, in the presence of the undersigned witnesses. Captain Melling, about 59 years of age, and Leonart Bramer, painter, about 58 years of age, both burghers in this town, who declared and attested at the request of Jan Reijniersz and Trijntgen Reijniers to the fact that they, witnesses, and I notary, were presente yesterday night on the 4th of this month at the house and in the presence of Joffr. Maria Tints, living in this town, when the question was raised by the aforementioned notary Ranck in our presence whether the aforesaid Joffr. Tints (assisted by Cornelia Tints, her sister) was prepared to sign the act of consent for the registration of the marriage vows between Joffr. Maria Tints's daughter, named Trijntgen Reijniers, and Jan Reyniersz. also living here, both of them aforementioned, in order to make public these vows according to the custom of this town; whom we then heard give for an answer, that she did not intend to sign and to put her signature to it, but would suffer the vows to be published and would tolerate it. and said several times that she would not prevent nor hinder those. Not testifying further, offering to confirm the foregoing by oath, if need be and if asked to do so, they consent to have a deed thereof drawn up and delivered in order to serve as may befit. Thus passed and executed in the town of Delft in the presence of Gerrit Jansz van Oosten and Willem de Lange. also notary in this town, requested as witnesses in this instance on the aforesaid day. [Signed] *B. Mellijng*. [signed] *W. de Langue*. [signed] *Leonart Bramer*. [signed] *Gerrijt Jansz van Oosten*. [signed] *Johannes Ranck, notaris. Anno 1653.*") (Delft, prot. not. J. Rank, no. 2112.)

The betrothal indeed took place. In the "*Legger van de persoonen, die haer begaven in den H. echten staat binnen de Stadt Delff, begonnen metten iare 1650 ende eyndigende den lesten December 1656*" ("Register of the persons who entered the marital state in the Town of Delft, starting in the year 1650 and ending the last of December 1656") this betrothal is mentioned as follows: "*Den 5en Apprill l653: Johannes Reyniersz. Vermeer, jongeman op't Marctvelt. Catharina Bolenes jongedochter mede aldaer.* [in margin:] *Attestatie gegeven op Schipluij den 20en April 1653.*" ("The 5th April 1653: Johannes Reyniersz. Vermeer, bachelor, living on the Marctvelt. Catharina Bolenes, spinster, also there." [In the margin:] "Attestation given in Schipluij 20 April 1653." This means that the couple married on 20 April 1653 in Schipluiden, a village near Delft, where the Jesuits had a station. (*Obreen IV*, p. 292: *van Peer 1946*: C. D. Goudappel, "Ondertrouwen huwelijk van Jan Vermeer," in *Delftse historische sprokkelingen*, Delft 1977, pp. 20-26.)

22 April 1653 "*Mons' Gerrit Terburch*" and "*Johan van der Meer*" appear together as witnesses. They sign "*Geraerdt Ter Borch*" and "*Johannis Vermeer*." (Delft, prot. not. W. de Langue, no. 1695: *Montias 1977*, pp. 280-81, and *Montias 1980*, p. 47.)

23 April 1653 "*Johannes Reyniersz. van der Meer*" (who signs "*Johannis Vermeer*") witnesses a procuration made by his maternal uncle Reynier Baltensz. from Gorcum. (Delft, prot. not. C. Georgin, no. 2083: *Montias 1977*, pp. 283-84.)

6 May 1653 "*Dingena Baltensdr, weduwe van Reynier van der Meer*" declares that "*ontrent vijff maende geleden*" ("about five months ago") she went to Brouwershaven and stayed in the house of Tobias Bres. The document is witnessed by the painters Leonaert Bramer and Evert van Aelst. (Delft, prot. not. A. Georgin, no. 2083: *Montias 1977*, p.284.)

29 December 1653 "*Register van alle de nieuwe meesters en winckelhouders behoorende onder Ste Lucas gilde Tsedert den lare 1650*": "*Schilder. Den 29 December 1653 lohannis Vermeer he(e)ft hem doen aanteijcken als meester Schilder, sijnde burger en heeft op sijn meester geldt betaelt 1 gul. 10 stuyv. rest 4 gul. 10st. Den 24 July 1656 is alles betaelt.*" ("Register of all the new masters and shopkeepers belonging to the Guild of Saint Luke since the Year 1650": "Painter. On 29 December 1653 Johannis Vermeer had himself registered as Master Painter, being a burgher and paid one gulden 10 stuivers toward his master's fee. 4 gulden 10 stuivers remain to be paid. On

24 July 1656 the total amount is paid.") *"Meesters-bouck behoorende onder Ste Lucas gilde 1650-1714: 78. Johannes Vermeer."* ("Masterbook of the Guild of St. Luke 1650-1714: 78. Johannes Vermeer.") (The Hague, Royal Library; *Obreen I*, p. 56, 45.)

30 April 1654 Johannes Vermeer appears as witness to a recognition of a debt incurred by Cornelis Jansz. Warmen, carpenter, living in Nieucoop. (Delft, prot. not. A. C. Bogaert, no. 1888; *Montias 1980*, p. 47.)

5 September 1654 In the inventory of the Rotterdam painter Cornelis Saftleven. Reynier Vermeer is said to owe him 25 gulden *"over koop van schilderij"* ("for the sale of painting"). (Rotterdam, Archives of the Orphan Chamber, no. 440: N. Alting Mees. "Aanteekeningen over oud Rotterdamsche kunstenaars:" *Oud-Holland* 31 (1913), p. 258.)

14 December 1655 *"Sr. Johannes Reyniersen Vosch Mr. Schilder ende Juffr. Catharina Bollenes, wonende binnen deze stadt. sijne huysvrouwe"* appear as witnesses. The name *"Vosch"* was crossed out and *"Vermeer"* inserted instead. (Delft, prot. not. G. Rota; van Peer 1959, p. 241.) According to Bredius, it emerges from this act, which has never been published completely, that Reynier Jansz. Vermeer, father of the painter, had borrowed 250 gulden, which were never repaid. Johannes Vermeer and his wife appeared before the notary to declare themselves secondary guarantors for the repayment of the loan. (*Bredius 1885*, p. 218: d, *Montias 1980*, p. 47.)

24 July 1656 See the document of 29 December 1653.

25 February 1657 Antony Gerritsz. van der Wiel, Vermeer's brother-in-law, registers in the guild of St. Luke as an art dealer. (*Obreen I*, p. 61: d. *Montias 1980*, p. 47.)

18 June 1657 In this, her first known, testament Maria Thins leaves most of her goods to her daughter Catharina (Vermeer's wife), to her goddaughter Maria Vermeer, and to her other grandchildren. (Gouda, prot. not. Straffintvelt; *Montias 1980*, p. 50.)

27 June 1657 A picture in this estate of the art dealer Johannes de Renialme is described as: *"Een graft besoeckende van Van der Meer 20 guldens"* ("Visit to the tomb by Van der Meer 20 gulden"). (Amsterdam, prot. not. Uyttenbogaert; A. Bredius. *Künstler-Inventare*, I, The Hague 1915, p. 233: see our cat. no. 32A.)

30 November 1657 *"Johannis Reyniersz Vermeer, schilder. ende Catharina Reyniers Bolnes, sijne huysvrou,"* living in Delft, borrow 200 gulden from Pieter Claesz van Ruijven, at an interest of 4 1/2%. (Delft, prot. not. J. van Ophoven; *Bredius 1885*, p. 218, and *Bredius 1910*, p. 61.) Swillens erroneously states that this loan took place on 30 November 1655 and was recorded in the records of the Orphan Chamber in Delft. (*Swillens*, p. 24.) On Pieter Claesz van Ruijven, see *Montias 1987*, pp. 68-71.

28 December 1658 A house figuring in the estate of the widow Schilperoort is mentioned as: *"Staende aende Noortzijde van 't Marctvelt, belent ten Oosten de weduwe van Reynier Vos, alias van der Meer"* and as *"Belent Dingenum Balten, Wed. van Reynier Vos, genaemt 'Mechelen'."* ("Situated on the northern side of the Marctvelt, with the eastern side next to the widow of Reynier Vos, alias van der Meer" and as "Contiguous with the house of Dingenum Balten. Widow of Reynier Vos, called 'Mechelen'." (Delft, Archives of the Orphan Chamber; *Swillens*, p. 25.)

27 December 1660 *"Een kint van Johannes Vermeer aen den O. Langendijck"* ("A child of Johannes Vermeer on the Oude Langendijck"). (Delft, Burial registers, no. 40, fol. 40, Oude Kerk; *Montias 1980*, p. 49.)

28 January 1661 and **11 April 1661** From the testament of Cornelia Thins, sister of Vermeer's mother-in-law, Maria Thins: *"In den Name Godes Amen. In den jare ons Hr. dusent ses hondert een ende sestich de 14de Indictie op den 28 dach der maent Ianuary de clock ontrent zes uyren nae de middag compareerde etc. de eerbare Iuffr. Cornelia Thins beiaerde dogter poortersse de stat Goude my Notario bekent, sieckelyck van lichaem op een stoel by de vier sittende nochtans haer verstant. rede ende memorie wel hebbende ende gebruyckende ende zoo uyterlyck blycken mochte, de welck ten opsigte van de*

sekerheyt des doots ende onseckere uyre vandien zeide van meeninge te zijn op de successie van heure tydelycke goederen testamentairlyck te disponerenf [. . .] Item, legateerde nog aan Maria lans Vermeer mede dochtert ie van dezelfde Catharina Bolnes een woning met omtrent tien en een halve morgen land. liggend in Bonrepas omtrent Schoonhoven. zijnde leen en te leen gehouden van de Grafelijkheid van Holland en West-Friesland." ("In the Name of God Amen. In the year of our Lord 1661 the 14th Indiction on the 28th of the month of January at about 6 o'clock in the afternoon appeared etc. the honorable Juffr. Cornelia Thins, of age, burgher of the town of Gouda and known to me. Notary, sick in body and sitting on a chair near the fire, nevertheless in the possession of, and using her reason, mind and memory, as much as may be clearly discernible, who, in view of the certainty of death and the uncertainty of its hour, stated to be intent on disposing by testament of the succession of her wordly goods [. . .] Similarly, [she] bequeathed to Maria Jans Vermeer, also daughter of the same Catharina Bolnes, a house with approximately 10 1/2 'morgen' of land, situated in Bonrepas in the neighborhood of Schoonhoven, being a fief and kept as a fief from the Earldom of Holland and West-Frisia.") (Gouda, prot. not. Straffintvelt.)

Maria Jans Vermeer was the eldest daughter of the painter. For obscure reasons, however, Bon Repas is transferred some days later (**1 February 1661**) to Catharina Bolnes, wife of Vermeer, *"zonder dat Maria lans Vermeer daeraen eenig prerogatieve ofte voordeel sal genieten"* ("without Maria Jans Vermeer enjoying any prerogative or advantage therefrom"). The Repertory of Loans (The Hague, State Archives, no. 227) mentions that the property came *"aan Catharina Bolnes, oud 30 jaar, bij dood ende makinge van Cornelia Thin"* ("to Catharina Bolnes, aged 30 years, at the death and by the testament of Cornelia Thin") on 11 April 1661. Furthermore the Repertory of Loans mentions: *"Ende voor de voorn, Catharina Bolnes heeft hierin ons hulde, eed ende manscap gedaen de voorn, loh, Vermeer haer man ende voogt in handen van onse lieve ende getrouwe Raadspensionaris lohan de Witt als stadhouder ende registermeester van onze lenen."* ("And in place of the aforementioned Catharina Bolnes the aforementioned Johannes Vermeer, her husband and guardian, has done us homage, oath and fidelity, in the hands of our dear and faithful Grand Pensionary Johan de Witt as Stadholder and master of the register of our loans.") (After *van Peer 1951*, pp. 618-19.)

16 May 1661 The first item in the inventory of Cornelis Cornelisz. de Helt, innkeeper *"In de longen Prins,"* who died on this date, reads: as *"Int Voorhuys* [:] *In den eersten een schilderye in een swarte lyst door Jan van der Meer"* ("In the front parlor [:] Firstly a painting in a black frame by Jan van der Meer). De Heirs possessions were auctioned on 14 June 1661. The painting by *"Van der Meer"* sold for 20 gulden 10 stuivers. (Delft, Orphan Chamber, *boedel* no. 673; *Montias 1980*, pp. 50-51.)

10 December 1661 and **4 January 1662** *"Compareerde Johannes Vermeer Mr. Schilder alhier ende constitueerde hem selve cautionaris voor Clement van Sorgen ter somme van acht en tseventich gul, die Phillijps van der Bilt tot laste van hem Van Sorgen is pretendeerende ende waevooren denselven Van der Bilt twee iapponse rocken hem Van Sorgen toebehoorende onder sich is behoudende geweest ende die ter ordonnantie van de Heeren Schepenen op het Stadhuys alhier gebracht heeft omme onder beneficie van dese cautie deselve rocken by hem Van Sorgen gelicht ende naer hem genomen te werden. beloovende deselve somme met de rechtelijke costen daar omme te doen onder renunciatie van de beneficie ordinis sive excussionis, van den effecte van dien wesende onderricht te sullen betalen ende voldoen in cas sulcx in tyt en wijlen souden mogen werden te verstaan te behooren, onder verbant als naar rechten. Gedaen den 10 December 1661.* (In margin:) *Compareerde ter Secretarie der Stadt Delft Philips van der Bilt ende verclaerde loannes Vermeer van de nevenstaende gedeponeerde borgtochte te ontslaen. Gedaen den 4 Ianuarij 1662."* ("Appeared Johannes Vermeer Master Painter in this town

and constituted himself guarantor for Clemens van Sorgen for the sum of 78 gulden, claimed by Phillilps van der Bilt from the said Van Sorgen and for which the same Van der Bilt has been keeping two Japanese robes [i.e. dressing gowns] belonging to him, Van Sorgen, which robes Van der Bilt has brought to the Town Hall in this town, on the order of the Lords Aldermen, so that they might be picked up and taken by him van Sorgen, under benefit of this guaranty. [he Vermeer] promising to pay and settle the said sum together with the pertinent legal costs, renouncing the beneficium ordinis sive excussionis [guarantor's right to compel the creditor who has sued him before the principal, to sue the principal first: see Adolf Berger, *Encyclopedic Dictionary of Roman Law*. Philadelphia 1953, p. 373], acquainted with the consequences there of to be done in case this would be necessary, in accordance with common law. Done the 10th of December 1661. [*In the margin:*] Appeared before the Secretary of the Town of Delft Philips van der Bilt and pronounced Joannes Vermeer discharged of the adjoining deposited guaranty. Done 4 January 1662.") (Reg. der Acten van Cautien voor Schepenen van Delft, f. 74; *Obreen IV*, pp. 293-94.)

15 May 1662 Maria Thins amends her testament of 18 June 1657. Apart from bequests to her daughter Catharina, to her goddaughter Maria, and to the other children of Catharina and Johannes, she gives her son-in-law Johannes Vermeer a sum of 50 gulden yearly. (Gouda, prot. not. Straffintvelt; *Montias 1980*, p. 51.)

1662 "*Regerende Hooftmans deses laers waren Cornelis de Man, Arent van Sanen, Aelbrecht Keijser, Johannes Vermeer, Ian Dirckse van der Laen, Ghijsbrecht Kruijck.*" ("Acting Headmen for this Year were Cornelis de Man, etc.") (The Hague, Royal Library, Register of all the new masters and shopkeepers belonging to the Guild of Saint Luke, Delft; *Obreen I*, p. 68.)

17 January 1663 Willem Bolnes (Vermeer's brother-in-law) recognizes a debt of 300 gulden to his mother, Maria Thins, Johannes Vermeer signs as witness. (Delft, prot. not. G. van Assendelft, no. 2130; *Montias 1980*, p. 51.)

August 1663 "*A Delphes ie vis Ie Peintre Vermer qui n'avoit point de ses ouvrages: mais nous en vismes un chez un Boulanger qu'on avoit paye six cens livres quoyqu'il n'y eust qu'une figure, que j'aurois creu trop payer de six pistoles.*" ("In Delft I saw the Painter Vermeer who did not have any of his works: but we did see one at a baker's, for which six hundred livres had been paid, although it contained but a single figure, for which six pistoles would have been too high a price in my opinion.") (*Journal de voyages de Monsieur De Monconys*, II, Lyon, 1666, p.149.) For De Monconys's visit to Delft, see also Neurdenburg 1951. One pistole was equal to ten livres.

1663 "*De regerende Hooftluijden deses iaers waren Ioannes Vermeer. Arent van Saenen. Gijsbrecht Cruick. Anthonij Pallemedes. Frans Ianse van der Fijn, Ian Gerritse van der Houven.*" ("Acting Headmen for this year were Joannes Vermeer, etc.") (The Hague, Royal Library, Register of all the new masters and shopkeepers belonging to the Guild of Saint Luke, Delft; *Obreen I*, p. 69.)

9 February 1664 Among the debts for medicines delivered, due to the estate of Dirck de Cocq, apothecary: "*Jan van der Meer schilder voor uts. 6 g. 13 st.*" ("Jan van der Meer, painter, for ut supra [= medicines delivered] 6 gulden 13 stuivers.") (Delft, prot. not. N. Vrijenbergh, no. 2061: *Montias 1980*, p. 52.)

4 August 1664 "*Een tronie van Vermeer,*" estimated at 10 gulden, figures in the inventory of the estate of Jean Larson, sculptor in The Hague (see our cat. no. 32b).

13 January 1665 From an act of 25 November 1676 it emerges that on 13 January 1665 Maria Thins was appointed guardian of the estate of her son Willem Bolnes. (*Obreen IV*, p. 296.)

19 October 1665 Vermeer's patron Pieter Claesz van Ruijven and his wife, Maria de Knuijt, make their last will and testament. In case Maria de Knuijt outlives both her husband and her child(ren). Johannes Vermeer will inherit 500 guilders. (Leiden, prot. not. N. Paets, no. 676; *Montias 1987*, pp. 69-70.)

3 July 1666 On this day an attestation was drawn up in which is stated that Vermeer's brother-in-law Willem Bolnes, while living in the house of Maria Thins and Johannes Vermeer, several times seriously threatened his mother. Maria Thins, and his sister, Catharina Bolnes. Finally Maria Thins obtained permission from the magistrate of Delft to have her son committed to custody. (Delft, prot. not. F. Boogert, no. 2006: *Montias 1980*, p. 53.)

1667 "*Ende gelijck tot hier toe d'afgestorvenen naer ordre en vervolgens den tijdt haeres overlyden, zijn gerangeert, soo sullen wy eenige resterende konstenaren, die, als ick dit schreef noch in leven waren, na haer ouderdom van laeren hares geboorte noemen, als daer zijn, Leonard Bramer, geboren op Kermis-avond 1596. Pieter van Asch, geboren Anno 1603, Adriano van Linschoten, geboren in den laere 1607, of acht, Hans Jordaens, in Maert 1616, Cornelio de Man, den 1 July 1621, Johannes Vermeer, 1632, en anderen meer, behalven noch die geene die hier boven by haer Vrinden zijn genoemt, en te dier occasie alberyts oock eeniger mate beschreven. En van deze, sich in de konst dagelijcx noch oeffenende, practiserende en in haer studie meer en meer geluckig toenemende. soude men met Iesus Siracch mogen seggen: Hun wercken . sullen in der Konstenaren hand / Altyd grepresen zyn van 't eene in 't ander Land.*" ("And in the same way as we just listed the deceased in order of the time of their death, we will now list a few other artists, who were still alive when I wrote this, according to their age, viz.: Leonard Bramer, born on Kermis-night 1596, Pieter van Asch, born Anno 1603, Adriano van Linschoten, born in the Year 1607 or eight, Hans Jordaens, in March 1616, Cornelio de Man, the first of July 1621, Johannes Vermeer, 1632, and others, apart from those mentioned above along with their Friends, already described in some measure on that occasion and of those who are still training and practicing their art daily and advance more and more happily in their studies. one could say with Jesus Sirach: 'Their works in the Artists's hand / will Always be praised from Land to Land'.") (D. van *Bleyswyck, Beschryvinge der Stadt Delft*, printed by Arnold Bon, Boeckverkooper, op 't Marct-velt, Delft 1667, p. 859, with reference to "I. Sirach.9.21" in the margin.)

Bleyswyck's book also includes a poem of eight stanzas by Arnold Bon, the printer of the book, titled, "*Op de droevige. en ongelukkigste Doot van den aldervermaarsten, en konstrycksten schilder, CAREL FABRICIUS*" ("On the sad and most miserable Death of the most famous and most artful painter, *CAREL FABRITIUS*"). Seven stanzas appear on p. 853, the eighth on p.854. The Royal Library (KB) in The Hague owns three copies of Bleyswyck's *Beschryvinge . . .* ; in these copies the title page, the page with "errata," and the first seven stanzas of the poem are all identical. When we apply the "ruler method" it becomes clear that all three copies are of one and the same typesetting (for this method see R. B. McKerrow, *An Introduction to Bibliography*, Oxford 1927, p. 183). There are two versions, however, of the eight stanza on p. 854; the first and last line differ. In copies KB no. 3113 D 24 and no. 553, 41, the stanza is:

"*Soo doov' dan desen Phenix (onser schade*
In 't midden. en in 't beste van zyn swier.
Maar weer gelukkig rees' er uyt zyn vier
VERMEER, die meesterlyck betrad zyn pade."
(Thus expired this Phoenix to our loss
In the midst and in the best of his powers.
But happily there rose from his fire
VERMEER, who, masterlike, trod his path.")

In KB no. 2000 F1.2:

"*Dus bleev' dien Phenix op zyn dertig jaren*
In 't midden. en in 't beste van zyn swier.
Maar weer gelukkig rees' er uyt zyn vier
VERMEER, die 't meesterlyck hem na kost klaren."

("Thus died this Phoenix when he was thirty years of age.
In the midst and- in the best of his powers.
But happily there rose from his fire
VERMEER, who, masterlike, was able to emulate him.")

C. de Wolf, of the department of early printed works in the Dutch Royal Library, told me that the first version must be the earlier one and the second the corrected one. In the seventeenth century the first word of the next page was printed at the bottom of the preceding one (the "catchword"). In all three copies the catchword on p.853 is "Soo," the first word of the first-mentioned version of the stanza beginning on p. 854; the later version begins with "Dus." There are other differences between the three copies: KB 3113 D 24 includes a theatrical work, "Delftsche Broertgens-Kermis," at the back; it also includes more portrait prints, and the entire work is bound in one volume, while the two other copies are bound in two volumes. The version in which "jaren" rhymes with "klaren" appears also in a copy bound in two volumes in the Widener Library of Harvard University. Cambridge, Mass. (A. Blankert).

3 March 1667 Vermeer serves as witness at the appointment of Jan van der Wielen as executor of the will of Jannetje van Buyten, sister of the baker Hendrick van Buyten (cf. document of 27 January 1676). (Delft, prot. not. C. P. van Bleyswyck; *van Peer 1957*, p. 95.)

10 May 1667 Maria Thins empowers Johannes Vermeer to collect sums owed her from her debtors and to invest these sums according to his judgment and discretion. (Delft, prot. not. F. Boogert, no. 2006; *Montias 1980*, p. 54.)

10 July 1667 Burial date of a child of Vermeer. See document of 15 December 1675.

27 September 1667 Maria Thins, Vermeer's mother-in-law, makes a testament leaving five-sixths of her goods to her daughter, Catharina Bolnes, the wife of the painter, and one-sixth to her son Willem Bolnes. She justifies this division by referring to the misbehavior of Willem. (Delft, prot. not. Frans Boogert, no. 2006: cf. *van Peer 1957*, p. 98.)

2 June 1668 Maria Thins empowers Johannes Vermeer to collect a sum from the Orphan Chamber in Gouda. (Delft, prot. not. F. Boogert, no. 2007: *Montias 1980*, pp. 55-56.)

2 January 1669 Digna Baltens, Vermeer's mother, puts up for sale at auction her house "Mechelen." Because the highest bid was only 3,700 gulden, the inn was evidently withdrawn. (Delft, prot. not. F. Boogert, no. 2007: *Montias 1980*, p. 56.)

1 February 1669 Digna Baltens rents out her house "Mechelen" to be used as an inn. Rent is set at 190 gulden a year. (Delft, prot. not. F. Boogert, no. 2007: *Montias 1980*, 56.)

16 July 1669 Burial date of a child of Vermeer. See document of 15 December 1675.

1669-1678 In a list of painters by the Amsterdam physician Jan Sysmus there occurs: "*Van der Meer, Jonkertjes en casteeltjes. Delft, hiet Otto.*" (Van der Meer, small paintings of dandies and castles. Delft, first name Otto.") (A. Bredius, "Het schldersregister van Jan Sysmus, Stads-Doctor van Amsterdam," in *Oud-Holland* 8 (1890), pp. 1-17, 207-234, 294-313; 9 (1891), pp. 137-49; 12 (1894), pp. 160-71; 13 (1895), pp. 112-20.) The note on Vermeer (1894, p. 163) has not been cited before in the literature on the painter. In view of the addition "Delft" Sysmus undoubtedly meant our Vermeer. He was mistaken about his first name ("Otto"), but he was often ill-informed about first names; compare his note on Bramer: "*te Delft, beel-ties, heet Adriaen*" ("in Delft, figures, is called Adriaen") instead of Leonaert (1890, p. 3).

The fact that Sysmus mentioned "casteelties" as a theme of Vermeer's suggests that he had a vague notion of the View of Delft (cat. no. 10). He cites "Jonkerties" ("dandies") also as a theme of Constantijn Netscher. Michiel van Musscher, and Eglon van der Neer (1890, pp. 302, 303; 1894,

p. 167). About Christiaen van der Laemen, Sysmus says: "*pinxit malle jonkertjes*" ("painted foolish dandies"). The subjects he mentions of Hieronymus Janssen de Danser and of the unknown "J. A. Talpa" are "*jonkertjes en juffertjes*" ("dandies and young ladies") (1890, pp. 13, 16). "*Juffertjes*" is the sole indication of the subject matter of Metsu and ter Borch (1890. p. 8: d. 1890. p. 308. Palamedes: "*geselschapjes, . . . juffertjes en cortegaerden*" ("merry companies . . . young ladies and guardrooms")). As far as we know, all these artists made genre painting of well-dressed people. Sysmus's remarks indicate that he, and possibly his contemporaries, called such paintings—including those by Vermeer—"*Jonkertjes*" and/or "*juffertjes.*" (A. Blankert).

11 February 1670 In their second testament, Anthony van der Wiel and Gertruy Reyniersdr Vermeer, Johannes Vermeer's sister, name each other universal heirs. If Gertruy should die before Anthony, he must within five years turn over all her clothes and personal possessions as well as the sum of 400 gulden to her relatives and heirs ab intestato. The "relatives and heirs" can only refer to Johannes Vermeer, her sole brother and heir *ab intestato*. Vermeer's patron Pieter Claesz van Ruijven was one of the witnesses. (Delft, prot. not. G. van Assendelft, no. 2128: *Montias 1980*, p. 56: *Montias 1987*, p. 70.)

13 February 1670 "*Begraven in de Nieuwe Kerk 13 Februarij 1670 Dyna Baltens, weduwe van Reynier Vermeer in de Vlamingstraet.*" (Buried in the New Church 13 February 1670 Dyna Baltens, widow of Reynier Vermeer, in the Vlaminstraet.") (*Register der doden te Delft, Part VIII: Obreen IV*, p. 291.) "*Dyna Baltens*" was Johannes Vermeer's mother. The death donation to the Camer van Charitate (donated on 26 August 1670) amounted to 6 gulden 6 stuivers. (Delft, *Opperste kleed boek* no. 74, fol. 8; *Montias 1980*, p. 56.)

2 May 1670 Gertruy Vermeer, Johannes's sister, is buried. The death donation to the *Camer van Charitate* (donated on **27 May 1671**) amounted to 6 gulden 6 stuivers. (Delft, *Begraafboek* no. 41, fol. 142 v: *Opperste kleed boek* no. 74. Part II, fol. 11 v: *Montias 1980*, p. 56.)

13 July 1670 After the death of Johannes Vermeer's parents (see documents of 12 October 1652 and 13 February 1670), notary Frans Boogert drew up the act of division of the parental estate on 13 July 1670. In his draft, which was later to serve as minutes, he first cited "*Johannes van der Meer*" as first attestant. He then crossed out "*van der Meer*" and wrote above it "*Vermeer.*" According to this division of the estate, the parental home "Mechelen" was allotted to Johannes Vermeer, with the approval of his brother-in-law, Anthony van der Wiel. (After *Bouricius*, p. 271.)

28 October 1670 "*De Hooftmans waren Louijs Elsevier. Michiel van den Houck, Gijsbrecht Kruijck, Loannes Vermeer. Jasper Serrot Jacob Kerton op den 28 October An. ° 1670.*" (The Hague, Royal Library, Register of all the new masters and shopkeepers belonging to the Guild of Saint Luke. Delft; *Obreen I*, p. 76.)

18 July 1671 According to an act of 18 July 1671, published by Bredius in part only, Johannes Vermeer, painter in Delft, acknowledges having received his part of the estate of Gertruy Vermeer, his late sister, with the exception of 648 gulden, which sum is still due to him as the remaining portion of the estate from his brother-in-law, Anthony van der Wiel. He also settled with the latter all matters pertaining to the estate of Digna Baltens, their late mother and mother-in-law. Johannes Vermeer assumed all debts and charges of the said estate. He thenceforth had the right to collect debts due to the estate, to his own profit. (Delft, prot. not. G. van Assenfelft; *Bredius 1885*, p. 218.)

28 October 1671 "*De regerende Hooftmans waren loannes Vermeer. Jasper Serrot. Jacob Corton. Comelis de Man. Cijbrant van der Laen, Claes lansz. Metschert.*" (The Hague, Royal Library, Register of all the new masters and shopkeepers belonging to the Guild of Saint Luke. Delft, *Obreen I*, p. 78.)

14 January 1672 According to a deed of this date, published by Bredius in

part only, Johannes Vermeer rented his house, "Mechelen," on the north side of the Marktveld OR the southwestern corner of the Oudemanhuis steegje, to Johannes van der Meer for the duration of six years, starting 1 May forthcoming, for 180 gulden per annum. (Delft, prot. not. F. Boogert *Bredius 1910*, p. 62.)

23 May 1672 "*Op huyden den 23 Mey 1672 compareerden voor mij Pieter van Swieten. Openb. Notaris [. . .] d'Heeren Johannes Iordaen ende Johannes Vermeer uytmuntende Kunstschilders tot Delft en verc1aerden sy deposanten te saemen ter instantie van Sr. Hendrick de Formanteau voor de oprechte waerheyt getuycht, verclaert en gedeposeert waer te syn dat sy deposanten op haere Confrery Camer alhier op dato gesien en gevisiteert hebben 12 stucks Schilderien d'welcke op de lijste ofte cathalogus die de requirant hen deposanten heeft geexhibeert, gestelt ende genaemt staen voor uytmuntende ltaliaense schilderien, mitsgaders getaxeert soodanigh als achter yeder stuck uytgetrocken Staet namentlyck:*"

	Ryxdaelders
een Venus en Cupido. beelden grooter als het leven van	
Michiel Angelo Bonarotti, Hollants gelt	350–320
een Conterfeytsel van Ciorgion del Castelfrancko van	
Titiaen, naer het leven geschildert	250–240
een harder ende harderinnetje van Titiaen	160–150
Weergadingh van deselve groote van Titiaen	120–110
een dans van naeckte Kindertjens levensgroote van	
Iacomo Palma	250–240
een Venetiaense Dame van Paris Pordinon	160–150
een Conterfeytsel van een Pre1aet van Hans Holbeen	120–110
een Ceres met overvloet, met veele naeckte Kindertjes van	
Ciorgion del Castel Franco	120–110
een out mans confeytsel van Raphael Urbin	150–140
een St. Paulus, halfbeelt, levensgroote, van de Oude	
Jacorno Palma	80–70
een Schoone Venetiaense vrouw van Titiaen	200–185
een lantschap van Titiaen met een Satier die de nimphe	
Caresseert	240–230

sijnde de voorsz. Schilderien gecachetteert met het signet van syne Ceurvorstelycke Doorluchticheyt Van Brandenburch, welcke Schilderien niet alleen niet en syn uytmuntende Italiaense Schilderien, maer ter contrarie eenige groote vodden ende slechte schilderien. die op verre nae de tiende part van de voorsz. uytgetrocke prysen niet weerdich en sijn, ende sy deposanten die niet en connen estimeren. dewijle. deselve niet geacht en konnen werden. Eyndigende enz . . Johannes Jordaen, Joanes Vermeer."

("Today 23 May 1672 appeared before me Pieter van Swieten, Public Notary) [. . . Messrs Johannes Jordaen and Johannes Vermeer, excellent Painters in Delft and they, attestants, declared together, at the request of Sr. Hendrick de Fromanteau, and in all truth testified, stated, and averred to be true, that they, deponents, saw and examined here, at this date in the Guildhall, 12 items of Painting, which were described and named as outstanding Italian paintings in the list or Catalogue shown to them, deponents, by the petitioner, as well as appraised as stated after each painting, viz.:

	2 1/2 gulden
a Venus and Cupid, figures larger than life-size.	
by Michiel Angelo Bonarotti, Dutch currency	350–320
a Portrait of Giorgion del Castelfrancko by Titiaen, from life	250–240
a shepherd and shepherdess by Titiaen	160–150
Pendant of the same size by Titiaen	120–110
a dance of naked Children life-size by Iacoma Palma	250–240
a Venetian Lady by Paris Pordinon	160–150
a Portrait of a Prelate by Hans Holbeen	120–110
a Ceres with abundance, with many naked Children by	
Giorgion del Castel Franco	120–110
a portrait of an old man by Raphael Urbin	150–140
a St. Paul, half-length, life-size, by the Old Jacomo Palma	80–70
a Beautiful Venetian woman by Titiaen	200–185
a landscape by Titiaen with a Satyr Caressing the nymph	240–230

being the aforementioned Paintings sealed with the signet of his Serene Highness the Elector of Brandenburch, which Paintings are not only no outstanding Italian Paintings, but, on the contrary. great pieces of rubbish and bad paintings, not worth the tenth part of the aforementioned proposed prices by far, which they, the deponents, cannot estimate, since the items have no value to speak of.

Ending, etc., Johannes Jordaen, Joannes Vermeer."

(The Hague, prot. not. P. van Swieten; *Bredius 1916*, pp. 89-91.) For other documents concerning this matter see: A. Bredius. "Italiaansche schilderijen in 1672, door Amsterdamsche en Haagsche schilders beoordeeld," in *Oud-Holland* 4 (1886), pp. 41-46; 278-80.

27 June 1673 One of Vermeer's children was buried. See document of 15 December 1675.

September 1673 Johannes Vermeer appears before the magistrates of Gouda to collect part of an inheritance coming from an aunt of Maria Thins. (*Montias 1980*, p. 57.)

18 January 1674 "Joannes Vermeer . . .Konstrijck schilder" ("Joannes Vermeer . . . Artful painter") acts as witness. (Delft, prot. not. C. P. Bleyswyck, no. 1913, fol. 130 sqq.) Kind communication of K. Wilkie.

21 January 1674 "Sr. Johan Vermeer" witnesses a deposition made by his mother-in-law, Maria Thins, (Delft, prot. not. A. van der Velde, no. 2177; *Montias 1980*, p. 62.)

25 January 1674 "*25 Januari 1674. Sr. Hendrick de Schepper wonende binnen Amsterdam, transport hebbende van Johannes Vermeer, Schilder tot Delft (zijnde dit transport gepassd te Amsterdam voor Not. Outgers 21 Juli 1673) verklaart te hebben verkocht aan . . . [not filled out]: 2 Obligatien ten laste van 't gemeene lant van Hollandt en Westvrie sland, een van f. 300 en een van f. 500 samen f. 800. die hij bekent ontvangen te hebben.*" ("Sr. Hendrick de Schepper living in Amsterdam, having an act of transfer of Johannes Vermeer, Painter in Delft [this transfer having been passed in Amsterdam before Notary Outgers 21 July 1673] declares having sold to . . .: 2 debentures chargeable to the common land of Holland and West-Frisia, one in the amount of 300 gulden and one of 500 gulden, together 800 gulden, which he declares having received.") (Amsterdam, prot. not. A. Lock: *Bredius 1910*, p. 62.)

31 March 1674 "*Sr. Johannis Vermeer Mr. Schilder*" witnesses an act drawn up at the request of Maria Thins. (Delft, prot. not. J. Spoors, no. 1680; *Montias 1980*, p. 62.)

4 May 1674 Johannes Vermeer travels to Gouda to settle some of his late father-in-law's affairs. (Gouda, prot. not. Straffintvelt, *Montias 1980*, p.62.)

24 May 1674 Maria Thins and Johannes Vermeer approve a compromise made by Reynier Bolnes and the heirs of Heijndrick Hensbeeck, made in Gouda on 25 July 1672. (Delft, prot. not. F. Boogert, no. 2009; *Montias 1980*, p. 62.)

5 March 1675 ("*Op huijden den 5en Maart 1675 compareerden voor myn Cornelis Pietersz Bleiswyck. Nots publ. by den Ed. Hove van Hollandt binnen Delff, de eerbare Jouffr Maria Tins, Wede van za. Sr Reynier Bollenes, moeder ende voochdesse van haren zoon Willem Bollenes, en heeft [. . .] machtich gemaeckt den E. Johannes Vermeer, haren Swager, Constryck Schilder, special, omme uyt haren naem hem te vervangen: eerst in den boedel van za. Henrick Hensbeeck, overleden binnen de stadt Gouda, (om tot scheiding enz. te procedeeren en de Willem Bolnes toekomende penningen te inn en) en tevens omme te ontfangen en uytgeeff te doen vant iaerlicx incommen weegen haren zoon Willem Bollenes, omme daerinne te handelen doen,*"

dezelve administreren, als een goet administrateur gehouden is te doen, dat sy comparante haren Swager ten vollen is toevertrouwende. Enz. [signed] Marya Thins." ("Today the 5th of March 1675 appeared before me Cornelis Pietersz Bleiswyck. Notary public to the Hon. Court of Holland in Delft, the honorable Jouffr. Maria Tins, Widow of the late Sr. Reynier Bollenes, mother and guardian of her son Willem Bollenes, and has authorized the honorable Johannes Vermeer, her son-in-law, Artful Painter, especially for the purpose of replacing her: first in the affair of the estate of the late Henrick Hensbeeck, deceased in the town of Gouda (to proceed to the division of the estate etc. and to collect the money due to Willem Bolnes) and also to receive the yearly income of her son Willem Bollenes, and make payments with it, to do business with it, to administer it, as a good administrator should do, that the attestant fully entrusts to her son-in-law. Etc. [signed] Marya Thins.") Pieter Roemer, master glass maker, is witness, (Delft, prot. not. J. van Bleyswyck; *Bredius 1885*, p. 218.) Willem Bolnes lived with his mother, Maria Thins, in Delft, together with his sister Catharina Bolnes and his brother-in-law Johannes Vermeer, until he was put in one of the reformatories of the town. (*Van Peer 1957*, p. 98.)

15 December 1675 From the register of the "*Person en die binnen deser Stad Delff overleden ende in de Oude Kerck als oock daer buijten begraven sijn tsedert den 19 Julij 1671*" ("Persons who have died in this Town of Delft and who are buried in the Old Church as well as outside of it, since 19 July 1671"): "*Jan Vermeer kunstschilder aen de Oude Langedijk in de kerk.* [In the margin:] *8 Me:J:kind*" ("Jan Vermeer painter on the Oude Langedijk, in the church. 8 children under age"). (*Obreen IV*, p. 294.) The body of Johannes Vermeer was laid in the grave that his mother-in-law, Maria Thins, had bought on 10 December 1661.

10 julij 1667 is in dit graf geleijteen baerkint van Iohan Vermeer, uijtge sondert dat baerkint is het graff ledigh.
Den 16 julij 1669 een kint van Iohan Vermeer. Den 27 junij 1673 een kint van Iohan Vermeer.
Den 16 dec. 1675 is in dit graf geleijt Iohan Vermeer ende het bovens taende baerkint op de kist van de voorn. Vermeer geset.
Den 23 maart 1676 is hier in geleijt Wm. Bolnes j.m.
Den 27 december 1680 Maria Thins wed. van Reijnier Bolnes, ende is nu vol.
("10 July 1667 an infant of Johan Vermeer was laid in this grave; apart from this infant the grave is empty.
The 16th July 1669 a child of Johan Vermeer. The 27th June 1673 a child of Johan Vermeer.
The 16th December 1675 Johan Vermeer was laid in this grave and the above mentioned infant was set on the coffin of the aforementioned Vermeer.
The 23rd March 1676 W. Bolnes bachelor was laid herein.
The 27th December 1680 Maria Thins widow of Reijnier Bolnes, and the grave is now full.") (*Van Peer 1968*, p. 223.)

16 December 1675 "*Johannes Vermeer kunstschilder aan de Oude Lange dijck niet te halen*" ("Johannes Vermeer painter on the Oude Lange dijck not to be collected") (Delft, Opperste kleed boek no. 74, Part II, fol. 50 v: *Montias 1980*, p. 57.) The entry in the Opperste kleed boek of the Camer van Charitate means that the death donation was not receivable, probably by reason of the widow's poverty.

27 January 1676 "*Op den 27 January 1676 compareerde voor mij Gerard van Assendelft, Nots. tot Delff [. . .] Catharina Bolnes, Wed. van za: Johannes Vermeer. in sijn leven kunstschilder binnen Delff, ende bekende aen Hendrick van Buyten, Mr. backer alhier vercoft ende getrasporteert te hebben twee schilderijen bij den voorn: Vermeer geschildert d'eene vertonende twee personagien waeroff d'een een brieff sit te schrijven, ende d'ander mede een*

personagie spelende op een cyter. En bekende daervoor voldaen te zijn met de somme van ses hondert seventien gulden en ses stuyvers die sij comparante aen gelevert broot aen den voorn, van Buyten schuldig was en welcke reeckening. door desen gehouden wert voor geannulleert ende vernietiecht. Voortsf ... Jsijn sij metten anderen verdragen en geaccordeert, dat in gevalle de voorn: wed, aen hem van Buyten op den 1 May 1677 comt te betalen de somme van vijftich gulden en soo voorts telcken Meydaege gelijcke vijftich gulden, geduyrende totte volle restitutie van de voorsz. 617 gulden 6 stuyvers toe, en dat hem ondertusschen volcoment: betaelt is de eenhondert negen gulden vijff stuyvers, mede spruytende uyt voorgaende leverantie van broot, hij van Buyten als dan wederom in vollen eigendom aen de voorn. Wed. off haere erffgenaemen overlaeten sal de twee aen hem vercofte stucken schilderije, maer soo het mochte comen te gebeuren dat des voorn. Weds. moeder quam te sterven, eer de voors. somme mochte wesen gerestitueert, soo sal de lossing vant geen hierop zoude mogen resteeren, moeten gedaen werden met 200 gulden iaerlycks, ende in dat gevalle vant restant van dese oock moeten betalen interest tegens 4 ten hondert in 't iaer vant overlijden van deselve haere moeder aff, totte voldoeningh toe, gelijck oock gelijcke intereste betaelt sal moeten werden in gevalle de gestipuleerde lossinge van 50 gl. iaerlijcks niet precijse quame te volgen. Maer de restitutie der penn: in voege voorz. gedaen sijnde, (daerbij gevoecht ende voldaen sijnde 't gunt in tijt en wijle weder op nieus soude werden gelevert) sal hij van Buyten alsdan de twee stucken schilderije hierboven gedesigneert, gehouden wesen te restitueren." ("On the 27th January 1676 appeared before me Gerard van Assendelft, Notary in Delft [. . .] Catharina Bolnes. Widow of the late Johannes Vermeer, during his life painter in Delft, and stated to have sold and transferred to Hendrick van Buyten, master baker in this town, two paintings done by the aforementioned Vermeer, one representing two persons one of whom is writing a letter and the other with a person playing the lute, and stated to have been paid the sum of 617 gulden and 6 stuivers for these paintings, which sum she, attestant, owed to van Buyten for bread delivered, and which bill he now considers null and void. Furthermore [. . .] they agreed and were accorded that in case the aforementioned widow should pay on 1 May 1677 to him, van Buyten, the sum of 50 gulden and so on, each first of May such 50 gulden, until full restitution of the afore mentioned 617 gulden 6 stuivers and if meanwhile he is paid the entire 109 gulden 5 stuivers, also due for preceding delivery of bread, he, van Buyten will then again relinquish in full property to the aforementioned widow or her heirs the two paintings sold to him, but should it come to pass that the mother of the aforementioned widow should die before the aforesaid sum had been restituted, then the redemption of any sum that might still remain outstanding must be effected with 200 gulden a year, and in that case [she] must also pay interest on this remnant at four percent per annum from the decease of her mother onwards, until settlement, just as the same interest shall be paid in case the stipulated repayment of 50 gulden a year had not precisely been paid. But the restitution of the money having been made in the above-mentioned fashion [having been added and paid that, which from time to time will be delivered again] he, van Buyten, will then be held to restitute the two paintings designated above.") (Solicitors of the widow are Floris van der Werff and Philippus de Bries.) In a second version of the same contract the following changes appear: van Buyten states that he made this restitution settlement "*bewogen door 't serieus versoeck ende instantelijck aenhouden van de voorsz. Transportante*" ("moved by the serious plea and urgent persistence of the aforementioned transferor"). Should the widow fail to meet her obligations, van Buyten is then allowed to sell the paintings, whereupon she "*sal suppleren, opleggen en vergoeden 't geent hij compt alsdan de twee schilderijen vercoopende, daervan minder als de 617 gl. 6 st. sal com en te consequeren*" ("shall supply, pay for and make good whatever may still fall short of 617 gulden 6 stuivers when the two paintings are sold"). (Delft, prot. not. G. van Assendelft; *Bredius 1885*, pp. 219-20.) On

baker van Buyten, see *Montias 1987*, pp. 74-6; see also document of 30 April 1676.

24 February 1676 "*Op huyden den 24 Febr: 1676 compareerde [. . .] Juffr*ᵉ *Catharina Bollenes, wed*ᵉ *wijlen Sr Johan Vermeer, woonende tot Delff en verc1aerde in minderinge van 'tgeene sy schuldich is, soo voor haer selven als in qualite als wed*ᵉ *en boedelhouster, en oock als voochdesse van haere kinderen, geprocreeert bij den voorn, Vermeer, haeren man za: aen Juff Maria Tins, Wed*ᵉ *wijlen Reynier Bollenes, haer moeder in vollen en vrijen eygendom over te geven een stuck schilderie, geschildert by den voorn, haeren man za: waerin wert uytgebeelt 'de Schilderconst', alsmede haer recht, actie en pretentie op de revenues van de helft van 5 mergen lants gelegen in Out-Beyerlant . . . enz. enz.*" ("Today the 24th of Febr. 1676 appeared [. . .] Juffr. Catharina Bollenes, widow of the late Sr. Johan Vermeer, living in Delft, and stated that she hereby ceded in full and free property, as part payment on her debt, both for herself and in her capacity as widow and trustee, and also as guardian of her children, procreated by the aforementioned Vermeer, her late husband, to her mother Juffr. Maria Tins, Widow of the late Reynier Bollenes, a painting done by her aforementioned late husband, in which is depicted 'the Art of Painting,' as well as her rights, action and claim to the revenues of half of 5 'morgen' of land situated in Out-Beyerlant . . . etc. etc.") [signed] Catharina Bolnes. (The Hague, prot. not. Vos; *Bredius 1885*, p.220.) Compare documents of 11 December 1676 and 12 March 1677.

29 February 1676 Within three months after the death of the painter an inventory of the estate was made up; separate lists stated which goods belonged to his widow, Catharina Bolnes, and which were the common property of Catharina Bolnes and her mother, Maria Thins, Bredius published an excerpt of these lists:

*Specificatie van alsulcke goederen [. . .] als Catharina Bolnes, wed*ᵉ *wijlen Sr. Johannes Vermeer, wonende aen den Ouden Langendijck op den houck van den Molepoort in eygendom sijn toecomende, en in opgemeite huysinghe berustende.*
In 't voorhuys: Een freuytschijderytge, een zeetje, een lantschapie. Een stuckie schildery door Fabritus.
In de groote zaal: Een schildery sijnde een boere schuyr—Nog een schijdery.— Twee schijdery—tronijen van Fabritius.—De conterfeytseis van Sr. Vermeers zairs, vader en moeder.—Een geteekent wapen van den voorn. Sr. Vermeer, met een ebbe ijst.—Meubels, harnas, storm hoed en kieinigheden.—Onder linnen en wolle: Een turxe Mantel van den voorn. Sr. Vermeer zalr—Voorts kleederen en huisraad.
In de binnenkeuken: Een groote schijdery, sijnde Christus aen 't Cruys.—Twee Trony schijderyen gedaen by Hoochstraten.—Een schildery daerin allerley vrouwentuijch.—Een van Veronica.—2 Tronyen geschijdeert opsijn Turcx.—Een Zeetje.—Een waerin een bas met een dootshooft.—7 ellen goutleer aen de muyr.
Op de keiderkamer: Een Christus aent Cruys, een vrou met een ketting aen (etc. . . . all without the names of the painters).
Op de voorkamer: Een rotting met een ivoren knop daerop.—2 schilderseesels, drye paletten, 6 paneelen, 10 schilderdoucken, drie bondels allerhande slach van printen, een lessenaer en rommelingh. Aldus gedaen te Delft enz. 29 Februari 1676.

("Specification of all such goods . . . as are due to accrue in ownership to Catharina Bolnes, widow of the late Sr. Johannes Vermeer, living on the Ouden Langendijck on the corner of the Molepoort, and present in the abovementioned house.
In the front part of the house: a painting with fruit, a small seascape, a small landscape. A small piece of painting by Fabritius.
In the big hall: a painting being a peasant's barn—Another painting.—Two painted 'tronies' by Fabritius.—The portraits of the late Sr. Vermeer's father and mother.—A drawing of the coat of arms of the aforesaid Sr. Vermeer, with an ebony frame.—Furniture, armor, marion and paraphernalia.—Among linen and wool: a turkish Coat of the aforementioned late Sr. Vermeer.—Furthermore clothing and household effects.
In the kitchen: A large painting. being Christ on the Cross.—Two 'Tronie' paintings done by Hoochstraten.—A painting on which all kinds of women's paraphernalia.—One [painting] of Veronica.
2 'Tronies' painted in Turkish fashion.—A small Seascape—One where in a bass viol and a skull.—7 Ells of goldleather on the wall.
In the basement room: A Christ on the Cross, a woman wearing a necklace.
In the front room: a cane with an ivory handle on it.—2 painter's easels, three palettes, 6 panels, 10 canvases, three volumes with prints of various kinds, a lectern and miscellaneous paraphernalia. Thus done in Delft etc. 29 February 1676." [Signed] Catharina Bolnes.

*"Specificatie der goederen, voor de helft toecomende Juffr. Maria Tins Wed.*ᵉ *wijlen Sr. Reijnier Bolnes en voor de helft haere dochter Juffr. Catharina Bolnes. Wed." wijlen Sr. Joannes Vermeer, berustende ten woonhuyse van de voorn. Wed. op den Ouden Langendyck tot Delft. Schilderijen: Een Mars en Apollo: nog 8 schilderijen: familieportretten, een drye Coningen, een moeder Christi, Nog 11 schilderijen, Een steene Tafel om verruwe op te vryven, met de steen daerby. Aldus gedaen enz. 29 Februari 1676.*

("Specification of the goods, due in half to Juffr. Maria Tins Widow of the late Sr. Reijnier Bolnes and for the other half to her daughter Juffr. Catharina Bolnes, Widow of the late Sr. Joannes Vermeer, deposited in the residence of the aforementioned Widow, at the Ouden Langendyck in Delft.
Paintings: A Mars and Apollo; 8 more paintings; family portraits, a Three Magi, a mother of Christ, 11 more paintings, A stone Table to rub paints on, along with the stone. Thus done etc. 29 February 1676.") (Delft, prot. not. J. van Veen; *Bredius 1885*, p. 219.)

A complete transcription of this document was published by van Peer. specifying the goods belonging to Maria and to Catharina. His lists include, apart from furniture and household effects, a painting representing Cupid, another with "3 pumpkins and other fruit on it," a yellow satin jacket hemmed with white fur, an ebony crucifix, and some 35 books. (*Van Peer 1957*, pp. 98-103.)

23 March 1676 Burial of Vermeer's brother-in-law Willem Bolnes. See document of 15 December 1675.

30 April 1676 Petition of "*Catharina Bolnes, Wed*ᵉ *van Johannes Vermeer, in sijn leven Schilder, wonende binnen der stadt Delft*" ("Catharina Bolnes, Widow of Johannes Vermeer, in his lifetime Painter, living in the Town of Delft") to the Supreme Court, in which she says: *"hoe dat sy Suppliante belast synde met elff levende kinderen vermits de voorn. haere man geduerende desen oirlogh met den Coninck van Vranckrijck nu eenige iaren herwaarts seer weinich ofte bynae nietwes hebbende connen winnen, oock die Kunst. die hy hadde ingekocht ende waermede hy was handelende, met seer groote schaede heeft moeten uijt sijn handen smijten tot alimentatie der voorsz sijne kinderen daerdoor dan soo verre is geraeckt in verloop van schulden, dat sij Supplte, niet machtich is alle haere crediteuren (die geen regard willen nemen op het voorsz haer groot verlies en Quade fortuijn door den voorsz oorloogh gecauseert)"* ("how she, Supplicant. charged with the care of eleven living children, since her aforementioned husband during this war with the King of France some years ago now, having been able to earn very little or hardly anything at all [and]—for the support of his children having also had to dispose—with great loss—of the works of Art which he had bought and with which he was trading, because of this he has then run into such debts, that the Supplicant is not able to pay all her creditors [who do not want to make allowance for her above-mentioned large losses and misfortune caused by the aforesaid war]") and requests letters of cession, which are granted to her 30 April 1676. (*Bredius 1910*, p. 62.) Mentioned as creditors

in this act are: Maria Thins, N. Hogenhouck, brewer, N. Rombouts, N. Dirckse, N. van Leeuwen, Hendrick Dircks, Tanneken, Hendrick van Buytenen. Emmerentia. (*Van Peer 1957*, p. 96.)

25 September 1676 In a testament of this date. which has never been published in its entirety, Maria Thins, Vermeer's mother-in-law, revokes all her preceding wills and names his (Vermeer's) children as her sole heirs. (The Hague, prot. not. Terbeeck van Coetsfelt *van Peer 1951*, p. 626; *Van Peer 1968*, p. 223. Compare also *Bredius 1910*, p. 63.)

26 September 1676 In a petition to the States of Holland and West-Frisia. Maria Thins, Vermeer's mother-in-law, declares: "*als wettige ende eenige patronesse van seeckre vicarie gefundeert inde kercke der stede Schoonhoven op St. Laurens ende Barbara altaer, nu sijnde comende te vaceren door doode van haer comparantes soon z.ʳ Willem Bolnes, deselve vicary te hebben gecon-fereert, gelijck sij confereert bij desen op haeren neeff Johannes Vermeer soon van haere dochter Catharina Bolnes ende haeren swager Johannes Vermeer Zr in sijn leven constrijck schilder gewoont hebbende binnen de stadt Delft.*" ("as legal and sole patroness of certain vi cary founded in the church of the town of Schoonhoven on the altar of St. Lawrence and Barbara, now becoming vacant by the death of her appearer's son, the late Willem Bolnes, to have assigned same vicary, as she assigns herewith, to her grandson Johannes Vermeer, son of her daughter Catharina Bolnes and of her late son-in-law Johannes Vermeer during his lifetime artful painter having lived in the town of Delft.") (The Hague, prot. not. Terbeeck van Coetsfelt van Peer 1951, p. 621). For Jan Vermeer II see also document of 6 January 1677.

30 September 1676 "*De Heeren Schepenen der Stad Delft stellen bij desen Anthonij [van] Leeuwenhouck tot Curateur over den boedel ende goederen van Catharina Bolnes weduwe van wijlen Johannes Vermeer in sijn leven mr. Schilder. Impetrante van mandement van cessie, des hij gehouden blijft . . . etc. Gedaen den 30ᵉ September 1676.*" ("The Lords Aldermen of the Town of Delft, hereby appoint Anthonij [van] Leeuwenhouck as Curator of the estate and goods of Catharina Bolnes widow of the late Johannes Vermeer during his lifetime mr. Painter. Cession obtained on request, so that he is bound to . . . etc. Done the 30th September 1676.") (Delft, Kamerboek. 1671-1684: *Obreen IV*, p.295.) See also the documents of 30 April 1676, 2 and 5 February 1677, 12 March 1677, 13 March 1677, and 1 February 1678.

25 November 1676 In an extensive act of this date, Maria Thins and her daughter Catharina Bolnes (Vermeer's widow) settle the inheritance of Willem Bolnes, respectively their son and brother, Maria Thins takes upon herself all debts and charges of her deceased son. From this same act it appears that Maria Thins authorized on 28 April 1676 the lawyer Pieter de Bie to represent her in matters concerning her claims to the estate of Catharina Bolnes. The entire act was published by Obreen. (The Hague, prot. not. Terbeeck van Coetsveld; *Obreen IV*, pp. 295-298.)

30 November 1676 "*30 November 1676 compareerde Sr. Jan Colombier Coopman binnen dese stadt . . . en heeft ten versoeke van d'eerbare lannetie Stevens, beiaerde dochter, wonende tot Delft verklaart . . . dat hij deposant op den 10en February deses iaers 1676 tot Amsterdam ten huyse van seker apothe-caris aldaer in 'De drie Limoenen' van de Wed. van salr Johannes van der Meer, in sijn Jeven Mr. Schilder tot Delft, voor rekening en in de name de voorsz. requirante heeft gekocht 26 stucks, soo groot als cleyne Schilderyen te samen om en voor de somme van 500 guldens welke somme soude strekken tot betalinge op tgene de voorsz. Wed. van Johannes van der Meer aen de voorn, requirante wegens winkelwaren schuldich was, dat voorsz. koopmanschap in voegen alsvoren getroffen sijnde, de voorn, 26 stuks schilderyen by de voorn, Wed. van Johannes van der Meer aenstonts aen hem deposant voor rekeningh ende in de name van de gemelte requirante sijn gelevert en bij hem deposant ook medegenomen, hebbende hij deposant de 26 stuks schilderyen naer dese Stadt Haerlem laten vervoeren en tsijnen huyse brengen, alwaer deselve schilderyen gebleven sijn, omdat hij deposant tot laste van de requirante eenige*

praetensie had en t'resterende aen haer reqte off met gelt off met waren soude voldoen. Eyndigende etc. ("30 November 1676 appeared Sr. Jan Colombier Merchant in this town . . . and declared at the request of the honorable Jannetie Stevens, spinster of age, living in Delft . . . that he deponent on 10 February of this year 1676 in Amsterdam at the house of a certain apothecary in that town in 'De drie Limoenen' has bought from the Widow of the late Johannes van der Meer, during his life Master Painter in Delft, on account and in behalf of the aforementioned petitioner, 26 large as well as small Paintings. together amounting to 500 gulden which sum has been set aside to pay that which the aforementioned Widow of Johannes van der Meer owed to the aforesaid petitioner for shop-wares: that after the aforesaid trans-action had been effected as described above, the aforementioned 26 Paintings were immediately delivered by the aforementioned widow of Johannes van der Meer to him deponent on account and in behalf of the mentioned petitioner and [they] have also been taken along by him depon-ent, he deponent having caused the 26 Paintings to be transported to this town of Haarlem and to be brought to his house, where these same paintings now remain, since he deponent had some claims on the petitioner and would settle the differences to her, petitioner, either with money or with goods. Ending etc.") [signed] "Jan Colombier." (Haarlem, prot. not. P. Baes; Bredius, schilderijen; p. 161.) "Jan Colombier" is the painter Jan Coelenbier. (*Obreen IV*, p. 298.) Compare documents of 2 and 5 February 1677 and 13 March 1677.

11 December 1676 In a document of this date published by Bredius, Maria Thins declares that she "*geen goederen van haar dochter of swager Johannes Vermeer in fraudem creditorium onder haer heeft geslagen*" ("has not taken in her keeping any goods belonging to her daughter or son-in-law Johannes Vermeer, in order to defraud the creditors"). (*Bredius 1910*, p. 63.) Cf. documents of 24 February 1676 and 12 March 1677.

6 January 1677 In a testament of this date which was never completely published. Maria Thins states: "*doch of binnen de voorsz. tijdt Johannes Vermeer sijne studie op het incoomen van de Vicarye goederen gefundeert op St. Barbara ende Laurens Autaer inde Kercke tot Schoonhove hem bij de voorsz. Testatrice geconfereert niet en soude conn en vervolgen*" ("but if within the aforesaid time Johannes Vermeer should not be able to continue his stud-ies on the income from the estate of the vicariate founded on the altar of St. Barbara and Lawrence in the church of Schoonhoven, bestowed on him by the aforesaid testatrix"), his guardian Mr. van der Eem can assist him with money from other sources. She also demands that her goods remain undivided and not be parceled out until the youngest child of her daugh-ter Catharina Bolnes will have reached the age of fourteen and she recom-mends that her grandchildren "*eenige coopmanschappe ofte eerlycke hantwerck coomen te leeren, oordelende, dat het getal van haer dochters kinderen al te groot is omme alle leedich te gaen en niets by de hand te nemen*" ("learn some kind of merchant's trade or honest handicraft, judg-ing that the number of her daughter's children is too large for them to be idle and not to take up any occupation"). (The Hague, prot. not. Terbeeck van Coetsfeld; Bredius 1910, p. 63; van Peer 1951, pp. 621, 626.) For data on Johannes Vermeer II and the estate of the vicariate, see also document of 26 September 1676.

2 February and **5 February 1677** "*Ingevolge van den appoinctemente van de Heeren Schepenen der Stad Delft gedateerd den . . .January longst voorleden syn op huyden den 2 February 1677 voor ons Adriaen van der Hoef ende Mr. Nicolaes van Assendelft Schepenen derselver Stad als Commissarissen hebbende tot adiunct den Secretaris Mr. Hendrik Vockestaert gecompareert ende verschenen Anthony Leeuwenhoek als Curateur van den Boedel van wylen Johannes Vermeer in syn Leven Mr. Schilder was. Eijsscher Geassisteert met Floris van der Werf synen Procureur ter eenre ende lannetge Stevens b:d: ged. ᵉˢˢᵉ geadsisteert met Steven van der Wert Mr. Metselaer alhier haren Neef ende Philips de Bries haren procureur ter andere syde: ende*

syn deselve part yen door intercessie van ons Commissarissen en adiunct, nopende hare differenten op approbatie van het Collegie van haer Agth: verdragen ende geaccordeert in manieren hierna volgende namentlyk dat by den eyscher in qualite voorsz., aen de ged. esse *sal werden betaelt de somme van drie hondert twee en veertig gl. eens ende dat in volle betalinge van sodanige vier hondert twee en veertig gl. als sy ged.* esse *van den Boedel van den voorn. Vermeer te pretenderen heeft welk hare pretensie ende de deugdelykheyt van dien sy ged.* esse *dan ook gehouden wesen sal t'allen tyde des nader versogt werden de met eede solemnelyken te verclaren, waertegens de ged.* esse *aengenomen ende belooft heeft, sooals by haer insgelyks aengenomen ende belooft wert by desen omme aen den eysscher in qualite voorsz. ter naester gelegentheyt te overhandigen sodanige 26 stucken Schilderie den voorsz. boedel aenbehorende als iegenwoordig berustende syn onder Johannes Columbier, woonagtig tot Haerlem onder speciale overgifte ende belofte van deselve ged.* esse *de welke hy mede doet by desen dat de voorsz. stucken Schilderie by publique vercopinge metten anderen t'allen tyde ten behouve van den voorsz. boedel suyver sullen comen te renderen de somme van vyf hondert gl. waer voren sig insgelyks den voorn. Steven van der Werven tot borge als principael onder speciale renunciatie van de beneijcien ordinis sive excussionis van den effecte van dien hem ten genoegen houdende onderregt, geconstitueert heeft, soo als hy synenthalven mede doende is by desen, alles onder verbant van hare respective person en ende goederen ende sullen daermede parthyen voorsz. differente at, doot ende te niette wesen met compensatie van costen. Actum ten dage en lare als boven.*

Op huyden den 5 febr: 1677 ter Camere van Haer Agth, de Heeren Schepen der Stad Delft van den inhoude van het bovenstaende verbael berigt ende communicatie gedaen wesende, is het selvig in het regard van Haer Agth, geapprobeert sooals hetselvige geapprobeert wert by desen.

Actum ten dage en lare als boven."

("In pursuance of the appointment of the Lords Aldermen of the Town of Delft dated the . . . January last, there appeared today, the 2 February 1677, before us Adriaen van der Hoef and Mr. Nicolaes van Assendelft Aldermen of this Town as Commissioners, having as adjunct the secretary Mr. Hendrik Vockestaert: Anthony [van] Leeuwenhoek as Curator of the Estate of the late Johannes Vermeer during his life Master Painter, Plaintiff, assisted by Floris van der Werf his solicitor on one side, and Jannetge Stevens, daughter of age, defendant, assisted by her nephew Steven van der Werf, master mason from this town and Philips de Bries her solicitor on the other side; and through intercession of us Commissioners and adjunct, concerning their differences, the same parties have agreed and arranged, with the approval of the College of their Hons. Messrs. the Aldermen, as follows: to wit, that the plaintiff in his aforesaid capacity shall pay to the defendant the sum of 342 gulden in one sum and as full payment of those 442 gulden as she defendant claims from the Estate of the aforementioned Vermeer, which claim and the validity thereof the defendant then will be obliged to affirm with solemn oath at any time, whenever asked for, in consideration of which the defendant has undertaken to do and promised, so as by her similarly is undertaken to do and promised herewith, to hand over to the plaintiff in his aforesaid capacity, at the first opportunity those 26 paintings belonging to the aforesaid estate as at present are deposited with Johannes Columbier, living in Haarlem. under special pledge and promise of same defendant, which he [Columbier] also does herewith, that the aforesaid paintings through public auction altogether will accrue to the sole benefit of the aforesaid estate up to the sum of five hundred gulden, for which the aforementioned Steven van de Werven has declared himself principal guarantor, under special renunciation of the beneficia ordinis sive excussionis, considering himself to be sufficiently instructed of the effect of this condition, so he does herewith on his own account, for all of which they pledge their respective persons and goods and state that the aforesaid disagreement between the parties shall be over, dead and nullified, with compensation of the costs.

Done on the day and the Year as above.

Today 5 February 1677 in the Chamber of their Honors Messrs. the Aldermen of the Town of Delft, having been informed of the contents of the record above and having consulted together, the same has been approved by their Honors, as the same is approved hereby.

Done on the day and the Year as above." (Delft, Kamerboek, 1671-84: *Obreen IV*, pp. 298-300.) Compare documents of 10 February 1676 and 30 November 1676.

12 March 1677 Maria Thins states: "*Alsoo op den 24 February 1676, volgens Acte van transport voor den Nots. J. Vosch bij mijne dochter Catharina Bolnes in mindering vant geene sij aen my schuldich is, soo voor haer selven ende in qualite als Weduwe ende boedelhouster ende oock als voochdesse van haere kinderen geprocreeert by Johannes Vermeer zal*er *in vollen en vrijen eygendom heeft o vergege ven opgedragen ende getransporteert seeker stuck schilderije, geschildert bij den voorn, Vermeer, waerinne wert uitgebeelt de Schilderkonst, van welcke voorsz. acte van overgifte ende opdracht Mons*r *Anthony Leeuwenhoek, als Curateur over den boedel van voom, Vermeer ende Catharina Bolnes, visie en copie is gegeven. Ende dat desniettegenstaende de voom. S*r *Leeuwenhoeck in de voorsz. qualiteyt by affixie van gedruckte billietten, (waervan mij een is toegezonden) by publicque opveylinge aen den meest biedende op den 15 Meert toecomende 1677 op St. Lucas Gildecamer binnen deser stadt Delft presenteert te vercoopen de voorsz. schilderije, aen mij opgedragen als voorschreven is. Soo sal den eersten not*s*, hiertoe versocht zich hebben te vervoegen aen den persoon, van den voorn, S*r *Leeuwenhoeck ende denselven uyt mijnen naem te insinueren ende aen te seggen, dat ick niet en verstae, dat de voorschreven schilderije bij hem sal werden vercocht, als moetende coomen in minderingh van mijn achterwesen, off wel dat hij, die vercoopen de, sal stipuleren, dat bij mij de penningen daervoor comende niet zullen werden uytgekeert, maer strecken in minderingh van mijn achterwezen. Enz.*

Actum Hage, den 12 Martii 1677."

("Whereas on the 24 February 1676, according to Deed of transfer before Notary J. Vosch, by my daughter Catharina Bolnes, in deduction of the amount which she owes me. both for herself and in her capacity as widow and trustee and also as guardian of her children procreated by the late Johannes Vermeer, has hanted over, assigned and transferred in full and free property a certain painting done by the aforementioned Vermeer, on which aforesaid deed of delivery and cession has been given vision and copy to Monsr. Anthony Leeuwenhoek, as Curator of the estate of the aforementioned Vermeer and Catharina Bolnes: and whereas nevertheless the aforementioned Sr. Leeuwenhoeck in the aforesaid capacity intends to sell, by posting of printed notices (one of which has been sent to me) by public auction to the highest bidder on the coming 13th of March 1677 in the St. Lucas Guild chamber in this town of Delft the aforementioned painting transferred to me as heretofore mentioned: so the first notary requested to do so will have to present himself before the person of the aforementioned Sr. Leeuwenhoeck and to inform him in my name and to tell him that I do not understand that the painting described before will be sold by him, as serving to reduce the debt owed to me, or that he, selling it, should stipulate that the money coming from this sale shall not be paid out to me, but serve to reduce the debt owed to me. Etc.

Done at The Hague, 12 March 1677." (The Hague, prot. not. J. Vos; *Bredius 1885*, p. 221). Compare documents of 24 February 1676 and 11 December 1676.

13 March 1677 "*Ingevolge van de bovenstaande insinuatie soo hebbe ick ondergeteektende, Notaris, my vervoegt aen de persoon van Antony Leeuwenhoeck en hem deselve insinuatie voorgelesen, die mij tot antwoort gaff, dat hij de schilderije daerin vermelt, niet hadde conn en machtigh werden als met proces en door transport van Annetge Stevens en dat hij daervoor hadde moeten betalen de somme van dryehondert tweeenveertigh gulden, behalve de*

oncosten vant proces, dat hij van sin was (niet iegenstaande dese insinuatie) met de vercoopinge van dien voort te gaen, en dat, soo de insinuante metieerde eenigh regt te hebben, sulcx soude op de preferentie moeten eijschen. Aldus op den 13 Martii 1677 gedaen ter presentie enz." ("In pursuance of the above-mentioned insinuation, I undersigned, Notary, have presented myself before the person of Anthony Leeuwenhoeck and have read to him the same insinuation, who replied that he had been unable to take possession of the paintings mentioned therein except by lawsuit and by transfer from Annetge Stevens and that for this he had had to pay the sum of three hundred forty two gulden, the costs of the lawsuit excluded, that he planned (the insinuation notwithstanding) to proceed with the sale of it and that, should the insinuator pretend to have any rights thereto, she would have to claim preferred debts. Thus done on 13 March 1677, in the presence of etc.") (Delft. prot. not. Corn. van Oudendijck.) Published by Bredius (*Bredius 1885*, p. 221), who makes it appear as if this deed concerns the sale by Van Leeuwenhoek of the painting *The Art of Painting* (see document from 12 March 1677). The text of the March 13 deed, however, makes it evident that it concerns the sale of the twenty-six paintings transferred to Jan Coelenbier by Vermeer's widow (see documents of 10 February 1676 and 2 and 5 February 1677).

27 July 1677 From a document of this date, published by Bredius in part only. it appears that Mr. Hendrick van der Eem, lawyer of the Court of Holland, appointed tutor to the underage children of Vermeer, in his lifetime "Artful Painter," authorized Juffr. Aleidis Magdalena van Rosendael to look after the affairs of Vermeer's widow and to collect at the Orphan Chamber in Gouda a sum of 2900 gulden, a debenture of 400 gulden, a bonded debt of 400 gulden, etc. (*Bredius 1910*, pp. 63-64.) For Aleidis Magdalena van Rosendael, see *van Peer 1951*, pp. 623-4.

1 February 1678 "*1 Febr. 1678 compareert Anthonij Leeuwenhoeck, te Delft, als bij de E. Heeren Schepenen der stad Delft gestelde Curateur over den insolventen en gerepudieerden boedel en goederen van Catharina Bolnes, Wede en boedelhoutster geweest van wijlen Johannes Vermeer, in sijn leven schilder binnen desert stadt en verclaerde machtich te maecken [. . .] Nicolaes Straffintvelt Notaris binnen Gouda, omme in den naeme van hem aen de coopers te doen wettige opdracht voor een gerecht derde part van een huys en erve met een bleekvelt daerachteren staende in de Peperstraet binnen Gouda, alsmede voor een derde part van drie morgen lants gelegen in Wilnis buyten Gouda, de voorn, Catharina Bolnes op en aenbesturven uyt den boedel van wijlen Jan Bolnes, haeren Oom sa:[. . .] de gereedde cooppenn: te ontfangen, en dienaengaende te rekenen en te liquideren. Enz.*" ("1 Febr. 1678 appears Anthonij Leeuwenhoeck of Delft as Curator appointed by the Hon. Lords Aldermen of the Town of Delft over the insolvent and abandoned estate and goods of Catharina Bolnes, Widow and former trustee of the estate of the late Johannes Vermeer, in his lifetime painter in this town, and declared to authorize [. . .] Nicolaes Straffintvelt, Notary in Gouda, to transfer in his name to the purchasers a precise third part of a house and yard with a bleaching field at the back situated in the Peperstraat, as well as a third part of three 'morgen' of land situated in Wilnis outside Gouda, inherited by the aforementioned Catharina Bolnes from the estate of the late Jan Bolnes. her late Uncle [. . .] to receive the ready money, and accordingly to settle and to liquidate. Etc.") (Delft, prot. not. Floris van der Werff; *Bredius 1885*, pp. 221-2.)

2 April 1678 According to an act of this date, published by Bredius in part only, Johannes Vermeer borrowed 1000 gulden in July 1675. On 2 April 1678 Maria Thins promises to pay this debt "*uit haar gereedste penningen*" ("from her ready money") to the housewife of Jacob Rombouts, Johanna Kieft, in so far as this debt should not yet have been paid entirely at her, Maria Thins's, death: she would, however, not pay the accumulated interest. (Amsterdam, prot. not. Hillerus; Bredius 1910, p. 64.)

26 November 1678 According to a document published by Bredius in part only,

on this date Maria Thins authorizes the solicitor Bogaert in Delft to look after her business as preferential creditor with respect to the other creditors of the late Johannes Vermeer, her son-in-law. (Bredius 1910. p. 63.)

24 January 1680 Maria Thins, mother-in-law of the painter, possessed about 27 "morgen" of land near Oud-Beijerland, the yield of which amounted to 486 gulden yearly. In a document dated 24 January 1680. published by Bredius in part only, she stipulates that this piece of ground may never be sold or mortgaged. The executors of her will are entrusted with the care, at their discretion, of her daughter, Catharina Bolnes, "*daer sy misschien geene genoegsame levensmiddelen soude konnen suppediteren*" ("since she might not have enough means to live on"). They will distribute the money according to her needs, be it once a month or four times a year. (Delft,. prot. not. Boogert; Bredius 1910, p.63.)

27 December 1680 Maria Thins. widow of Reynier Bolnes, was buried in Delft. See document of 15 December 1675

16 July 1681 From an act of this date, mentioned by Bredius, it appears that Catharina Bolnes, the widow of the painter, borrowed 400 gulden from Pieter van Bleeck, at an interest of 5%. (*Bredius 1910*, p. 63)

28 July 1681 From an act of this date, mentioned by Bredius, it appears that Catharina Bolnes borrowed 400 gulden from Francois Smagge, at an interest of 4 1/2%. (*Bredius 1910*, p. 63.)

20 June 1682 and **April 1683** Magdalena van Ruijven, the wife of the bookprinter Jacob Abrahamsz. Dissius, was buried in the Old Church in Delft. (Burial register 44; Neurdenburg 1942, p. 73.) Nine months later, early April 1683, an inventory of their estate was drawn up, in which were found: "*Acht schilderijen van Vermeer. Drie dito van denselven, in kasties.— Een zee, door Percellus.—Op de achterkamer: Nogh vier schilderijen van Vermeer.—In de keuken: een schilderij van Vermeer.—Op de kelderkamer: Twee schilderijen van Vermeer.—En later; Nogh twee schilderijen van Vermeer.*" ("Eight paintings by Vermeer.—Three ditto by the same, in boxes.—A sea by Percellus.—In the back room: Four more paintings by Vermeer.—In the kitchen: a painting by Vermeer.—In the basement room: two paintings by Vermeer.—And later: Two more paintings by Vermeer.") (Delft, prot. not. P. de Bies, no. 2325; *Bredius 1885*, p. 222; *Montias 1987*, pp. 71-2.)

12 July 1682 "*Register vande schilderyen alhier onsen huyse my Diego Duarte aengaende tot heden july 1682 . . . 182. Een stukxken met een iouffrou op de clavesingel spelende met bywerck van Vermeer, kost . . . guld. 150.*" ("Register of the paintings here in our house belonging to me Diego Duarte up to this day july 1682 . . . 182. A piece with a lady playing the clavecin with accessories by Vermeer, costs . . . 150 gulden"). (H. G. Dogaer, "De inventaris der schilderijen van Diego Duarte" in *Jaarboek van het Koninklijk Museum voor Schone Kunsten*, Antwerp, 1971.) Duarte was a rich jeweler and banker who lived in Antwerp in a large house on the Meir. The list of 192 paintings from his property was published by F. Muller (in De Oude Tijd 1870, p. 397 ff.) with the deceptive title "Catalogus der schilderijen van Diego Duarte, te Amsterdam." The list was not drawn up in Amsterdam, but in Antwerp. (Dogaer, op. cit., p. 198.) J. Zwarts brought out the story, presumably based only on Muller's title, that Duarte moved to Amsterdam in 1682. (Nieuw Nederlandsch Biografisch Woordenboek . . . VI, Leiden, 1927, col. 390 ff.) In 1687, however, Duarte is still mentionned as resident of Antwerp and Nic. Tessin pays him a visit in that city (J. Denuce, De Antwerpsche "Konstkamers" . . . , Antwerp, 1932, p. 345: Dogaer, p. 196.) In 1676 Constantyn Huygens Jr. had admired Duarte's collection in the same city. (Dogaer, p. 196.) Huygens also corresponded about music with Duarte, who was a famous organist and composer. Duarte's father had had a clavecin built for Huygens. (Zwarts, loc. cit.) (A. Blankert).

1684 and **1687** Catharina Bolnes, widow of the painter, living in Breda, receives financial support from the Weeskamer of Gouda. (Gouda, Municipal Archives, Requestboek 1683-1695; *van Peer 1951*, p. 620.)

April 1685 The estate of Jacob Abrahamsz. Dissius and his late wife, Magdalena van Ruijven, containing twenty paintings by Vermeer, is divided between Jacob Dissius and his father, Abraham Dissius. (Delft, prot. not. P. de Bies, no. 2327; Montias 1987, p. 72.)

30 December 1687 and **2 January 1688** The registers of the Jesuit Station of the Cross (Roman Catholic Presbytery, Burgwal in Delft) record that Domicella Catharina Bolnes was given the last sacraments on 30 December 1687. (Van Peer 1946, p.469; van Peer 1951, p. 620.) The burial book of the New Church in Delft mentions: "*2 Januari 1688 Catharina Bolnits Wed. van Johan Vermeer aen de Verwersdijck in de blaauwe hant in de kerck.*" ("2 January 1688 Catharina Bolnits Widow of Johan Vermeer from the Verwersdijck in [the house] the blue hand, in the church.") In the margin: "12 Dragers. 5 m:j.k." ("12 Beares, 5 children under age.") (*Obreen IV*, p. 300.)

Also on 2 January 1688, an entry appeared in the Opperste kleed boek (no. 75, part I); "Catharina Bolnes wede van Johan van der Meer, niet." ("Catharina Bolnes widow of Johan van der Meer, not.") (*Montias 1980*, p. 57.) This entry in the Opperste kleed boek means that the usual death donation was not receivable, probably because of the poverty of the next of kin.

25 October 1688 Baptism of Jan Vermeer III, grandson of the painter. (Rotterdam, Municipal Archives, baptismals of the Roman Catholic Community; *van Peer 1951*, p. 620.)

1690 Joannes Cramer, Vermeer's son-in-law, tries in vain to get (on dubious grounds) money from the Orphan Chamber of Gouda. (Gouda, Municipal Archives, Requestboek 1683-1695; *van Peer 1951*, p. 620.)

16 May 1696 "Catalogus van schilderyen, Verkogt den 16, May 1696, in Amsterdam.

1. Een Juffrouw die goud weegt, in een kasje van J. vander Meer van Delft, extra-ordinaer konstig en kragtig geschildert. 155-0

2. Een Meyd die Melk uytgiet, uytnemende goet van dito. 175-0

3. 't Portrait van Vermeer in een Kamer met verscheyde bywerk onge meen fraai van hem geschildert. 45-0

4. Een, speelende Juffrouw op een Guiteer, heel goet van den zelve. 70-0

5. Daer een Seigneur zyn handen wast, in een doorsiende Kamer, met beelden, konstig en raer van dito. 95-0

6. Een speelende Juffrouw of de Clavecimbael in een Kamer, met een toeluis-terend Monsieur door den zelven. 80-0

7. Een juffrouw die door een Meyd een brief gebragt word, van dito. 70-0

8. En dronke slapende Meyd aen een Tafel, van den zelven. 62-0

9. Een vrolyk geslschap in een Kamer, kragtig en goet van dito. 73-0

10. Een Musiceerende Monsr. en Juffr. in een Kamer, van den zelven. 81-0

11. Een Soldaet met een laggent Meysje, zeer fraei van dito. 44-10

12. Een Juffertje dat speldewerkt, van den zelven. 28-0

[Nos. 13 to 30 are paintings by other masters.]

31. De Stad Delft in perspectief, te sien van de Zuyd-zy,. door J. vander Meer van Delft. 200-0

32. Een Gesicht van een Huys staende in Delft, door denzelven. 72-10

33: Een Gesicht van eenige Huysen van dito. 48-0

35. Een Schryvende Juffrouw heel goet van denzelven. 63-0

36. Een Paleerende dito, seer fraey van dito. 30-0

37. Een Speelende Juffrouw op de Clavecimbael van dito. 42-10

38. Een Tronie in Antique Klederen, ongemeen konstig. 36-0

39. Nog een dito Vermeer. 17-0

40. Een weerga van denzelven. 17-0

("Catalogue of paintings, Sold on 16 May 1696, In Amsterdam.

1. A Young Lady weighing gold, in a box by J. van der Meer of Delft, extraor-dinarily artful and vigorously painted. 155-0

2. A Maid pouring out Milk, extremely well done, by ditto. 175-0

3. The Portrait of Vermeer in a Room with various accessories uncommonly beautifully painted by him. 45-0

4. A Young Lady Playing the Guitar, very good of the same. 70-0

5. In which a gentleman is washing his hands, in a see-through Room, with sculptures, artful and rare by ditto. 95-0

6. A Young Lady playing the Clavecin in a Room, with a listening gentleman by the same. 80-0

7. A Young Lady who is being brought a letter by a maid, by ditto. 70-0

8. A drunken, sleeping Maid at a Table, by the same. 62-0

9. A merry company in a Room, vigorous and good, by ditto. 73-0

10. A Gentleman and a Young Lady Making Music in a Room, by the same. 81-0

11. A Soldier with a Laughing Girl, very beautiful, by ditto. 44-10

12. A Young Lady doing needlework, by the same. 28-0

31. The Town of Delft in perspective, to be seen from the South, by J. van der Meer of Delft. 200-0

32. A View of a House standing in Delft, by the same. 72-10

33. A View of some Houses, by ditto. 48-0

35. A Writing Young Lady very good by the same. 63-0

36. A Young Lady adorning herself, very beautiful, by ditto. 30-0

37. A Lady playing the Clavecin, by ditto. 42-10

38. A "Tronie" in Antique Dress, uncommonly artful. 36-0

39. Another ditto Vermeer. 17-0

40. A pendant of the same. 17-0)

(G. Hoet, *Catalogus of Naamlyst van Schilderyen, met derzelver pryzen*, I, The Hague, 1752, pp. 34-136.) N.B.: no. 34 is missing from Hoet's list.

Neurdenburg showed that these paintings probably came from the collection of Jacob Abramsz. Dissius. (cf. document of 20 June 1682: *Neurdenburg 1942*, pp. 72, 73; *Neurdenburg 1951*, p. 38.) Earlier, a large part of the paintings probably belonged to Pieter Claesz. van Ruijven, Jacob Dissus's father-in-law. (*Montias 1987*, pp. 68-73.) Dissius had died seven months before the auction took place: "*Op 14 October 1695 Jacob Abrahamsz Dissius weduwnaar op 't Marctvelt int Vergulde A.B.C. vervoert met een koets naar 't Wout (met 18 dragers).*" ("On 14 October 1695 Jacob Abrahamsz Dissius widower on the Marctvelt in the Golden A.B.C. transported in a carriage to't Wout [with 18 beavers].") (Delft, Burial Register 45, New Church; Neurdenburg 1942, p. 73.) In April 1696 an advertisement for the auction mentioned: "*uytstekende konstige Schilderyen. daer onder zyn 21 stuks uitnemend krachtig en heerlyk geschildert. door wylen J. Vermeer van Delft, verbeeldende verscheide Ordonnantien. zynde de beste die hy ooit gemaekt heeft, nevens nog eenige andere van dese voorname Meesters . . .*" ("excellent artful Paintings, among them 21 pieces extraor-dinarily vigorously and delightfully painted by the late J. Vermeer van Delft, representing several compositions, being the best he ever made, besides some others of these eminent Masters . . .") (the names of fourteen painters follow; see S.A.C. Dudok van Heel, in *Jaarboek van het Genootschap Amstelodamum* 67 (1975), p.159.)

22 April 1699 "*Catalogus van Schilderyen, van Herman van Swoll verkogt den 22 April 1699 in Amsterdaam . . . 25. Een zittende Vrouw met meer beteekenisse, verbeeldende het Nieuwe Testament door Vermeer van Delft kragtig en gloeient geschildert 400-0.*" ("Catalogue of Paintings, sold on 22 April 1699 in Amsterdam by Herman van Swoll. . . 25. A seated Woman with several [symbolical and allegorical] meanings, representing the New Testament, by Vermeer of Delft, vigorously and glowingly painted 400-0." (G. Hoet, *Catalogus of Naamlyst van Schilderyen, met derzelver pryzen*, I, The Hague, 1752, p. 487; see cat. no. 29. On Herman van Swoll. see *Montias 1987*, p. 74.)

On **24 February 1699** an advertisement for the auction mentioned "*een konstig stuk van Vermeer van Delft.*" ("an artful piece by Vermeer of Delft.") (S.A.C. Dudok van Heel, in *Jaarboek van het Genootschap Amstelodamum* 67 [1975], p. 160.)

Critical Anthology
by Phillippe Resche-Rigon

The literature on Vermeer dating from before his "rediscovery" is covered in Albert Blankert's essay, "Vermeer's Work," or referred to in the catalogue. Assembled here are a number of responses to Vermeer's painting after its greatness was acknowledged, drawn from sources in the second half of the nineteenth century on. The result is a mixture of art appreciation, criticism, and straight literature. There is something about the silent immobility of Vermeer's images that seems to defy description. The response to that implied challenge, the attempt to find works to echo the mute power of the image, has in fact been one of the more intriguing directions taken by modern literature in general. Vermeer, that most silent of painters, has inevitably attracted the attention of major creative writers. Proust is the key figure here, but only one of many who have felt impelled to record their highly subjective impressions of the painter. Perhaps surprisingly, there are practically no philosophers represented, apart from Maurice Merleau-Ponty and Michel Serres, and the phenomenologists have been curiously reluctant to comment on an *œuvre* which is distinguished above all by its thoughtfulness and implacable calm. Nevertheless, with all its inevitable and regrettable deficiencies, its leitmotivs and its digressions, this "critical anthology" of the artist supplies an added dimension to the understanding of Vermeer, a sort of counterpoint to the themes discussed elsewhere in the book.

MAXIME DU CAMP
En Hollande, Lettres à un ami, 1859

Let me tell you something about a picture by Jean van der Meer, a painter who up till now I knew as a name only. This canvas represents a *View of the Town of Delft,* a fine town which I saw when I passed through and where formerly most attractive and highly prized pottery was made, which cannot be found today. The town extends in a panorama of red-brick houses, pointed roofs, tall bell tower, tree-lined bridges, the canal of sleepy water, boats moored alongside deserted quays and drawn up against a yellowy embankment, where five or six people stand and chat; that is all there is; but, apart from the sky, which is soft, like cotton wool, it is painted with a vigor, a solidity, an assured impasto that is very rare among Dutch landscape painters, who, when they reproduce the tidy nature of their country, have an innate propensity to paint in excessive detail. Van der Meer is a robust painter, who uses broad expanses of flat color superimposed in layers; he must have visited Italy. He is an exaggerated Canaletto.

EDMOND AND JULES DE GONCOURT
Journal, 11 September 1861

The Milkmaid by van der Meer. An astonishing master, greater than the Terburgs, the Metzus, the very best of the miniaturists. Chardin's ideal, a wonderful thick *creaminess,* a power he himself never achieved. The same broad touch dissolving into the mass. Rough impasto on the accessories. Neutral, whitish background, shading wonderfully into half-tones. Stippling of paint; much the same scheme of small patches of impasto, juxtaposed, a thick, buttery texture; stippling of blue in the skin, reds.—Wicker basket at the rear; table with green cloth; blue linen; cheese; knobbly blue stone jug; the crock from which she pours, red; pouring into another crock that is reddish-brown.—Another analogy with Chardin: he too did a servant wearing lace, at the house of Monsieur Blokhuyzen, in Rotterdam. Pearl gray backgrounds, as in Chardin. The intensity of the red crock.

A Delft Street: the only master who has made a daguerreotype of the red-brick houses of that country, one that springs to life. Here, van der Meer begins to reveal himself the master of Decamps—a master, a father he probably never even knew existed.

The Hague, 13 September 1861

Another picture here by the amazing van der Meer, a sketch of a broad view of the quayside. It's absolutely the way Decamps painted things, that house, the tree, the gateway! A muted, somber, imposing palette. Painting in sheets, applied like watercolor onto oiled papers. One of the greatest of Holland's masters.

WILLIAM THORÉ-BÜRGER
"Van Der Meer De Delft," *Gazette des Beaux-Arts,* Paris, XXI, 1866

We must, please, admit van der Meer of Delft into that select company of the Dutch "little masters," as their equal in every respect. Like them, he is instinctively an originator, and what he has done is perfect. Of what does his *œuvre* consist? First, domestic scenes, typical of the customs of the epoch and the country in which he lived; then, views of the interiors of towns, simple fragments of streets, sometimes a simple portrait of a house; finally, landscapes in which the air and light circulate as freely as in nature itself.

With Vermeer, light is not one whit artificial: it is exact and ordinary, as in nature, and all a meticulous physicist could wish. The ray that enters from one side of the picture slices through space to the other side. The light seems to come from the painting itself, and unsophisticated observers might easily assume that daylight has found its way in between the canvas and the frame. Someone going into the house of M. Double, where the *Soldier and the Laughing Girl* was exhibited on an easel, went to examine the back of the picture to see where this marvelous sunshine in the open window was coming from. That is why the black frames particularly suit Vermeer's paintings. In Vermeer, there is no black. No blurring, no fudging either. Everything is sharp and clear, on the back of a chair or table, or a harpsichord, just as if it were right by the window. Except, each object has its own penumbra and mingles its reflected light with the surrounding brightness. It is to this precise rendering of light that Vermeer owes also the harmony of his colors. In his pictures, as in nature, colors that are antipathetic, such as the yellow and blue he particulary favored, cease to be discordant. He brings the most contrasting tones together, depths of softness and heights of brilliance. Brightness, power, finesse, variety, novelty, quirkiness, that indefinable and rare quality of excitement, he possesses all these attributes of the gifted colorist, for whom light is the source of inexhaustible magic.

HENRI HAVARD
"Johannes Vermeer," *Gazette des Beaux-Arts,* Paris, 1883

Equable, but reticent, he does not need a flood or even an ocean to quench his thirst. His customary glass suffices him. A small glass or a large one, but just that, he wants nothing else. He looks about him and shows us what he sees; but he sees accurately and shows it with discrimination. Far from being carried away at the least pretext and losing himself in the "beyond," he retreats into himself and concentrates. None of his works is disturbing, on the contrary they all induce in the person who contemplates them a sort of calm and tranquillity. Not only are life's dramas not his major preoccu-

pation, they are actually firmly banished from his work, and his characters, all restful and at peace, make scarcely more fuss than the various objects with which he surrounds them. Vermeer is above all else a silent painter.

VINCENT VAN GOGH
Correspondance, Letter to Emile Bernard, July 1888

So, do you know a painter called Vermeer who painted, among other things, a very beautiful Dutch woman, pregnant. The palette of this extraordinary painter is: blue, lemon yellow, pearl gray, black, white. Of course, when the occasion demands, his rare pictures have in them the full range of colors; but the scheme of lemon yellow, pale blue and pearl gray is as personal to him as black, white, gray and pink is to Velasquez.

Letter to Theo, August 1888

Not beyond the bounds of possibility that I shall get her to pose out of doors, and the mother too—a gardener—the color of the earth, on that occasion clothed in dirty yellow and faded blue. The girl's coffee-colored skin was darker than the pink of the bodice. The mother was astounding, the figure in dirty yellow and faded blue stood out sharply in the full sun against a brilliant square of flowers, snow-white and lemon. So, a real van der Meer of Delft. The Midi has its attractions.

CAMILLE PISSARRO
Lettres à son Fils, November 1882

And the thought came to me, after seeing not only the Rembrandts but the Franz Hals, the van der Meers and many other works by great artists, that we moderns are frankly quite right to search for something different, or rather to feel differently, because we are different, and besides, it is an art so specific to its age that it is absurd to try to follow along that route. How can I describe to you the portraits of Rembrandt, the Hals, and that *View of Delft* by van der Meer, masterpieces not so unlike the Impressionists? I returned from Holland more than ever an admirer of Monet, Degas, Renoir, Sisley.

ÉLIE FAURE
Histoire de l'art, 1921

Vermeer painted even the shining silence that flows out from friendly things, even the welcome they extend to you.

No one has penetrated further into the intimacy of matter. Crystallizing it in his painting, bringing out its texture and solidity, its mute inner life, Vermeer has at the same time enhanced it, with all that limpid brilliance and warm transparency it acquires under the most perceptive painter's eye there probably ever was.

After rain, all that opacity in the Dutch atmosphere takes on a luminous liquid depth, which Vermeer incorporated into his color as a dusting of pearl and turquoise over the molecular vibrations of living organisms.

MARCEL PROUST
Correspondance générale, Letters to J.-L. Vaudoyer, Paris, 1921

After seeing a view of Delft in the museum at The Hague, I realized I had seen the most beautiful picture in the world. In *Du côté de chez Swann,* I could not stop myself making Swann work on a study of Ver Meer. I did not dare hope you would be so appreciative of this extraordinary master. For I know your views (in all their variety) on the hierarchy in Art and I feared he was a bit too Chardinesque for you. So what a joy to read that page. Especially as I know practically nothing about Ver Meer.

Paris, 1922

I hope you haven't stopped contributing to that "Opinion" of Boulenger's. I haven't seen anything by you in the latest few. I still have a vivid memory of that morning's, the only one I have reread, when you affectionately

guided my unsteady steps toward that Vermeer in which the gables of the houses are "like precious Chinese artifacts." Since then I have managed to obtain a Belgian publication whose numerous reproductions, studied with your article in my hand, have enabled me to recognize the identical items appearing in the various pictures.

À la recherche du temps perdu, 1923

But a critic having written that in Ver Meer's *View of Delft* (lent by the museum in The Hague for an exhibition of Dutch art), a picture he adored and thought he knew very well, a little patch of yellow wall (which he did not recall) was so well painted that if you looked at it in isolation it was like a precious Chinese artifact, of a beauty all its own, Bergotte ate a few potatoes, went out and entered the exhibition. From the first steps he had to climb, he was seized with giddiness. He walked past a few pictures and had an impression of the dryness and futility of such an artificial art, worth nothing compared with the breezes and sunshine of a palazzo in Venice, or of a simple house by the sea. At last he stood before the Ver Meer, which he remembered as more brilliant, more of a contrast to everything else he knew, but in which, thanks to the critic's article, he noticed for the first time some little figures in blue, that the sand was pink, and finally the precious pigment of the tiny patch of yellow wall. His giddiness increased: he fixed his gaze, like a child on a yellow butterfly he wants to catch, on the precious little patch of wall. "That is how I should have written," he said. "My latest books are too dry, I should have applied several layers of color, made my phrases precious in themselves, like this little patch of yellow wall." Yet the seriousness of his giddy fits did not escape him. His own life appeared to him in one pan of a heavenly scales, while the other contained the little patch of wall so finely painted in yellow. He felt he had foolishly given the first for the second.

JEAN-LOUIS VAUDOYER
Vermeer de Delft, 1921

But if once one has viewed the original, the recollection of it transfigures any reproduction, and straightaway a feast of color, light and space invades your memory. You see again that stretch of gilded pink sand which forms the picture's foreground and on which there stands a woman in a blue apron, creating a miraculous harmony all around her, because of that blue; you see again the dark lighters at their moorings; and those brick houses, painted with a pigment so precious, so rich, so full, that, if you isolate a small patch and forget the subject matter, what you see before you could be ceramic just as well as painting. Above all, you see again that vast sky which, from the top of the roofs to its zenith, gives the impression of an almost vertiginous infinity. Finally you savor the smell, that breath of the atmosphere, wafted toward you from the canvas, flooding through you in rather the way the unexpected tang of water and swift rush of air flood over you when, after traveling for a long time in a closed compartment, you lower the window and receive from nature, even if it is not visible, the physical evidence of your changed surroundings. Vermeer's *View of Delft* is perhaps the picture that expresses best in the world the meteorological poetry, if one may venture to call it so, of a landscape; and how inexpressibly pretentious by comparison, once one has studied at length this compact and coherent canvas, do the slipshod and niggardly dabblings of the Impressionist painters seem.

ROBERTO LONGHI
Piero della Francesca, 1927

And when, at length, one notices that this diamond of sunlight on the wall is related to the source of its illumination by means of a minuscule aperture, one wonders if in this reconciliation of the minute and the massive, Piero does not extend a hand beyond the Quattrocento to those Dutch painters who, two centuries later, will construct their light according to a concept of space derived from Italy: De Hooch and Ver Meer.

HEINRICH WÖLFFLIN
Principes fondamentaux de l'histoire de l'art, 1929

Vermeer's *Woman Reading* (Amsterdam Museum), viewed in profile against a rectilinear backdrop, is an image with depth, in the sense understood by the seventeenth century, the reason being that the eye naturally relates the female figure to the most brightly lit section of this backdrop. In Vermeer's picture, one feels that the composition in depth starts with oneself. The model is relegated to the very back of the room; yet she exists purely in relation to the painter before whom she poses; thus straightaway a very rapid movement is established toward the back plane of the scene, reinforced by the direction of the light and the use of perspective. The luminous center is at the back of the picture; and the strange contrast that is set up between the woman's dimensions and those of the cloth that, like the chair and the table, is seen from close to, creates an effect of extraordinary charm, indisputably that of depth. The backdrop, parallel to the lower edge of the picture, closes off the scene completely; it has no particular role to play, however, in the optical orientation.

JOHAN HUIZINGA
Dutch Civilization in the Seventeenth Century, 1932

In the case of Hals, it is possible to get away with using the term "realism"; but its inexactitude strikes us again when we pass from Hals to Vermeer of Delft. Apart from one "Allegory" which shows his meager gift for rendering successfully a totally imaginary scene, and one mythological painting which lacks any sense of mythology whatsoever. Vermeer apparently painted only the outward aspect of daily life. He paints only the exterior: the objects appear to have been rendered just as they are in reality, both in paintings of people or in the *View of Delft* and in *The Street.* However. looking at them more closely, these scenes with figures, almost all of young women in an interior, appear by no means spontaneous, and show themselves to have been arranged with delicate precision. And to tell the truth, these women appear to belong to an unknown, mysterious demi-monde which is only hinted at. Vermeer has created a half-imaginary world of his own, a tiny ideal world full of *joie de vivre* and luxury, and has transfigured this world by the clarity and amazing harmony of his colors, and by the inoffensive simplicity of his ingenuous soul. In everything that Vermeer paints there float at one and the same time an atmosphere of memories of childhood, a dreamy calm, an utter stillness and elegiac clarity, which is too fine to be called melancholy. Realism? Vermeer leads us far from the grossness and nakedness of everyday reality.

But what remains most important is this: Vermeer has no thesis, no idea, not even, in the true sense of the word, any style.

RENÉ HUYGHE
Vermeer et Proust, 1936

Moreover, it is misleading to praise Vermeer for his *painstaking art* of *detail and imperceptibility.* In fact no painting is broader than Vermeer's, with its prodigiously accurate but dissolved touch, almost anonymous, applied in spreading pearls, scorning petty precision, and which, viewed from close at hand, as too few have remarked, gives the impression of a slightly blurred image not quite "in register"; in that respect his technique is the very opposite of realists like Dou, Netscher or Metsu.

What a narrow world do Vermeer's few characters inhabit, in two or three rooms at most, the tiling recognizable, and the windows with their familiar pattern of glass panes, the matching chairs with their lions' heads. The same objects recur, again and again, their symbolism emanating from them like a gentle glow of light: what a strange and pressing invitation to venture abroad resides in those huge bluish maps which take the place of pictures on the walls of this stifling little interior!

Everything suggests a human being tied to the most humdrum of exis-

tences, escaping only in his dreams: those shadowy rooms which so often have a window opening onto the sunny outdoors, those summonses from the external world in the form of letters, those geographers and astronomers exploring the world and space in the silence of their chambers.

Let us single out in particular the strange coincidence that introduces into so many of Vermeer's works the very object that one would choose to symbolize his art and poetry: the pearl. Vermeer has all its purity, its mystery, its perfect and perpetual soft-shining simplicity. His universe, closed and inward-looking, is as secret as that tiny sphere, pure as crystal and as water-lacking their transparency, it is true, but amply compensated by the full hard roundness of its form and its immaterial sheen.

AMBROISE VOLLARD
En écoutant Cézanne, Degas, Renoir, 1938

So one fine morning I took the train to Dresden where I had long wished to see the greart picture by Vermeer of Delft *The Courtesan.* In spite of its title, it is of a woman who looks the most straightforward of creatures. She is surrounded by young men, one of whom lays his hand on her breast so that one will be in no doubt that she is indeed a courtesan, a hand full of youth and color, standing out against a lemon-yellow bodice, powerful.

There is another Vermeer of great reputation: *The Painter in his Studio,* in Vienna, I would so love to have seen that! It's like Athens: all my life I have longed to go there.

PAUL CLAUDEL
L'oeil ecoute, 1946

A painting by Vrel, by Vermeer, by Pieter de Hooch, we do not look at it we do not caress it for a minute with a superior blink of the eye: at once we are inside it, we inhabit it. We are caught. We are contained by it. We experience its form all about us like a garment. We immerse ourselves in its atmosphere. We draw it in through our pores, through all our senses, and as if through the channels of the soul. And indeed the house in which we find ourselves, that too has a soul. Receiving, sorting and apportioning external illuminations, rather like our own mind. Inundated with the silence of the present moment. We observe the process by which external reality is transformed in our depths into shadow and reflection, and the registering, line by line, of the waxing or waning daylight as it strikes the screen we present to it. The succession of rooms and courtyards, that glimpse down there over the garden through an open door or up to the sky through a fanlight far from distracting us, gives us a more intimate enjoyment of our own depth and security. This is our private domain. A sudden touch sparks off in us a memory of an idea, the patient growing of the light models a figure and imparts volume.

There is someone, I will not say he is among the very greatest for greatness has nothing to do with it, but someone who is perfect rare, utterly exquisite, and if more adjectives are needed then they would be those that exist only in another tongue, "eerie," "uncanny." I have made you wait for his name: it is Vermeer of Delft. And at once, I am certain, there is emblazoned on your mind, like the colors of a coat of arms, that stirring contrast of heavenly blue and limpid yellow, as pure as Arabia! But it is not with colors that I am concerned here, whatever their quality, however enthralling the interplay between them, so precise and icily perfect that it seems to have been achieved rather by the operations of the mind than by the paintbrush. What fascinates me is the purity of this vision, honed, sterilized, cleansed of all that is material, of an almost mathematical or angelic candor—one might say simply photographic, although what a photograph! in which this painter, retreating behind his lens, captures the external world. The results can be compared only with the delicate marvels of the darkroom and those first impressions on the daguerreotype plate of figures drawn with a pencil more sure and more telling than that of

Holbein, I mean the ray of the sunlight. The canvas it strikes is like a sort of silvered surface of the mind, a magical retina, By means of this purification, this arresting of time in the action of the silvered glass, the external world is elevated into the paradise of necessity. Before our eyes a balance is created, where tone is measured in commas and atoms and where all lines and surfaces are united in the concert of geometry. I have in mind those compositions of squares and rectangles for which the pretext is supplied by an open harpsichord, a painter working at his easel, a geographical map on the wall, a half-opened window, the corner of a piece of furniture or the angle of a ceiling, formed by the meeting of three surfaces, the parallel lines of the rafters, the diamond patterns of tiles under our feet.

A. B. DE VRIES
Jan Vermeer van Delft, 1948

Rarely does the union of line, form, light and color produce such an absolute harmony as in the work of Jan Vermeer. When you look at his paintings, it is always the musical analogy that springs to mind: the rhythm that articulates the compositions he has devised and ordered, the melody that emerges from the harmony of his tones, his acute sensibility.

In seventeenth-century Holland, Vermeer was a unique phenomenon. In spite of his piercing gifts of observation and his realism, he always maintained a distance between himself and his surroundings. The domestic life so marvelously portrayed by the other Dutch painters interested him hardly at all. He had no sense of history and little enthusiasm for human dramas. For him, there can be little doubt what mattered supremely was to capture the varied play of the light.

His creative impulse arose not out of the vitality of an artist passionate to give form to ideas and events, but out of the intuitive certainty that contemplation alone was the source of painting.

Whatever efforts are made to achieve a greater understanding of the man and his work, no one will ever penetrate to the heart of the mystery that surrounds the master of Delft. Like the painting of the Venetian artist Giorgione, his art remains eternally seductive: both are possessed of infinite means of expression, and awaken in us sensations that are almost indefinable, tinged with a faint melancholy. Calm and equilibrium, the hallmarks of art that is objective and eternal, represent for us today an almost inaccessible ideal, and all of us whose minds have become too subtle, no longer capable of synthesis and simplicity, fall victim to Vermeer's spell. If you want to understand him at all, you have to be aware of the allusive character of his realism. The repetition of motifs and the use of the same details are indicative not so much of a lack of imagination as of a mental communion between the artist and the object, which for him has practically a symbolic value. By using a small number of figures and a few objects, Vermeer gives a simple interior a life of its own, in which the material and spiritual worlds meet. If he had lived in the fifteenth century, he would have been accounted one of the great primitives. But regarding him as he is, shaped by the seventeenth century, one senses rather that, in creating his prodigious *œuvre,* he was guided by the promptings of some sort of pantheistic mysticism. The name of Jacob Böhme has already been raised in this context.

ANDRÉ LHOTE
Traité de la figure, 1950

But the artist who most deserves study, because of the multiplicity of his concerns and many masterpieces, is Vermeer. Everything is there: construction in space, sumptuousness achieved precisely through a restriction of the palette and a masterly keeping of tone values, rigorous drawing, economy of modeling, extending even to the use of flat tints (the modulations obtained solely through the fragmentation of this mosaic of tones), reduced dimensions. And the result of such restraint of prodigality? A succession of masterpieces that are as shrouded in mystery as Rembrandts, as spare as the works of Piero della Francesca.

What is it then, that is so remarkable about this essentially modest painting, whose singularity and greatness passed unnoticed by so many connoisseurs?

It is not easy to analyze an *œuvre* that has no outstanding characteristic, that conceals its processes, in which an irreducible abstraction assumes always the outward show of necessity.

The art of Vermeer is an art of compromise. Vermeer almost always respects the integrity of continuous line, yet at the same time he subjects his forms to that phantasmagorical illumination which, as we have noted, frequently destroys the abstract purity of the line. It is a complex art that creates a synthesis of the two faces of nature, capable, like nature itself, of reconciling extremes.

It is important to understand the significance of *transitions* in Vermeer. It is by the blurring of contrasts that this great painter achieves the mystical lightening of his figures and strips them of the superfluity of minute detail. The great lesson of Vermeer, absorbed by Ingres and later Bonnard, lies in that much neglected precept: to give an ensemble its desired intensity without making it heavy with the multiplicity of values, you must reduce the secondary contrasts to musical modulations. This musicalization, if I may so call it, of the secondary plastic elements can be achieved only by transposing to pale blue those shadows that a less practiced eye tends to visualize as being the same color as the light, except darker.

ANDRÉ MALRAUX
Les voix du silence, 1951

At the age of thirty he was bored by anecdote; and in Dutch painting the anecdotal is all. The sincere sentimentalism of his "rivals" was quite alien to him; the only atmosphere he knew was of a lyricism arising above all from the subtle perfection of his art.

His anecdotes are not anecdotes, his atmospheres are not atmospheres, his sentiment is not sentimental, his scenes are barely scenes, twenty of his pictures (and we know of fewer than forty all told) contain only a solitary figure, and yet they are not precisely portraits. He seems always to strip his models of their individuality: obtaining, not types, but an extremely sensitive abstraction, not unreminiscent of certain Greek "Kouroi."

P. T. A. SWILLENS
Johannes Vermeer, 1950

He composed his pictures with a very great concern for accuracy, neglecting no detail, leaving nothing to chance.

The elements of the perspective are all strictly determined. It is impossible to say with any certainty whether these were arrived at mathematically, and if that was the case what method he used, or whether the effect was achieved simply by precise observation.

Whatever the truth, even though it did not represent any particular order of difficulty at the time, such exact perspective is not found in all painters of interiors.

If we look at Vermeer's work as a whole and break it down according to its various attributes, four principal elements emerge: light, color, stillness, silence.

Not one of these scenes is lit by anything but sunlight. Candle-flames and torches, moonlight, sharp contrasts of light and shadow, these interested him not in the least.

The leitmotiv is the interior scene, the town view, occasionally a portrait. These subjects are required to perform their variations on a symphonic theme in blue, yellow and red. In reach there is the same calm stillness, the same silent serenity, the same dream, the same thought, the same silence, the same exaltation, the same spiritual equilibrium, the same joy, the same gravity, the same dignity. If we destroy this unity, if we make additions, if we separate out certain elements, if we change the focus of the energy, if we modify the rhythm, if we disturb the stillness or interrupt the silence, then the painting is no longer the work of Jan Vermeer.

CHARLES DE TOLNAY
"L'atelier de Vermeer," *Gazette des Beaux-Arts,* Paris, 1953

As we will see, his sunlit harmony is not merely the result of a crude realism but is also the expression of a deep yearning in the artist's soul, a kind of vision of happiness.

The paintings of Vermeer could actually be regarded as the most perfect stilllifes ever produced in European art. Still lifes, that is, in the fundamental sense of that term—still, silent life. *Stilleben,* the vision of a perfect reality in which peace envelops all things and beings are transmuted almost to a substance, where objects and figures (treated as objects) subtly intimate that they are joined in some secret relationship. Where time seems to be suspended and daily life takes on the aspect of eternity. Vermeer's realism, although derived from the Dutch Caravaggisti, is nevertheless distinguished from the sometimes rather pedestrian realism of that group by its quality of lyricism. The composition of his paintings is utterly simple: the horizontal, vertical and diagonal lines supply a sort of armature within which the objects are disposed in their planes (usually three), these in turn being sharply differentiated by variations in scale. Vermeer likes to place very large objects in a corner of the extreme foreground, so that these appear to push back objects in the middle ground and at the rear of the pictures.

It is not difficult to see in this the influence of the sixteenth-century Italian tradition: essentially, these chairs and tables serve precisely the same function as the huge figures placed at the front of the canvas by the Italian Mannerists, except that here they have become still lifes. Vermeer's vision is cloaked in the visible appearances of naturalism, and it is that which accounts for the distinctive lyricism of the so-called "realism of Vermeer": the warm, fluid sunlight that penetrates the room is not that of everyday, it is the light of childhood: the magic of the past.

MARCEL BRION
Vermeer, 1963

Tha way the silence falls, lights and settles on beings and things, like something palpable, material, almost a kind of dust, that alone shows the extent to which Vermeer's art differs from that of his contemporaries, and although he takes on Hoogstraten or Fabritius at their own game (the *Memento Mori* of the one and the *View of Delft* by the other), he suppresses everything that might appear extraneous or smack of virtuosity. His mystery does not reside in shimmering enigmas: it is buried in the depths, and only he who has the key of this mystical world may join him there and understand. While Janssens and Pieter de Hooch may possess an ability analogous to his own in making time material—that time that settles over objects—the suspension of time in their work does not have the dramatic and almost desperate intensity it acquires in the pictures of Vermeer.

GIULIO CARLO ARGAN
L'Europe des capitales, 1964

When Pieter de Hooch and, even more so, Vermeer paint the limited span of a room, what they represent is a universal space, or, to put it another way, they represent in terms of the universal a particular act or situation. They do not abandon local color in favor of broad generality, as Rembrandt does. Rather, by making a series of choices and adjustments, they make local color coincide with the light of universal values, and succeed in obtaining the same intensity of light from all the colors in the picture. That is why Vermeer's forms, without owing anything to classical drawing, do have the quality of drawing, of precise measurement and proportion, a phenomenon that, at this high point of the century's painting, marks the meeting and synthesis of the Italian and Flemish traditions.

The third of the great "humanists" of the seventeenth century is Vermeer. He is also the closest in spirit to the ideas later propounded by the *illuminati.* In *The Art of Painting,* which, as has been suggested already, is a personal manifesto of his poetic creed, we are shown the artist turning his back on the world. In almost all the interiors, the back wall, sometimes in a series of planes, is hung with paintings, mirrors and tapestries: the picture is thus the image of a picture, the fiction of a fiction. It has its origin not in a desire to illustrate nature but rather to represent painting. And painting cannot represent, or be, anything but itself. Vermeer does not neglect in his painting that precept of classical art according to which all content, all intellectual significance must be fully realized in the formal construction. He resolves the problem, however, by adopting this new relationship of perception and cognition, in a manner that is entirely modern, with an anticipatory genius that is certainly more innovatory than that of painters who confined themselves to "classical history painting" or "classical studies after nature." It will be apparent that, although the spread of his fame was rapid, Vermeer's true importance has scarcely begun to be appreciated until the present day.

VITALE BLOCH
Vermeer, 1966

It would be pointless to try to uncover the secret of the "Sphinx of Delft." For us he will always remain, in Max J. Friedlaender's phrase, "a hummingbird among the sparrows." We would perhaps reach a better understanding of his art if we regarded it not as an exception that is in contradiction to its context, but as a sublimation of the Dutch way of life, of the Dutch taste for all that is polished, clean, tidy, bright, gleaming, and spotless; more or less a sublimation of the surface of things, the quiet life, the peaceful existence.

In the last analysis, the significance of the art of Vermeer is to raise what is in this world here below to a higher domain, translate it to the enchanted sphere of silence, whereas Rembrandt, on the contrary, attempted to bring the supernatural down into our world, among men. The strange seductiveness of Vermeer's poetry has lost none of its power in the age in which we live. I can think of two evidences of this, one from an Italian painter, the other from a novelist of the same nationality, Giorgio Morandi, whose work is at heart none other than a long meditation on silence in painting, spoke on his deathbed of the unforgettable impression made on him by the pictures of Vermeer at the exhibitions of Dutch painting in Milan and Rome; while Anna Banti, who otherwise inclined strongly toward the painting of the European Seicento, wrote on the occasion of a recent visit to Holland: "The Vermeers are the most beautiful pictures in the world!"

JORGE SEMPRUN
La seconde mort de Ramon Mercader, 1969

He would find himself on this side of the expanse of gray water, over which some bright patch of sky cast shimmering reflections, but which, curiously, did not at all appear to reflect the hazy light of a sun one assumed was suspended somewhere above the landscape, but rather seemed itself to be the source of this iridescent light. causing it to well up from its own depths, as if beneath the flat and apparently sleepy surface of the water some obscurely luminous force were surreptitiously gnawing away at the gray shadow of the canal and the crumbling, mossy stones of the quayside, blank façades, rising up like a sheer cliff, ocher and tinged with blue, above the dead waters—at least they seemed dead at first sight—and pierced, simply, by the yawning gap, ravaged with brilliance, of the arch of a bridge on a side canal, and by the equally yawning gaps, though these of a perceptible opacity, of a few deep and massive gateways on the wharfs.

Anyway, in the silence he would contemplate this town, familiar, known in all its guises, yet unpredictable, capable of surprising, and, in a blissful state of peaceful contemplation, he might wonder about the significance of this surprise, this thudding heart that immobilized him where he stood—

there was a cliched phrase that after all expressed just what he had felt, with precisely that hint of melodrama that often characterizes the cliché, for indeed *his blood froze in his veins* at the sight of this familiar yet astounding landscape—that rooted him to the spot on this sandy bank, to the right of and slightly back from the visible figures, as though he had himself been the final, invisible figure in the picture, as though the painter—three centuries before—amused, had predicted his arrival, the position he would occupy, and the angle of his vision, and even this premonitory beating of his heart, only at once to deny them, refusing to paint the figure whose presence he may have divined, making him invisible, or even making him dissolve away in a final sequence of precise little brushstrokes, into the brownish sand, into the shimmering water, into the deeper shadow of the towers by the canal replete with light.

MAURICE MERLEAU-PONTY
La prose du monde, 1969

Malraux supplies a profond insight when he demonstrates that what "a Vermeer" means for us is not that a canvas painted one day was by the hand of a man called Vermeer, rather that it is the realization of the "Vermeer structure," or that it speaks the language of Vermeer, or in other words observes the particular system of equivalences that makes all the moments of the picture, like one hundred needles on one hundred compass dials, indicate precisely the same immutable deviation. If as an old man Vermeer painted in dribs and drabs a picture that lacked coherence, it would not be a "genuine Vermeer." But if on the other hand a forger managed to reproduce not only the brushwork but the style of the great Vermeers, he would be something rather more than a forger. He would be one of those painters who worked in the studios of the great classical painters and painted for them. True, that is not possible: to be capable of imitating Vermeer's style after centuries of other painting, and when the concerns of painting have shifted, the forger would have to be a painter himself, and then he would not paint "fake Vermeers" but, in between two original pictures, would do a "study after Vermeer" or an "homage to Vermeer," in which he would put something of himself.

ANDRÉ CHASTEL
Fables, forms, figures, 1978

There is a striking regularity and authority about Vermeer's frontal views, which forces us to the conclusion that the paintings, maps and mirrors that appear so frequently in his compositions were for him an indispensable means of enlivening the surfaces. The inset picture may be further emphasized by being framed within a doorway leading into the room that contains it (*The Love Letter,* Rijksmuseum), or by the introduction of a direct proportional relationship, such that it is an exact reduction of the dimensions of the larger canvas (*Lady Seated at a Virginal,* London). In all these instances the picture, so prominently displayed, tends to take on an exaggerated importance, as though it were intended to supply the key to the psychological theme of the work as a whole. That suspicion is particularly difficult to dismiss in a painting such as *Lady Seated at a Virginal,* where the motif of Eros triumphant precisely echoes the satisfied air of the model. But Vermeer's intentions are complex, perhaps inaccessible. Possiby they seem so to us precisely because the motif of the inset picture is equally adept at fulfilling its iconographical and morphological functions. The resonant power of the motif is but one of the elements exploited by Vermeer in his virtuoso explorations.

MICHEL SERRES
"L'ambroisie et l'or," Hermès III, 1974

Through the fixed point, representation is made logical, and argument acquires the capacity to be represented, In the fixed point the classical age is subsumed and focused. Delicately, with her hand, her lowered gaze, the woman weighing gold designates that point, and Vermeer's scheme divides naturally into four sections. Starting from the still center, this point of origin, we can embark on a discussion of the picture, fill in the horizon and the vertical axes. The sun gazes down from infinity, through the high window, and indicates the spot the light strikes it, symmetrical with the visible direction of the woman's hidden gaze. Thus, two bisectors of the quadrants, appearing as diagonals. The infinite and the finite coinciding in the shape of a fan. As the century perfected its simple machines, it finally discovered the highly effective technique of the fixed anchor point, the still center which multiplies the degree of force applied against it. All that remained to do was mechanize it, make it mathematically precise, speak or write it in universal langage: then its dominion extended into the cultural sphere as well. Geometry developed its variations from the center outward, astronomy and politics orientated themselves from the sun, and all the forms of representation followed suit. The hand of the woman weighing gold, a hand that is graceful yet firm, holds and designates the real point on either side of which the scales are in equilibrium. Her gaze, under lowered eyelids, points where to look.

The scales heavy with the calm of that still center. Governed by the arm and the three verticals. The geometric center of the picture, the static pole of balanced equality. Golden mean, reference point. Cartesian space. Four quadrants on the back wall and, indeed, in the top right, a second picture. So, Descartes everywhere: horizon, verticals, perpendiculars, the central point of reference echoed in every place where there are man-made objects. Relationship of the hand to this point: the subject of the picture. And the light and the woman's gaze, along the diagonals of the first two quadrants. lead down to the point where they intersect. What is the theme, if not the spot where the ray of sunlight meets the direction of a look?

GILLES AILLAUD
Vermeer et Spinoza, 1984

It is true that many of the very greatest artists are like skies massed with cloud, they insist on subjecting our ears and eyes to a thunderstorm before they will let a patch of blue appear. They are, like saints and heroes, restless spirits. They see the world from where they stand, and it never occurs to them to seek out a better vantage point. But the essential is not to reveal the pandemonium that is hidden in the clouds of the human spirit. but rather the force of necessity, the pacific power of nature in whose delicate embrace we live. Which is why, however impressive and exhilarating certain poetic transports may be, yet it is clearly the smallest transference that is the most poetic. It is in this that Vermeer shows himself a great master. Not a saint or a hero, but a sage, sitting in the middle of a whirlwind of atoms, as though occupying the tiny space we usually refer to as the "mechanical point" of a lens, the zone in which rays emanating from a single point meet after refraction, the best point from which to view the organization of matter, in all respects the ideal vantage place.

Chronology
by Philippe Resche-Rigon

1609. Start of a twelve-year truce between Spain and the United Provinces, marking the de facto recognition of the independence of the seven northern provinces.

1615. Marriage in Amsterdam of Reynier Jansz. Vos and Digna Baltens, future parents of Vermeer; shortly afterward they move to Delft, where they run an inn on the Market Square.
Birth of Emanuel de Witte (died 1692) in Alkmaer.
Birth of Salvator Rosa (died 1673).

1616. Birth of Ferdinand Bol (died 1680), future pupil of Rembrandt, in Dordrecht.
Birth of Eustache le Sueur (died 1655).
Death of Shakespeare.

1617. Birth of Gerard ter Barch (died 1681) in Zwolle.

1618. Defenestration of Prague and start of the Thirty Years' War.

1619. Foundation of town of Batavia in Java as headquarters of the Dutch East India Company.
Birth in Rotterdam of Willem Kalf (died 1693), later to be a pupil of Rembrandt.
Death of Hendrick Terbrugghen (born Deventer, 1588) in Utrecht.
Birth of Charles Lebrun (died 1690).

1620. Birth of Nicolaes Berchem (died 1683) in Haarlem.
Bacon writes the *Noveum Organum.*

1621. Resumption of hostilities between the United Provinces and Spain, against the background of the more widespread conflict of the Thirty Years' War.
Birth of Adam Pijnacker (died 1673), who moves to Delft in c. 1649.
Birth of Gerbrand van der Eechout (died 1674), a future pupil of Rembrandt.

1622. Birth of Carel Fabritius (died 1654) in Midden-Beesmster.
Dirck van Baburen paints *The Procuress,* later the property of Vermeer's mother-in-law and represented by Vermeer in *Lady Seated at a Virginal.*

1623. Death of Domenico Fetti (born 1589).

1624. Death in Utrecht of Dirck van Baburen (born Utrecht, 1590).
Death of Willem Buytewech (born 1591/92), one of the first painters of interiors.
Bernini is put in charge of building operations at St. Peter's, Rome. He creates the magnificent bronze canopy under the dome.

1625. Death of Maurice of Nassau. He is succeeded as Stadholder by his brother Frederick Henry, grandson of Admiral de Coligny. Under his wise and conciliatory rule, the authority of the Orange dynasty is consolidated.

Birth of Willem van Aelst (died 1683).
Death of Jan Brueghel, called "Velvet Brueghel" (born 1568).
Rubens paints *The Coronation of Marie de' Medici.*
Hugo de Groot. called Grotius (1583-1645). publishes in exile *De jure belli et pacis,* establishing the fundamental principles of international law.

1626. Birth of Jan Steen (died 1679) in Leiden.
First painting by Pieter Jansz. Saenredam (1597-1665), *Christ Driving the Money-lenders from the Temple.*
Founding of New Amsterdam, later called New York.

1627. Birth of Samuel van Hoogstraten (died 1678).

1628. Leonaert Bramer, believed by some to have been Vermeer's master, returns to Delft after a visit to Italy.
Birth of Jacob van Ruysdael (died 1682) in Haarlem.
William Harvey discovers circulation of the blood.

1629. Capture of Hertogenbosch by the United Provinces.
Birth of Gabriel Metsu (died 1667) in Leiden.
Birth of Pieter de Hooch (died 1684) in Rotterdam. Descartes moves to Holland.

1631. Reynier Jansz. Vos becomes a member of the painters' guild (Guild of Saint Luke) and sets up in business as an art dealer.

1632. Birth of Vermeer, second child of Reynier Vos and his wife, Digna, who already have one daughter.
Birth in Delft of Anthony van Leeuwenhoeck (died 1723), who is to become a distinguished scientist, known for improvements in the microscope and for the discovery of blood corpuscles and spermatozoa. In connection with his official duties in the Delft municipality, he is to play a part in the settlement of Vermeer's estate.
Birth of Spinoza (died 1677) in Amsterdam.
Denunciation of Galileo.

1633. Calderón writes *Life Is a Dream.*

1634. Alliance of the United Provinces and France against Spain.
Birth of Nicolaes Maes (died 1693) in Dordrecht.
Gassendi publishes *Apologia for Epicurus.*

1635. Birth of Frans van Mieris (died 1690).

1636. Birth of Adriaen van der Velde (died 1672).
Nicolas Poussin paints *Rape of the Sabine Women.* Corneille writes *Le Cid.*
Capture of Breda by Frederick Henry of Nassau. Descartes writes *Discourse on Method.*

1638. Death of Adriaen Brouwer (born 1605) in Antwerp.
Francesco Borromini begins work on the church of S. Carlo alle Quattro Fontane, Rome.
Cornelius Jansen, Bishop of Ypres, writes *Augustinus,* completed only a few days before his death.

1639. Admiral Tromp leads the Dutch navy to a triumphant victory over the Spanish fleet in the battle of the Dunes.

1640. Death of Rubens (born 1577) in Antwerp.

1641. Death of Van Dyck (born 1599) in London.
Death of Domenichino (born 1 581) in Naples.

1642. Emanuel de Witte (born 1615) is admitted to the guild of painters in Delft; he remains in the town until 1651.
Rembrandt paints *The Night Watch.*
Death of Guido Reni (born 1575) in Bologna.
Death of Galileo.
Birth of Newton (died 1727).

1643. Willem van Aelst (1625-83), pupil of his uncle Evert van Aelst (1602-52), is admitted to the painters' guild in Delft. He is to revive the tradition of still life.

1644. Publication of Dutch translation of Cesare Ripa's *Iconologia.*

1645. Birth of Aert de Gelder (died 1727) in Dordrecht; he is to be one of Rembrandt's last pupils.
François Mansart begins building the Val de Grace.

1646. Paulus Potter (1625-54) joins the painters' guild in Delft; he is to leave the town in 1649.

1648. Treaty of Westphalia marks the end of the Thirty Years' War.
In January, signing in Munster of a separate peace accord between the United Provinces and Spain signals definitive recognition of the independence of the United Provinces.
Jacob van Loa (1614-70) paints *Diana and her Companions.*
Death of Louis Le Nain (born 1593).
Claude paints *The Embarkation of St. Ursula.*
Insurrection of the Fronde in France.

1649. Death of Simon Vouet (born 1590).
Charles I of England beheaded.

1650. Death of William II, Count of Nassau, Prince of Orange.
Holland, followed by five other provinces, decides to abolish the office of Stadholder, thus bringing to an end the rule of the Orange dynasty and ensuring the dominance in the future of the republican aristocracy of the province of Holland.
Gerard ter Barch (1617-1681) begins to specialize

in genre painting. Rembrandt paints *The Man with the Golden Helmet.*

Death of Descartes in Sweden.

1651. Cromwell passes the Navigation Act, which restricts imports to England to goods carried in English vessels; the act marks an intensification of rivalry between England and Holland as trading nations.

Death of Jacob Backer (born 1608).

The Dutch colonize the Cape of Good Hope.

Start of the first Anglo-Dutch war.

Death of Vermeer's father.

Death of Evert van Aelst (born 1602).

Carel Fabritius enrolls in the Guild of Saint Luke. That same year he paints his *View of Delft.*

Death of Georges de La Tour (born 1593).

1653. John de Witt appointed "council pensionary" of the province of Holland.

Death of Admiral Tromp in a naval engagement.

Marriage of Vermeer and Catharina Bolnes.

Aged 21, Vermeer is enrolled as a master in the Guild of Saint Luke.

Hals is now age 73, Saenredam 56, Rembrandt 47, Dou 40, ter Borch 36, de Hooch 34, Metsu 34, Fabritius 31, Steen 27, Maes 19.

Jan Steen paints *Christ in the House of Mary and Martha.*

1654. Treaty of Westminster brings to a close the war between England and the Dutch.

Between now and 1656, probable date of execution of *Christ in the House of Mary and Martha* and *Diana and her Companions.*

Carel Fabritius paints *The Goldfinch,* and his colleague in Dordrecht.

Samuel van Hoogstraten, executes the earliest known trompe-l'œil painting, or "cheater."

Explosion of the powder magazine in Delft; Fabritius is killed in the disaster.

Daniel Vosmaer and Egbert van der Poel begin to paint a series of views of Delft, showing the town as it looked after the explosion; there, together with works by Fabritius and Saenredam, are the first true city views.

Jan Steen runs the Snake brewery; he is to leave Delft in 1657.

Death of Paulus Potter (born Enkhuizen, 1625) in Amsterdam.

1655. Nicolas Maes paints the *Idle Servant.*

Pieter de Hooch enters the Guild of Saint Luke; he is to leave Delft in 1660.

Opening of the town hall of Amsterdam, built by J. van Campen (1595-1657). The interior decorations are the work of the Antwerp painter Erasmus Ouellinus.

Velasquez paints the *Venus and Cupid* in the National Gallery, London.

1656. Date inscribed on *The Procuress.*

Death of Gerrit van Honthorst (born Utrecht. 1590).

Death of Dirck Hals (born 1591).

Christian Huygens (1629-1695) uses the pendulum to regulate clock movements.

Velasquez paints *Las Meninas.*

Work begins on Bernini's colonnades in St Peter's Square. Pascal writes *Les Lettres provinciales.*

1657. Probable date of *Girl Asleep at a Table.*

1658. Probable date of *Soldier with a Laughing Girl.*

Date of the finest urban landscapes by Pieter de Hooch, on the theme *The Courtyard of a House in Delft.*

Frans van Mieris the Elder paints *The Duet.* Death of Cromwell.

1659. Probable date of *Girl Reading a Letter at an Open Window.*

Huygens identifies the rings of Saturn.

1660. Probable date (or 1661?) of *The Milkmaid* and *A Lady Drinking and a Gentleman.*

Death of Velasquez (born 1599).

Restoration of the monarchy in England with accession of Charles II.

1661. Probable date of *The Little Street* and the *View of Delft.*

Spinoza starts writing *Ethics.*

Death of Mazarin and inauguration of the absolute monarchy of Louis XIV.

1662. Vermeer is elected an officer of the Guild of Saint Luke.

Probable date of *Woman with a Lute near a Window, A Lady and Two Gentlemen, Woman with a Water Jug.* Between 1662 and 1665, probable date of *Woman with a Pearl Necklace, Woman in Blue Reading a Letter, Woman Holding a Balance* and *The Art of Painting.*

Death of Pieter Saenredam (born 1597) in Haarlem.

1663. New Amsterdam is seized by the English and renamed New York.

Visit of Balthasar de Monconys to Delft and his meeting with Vermeer, recorded in his travel journal.

1664. Probable date of birth of Johannes, one of the two known sons of Vermeer.

Probable date of *The Music Lesson* and *The Trio.*

Frans Hals paints *The Regentesses of the Old Men's Almshouses, Haarlem.*

Publication by Spinoza, in The Hague, of *Geometric Version of Descartes' Principia and Metaphysical Thoughts.*

Occasion of the "fête de l'île enchantee" at Versailles.

Death of Francisco Zurbaran (born 1598).

1665. Start of the second Anglo-Dutch war, which is to last until 1667.

Probable date of *Woman with a Pearl Necklace.*

Death in Rome of Nicolas Poussin (born 1594). Molière writes *Don Juan.*

1666. Probable date of *Writing Lady in Yellow Jacket* and *Lady with a Maidservant Holding a Letter.*

Death of Frans Hals (born Antwerp, 1580) in Haarlem.

Death of Gerrit van Honthorst (born Utrecht, 1590); together with Terbrugghen and van Baburen, he was one of the preeminent Utrecht Caravaggisti.

Death of Guercino (born 1591).

Louis XIV invades the Spanish Netherlands.

1667. Admiral de Ruyter sails his navy into the mouth of the Thames and, in a daring raid on the Medway, destroys the English fleet.

Treaty of Breda marks the end of hostilities between England and the Netherlands: the United Provinces definitively relinquish their claim to New Amsterdam but retain Surinam and Pula Run in the Moluccas. Probable date of *The Love Letter.*

Description of the Town of Delft by Dirck van Bleysweyck, which contains a reference to Vermeer.

Death of Gabriel Metsu in Amsterdam, of Cornelis van Poelenburgh (born 1586) in Utrecht, and of Christiaen van Couwenbergh (born 1604).

1668. The Triple Alliance (England, the United Provinces, and Sweden) halts French conquest of the Spanish Netherlands. Signing of the peace of Aix-a-chapelle.

1669. Date inscribed on *The Geographer.*

Death of Rembrandt (born Leiden, 1606) in Amsterdam.

Death of Pietro da Cortona (born 1596).

1670. On his mother's death, Vermeer inherits the Mechelen inn. He is again elected to hold office in the Guild of Saint Luke.

Probable date of *Lady Standing at a Virginal* and *The Lacemaker* (or 1671?).

Publication of Pascal's Pensées.

Spinoza writes *Tractatus Theologico-Politicus.*

1672. Louis XIV, having successfully undermined the Triple Alliance, invades the United Provinces. The Dutch open the dikes and manage to hold the French within a day's march of Amsterdam. John de Witt and his brother are held responsible for the invasion and are massacred on 20 August.

Once more Vermeer is elected as an official of the Guild of Saint Luke. He is asked, together with Johannes Jordaens and other painters from The Hague, to appraise a collection of Italian pictures in a transaction between a dealer and the Elector of Brandenburg.

Probable date (between 1672 and 1674) of *Allegory of Faith* and *Head of a Girl.*

1673. The French army is finally expelled from Dutch territory, but not before its soldiers have laid waste large areas of the country.

Date of a deed in which Vermeer's mother-in-law gives him power of attorney to handle her affairs.

Death of Adam Pijnacker (born 1621) and Anthony Palamedesz. (born 1601).

1674. Marriage of Vermeer's eldest daughter, the only one of his children to marry in his lifetime.

Probable date of *Lady Seated at a Virginal* (or 1675?).

Death of Philippe de champaigne (born 1602).

1675. Vermeer makes a last trip to Amsterdam to borrow 1,000 guilders.

Death of Johannes Vermeer; according to the register of the church where he is buried, he leaves eight underage children.

Death of Gerard Dou in Leiden (born Leiden, 1615).

1676. Vermeer's widow consults a notary to formally acknowledge a debt to the baker van Buy ten, to whom she hands over two paintings. She gives 26 pictures to a dealer in Amsterdam and transfers title of *The Art of Painting* to her mother, probably to keep it from her creditors.

Inventory of Vermeer's possessions, which lists three works by Fabritius and two portraits by van Hoogstraten.

Vermeer's wife is forced to declare herself bankrupt. Anthony van Leeuwenhoeck is designated to administer her affairs.

1677. Death of Spinoza.

Van Leeuwenhoeck discovers spermatozoa.

1678. The settlement of Nijmegen concludes hostilities between France and her adversaries.

Death of Jacob Jordaens (born 1593) in Antwerp.

Death of Samuel van Hoogstraten (born 1627).

Death of Pieter codde (born 1599/1600).

Hardouin-Mansart takes over construction of the Palace of Versailles.

1681. Death of Vermeer's mother-in-law.

Death of Gerard ter Barch in Deventer.

1682. Following the death of his wife, the Delft printer Jacob Dissius draws up an inventory of his possessions; at this time he owns 19 Vermeers. Death of Claude (born 1600) in Rome.

1684. Death of Adriaen van Ostade (born Haarlem, 1610) in Haarlem.

1688. Death of Vermeer's wife, Catharina.

1696. Sale at auction in Amsterdam of what is probably the Dissius collection, including 21 pictures by Vermeer.

1699. Sale of *Allegory of Faith* (400 florins).

1781. Joshua Reynolds mentions *The Milkmaid* as among the paintings he saw during a visit to the Netherlands.

1789. Andreas Bonn, professor of anatomy in Amsterdam, refers to Vermeer as one of the most remarkable of Dutch painters.

1800. Christiaan Josi, a Dutch art dealer and engraver, praises the outstanding merits of Vermeer's painting.

1822. *View of Delft* is acquired by the newly opened Mauritshuis.

1866. Date of the first articles by E. J. Th. Thore (Thoré-Bürger) on the "Sphinx of Delft," in *La Gazette des Beaux-Arts*.

Abbreviated Literature

Bleyswyck: D. van Bleyswyck, *Beschryvinge der Stadt Delft,* printed by Arnold Bon, bookseller on the Marct-velt, Delft, 1667.

Bloch: V. Bloch, *Tutta la Pittura di Vermeerdi Delft,* Milan, 1954 (English edition: *All the Paintings of Jan Vermeer, 1963).*

Boogaard-Bosch: A. C. Boogaard-Bosch, "Een onbekende Acte betreffende den Vader van jan Vermeer," in *Nieuwe Rotterdamsche Courant,* 25 January 1939.

Bouricius: L. G. N. Bouricius, "Vermeeriana," in *Oud-Holland* 42, 1925, p. 271.

Bredius 1885: A. Bredius, "Iets over Johannes Vermeer," in *Oud-Holland* 3, 1885, p. 217 ff.

Bredius 1910: A. Bredius, "Nieuwe bijdragen over Johannes Vermeer," in *Oud-Holland* 28, 1910, p. 61 ff.

Bredius 1916: A. Bredius, "Italiaansche schilderijen in 1672 door Haagsche en Delftsche schilders beoordeeld," in *Oud-Holland* 34, 1916, p. 88ff.

Bredius, Schilderijen: A. Bredius, "Schilderijen uit de nalatenschap van den Delftschen Vermeer," in *Oud-Holland 34,* 1916, p. 160ff.

Brown: chr. Brown, *Carel Fabritius, Complete Edition with* a *catalogue raisonné,* Oxford, 1981.

Bürger: W. Bürger, "Van der Meer de Delft," in *Gazette des Beaux-Arts* 21. 1866, pp. 297-330, 458-70, 542-75.

Van Gelder 1956: J. G. van Gelder, "Diana door Vermeer en C. de Vos," in *Oud-Holland* 71, 1956, p. 245 ff.

Van Gelder 1958: J. G. van Gelder. with comments by J. A. Emmens, *De schilderkunst van Jan Vermeer,* Utrecht, 1958.

Gerson: H. Gerson, "Johannes Vermeer," in *Encyclopedia of World Art,* New York/Toronto/ Londen, XIV, 1967, col. 739 ff.

Goldscheider: L. Goldscheider, *Johannes Vermeer, the Paintings,* London, 1967².

Gowing: L. Gowing, *Vermeer,* London, 1952 (second edition, London, 1971).

Gudlaugsson 1959: S. J. Gudlaugsson, *Gerard ter Borch,* 2 vols" The Hague, 1959.

Gudlaugsson 1968: S. J. Gudlaugsson, "Kanttekeningen bij de ontwikkeling van Metsu," in *Oud-Holland* 83, 1968, p. 13 ff.

Gudlaugsson, Kindler: S. 1. Gudlaugsson, "Johannes Vermeer," in *Kindlers Malerei Lexicon V, Zürich,* 1968, *p. 657 ff.*

Haskell: F. Haskell. *Rediscoveries in Art. Some Aspects of Taste, Fashion and Collecting in England and France,* London, 1976.

Hoet: G. Hoet. *Catalogus of Naamlijst van Schilderijen, met derzelver prijzen,* 2 vols" The Hague, 1752; vol. 3 by P. Terwesten, The Hague, 1770.

Hofstede de Groot: C. Hofstede de Groot. *A Catalogue Raisonné of the Works of the Most Eminent Dutch Painters of the Seventeenth Century,* 9 vols., London, 1908 ff. (where no vol. is indicated: vol. 1, p. 587 ff.).

De Jongh 1967: E. de Jongh, *Zinne- en minnebeelden in de Schilderkunst van de 17e eeuw, 1967.*

De Jongh 1976: E. de Jongh et al., exhibition catalogue *Tot Lering en Vermaak,* Rijksmuseum, Amsterdam, 1976.

Koslow: S. Koslow, "De wonderlijke Perspectiefkast: An aspect of seventeenth-century Dutch Painting," in *Oud-Holland* 82, 1967, p. 35 ff.

MacLaren: N. MacLaren, *National Gallery catalogues, The Dutch School,* London, 1960.

Manke: I. Manke, *Emanuel de Witte 1617-1692,* Amsterdam, 1963.

Mayer-Meintschel: Anneliese Mayer-Meintschel. "Die Briefleserin von Jan Vermeer van Delft—zum Inhalt und zur Geschichte des Bildes," in *Jahrbuch der Staatlichen Kunstsammlungen Dresden* 11, 1978/79 (published in 1982), Dresden, 1982, pp. 91-99.

Mirimonde: A. P. de Mirimonde, "Les sujets musicaux chez Vermeer de Delft," in *Gazette des Beaux-Arts* 103, 6th series, vol. 57, January/June 1961, pp. 29-50.

Montias 1977: J. M. Montias, "New Documents on Vermeer and his family," in *Oud-Holland* 91. 1977, pp. 267 -87.

Montias 1980: J. M. Montias, "Vermeer and his Milieu: Conclusion of an Archival study," in *Oud-Holland* 94, 1980, pp. 44-62.

Montias 1982: J. M. Montias, *Artists and Artisans in Delft. A Socio-Economic Study of the Seventeenth Century,* Princeton, 1982.

Montias 1987: J. M. Montias, "Vermeer's Clients and Patrons", in *The Art Bulletin* 69, 1987, pp. 68 - 76.

Murray; (Sir John Murray), *Tour in Holland in the year MDCCCXIX,* London, 1824 (N.B.: reports also on journeys of 1822 and 1823).

Naumann: Otto Naumann, *Frans van Mieris (1635-1681) The Elder,* 2 vols., Doornspijk, 1981.

Neurdenburg 1942: E. Neurdenburg, "Johannes Vermeer. Eenige opmerkingen naar aanleiding de nieuwste studies over den Delftschen Schilder," in *Oud-Holland 59,* 1942, p. 65 ff.

Neurdenburg 1951: E. Neurdenburg, "Nog enige opmerkingen over Johannes Vermeer van Delft," in *Oud-Holland 66,* 1951. pp. 33-44.

Obreen: F. D. O. Obreen, *Archief voor Nederlandsche Kunstgeschiedenis,* 7 vols., Rotterdam, 1877-90.

Van Peer 1946: A. J. J. M. van Peer, "Was Jan Vermeer van Delft Katholiek?" in *Katholiek Cultureel Tijdschrift* 2, 1, 1946, pp. 468-70.

Van Peer 1951: A. 1. 1. M. van Peer, "Rondom Jan Vermeer van Delft: de kinderen van Vermeer," in *Katholiek Cultureel Tijdschrift* Streven, New Series 4, 1 no. 6, 1951, pp.615-26.

Van Peer 1957: A. J. J. M. van Peer, "Drie collecties schilderijen van Jan Vermeer," in *Oud-Holland* 72, 1957, p. 92 ff.

Van Peer 1959: A. J. J. M. van Peer, "Rondom Jan Vermeer van Delft," in *Oud-Holland* 74, 1959, p. 240 ff.

Van Peer 1968: A. 1. J. M. van Peer. "Jan Vermeer van Delft: drie archiefvondsten," in *Oud-Holland* 83, 1968, p. 220 ff.

Rosenberg-Slive: J. Rosenberg, S. Slive, E. H. ter Kuile, *Dutch Art and Architecture 1600 to 1800,* Harmondsworth, 1966.

Slive: S. Slive, "'Een dronke slapende meyd aen een tafel' by Jan Vermeer," in *Festschrift Ulrich Middeldorf,* Berlin, 1968, pp. 452-59.

Stechow: W. Stechow, "Landscape Paintings in Dutch Seventeenth-Century Interiors," in *Nederlands Kunsthistorisch Jaarboek* 11, 1960, pp. 165-84, in particular pp. 177 -80.

Sutton 1980: P. C. Sutton, *Pieter de Hooch, Complete Edition,* Oxford, 1980.

Sutton 1984: P. C. Sutton et al., exhibition catalogue *Masters of Seventeenth-Century Dutch Genre Painting (Von Frans Hals bis Vermeer. Meisterwerke holländischer Genremalerei),* Philadelphia Museum of Art; Berlin-Dahlem, Gemäldegalerie; London, Royal Academy of Arts, 1984.

Swillens: P. T. A. Swillens, *Johannes Vermeer, Painter of Delft 1632-1675,* Utrecht/Brussels, 1950.

Thieme-Becker: U. Thieme, F. Becker. *Allgemeines Lexikon der bildenden Künstler von der Antike bis zur Gegenwart,* 36 vols., Leipzig, 1907-47.

Van Thienen: F. van Thienen, *Vermeer,* Amsterdam, n.d. *Trautscholdt:* E. Trautscholdt. "Johannes Vermeer," in *Thieme-Becker,* vol. XXXIV, 1940, p. 265 ff.

Valentiner: W. R. Valentiner, "Zum 300. Geburtstag Jan Vermeers. Oktober 1932, Vermeer und die Meister der holländischen Genremalerei," in *Pantheon* 10, 1932, p. 305 ff.

De Vries: A. B. de Vries, *Jan Vermeer van Delft,* Basel. 1948².

Walsh and *Sonnenburg:* J. Walsh, Jr., "Vermeer," in *The Metropolitan Museum of Art Bulletin* 31, no. 4, summer 1973, p. 17 ff., followed by H. von Sonnenburg, "Technical Comments."

Welu: J. A Welu, "Vermeer: His cartographic Sources," in *The Art Bulletin* 57, 1975, pp. 526-47.

Wheelock 1977: A. K. Wheelock, Jr., *Perspective, Optics and Delft Artists around 1650,* New York/London, 1977.

Wheelock 1977, Review: A. K. Wheelock, Jr.: Review of "Albert Blankert, Johannes Vermeer van Delft," in *The Art Bulletin* 59, 1977, pp. 433-41.

Wheelock 1978: A. K. Wheelock, Jr., "Zur Technik zweier Bilder die Vermeer zugeschrieben sind," in *Maltechnik, Restauro* 4, 84, October 1978, pp. 242-58.

Wheelock 1981: A. K. Wheelock, Jr., *Jan Vermeer,* New York, 1981.

Wheelock 1981. Art Journal: A. K. Wheelock, Jr., "Vermeer's Painting Technique," in *Art Journal* 41. no. 2, summer 1981. pp. 162-64.

Wichmann: H. Wichmann, *Leonaert Bramer, sein Leben und seine Kunst,* Leipzig, 1923.

Index